SO-AEC-692

# DRESSED

SEP 0 6 2013

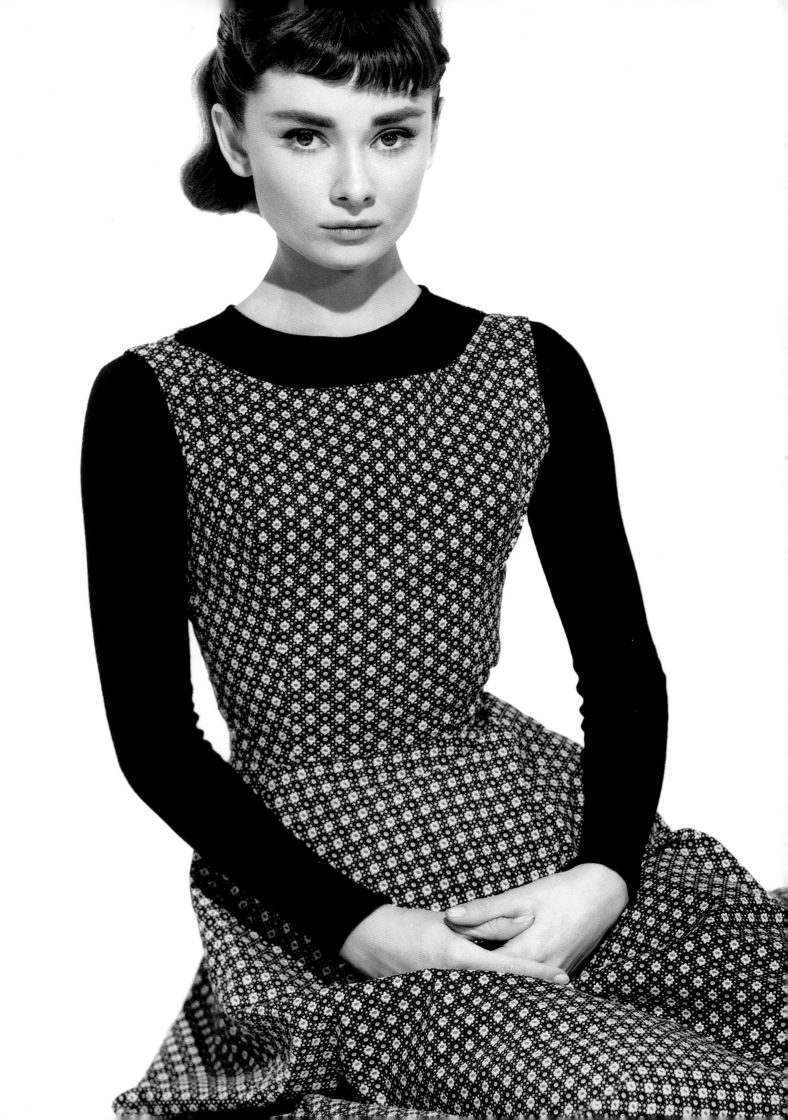

Columbia College Library
600 South Michigan
Chicago, IL 60605

WITHDRAWN

# DRESSED

## A CENTURY OF HOLLYWOOD
## COSTUME DESIGN

Deborah Nadoolman Landis

Collins
*An Imprint of* HarperCollins*Publishers*

ALSO BY DEBORAH NADOOLMAN LANDIS

*Screencraft: Costume Design*
(as editor)

*50 Designers/50 Costumes: Concept to Character*
(as editor)

For John

*L'enfer, c'est les autres.*
—Jean-Paul Sartre

DRESSED. Copyright © 2007 by Deborah Nadoolman Landis. All rights reserved. Printed in China. No part of this book may be used or reproduced in any manner whatsoever without written permission except in the case of brief quotations embodied in critical articles and reviews. For information, address HarperCollins Publishers, 10 East 53rd Street, New York, NY 10022.

HarperCollins books may be purchased for educational, business, or sales promotional use. For information, please write: Special Markets Department, HarperCollins Publishers, 10 East 53rd Street, New York, NY 10022.

Library of Congress Cataloging-in-Publication Data is available upon request.

ISBN 978-0-06-081650-6

12 13 14 SCP 10 9 8 7 6 5 4

# Contents

# Foreword

## BY ANJELICA HUSTON

If there is a seminal moment in my relationship to costume and entertainment, the occasion that springs to mind is an Irish summer. I must have been four or five years old. My brother and I were running feverishly from our dress-up hamper in the nursery into my mother's bedroom, trying to outdo each other in costume originality for the grown-ups. Suddenly, I hit a wall: I'd run out of clothes. A brainwave, however, caused me to strip down, sprinkle a liberal amount of talcum powder on my bare rear end, and triumphantly declare, "I'm Japanese." This action had a brilliant effect on my parents. They laughed heartily. I remember so well the triumph and elation of that moment; I think it was then that I clearly decided to be an actress.

Another early inspiration, Dorothy Jeakins, designed costumes for everyone from Cecil B. DeMille to my father, John Huston. Dorothy was a great friend of my mother's, and I credit her as much as I do my parents for drawing me into the magical world of costume and transformation. She was tall—taller than any other woman I can remember when I was growing up—and she generally coiled her long hair up in a bun and wore ballet flats. Dorothy and my mother loved to

*OPPOSITE: Anjelica Huston (off-set) in Seraphim Falls (2006) • Deborah L. Scott, costume designer*

go antiquing, and also shared great hilarity in the creation of something they called "The Merkin Society," although it was hard as a child to figure out what was so unutterably funny to them. When Dorothy would go back to the States after prolonged visits to Ireland, the packages of Dorothy's treasures would start arriving: Russian dancers' boots for my mother (I was mortified when she wore them to Dublin; none of the other mothers wore boots outside of foxhunting); silk embroidered stockings for me, with butterflies and shamrocks; beautiful little dresses from the 1920s; fans, postcards, gloves, fabrics, hats, and books on costume.

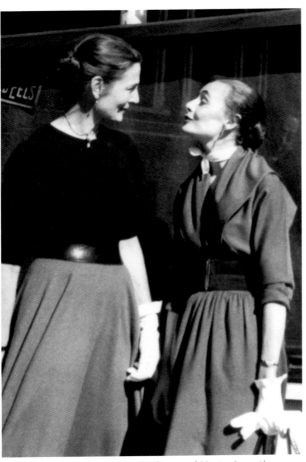

Costume designer Dorothy Jeakins and Huston's mother, Ricki Soma.

Dorothy also drew beautifully; she had big hands with long tapered fingers, and often would sketch from life in pen and ink. Her costume illustrations, some of the most beautiful I have ever seen, are famous among costume designers. Dorothy wore long white cotton nightdresses with lace at the cuffs, and Donegal tweeds in colors she relished, like "goose turd green," which I remember as an eternal favorite on her palette. Dorothy's taste was Zen-like in its simplicity. She was the Krishnamurti of costume.

Costumes have to accommodate not only the extraordinary shapes and sizes of the human body but also its life and spirit. Costume must not only serve to clad the body but reflect an understanding of the body's expression, age, sex, circumstance, and state of mind. An individual's human condition is possibly explained best by how he or she looks. Their look declares their origin, their position in society, their place in time, their relationship to life. While dressing a group of extras, the designer Marit Allen once said to me: "Look at any crowd: There is no such thing as an ordinary-looking person."

Since the beginning of time, people have used clothing to both hide and reveal who they are. Filmmaker Shigesato Itoi says, "In our society, people must wear clothes. Nakedness is considered offensive. This moral code belies a basic inconsistency between the need to cover our nakedness in public and the desire to see and show our bodies. It is a conflict deeply rooted in human nature. It polarizes us into two categories: those that are delighted to show themselves and those that feel compelled to hide themselves." Not measured only by the amount of skin on display but also by adornment, by the trappings of luxury, or by the absence thereof. Costume is the expression of individual character: purpose, color, fit, and fabric—all delineate the choices that are achieved in the fascinating collaboration between actor and costume designer.

As costume and entertainment have been inextricably linked in my perceptions as far back as I can remember, so too clothing and character are inseparable in my reflections of films I have worked on.

### PRIZZI'S HONOR (1985)

When I went to my first costume fitting on *Prizzi's Honor,* I was as unsure as everyone else about the period of the movie. (At one point, my father said, "Let's see if it matters.") But I had the feeling that the characters were somehow rooted in the '40s. The designer, Donfeld, arrived

at the fitting. He was tall and quite grand and, as I recall, a little condescending. He had brought a wide array of things he'd picked from costume houses for me to try on. We were looking for a dress that made a big statement—the dress that would get Maerose into trouble with her father at a family wedding.

After trying on an assortment of things, I pulled on a little black dress with a swath of black taffeta that crossed over one shoulder. Maybe, I dared, the swath should be a hot pink or green; what did Donfeld think? He looked dubious. Green would be a disaster, he said. Reflects badly under the lights. We decided to bring the problem to Dad. When I came out of the dressing room, though he'd not heard a word of our conversation, he didn't miss a beat. "Maybe the fabric over the shoulder should be pink." he offered. "Schiaparelli pink."

### ENEMIES: A LOVE STORY (1989)

[Costume designer] Albert Wolsky has a phenomenal eye for proportion. When I first met him he had all kinds of things, all vintage, ready for me to try on. To my utter surprise, everything fit! Even though I have quite a modern body—I'm tall and long-waisted and long-legged, and have the shoulders of a linebacker—somehow he amassed these great choices for me. There's a dress I wear in my first scene in the movie. My character has just come out of a concentration camp and is newly arrived in America. She's had a cheap makeup job and dyed her hair too dark, and Albert chose this sad dress, a bluish, mirthless pink, with a little effort at a flounce on the side. That dress said it all.

### THE GRIFTERS (1990)

I loved [costume designer] Richard Hornung immediately: He was handsome and smart and wry and dry and witty and the perfect choice for *The Grifters*. Since Annette Bening and my character get mixed up at one point in the movie, and since we don't look alike in the least, it occurred to me that it might be a better idea to emphasize not our faces but our backs. I had a great dress that Azzedine Alaia had given to me (in Paris): forest green, made of silk jersey knit, with crossed straps over a naked back. Richard loved the idea but decided to make the dress in deep red, "the color of clotted blood."

### THE ADDAMS FAMILY (1993)

The costumes for Morticia were quite extraordinary. Who knew that so many shades of black existed? The designer Ruth Myers used greenish oxidized black lace, purplish black satin, jet—all the colors you'd find in a black pearl. Although Morticia essentially wears only one ragged black dress in the cartoons by Charles Addams, Ruth had devised at least eight radically different dresses, all based on the original theme. The beading and the detail of each gown was fantastic— ancient monkey fur being one of the main components. The dresses were rigidly tight at first, worn over a breath-defying corset. Until the dresses started to give a little from wear, I was unable to sit down and was forced to use a leaning board—a contraption I think was created by fanatics during the reign of Elizabeth I.

To add to the discomfort, eye lifts were glued to my temples and fastened with a good deal of traction behind my ears, under a waist-long black wig. Another set of lifts was attached to my jawline

and fastened to the nape of my neck, causing extreme headaches throughout the afternoon if I neglected to loosen up the rubber bands at lunchtime—an exercise that cost me forty-five of the sixty-minute lunch break. Then, the nails! I finally resorted to using the cheap plastic glue-on ones, since any effort at using more permanent porcelain resulted in my breaking them, painfully, down to the quick, requiring the enlistment of a permanent manicurist. For years thereafter, those glue-on nails would crop up mysteriously—in pockets; in handbags; once, two years later, stuck to my dog's fur. It was like being haunted.

On set, I soon realized that whenever I turned my head a certain way, Barry Sonnenfeld, the director, would call "Cut," and he and producer Scott Rudin would go into an urgent whispered conference. The reason, I learned from my hairdresser and makeup artist, Anthony Cortino and Fern Buchner, was that Barry and Scott didn't like seeing Morticia's hair split over the shoulder. In response, I devised a way to turn my entire body at once, from the feet up, which on reflection I think was good for the character. At the end of the first *Addams Family* movie, at wrap, I slipped out of my corset, lifts, nails, wig, and eyelashes, and called the fire department to a corner of the lot outside my trailer, where they allowed me to light a little "bonfire of the vanities." This ritual allowed me a small measure of revenge for my discomfort.

Theoni Aldredge, who designed the costumes for the second Addams film, *Addams Family Values*, managed to combine the harsh restrictions of the Morticia silhouette with softer, more elastic fabric, which enabled me to sit down between shots. These dresses were as extraordinary and elaborate as Ruth Myers's: one embroidered with spiders, another layered over by a magnificent cloak of black and silver, cut in the shape of bat wings.

### THE ROYAL TENENBAUMS (2001)

I first met Wes Anderson over breakfast at the Carlyle Hotel in New York. He gave me a script called *The Royal Tenenbaums*, about a fictional but oddly real dysfunctional family living in a house with bubblegum walls somewhere on the Upper West Side. Wes is captivated by costume, and has a very unique and stylized fashion sense. He sent me a detailed drawing of how Etheline Tenenbaum should look. I remember the designer Karen Patch presiding over endless fittings for four identical cashmere suits, all in different shades of pastel; the tailor was upset and confused at having to overshorten sleeves and raise buttons to give clothes that look of being several sizes too small—a kind of neo-sixties look. I always like to bring something of my own to wear; in Etheline's case, her silver locket belonged to my grandmother.

(ETHELINE T. FOR ANJELICA H.)

SUNGLASSES HAVE A PRESCRIPTION USED OFTEN INDOORS BECAUSE REGULAR GLASSES ARE BROKEN.

SILVER STREAKS OF HAIR OFF-CENTER, HAIR WORN "UP."

(PRINTED SCARF SOMETIMES WORN OVER HAIR AND KNOTTED UNDER CHIN.)

LOCKET CONTAINS PICTURE OF THE THREE CHILDREN.

(VERY FITTED BUT PRACTICAL.)

BLUE, PALE BLUE, TAN, CREAM, AND ROSE-COLORED VERSIONS OF THIS SUIT WITH EXACTLY MATCHING BLOUSES WITH BUILT-IN NECKTIES, WORN LOOSELY WITH VERY OPEN SHIRT.

LOW HEEL OR SLIPPERS,

The Royal Tenenbaums (2001) • Karen Patch, costume designer; illustration by Wes Anderson

I was very excited to learn that Milena Canonero would be designing the costumes on *The Life Aquatic*. I have admired her exquisite taste since I first saw Kubrick's *Barry Lyndon* in 1975, and met her soon afterward. Milena belongs more to the eighteenth century than this one. She's small and delicate and porcelain, but has great humor and determination and fantastic style. She herself dresses with great modesty, always cocooned in a scarf and gloves.

Milena's first suggestion for Eleanor Zissou was that we should use extensions on my hair and dye some strands in different shades of blue, like a Japanese mermaid (you have to look hard; it's very subtle on film!). Then we followed up with turquoise contact lenses. Eleanor reflected all the hues of the ocean—a woman of the sea, someone an oceanographer might be drawn to. Milena also discovered some fantastic necklaces from the collection of Marta Marzotto—a necklace with pale emeralds the size of paperweights and a wonderful coral, pearl, and diamond choker that I refused to leave Italy without. Shopping with Milena is fatal. She is terribly seductive and encourages you to buy things you never would otherwise—but you never regret it.

As Elizabeth Taylor said of Edith Head, "It was her method of working that was so phenomenal. She got 'inside' the characters as much as the actors and directors did. She would find little personality quirks for each different individual, like a funny cup, a favorite scarf, or pockets in odd places, sort of built in props for each role." Deborah Nadoolman Landis's beautifully researched book not only investigates the importance of costume in film but also includes us in the actor's process as he collaborates with the designer to embody a role. Filled with the words of stars, filmmakers, and designers themselves, along with fabulous photographs and illustrations from Hollywood's Golden Age to the present day, this book offers a unique lens on the relationship between actors, designers, and the movies.

*"I was blessed with a part so solid that it protected me. One could wear the part like a coat. Maerose was there on the printed page with her Sicilian nose and her manipulations and her great love of Charley." —Anjelica Huston, Prizzi's Honor (1985) • Donfeld, costume designer*

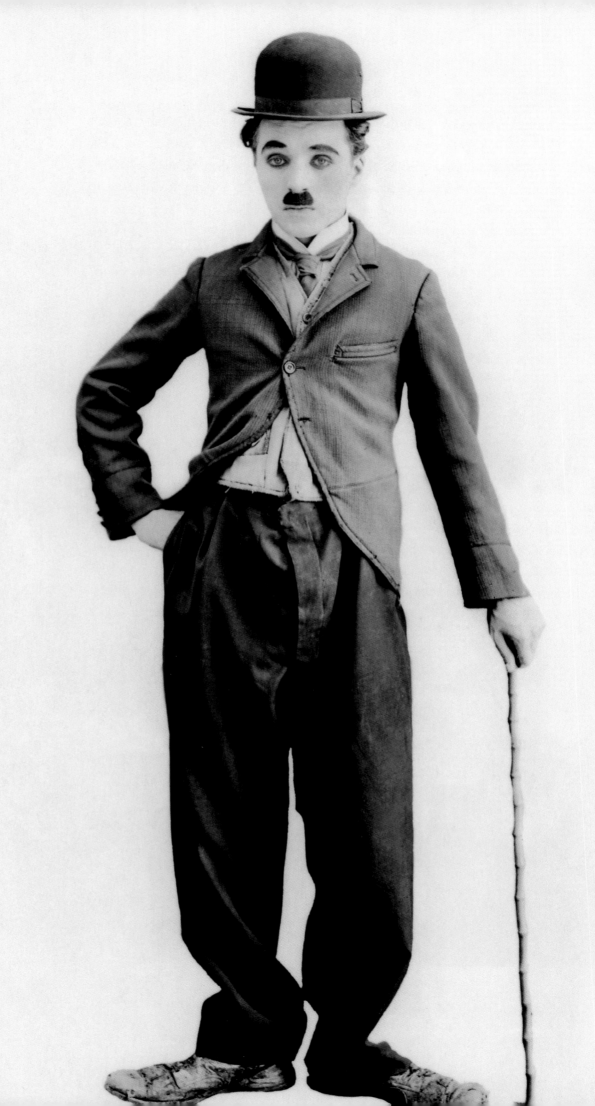

# Introduction

*Clothes are never a frivolity: they always mean something.*

—JAMES LAVER

Filmmakers aspire to seduce. Theirs is a consensual art. It is pure pleasure to be totally immersed in an unfolding story. And great movies, regardless of genre, can produce an intensely emotional and cathartic experience—a journey that is never forgotten. At least, that's the way it's supposed to be. "A film is—or should be—more like music than like fiction," Stanley Kubrick said. "It should be a progression of moods and feelings. The theme—what's behind the emotion, the meaning—comes later." This may come as a surprise, but *Dressed* is not really about clothes or style or fashion, and certainly not about celebrity. It's about the magic and the romance of the movies and the power of our collective imagination. It's about falling in love.

To outsiders, filmmaking is a mystery. And from the way it's covered in the press, costume design for movies is even more confusing. Our product may be perceived as glamorous, but the making of movies is certainly not. Ask any crew member. It's hard physical labor; we work in trenches and trucks, suffer hideous weather, long hours, institutional food, and bad motels. Francis Ford Coppola knows it well: "This kind of work is really grueling. You're in a lot of uncomfortable

*OPPOSITE: "The moment I was dressed, the clothes and the make-up made me feel the person he was. I began to know him, and by the time I walked onto the stage he was fully born." —Charlie Chaplin*

situations for many, many hours." And while we are waiting for the camera to roll we are on our feet—wearing ugly shoes and comfortable clothes.

At its best, making movies can be scandalously fun and bear an uncanny resemblance to an adult summer camp. At its worst, it's an insane asylum or a prison sentence with a release date. This is not an industry secret. Our dismal working conditions, long hours, and meal breaks are regulated in minute detail under our union and guild contracts. The gauntlet of film production is covered in a proliferation of books about motion picture producing, directing, writing, and acting. But the creative process and practice that a costume designer follows (research, collaboration, and designing) is conspicuously absent on the bookshelf.

Researching the history of motion picture costume design is particularly problematic. The paper trail inherent to conventional businesses does not exist in the movie industry. All of the major film studios have been bought and sold (especially over the last thirty-five years), becoming satellites of large multinational conglomerates, and with each new acquisition paper records are jettisoned, and archival information becomes more difficult to retrieve. Studios routinely discard ancillary design materials from the costume and art departments, including costume design illustrations now cherished by collectors. The Internet and specialty auction houses have become an active marketplace for movie memorabilia such as costume illustrations, costumes, and props. But a wealth of prosaic paperwork—costume budgets, continuity photographs, costume change breakdowns, and fabric swatch books—is dumped after a film has been released and the need for reshoots has ended. Not long after a movie has wrapped, its entire costume department disappears.

This information vacuum has been the reason for much of the misunderstanding about the role of the costume designer on a film and the function that costume plays in telling the story. The absence of such evidence reinforces the popular impression that costumes simply appear when summoned by a director. But costumes do not design themselves; they don't arrive in the morning with the actor nor do they spontaneously materialize from somewhere within the collective unconscious. Costume design plays a serious role in the movies: it helps bring authentic characters to life. It is an art in its own right, with its own standards and legitimacy. In mainstream and independent Hollywood film, costume design exists solely to serve the story and its characters.

*Dressed* collects the work, and the words, of scores of important costume designers from throughout the history of Hollywood—along with first-person comments from directors, actors, collaborators, and cinephiles. Along the way, it illuminates the creative path costumes travel from script to screen, and demystifies such loose concepts as so-called screen style and the mellifluous but mistaken moniker "fashion in film." Ultimately, everyone involved in the making of a motion picture is engaged in conjuring human beings as if from thin air: "trying to come up with characters surprising to people and surprising to me," as writer/director Wes Anderson has put it. If the first rule of screenwriting is "Show, don't tell," costume is a key to that process because it subtly telegraphs everything the audience needs to know about a character before one word of dialogue is spoken.

D irectors are acutely aware that the costume expresses volumes to the audience before the actor speaks. Simple details reveal volumes about character and scene—a cuff, a lapel, lipstick on a collar. "The right hat is very important," writer/director Cecil B. DeMille said. "Shoes don't matter so much. Usually, you don't even see them. But if you wear a hat, it's in every shot and featured in every close-up." Subtle signals are embedded throughout

every picture; the characters and their environment are shaped from the first page of the screen-play by the directors' decisions about design, lighting, music, costume, and casting. "Everything must serve the idea," John Huston advised. "The means used to convey the idea should be the simplest and the most direct and clear. I don't believe in overdressing anything. Just what is required. No extra words, no extra images, no extra music. But it seems to me that this is a universal principle of art. To say as much as possible with a minimum of means."

Costume is one of the director's most effective tools for telling a story—so powerful, in fact, that a distracting garment can ruin a scene. Hollywood glamour and spectacle has been known to sabotage a dramatic screenplay, as director Fred Zinnemann notes: "There seems to be a close connection between authenticity and economy; the realistic story can be told without the help of large studios, expensive stars, and elaborate wardrobes." This intimate relationship between director and costume designer goes unacknowledged by the fashion press, which focuses solely on the clothes while giving little thought to the narrative purpose it was intended to serve.

Alfred Hitchcock contended, not without reason, that "in feature films the director is God." But even Hitchcock could not make a film alone. Movies are a collective effort, the result of a team's creative collaboration, not the product of an individual artist. Like an orchestra conductor, the director profits from the talent and expertise of his collaborators. Costume designer James Acheson reminisced that on *The Last Emperor* (1987), director Bernardo Bertolucci likened his creative colleagues (cinematographer, production, and costume designer) to lemons—each day of production he gave them a little "squeeze."

Most directors prefer to work with the same artists from film to film, developing a trust and a shorthand that saves time and tension as they travel from film to film. As John Landis says, "When you look at directors who work with the same designer over and over again, it's because they are confident they will never be disappointed." That close attachment is reflected ultimately in their distinctive cinematic style. Costume designer Anna Hill Johnstone designed twelve movies for director Sidney Lumet; Jeffrey Kurland designed fifteen films for Woody Allen. Costume designers Joanna Johnston and Colleen Atwood have each worked for Bob Zemeckis and Tim Burton on eight films. Johnstone, Kurland, Johnston, and Atwood adopted their own personal styles to serve their directors as precisely as possible, along the way making incalculable contributions to the look and feel of those pictures and each director's body of work.

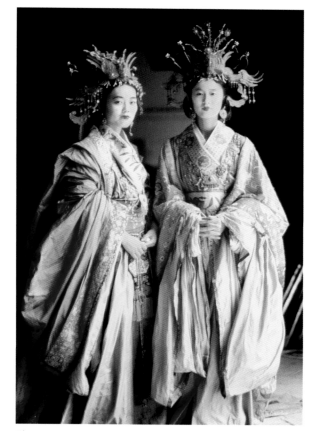

The Last Emperor (1987) • James Acheson, costume designer

The same intimate connection exists between costume designers and actors. After collaborating on eight films with actress Meryl Streep, costume designer Ann Roth confided, "We wait in the fitting room until a third person appears"—that is, the character. "You just kiss her [Ann Roth's] feet," Streep has said. "She gives you the whole deal." Costume design provides performers with an immediate conduit to character. According to Michael Caine, "The best movie actors become their character to such an extent that the product isn't viewed by an audience as a performance. . . . In a film a person is a person, not an actor; and yet you need an actor to play the person." Actors must find a way to submerge

into their characters. Designer Michael Wilkinson said, "A costume should appear to have grown on the back of the actor." Sometimes this means gaining or losing weight for a role, changing a nose, wearing a wig, but most of the time it means changing their clothes. And it's not unusual for actors to find their character in the fitting room: actors like Robert De Niro wear their costumes for weeks prior to appearing on the set, allowing themselves to inhabit the character before the camera records the first frame of their performance.

Because costume designers are usually preparing a film for weeks or months before actors finally are cast, the costume designer is often the first person with whom an actor discusses a new role. Sometimes a complete transformation can be unnerving. When Helen Mirren came face-to-face with costume designer Consolata Boyle's dowdy costumes for *The Queen* (2006), she stopped dead at the fitting room door, shocked. "I had to imagine myself as the woman who would *want to wear* those clothes," Mirren said. Yet Boyle's costumes enabled Mirren to make the clothes her own. As Edith Head said, "Bette Davis never thinks, 'Do I look nice in this?' She thinks only, 'Is it good for the part?'"

Ultimately, a costume must perfectly describe the individual for whom it was designed—not the superficial shell of a character but the outward expression of inner experience, the concrete manifestation of the character's self-image. These qualities have less to do with clothes, style, or glamour than with truthful on-screen portrayals of real people. While shooting *Nashville*, Robert Altman was visited by a group of Hollywood agents who said, "Well, you've got a way of making real people look like actors." And Altman shot back, "Well, I hope I have a way of making actors look like real people." Costume design aspires to do the same thing.

Costumes occupy prime real estate in nearly every frame of a film, worn by actors who dominate the foreground. Screenplay and director raise countless questions about the story, and each costume in a motion picture solves both a dramatic and a design problem. The costume designer's mantra is authentic characterization; this zeal for the real makes more practical design problems secondary. Costume designers study the people in a screenplay; they are the anthropologists whom the directors and actors depend upon to get the research right. Costume can define identity, ethnicity, economic and social status, as well as the personality and individuality of each character. A costume designer must choose clothes that each fictional character would choose, creating an individual by layering specific and nuanced personal choices. When she was preparing for her role in *Psycho*, Janet Leigh said, "I invented a complete life for Marion Crane. I knew where she went to school, what church she attended, what kind of a student, daughter, friend, and relative she was. I knew her likes, dislikes, color preferences, favorite foods, favorite books, and favorite movies. I knew her secrets, her passions, her fantasies, her fears. I knew her intimately." So, you can wager, did Hitchcock and his designer, Helen Colvig, who collaborated on every seemingly inconsequential detail of Marion Crane's costume changes.

Costumes also telegraph the "where" and "when" of a story—the period, genre, season, time of day, and dramatic context of each scene—aiding the transition to each new scene. Costumes inform a story's themes, its story arc, and its color palette. They present a resting place for our eyes during dialogue, and provide color, silhouette, balance, and symmetry to the frame. Costume design is never generic because people are not generic: they are defined by the culture in which they live. Producer Albert "Cubby" Broccoli, who brought Ian Fleming's James Bond novels to the

screen, reflected: "The way Bond dressed was intrinsic to the character. We're talking about an ex-Eton type who mixed with the aristocracy, belonged to the most exclusive clubs, gambled at Monte Carlo and wore handmade silk shirts and Sea Island cotton pajamas." In a rigid British club culture, Bond's entrée depended on the cut of his coat.

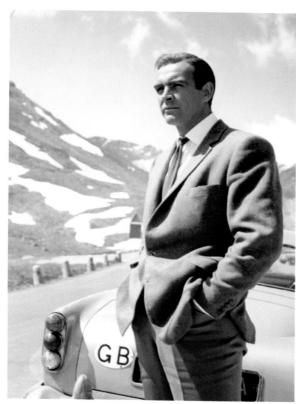

Sean Connery in Goldfinger (1964) • Elsa Fennell, costume designer

The successful costume, then, is the amalgamation of the screenwriter's intent, director's interpretation, and the costume designer's intuition and talent. The clothes are almost beside the point. But clothes, finally, are the foundation upon which a costume is created. Each actor and extra must arrive on the set dressed and ready for camera—a deceptively complex task that requires a well-organized costume department. The costume designer serves as creative chief of the costume department, seconded by the assistant costume designer and the illustrator. The costume supervisor is the department manager, supervising a crew of costumers that grows or shrinks in number depending on the size of the cast to dress on set that day. Under the intense pressures of contemporary production, the choreography of this collegial unit must be completely synchronous. *Spider-Man* costume designer James Acheson links the ultimate success of his work to his crew: "They stood by me when I asked for something that seemed too crazy and made it work. Without their skills, knowledge, and stamina I could not have done it."

The first step for designer and costume supervisor is to evaluate the requirements of the script, the number of changes for each character, the potential budget, and countless other practical details. When asked how many costumes he designed for *Gone with the Wind*, designer Walter Plunkett replied, "The only thing I remember is that the laundry bill was more than $10,000. It got awfully dirty out there at the plantation."

After haggling over budget with the producer and finding a suitable design studio space (not as easy as you'd expect), the real work begins. Whether the film is period or modern, research materials of all kinds are collected into a richly illustrated and annotated "design bible," a volume that includes details on clothing, accessories, hair, makeup, props, inspiration, and influences. The design bible is shared with the director, actor, cinematographer, production designer, and the hair and makeup department. For Spike Lee's *Malcolm X*, costume designer Ruth Carter was determined "to know [Malcolm X] and understand who he was before we began the project." After conducting extensive research, she and actor Denzel Washington "discussed every detail about Malcolm's clothes—his eyeglasses, his shoes, his ties—and what was happening in his life during particular periods. Photographs and research materials about Malcolm and his era helped us a lot." Designers also draw inspiration from literature, fine art, as well as films of every era, genre, studio, and culture.

The design bible also serves as the centerpiece of discussions with the costume crew and the workroom. A research bible may include: copies of archival pages on the history of dress and textiles, *National Geographic* and ethnographic journals, fashion magazines (current/archived), the work of couturiers, eastern and western royal regalia, international military, clerical and liturgical dress, and the world of sports. Perhaps the most valuable contribution a designer can make is

from his or her own personal family history, high school and college yearbooks, and family albums. When she was designing *Chinatown* (1974), which took place in 1937, Anthea Sylbert said, "At least sixty percent [of her inspiration] was from my own family's photo albums and those of friends. Other sources were news magazines like *Life* and local L.A. periodicals and newspapers. I've never used fashion magazines because I find them misleading."

After the research is internalized, the designing begins. Costume design illustrations are an essential part of the design process. As *Lord of the Rings* costume designer Ngila Dickson explains, "First I draw the actors. I need to know them, and I need to get a handle on how they're going to portray their characters. Once I have fully understood the physicality of the actor and what that person is going to bring to a role, then I can take full advantage of both." While illustrations can help the designer clarify her ideas, their primary purpose is to communicate with the director and actor, and later, the cutter/fitter, tailor, and costume work room.

To speed up the process, many notable costume designers, such as Colleen Atwood and Edith Head, have employed professional illustrators as their "public letter writers." Using sketch artists for efficiency's sake is a time-honored practice in Hollywood and has fostered lifelong collaborations between designers and illustrators. Although they are not created to stand alone as art, many costume sketches are irresistibly appealing—but they're also practical documents, used as construction blueprints by the costume workroom. "Mood boards," pictorial collages, and tear sheets of modern inspirations are also used frequently, most often on contemporary productions. The more specific the designer can be with the research, the more accurate a response he or she is likely to get from the director.

Once the research and illustrations are finished and the conversations with the director and the creative collaborators have taken place, a designer must wait for the film to be cast. Actors are then met and measured—a ritual that unfortunately often takes place the day before shooting begins. The costume designer then corrals rented pieces, alters "shopped" costumes, and fabricates new designs for each character, often laundering, distressing, and aging them to taste.

Unlike real-life clothes, costumes are also required to meet extraordinary physical demands without restricting the actor or showing up badly on camera. Actress Tippi Hedren recalled filming a scene in Alfred Hitchcock's *Marnie:* "I'm dressed for a cocktail party. My husband brings my beloved horse that I have missed so terribly. My character runs straight out the door, grabs the mane of that horse, jumps up, races off, and jumps the fences. That cocktail dress had to be able to do all of that action." Costume designers relish such challenges. As Ngila Dickson admits, "You get hooked on the level of stimulation. The words 'impossible,' 'won't happen,' and 'can't do,' are not part of the vocabulary. I say to my crew, 'Don't tell me about the problem. Tell me the solution.'" For one hundred years, "Yes!" has been the only acceptable response on the set of any Hollywood film.

Contemporary films can be a minefield for costume designers. During his brief stint designing Hollywood costumes in the early 1920s, the fashion designer Erté recognized the peril of trying to represent fashion trends in a film that might not be released for a year after being shot. "I always worked on the basic premise that the dress must not look old-fashioned and ridiculous a few years later," he said, "for the life of a film can sometimes be very long. Almost all clothes that are fashionable at any given time are likely to cause mirth and derision a year or two later." Working on *North by Northwest,* actress Eva Marie Saint watched Alfred

Hitchcock send home dozens of fashionably dressed extras "wearing the shift dress without a waistline and without a belt" because he recognized that that look, an "in" fashion while they were filming, would "date the film." Costume designer Theoni Aldredge notes that "period costuming is far easier to do than contemporary because no one knows enough to complain. A hoop skirt is a hoop skirt." Costume design on modern films is produced with the same unanimity of purpose, and the same painstaking design process, as ambitious period and fantasy projects.

Directors need the audience to be active participants in each scene. As producer Jerry Bruckheimer put it, "We're in the transportation business. We transport the audience from one place to another." The more a film carries its viewers away, the more likely they are to encourage their friends to see it. By the same token, when the costumes distract from the story, chances are the movie has lost the viewer. From period to modern to sci-fi to Western productions, the most successful costumes are those that completely disappear into the narrative. This is one of the key differences between costume and fashion: Disappearing is bad business for fashion designers, whose label is their license. The fashion designer aspires to create a look that is recognizable enough that it can be copied, reproduced, and sold successfully at every marketable price point. The most successful fashion designers create a durable brand, licensing their name for a cornucopia of products; some manage to extend their look into a total lifestyle in which the customer is the star. Costume designers, in contrast, have no "look" beyond what the script and the director requires.

Fashion and costume do have some things in common—both express identity. *Haute couture* is a living art form whose purpose may be decorative, provocative, humorous, revolutionary, promotional, and political; it is also an artistic engine that generates income. A great fashion designer's goals are to tell stories through their evolving seasonal collections, and to make men and women look beautiful. Ultimately, their clothes must sell. Making stars look beautiful is often not part of the assignment for great costume design—unless, of course, the story demands it. Real people wear a messy amalgam of inherited, gifted, found, favorite, comfortable, vintage, aged, and new accessories and garments that are appropriate for their day at work, school, or home. As designer Abigail Murray notes, "Characters are not about fashion. Characters are about real life." What they wear may be what's just been washed or ironed, or just come back from the cleaners.

Costume design is an art that calls for acute powers of observation, a keen sense of scale, and a great sensitivity to people. A costume that may be beautiful in person may not be beautiful projected when forty feet wide. Unlike the products of the fashion industry, which are designed for our three-dimensional world and appraised by simply looking at ourselves in the mirror, movie costumes are seen in two dimensions, photographed through a lens that flattens and distorts an image. As costume designer Anthea Sylbert states, "It must never be about the costumes; it must always be about the character. You must not leave a movie whistling the clothes." It can take enhancing color, exaggerating texture, or extending a silhouette for a certain garment to "read" on camera. Stories abound of painstaking dyeing, aging, and distressing of individual garments to achieve a look so real the audience can almost smell it. On *Midnight Cowboy,* Ann Roth found Ratzo Rizzo's signature suit on Forty-second Street. "It was dark red and I over-dyed it green and then white. . . . And the pants came from this shop called Robin's next to the Port Authority [bus station], where they had a table out front with pants for five bucks each, with a dirty ridge where they'd been folded." She even imagined a history for the suit: "I pretended that it came out of the trash can and that some high school kid had thrown up on it after his graduation party or prom."

In one sense, of course, costume designers—like all theater folk—are illusionists, con artists practicing deception on a willing audience. The diamonds and furs, cashmere and crocodile you see on screen are usually *faux.* They don't have to be expensive; they just have to *look* expensive on film. This helps explain why, when displayed in exhibitions, costumes can sometimes be disappointing: without the context of story, set, lighting, and actor, they are incomplete. Fashion and costume designer Jean Louis, who designed the iconic *Gilda,* was surprised by the dramatic shift in culture and tension between the two disciplines. "Designing for films was a totally new experience for me. The character was the important thing now. I couldn't dress Gilda as I would have dressed Rita Hayworth in her private life." For the star herself, the disconnect was apparently bittersweet; as Hayworth famously observed, "Men go to bed with Gilda and wake up with me."

In our celebrity-obsessed, red-carpet-crazed culture, celebrity and stardom may seem to eclipse the serious endeavor of creating authentic characters—and yet each year it is the plain-Jane characterizations that walk away with the Oscar for best actress. As Edith Head noted, the demands of fashion were antithetical to her craft. "I am not concerned with mass production of clothes for a certain season and a certain market. I don't care whether a dress will sell in the Deep South or whether every woman in the world can wear it. My job is to help the girl who wears the dress become the person she is playing on screen." In life, as in the movies, clothes must fit the moment—and the moment for glamour is most often on the red carpet, *outside* the theater.

And yet sometimes the allure of a movie, its characters, and its costumes are inextricably intertwined. Fashion designer Hubert de Givenchy's little black dress made *Breakfast at Tiffany's* and Audrey Hepburn's unlikely call girl unforgettable. With an assist from director Blake Edwards, screenwriter George Axelrod, and composer Henri Mancini's "Moon River," Audrey Hepburn became an icon in that dress. The power of the movies to create stars is almost hypnotic.

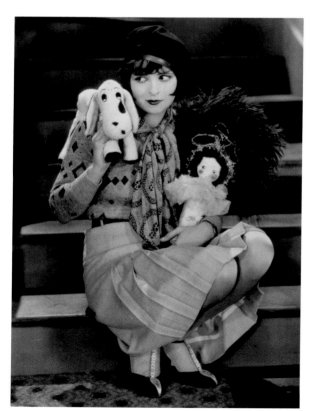

*It (1927) • Travis Banton, costume designer*

MGM's publicity department captured that mystique in its famous ad line about Clark Gable: "Men want to be him, and women want to be with him." Gable's irresistible persona was no accident; it was the result of a career of carefully written and crafted screen roles chosen for Gable, ushered into life by the studio's prodigious design and production team, and diligently marketed by MGM. Gable, of course, provided his charm.

From the very beginning of Hollywood, movies have influenced fashion. The release of the movie *It* (1927), with costumes designed by Travis Banton, made actress Clara Bow an instant sensation—the "It Girl" whose short skirt and bobbed hair defined the sexually liberated flapper. For *Letty Lynton* (1932), designer Adrian's array of costumes for Joan Crawford included a fluffy white organdy gown that purportedly went on to sell five thousand copies at Macy's alone. As Adrian said, "Fashion evolves in spite of designers, and not because of them. I put those huge sleeves on Miss Crawford in *Letty Lynton* because she was playing an extreme person, and it suited the character to have extreme clothes. They just happened to click with the rest of the world."

The list of the costumes, costume designers, and films that have influenced our culture is long and grows every year. Costume designer Theadora Van Runkle's beret, long skirts, and belted cardigans for

Faye Dunaway created a fashion sensation when *Bonnie and Clyde* was released in 1968. Ruth Morley created the idiosyncratic and androgynous costumes for *Annie Hall* from a dozen vintage New York boutiques, and Diane Keaton's layered look became her signature. As Morley said, "It's rare for a contemporary film to create a trend. Anyone could duplicate the 'Annie Hall' look. Even teens could wear a man's shirt and add a vest and tie. The stores already had all the ingredients for mixing and matching. People were tired of being dictated to by the fashion industry. Take a look in the street, the consumer can wear any 'look' she chooses." Harrison Ford's Indiana Jones wore a reinvented leather jacket and wide-brimmed fedora that I designed for *Raiders of the Lost Ark* (1981); Indiana Jones became a new macho icon.

In recent years, as historical epics have almost monopolized the costume category at the Academy Awards, it has become commonplace to think of such period dramas as "costume pictures." If *Dressed* accomplishes anything, I hope it demonstrates, once and for all, that *every* picture—plain or fancy, comic or dramatic, contemporary or historical—is a *costume picture*.

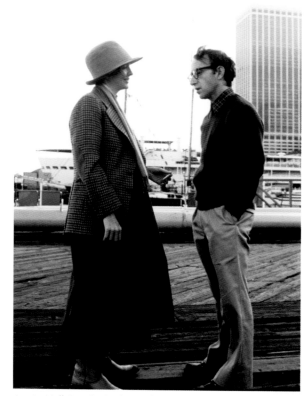

Annie Hall (1977) • *Ruth Morley, costume designer*

A word on the costumes, sketches, and photos: Costumes can't make a bad movie good, but they can make a good movie better. Included here are more than eight hundred images from the iconic, artful, and commercial films of the past one hundred years of Hollywood history, accompanied by the words of the people who made them unforgettable.

The choices were personal and subjective, embracing films of all types: many groundbreaking or critically acclaimed, a few pedestrian yet memorable, some altogether lambasted or pilloried, and every film that ever made me laugh or cry. Costumes were included for the pivotal role in a film, not just for their beauty. If anything, there was a decided bias against glamour and celebrity. Modern, period, and fantasy films were treated with equanimity. Balancing genre, careers, and studios was a daunting task. Disappointingly, I could not show every designer's work.

Since my scope was limited to movies generated by the Hollywood production companies and studios, some of the world's most influential filmmakers—Lean, Visconti, Fellini, Kurosawa, Bergman, Truffaut, Renoir, and Buñuel—are missing. Also absent are some of the greatest costume designers: Piero Tosi, Danilo Donati, Piero Gherhardi, and Shirley Russell. There is no Bollywood or Hong Kong sidebar. I consoled myself with the hope of a sequel covering international cinema and the rich tradition of motion picture costume outside the United States. There are a few exceptions here: American "independent" films produced outside the Hollywood studio system are included. And *Barry Lyndon* (1975) and *The Last Emperor* (1987), whose Hollywood status is questionable, were included because it was inconceivable to leave them out.

In matching each sketch or photo to a first-person caption, we hoped to transform each vintage or modern image into a fresh and intimate look inside the dressing room. The captions—gathered over the ten-year period my research assistants, student interns, and I spent scouring

libraries, archives, and private collections—often capture the transfigurative moment when the actor becomes the person in the photograph. With relatively few exceptions, we have favored eye-witness accounts over the reflections of historians, biographers, journalists, or reviewers. Thank goodness for those directors, actors, and designers who kept diaries and wrote detailed memoirs.

We were struck by how closely the newest Hollywood anecdotes about costume design mirror the oldest. The testimony by actors and designers at the end of this volume, in the twenty-first century, echo those at the very beginning of the twentieth. Silent-film star Lillian Gish would be all too familiar with the anxieties of present-day indie actresses. Today's compressed production schedules parallel the earliest days of shotgun moviemaking, when actresses arrived at the set dressed to impress or were clothed from secondhand (now vintage) shops or rental house hampers. It's irrelevant whether a costume is a manufactured or found object; it need only be right for the shopgirl, the princess, the gangster, or the boy next door.

To do justice to a century of Hollywood costume design requires the inclusion of hundreds of films and as many photographs. This is a picture book, and each photograph has a complex history. In many cases, we were limited to a single image, regardless of the movie's size. This left me with the impossible problem of picking the one costume (from hundreds or thousands in a given movie) to tell the entire story. Showing the scale of a production was impossible. Moreover, any photograph portrays just one moment in a screenplay, whereas a film covers a character's entire journey. As a costume designer myself, it was a heartbreaking task to choose one image above the others.

A certain school of classic Hollywood photography is not heavily represented here. George Hurrell single-handedly revolutionized the glamour portrait during his decades at MGM; he was the quintessential portrait painter. But the costumes Hurrell shot in his studio were taken out of the cinematic context—set, lighting, story—for which they were created by Adrian, MGM's master costume designer. Hurrell's gorgeous black-and-white imagery is deliberately frozen in time. A static photograph cannot encompass many aspects of costume design, which is created to move on a figure. Clothes come to life when the director calls "Action!"

The photographs we chose came in many forms. During the Golden Age, costumes for black-and-white films were created in color but filmed and photographed in black and white. The designers intended the costume to be seen by the audience in shades of gray. When films began to be produced in Technicolor in the late 1930s, designers designed for color, enlisting the help of a color consultant. For this book, we have chosen black-and-white photographs for black-and-white movies, and color photos for color movies, whenever available.

The task of finding color images for color films might seem simple, but it wasn't. The problem lay in the custom and tradition of studio publicity departments and studio set photographers. At the height of the Golden Age, studio publicity departments dressed up their contract players in character costume and current fashion, and kept large files of publishable photographs for marketing and promotion. Until the late 1960s, each studio employed studio photographers exclusively for this purpose. Publicity for the international release of each feature required complete press kits, including theater lobby cards, and photographs of the cast in many changes of costume. After the 1940s, the kits may have also included color pictures from black-and-white features.

But as color movies became established, it was standard practice for the set photographer to shoot black-and-white publicity photos for color films—even as late as the 1980s. Newspapers, the largest market for these photos, converted to color printing only in the last twenty years, so

there was little need to commission expensive color photography. Where it survives, the work of set photographers—who catalogue the production, often for the continuity of set design, location, and action—is reflected largely in black-and-white contact sheets. Rarely did they shoot the actors on the set in color or add lighting beyond what was created by the cinematographer for the scene. In many cases, we found great arrays of black-and-white photography for a given color film but struggled to find one high-quality color shot. (Frame enlargements, often out of focus yet found in many movie books, were not an option here.) Occasionally a great film was deleted because a high-resolution photograph of any kind simply couldn't be found—a tragedy that befell one of my personal favorites, *Dog Day Afternoon*, designed by Anna Hill Johnstone.

The costume sketches appear courtesy of a dozen private collectors, public and private libraries, museums, costume designers, and illustrators. Many Golden Age costume designers, such as Travis Banton, created their own sketches; others, such as Edith Head, depended on drawing partners to provide an instant snapshot for a director to approve. Once a costume was fitted on the actor, the costume illustration's mission was accomplished. Some designers gave them away at the end of production to stars, seamstresses, costume crew, and each other. Others simply dropped them into the trash or abandoned them among the detritus in studio costume workrooms; some were cut up as rack dividers or put to use as doormats. A few were found with dirty footprints intact. Many of the sketches that survived are being published for the first time.

Many costume designers created their own sketches, but many did not. The same is true today. We have made best efforts to credit illustrators, but because sketches are often signed only by the designer, sometimes I have made informed guesses. All of the great Hollywood illustrators and artist designers are represented by at least one drawing. Wherever possible, we have tried to match each illustration with a photograph of the same costume.

As MGM costume designer Adrian once observed, "The story of any gown worn before the cameras is a history of untiring work, skilled technicians, expert planning, and flawless execution." I hope that *Dressed* captures some of the tradition, art, and magic behind those stories, and reveals the skill and style that Hollywood costume designers continue to bring to every production.

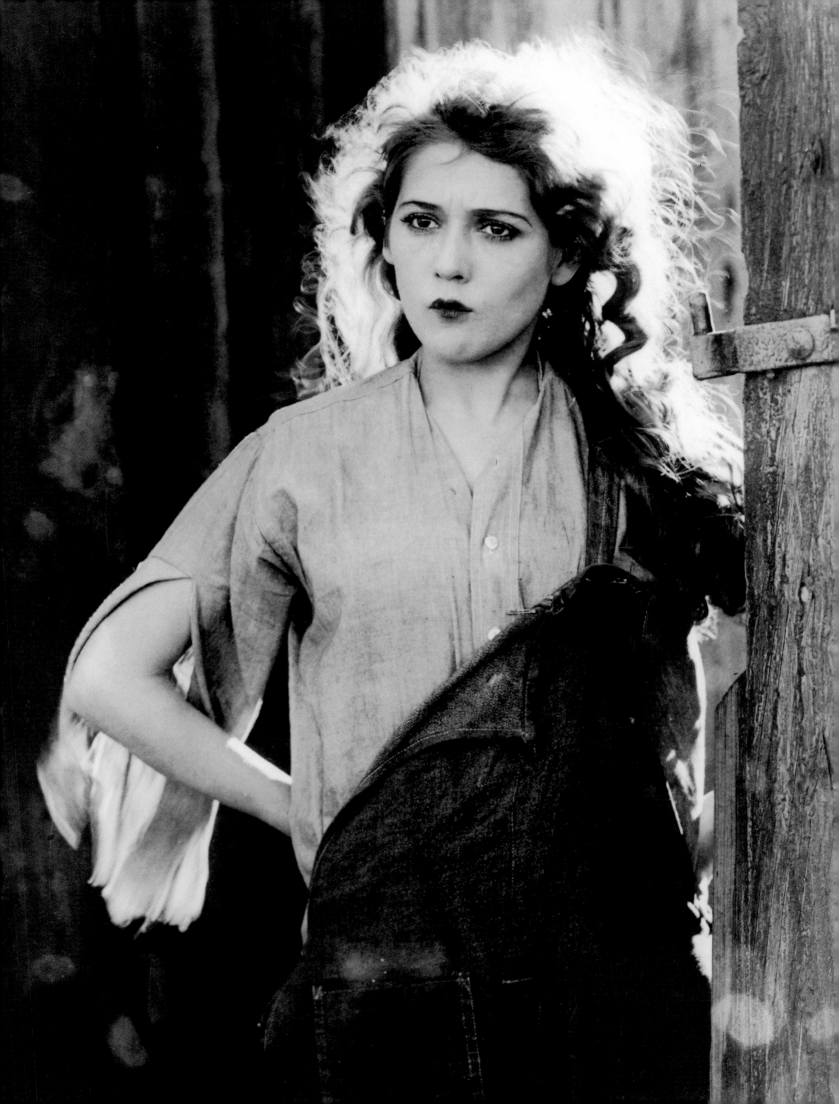

# ONE

# Early Years

The story of costume design in American movies starts, surprisingly, without costumes. The first moving pictures shown on a screen were one-minute scenes of anything that could be caught in motion—trains, dancers, bears, ships at sea. Moving pictures were simply a novelty. But they did not remain a novelty for long. In 1903, the visionary Edwin S. Porter, a cameraman for the Edison Company, created *The Life of an American Fireman* and *The Great Train Robbery*, and the movies revealed their power for narrative.

To tell stories, moviemakers needed actors, and those actors needed costumes. The movie business in America first blossomed in New York, the center of the nation's live-theater business. Budding moviemakers hired actors and actresses from the Broadway stage, most of whom welcomed a chance to augment their earnings from live theater. At first, the movie companies relied on the actors to provide their own costumes, unless they were filming a period piece or required uniforms, which could be rented from a theatrical costume house. For contemporary stories, actors and actresses wore, made, or purchased their own clothes. With no organized system in place, then, costuming was inevitably a hodgepodge affair.

OPPOSITE: Rags (1915) • *"With Mary Pickford, there is a fairy glamour about rags, and a spirituality of unkemptness." —E.E. Barrett (writer)*

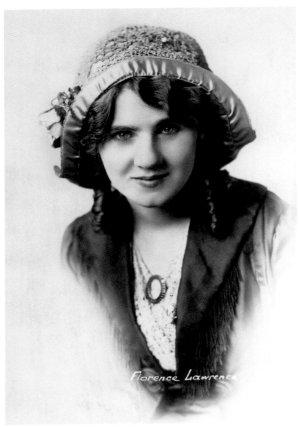

*Florence Lawrence, "The Biograph Girl"*

One of the first film studios in America was the American Mutoscope and Biograph Company (later known simply as Biograph), founded in 1896. On sunny days, the Biograph moviemakers shot their films on the rooftop of the company's New York office. Audiences were enthralled. Store owners converted shops into nickelodeons—simple theaters with a screen and a few seats—where people could see the first films. One early movie viewer, upon seeing a film, remarked, "All that trouble, just for me."

Actors in the first movies were not identified by name. But audiences quickly developed favorites and fierce loyalties, and showed up for the latest movie featuring the "funny fat man" or the "girl with the golden curls." Florence Lawrence was known popularly, but anonymously, as "the Biograph Girl" until she was lured away by Carl Laemmle. Laemmle kept the actress in the public eye, even off screen, and honored her with the first actor credit in the film titles. The national press noticed, and Lawrence became the first movie star. In a 1910 *Washington Post* profile, "Girl of a Thousand Faces," Lawrence—who was an accomplished mime—gushed about her profession: "The eyebrow must be on the job all the time. Likewise the lips, the nose, the mouth, the eyes, the arms, the fingers and the very feet!"

The growing industry was controlled by a trust known as the Motion Pictures Patents Company. Led by Thomas Edison, the trust controlled access to cameras, film, and theaters. Chafing under the restrictions, a stream of rebellious filmmakers traveled to the West Coast, far from the patent courts and close to the Mexican border in case the patent office chose to make trouble. In California they found sunshine, a variety of architectural styles, and virtually any landscape they needed—from the ocean to the desert, snow-covered mountains to alpine forests. The new movie companies clustered in a subdivision near Los Angeles that had been dubbed "Hollywoodland." It would take just a decade for the center of the industry to move from New York to Los Angeles, palm trees, and paradise.

It was in these early years that the rigid feudal hierarchy of the film business first emerged. As in the theater, the moviemakers relied on directors to oversee production, and writers to provide a never-ending supply of stories. By 1908, there were already quite a few actors making their living solely from films. Yet costumes were still largely the responsibility of the actors; not until a few years later would the role of costume designer be defined. Because films were silent, the visual was the narrative. These flickering images communicated, unencumbered by sound, with the audience.

It was the producer Adolph Zukor, the founder of Paramount Studios, who introduced the concept of the film costume designer as a creative collaborator. For $40,000, Zukor acquired the rights to the French film *La Reine Élisabeth* (1912), starring Sarah Bernhardt as the English queen, wearing unlikely lavish Italian Renaissance costumes designed by the French couture designer Paul Poiret, known as "Le Magnifique." The inventor of the modern brassiere, Poiret designed for stage and film stars; his exotic and sumptuous influence was entrancing on screen, and soon it was seen on the street as well. American audiences were learning what Europeans had already discovered—that, more than mere entertainment, films could be art.

Costumes in a film were capable of igniting immediate fashion trends. In 1910, *Moving Picture World* reported that "It is an undoubted fact that innumerable women go to the theater in

London or Paris to study the latest modes and styles. Do they do this in New York? In recent releases special pains seem to have been taken by the producers to dress the characters in conformity with the height of modern fashion."

Following Poiret, fashion designers on both sides of the Atlantic were asked to design for contemporary movies with some regularity, although the medium was still considered a bit vulgar in lofty social circles. The practice was less common in California than in New York, where the fashion houses clothed actresses both on screen and off. One of the most influential design houses, patronized by such actresses as early dance sensation Irene Castle, was Lucile Ltd., the house founded by London's Lady Duff Gordon. Her own best advertisement, Gordon was glamour personified; indeed, she is widely credited with introducing the word "chic" to the English language. Her gowns were known as the most stylish, the grandest, and the most expensive in the world. One observer called Gordon "the highest, twinkling spangle on the audacious headdress of fashion frippery." The first film featuring Lucile's couture may have been *The American Princess* (1913), starring clotheshorse Alice Joyce. Personally and professionally, Gordon had a lasting influence on Hollywood. Paramount's Howard Greer and Travis Banton, who later became top movie costume designers, trained under her discerning eye.

Lady Duff Gordon's sister Elinor Glyn was a novelist; her steamy novels were adapted into a series of racy films that made stars of several actresses, among them the dark-haired beauty known as Theda Bara. One of the first film sex symbols, Bara graced the screen scantily clad in costumes that accentuated her generous curves. Her image of mystery and passion was carefully crafted by the nascent studio publicity department: Her 1917 Fox contract specified that she was not to appear in public "without a veil," and was not to ride in her limousine "without the windows up and the net curtains drawn." Bara was aware of the subliminal power of costume to heighten audience emotions and set a scene, and she strove for historical accuracy. For *Cleopatra*, Bara spent weeks researching ancient Egyptian culture, claiming to have "worked for months with the curator of Egyptology at the Metropolitan Museum in New York."

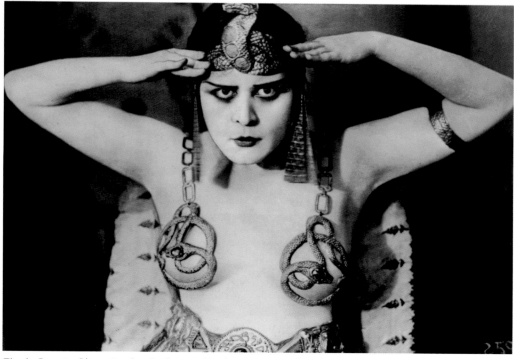

*Theda Bara in* Cleopatra *(1917) • George Hopkins, costume designer*

Throughout the 1910s, motion picture attendance grew exponentially, with more theaters springing up around the country, creating an ever-increasing demand for more films. Studios began to standardize the way movies were made. The creation of specialized movie costume departments may be credited to D. W. Griffith, whose employment of film designers was just one of his many innovations in moviemaking. Prior to Griffith—the first filmmaker to commission costumes specifically for a single film, *Judith of Bethulia*—movies were costumed from a grab bag of sources. The extras in *Bethulia* continued to be responsible for their own costumes, wearing primitive beards created from crepe paper and cardboard. Two years later, for Griffith's landmark *The Birth of a Nation* (1915), a number of the costumes were made by actress Lillian Gish's mother. With no organized costume department yet created, there was no one to keep track of costumes. "In those days there was no one to keep track of what an actor was wearing from scene to scene," said Gish, the film's star. "He was obliged to remember for himself what he had worn and how his hair and makeup had looked in the previous scene. If he forgot, he was not used again."

Even in these early, haphazard days, actors understood that the primary purpose of costume was to help tell the story. As Lillian Gish remembered, "In *Birth of a Nation,* during the famous cliff scene I experimented with a half dozen dresses until I hit upon one whose plainness was a guarantee that it would not divert from my expression in that which was a very vital moment."

For *Intolerance* (1916), Griffith had new costumes created for not just the lead actors but also the movie's thousands of extras—another moviemaking first. Crowd control was an issue, as actress Bessie Love recalled, and the filmmakers devised a clever strategy to keep order on the set: "Half a dozen second assistant directors were made up in costume and mingled in shot with the crowds, inciting the mob and relaying the directions of Mr. Griffith." After Griffith's innovations, the restricted scale of the legitimate theater could never again compete with the depth of field and spectacle on screen.

Griffith's commitment to costuming was legendary. His wife, Linda Arvidson, often told the story of his "auditioning" practices: "I have no part for you, Miss Hart, but I can use your hat. I'll give you five dollars if you will let Miss Pickford wear your hat for this picture." The golden-haired Mary Pickford had been acting in a theatrical troupe since she was six years old. She had already formed the essence of her "Little Mary" character, the little girl with the long golden curls, by the time she started working with D. W. Griffith at Biograph. Pickford later recalled one of her first days in the movie business. "I played a ten-year-old girl in a picture titled *Her First Biscuits . . .* and to costume me for that one day's work had cost all of $10.59. If I had had any doubt before, I had absolutely none now that the picture industry was mad."

A savvy stage veteran, Pickford didn't fit easily into Griffith's mold as a virginal heroine, but she rated Griffith first of all her directors. She remembered working on *The New York Hat* (1912), and Griffith's tender depiction of a scene in an impoverished New York tenement. Griffith coached Pickford not to throw her shabby hat and coat on the bed, but to treat them as the character would have treated them, to cherish the precious tattered garments—the only ones she possessed. With her petite stature, Pickford played children well into her adult years. At twenty-seven, when she portrayed Little Lord Fauntleroy, she was refused admittance to her own movie because she looked too young.

The silent-film industry quickly produced a multitude of comedy stars. Among the first were Fatty Arbuckle, Louise Dressler, Laurel and Hardy, Harold Lloyd, Charlie Chaplin, and Buster

Keaton—all brilliant comedians who used costumes to help build their characters and add power to their comedy. Silent film comedienne Mabel Normand described the hectic scene at the Mack Sennett Studios: "We, like other companies, would stop in the middle of one film and start another, simply rearranging the props, pulling a pair of overalls on over my frock, putting a cop's cap on Fatty Arbuckle, and having Ford Sterling or Charlie Chaplin chase us around in front of the camera."

Gloria Swanson started with Mack Sennett's company as a light comedienne. Forever mindful of her dignity, she always insisted that she was not one of Sennett's famous "Bathing Beauties," considering herself a "serious" actress. Eager for more substance and less slapstick, in 1919 she signed with Cecil B. DeMille and promptly found herself "awash in fashion." Swanson complained about the "strict orders from Hollywood to have lots of scenes where I could wear lots of beautiful clothes. Jesse Lasky [of Paramount Pictures] demanded one fancy-dress picture from me a year, because the public

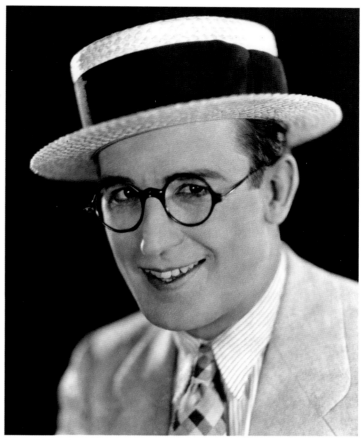

*Harold Lloyd*

demanded it, and he said they had certainly not had one yet. They had said under my picture on all the *Manhandled* [1924] ads and posters, 'More gorgeously gowned than ever!'"

Even before costume departments were clearly defined, the costumes of leading ladies were an important aspect of moviemaking. Studio publicity departments fed fan magazines a constant stream of stories about what the leading ladies of the screen were wearing—in their boudoirs as well as on the street. Every detail was breathlessly recounted, no matter how unlikely the outfit or the occasion. The studio's costume department provided the clothing for the stars to wear while being photographed by the fan magazines so their images could be carefully controlled. In his 1914 piece "Dame Fashion and the Movies," William Lord Wright declared, "Dame Fashion has finally consented to become a photoplay fan . . . modishly gowned ladies are obtaining their ideas of dress in the Motion Picture theater. Many a fashionable dressmaker also visits the Motion Pictures with the same interest and purpose, namely, to see the latest in frills and foibles. Dame Fashion, by transferring her affections to the movies, has added to the popularity of Cinematography. The more astute manufacturers are realizing what an effect modish gowns are having on the popularity of their output, and more and more expensive wardrobes are now very essential. The drama may be good, but, oh, the dresses!"

As the 1910s proceeded, each studio released at least one new movie every week. To meet this massive demand for costumes, studios hired armies of costume designers, seamstresses, wardrobe supervisors, and others to design, produce, and care for the mountains of clothing. D. W. Griffith found his costume department manager when a former actor, Curt Rehfeld, lost his leg in a street-car accident. As Bessie Love remembered, "Curt had the whole place scrubbed from ceiling to floor; divisions, shelves, cubicles and cupboards made for different categories of costume. Everything was inventoried; all character clothes were sent to the wet-wash laundry and left unironed so they looked crumpled and dirty but would not, frankly, smell."

The inventory of costumes increased in these years, allowing the studios to reuse costumes from one movie in another. Costumes were catalogued and stored, repurposed and reused, then stored, redecorated, retrimmed, and used again. It was from one of these dressing room closets that Charlie Chaplin gathered what became the trademark clothing of "the Little Tramp," debuted in *Mabel's Strange Predicament* (1914). One version of the story has him discovering the "Tramp" after experimenting with clothes; another envisioning the character, then finding the pieces to match. Biographer David Robinson recounts, "The legend is that it was concocted one rainy afternoon in the communal male dressing room at Keystone, where Chaplin borrowed Fatty Arbuckle's voluminous trousers, tiny Charles Avery's jacket, Ford Sterling's size fourteen shoes which he was obliged to wear on the wrong feet to keep them from falling off, a too small derby belonging to Arbuckle's father in law, and a moustache intended for Mack Swain's use, which he trimmed to toothbrush size." Whatever the origin, this unlikely outfit transformed Chaplin into the Little Tramp. Chaplin's first film appearance had been a disappointment, but he rose to fame wearing the Little Tramp's ill-fitting clothes and miniature moustache. The costume became known as "the clothes that saved Chaplin." If cultural icons can be identified by the shadow of their silhouette, then surely Chaplin may be our first film icon—in baggy pants, cutaway, bamboo cane, and derby.

Both theatrical stage and film companies relied heavily on rental costume houses to provide background costumes. The Western Costume Company in Los Angeles grew out of entrepreneur L. L. Burns's personal collection of Native American paraphernalia, accumulated as he traded and traveled across the United States. When he arrived in Los Angeles, Burns stumbled upon a Western movie set where actors portraying Native Americans were wearing a clownish concoction of beads, furs, and blankets, with no resemblance to the actual attire of American Indian tribes. When Burns objected to the man in charge, silent cowboy star William S. Hart, he was hired to outfit the Indians accurately, and Western Costume Company was born.

Tom Mix found similar problems with the cowboys in the Hollywood Westerns he had seen. "They're not *real* enough," he said. "Just a lot of counterfeit cowboys making fun of the West. They're an insult to the true West!" Mix was as disgusted with the outlandish acting styles as with the phony costumes, eyeliner, and painted faces. Although stardom came as a surprise to Mix, from 1910 to 1918 he triumphed as Selig Studio's most valuable property. With box-office draws Bronco Billy Anderson, William S. Hart, Tom Mix, and others, the Western established itself early on as an immediate international favorite and the most enduring American film genre.

Director Cecil B. DeMille lured costume designer Clare West away from D. W. Griffith and put her in charge of Paramount's bustling wardrobe department. DeMille credited West for one third of his unabashed formula for success: "sex, sets, and costumes." Along with costume designers Paul Iribe and Mitchell Leisen, she created costumes for the 1919 spectacular *Male and Female*, whose action takes place across three different time periods. As Gloria Swanson remembered, "I would wear the most exotic array of costumes imaginable. In society, I would wear afternoon dresses of the finest Belgian lace, and evening gowns made of satin and moleskin and gold

*OPPOSITE: "Tom Mix . . . had hundreds of extravagant suits, shirts, pants and boots all decorated with silver buckles, and wardrobes full of sombreros and fancy gun belts. [William S.] Hart dressed in well-worn range clothes. Mix was an out-and-out dandy. Hart walked as though his riding boots were full of cement. Mix pranced and leaped as athletically as a ballet dancer." —Leonard Matthews (historian)*

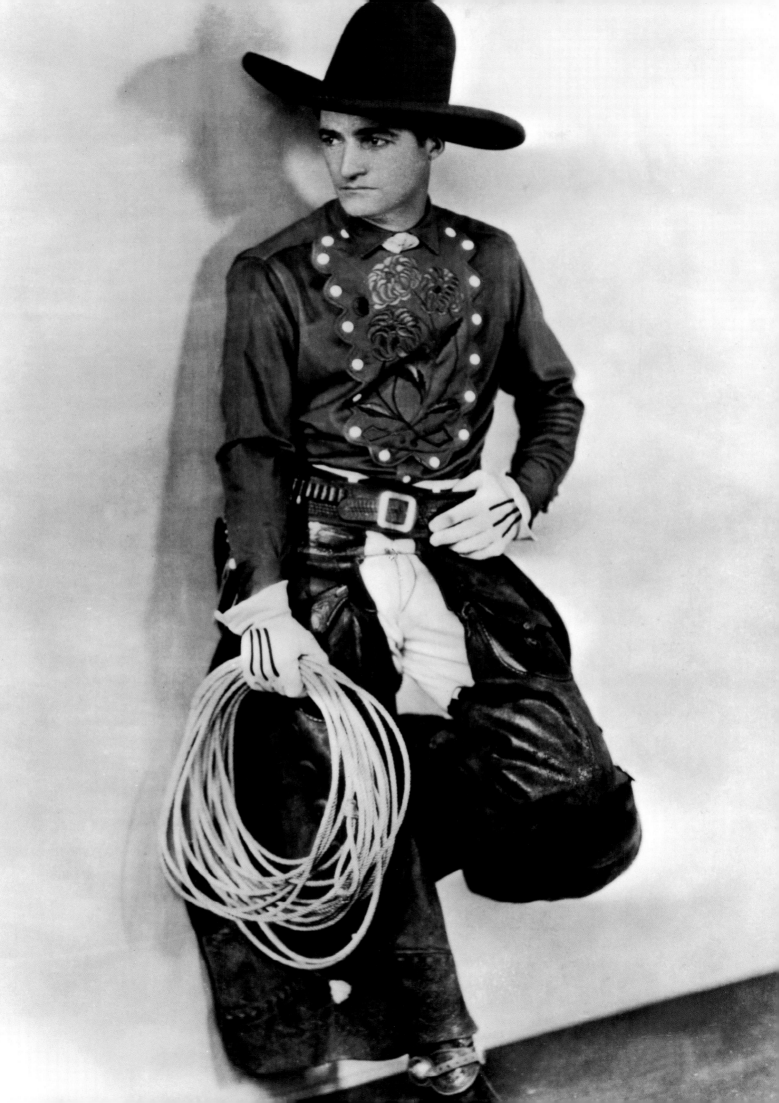

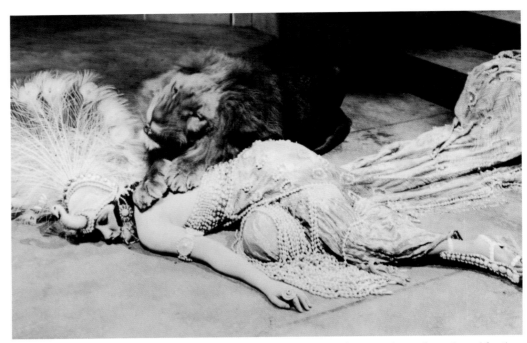

*"Mr. DeMille added a 'vision' set in ancient Babylon in which I would wear a dress of pearls and feathers and be tossed into a den of real lions. Designer Mitchell Leisen had an entire crew working on the pearl gown and headdress." —Gloria Swanson*
Male and Female (1919) • Mitchell Leisen, costume designer

beads. On the desert island I would wear animal skins. I would also have an elaborate bathtub scene wearing nothing at all. . . ."

The role of the costume designer was gaining stature. Studio chiefs, directors, and producers recognized the power of costume to create the look and feel of a movie, and deliver the female audiences to the theater. The first costume designers may have thought of themselves as fashion designers, but they were costume designers in everything but title. They were interpreting character in costume. Costume helped actors communicate character when movies were silent and the dialogue delivered by title cards. In the next decade costume design would evolve in all aspects, as realistic films became more naturalistic and "spectaculars" even more spectacular.

As the output of the studios expanded exponentially throughout the decade, the benefits of obtaining costumes quickly and inexpensively became increasingly important to each studio's bottom line. Flourishing studios, who had been employing costume designers on a freelance basis, now hired them full time. By decade's end, many studios were providing a restaurant (the studio commissary), a barber shop, and a fully staffed wardrobe department, helping them lure the cast and crew back on set more quickly and wasting less valuable time. The movies had barely been around for a decade when journalist Nance Monde wrote in the August 1918 issue of *Motion Picture Magazine:* "Clothes, clothes, clothes—Everybody knows, You can't get on in the picture game—Without clothes, clothes, clothes!"

**Gloria Swanson (actress):** "I reported to wardrobe the following morning and they outfitted me in a perfectly hateful bathing suit and a beach hat topped by a loud checkered bow. . . . I had to sit on a rock being cuddled by Mack Swain, who was wearing a striped bathing suit stretched tightly over his bulging stomach and a silly hat perched on top of his clown face. I was absolutely miserable every minute I had to pretend I was having the time of my life."

*THE PULLMAN BRIDE* **(1917)**

*LA REINE ÉLISABETH* (1912) · **PAUL POIRET, COSTUME DESIGNER**

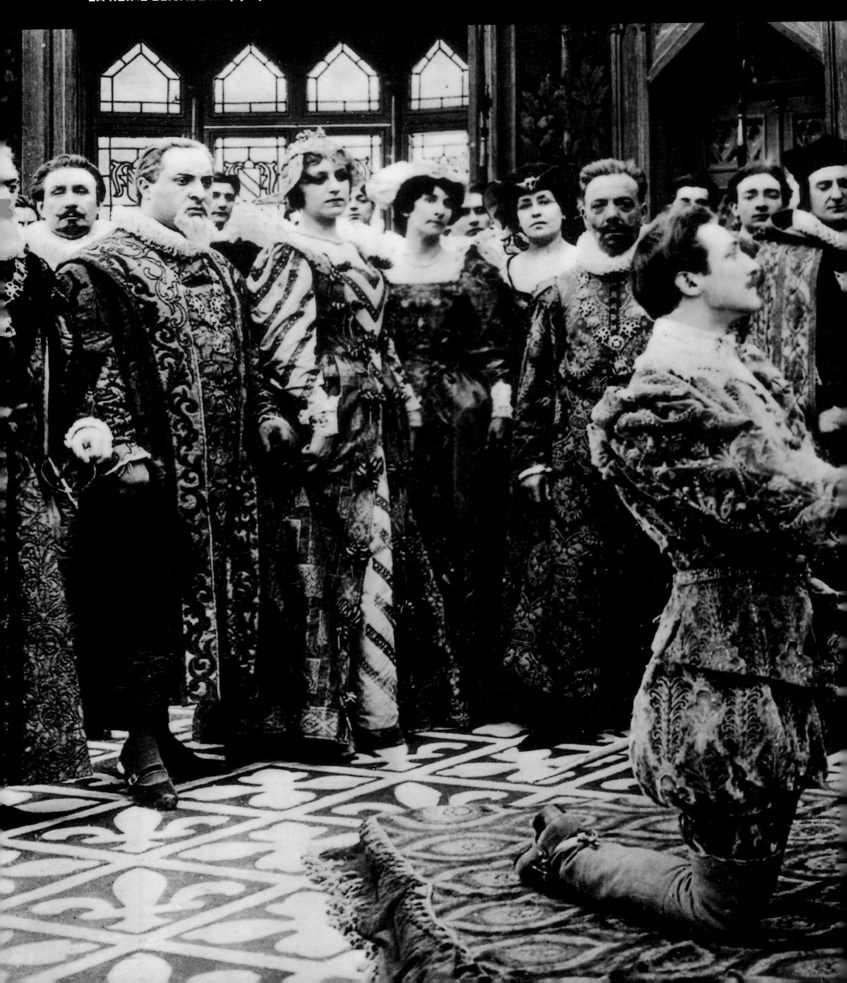

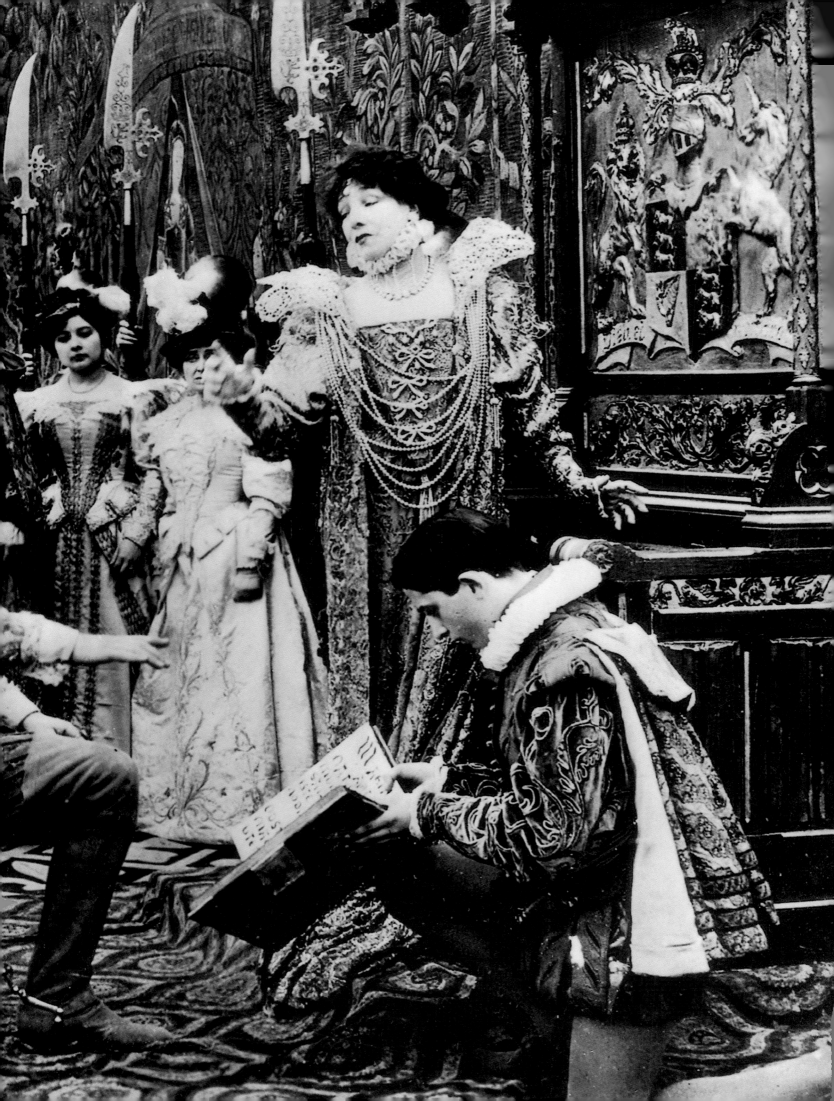

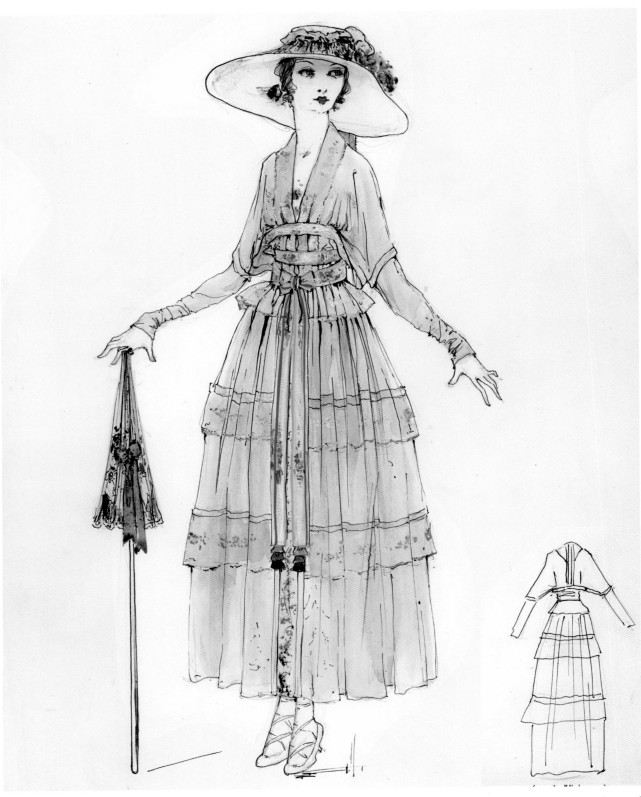

**William Lord Wright (writer):** "The ladies of the animated screen can be depended upon to wear a thing of beauty, to the delight and the edification of feminine admirers in all parts of America. Mr. Jenkins of Jonesville has long been puzzled why wifey insists on issuing forth on a dark and stormy night to see her favorite actress in a society play. Mrs. Jenkins keeps a wary eye on the latest styles. She knows that the Motion Picture actresses wear the latest modes, and that she can revel in the style of a gown much better in the picture show than she can in the pages of some fashion journal."

### *THE RISE OF SUSAN* (1916) · LUCILE, COSTUME DESIGNER

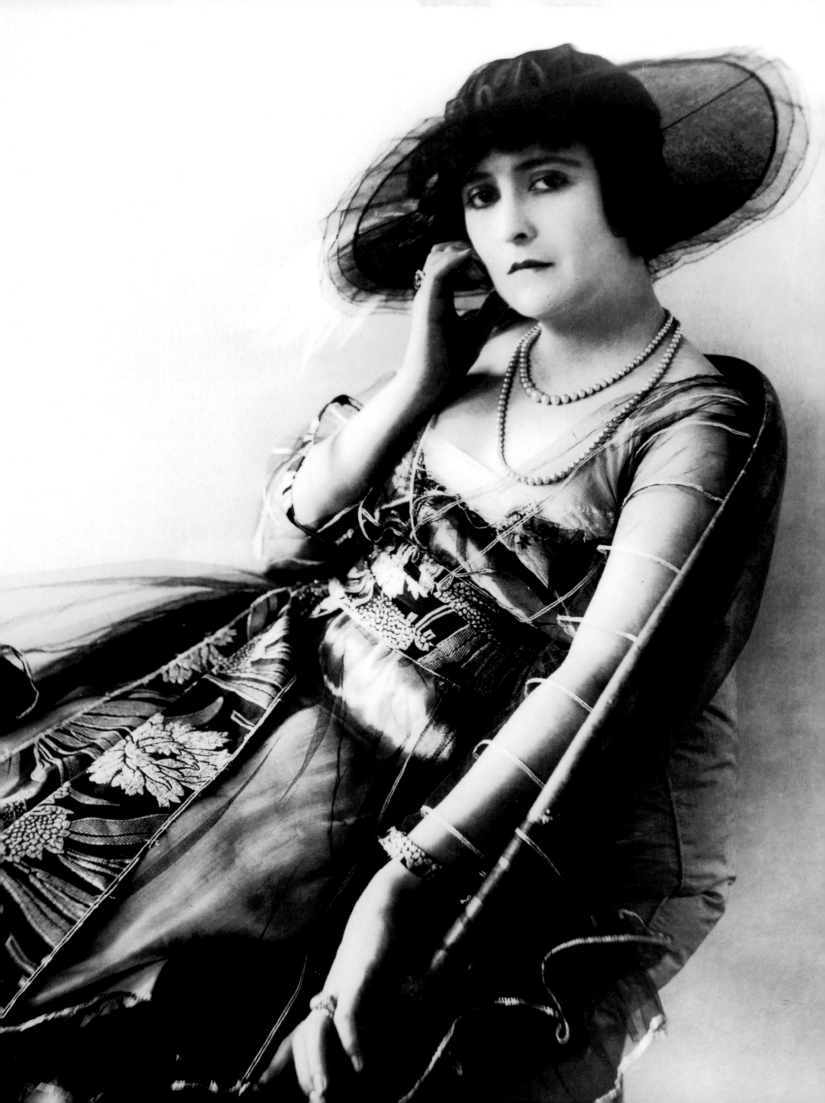

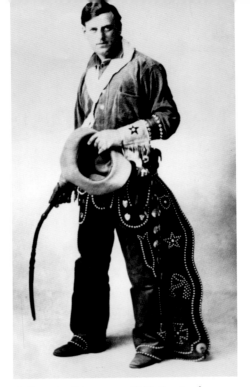

**Gilbert "Bronco Billy" Anderson (actor):** "I looked like a tough hombre. Of course, the cowboys only wear those chaps when they go out in the chaparral to guard against the stickers."

**William S. Hart (actor):** "The wardrobe lady, Mrs. Harris, told me she did not think laced shirts would be correct, and got out a heavily bound book containing the different costumes of all periods to prove her argument. The costume of the cowboy as the 'correct' thing had a laced shirt. It was the very one that my sister Mary had made for me in *The Squaw Man*, and [the] picture of the cowboy inside of the laced shirt was myself!"

**HELL'S HINGES (1916)**

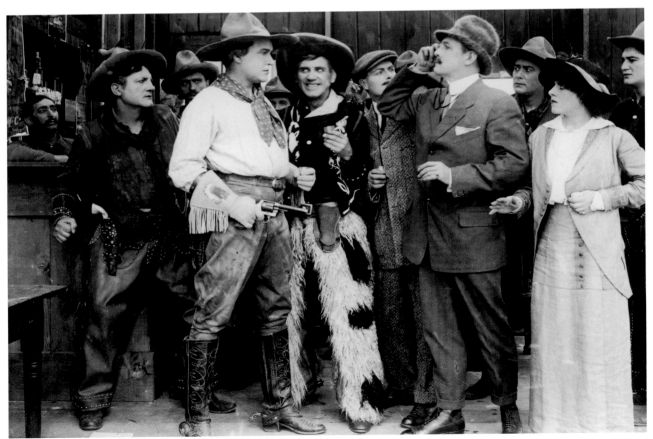

**Cecil B. DeMille (director):** "It has been said that I was the first director to provide actors with individual dressing rooms near the sets on which they worked. I give credit where credit is due, and in this case, to Jacob Stern or whoever built his barn. The actors in *The Squaw Man* dressed in the horses' stalls."

**THE SQUAW MAN (1914)**

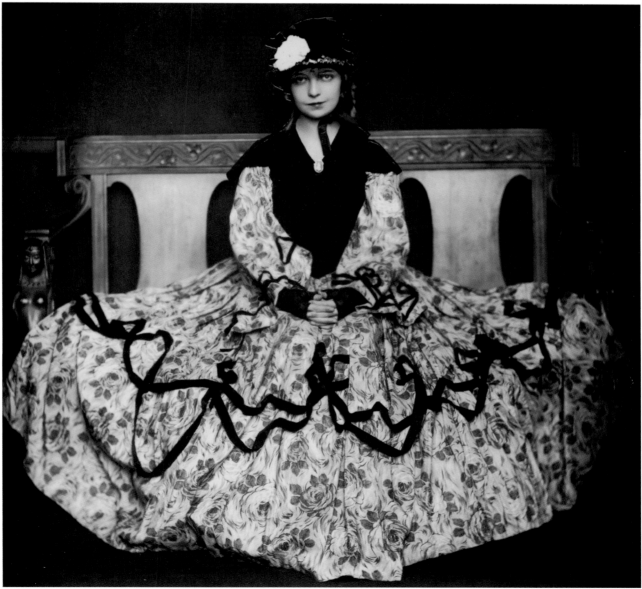

**Lillian Gish (actress):** "We pored over photographs of the Civil War and *Godey's Lady's Book,* a periodical of the nineteenth century, for costumes, hair styles, and postures. We had to rehearse how to sit and how to move in the hoop skirts of the day."

*THE BIRTH OF A NATION* (1915) · ROBERT GOLDSTEIN AND CLARE WEST, COSTUME DESIGNERS

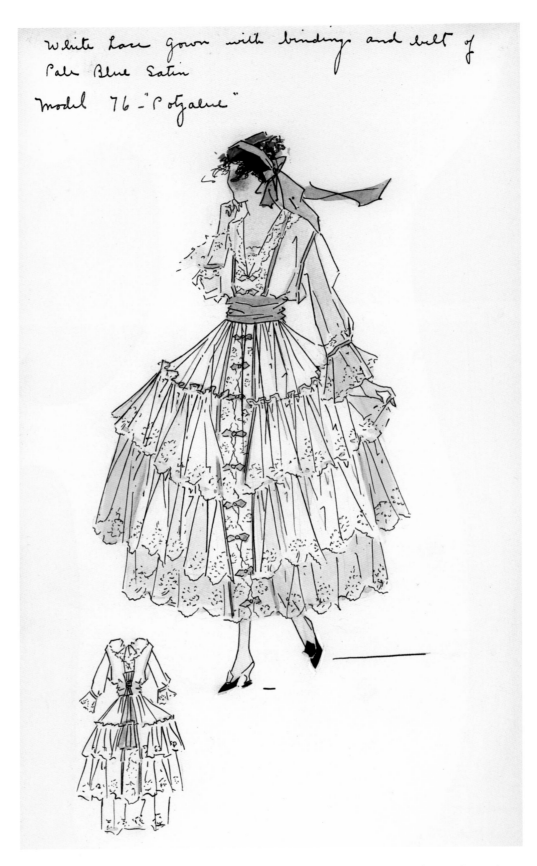

*White Lace gown with bindings and belt of Pale Blue Satin*

*Model 76 – "Potyalue"*

**Roberta Courtland (writer):** "Lucile, of the daring, the shy, the bold, the modest, whose frocks are a dream. . . . Billie Burke profits by that dream with a frock that is in every way worthy of the story told about it."

### GLORIA'S ROMANCE (1916) · LUCILE, COSTUME DESIGNER

**Lillian Gish (actress):** "Mr. Griffith wanted the main characters of the Babylonian episode to be larger than life. Alfred Paget, who played the young king, was well over six feet tall. He was made to look taller with built-up shoes. . . . There were no Adler elevated shoes in those days; Mr. Griffith had to create his own."

**Bessie Love (actress):** "I used my own clothes for a scene in the modern period of *Intolerance*—a black-and-white checked skirt and jacket which Mother had altered to fit me."

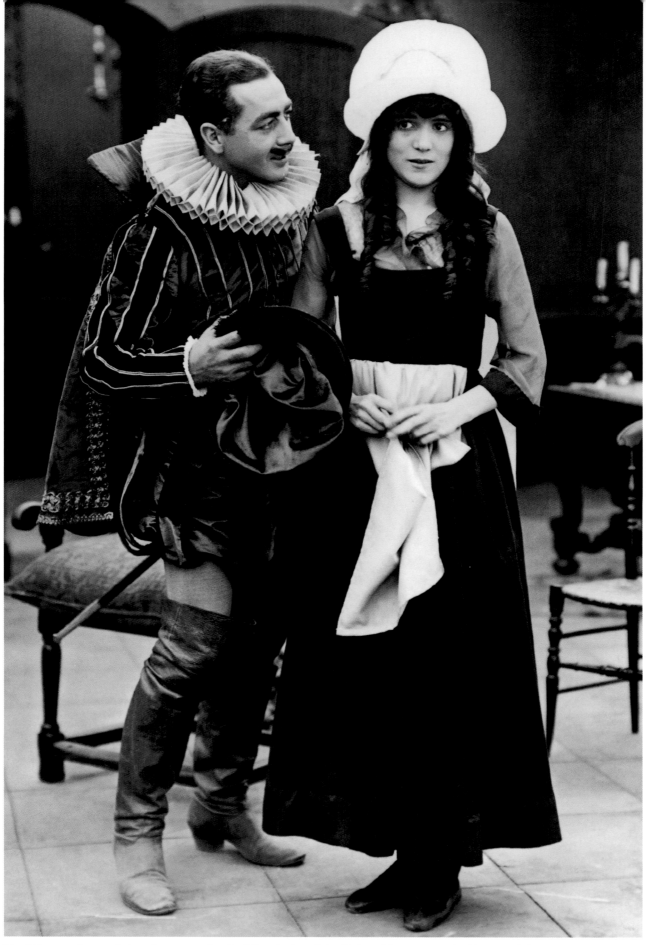

**Karl Brown (associate photographer):** "The desks of Griffith's office were piled high with books. It would take a full day for anyone to thumb through them even in the most cursory manner. So the significant pictures were cut out and mounted in a scrapbook for ready reference. Then there was another scrapbook, and another, full to the bulging point. No two authorities agreed about anything."

*INTOLERANCE* **(1916) · CLARE WEST, COSTUME DESIGNER**

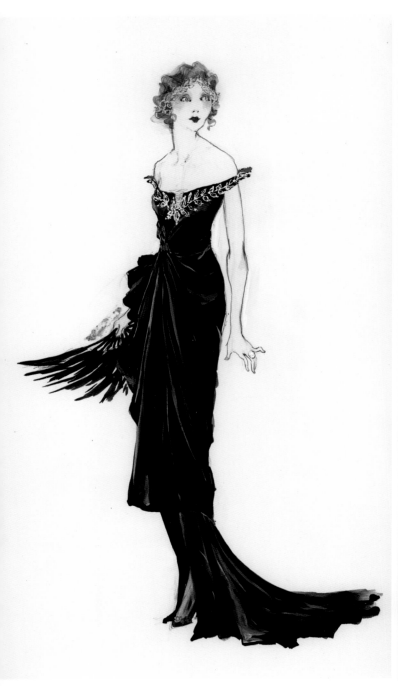

**Hedda Hopper (actress, columnist):** "'I don't like it,' said the star, Miss [Anita] Stewart, coldly. 'I'm terribly sorry,' I said, 'but I have nothing else to wear. I never wear anything ready-made (As heaven is my judge, I said it with a straight face).' For three days, at great expense to her producer, [Anita Stewart] sulked. . . . Thunder rolled with each change of my costume. My clothes built to a crescendo. We'd spent ten days shooting when I had to wear a four-hundred-and-fifty-dollar evening gown—red satin, pulled up in a pouf in back, with tulle and paradise feathers. We all but needed the riot squad for that one!"

***VIRTUOUS WIVES* (1918) · LUCILE, COSTUME DESIGNER**

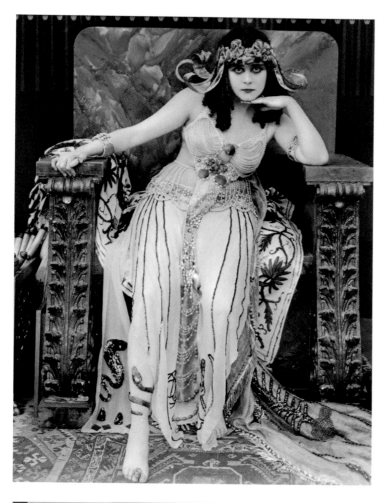

**Ronald Genini (biographer):** "The *Cleopatra* costume created quite a stir because it cost $1,000 a yard and Theda seemed to be wearing only ten cents' worth. . . . The *Plain Dealer* declared that 'Of all the Vampires of Screen There's None So Bare as Theda,' and the *Cleveland Leader*'s reviewer noted unkindly 'that the brief costumes showed that the vamp had been gaining weight and perhaps should change her name to 'Feeda Bara.'"

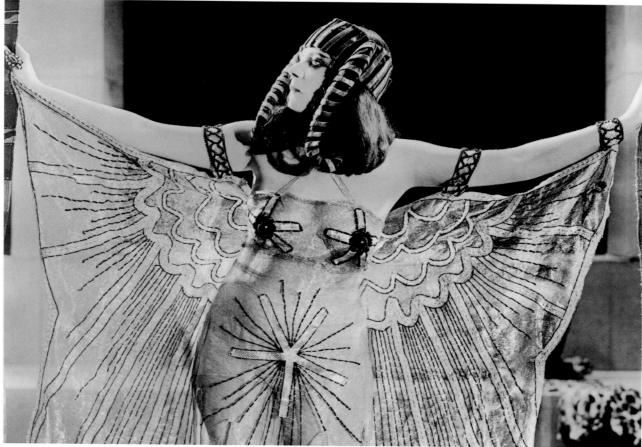

**Ronald Genini (biographer):** "The exposure of flesh caused a furor, causing the Better Films Committee of the Women's Club of Omaha to condemn the movie in what was described as the most exciting meeting the group ever had. Theda Bara filed a $100,000 suit against the Chicago censor for refusing to give the picture a permit. Of course, the film was booked solid, and made a million dollars."

*CLEOPATRA* (1917) · **GEORGE HOPKINS, COSTUME DESIGNER**

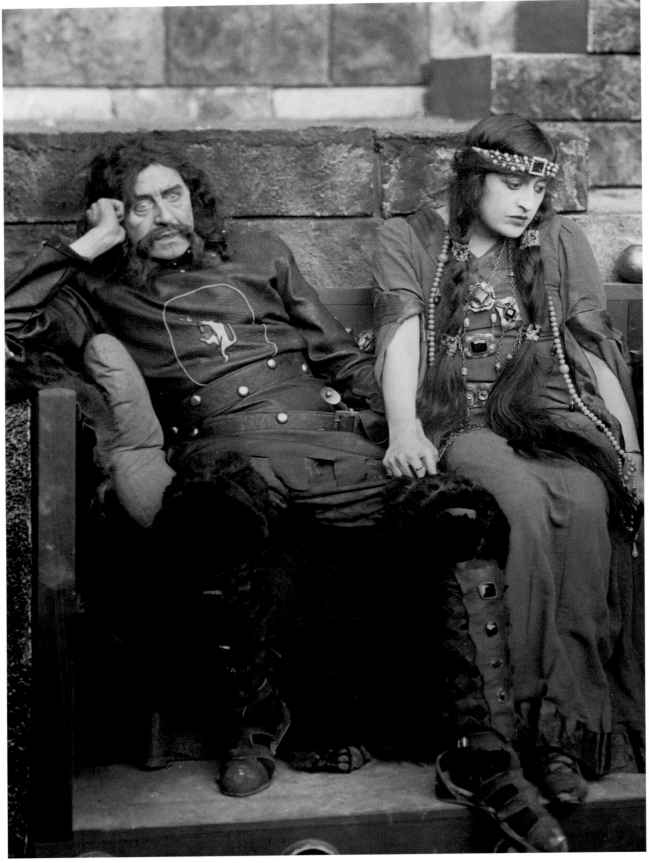

**Constance Collier (actress):** "Sometimes we would leave the studio too tired to change our costumes. One night, I remember Herbert Tree, still in Macbeth's wig and beard and dress, his daughter's mackintosh wrapped round him, myself with long strands of black hair down to my knees, flowing robes and a crown, and somebody's overcoat over my head, going along Sunset Boulevard in the drenching rain because we had been too kind-hearted to keep the chauffeur waiting all night."

*MACBETH* (1916)

**Pearl White (actress):** "I have remained in New York, wearing furs in the summer and the thinnest kind of clothes in the winter. For it seems that the minds of scenario writers turn toward summer scenes in the winter and toward winter scenes in the summertime; therefore, we poor actors are about half the time roasting or freezing while we work."

*PERILS OF PAULINE* (1914) · LUCILE, COSTUME DESIGNER

**Mary Pickford (actress):** "I was both the crippled rich girl Stella, who knew nothing of death, poverty, sickness, or war, and Unity Blake, who knew all the black things that were kept from Stella, yet could still laugh. As Unity, I also plastered my hair with Vaseline to take out the curls and make it look darker and scraggly in contrast to Stella's curls."

*STELLA MARIS* (1918)

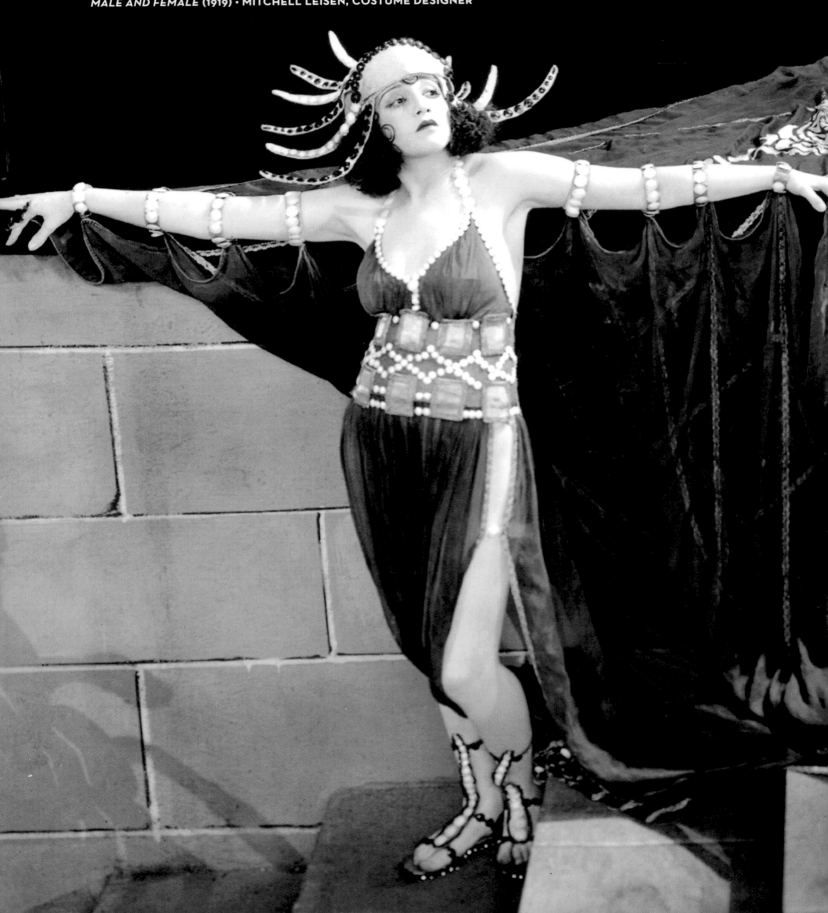

**Cecil B. DeMille (director):** "I want clothes that will make people gasp when they see them. Don't design anything that anyone could buy in a store."

*MALE AND FEMALE* (1919) · MITCHELL LEISEN, COSTUME DESIGNER

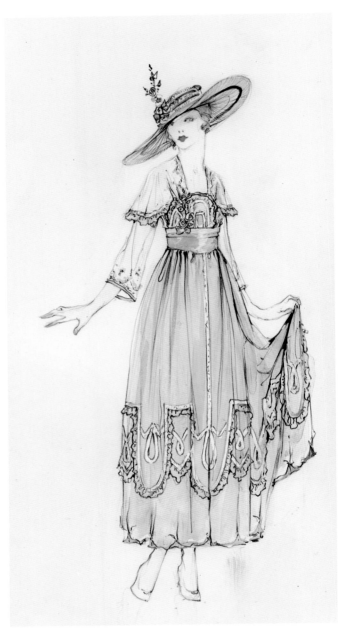 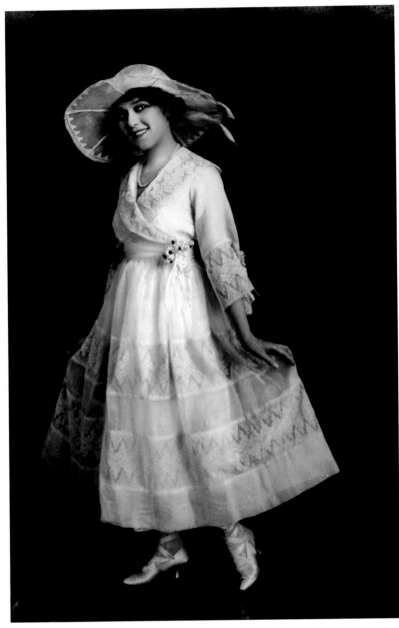

**Lucile:** "One lovely afternoon in late spring I was hard at work in my studio when I was told that Miss Pickford wanted to see me. She had told me that she had come from Hollywood to New York on purpose to consult me, as she wanted some dresses designed by me for her next film. She was as excited as a child over the prospect of her new clothes and begged me to sketch her something immediately. It was not a very easy matter because she was so petite that ordinary fashions looked absurdly incongruous on her; furs almost smothered her, and even the long dresses with trains, which everyone was wearing for evening at that time, made her look smaller than ever. 'What I really ought to put you in,' I told her, 'is a little white, muslin frock with a blue sash and strapped shoes and socks.'"

### *REBECCA OF SUNNYBROOK FARM* (1917) · LUCILE, COSTUME DESIGNER

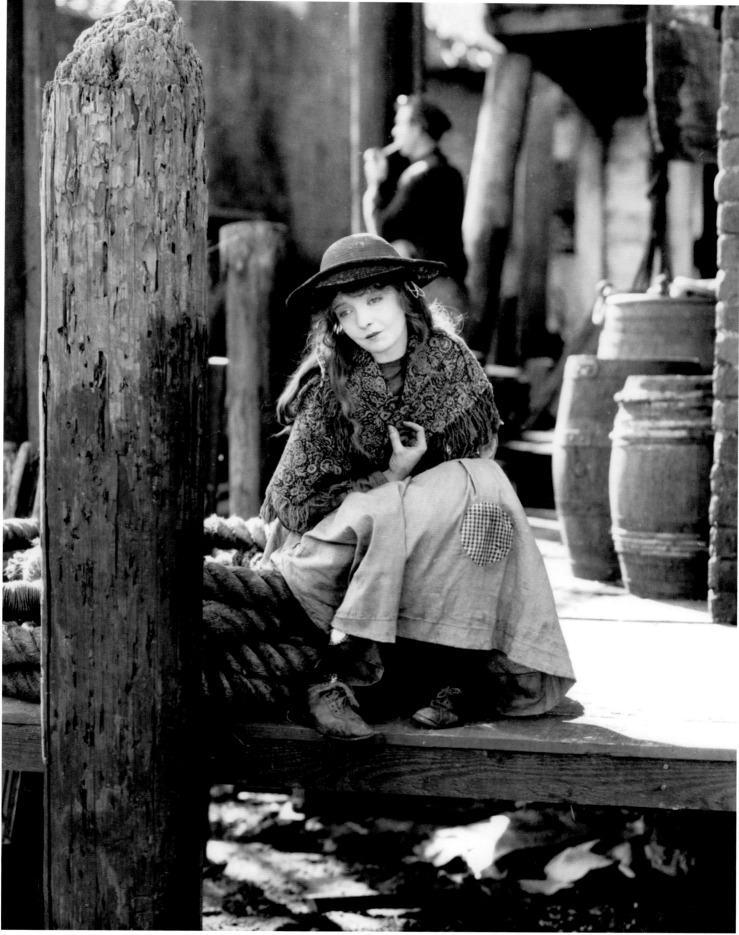

**Lillian Gish (actress):** "The little thin dress that I wore was inadequate protection against the cold winter nights. Dorothy Gish announced, 'If Mr. Griffith works my sister to death, I'll get a gun and shoot him.'"

***BROKEN BLOSSOMS* (1919)**

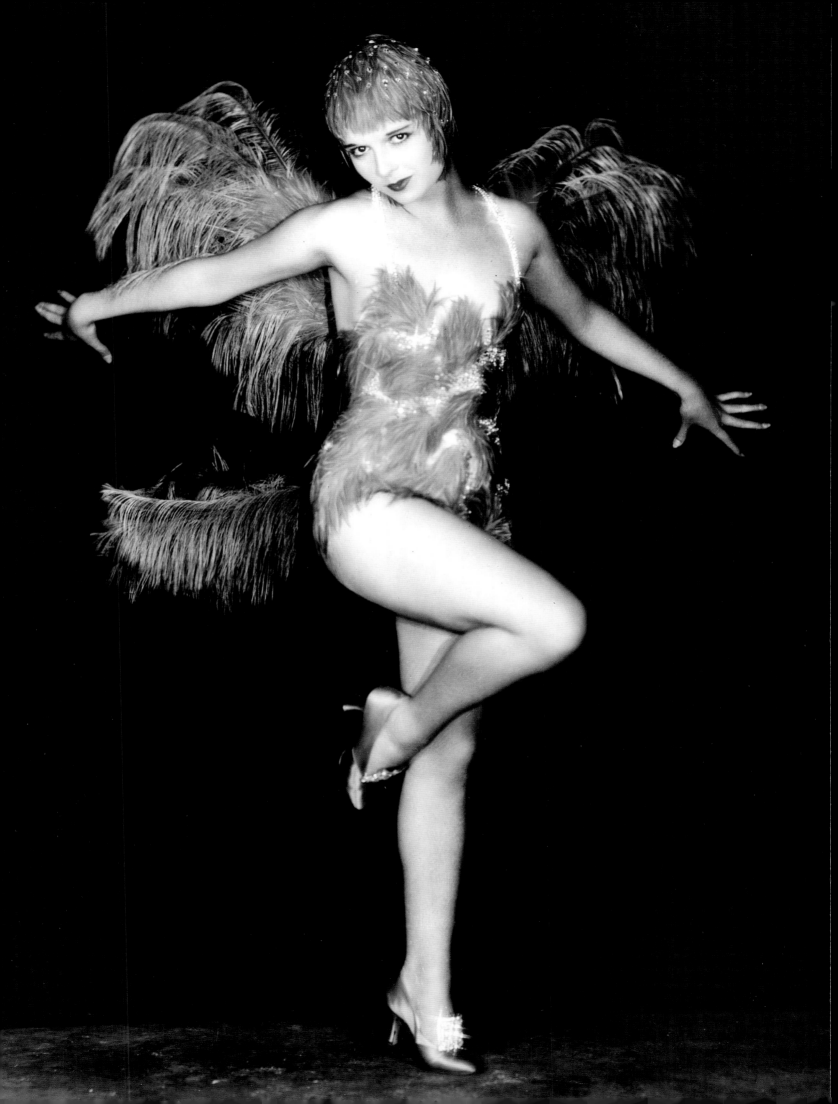

# 1920s

By the 1920s, Hollywood was universally recognized as the capital of the movie business. The theater chains, which owned the movie studios, pressured producers to produce more and more new films to satisfy the enthusiastic public. The speed of production forced the film companies to become true manufacturing plants, with factories staffed with specialized professionals dedicated to the production of handmade features. Throughout the decade, costume departments became bustling, efficient clothing assembly lines. In her 1921 article "Dressing the Movies" for *Women's Home Companion,* Miss Walker observed: "The motion pictures have opened up a most fascinating field for the man, woman, or girl who is clever at designing and making clothes, particularly if she is able to express personality, character, and emotions through clothes. Almost any producer of motion pictures can secure the services of a tailor whose lines are admirable, of a milliner whose hats are ravishing, or a draper who can hide defects and emphasize slimness, but they are all watching keenly for the worker in the shop who adds to any of these gifts the ability to express human emotions in terms of clothes."

OPPOSITE: *"The canary costume came with a detachable tail so that I could sit down." —Louise Brooks*
*The Canary Murder Case (1929) • Travis Banton, costume designer*

To accommodate the films produced on the lot, MGM developed a system to clothe actors efficiently and effectively. Fortunately, they had acquired the Goldwyn wardrobe facilities and vast costume stock, which had been assembled in the previous busy decade by wardrobe director Sophie Wachner. The department filled a two-story building sixty feet wide and half a block long. To staff MGM's costume department, studio chief Louis B. Mayer sought out the best artisans, and many of those professionals spent their entire careers with the studio.

As today, the costume design for each project started with the script and a candid discussion between the designer and the producer and director. After determining the nature and the number of costume changes for each character, the designer illustrated each costume and met with the director, producer, and star for their approval. Assistants were sent to the studio storeroom to acquire the fabrics, trims, ribbons, and buttons for each costume. The orthochromatic black-and-white film used at the time distorted colors—reds and yellows photographed unusually dark, blue faded to white, and velvets took on a strange sheen—so the designers chose colors carefully, and screen-tested each costume before the movie began shooting. The final costume sketch was delivered to a head fitter who would drape and make the pattern of the suit or dress. After many fittings and a final film test, the costume was finally approved.

The studios' expert designers were vital to the industry, but they and their creations were also expensive. Paramount spent about $125,000 each year to dress actress Gloria Swanson, and rented $500,000 worth of jewelry at a cost of about $50,000. Yet few actors were so pampered, and studio accountants encouraged designers to reuse costumes as often as possible. By the 1920s, Paramount Studios owned an estimated fifty thousand costumes; their racks bustled with costumes representing every time period from ancient to modern, ethnic costumes from the four corners of the globe, and military uniforms of every nation. Whether a script called for a few minor characters or hundreds of extras, the costume warehouses filled a film's needs. New garments were almost always produced solely for a movie's lead characters, especially the lead actresses. Ethel P. Chaffin, who was in charge of designing the gowns at Paramount, created some three thousand ensembles in 1920 alone.

Determined to have the world's best at the studio, Mayer wasted no time looking for star power to lead his costume department. In 1924, he employed renowned French stage designer Romain de Tirtoff, known as Erté. When Erté arrived in New York on February 25, 1925, the *Morning Telegraph* announced that his "advent into motion pictures is of special significance to the film industry as it is the first notable recognition paid to the importance of the costuming phase in motion picture production." Erté was brought to MGM with all the fanfare afforded the biggest stars.

Unfortunately, his tenure would not live up to the hype. Experienced with creating showy costumes for large stage revues such as the Folies Bergère, Erté brought his same sense of outsized drama to the screen. Though his fabulous showgirl costumes looked stunning from the back of a live theater, they looked awkward and ridiculous in black and white on a movie screen forty feet wide. Erté viewed actresses as mannequins for his gowns, rather than as characters in a story, and actresses in his designs appeared uncomfortable. For the tubercular seamstress played by Lillian Gish in *La Bohème*, Erté produced a collection of crisp calico dresses. The dresses were made of cheap fabric, and Gish argued that they would look too new on the screen. Star and designer steadfastly refused to compromise; Erté banished the star from his workshop, and Gish collaborated with Lucia Coulter, head of wardrobe at MGM, to replace Erté's work with tattered gar-

ments of old silk that would look worn and cheap on screen. After just one year, Erté returned to Paris, brimming with nasty comments on the state of American taste.

The world of couture, however, did produce some of the best early designers in movies. Howard Greer, who began his career at Lucile in New York, joined Paramount in 1923, clothing the studio's principal stars—Anna Q. Nilsson, Bessie Love, and Pola Negri. Travis Banton, a prodigy born in Waco, Texas, also began as a society couturier; his career was made when Mary Pickford chose one of his designs for her celebrated marriage to Douglas Fairbanks. After a stint at the Ziegfeld Follies, Paramount producer Walter Wanger offered to showcase Banton's talents in *The Dressmaker from Paris* (1925). Studio boss Adolph Zukor offered him $150 a week as second to Howard Greer, the studio's head designer, promoting him as an imported French designer with as much hoopla as the studio publicity department could muster.

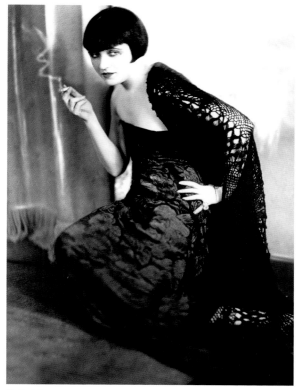

*Pola Negri*

Greer hired Edith Head as a sketch artist in 1923, never dreaming that this modest Stanford French major would become a household name. Before coming to Paramount, Head had no formal training in either fashion or the theater. She was teaching high school French and attending art school when she heard about an illustrator position at Paramount's wardrobe department. She later admitted to stealing her classmates' sketches to include in her portfolio for the interview with Greer. Under the mentorship of Greer and Banton, Head attended all dress fittings and gradually was given autonomy designing the studio's "bread-and-butter" B-pictures. As she later recalled fondly, "Travis gave me more responsibility than I ever had. He let me do Westerns on my own. In the big pictures he'd do the leading lady—Marlene Dietrich for instance—and I'd do the others." Tenacity and ambition made her fifty-year career the longest lasting of costume designers— and the most honored.

At Film Booking Offices of America (FBO, later RKO), Walter Plunkett was hired as a costume designer—a position that was part of the studio's Drapery Department. Across town from MGM, this struggling studio usually bought or rented garments for its actors, but Plunkett finally persuaded executives that it was cheaper to set up a proper costume shop with sewing machines and seamstresses. From his new workroom, he dressed actors for Westerns, action pictures, and stunt thrillers. Plunkett designed all these concurrently, sometimes with the help of freelance designers.

If the budget was high enough, new costumes were created for the entire cast. With the support of an involved producer or director, designers went to extraordinary lengths to attain historical accuracy. For 1923's *Robin Hood,* starring Douglas Fairbanks Sr., designer Mitchell Leisen created detailed shields and tabards with matching crests for every extra. The "armor" was painstakingly constructed out of hemp and silver leaf woven to simulate chain mail. No less attention was invested in the 1924 film *Monsieur Beaucaire.* Two experts were sent to Paris to ensure accuracy for the film's late-eighteenth-century costumes. Heartthrob Rudolph Valentino's wife, costume designer Natacha Rambova (née Winifred Shaughnessy of Salt Lake City, Utah), and French designer George Barbier created sixty costumes for the film, including lavish brocade

frock coats for the leading man. As the *New York Times* noted in 1924: "Valentino, not so very long ago a modest employee in a Broadway café, has a costume of silver brocade, and shimmers like metal cloth with stamina. Valentino wears a band around his shoulder of peacock blue, and the merest soupçon of lace at his throat." Rambova also designed the sets and costumes for Oscar Wilde's *Salome* in 1922. Inspired by Aubrey Beardsley's 1894 art nouveau illustrations, her sets and costumes look startlingly modern. Rambova's mini-dresses for film star and producer Alla Nazimova and the Art Deco imagery are among the most memorable in the history of motion pictures.

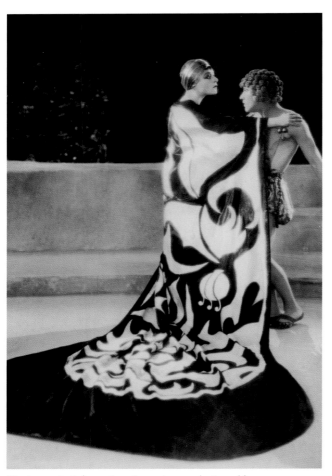

*Nazimova in Salome (1922) • costumes designed by Natacha Rambova*

For *The Ten Commandments*, Cecil B. DeMille was so intent to re-create everyday life in Moses' Egypt authentically that he sent his assistant, Jeanne MacPherson, to the Middle East to buy props, costumes, and accessories. DeMille decreed, "Buy everything you can find. Buy Mount Sinai and the original Ten Commandments if you can get away with them." At the same time, his trusted collaborator, costume designer Clare West, commanded hundreds of dressmakers constructing the thousands of costumes that would be required for the epic—even before casting was completed.

Although great care went into ensuring historical accuracy in such films, the aspect of other films depended on the idiosyncratic personal style and perspective of the studio and producers. Bessie Love gave this account of her appearance in *The Lost World* (1925): "At first I was dressed for the part in the usual Hollywood conception of the secretary/heroine, whether she was roughing it in London's West End or in the jungles of South America. A pretty silk blouse trimmed in pleated ruffles (this was before permanent pleats); and I don't know how we thought a secretary would keep these pleats in a rain forest. And for my hair I had a three-quarter wig as glam as Percy Westmore, the studio hairdresser, could make it. The producer took one look at my silk pleated get-up and said, 'But you look like you're made up for the Follies, dear.'"

The attitude in Hollywood was that glamour and grunge could happily coexist—so long as the costume never sabotaged the story. Silent-film director Wallace Wisely's attitude expressed the industry standard: "The costumes must be incidental—accurate, correct, but inconspicuous." Inconspicuous but never invisible, the costumes of the 1920s gave the audience precious clues into their characters, telegraphing information in countless details and nuances.

Designer Max Rée observed that "the designer of costumes should begin with a conception of the personality. He is at least as much an analyst as the actor who plays the part, for he must familiarize himself with the character so that the kind of thing the person in question would wear is immediately obvious to him." With such a forward-looking approach, the evolution of film costume had begun. Going beyond the role of the fashion designer—or theater designer—the costume designer for film now followed his own particular set of rules and requirements.

Some actresses were passionately involved in every aspect of costume. Pearl White, who starred in the popular Fox serial *The Perils of Pauline*, provided her own wardrobe. White consid-

ered what every aspect of her attire might suggest to the moviegoer—from the silhouette of her suit to the "clocking" weave pattern in her stockings.

Although costume decisions were driven by a myriad of influences, designers soon realized that their work was having a direct effect on fashion outside the theater. What women saw on the screen, they wanted in their closet. When audiences identified with a character and her story, they emulated her style. From film's earliest days, when fashion designers often clothed stars on and off-screen, fashion took its cues from film. With the construction of more and more movie palaces and the public's increasing moviegoing habit, Hollywood costume designers continued to influence contemporary fashion even more than before. "We are the first to exploit a style," said Joan Crawford.

One woman whose every clothing choice was watched carefully was Greta Garbo, who owed her glamorous image first to Clement Andreani ("André-Ani") and then to Adrian Adolph Greenburg ("Adrian"), hired as MGM's head designer in the late 1920s. "When I first came to the studio," Adrian said, "Garbo was being dressed in the most fantastic, unreal manner. Standing collars, more Elizabethan than modern, made her a weird, exotic personality unlike anyone genuine." Instead, Adrian chose simple lines for the Swedish actress, letting her natural fragility and earthiness emerge. The audience, no longer distracted by her clothes, was able to linger on her intense eyes. Women may not have been able to get her eyes, but they wanted her charisma—and her clothes.

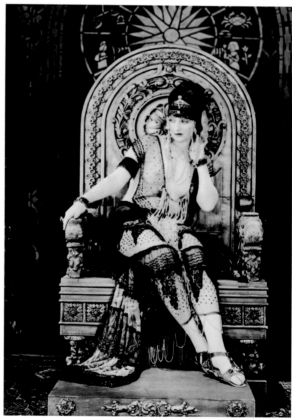

While women might have wanted to emulate the stars on the screen, costumes for film were never intended for real life. Howard Greer said of his movie creations, "If they were gaudy, they but reflected the absence of subtlety which characterized all early motion pictures. Overemphasis, as it applied to acting techniques and story treatments, was essential. If a lady in real life wore a train one yard long, her prototype in reel life wore it three yards long. When you strip color and sound and the third dimension from a moving object, you have to make up for the loss with dramatic black-and-white contrasts and enriched surfaces."

Clara Bow, one of the screen's first sex symbols, generously shared her natural assets. "When they line up a story for me," she observed, "the first thing they think of is: 'How do we get Clara undressed?'" Ironically, it was the curvaceous Bow who inspired the flat-chested, low-waisted flapper fashions of the 1920s. Makeup chief Monte Westmore strapped flat Bow's wayward breasts in glorious Travis Banton mini-dresses for Elinor Glyn's picture *It* (1927); Bow became known as the "It" girl, and was transformed into the hottest babe in moving pictures. The coy peekaboo trend for sheer and diaphanous fabrics, exposed garters and lingerie (where there was lingerie to expose) would continue through the still-naughty early 1930s. Clara Bow wasn't the only leading lady who spent large amounts of time on screen barely clothed. Betty Blythe was so naked in *The Queen of Sheba* that the *Los Angeles Times* called the movie "one of the most notable 'undress' pictures of the year," adding, "Still what is worn is displayed in such a way as to have a high appeal to the eye of the beholder.

*"If Theda Bara had been given the clothes (or not given the clothes) of Miss Blythe, she would have appeared vulgar and ridiculous and would have raised hubbub with the censors. This girl, apparently serenely unconscious of her exquisite body, never offends. You are only conscious of the beauty and charm of her." —Mae Tinee (writer)*
*Queen of Sheba (1921) • Margaret Whistler, costume designer*

Sheba's queen is arrayed in the exotic dress of the Orient, with glistening jewels lending luster to her beauty."

That appeal was certainly not universal. Hollywood's frequent use of nudity quickly attracted the attention of conservative civic and religious groups, which began to voice concerns about the industry's product and its contribution to lowering of national morals. In a preemptive strike against federal regulation of films, the studios joined together in 1922 to create the Motion Picture Producers and Distributors of America (MPPDA). The organization's goal was to self-regulate the industry, thus disarming the crusading right-wing factions. Led by Will H. Hays, the MPPDA created a master list of offensive plays and books that were prohibited as the story line for films. The Hays Office, or "Hays Code" as it became popularly known, banned cleavage, women's navels (although men's were acceptable), and pregnancy. In coming years, the scrutiny and tyranny of the Hays Office would only increase, and costume designers would waste inordinate amounts of time meeting the desires of a star and a director while keeping within the confines of the policing censors.

By the end of the 1920s, the art of costume design was well established within the studio factory system, but the newly founded Academy of Motion Picture Arts and Sciences ignored the craft at their inaugural Academy Awards ceremony in 1928. Excellence in Art Direction and Cinematography were recognized, but the Oscar for costume design would not be presented until 1948—after many of the field's originators had retired. For fifteen years, costume designers had conjured their screen magic so well they had succeeded in virtually disappearing; their illusions had made the art of costume design look easy. Designers had made an art of the artifice. Actors remained anchored to the center of the screen, but the Academy of Motion Picture Arts and Sciences took the perfection of their image for granted. It was as if the costumes had designed themselves.

**Randy Skretvedt (biographer):** "Stan and Babe wore formal stand-up collars, to give their characters a sense of dignity. Stan wore a flat-brimmed Irish children's derby—appropriate for his childlike character—and he fastened his cuffs with string. His shoes had no heels, which made Stan look shorter and more vulnerable; this device also gave him his flip-flop walk."

*LAUREL AND HARDY*

**Max Rée:** "The designer of costumes should begin with a conception of the personality. He is at least as much an analyst as the actor who plays the part, for he must familiarize himself with the character so that the kind of thing the person in question would wear is immediately obvious.

"Changing an actress's figure by means of her clothes came up when I designed the costumes for Lillian Gish in *The Scarlet Letter*. We wished to stress the pathos of Hester Prynne by making her small—almost immature. To give her the appearance of being shorter I broke the lines wherever possible. Across her circular skirt I put several rows of broad tucks. On her very short jacket were wide bands of black velvet edging the neck and the end. Her shoes and cap were round. All this tended to flatten her silhouette, and Miss Gish is sufficiently slender to stand the ordeal."

*THE SCARLET LETTER* (1926) · MAX RÉE, COSTUMER DESIGNER

**Lillian Gish (actress):** "For *Orphans* Mr. Griffith had a designer do the costumes, but for my taste they were too much in the fashion of the time. I went to Herman Tappe and told him my ideas and the two of us worked out Dorothy's and my costumes for *Orphans*. All the other costumes were duplicates of those worn in the Revolutionary period."

**ORPHANS OF THE STORM (1921) · HERMAN PATRICK TAPPE, COSTUME DESIGNER**

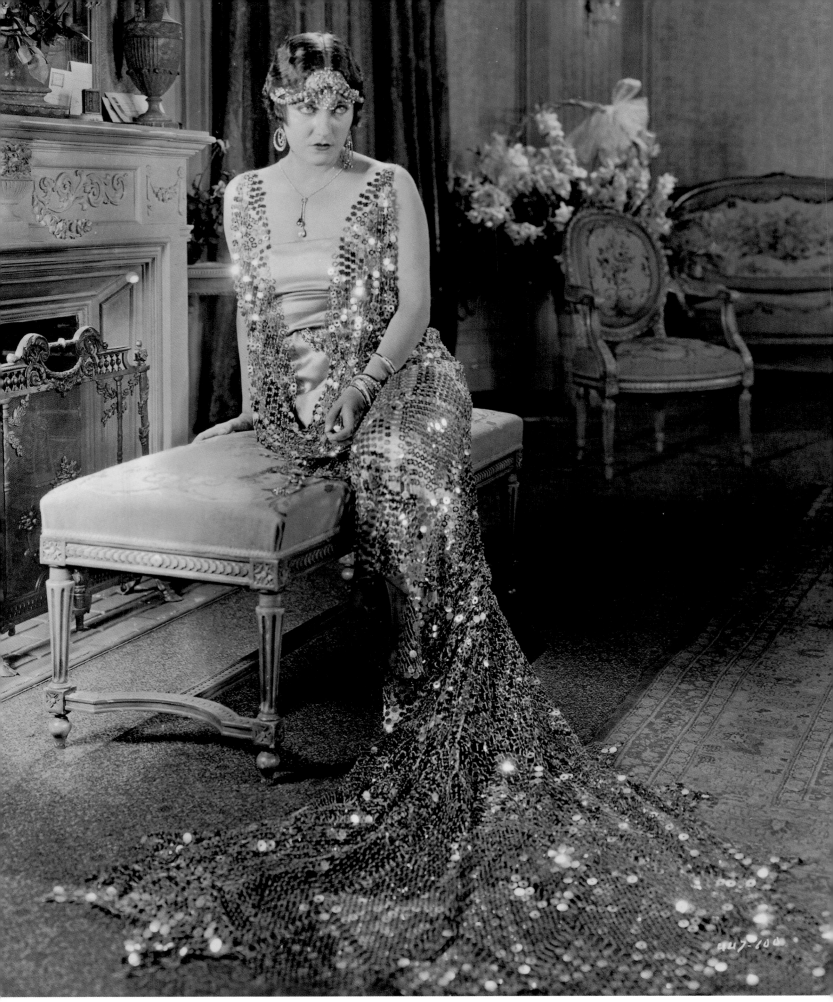

**Gloria Swanson (actress):** "We had clearly found the formula for success in these romantic comedies of marriage and intrigue laced with a series of handsome leading men and a never-ending parade of fabulous gowns."

*THE IMPOSSIBLE MRS. BELLEW* (1922) • CLARE WEST, COSTUME DESIGNER

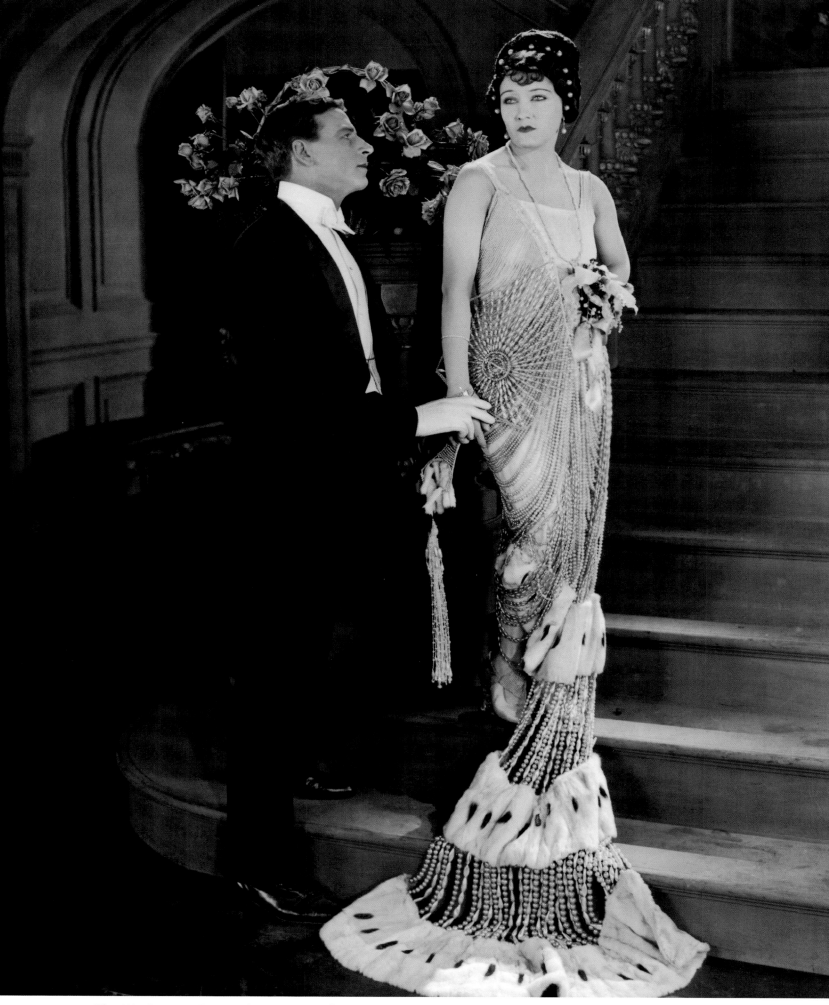

**The Washington Post**: "Gloria Swanson has an interesting robe, which she wears in *The Great Moment*. There are, of course, a number of pearls in the costume, but the rest of it seems to be mainly Gloria."

**THE GREAT MOMENT (1921) · CLARE WEST, COSTUME DESIGNER**

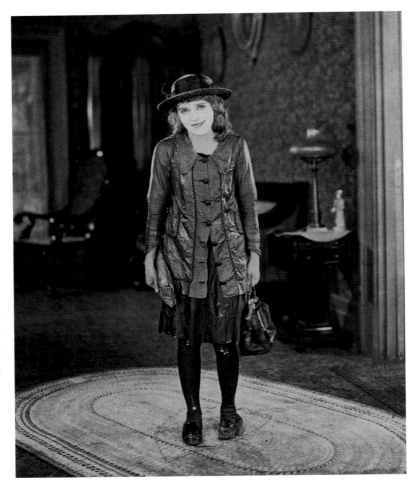

**Robert Windeler (biographer):** "There were times, from 1916 to 1926, when Mary so successfully lived the character of the little girl she couldn't give it up, and [producer Adolf] Zukor recalled the time when she was refused admission to one of her own films because she looked too little and too young."

*POLLYANNA* **(1920)**

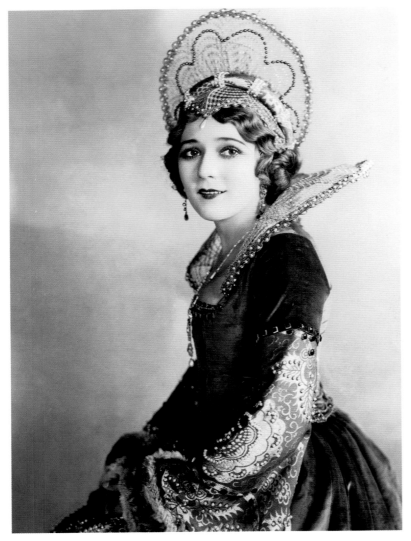

**Mitchell Leisen:** "We really spent the money on that one. Mary Pickford found out that Blanche Sweet had just made a Renaissance-era film that had a gown which supposedly cost $25,000, so Mary wanted one that cost more. I gave her one that cost $32,000. It was embroidered with real pearls."

*DOROTHY VERNON OF HADDEN HALL* **(1924) · SOPHIE WACHNER AND MITCHELL LEISEN, COSTUME DESIGNERS**

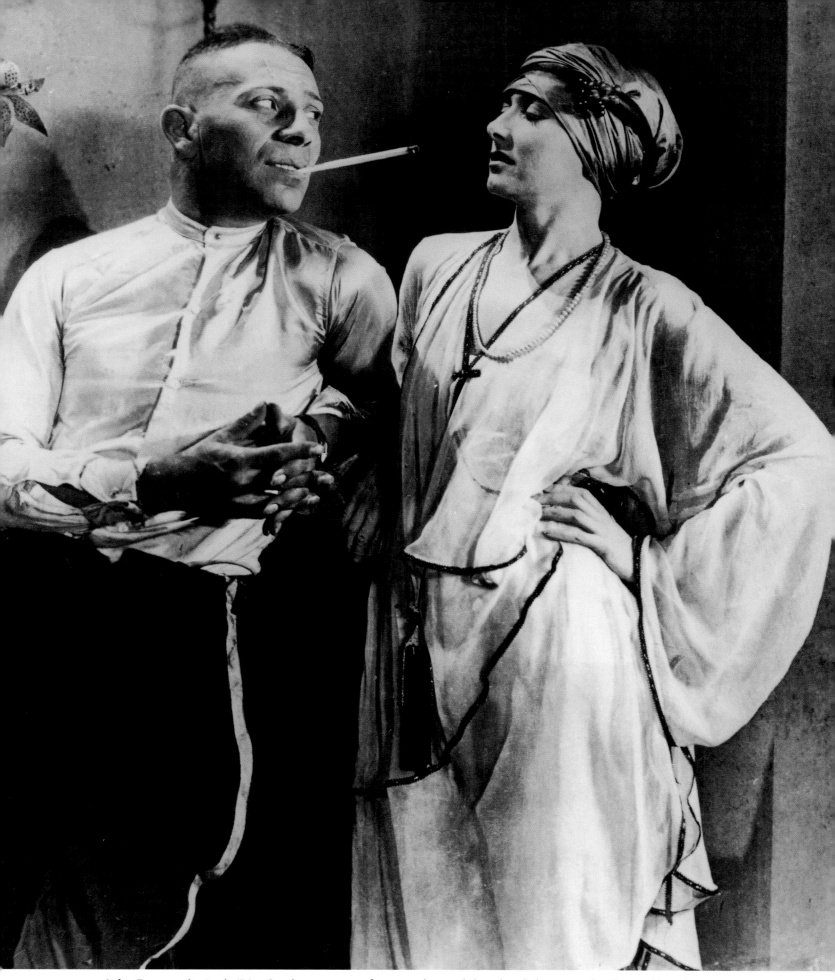

**John Bowers (actor):** "Von Stroheim goes so far as to demand that the slightest cord or knot of braid on every military uniform be just so; perhaps that again is going too far, but what other court or military scenes in films have just that certain éclat that Von Stroheim gets into his pictures?"

*FOOLISH WIVES* (1922) · COSTUMES DESIGNED BY WESTERN COSTUME COMPANY

**Gavin Lambert (biographer):** "Nazimova asked Rambova to create something as form-fitting as the Syrian guard's jersey. Rambova's solution was a sheath-like tunic of white satin, with a rubber lining (specially made by a manufacturer of automobile tires) that clung to her body. Nazimova liked it so much that she asked for another in the same style but dark in color, to wear in the earlier scenes."

*SALOME* **(1922) · NATACHA RAMBOVA, COSTUME DESIGNER**

**Raoul Walsh (biographer):** "*The Thief of Bagdad*, the first picture to cost a million dollars, was made in thirty-five days. The costumes had been designed by Mitchell Leisen; his flair for period dress beautifully complemented the wizardry of [art director William Cameron] Menzies's sets. Doug Fairbanks got around in baggy pants, slippers, and his skin. This outfit showed off his athletic ruggedness to perfection. It is a toss-up whether the princess responded to his vehement declarations of love or his physical comeliness."

### *THE THIEF OF BAGDAD* (1924) · MITCHELL LEISEN, COSTUME DESIGNER

**Erich Von Stroheim (director), to actor Jean Hersholt auditioning for the role:** "'Schouler' is a helper in a dog hospital. A greasy, smart-aleck type in a loud suit and derby hat, a cigar always between his lips. Your haircut is wrong; I'm sorry, but I don't think you'll do!"

*GREED* **(1925)**

**Eleanor Keaton (biographer):** "In silent films, every film comedian had a signature hat. Derbies were the most popular, with both Charlie Chaplin and Roscoe Arbuckle wearing them, and Harold Lloyd adopted the straw boater. Buster set out to create his own hat, which would set him apart from the other comedians as well as endure rough treatment and still keep its shape.

"When we were in Germany in 1962 to promote screenings of *The General*[,] he needed a new hat. Buster went to a little hat shop next to our hotel in Frankfurt and pointed out the hat he wanted to the little elderly man who ran the shop. Buster pantomimed everything as he did not speak German and the shopkeeper did not speak English. Buster tried on the fedora and liked it. He then pantomimed scissors[;] the shopkeeper handed Buster a pair of shears. Buster proceeded to tear the entire hat lining out, fold down the crown, and cut the brim. The old man looked like he was about to have a stroke because Buster had not yet paid for the hat. When Buster finished and placed the hat on his head to test it, the old man recognized who Buster was—and what was taking place in his hat shop."

**BUSTER KEATON**

**Mitchell Leisen:** "I have always been a fiend for authenticity and *Robin Hood* was as correct as I could make it. Each knight had a tabard he wore on his chain mail, which had his crest on it. His shield had the same crest, his helmet carried it and so did the banner on his spear. The chain mail was knitted out of hemp, ironed flat and silver leafed."

*ROBIN HOOD* (1922) • MITCHELL LEISEN, COSTUME DESIGNER

**Lois Wilson (actress):** "Conditions were rough, but no worse than some of the other Westerns I was on. I got slight frostbite, we ran out of supplies and had to live on apples and baked beans for a while, but I loved every minute of *The Covered Wagon*. Oh, we were cold, but I don't think the film would have been as good if we hadn't been uncomfortable and if we hadn't run into unexpected circumstances. For instance, snow. Nobody expected snow in the desert at that time of year. The tents were so laden with snow they were practically falling on our beds."

### *THE COVERED WAGON* (1923) • CLARE CRAMER AND ELLA DIXON, COSTUME DESIGNERS

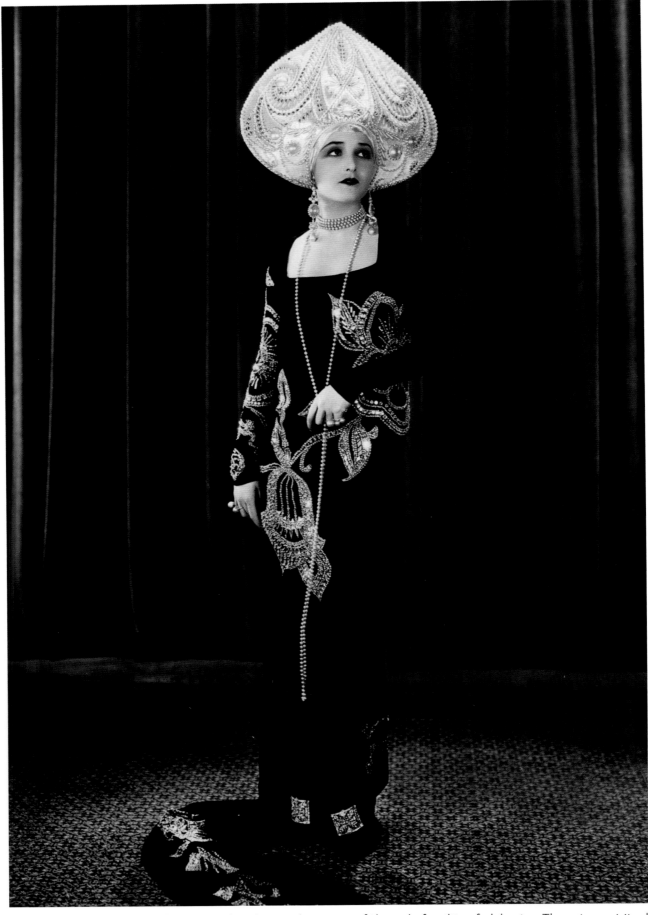

**H.M.K. Smith (writer):** "Florence Vidor's beauty has more of the pale fragility of alabaster. There is a spiritual quality about her very person that justifies her having been called 'the Madonna of the screen.'"

*YOU NEVER KNOW WOMEN* (1926) · TRAVIS BANTON, COSTUME DESIGNER

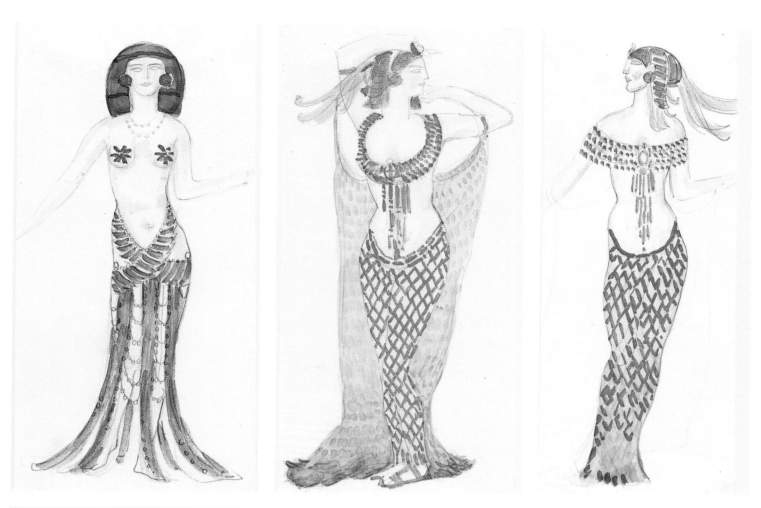

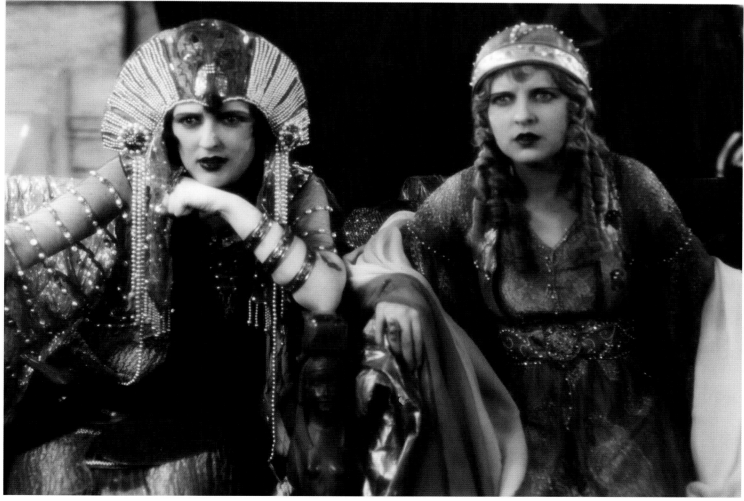

*BEN-HUR: A TALE OF THE CHRIST* (1925) · HERMANN J. KAUFMANN AND HAROLD GRIEVE, AND ERTÉ, COSTUME DESIGNERS

**Allan R. Ellenberger (biographer):** "All of Novarro's training could not solve one problem. Co-stars George Walsh and Francis X. Bushman were approximately the same height, but Novarro, at five feet, eight inches, was at least three to four inches shorter. As a solution, they added heels and padding to Novarro's sandals, which gave the actor an additional inch and a half of height."

***BEN-HUR: A TALE OF THE CHRIST* (1925) ·**
**HERMANN J. KAUFMANN**
**AND HAROLD GRIEVE,**
**COSTUME DESIGNERS**

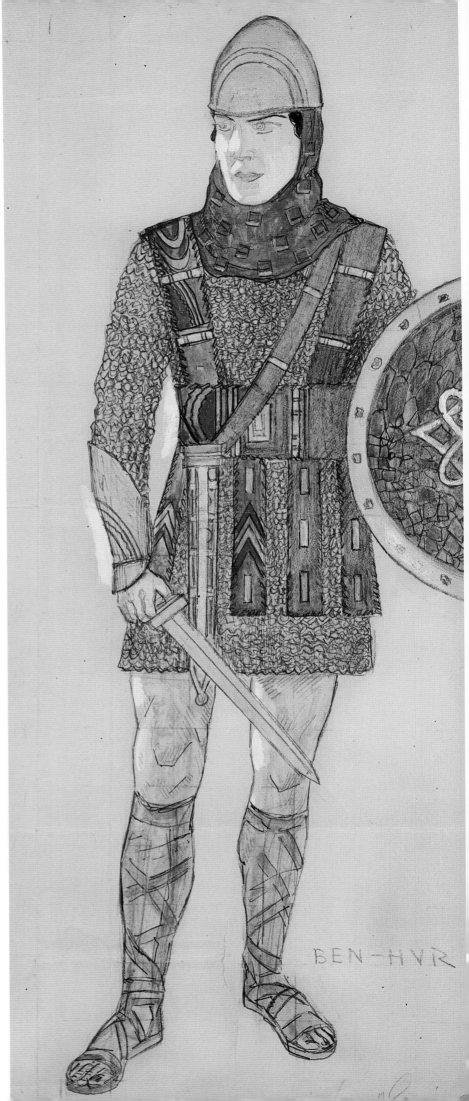

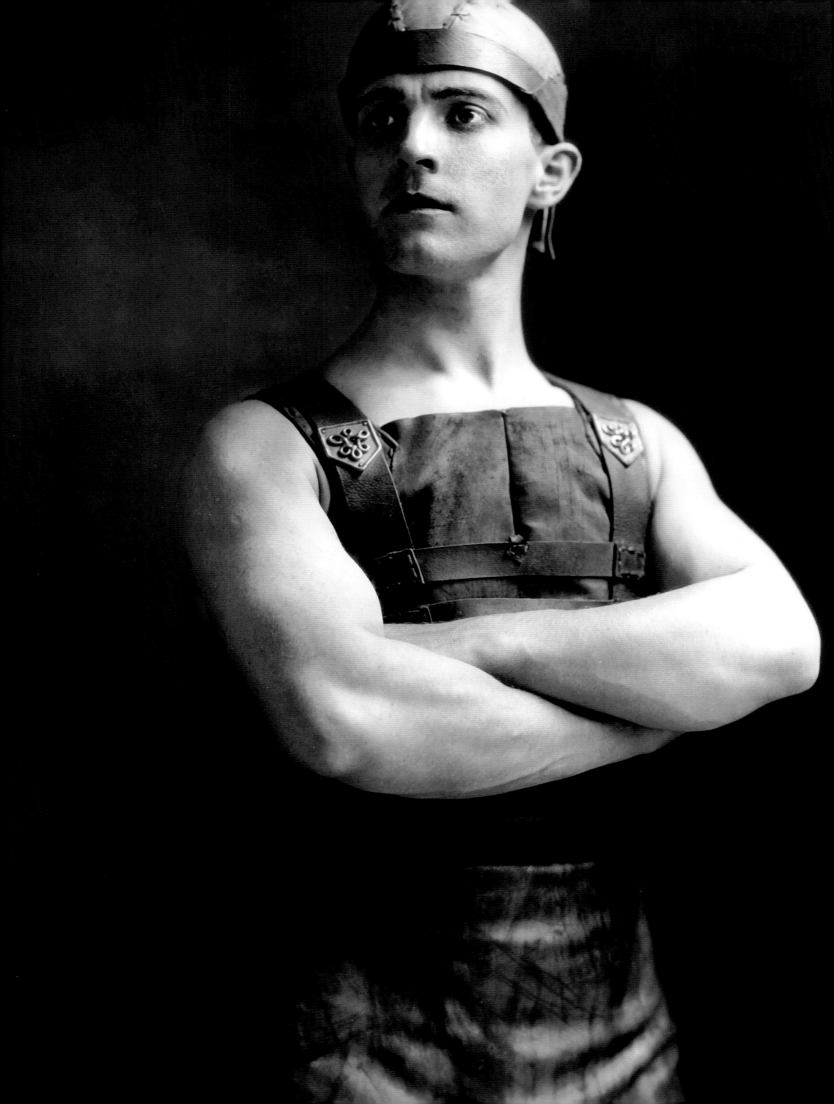

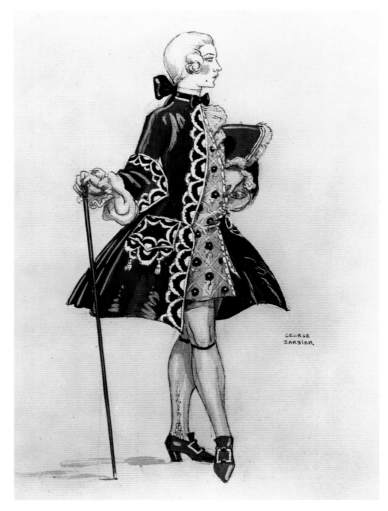

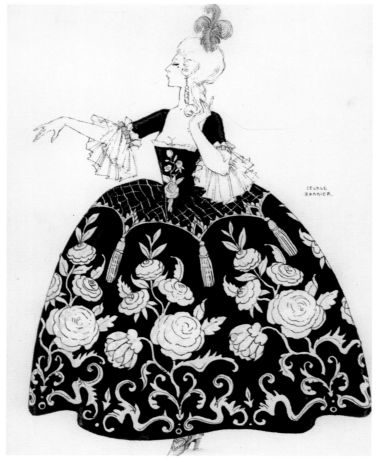

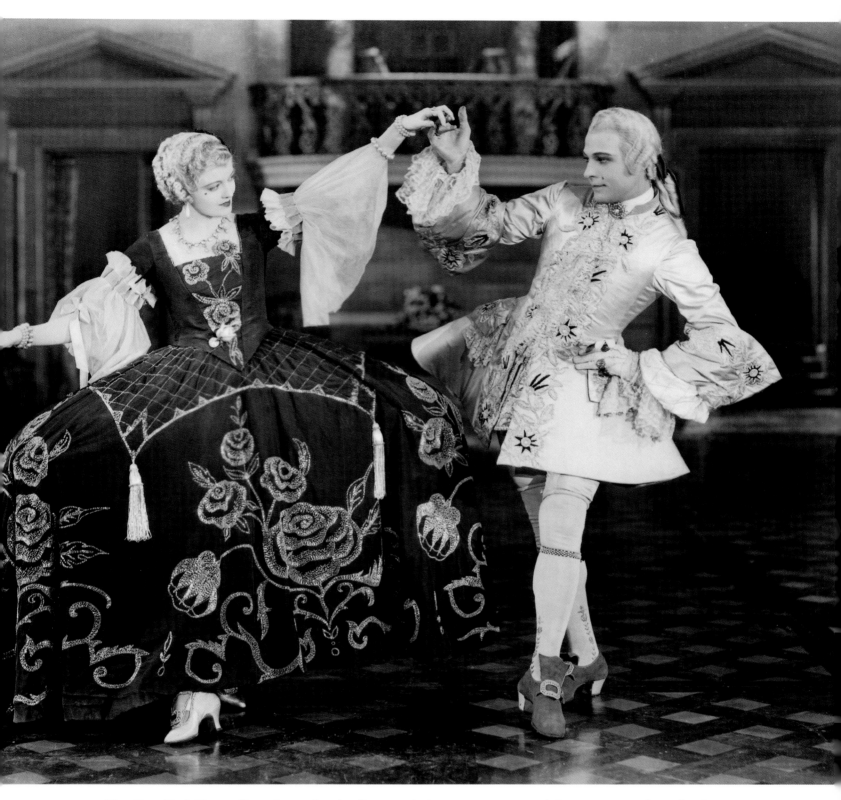

**The *New York Times*:** "A costume director, four wardrobe women, an expert draper, a supervisor of makeup, a director of etiquette, a wig specialist. . . . Sixty of the elaborate costumes in this production were designed by George Barbier, a French illustrator. They were completed in Paris after two period experts of the film had spent a month in the French capital in order to insure accuracy."

**The *New York Times*:** "Valentino has a costume of silver brocade and shimmers like metal cloth with stamina. His gray silk stockings sparkle with rhinestones, tightened with glistening garters, and in his hand a mauve tri-cornered hat trimmed with lines of ostrich plumes. His white wig met his forehead so perfectly that it may have been his own hair, powdered. Attached to one of the false plaits hanging down his back was a neat black bow."

***MONSIEUR BEAUCAIRE* (1924) · NATACHA RAMBOVA AND GEORGE BARBIER, COSTUME DESIGNERS**

**King Vidor (director):** "John Gilbert and Renée Adorée were cast for the leading roles of the American dough-boy and the French farm girl. I decided that in Gilbert's new character of down-to-earth doughboy, he would use no makeup and wear an ill-fitting uniform. Jack rebelled, as I knew he would. . . . But to me the integrity of this picture was more important than anyone's career, so I stood firm and Thalberg backed me up. When he had seen the first few days' rushes, Gilbert was so sold on the down-to-earth characterization that he never used makeup again."

*THE BIG PARADE* (1925) • ETHEL P. CHAFFIN, COSTUME DESIGNER

**Colleen Moore (actress):** "I made *Flaming Youth*, the first flapper picture; the flapper was already well established, but no one had portrayed her. I knew she was an established type because these were the girls my brother used to bring home from college, that's how I knew about them. . . .In the picture I had to smoke, which was awful because I never smoked; it was the perfect image of the flapper, but I haven't had a cigarette since. I never even had a cocktail until I was probably thirty. A flapper I wasn't, but I was the right age and looked the part and I had the 'bangs' and I was it."

*FLAMING YOUTH* **(1923)**

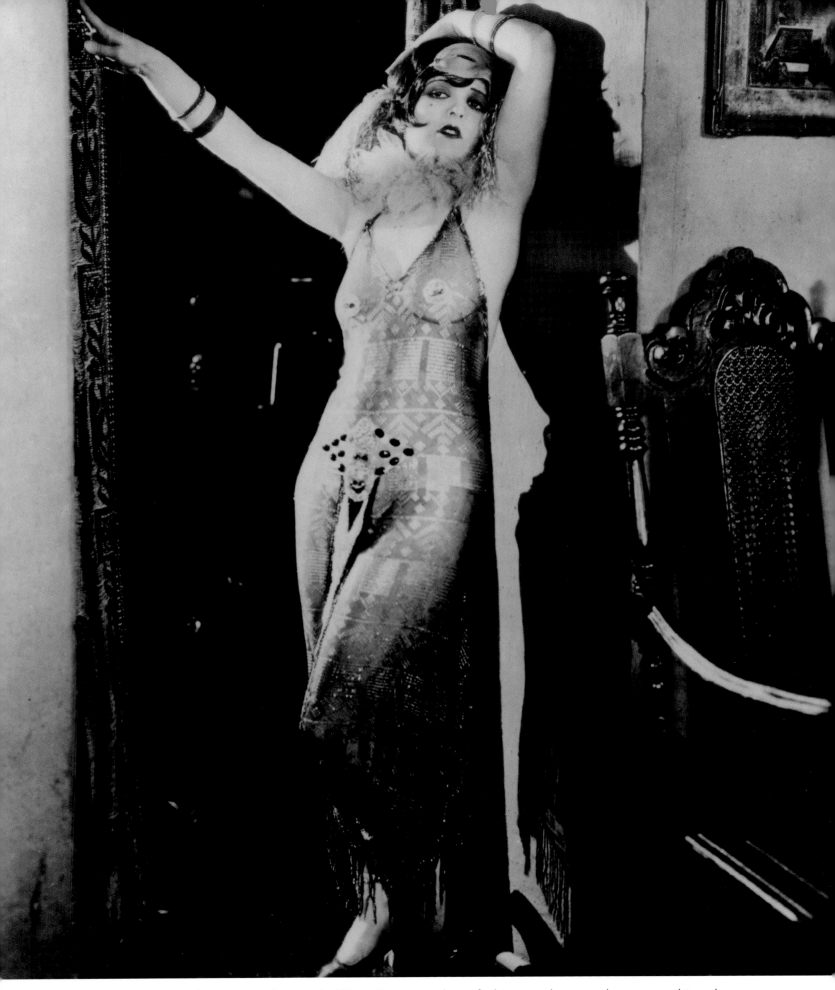

**Hedda Hopper (actress, columnist):** "Clara Bow rose above fashion, as she rose above everything else. Whether she wore a nightgown or a hoopskirt didn't matter a whoop to Clara. She rocked young America, and how!"

*MY LADY OF WHIMS* **(1926)**

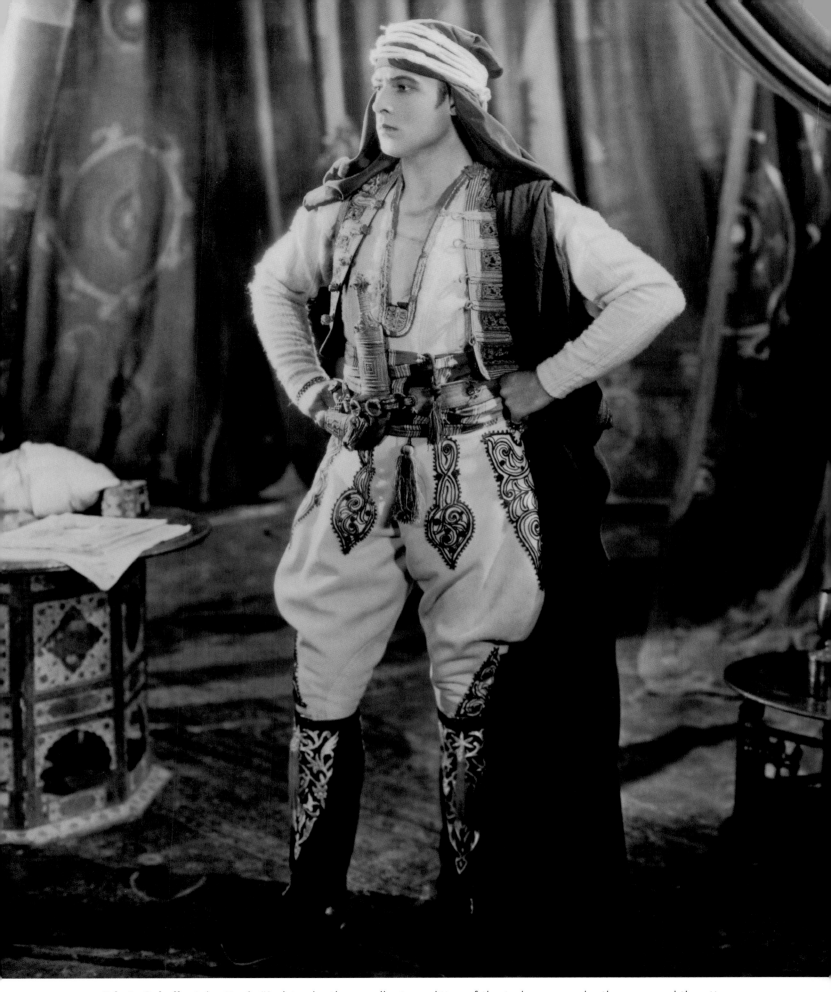

**Edwin Schallert (writer):** "Judging by the excellent condition of the turbans worn by the men, and the attractiveness of the coiffures adorning the women . . . the fact may be gratuitously chronicled that the laundries and the hair-dressing parlors in the Arabian desert of romantic memory are still doing a land-office business."

*THE SON OF THE SHEIK* (1926) · COSTUMES DESIGNED BY WESTERN COSTUME COMPANY

**Cora MacGeachy:** "I always endeavor to make the execution of my designs as simple as possible. One of the first principles of costume designing, as well as of women's attire, is to understand the process of elimination. I never draw a drapery, for instance, that means nothing. Everything I put into a sketch of a costume can be duplicated in materials by the modiste. Femininity is the quality everyone loves in a woman and in my work I do everything to accentuate it."

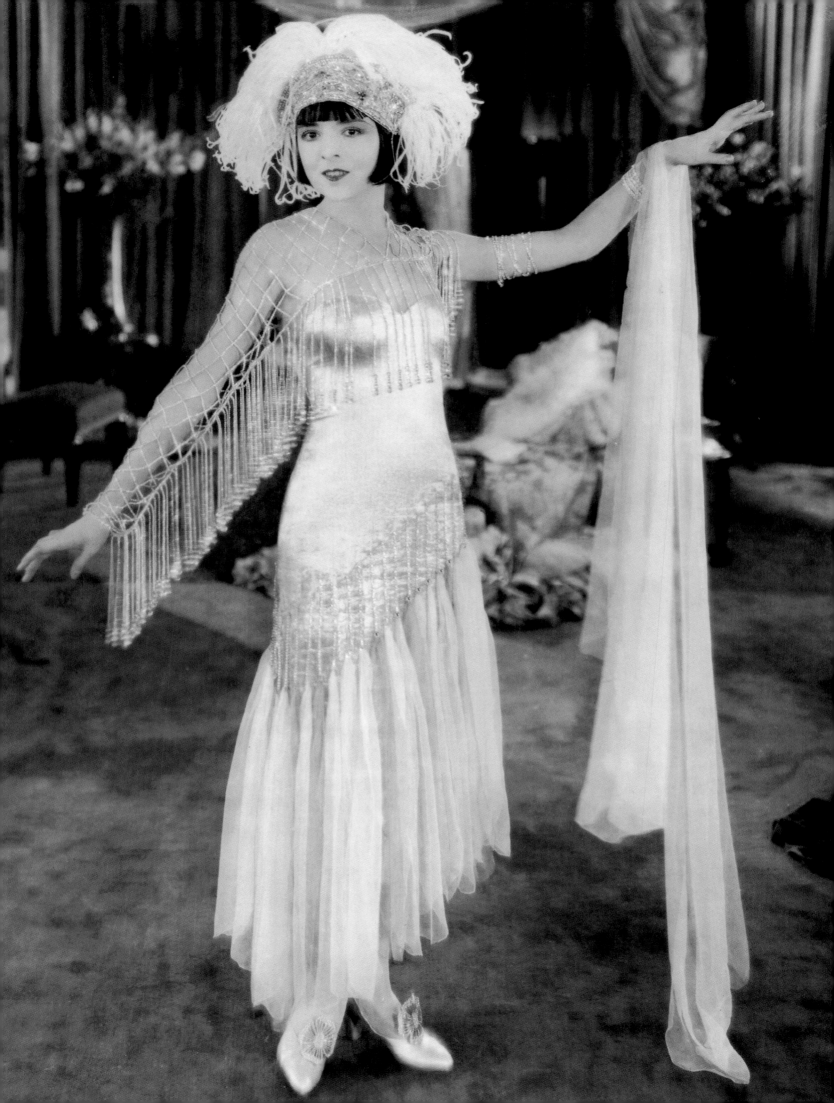

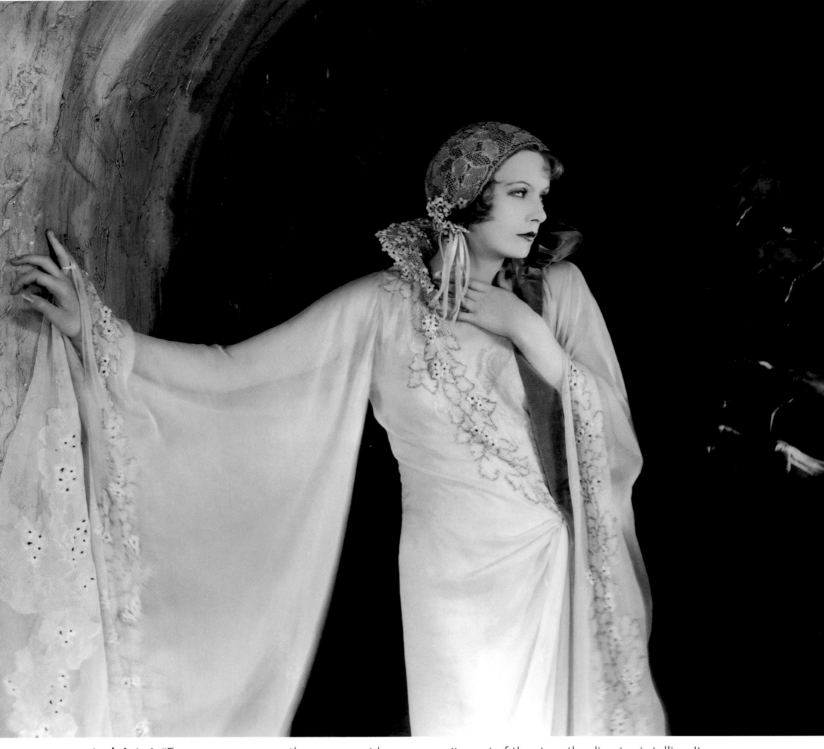

**André-Ani:** "For screen purposes the gown must be a composite part of the story the director is telling. It may be that he will want a gown to help in portraying sex appeal, or hardened sinfulness, or love, or constancy, prudishness or boldness, coyness or any one of the human feelings that go to make up drama."

**André-Ani:** "Garbo has foreign ideas about clothes that do not go well in American pictures. And her figure—it is difficult to dress."

**THE TEMPTRESS (1926) · ANDRÉ-ANI AND MAX RÉE, COSTUME DESIGNERS**

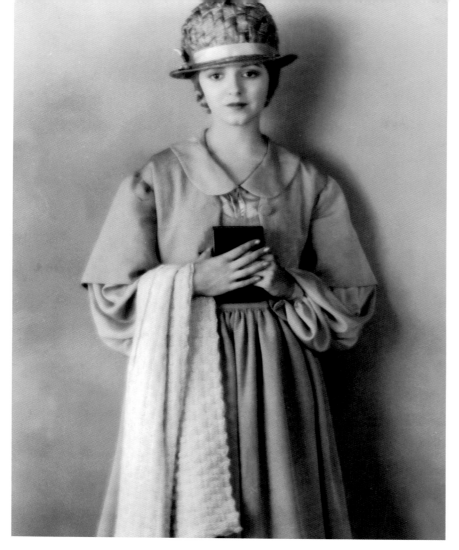

**E. E. Barrett (writer):** "Janet Gaynor . . . is very much at her best in simple garments. I hope she will never make the mistake of dressing up for the screen."

***SUNRISE: A SONG OF TWO HUMANS* (1927) · LUCIA COULTER, COSTUME DESIGNER**

**Rouben Mamoulian (director):** "[The studio] wanted to glamorize Helen Morgan. She was the star of the film, and they insisted that a star should be glamorous, as nobody wanted to see a blowzy leading lady. Since she was supposed to be playing a burlesque stripper who dreamt of a future when she was already in the past, I held out against it. Naturally, I was not very popular on the lot. Then the reviews came out and they were sensational, saying things like 'Why doesn't Hollywood learn from this?'"

***APPLAUSE* (1929)**

**Edith Head:** "Clara [Bow] loathed the uniform and I couldn't blame her. She would sneak around and try to belt it. I'd have to be on the set every minute to snatch it off her. She thought I was out to get her, to make her look less sexy. Granted, it's pretty hard to look sexy in a U.S. Army uniform, but Clara managed.

"Putting Clara in a drab uniform was like bridling an untamed horse. She loved wild colors, the wilder the better. They reflected her true, vibrant personality. I still cherish an old photograph she inscribed, 'To Edith with love, but why don't you put your goddamn belts around your waist where they belong?'"

**_WINGS_ (1927) · EDITH HEAD, COSTUME DESIGNER**

**Gloria Swanson (actress):** "I went over the script with René Hubert. I was counting on him to turn the world of fashion upside down and set America on fire with a barrage of fantastic gowns. 'We have to dazzle them, I know you won't disappoint me.' The audience actually applauded when I appeared in a number of creations, particularly a dark sleeveless gown with jeweled straps and matching Art Deco jewelry."

*THE LOVE OF SUNYA* (1927) · RENÉ HUBERT, COSTUME DESIGNER

*"To think I ever
looked like that!
To think anyone could
suggest sex-appeal
in such get-ups!"*

—GLORIA SWANSON

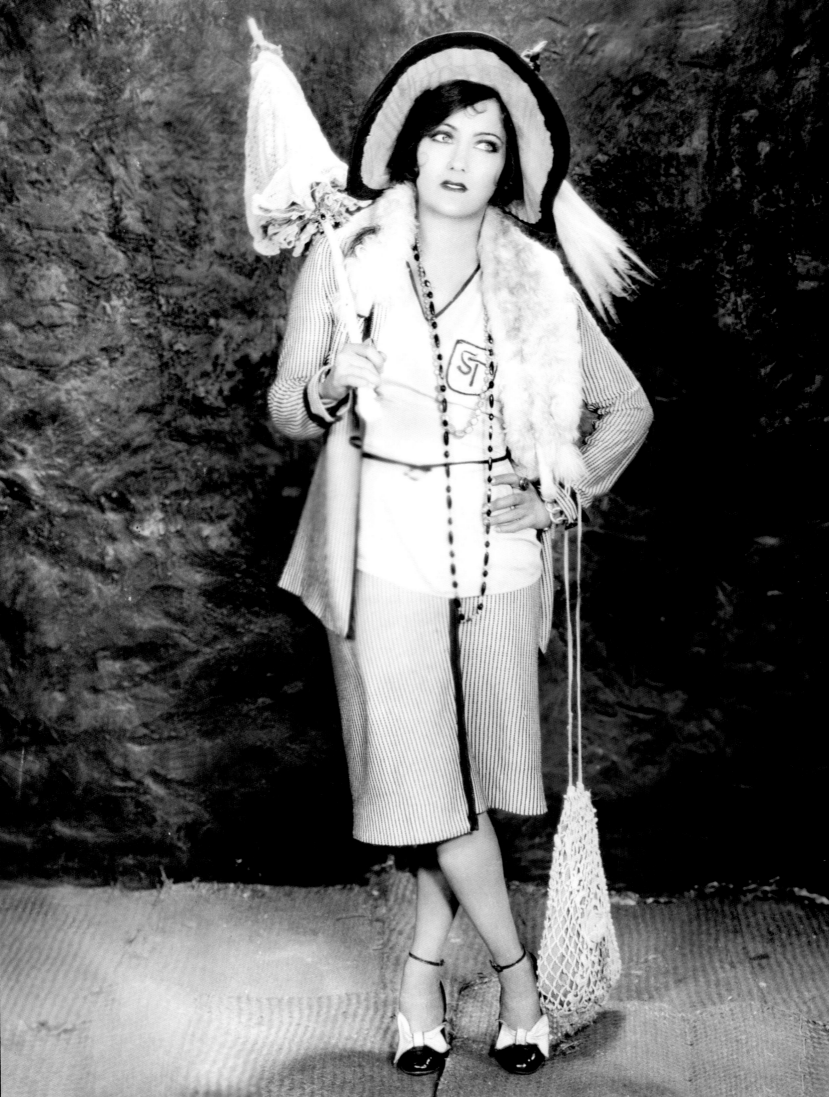

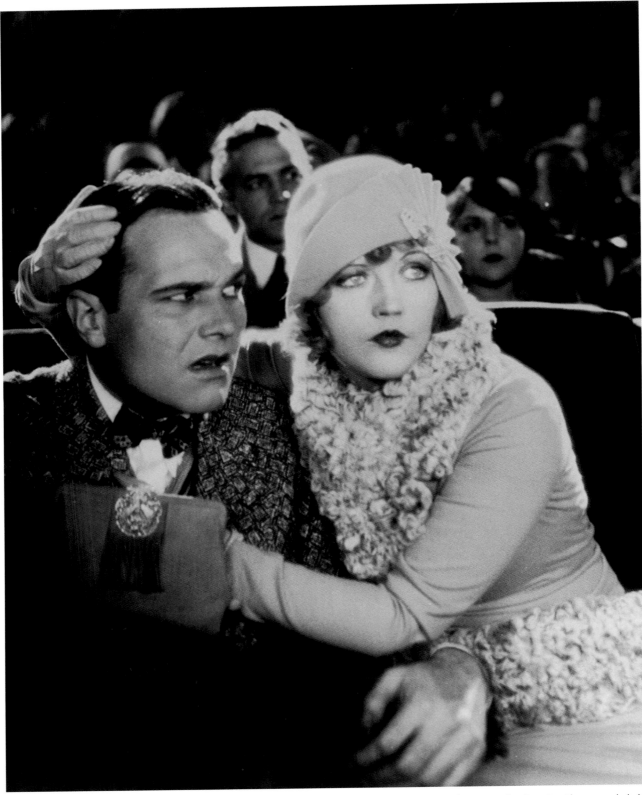

***Photoplay:*** "Marion Davies checks up $100,000 for clothes in a year. Of this, she spends about a thousand dollars a week for costumes for her pictures. Off the screen, Miss Davies dresses conservatively; the $48,000 which she allows for her own clothes represents the cost of dressing simply. Only the finest materials can be used in Miss Davies's costumes, because they must be able to stand the constant wear of between six months and a year in the studio, for it requires that period to make a big production."

### *SHOW PEOPLE* (1928) · HENRIETTA FRAZER, COSTUME DESIGNER

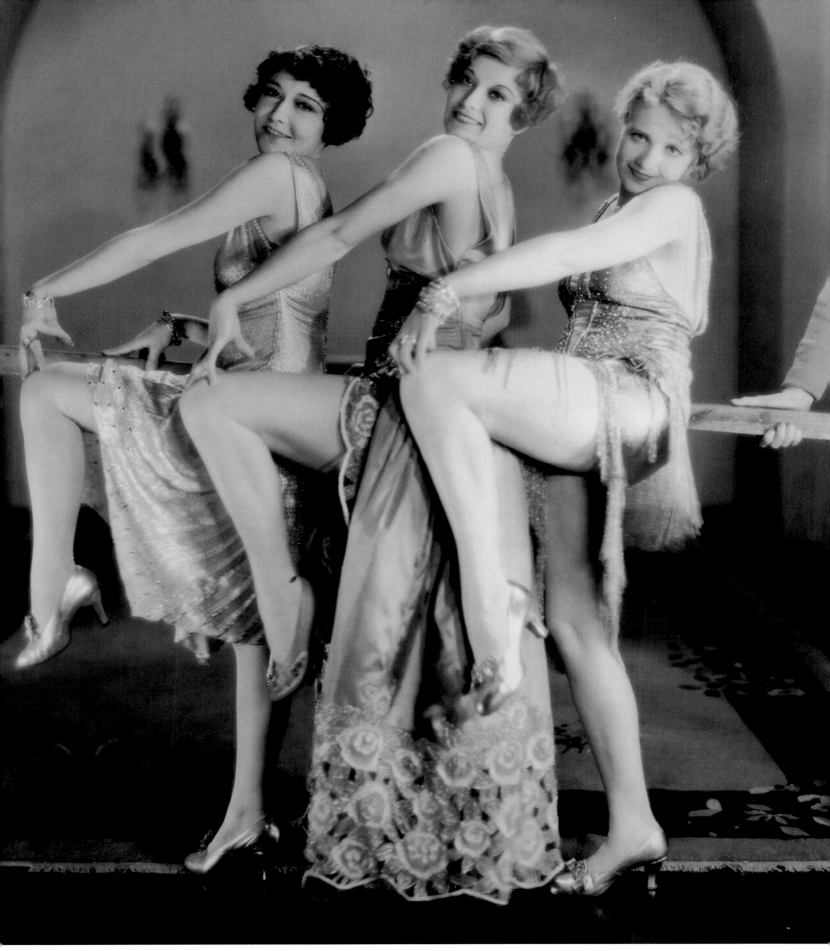

**Joan Crawford (actress):** "The spirit of modernity finds expression in the clothes we wear. They are startling. They do not blend; they contrast. They do not conceal; they expose. They do not rustle; they swing. They do not curve; they angle. Perhaps this new feeling in dress finds its first and most definite expression in the motion picture world. We are the first to exploit a style . . . my own wardrobe, and the wardrobe worn by Dorothy Sebastian and Anita Page, breathe the very essence of restless activity."

**OUR DANCING DAUGHTERS (1928) · DAVID COX, COSTUME DESIGNER**   67

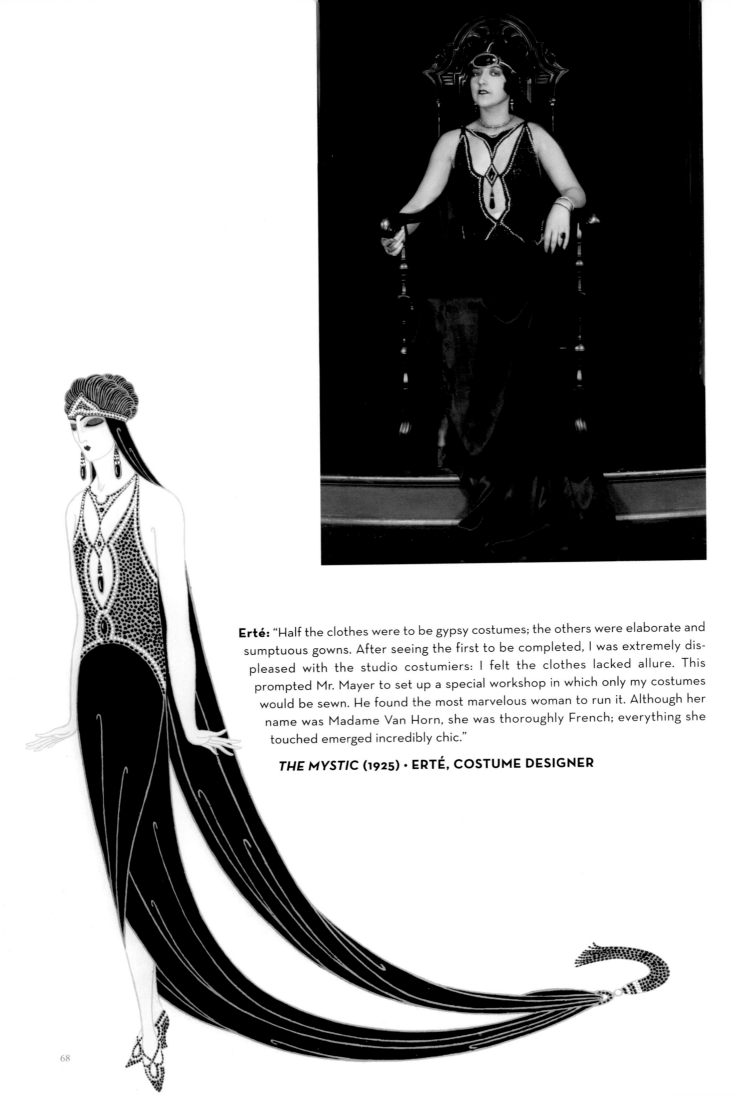

**Erté:** "Half the clothes were to be gypsy costumes; the others were elaborate and sumptuous gowns. After seeing the first to be completed, I was extremely displeased with the studio costumiers: I felt the clothes lacked allure. This prompted Mr. Mayer to set up a special workshop in which only my costumes would be sewn. He found the most marvelous woman to run it. Although her name was Madame Van Horn, she was thoroughly French; everything she touched emerged incredibly chic."

### *THE MYSTIC* (1925) · ERTÉ, COSTUME DESIGNER

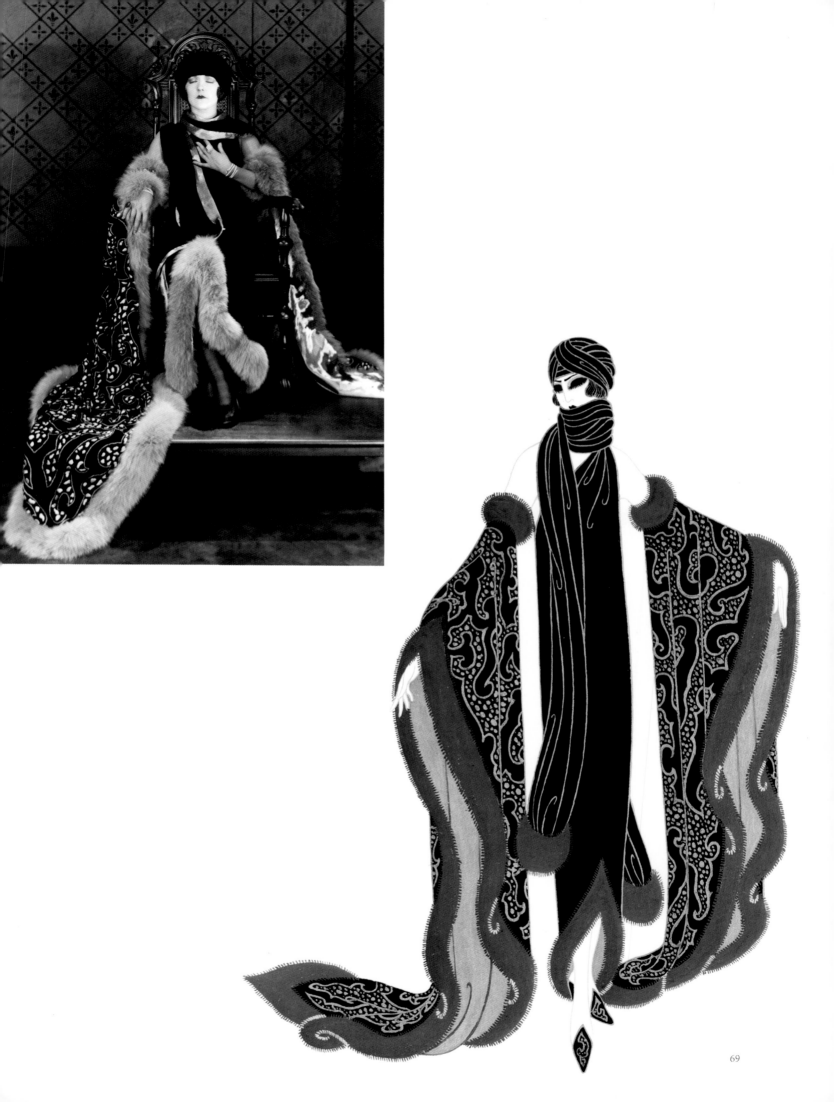

# THREE

# 1930s

"You ain't heard nothin' yet!" With those five words uttered in the Warner Bros. 1927 *The Jazz Singer*, superstar Al Jolson signaled that a new era had begun—movies came alive with song. With the addition of the human voice, the physical production process moved to indoor "sound" stages. With dialogue, performers soon learned that less meant more, and the phrase "Quiet on the set!" was heard for the first time.

For costume designers, sound created unanticipated technical complications. Suddenly every ruffle's rustle, every bead's clack, every heel's click was an unwelcome interloper on the set, a distraction from the story on screen. Noisy accessories were forsaken or sewn securely onto a garment. Tassels were removed, and rustling taffeta became "*textilis non grata.*"

When actors began to tell the story through spoken dialogue (replacing the title cards of the silent era), the old reliance on visual elements for character development evaporated; the exaggerated pantomime and extreme costumes of the silent era became instantly anachronistic. "The studio dress designers have been thinking in terms of dramatic moments instead of the genuine, real

OPPOSITE: "*Myrna Loy . . . seldom makes demands of anyone but herself. I once asked her why, during her MGM heyday, she had never stipulated that Adrian design her clothes. 'Dolly Tree was better for me,' she replied. 'Besides, I wasn't in a position to make such demands.'*" —James Kotsilibasa-Davis (biographer), The Thin Man (1934) • Dolly Tree, costume designer

moments that occur in life," noted Adrian, MGM's costume guru. "With the entrance of the human voice, actresses suddenly became human beings. . . . Everything had to be more real. . . . The clothes took on a genuine character." Designers tempered their outrageous creations and allowed the actor's voice to dominate the audience's attention. For Greta Garbo's first appearance in a "talkie," the gloomy 1930 melodrama *Anna Christie,* Adrian assembled the dowdy components. Audiences focused on hearing Garbo's low, husky voice utter its first line on film: "Gimme a whiskey with ginger ale on the side, and don't be stingy, baby." MGM's marketing strategy was simple: "Garbo Talks!"

The 1930s were Hollywood's Golden Age, a time when the classical Hollywood style would emerge and consolidate. The studios developed individualistic "house styles," with the studio and producer, not the designer or director, setting the look of any production. With advances in film technology and an ever-increasing audience's demand for entertainment, escapism, and glamour, the 1930s would also become the golden age of Hollywood costume design.

As the decade began, each major studio had a head designer who created the on-screen wardrobe for the studio's leading ladies. In a 1930 "ladies' interest" piece called "Can the Stars Choose the Clothes?" for *The Picture Goer,* Pat Wallace explains: "I am now going to reveal a hideous secret about film clothes! If ever you see a star really beautifully dressed, in nine cases out of ten it will be due to the excellent taste of the costume designer, and not at all to the star's own choice of clothes. All the big studios have these costume designers, as you probably know. But a great many people think that they are there merely for the 'period' pictures, to supply the right kind of medieval headdresses and to fit out the hundreds of 'supers' for the big crowd scenes. But not at all: they have just as much influence in the dressing of modern pictures and are often perfect tyrants where temperamental actresses are concerned."

At Paramount, Travis Banton, favorite of Marlene Dietrich, also designed for Carole Lombard and Claudette Colbert. Still a second-tier designer, Edith Head would go on to earn thirty-five Academy Award nominations and take home eight Oscars before her six-decade career at Paramount and Universal ended. Mitchell Leisen, Natalie Visart, Raoul Pene du Bois, and Mary Kay Dodson also designed at Paramount during this era of prolific production.

The costume designing pool in Los Angeles was deep; RKO had freelancers Bernard Newman (of Ginger Rogers and Fred Astaire fame), and Edward Stevenson working with costume director Walter Plunkett. Earl Luick left Warner Bros. for Fox in 1932; John Orry-Kelly (known simply as "Orry-Kelly") enjoyed an inspired tenure at Warner of more than twenty years, sharing a department that included Milo Anderson, Howard Shoup, and Leah Rhodes. Fox Studios rotated freelance designers in the thirties such as Herschel McCoy ("Herschel"), Omar Kiam, René Hubert, Gwen Wakeling, and Lewis Royer Hastings ("Royer"). At the lower-budget "poverty row" studios, Columbia hired the gifted Robert Kalloch, and Universal relied on Vera West and later Muriel King.

It was customary for designers to collaborate on each production. The chief designer worked with the star, a second designer designed the other female roles, a third designer took care of the men's costumes. Yet leading men were still expected to look to their own closets for contemporary roles. As Ray Milland informed *Picture Play* fans in 1938: "I must have between thirty and forty suits. In ordinary life, a man can be darn well dressed with three or four. Most studios furnish the wardrobes for their women stars but the men have to furnish their own. If I wore the same suits in every picture, audiences would soon spot them. I always let at least a couple of pictures elapse

between screen appearances of any one suit." Only occasionally were male stars reimbursed by the studios for their modern wardrobe. Additional designers were rarely given credit on pictures, and titles during this time were likely to read only "Gowns by . . ." As a result, costume design credits on many early films are nearly impossible to verify today.

In the 1920s, MGM had begun with only two designers, Gilbert Clark and Clement Andreani ("André-Ani"); by the early thirties the studio had an extensive staff, England's Dolly Tree among them. MGM's Adrian (Adrian Adolph Greenburg) became a celebrity in his own right. Pattern-makers and stitchers, embroiderers and lace makers were at his service. Jewelers and furriers produced custom accessories, and beaders painstakingly ornamented gowns according to Adrian's exacting standards. Warehouses were filled with every imaginable imported fabric and trim, storerooms loaded with buttons and braid from every era and region. In a December 1935 piece in *Modern Screen*, journalist Adela Bird offers a sense of the designers' resourcefulness: "René Hubert showed me some fabric swatches which he had brought back from Paris. All of them had exotic textures. Some were shaggy with cellophane threads woven through the materials to give them [a] hairy look. Others were skillfully executed in stunning patterns. All his costume fabrics are selected with a camera eye—they are chosen in textures that will photograph well and will give you some idea of 'feel' to the fabrics."

The studios' factory-like environment, born in the 1920s, transformed a simple tailor shop into an on-site assembly line in the interest of getting actors clothed as efficiently as possible. Edith Head, who sometimes designed four or five films simultaneously, reflected that "the studios had an enormous stock of fabrics, everything I could possibly need." Adrian created some fifty to seventy-five sketches a day in genres from period to contemporary to fantasy. To speed production, Adrian maintained a collection of padded dress forms in the measurements of MGM's most prominent stars, so that dress patterns could be completed without having to wait for the star herself. Finally, a formal separation was established between costume crew who worked on the set—known as costumers/dressers—and the professionals who labored off-set in the wardrobe department creating the costumes. It was the wardrobe workers, not the designers, who first formed a union (Motion Picture Costumers Local 705) in 1937 to protect their membership.

With a slate of new films released each week, screen designers worked to exhaustive standards. First they would "break down" the script to determine what (and how many) outfits would be needed in which scene. After creating a rough sketch of each change, a designer would present a finished watercolor for approval by the producer, director, and actress. Later the dress would be created in muslin and fitted to the actress, who would stand under studio lights approximating those used on the set. The designer would study the dress from every possible angle and make the necessary adjustments. Only then would the dress be shaped in the expensive fabric intended for the film.

"Now we're going to let you in on something very special. That glamour, that allure, that—whatever the heck it is—is manufactured right in Travis Banton's fitting room," Sara Hamilton declared to her reading public in "Secrets of the Fitting Room" in March 1934's *Photoplay*. At the final fitting, Adrian would film the actress in costume with his 16mm home movie camera to ensure the effect was flawless. He also used this research to discover which fabrics were most appealing on film, how they responded to light, and how they created a mood. His meticulous approach produced some of Hollywood's most memorable costumes, from the four thousand embellished eighteenth-century gowns for *Marie Antoinette* (1938) to the whimsical costumes of *The Wizard of Oz* (1939).

Walter Plunkett, who served as RKO's executive costume designer through most of the 1930s, said he preferred designing period pictures to contemporary films. "Everyone wants to stick his nose into modern things—the directors' wives, secretaries, actresses with rather bad taste. It's far easier when you can tell them, 'I love your idea, but it's just wrong for the period.' That gets them the hell off the set and out of your hair." That is not to say that designers were left alone when creating costumes for period pieces. While designing *Gone with the Wind*, Plunkett had to balance historical accuracy with producer David O. Selznick's commitment to Margaret Mitchell's popular novel.

*Vivien Leigh in* Gone with the Wind *(1939) • Walter Plunkett, costume designer*

"I think you took the period thing, knocked off an awful lot of things that truly dated it, and then blended in a little of what the modern eye would accept as 'smart,'" explained Plunkett. He read Mitchell's novel numerous times, then visited her in Atlanta. He recalled, "She was very amused when I showed her that she had described almost every dress of Scarlett's as green." With Mitchell's personal introductions, Plunkett traveled throughout the South viewing collections of vintage dresses. "One woman in Charleston even sent her children out to gather a box full of thorns from a tree native to that area because during the blockade days of the war, there were no metal pins and clothing was held together by these thorns."

In the end, however, the film's costumes had less to do with the antebellum South than with David O. Selznick's romanticized vision of Scarlett O'Hara. When faced with a choice between authenticity and the best-selling novel, Selznick always went with Mitchell. "Selznick didn't care about history," Plunkett said. "Look at the opening, with Scarlett twirling a plastic daffodil and wearing what was about to become the forties' hairdo." History wasn't completely forsaken, though. During shooting, Plunkett telegraphed with an urgent request: "Margaret Mitchell was startled to receive a wire from Hollywood demanding to know how Mammy (Hattie McDaniel) should tie her kerchief!" The costumes needed to be, first and foremost, correct for the character and the story.

Solutions were found for unique dilemmas. The undercarriage of Marie Antoinette's gown was so broad that the doors of actress Norma Shearer's dressing room were widened to accommodate the gigantic width of her skirts. Jean Harlow's slinky, body-hugging, bias-cut silk charmeuse gowns wrinkled so easily that she couldn't sit down to rest between takes—so prop men and costume designers developed the "slant board," which tilted at a 45-degree angle (complete with arm rests), allowing the actress to rest her legs and refresh her makeup without taking the time to

remove the dress for steaming between takes. Few audience members noticed such attention to detail, but the designers knew that the audience would notice if these details were forgotten. "Few people in an audience watching a great screen production realize the importance of any gown worn by the feminine star," said Adrian. "They may notice that it is attractive, that they would like to have it copied, that it is becoming, but the fact that it was definitely planned to mirror some definite mood, to be as much a part of the play as the lines or the scenery, seldom occurs to them. But that most assuredly is true."

At Warner Bros, Orry-Kelly reflected the same mindset. "I dressed her for the character she had to play," he said of the costumes he created for Bette Davis in *Fashions of 1934*. "She was an actress who had a job to do and it was mine to help her do it." His respect for the actress's work earned him her respect. "Orry-Kelly knew how to dress ladies as well as glamour queens," said Davis. "Like Edith Head, he understood that his creations were meant to enhance the actress, not be the star of the production."

One thing all Hollywood costume designers shared was an understanding that they were designing costumes, not clothes. In these early years, publicity-hungry Hollywood moguls famously embraced two world-renowned fashion designers. Both designers failed spec-

*Jean Harlow on the set with director George Cukor.* Dinner at Eight *(1933) • Adrian, costume designer*

tacularly and quickly. Erté's tenure with MGM lasted just one year. In 1931 Coco Chanel came to United Artists/Samuel Goldwyn Productions, determined to end the Hollywood practice of "overdressing" its stars. "I have been asked a hundred times by Americans to go to California to create fashions. I refused, knowing that the solution would be so artificial, and so negative." Unfortunately, in the two-dimensional world of the movies, Chanel's understated, elegant couture simply looked flat. Exaggerated silhouette and texture were required to lift the image off the screen, but for Chanel character interpretation was a foreign concept. Her wardrobe for Gloria Swanson in *Tonight or Never*, the only film she worked on, failed to capture the needs of the character and the context of the art direction. As the *New Yorker* reviewer noted, Hollywood wags "told [Chanel] her dresses weren't sensational enough. She made a lady look like a lady. Hollywood wants a lady to look like two ladies!" The designer and Hollywood quickly parted ways.

Edith Head became chief of the wardrobe department at Paramount after Travis Banton left. Her philosophy was clear from the beginning: "I do not consider a motion picture costume designer necessarily a fashion creator because we do what the script tells us to," she said. "If we do a period piece, then we re-create fashion that was done before, and if we have a character role, we do character clothes. It is only by accident, if a script calls for *fashion*, that some beautiful 'clothes' will emerge." Adrian astutely described the tension between clothes and costumes: "There are some clothes that are not in good taste if worn off the set. They are put into the picture like futuristic scenery—to help the drama—and are out of place anywhere else."

The clothes may have been out of place, but American women wanted them. Magazines were filled with long articles with photographs of actresses in the latest designs. Headlines encouraged women to "Dress Like Claudette Colbert!" and articles offered advice from the stars: "Keep your nails trim," counsels Carole Lombard. "Carry your manicure kit with you always." *Modern Screen* magazine offered copies of dresses designed by Orry-Kelly and worn by Olivia de Havilland as contest prizes. For women who sewed their own, magazines offered patterns of the stars' styles. The purchasing public waited on the next Joan Crawford, Greta Garbo, or Norma Shearer vehicle before buying new frocks. And what appeared on the screen could often create a rush of demand for a garment that hadn't yet been produced. By 1931, Hollywood designers were constantly featured in fan magazines.

In an article titled "Secrets of the Hollywood Stylists," Travis Banton noted that even period costumes were having an impact on contemporary fashion. "We can often trace a prevailing style to some well-costumed drama even though it is laid in bygone times. The actresses are mannequins in the women's eyes. It is the reason talking pictures are showing such an influence on current fashions. And why Hollywood, in turn, is becoming the arbiter in dress." The white organza tea gown that Adrian created for Joan Crawford in MGM's *Letty Lynton* (1932) has been called the most copied dress in history. Contemporary reports estimated that somewhere between fifty and five hundred thousand commercial and homemade copies of the dress were manufactured, and Macy's alone allegedly sold five thousand ready-to-wear copies—proof positive that films could use costume as an effective marketing tool.

Men were not immune to the influence of Hollywood fashion. When Clark Gable removed his shirt in *It Happened One Night* (1934) to reveal a bare chest—no undershirt!—men abandoned their own. Makers of men's undershirts, understandably, panicked. In the same scene, later that night, Claudette Colbert appeared in men's-style pajamas, and women began adopting them. Studios used the popularity of costumes to their advantage, actively promoting the costumes. A costume exhibition for *Gone with the Wind*—including some thirty-six costume changes for Vivien Leigh's Scarlett O'Hara—traveled around the country in advance of the movie's opening.

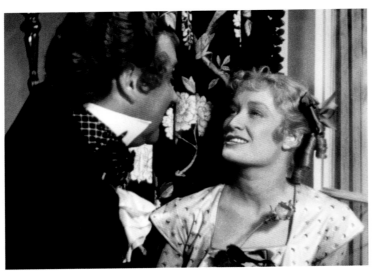

Becky Sharp (1935) • Robert Edmond Jones, costume designer

The million-dollar 1935 production of *Becky Sharp* was the first full-length motion picture to use the three-strip Technicolor process. Technicolor, developed more than a dozen years before, had caught the attention of producers eager to exploit the technology. Dr. Herbert Kalmus, founder of the Technicolor Motion Picture Corporation, had succeeded in creating alliances with Hollywood innovators: Douglas Fairbanks embraced an early two-strip Technicolor process for his silent box-office hit *The Black Pirate* (1926), and Walt Disney collaborated with Kalmus to use color for *Flowers and Trees* (1932), the first Disney production to win an Academy Award. After some disappointing screen tests for *Becky Sharp*, where the red costumes and interiors upstaged the actors, director Rouben Mamoulian and Robert Edmond Jones, who designed both sets and costumes, adjusted the color palette to accommodate the groundbreaking process. "Motion-picture costume designers," observed designer

Omar Kiam, "have long been indifferent to color as the eye of an earth dweller before the sun's rays burned away primeval vapors, and the only distinguishable colors were black, white, and gray. But now that the sun of Technicolor is shining, we must accustom our artistic eye to the effect of other shades on the screen besides black and white—and gray. We must learn to paint scenes with a whole palette of colors."

Throughout the 1930s, costume designers were obliged to adhere to the puritanical "moral guidelines" of the Hays Office. Before the Hays Code, said Edith Head, "Our only rule in those days was . . . will it stay on? If dresses fell off, we just shot again." A censor ensured compliance to the Hays Code on film sets. Suggested cleavage, or a seductive shadow, could suspend production until the offensive décolletage was reworked to suit the censor—a delay that could cost thousands of dollars. Designers were summoned to raise problematic necklines; handkerchiefs and extra ruffles were always in demand for camouflage. In *Tarzan and His Mate* (1934), Maureen O'Sullivan, as Jane, ravished audiences in a getup that left her hips entirely bare. In later sequels, now demurely attired for equatorial Africa, Jane scampers about covered from chest to mid-thigh.

The Great Depression may have defined the decade, but as Bette Davis observed, Hollywood offered a luxurious answer to hard times: "This was the period when Joan Crawford would start

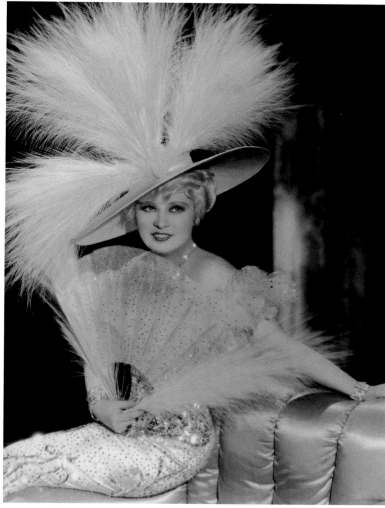

*"You can bet clothes make the woman—and there wasn't enough to these skimpy things the girls have been wearing to do 'em much good! I don't see why there can't be modified versions of Lady Lou's costumes, especially for evening. They won't kill the girl of 1933 any more than they did the 1890 belle. She ought to be able to carry them as well as her mother did. Oh, I don't mean to go back into all that tight corseting. Heaven knows, I don't blame women to fight stays. But the big hats, the voluminous furs, the wide spreading skirts and the curves—if you think they don't make a woman attractive, just ask any man." —Mae West*
Belle of the Nineties (1934) • Travis Banton, costume designer

every film as a factory worker who punched the time clock in a simple, black designer dress with white piping (someone's idea of poverty), and ended marrying the boss who now allowed her to deck herself out in tremendous buttons, cuffs and shoes with bows (someone's idea of wealth). A change of coiffure with each outfit kept her so busy it was a wonder she had time to forward the plot. All of this was not Miss Crawford's fault, the public adored it. Hollywood had its own type of reality and the Misses Crawford, Shearer and Dietrich were gorgeously glamorous."

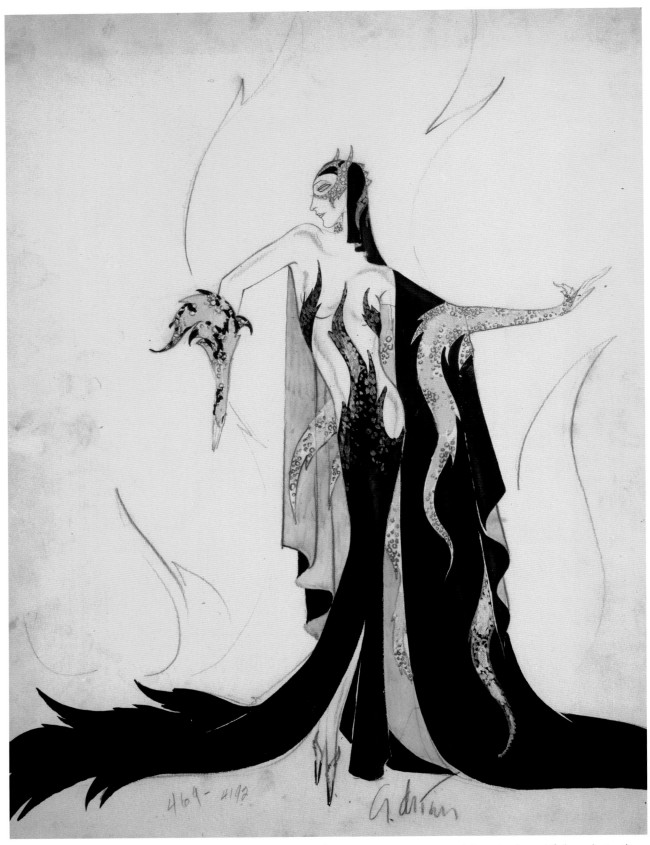

**Rosalind Shaffer (writer):** "In true DeMille manner, the costumes are most elaborate, beautiful, and startling. The costume of Kay Johnson, as Madame Satan, formfitting in the extreme, leaves Milady bare almost to the waist in front, with elaborate silver sequin scrolling; the back just isn't; and the skirt has two long scrolls over each hip and one over the stomach, while a long skirt with a voluminous train is edged in a series of points embellished in silver sequins, giving the impression of a forked tail with scales. It is beautiful beyond description."

### *MADAM SATAN* (1930) · ADRIAN, COSTUME DESIGNER

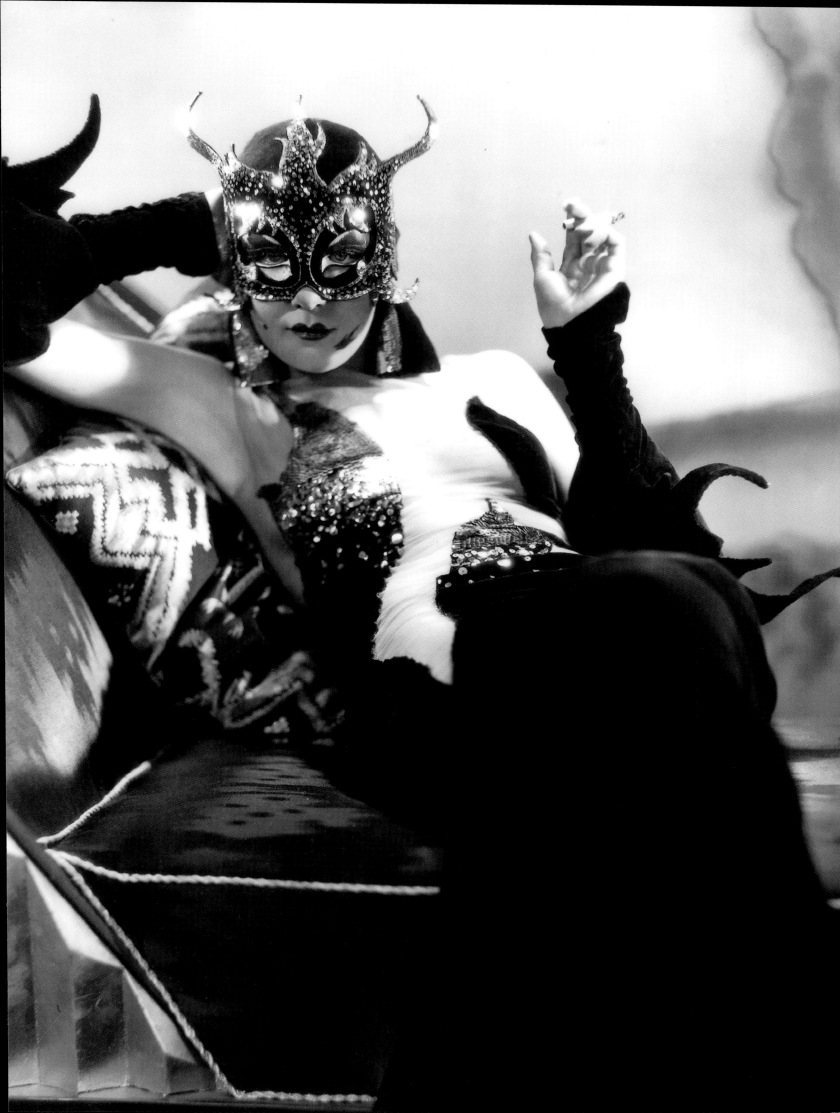

**Thomas Doherty (writer):** "Sylvia Sydney is heartbreaking as the doomed factory girl Roberta, whom Clyde seduces, abandons, and murders. The only tragedy is von Sternberg's decision to deny audiences the satisfaction of watching Clyde's end-reel electrocution on screen."

***AN AMERICAN TRAGEDY* (1931) · TRAVIS BANTON, COSTUME DESIGNER**

**Adrian:** "Few people in an audience watching a great screen production realize the importance of any gown worn by the feminine star. They may notice that it is attractive, that they would like to have it copied, that it is becoming, but the fact that it was definitely planned to mirror some definite mood, to be as much a part of the play as the lines or the scenery, seldom occurs to them. But that most assuredly is true."

***RED DUST* (1932) · ADRIAN, COSTUME DESIGNER**

**Murray Schumach (writer):** "A décolletage then, according to Edith Head, could be cut almost to the navel without revealing anything. Jean Harlow and Carole Lombard, two sirens of the thirties, wore no bras. 'Our only rule in those days,' she recalls, 'was . . . will it stay on? If dresses fell off, we just shot again.'"

*THE PUBLIC ENEMY* (1931) · **EARL LUICK AND EDWARD STEVENSON, COSTUME DESIGNERS**    81

Jack Jamison (writer): "Greta does have ideas concerning her pictures. . . . In the making of *Mata Hari* she was given a gown which she did not like. She did not say a word. But, a minute later, there was simply no Garbo. Garbo was in her dressing room, probably reading a book. And Garbo did not come out. Nor did she come out for seven hours . . . until permission had been given for her to wear another dress. The first dress had cost three thousand dollars. And the delay on the set cost at least another three thousand, perhaps twice that. Garbo did not care. She was sure the dress was wrong for her. And Garbo wrongly dressed would lose more than six thousand dollars for the studio at the box office—far more."

*MATA HARI* (1931) • ADRIAN, COSTUME DESIGNER

Adrian: "My first efforts were to give her genuine, real clothes, not 'motion picture gowns.' Simplicity is Garbo's god—as it should be."

*ANNA CHRISTIE* (1930) • ADRIAN, COSTUME DESIGNER

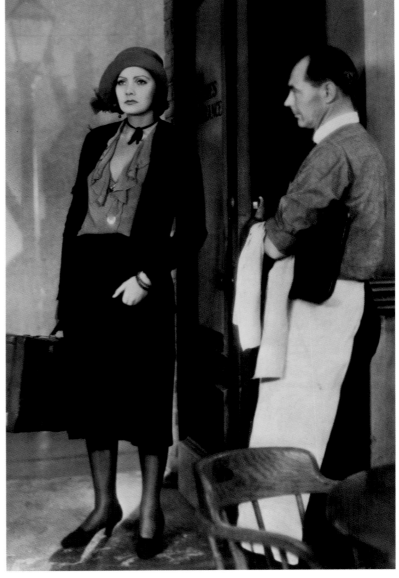

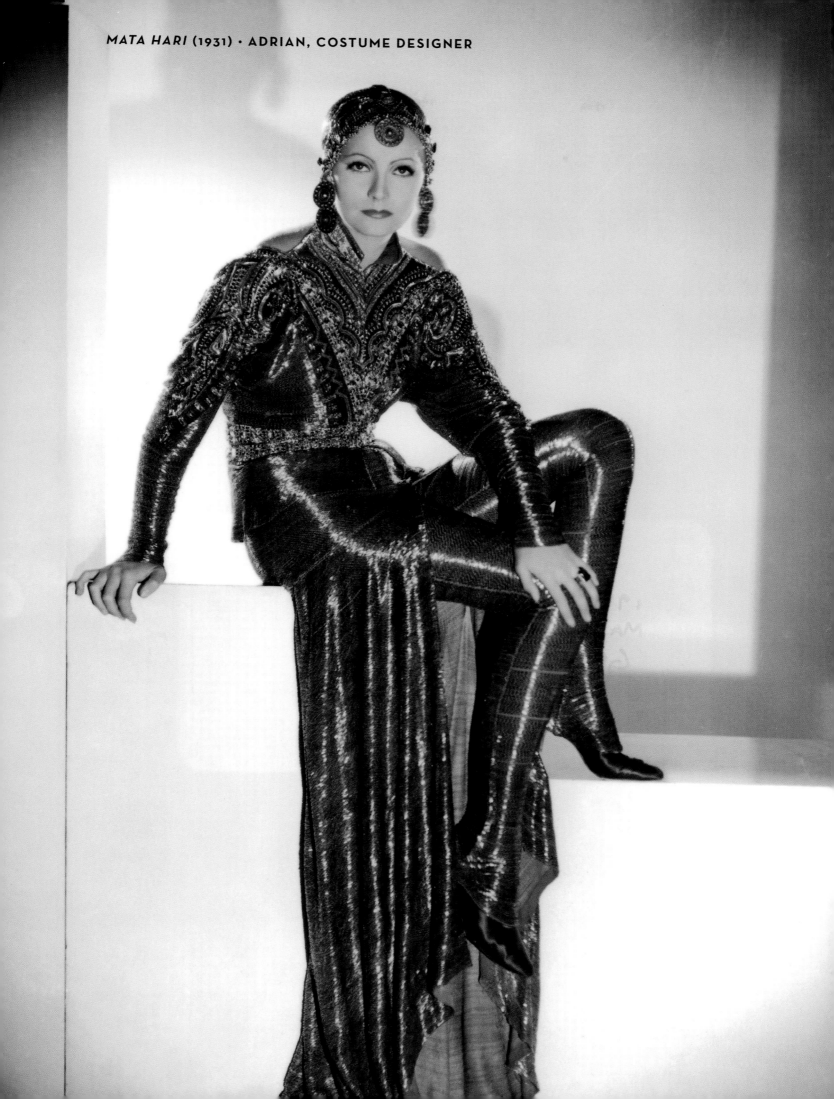

**Jonah Maurice Ruddy (biographer):** "Karloff wore great wooden shoes, heavily padded inside. His built-up misshapen skull was sutured with gleaming metal clips. The pasty face was deformed and evil-looking. The forehead bulged ominously. Forming a hinge for his head, a silver rod pierced his neck. The clay-like eyelids were heavy and entirely devoid of lashes. On the neck and wrists were thin, livid scars, showing where the parts of his body had been joined. Walking with a peculiarly menacing and cumbersome gait, slowly and heavily dragging his feet across the floor, the monster was the personification of awe-inspiring evil.

"Karloff was fortunate in being a naturally strong man. The total weight of his makeup and costume was 67 lbs. The enormous shoes he wore weighed 21 lbs. each. Under his costume, heavy pads and bandages were placed to create the giant-like illusion. At no time was there any complaint from the actor."

*FRANKENSTEIN* **(1931)**

**Elsa Lanchester (actress):** "Sometimes members of the cast would have tea. After all, many English actors were in the cast. I may have been seen drinking tea, but I drank as little liquid as possible. It was too much of an ordeal to go to the bathroom—all those bandages—and having to be accompanied by my dresser!"

***BRIDE OF FRANKENSTEIN* (1935) · VERA WEST, COSTUME DESIGNER**

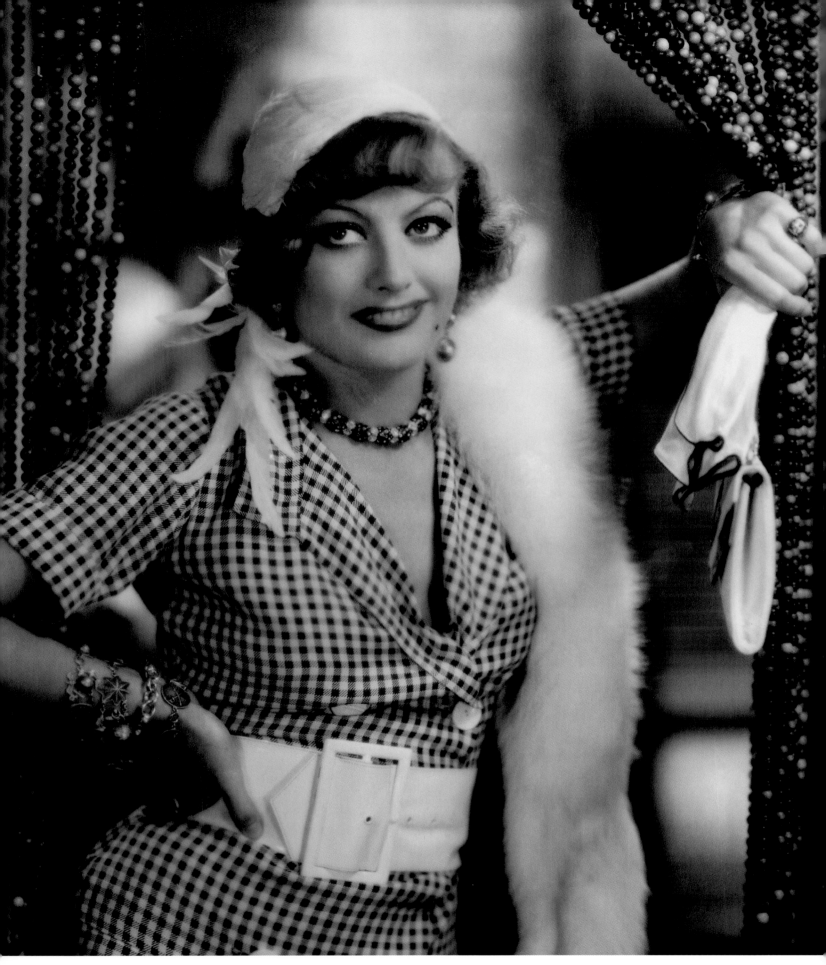

**Charles LeMaire (Fox wardrobe director):** "Joan Crawford, I believe, could wrap a tablecloth about her, pin it with a safety pin and make a sensational entrance to a crowded room, and people would cry, 'How gorgeous!'"

*RAIN* (1932) • ADRIAN, COSTUME DESIGNER

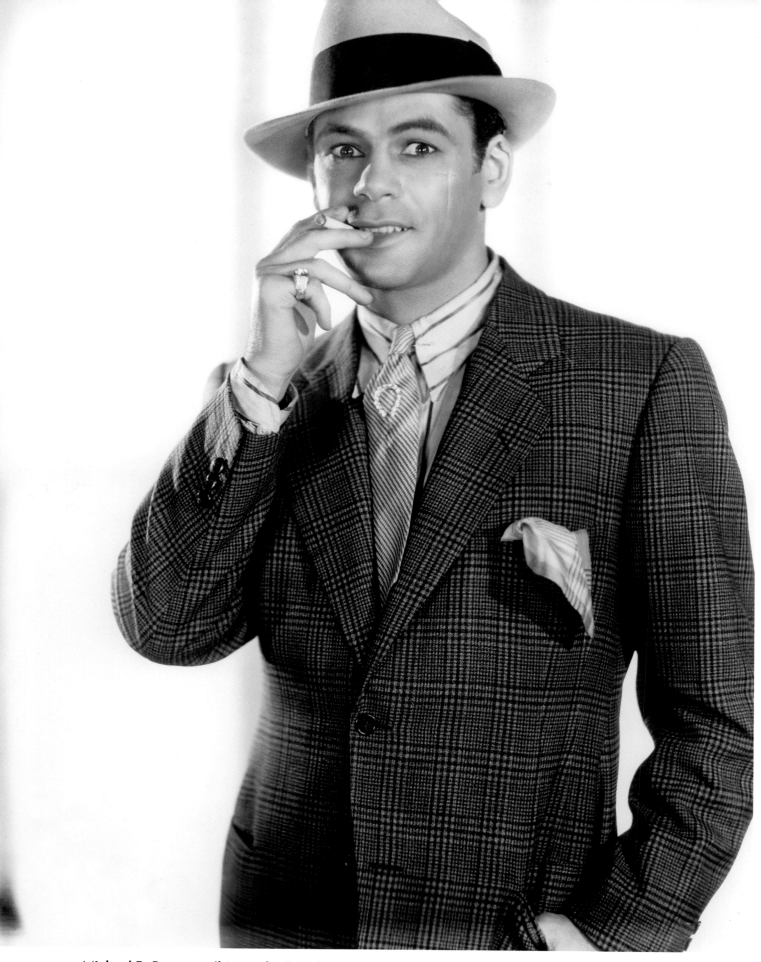

**Michael B. Druxman (biographer):** "When he was not in a serious mood, [Paul] Muni would compare his theory of acting to his wife's grandmother's method of making apple pie. When she was asked the secret of how she made such delicious pies, she would reply: 'First, I comb my hair. Then I wash my hands. Then I put on my apron. Then I make apple pie.'"

**SCARFACE (1932)**

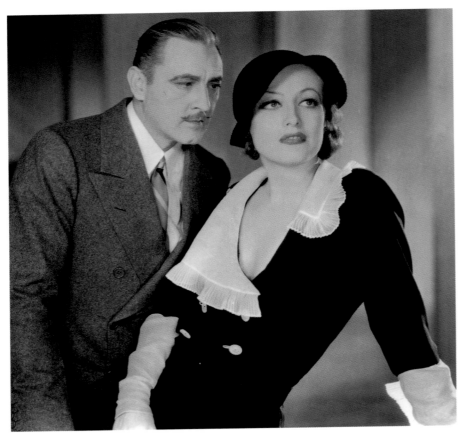

**Joan Crawford (actress):** "I played the prostitute and I felt that a more sensuous look was needed. Full, natural lip line and generous eyebrows—no bra, no girdle. Definite features were called for, and I found that I liked that look so much that I kept it."

**GRAND HOTEL (1932) · ADRIAN, COSTUME DESIGNER**

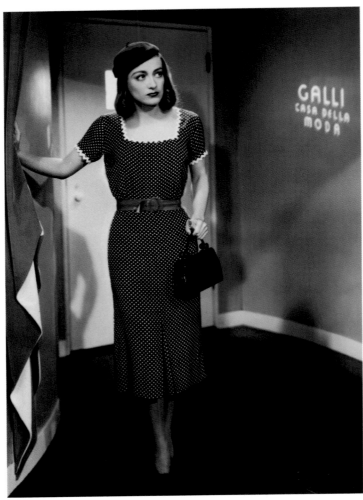

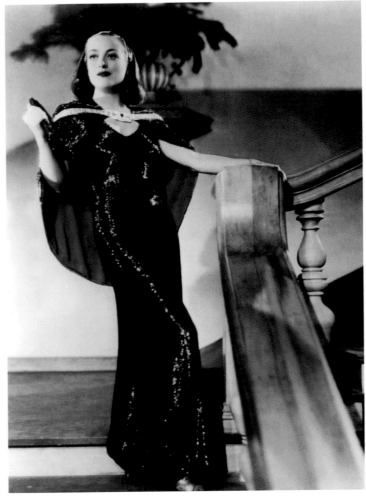

**Adrian:** "With Joan Crawford, our greatest difficulty is to subdue, tone down, and simplify her personality."

**THE BRIDE WORE RED (1937) · ADRIAN, COSTUME DESIGNER**

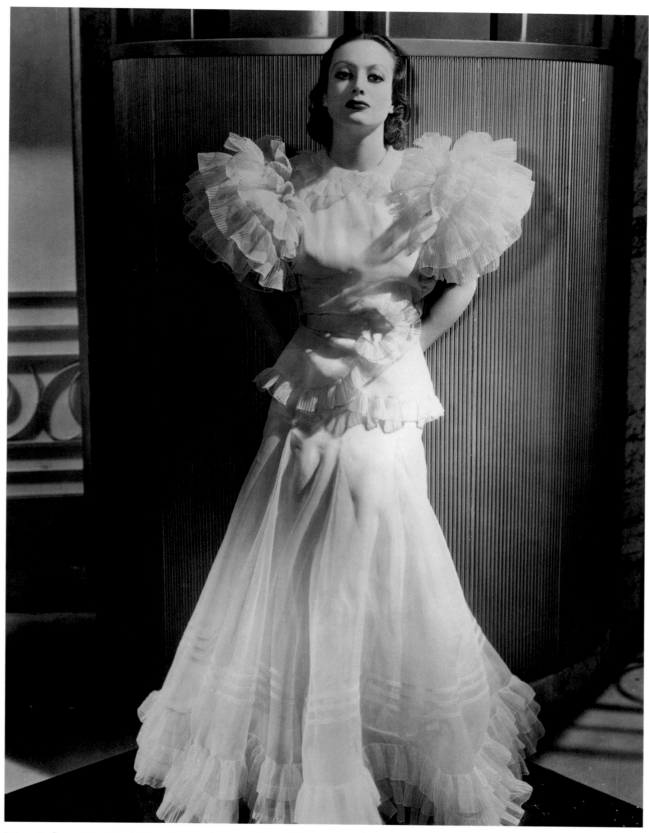

**Wes Colman (writer):** "Paris may decree this and Paris may decree that, but when that Crawford girl pops up in puffed sleeves, then it's puffed sleeves for us before tea-time."

**Joan Crawford (actress):** "Adrian always played down the designs for the 'big scene.' For the lighter scene he'd create a 'big' dress. His theory, of course, was that an absolutely stunning outfit would distract the viewer from the highly emotional thing that was going on. There should be just the actress, her face registering her emotions, the body moving to express her reactions—the dress is only the background. But in the next scene, where she goes to the races and cheers for her horse, the costume would be just absolutely smashing."

### *LETTY LYNTON* (1932) • ADRIAN, COSTUME DESIGNER

**Ginger Rogers (actress):** "Costume fittings were done after the day's shooting; consequently, I never got home before nine in the evening. The studio agreed to have the fittings done on the set during shooting. Even this turned out to be too hectic as I had to rush off the stage into my portable dressing room. A wardrobe lady whipped me out of my filming costume into another one. Because I had to *stand* and be tugged and pinned, this broke my train of thought for the character. Then I'd change back into my filming dress and return to the set, where the director was tapping his pencil, waiting for me. After three months of doing fittings while shooting, I asked to find someone with my measurements to stand in for me. This did not eliminate the last fittings on each gown, for although measurements may be identical . . . shapes are not."

### *GOLD DIGGERS OF 1933* (1933) · ORRY-KELLY, COSTUME DESIGNER

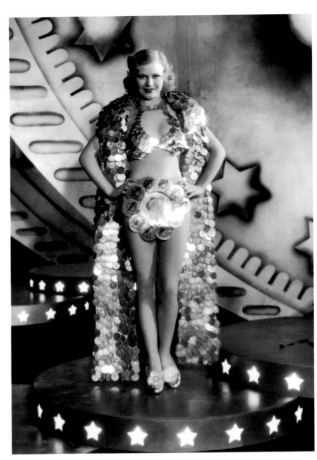

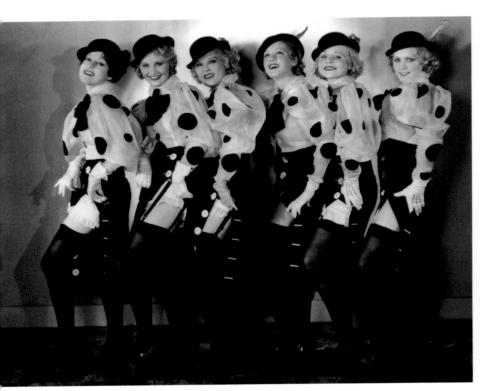

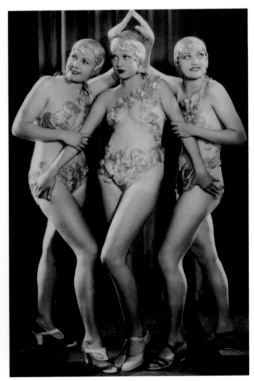

***Photoplay:*** "Warner Brothers released these facts for prospective chorus girls: . . . 'the ideal movie chorine measured a 32½-inch bust, 23-inch waist, 34-inch hips, 12½-inch calf, 7½-inch ankle. Venus de Milo with her 28½-inch waist couldn't get a job as a script girl on poverty row.'"

### *42ND STREET* (1933) · ORRY-KELLY, COSTUME DESIGNER

**Busby Berkeley (choreographer):** "For *Footlight Parade* I designed a special bathing costume with rubber head pieces looking like hair, that ran down across the girls' bodies to give a semi-nude effect."

### *FOOTLIGHT PARADE* (1933) · MILO ANDERSON, COSTUME DESIGNER

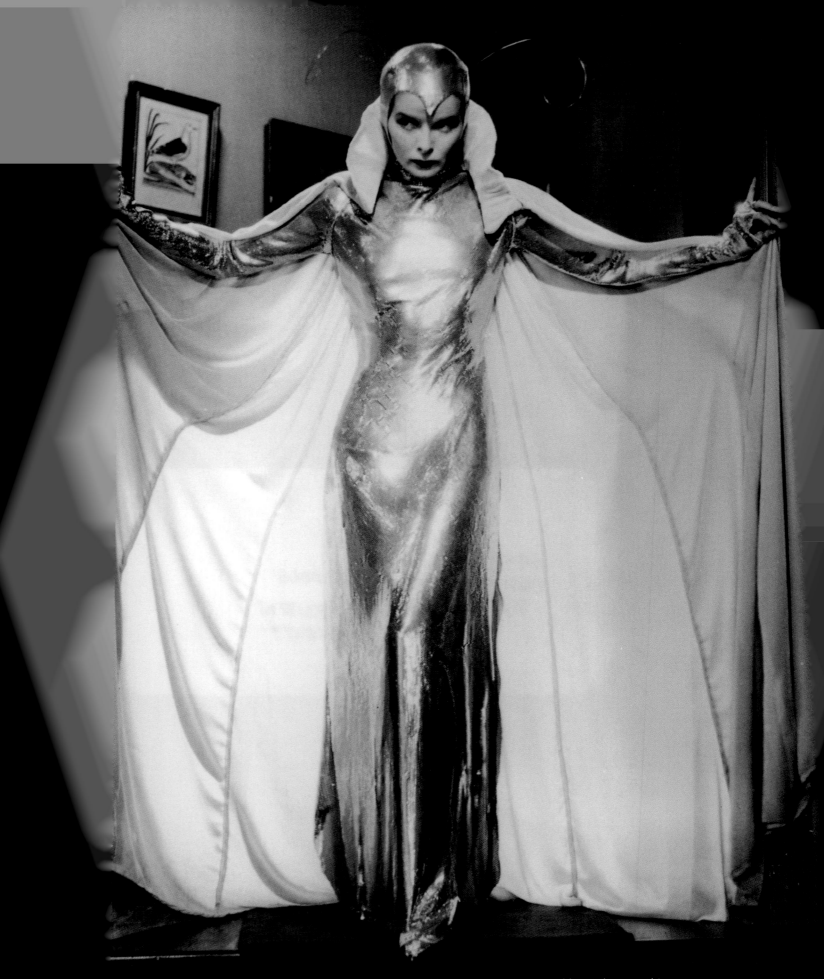

elyn Tey (writer): "There was the encounter between Katharine Hepburn and her 'silver moth' costume in istopher Strong (1933). The costume was made of hundreds of tiny metallic squares and clung to her long and frame like a second skin. It proved painful to Hepburn as the wires holding the squares together pinched skin and fried under the hot lights. A hastily contrived emergency lining had to be fitted."

RISTOPHER STRONG (1933) · WALTER PLUNKETT, COSTUME DESIGNER

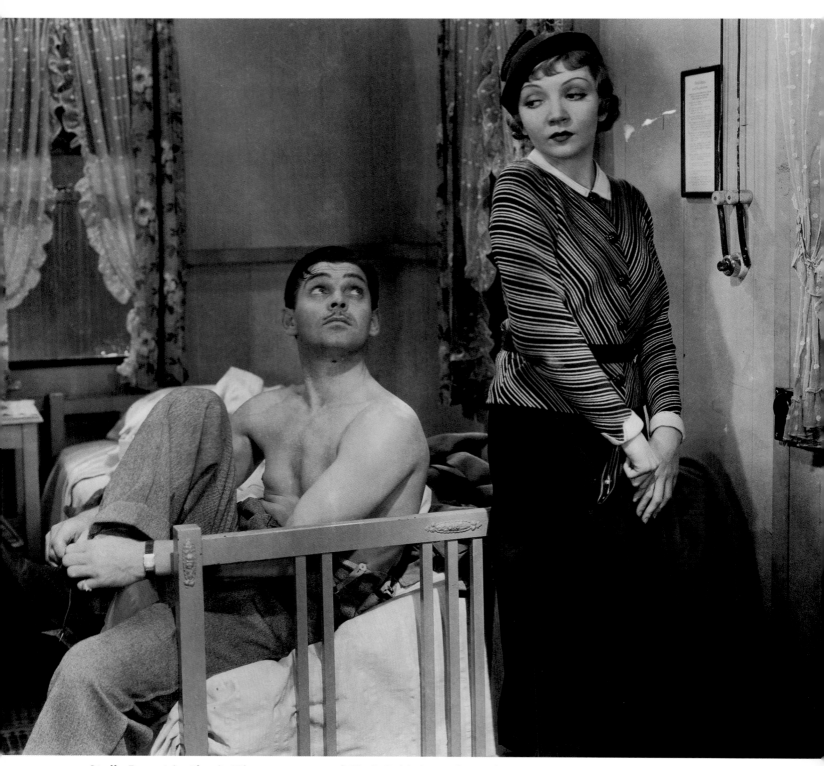

**Stella Bruzzi (author):** "The appearance of Clark Gable bare-chested in *It Happened One Night* in 1934 led to an immediate drop in the American sales of men's undershirts of around 30 percent."

### *IT HAPPENED ONE NIGHT* (1934) • ROBERT KALLOCH, COSTUME DESIGNER

**Mary Astor (actress):** "The character I played was a charming and gracious woman. My first line was spoken on screen, but the moment they heard it the audience burst into spontaneous applause. Nothing has ever warmed me so much. I was told that it happened at every performance at that theater, and that it happened in many cities."

**DODSWORTH (1936) •
OMAR KIAM, COSTUME DESIGNER**

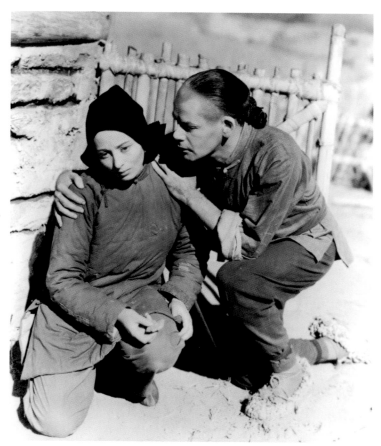

*Fan Magazine:* "Luise Rainer's great performance in *The Good Earth* was not marred by the desire on her part to appear, at least once, as the beautiful girl that she is. She really threw herself unreservedly into the part of the timid downtrodden coolie woman. The complete unselfconsciousness of Rainer in the role was marvelous. She bent down, hiding her face, as the woman, O-lan, would have done in life, completely disregarding the camera. However, in humble lives it is the nobility of thought that molds the faces of the poor into the outlines of loveliness. Because of this, Rainer appears at times transfigured and her face shines with true Beauty."

**THE GOOD EARTH (1937) •
DOLLY TREE, COSTUME DESIGNER**

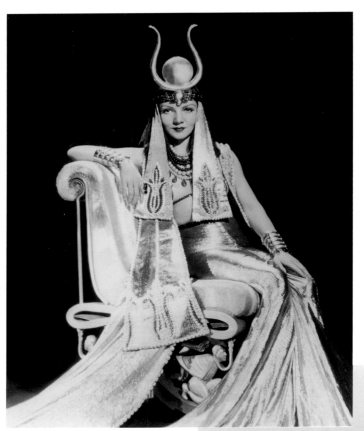

**Leon Surmelian (writer):** "The toughest spot Banton found himself in was when Cecil B. DeMille started shooting *Cleopatra,* and Claudette Colbert refused to wear the gowns made by DeMille's own costume staff at Paramount. You can imagine the state of affairs when Colbert did not choose to go on the set. When shooting starts on a picture of such magnitude, a delay of a few hours would cost the producer thousands of dollars. Banton was called in to design an entirely new wardrobe and the very next day he had the first dress ready. In fact, from day to day he produced one of the most extravagant wardrobes in the history of movies, while the cameras recorded scenes of ancient Egypt as conceived by DeMille."

*CLEOPATRA* **(1934) ·**
**TRAVIS BANTON, COSTUME DESIGNER**

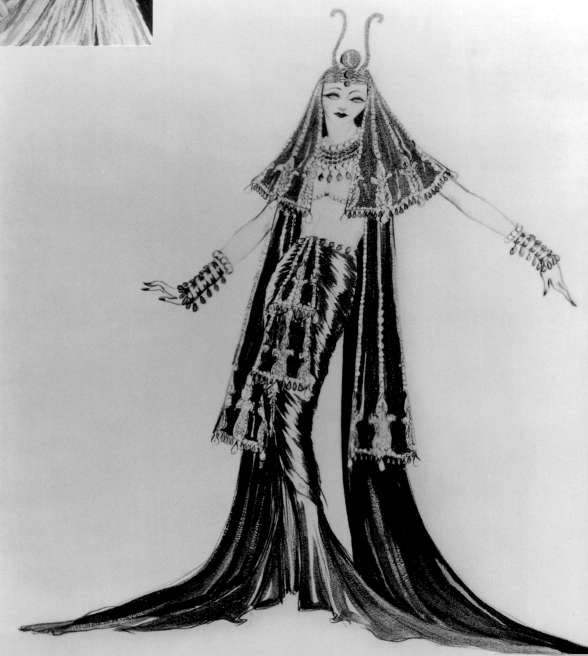

**Travis Banton:** "My aim is for the legitimate. When a woman is required to dress for golf in a certain scene there is really no point in making her seem ready for a dance at the country club. When she is fitted with a bathing suit it should at least look suitable for water. I muster new fashions . . . and adjust them to the role."

### *IMITATION OF LIFE* (1934) · TRAVIS BANTON, COSTUME DESIGNER

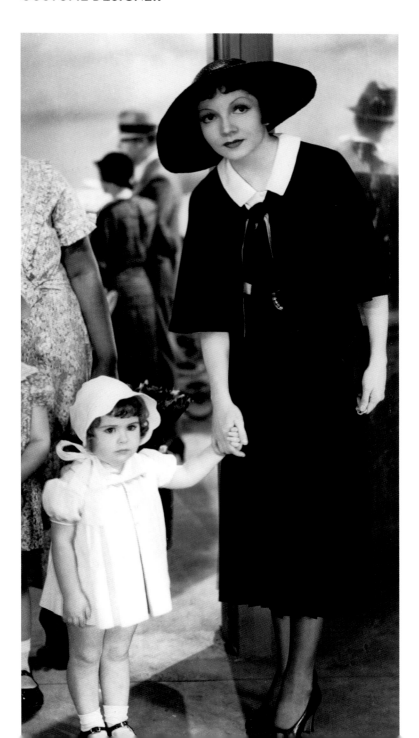

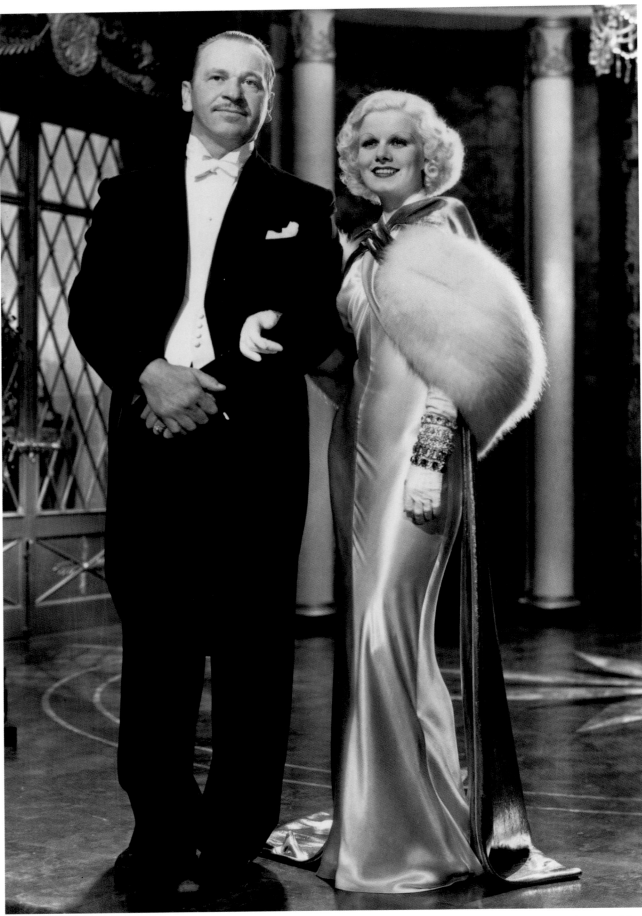

**Adrian:** "Women can hardly copy every gown we create for the screen. Most screen gowns are designed for especially dramatic women, to wear in a series of dramatic scenes that comprise more drama than most women have in their whole lives."

***DINNER AT EIGHT*** **(1933) • ADRIAN, COSTUME DESIGNER**

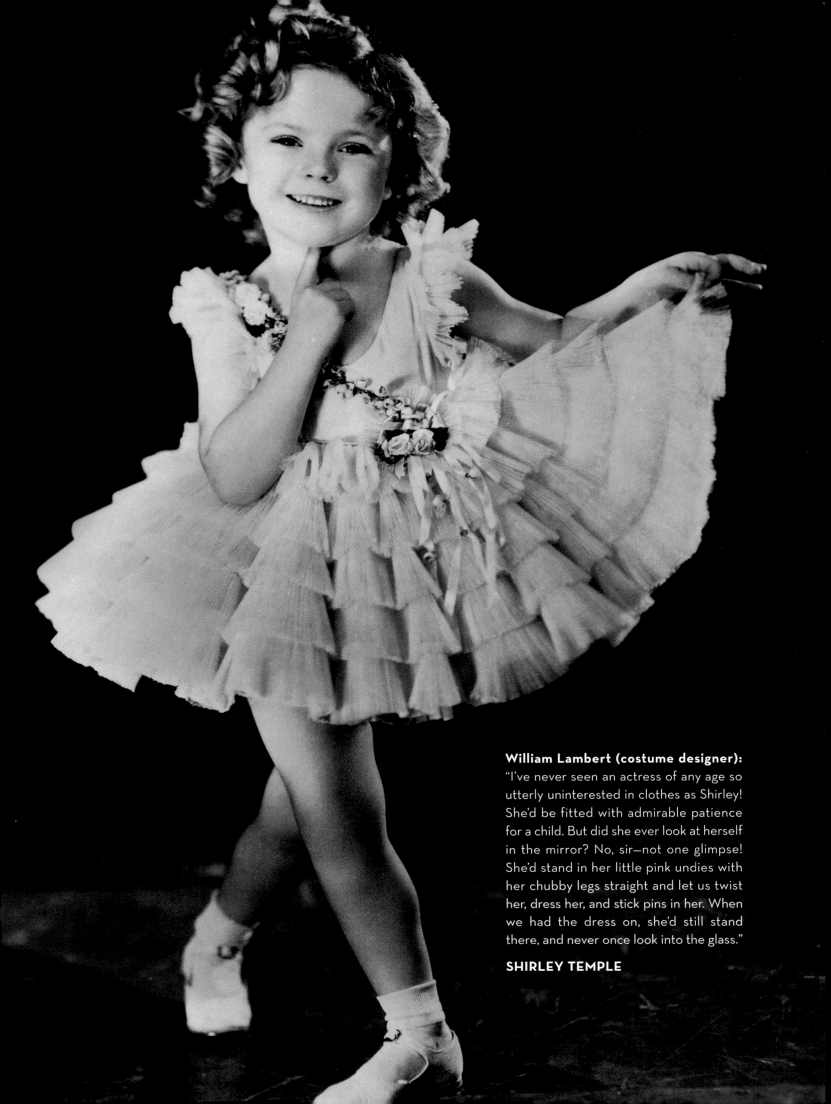

**William Lambert (costume designer):** "I've never seen an actress of any age so utterly uninterested in clothes as Shirley! She'd be fitted with admirable patience for a child. But did she ever look at herself in the mirror? No, sir—not one glimpse! She'd stand in her little pink undies with her chubby legs straight and let us twist her, dress her, and stick pins in her. When we had the dress on, she'd still stand there, and never once look into the glass."

**SHIRLEY TEMPLE**

"Ah like gowns
that are tight enough
to show I'm a woman
and loose enough to
show I'm a lady."

—MAE WEST

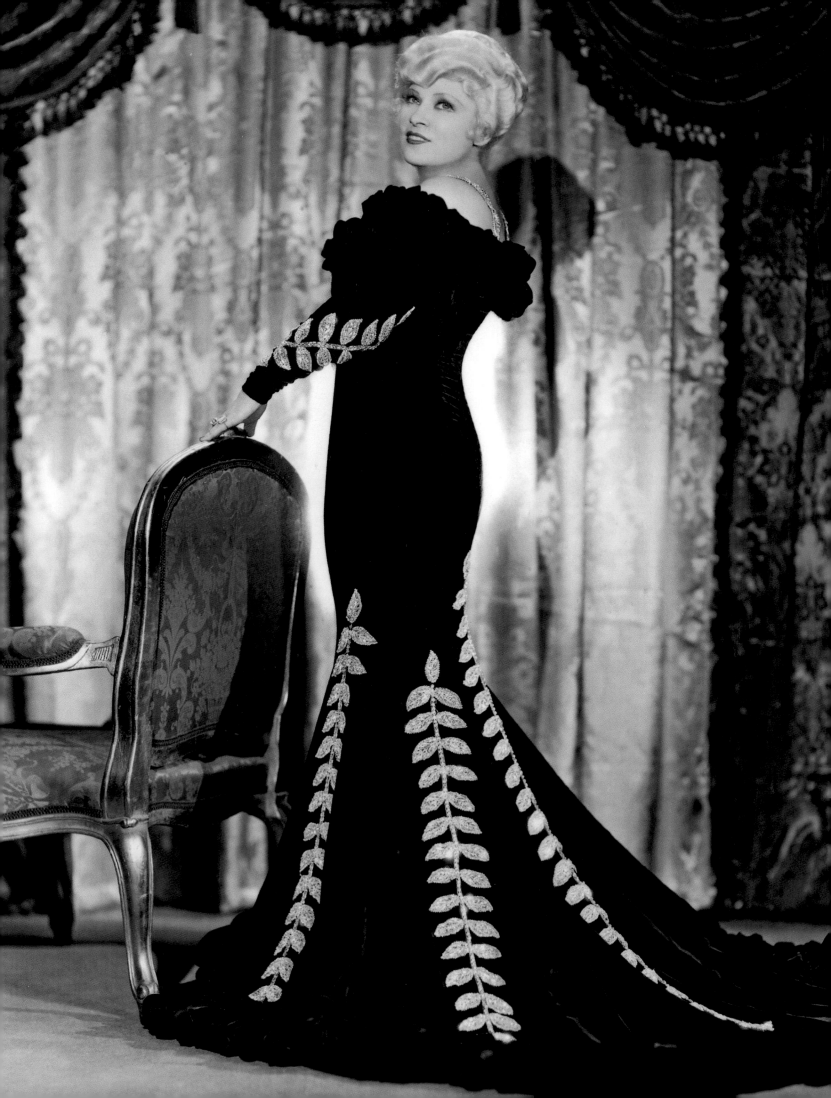

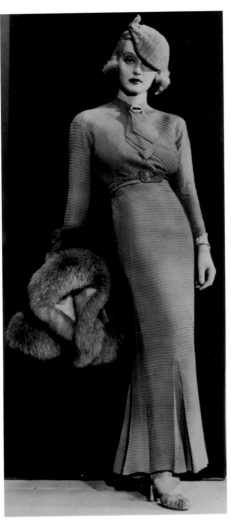

**Bette Davis (actress):** "I was glamorized beyond recognition. I was made to wear a platinum wig. Makeup had been given the green light with nary a 'may I?' The boss men were trying to make me into a Greta Garbo. They even dressed the wig like her hair, to say nothing of the false lashes and huge mouth and the slinky clothes."

*FASHIONS OF 1934* (1934) · ORRY-KELLY, COSTUME DESIGNER

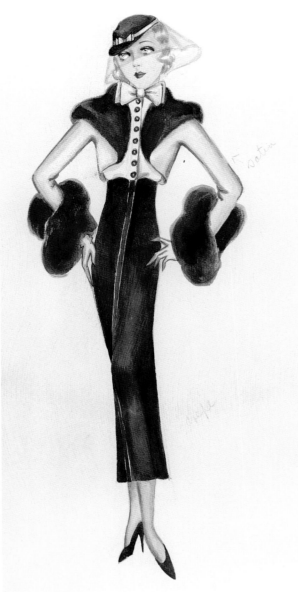

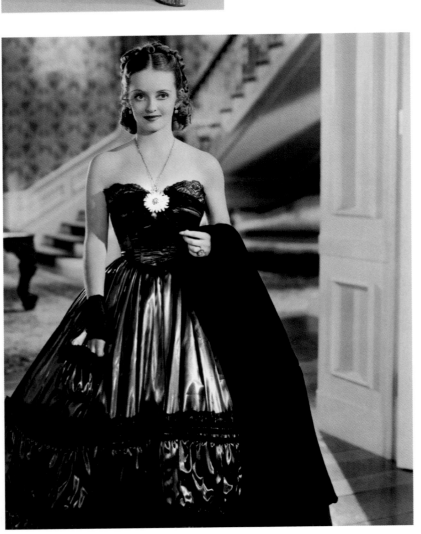

**Bette Davis (actress):** "Jack Warner insisted no one would want to see a film about a girl who wore a red dress to the New Orleans ball. The custom was to wear a white dress. I told Warner only 10 million women would want to see this film. As it turned out, I was right."

*JEZEBEL* (1938) · ORRY-KELLY, COSTUME DESIGNER

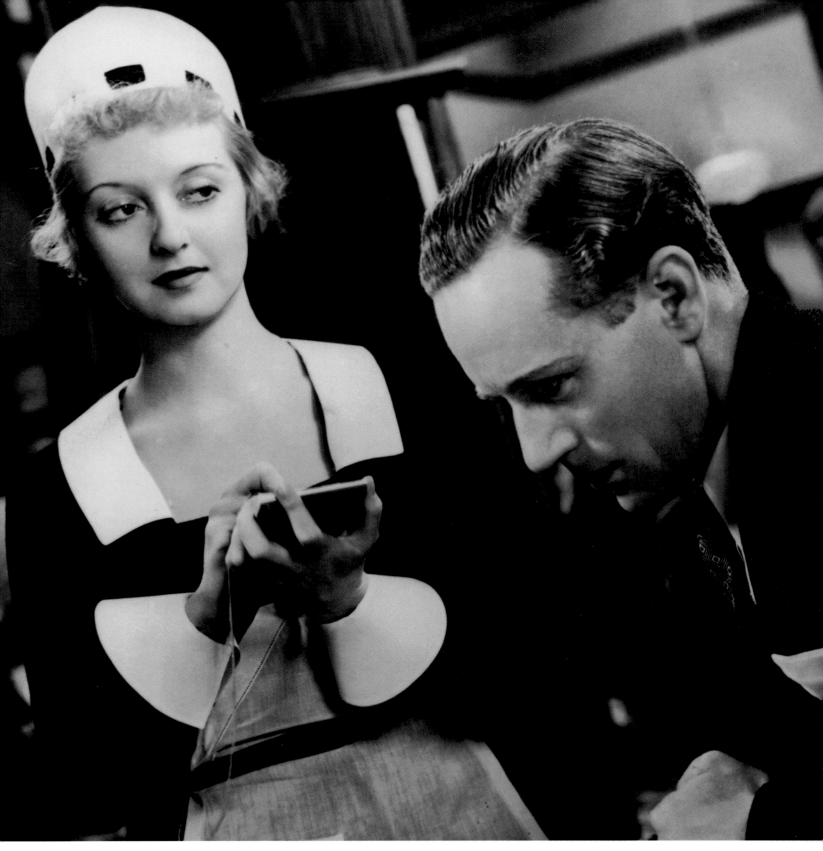

**Bette Davis (actress):** "Walter Plunkett, the costume designer, was a great boon. His waitress uniform and cap were typical of the type used in English tearooms. Since I've always been round-shouldered, I stooped just a little more as Mildred standing there taking an order, as if she was bored out of her mind. She was just marking time to get off work and go out with one of her beaux."

**Walter Plunkett (costume designer):** "Bette insisted that they shoot in continuity because she wanted to start bleaching her hair, and when they were sure they had that sequence, bleach it a little more and a little more. At the end of the film, her hair was almost burned off of her scalp—it was terrible. She also allowed her body to get sloppy, and her clothes became progressively filthier and shabbier. Finally, in the last sequence, she said, 'Everything is fine, Walter, but in order to really loathe myself, I want my costume to smell.' So we rubbed cheese into it. Everyone stayed away from her, and she began to hate herself and feel right for the part."

*OF HUMAN BONDAGE* (1934) • WALTER PLUNKETT, COSTUME DESIGNER

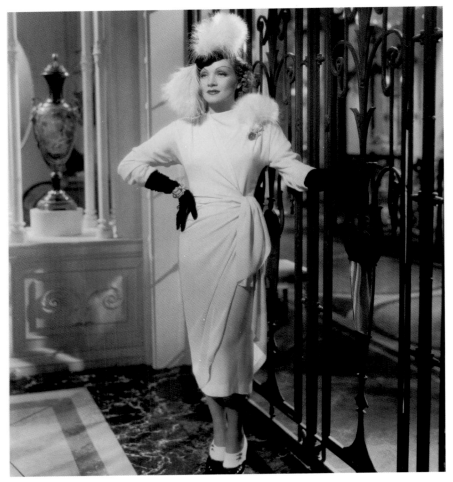

**Edith Head (associate costume designer):** "Marlene and I sat up for hours trying on dozens of different hats, changing them, tilting them, taking the feathers off this one and trying them on that one, snipping off a veil or a brim, switching ribbons and bows. Finally we got what she wanted. I was amazed at her stamina and determination."

**DESIRE (1936) ·
TRAVIS BANTON,
COSTUME DESIGNER**

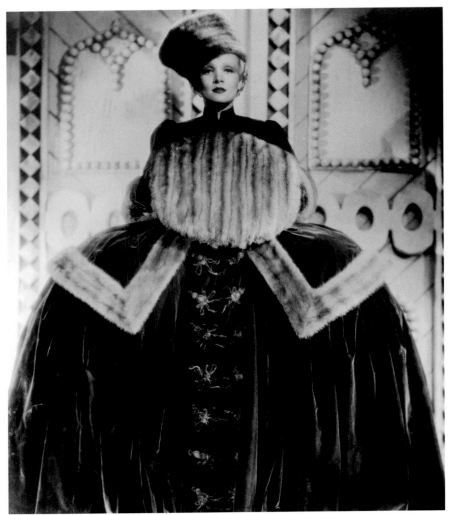

**Travis Banton:** "As a rule, clothes should serve as a background and not attract any special attention to themselves, but sometimes they must have the opposite effect; emphasize the character of the wearer . . . and take on a special dramatic quality. Russian court life in the time of Catherine the Great was productive of the most gorgeous costumes of any period in European history."

**THE SCARLET EMPRESS (1935) ·
TRAVIS BANTON,
COSTUME DESIGNER**

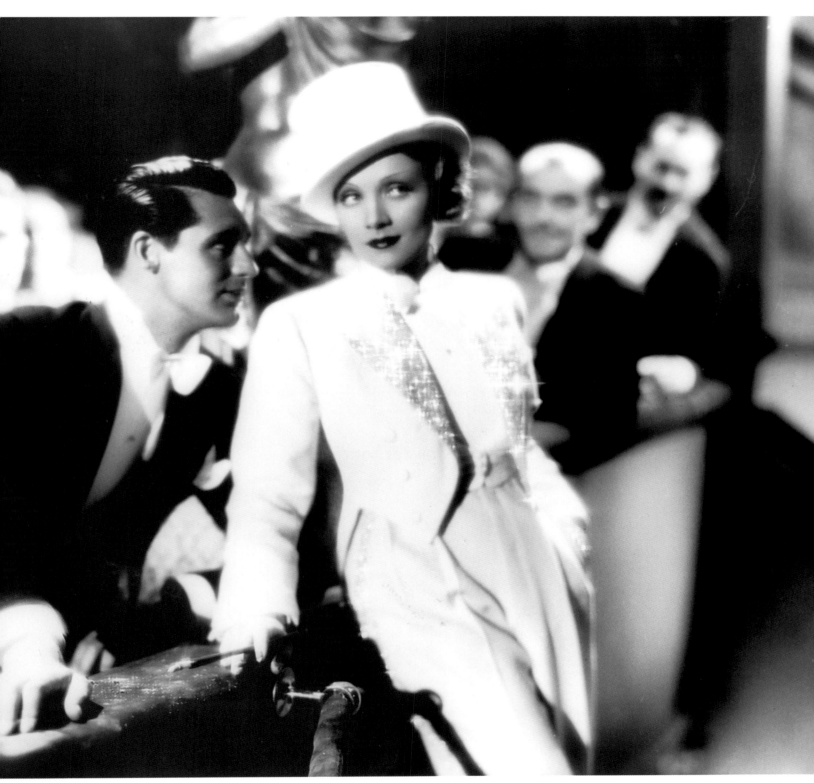

**Joseph von Sternberg (director):** "Having Dietrich wear trousers was not meant to stimulate a fashion, which encouraged women to ignore skirts in favor of the less picturesque lower half of male attire. Asked to make a trailer in which Dietrich appeared wearing white tie and tails, I ran into a storm of opposition. The studio officials swore by all that was sacred that their wives wore nothing but skirts, going as far as to claim that a pair of trousers could not be lifted. Hours of debate ensued, draining my energies and theirs."

**_BLONDE VENUS_ (1932) • TRAVIS BANTON, COSTUME DESIGNER**

**Ginger Rogers (actress):** "Bernard Newman met with me to discuss the colors and shapes of the various dresses. He'd say, 'Tell me what kind of dress you want to wear and what color you'd like.' Then he'd show me swatches of all sorts of beautiful materials. 'I want a blue dress, like the blue you find in the paintings of Monet . . . made of satin with myriads of ostrich feathers, low in the back and high in the front.' Bernie sketched as I spoke. It's funny to be discussing color when you're making a black-and-white film, but the tone had to be harmonious. Bernie's final sketch had an extremely low back, form-fitting satin encircled by lots of feathers. A specialist was hired to extend the feathers and Bernie said it would take roughly $1,500 worth of ostrich plumes."

**Fred Astaire (actor):** "The dancing dresses of my partners have, for years, been a working problem, and in *Top Hat* I daresay it reached its dizzy peak. The feathers started to fly as if a chicken had been attacked by a coyote. They were floating around like millions of moths."

**Ginger Rogers (actress):** "On the day of shooting we rehearsed in ordinary clothes to mark the positions for camera. My beautiful blue feather dress was still up at wardrobe for finishing touches. Our assistant director called to have it brought over. As I headed for my portable dressing room, I saw Clarkie, the wardrobe lady, walking through the stage door. She held my dress high above her head as she marched toward my dressing room. Mark Sandrich, the director, Fred Astaire, cameraman David Abel, Hermes Pan, the choreographer, and the technicians turned their heads to watch this blue apparition go by. 'What is it? A bird? A plane?' 'No, it's Ginger's dress!'

"Fred didn't like the dress. That was the root of the problem. When he approached me for the trial run, it was written on his face. Our emotions were high-pitched. First he sang and then we danced. In our rehearsal for camera, it's true, some of the feathers did flutter and annoy Fred. He muttered to himself as he plucked the feathers off his tailcoat.

"Four days later, a small, plain white box with a tailored white bow was delivered to my dressing room. There was a note, which said simply: 'Dear Feathers. I love ya! —Fred.' Underneath the cotton was a gold feather for my charm bracelet."

## *TOP HAT* (1935) · BERNARD NEWMAN, COSTUME DESIGNER

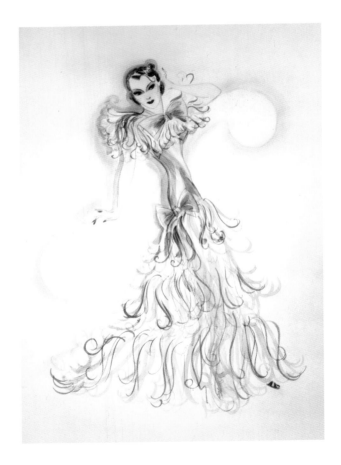

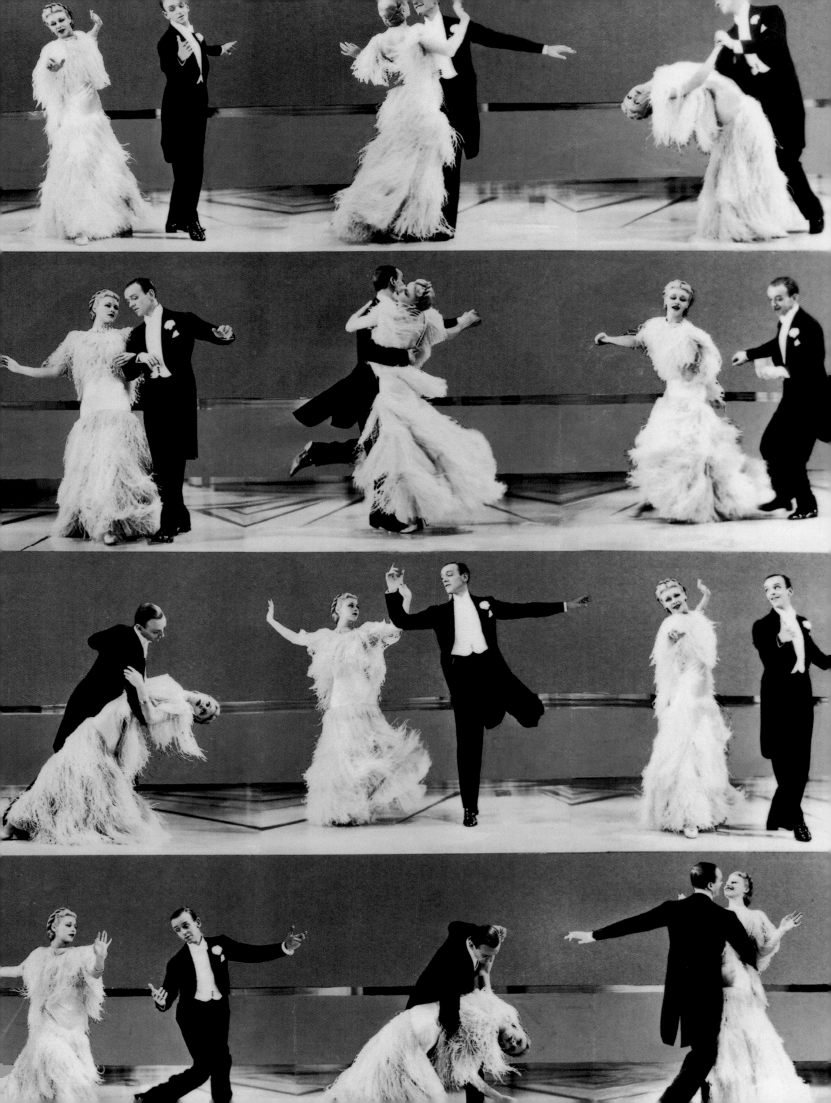

**Katharine Hepburn (actress):** "I had bought all the clothes for an insignificant amount of money. The only one which cost anything was the party dress. I made it tacky-looking by putting little black bows on it and in my hair."

*ALICE ADAMS* (1935) • WALTER PLUNKETT, COSTUME DESIGNER

**George Cukor (director):** "Walter Plunkett designed the clothes with a great sense of the family—the girls were poor but high-minded, and it was arranged that one of them would wear a certain dress at a certain time, and then another would borrow a skirt or a jacket, and so on. The frugality was very real."

*LITTLE WOMEN* (1933) ·
**WALTER PLUNKETT,
COSTUME DESIGNER**

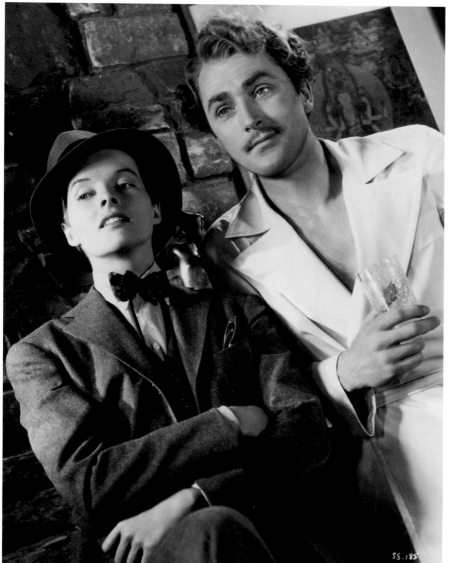

**Guy Babineau (writer):** "Katharine Hepburn's mannish wardrobe inspired an unprecedented demand for stylish women's trousers—now a wardrobe staple."

*SYLVIA SCARLETT* (1935) ·
**MURIEL KING, COSTUME DESIGNER**

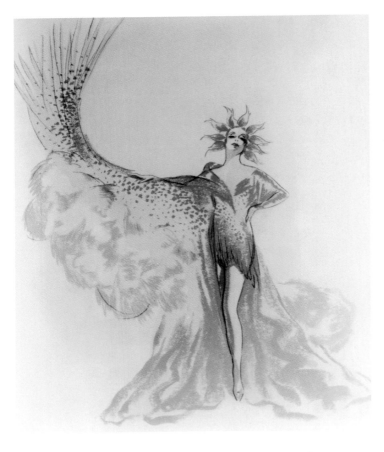

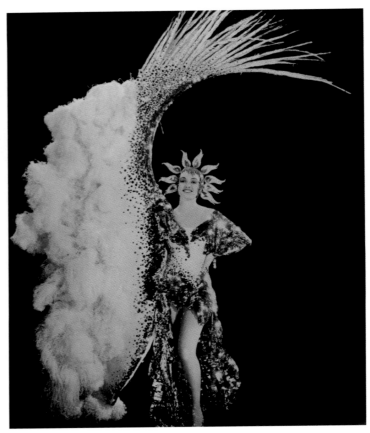

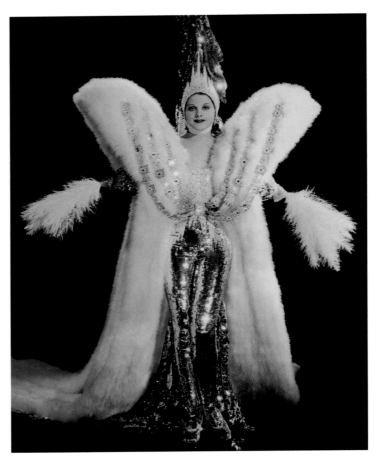

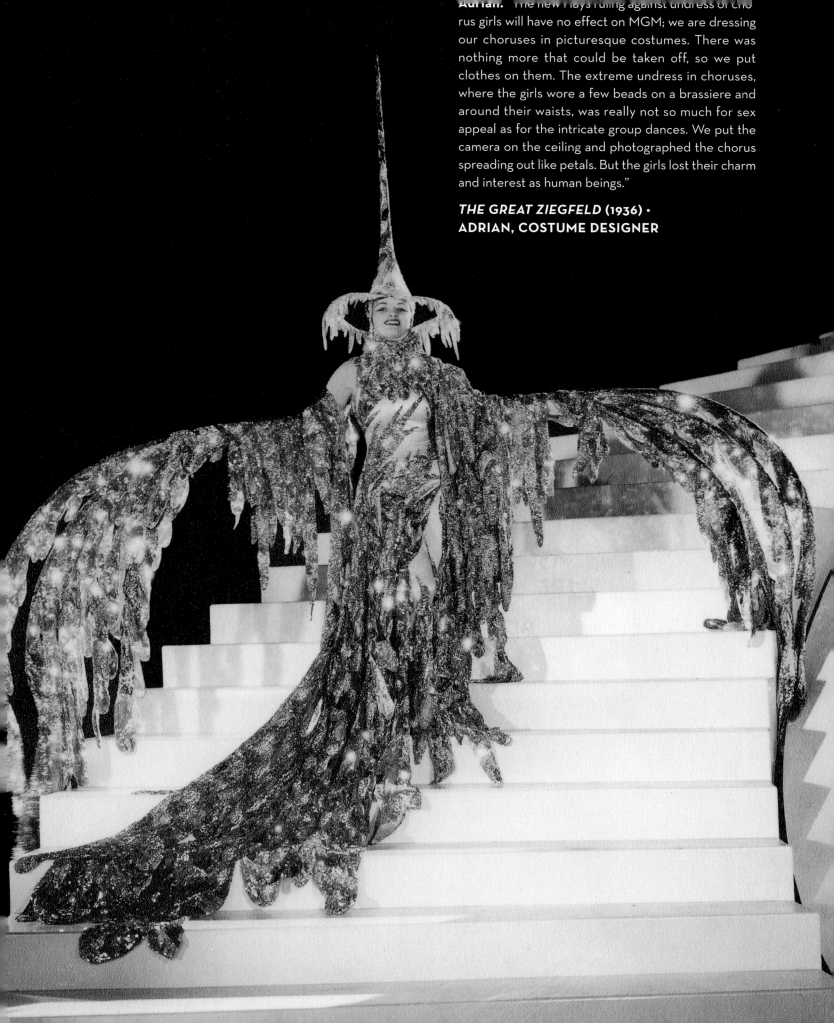

**Adrian:** "The new Hays ruling against undress of chorus girls will have no effect on MGM; we are dressing our choruses in picturesque costumes. There was nothing more that could be taken off, so we put clothes on them. The extreme undress in choruses, where the girls wore a few beads on a brassiere and around their waists, was really not so much for sex appeal as for the intricate group dances. We put the camera on the ceiling and photographed the chorus spreading out like petals. But the girls lost their charm and interest as human beings."

*THE GREAT ZIEGFELD* (1936) ·
ADRIAN, COSTUME DESIGNER

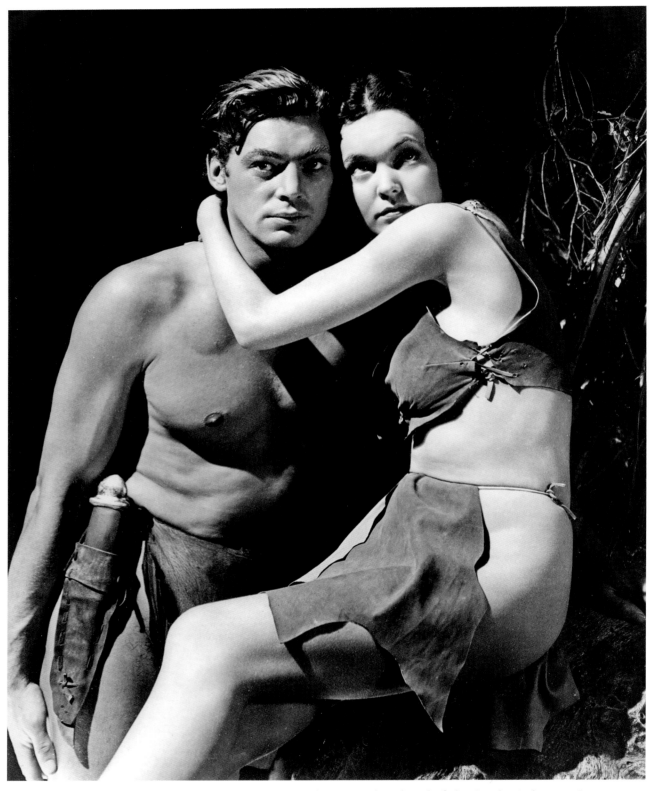

**Thomas Doherty (historian):** "In April 1934, Joseph Breen, then head of the Studio Relations Committee, rejected *Tarzan and His Mate* for its quite visible violation of the prohibition against nudity. A hearing was held, the film screened, the offending sequence rewound and re-viewed for the assembled bigwigs. The jury backed Breen. The nude scene was cut and the film granted approval. The author theorizes that the scene was deliberately put in the film as 'a negotiable offering to the censors,' which would take the focus off of other scenes with Tarzan and Jane 'prancing around in their revealing jungle togs.'"

**TARZAN AND HIS MATE (1934)**

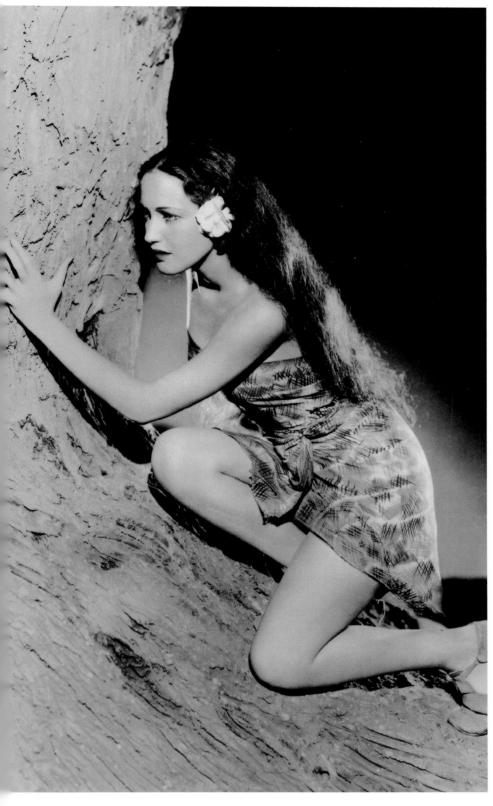

**Dorothy Lamour (actress):** "[Travis Banton] put me in the hands of one of his assistants, a small, dark-haired lady who wore glasses. Her name was Edith Head. . . .

"She pulled out some beautiful cotton print material and began to drape it around me. Beginning to daydream of all the beautiful gowns [and] magnificent jewels that I would be soon wearing . . . I asked how many dresses I would wear in the film. 'Dresses?' she exclaimed. 'Young lady, this is going to be a sarong!'. . . I had been embarrassed to wear a bathing suit in the Miss New Orleans contest because I thought that my hips were too big, my shoulders too narrow, and my long, narrow toes made my feet look big. And now Paramount wanted millions of people to see me with no shoes, in a little strip of cloth. I would have to wear that darned sarong all through the film!"

**Edith Head:** "Paramount conducted a nationwide beauty contest. One by one the state finalists were sent to my department. We'd dress each girl in the same sarong . . . and slip the same shell bracelets on her arm. Then the pretty native would go over for her screen test. Among the candidates [was] Dorothy Lamour, a girl with dark hair twisted into a bun at the back of her head. . . . She was incredibly beautiful with clear, creamy magnolia skin, big blue eyes, and a big bosom. But the minute she took off her sweater, half the 'big bosom' came off with it! Falsies!

"She kicked off her shoes, pulled down her long, luxuriant hair and the red sarong was wrapped around her. . . . We helped nature fill out the sarong to the proper proportions and used adhesive tape to hold it in place. From the least voluptuous of the contestants she became the very promise of voluptuousness and won the role! . . . In the more than ten years of jungle and adventure pictures that followed Dottie was able to hold up her own sarong without any artificial means of support."

***JUNGLE PRINCESS* (1936) ·
EDITH HEAD, COSTUME DESIGNER**

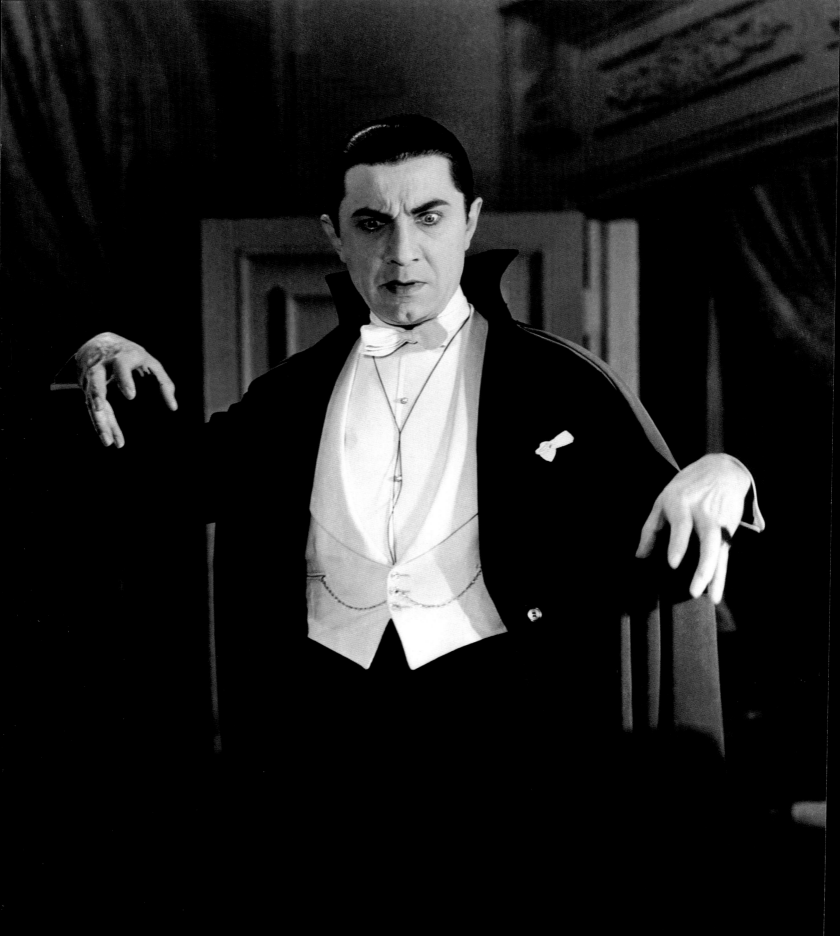

**Gary J. Svehla and Susan Svehla (biographers):** "Lugosi's suave, slightly smarmy good looks do much to establish a romantic link between vampire and victim; but the sexuality is far from 'normal.' Upon reading the screenplay, Carl Laemmle Jr. dictated firmly that 'Dracula should go only for women and not men.'"

**David Manners (actor):** "I can still see Lugosi, parading up and down the stage, posing in front of a full-length mirror, throwing his cape over his shoulder and shouting 'I AM DRACULA!'"

*DRACULA* (1931) · **ED WARE AND VERA WEST, COSTUME DESIGNERS**

**Michael Benson (film historian):** "Buster Crabbe had to lighten his hair for the part, a facet of his role that made him ill at ease on the set. Crabbe donned a cap between takes, complaining that men whistled when he removed it."

**Michael Benson (film historian):** "Mongo is a combination of the futuristic and the primitive. Though their technology is advanced, their Hollywood costumes resemble those of the Roman Empire. Mongonian soldiers, despite their superior arsenal, would prefer to draw swords for battle."

**_FLASH GORDON_ (1936) · COSTUMES DESIGNED BY WESTERN COSTUME COMPANY**

**Milo Anderson:** "It's a bold designer who forecasts future fashion facts. No man can say what feminine whimsy will reject or welcome. Every time a dress appears in public it will have a new disguise. It will wear a dashing bolero, a winding sash, a Robin Hood tabard or cavalier gloves. With the high-low waistline gaining in importance the cummerbund should continue to encircle it. The double girdle such as Olivia de Havilland wears in *The Adventures of Robin Hood* gives the impression of a high-low waistline. When wrought in metal and set with gems it should have an evening vogue."

### *THE ADVENTURES OF ROBIN HOOD* (1938) • MILO ANDERSON, COSTUME DESIGNER

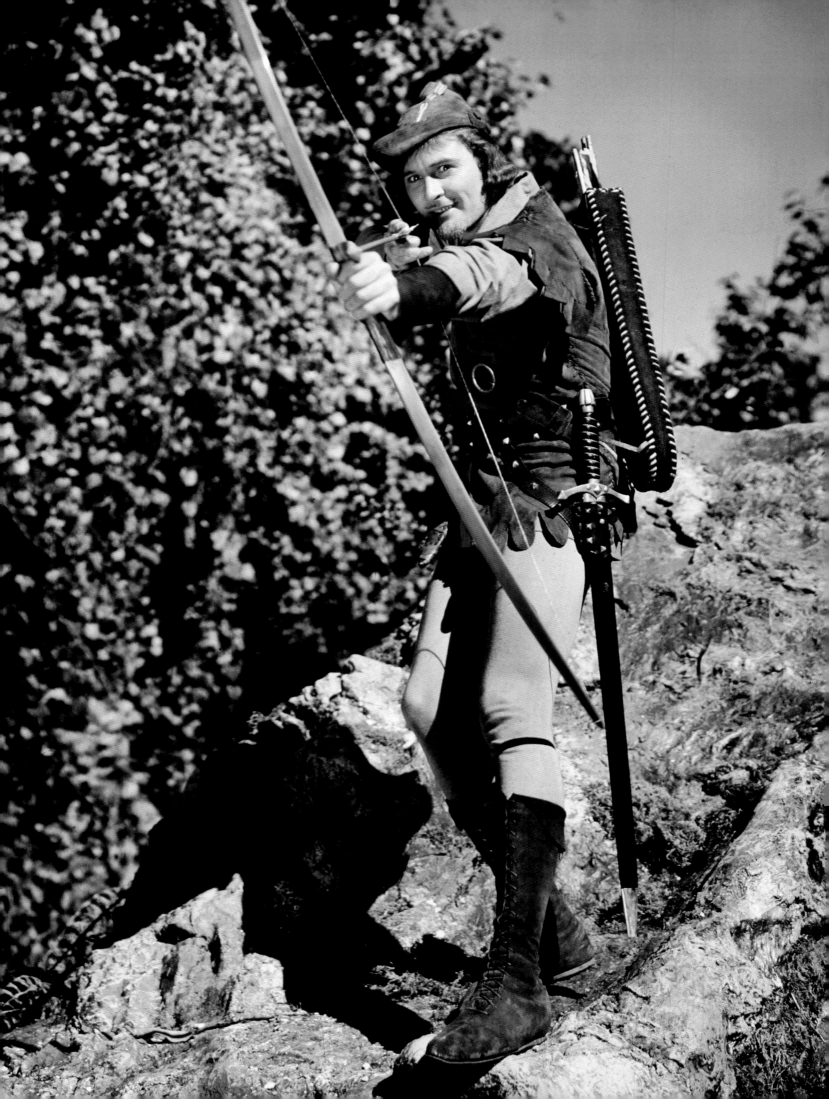

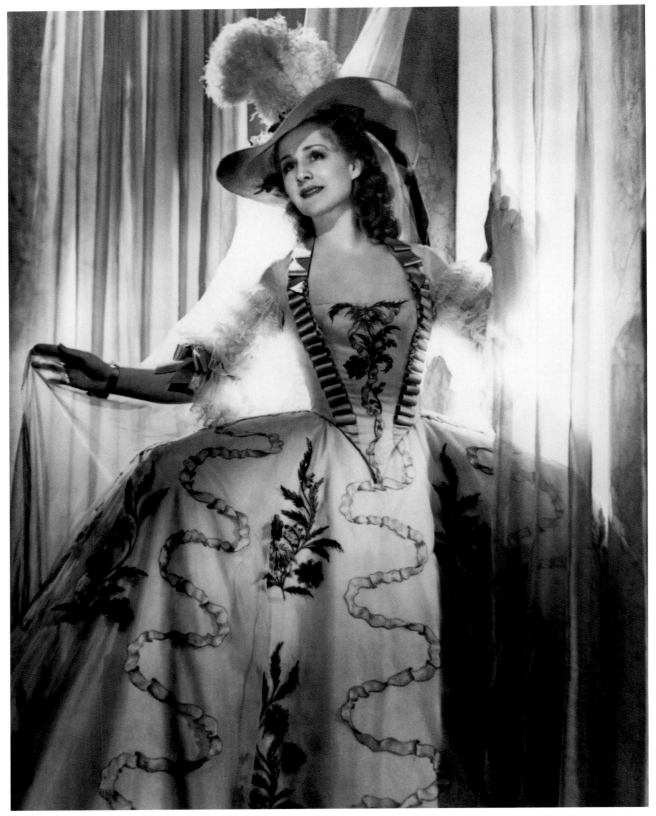

**Whitney Williams (writer):** "For her new picture, Norma must wear thirty-four different costumes and eighteen wigs. For the past four months the star has spent from four to five hours daily, three or four times a week for fittings! And the end is not yet in sight."

**Norma Shearer (actress):** "Every woman on the set feels the same way. These absurd skirts, these wigs, the glittery jewels, the tiny ornaments for the powdered hair—they're all exciting and romantic. When we take them off to go home, life becomes drab, somehow. You know, in that period, when life became really serious, the skirts collapsed and the fun was over!"

### *MARIE ANTOINETTE* (1938) · ADRIAN AND GILE STEELE, COSTUME DESIGNERS

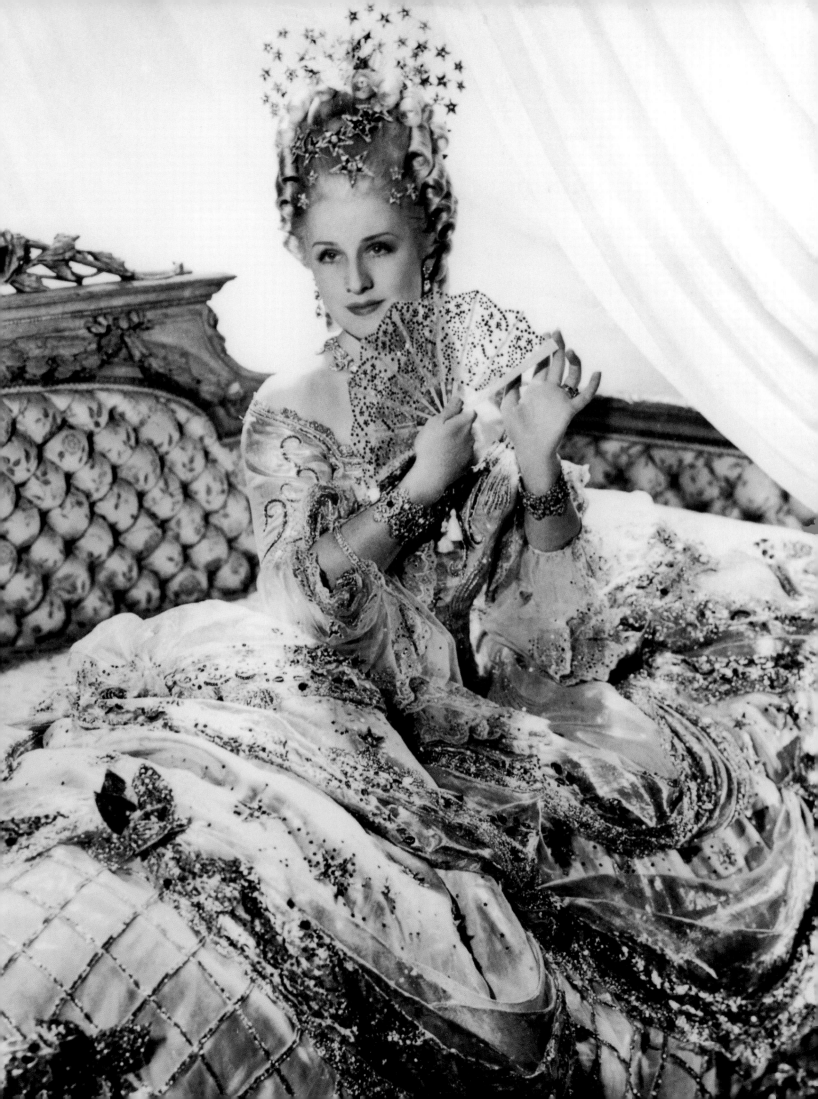

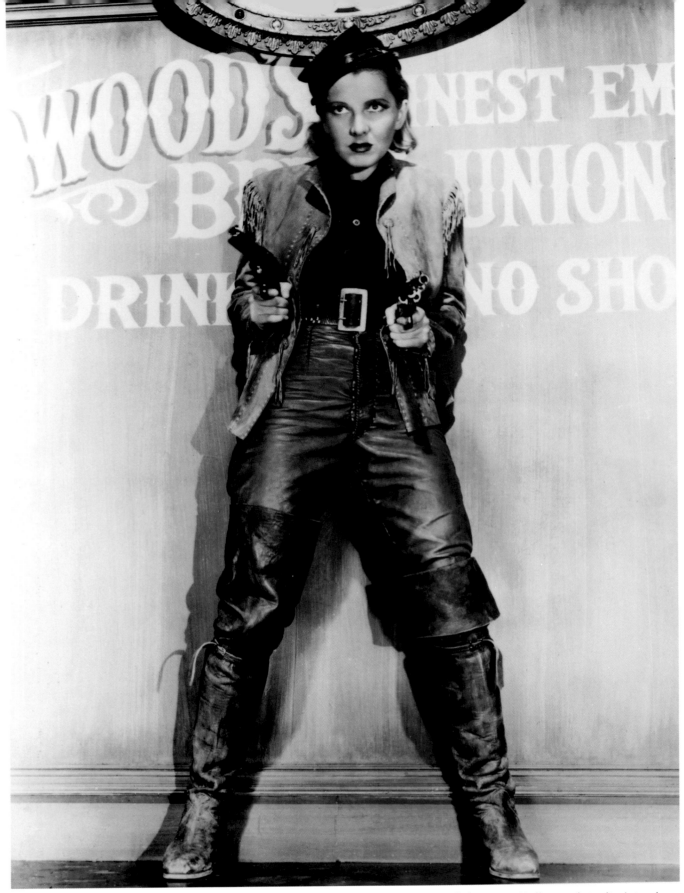

**Kathleen Howard (journalist):** "I had arranged (through the courtesy of the great Hollywood studios), to show a group of costumes from period pictures which will have fashion influence. Jean Arthur's leather jacket and breeches from *The Plainsman,* will inspire suede jacket fashion trends—you will soon see it in color."

### *THE PLAINSMAN* (1937) · NATALIE VISART, DWIGHT FRANKLIN, AND JOE DE YONG, COSTUME DESIGNERS

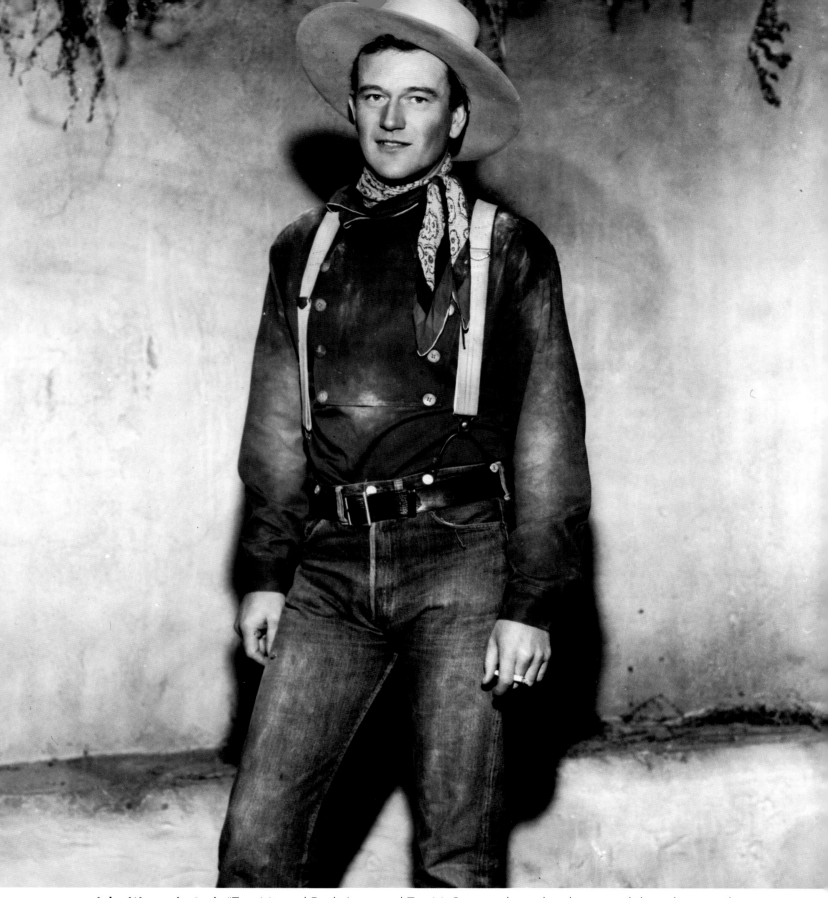

**John Wayne (actor):** "Tom Mix and Buck Jones and Tim McCoy put their white hat on and their gloves, and they stood and waited for the fella to get up and he could hit them with chairs and everything else, and they were just clean and pure. Well, my dad told me if I got in a fight to win the goddamn thing. When I went into Westerns I didn't like to wear the rodeo clothes, so I started wearing the Levis that they have now. I'm the first one ever to use those brown Levis that they have now. I got Western Costume to make some for me to kind of take the place of booger reds.

"I figured[,] a good Western hat and a good pair of boots, and what's in between is unimportant, which is the way most of the fellas were in those days. . . that was antihero."

**STAGECOACH (1939) • WALTER PLUNKETT, COSTUME DESIGNER**

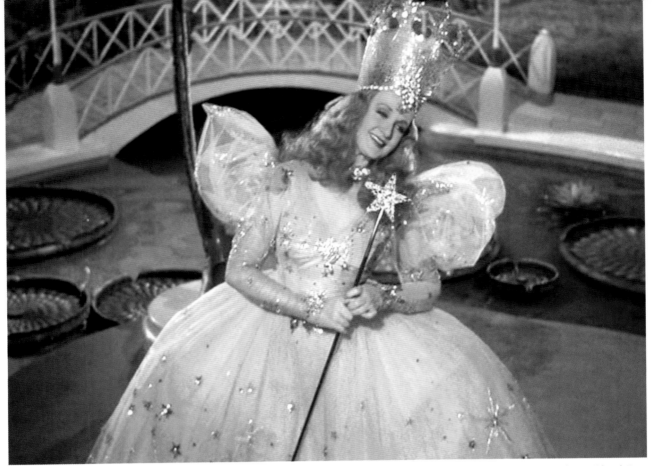

**Billie Burke (actress):** "I look like a fugitive from German opera . . . but, in a way, I'm supposed to. Glinda's a heroic figure. She has only to wave her wand and the world is changed, much as Queen Victoria did in real life."

**Jay Carfone and William Stillman (authors):** "Much of the Ozian attire echoed their earliest incarnations in Oz books written more than three decades before. These concepts lacked the modern flair and embellishment Adrian sought. MGM reported Adrian's next course of action: 'From the fly-leaves of Adrian's schoolbooks came the inspiration for the fantastic Munchkins and their fellow characters. On these childish sketches, taken directly from the old schoolbooks, Adrian's costume designs for *The Wizard of Oz* were based.'"

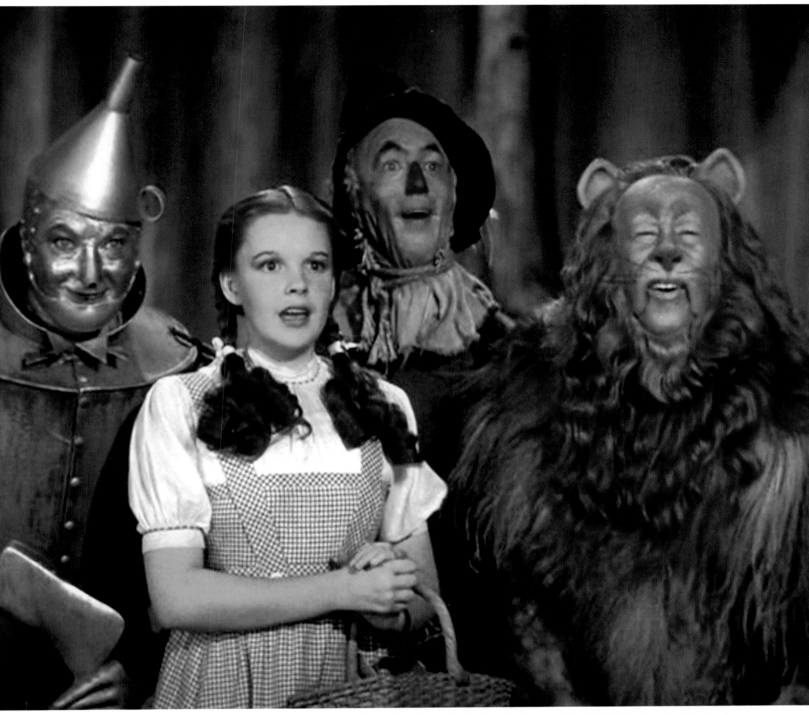

**John Fricke, Jay Carfone, and William Stillman (authors):** "Adrian's designs for MGM leading ladies had already gone beyond film fame to influence the entire fashion world. When assigned to Oz, he reveled in the expansive demands it posed. Hedda Hopper quoted him as 'having more fun over Oz than a trip to Europe,' and the Oz books were announced as 'favorite stories of his youth.' The designer sent home to Naugatuck, Connecticut, for his old schoolbooks; he had sketched Oz characters and wardrobe in their margins twenty years earlier. Adrian developed at least four designs for Judy Garland's single costume and at least one design for the ruby slippers prior to the start of principal photography."

**L. Frank Baum (author):** "It was gingham, with checks of white and blue; and although the blue was somewhat faded with many washings, it was still a pretty frock."

### *THE WIZARD OF OZ* (1939) · ADRIAN, COSTUME DESIGNER

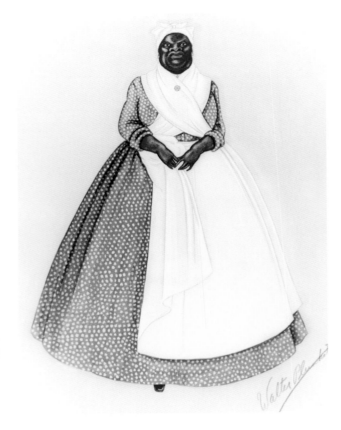

**Walter Plunkett:** "Margaret Mitchell was startled during the production schedule to receive a wire from Hollywood demanding to know how Hattie McDaniel should tie her kerchief!"

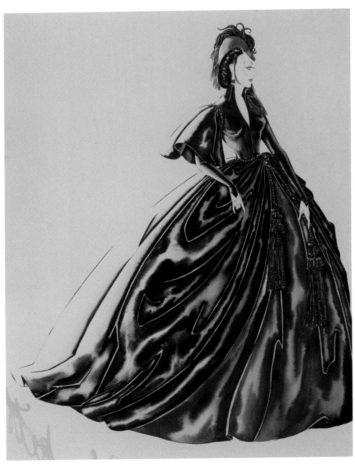

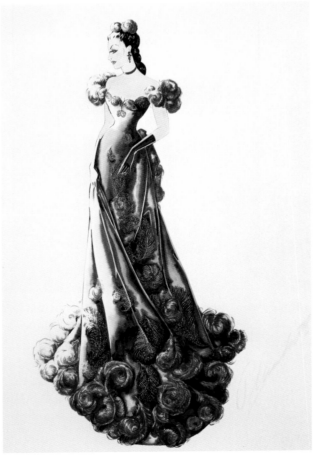

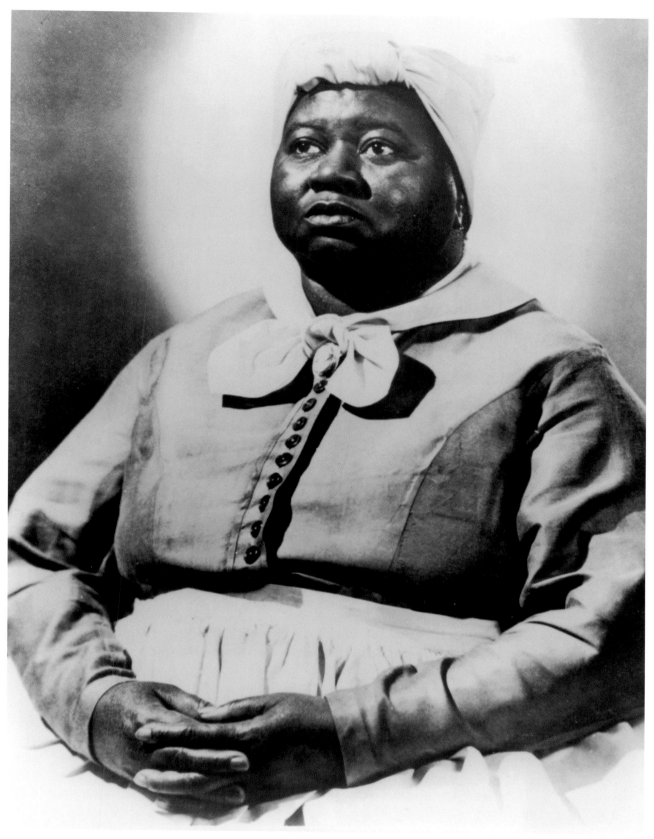

**Hattie McDaniel (actress):** "I'd rather play a maid and make $700 a week, than *be* a maid for $7."

**GONE WITH THE WIND (1939) · WALTER PLUNKETT, COSTUME DESIGNER**

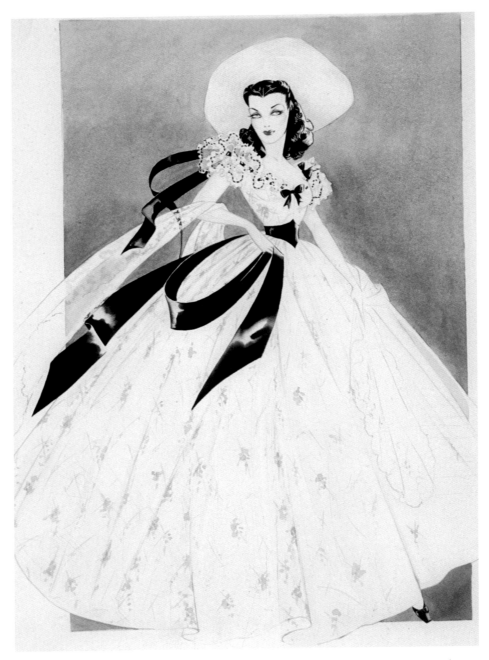

**Jocelyn Tey (writer):** "Plunkett quickly noticed from his readings that Scarlett seemed to be wearing the color green most of the time. While in Atlanta, he obtained Mitchell's permission to introduce more variety into Scarlett's wardrobe. She said that Selznick was entitled to dress Scarlett in any colors he pleased. Green was merely her favorite color. Selznick had insisted that for the 'Twelve Oaks' sequence the camera should pan across six ladies frocks 'which stand stiffly in a prim row like so many headless bodies, on their crinoline petticoats.' Plunkett objected to this preposterous notion in a memo to Selznick's technical adviser, Susan Myrick: 'As you know, neither hoops or crinolines could stand by themselves. If they were rigid vertically it would be impossible to sit in them. I have called Mr. Selznick's attention to this but find myself ignored.' Plunkett finally prevailed and the scene was eliminated.

"At his own expense and initiative, Plunkett also journeyed to Atlanta and Philadelphia seeking the swatch books from mills of the 1840s with pictures from the *Godey's Lady's Book* publications of the day as guides, he finally found a mill near Philadelphia that had been producing some of the same patterns since 1840. He also found that Atlanta ladies had used materials at hand for their dresses during the Union blockade. Most of the gowns were made of cotton and were dipped in butternut dyes. The hats, moreover, were adorned with chicken feathers!"

### *GONE WITH THE WIND* (1939) · WALTER PLUNKETT, COSTUME DESIGNER

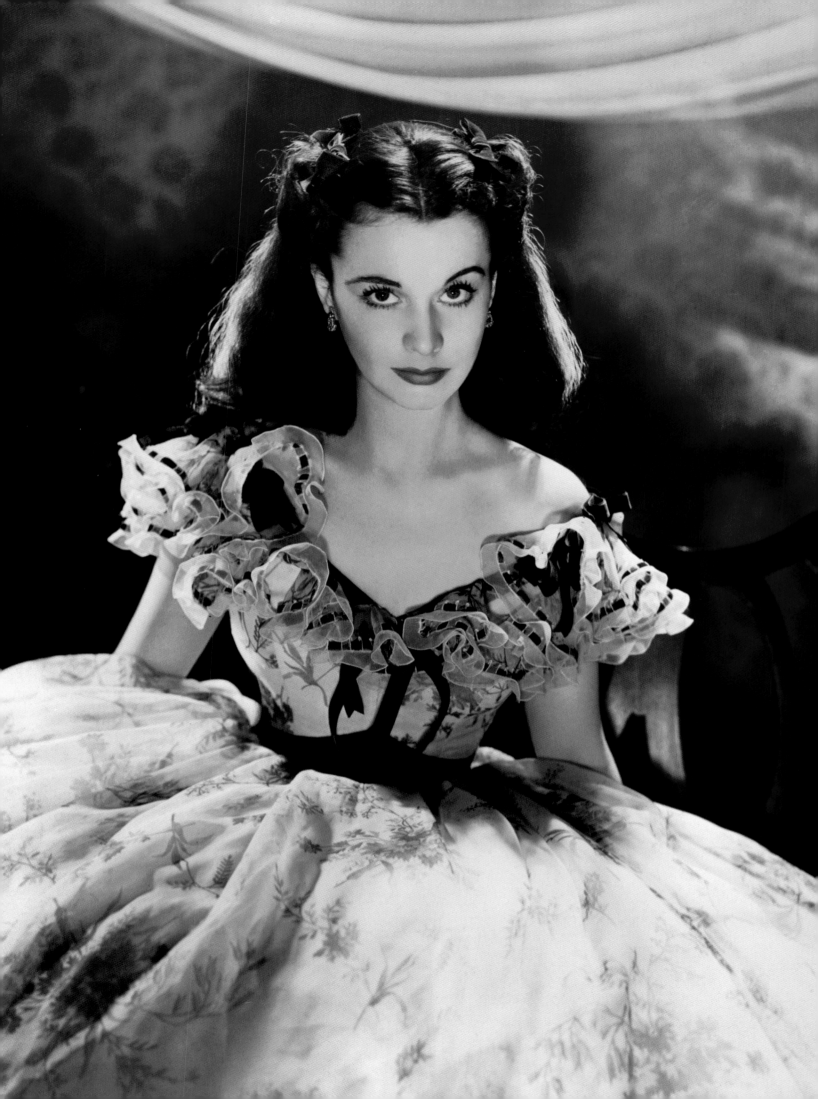

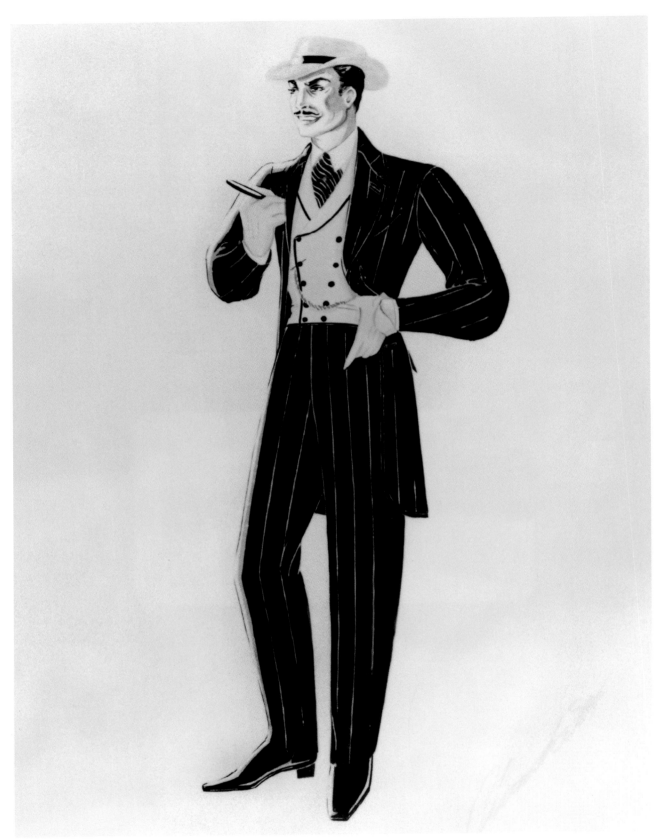

**Walter Plunkett:** "David Selznick wasn't interested in accuracy. I did research in the South because I thought it was necessary. Selznick was much more worried about being true to Margaret Mitchell. When he objected to a design, I'd only have to point out one of her descriptions in the novel and he was satisfied. The movie had nothing to do with history."

### *GONE WITH THE WIND* (1939) · WALTER PLUNKETT, COSTUME DESIGNER

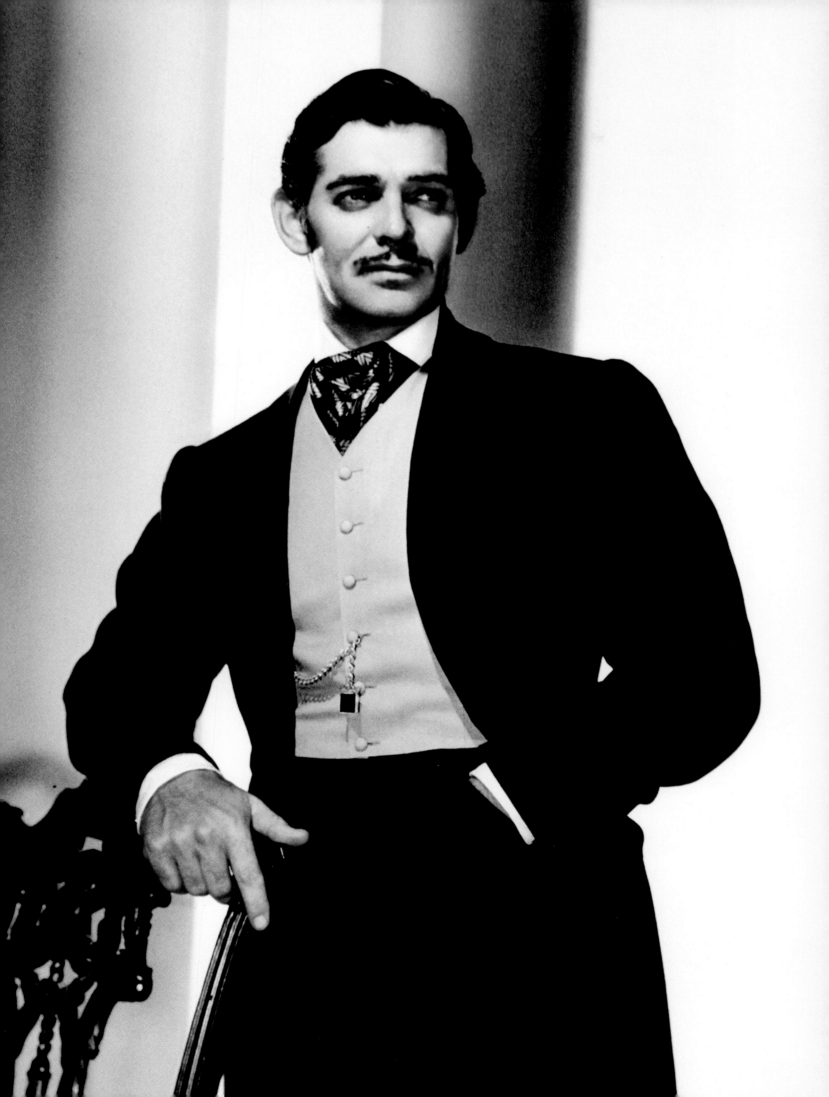

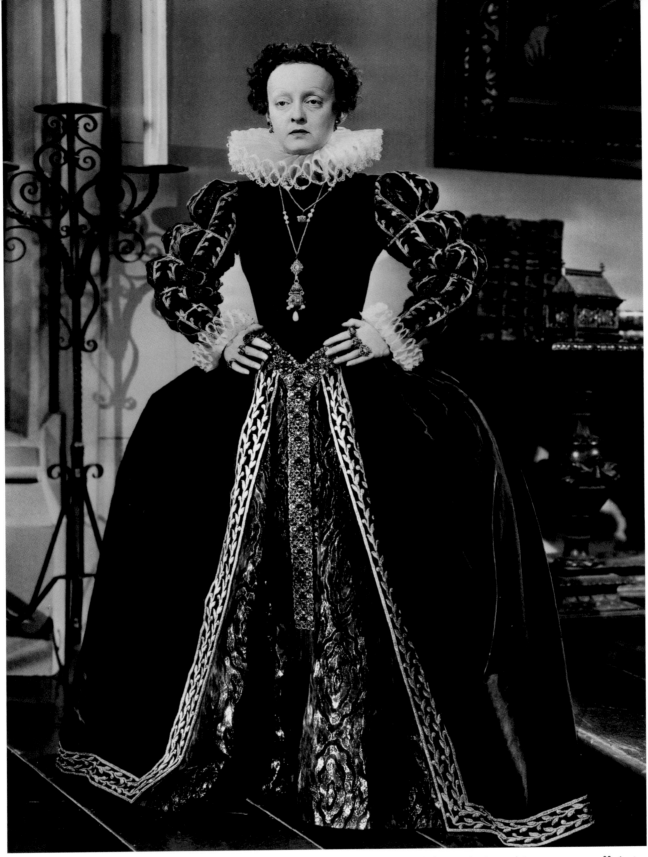

**Bette Davis (actress):** "[Michael Curtiz, director] said, 'No, no, you can't have skirts so big, so many ruffs,' etc. The designer and I had copied the Holbein paintings of the era. So we just went and made up a *totally different* wardrobe and got it tested and approved by Curtiz. Then, when we started shooting and wore the original clothes, nobody ever knew the difference. I had very definite ideas about costumes, hair, all those details. As the star, you're the one who gets the blame or the praise in the end, when a film comes out. And *that* is something you must never, never forget... Definitely, I was going to get it right, one way or another.... And that's why, when I see my films today, those scripts don't embarrass me, the performances don't embarrass me, the clothes don't embarrass me."

## *THE PRIVATE LIVES OF ELIZABETH AND ESSEX* (1939) • ORRY-KELLY, COSTUME DESIGNER

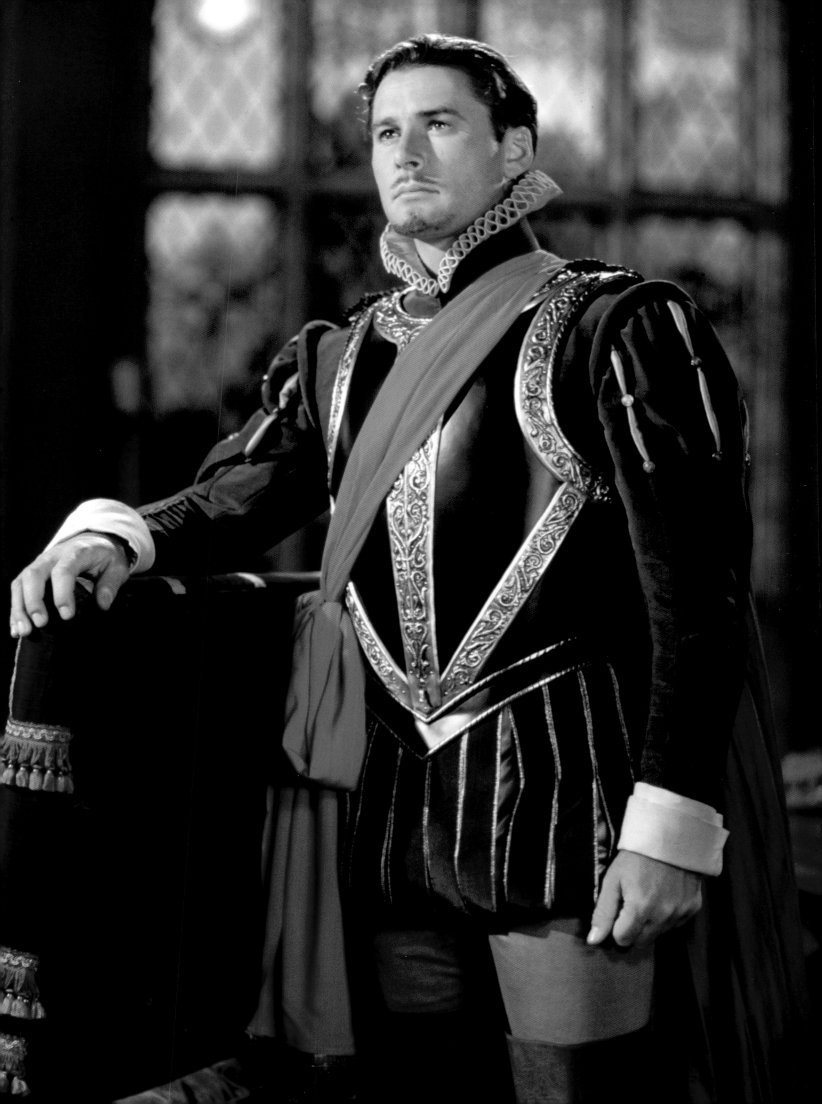

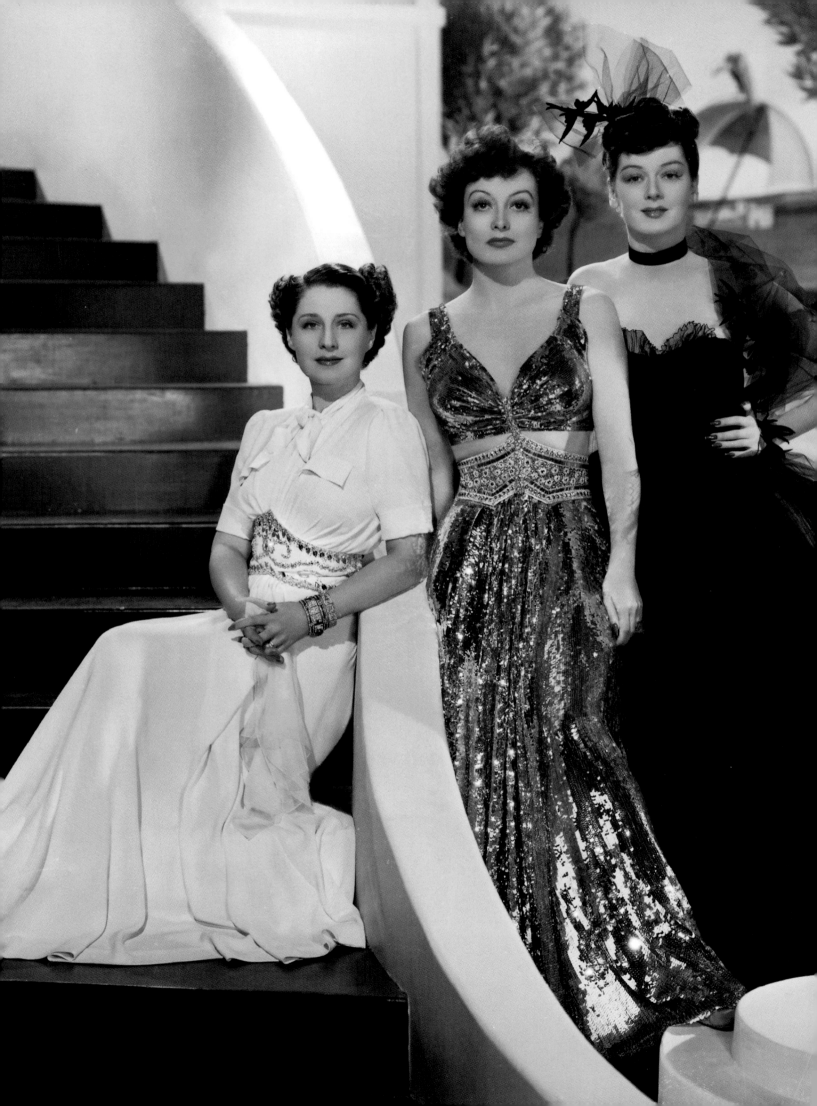

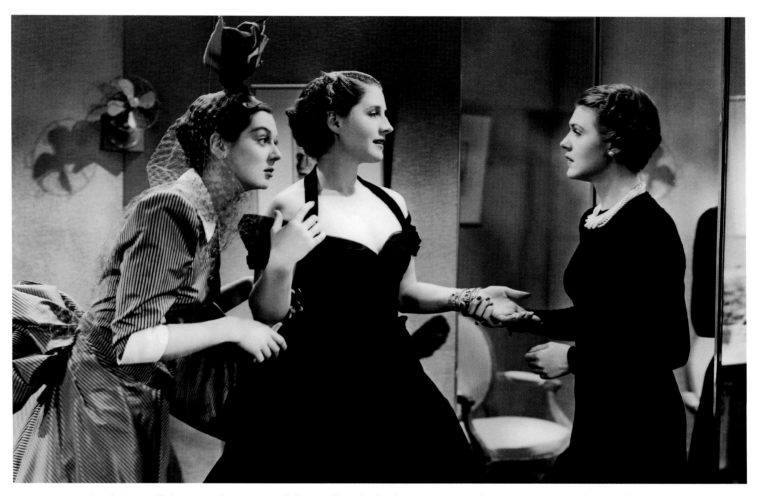

**Rosalind Russell (actress):** "Norma [Shearer] and I had a scene in a dressing room and I'm talking a mile a minute. There's a woman down on the floor fiddling with a hem. There I am buzzing, buzzing, buzzing. 'Just think of it like a bee,' [George] Cukor had told me. 'Get into her ear, and if she turns away, get into her other ear.'

"In the midst of my buzzing, Norma left the set. When she came back she was wearing a dress left over from *Marie Antoinette*. It had never been worn; it was black velvet and it had an enormous hoop skirt. 'I just hated that other dress, George,' she said. He studied her, he studied the dress, and then he said, 'Take a few minutes.' The set was a tiny dressing room with a platform, and once Norma was in the gown with the hoops, I wasn't going to be able to get anywhere near her ears.

"'Rosalind,' Cukor said, 'I want you to stand on that platform. Now pull those full-length mirrors around her,' he told the prop men. 'Now, Norma,' he said, 'you go stand next to her as close as you can get,' Norma came up beside me, and Cukor surveyed his handiwork. 'Light that, fellows,' he said."

### *THE WOMEN* (1939) · ADRIAN, COSTUME DESIGNER

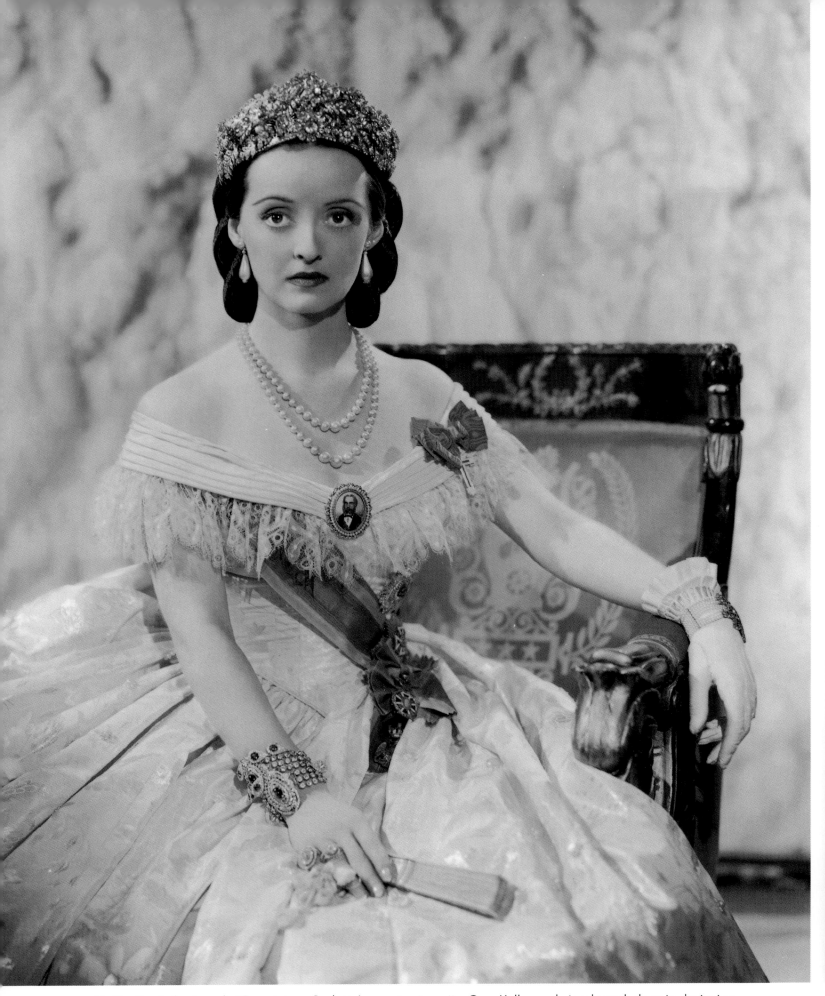

**Bette Davis (actress):** "To point up Carlotta's growing insanity, Orry-Kelly used visual psychology in designing her clothes. He created a white dress for her first scene, and, as the picture progressed, the color of the gowns change from white to gray. Finally, when she is completely mad, she is seen in black."

*JUAREZ* (1939) · ORRY-KELLY, COSTUME DESIGNER

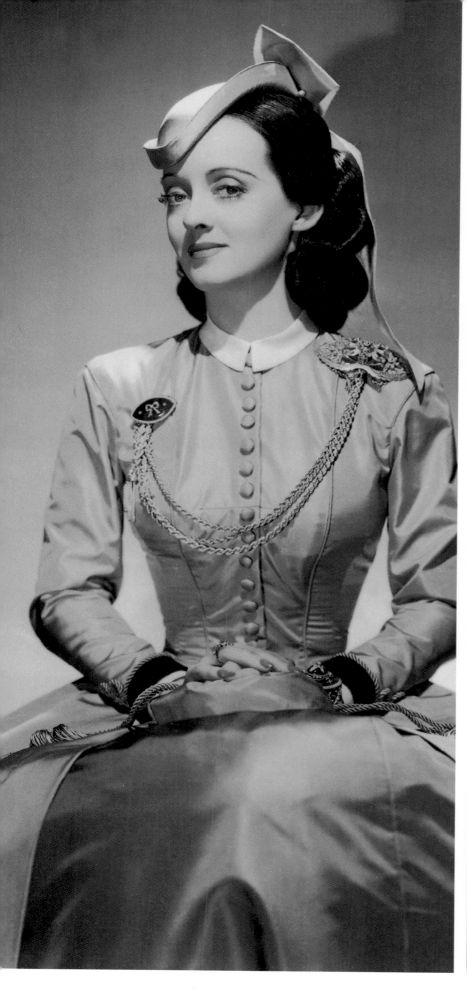

133

# 1940s

Joan Crawford understood from the beginning that her screen style was of constant interest for her public. And no silhouette is more associated with an era than the extended "Crawford shoulders" of the 1940s. Few of her adoring fans knew that those shoulder pads were Adrian's solution to a figure problem. As the actress remembered, "The first time Adrian saw me he uttered an unforgettable line: 'You,' he said, 'are a female Johnny Weissmuller.' I just stood there. What could I do? Five feet, four and a half inches tall, with size twelve hips and size forty shoulders! 'Well, we can't cut 'em off,' he said finally, 'so we'll make them wider.' That was the start of a look that lasted for more than ten years. Broad padded shoulders, small waist, and slim hips."

The 1940s were glory years for the Hollywood studios. The public's moviegoing habit seemed insatiable. For costume designers, however, the years of World War II were a time without ribbons, pleats, ruffles, cuffs, and frills. Costume departments, like the rest of the nation, were subject to government rations created to reserve resources for wartime use, and the government directive that ordered conservation of sugar and meat also rationed fabric. "It drastically limited the

*OPPOSITE: "For the low budget potboiler, Cat People, the wardrobe man fit moldy cat-man costumes on some players. They were ill-fitting as they were ill-smelling. They retired to a projection room. Director Val Lewton decided never to show the cat people, but to suggest their presence through imagination. And Lewton succeeded in making something quite distinguished out of nothing." —Vincente Minnelli*

**CAT PEOPLE (1942) · RENIÉ, COSTUME DESIGNER**

amount of fabric that could be used in any garment construction—including Hollywood costumes," sighed Edith Head, by now costume chief at Paramount. Luxurious imported fabrics were impossible to obtain. Forget satin, velvet, and gold lamé, the age of extravagant gowns was over—for a time.

Instead, costume designers resorted to the time-honored practice of foraging, searching for buried treasure in the racks of studio costume stock—even for the stars' outfits. Cotton stood in for silk, and actresses made the best of straight skirts and short jackets. The government even enlisted Hollywood's help in convincing citizens to conserve fabric, and especially silk (which was needed for parachutes): In a promotional message early in the war, Edith Head counseled that "All designers are turning to cotton. Silk is 'out' for 1942. Synthetic materials will be used more than ever before, and we are fortunate because they have been perfected to such a degree that it is almost impossible to detect that they are not pure fibers."

Fabric was not the only thing in short supply; the studios also had to deal with an acute shortage of experienced seamstresses. Stitchers could earn more sewing uniforms and parachutes for the war effort than at any studio's wardrobe department. Assembling aviation instruments turned out to be a perfect match for the dexterous fingers of skilled embroiderers, beaders, and lace makers.

Meanwhile, costume designers overcame the limitations of rationing, working in multiple job jurisdictions to meet the production deadlines (which hadn't disappeared with the resources). Ginger Rogers recalled shooting *Weekend at the Waldorf* (1945): "When the day came to do a particular scene, however, the dress I was supposed to wear wasn't finished. Rather than hold up production, [producer] Arthur Hornblow asked if I had a dress of my own that might be suitable. I never expected to hear a question like that from MGM! I did have a black silk grosgrain dress designed by Irene, and I sent home to get it. It must have been somewhat embarrassing for the producer to ask the star to dip into her own wardrobe to help costume the film."

In like fashion, Vincente Minnelli asked star Robert Mitchum to "Bring me something tweedy" for his role in *Undercurrent* (1946). "At the time, Bob had only two suits, and both of them were still being made." Mitchum continued the story: "I show up on the show with my clothes stuck together with pins. Minnelli notices that I don't look too elegant. 'Are those your own clothes?' he asked. I'm sure he didn't understand that an important player would be tapped out and have no money for clothes."

But Hollywood did not completely give up its love of luxe. For the 1944 film *Laura*, producer Otto Preminger spent fifteen thousand dollars to clothe Gene Tierney by costume designer Bonnie Cashin—and made sure both the cost and the costumes got plenty of publicity. Most "real" gold and "fur" trim during this time were faux; the simple materials reflected the tenor of the era's realistic movies, which captured the somber mood of the nation. Audiences responded devotedly; weekly cinema attendance rose from 80 million in 1940 to almost 100 million by 1946.

Hollywood had its best year in 1946, when servicemen returned from the war with time and money to spend. Movie theaters sold more than 4 billion tickets that year. By the end of the decade, the novelty of television would start eroding the audience, and movie attendance would drop while Hollywood struggled to find another formula that might draw the public back into the theaters.

The neorealistic trend in America gave us what became known as *film noir*, a crime-drama genre whose landmarks included *Laura* (1944), *The Big Sleep* (1946), *Kiss of Death* (1947), among scores of others. Film noir took audiences to a shadowy underworld of con men and cops, tough guys and dangerous dames; their stories were infused with dark passion, gunplay, and heart-

pounding intrigue. In addition to film noir, innovative movies such as Orson Welles's *Citizen Kane* (1941) challenged the studio status quo, and films illuminating the difficult choices of wartime resonated with audiences. Notable among these was 1942's *Casablanca*, conceived as a piece of anti-Hitler propaganda before the United States entered the war. Still, there was real life, and then there was Hollywood. "Realism in movies at that time was still largely of the brand popularly associated with Hollywood, with its peculiar air of the unreal," mused Broadway designer Irene Sharaff, at the time designing musicals at Metro-Goldwyn-Mayer. "Audiences enjoyed and apparently wanted this kind of exaggeration, slickness, superficiality, and the heavy dose of saccharine. A star playing the role of a secretary of modest means changed her dress and matching accessories for every scene."

No movie exemplified this polished Hollywood reality better than *Casablanca*, in which Ingrid Bergman and Paul Henreid's immaculately dressed resistance fighters fled the Nazis across northern Africa. Henreid's Victor Laszlo arrived at Rick's Café Américain in a spotless and perfectly pressed off-white suit. Ingrid Bergman's character, Ilsa Lund, shopped in the Moroccan Kasbah in an immaculate white Orry-Kelly ensemble with a white hat.

Yet costumes could still reflect the deeper truths of their characters. Edith Head described the challenge of designing costumes for Olivia de Havilland in the 1949 period film *The Heiress*. "Olivia's character, Catherine Sloper, was slightly clumsy and awkward. You had the feeling that she wasn't quite put together. . . . I had to get across how uncomfortable she was with herself in whatever image she projected. I could not do it by giving her inexpensive or ugly clothes, because her father was a wealthy man and everything she wore was of the finest quality. No matter how much money she had, she never looked soignée because she was insecure. Rather than give Olivia a perfect fit, I made things purposely gap or wrinkle in the wrong place. I would cut a collar too high or a sleeve a bit too short. If her dress had ruffles, it had a few too many ruffles combined with too much ribbon and a bit too much lace, reflecting her unsophisticated taste." Her collaboration with director William Wyler produced costumes so perfect for the characters and story that, as Head later said, "[if it] had been a silent picture, anyone could have told the story simply by watching the costumes."

By the 1940s, color had begun to dominate the art of moviemaking; indeed, Technicolor became a star in its own right. The use of color film stocks added another dimension to the costume designer's tasks. "The designer must use almost mathematical precision in selecting the exact color, design, and fabric and in figuring out the reaction of the studio lights upon them," explained 20th Century Fox costume designer Charles LeMaire. "His job also entails the proper blending of the costumes with the background so there will be no jarring note between the two."

Edith Head made sure she coordinated with the rest of the production staff when designing costumes. "The production designer is the man to whom I show the sketches even before I show them to the director," she said. "I think that unless clothes are synchronized with a room that is a cool color, or a hot color, or that's going to have a floral pattern or no pattern at all, it's impossible to do a coherent job of designing."

For his work on *Meet Me in St. Louis* (1944), Vincente Minnelli recalled, "I was advised to rely heavily on the advice of Natalie Kalmus, the studio's color consultant. She came over regularly to check on our progress. 'You've heard the truth about Natalie Kalmus,' someone told me. 'No, I haven't,' I answered, 'She's color blind.' A laugh was very much needed at that point. My juxtaposition of color had been highly praised on the stage, but I couldn't do anything right in Mrs.

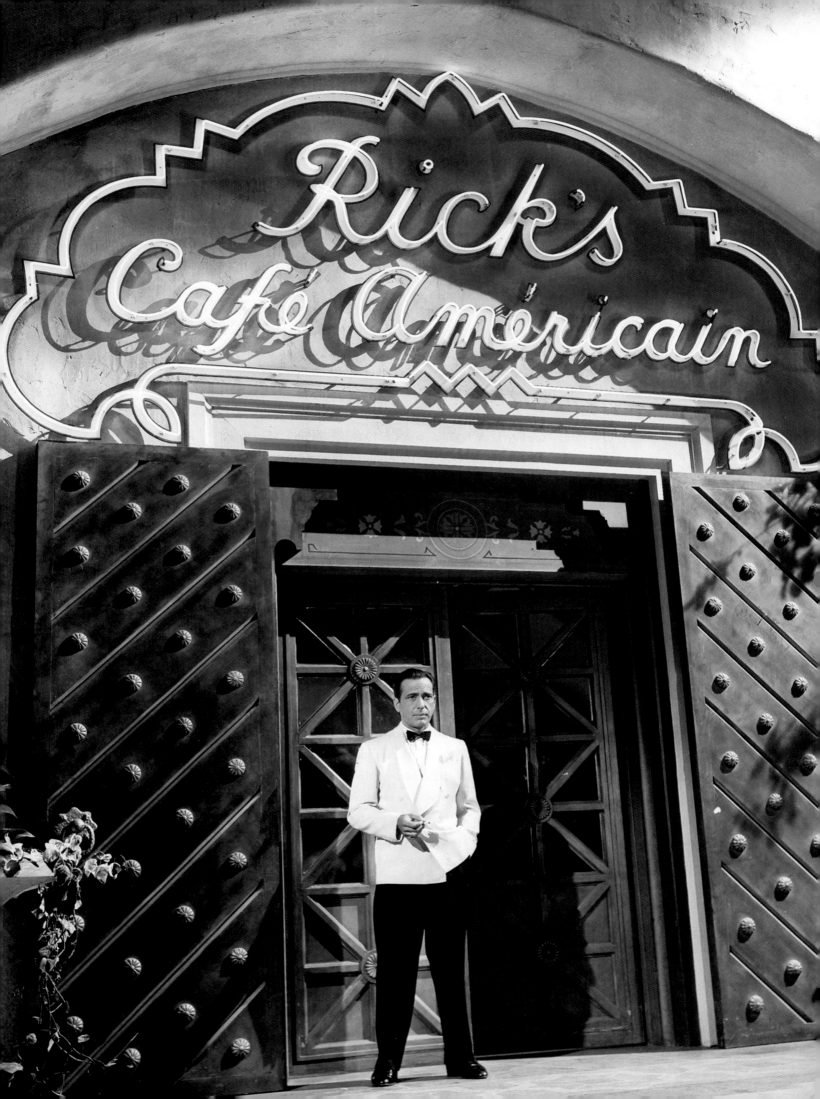

Kalmus's eyes. 'You can't have one sister in a bright red gown and another in a bright green,' she said. 'The colors together are wrong. The camera will pick them up as rust and greenish black.' She was basing her judgment on the trial color shot of swatches of the material. I had enough faith in the technology of the time to assume the camera wouldn't distort the colors, as it picked up the movement of the costumes under the constantly changing lights. Her advice was probably right—and safe—but I depended on my own instincts from then on."

Director Alfred Hitchcock was particularly sensitive to the new problems caused by color photography. "He has a complete phobia about what he calls 'eye-catchers,' like a scene with a woman in bright purple or a man in an orange suit," said Edith Head, who designed the costumes for many Hitchcock films. "Unless there is a story reason for a color, we keep the colors muted, because Hitchcock believes they can detract from an important action scene." Head learned to use color to her advantage, letting color help establish character. "I think you see colors before you see details, and certain clichés will work—virginal white for a girl, black for a vamp," she said. "Over the years, we've come to accept certain connotations from certain colors. If I'm doing a very sweet old lady, I'm apt to consider lavender or purple and old lace."

More than ever before, American women wanted the clothes they saw on their favorite actresses. The work—and wisdom—of Hollywood designers remained a staple of magazine photo spreads, as did features on how to achieve glamour on a limited budget. Ginger Rogers described this screen costume-to-street fashion migration after co-starring with a teenage Shirley Temple in *I'll Be Seeing You* (1944). "Shirley was grown up, all of fifteen. In one scene, Shirley was supposed to wear a skirt and sweater. Producer Dore Schary asked why she wasn't wearing the sweater he'd okayed. It turned out Mama Temple didn't want her little girl wearing a sweater in a movie. I'm sure she thought it would delineate her daughter's figure too much. The next thing I knew, Shirley was wearing the sweater. The film was released in late 1944 and immediately teenagers across the U.S.A. began wearing sweaters."

When Irene Sharaff arrived at MGM from Broadway in 1942, she inspired a radical shift in the studios' approach to costume design. Until that time, most lead designers or executive costume designers had created costumes for the female lead of a film, and another designer had created costumes for the men and the supporting players. The wardrobe department staff coordinated costumes and accessories for the extras. As Sharaff noted, "Hardly any attention was given to integrating the costumes of stars with the company, and little thought was given to a degree of coherence in the look of a scene and of the production as a whole. No one designer was assigned to do an entire movie and made responsible for the final results."

That system was new to Sharaff who, as a designer for theater in New York, had always created all the costumes in a production. "When Arthur Freed brought me to Hollywood, I believe he had some idea of applying the Broadway pattern and trying for a unified approach in the costumes through the whole picture," Sharaff said. She quickly brought the live theater's design process to the movies. Forever afterward, designers adopted the live theater approach, conceiving an overarching color palette and integrating the design of an entire cast of characters. Ultimately, it was not the beautiful stars, nor the opportunity to create a gown for a dramatic entrance, that provided the inspiration for these Golden Age designers. "A good story . . . supersedes the star and

OPPOSITE: *Humphrey Bogart in Casablanca (1942) • Orry-Kelly, costume designer*

all other elements in the making of a film," said Sharaff. "Costume designing is one cog in the wheel. What makes the wheel go round is the story."

The close of World War II signaled the beginning of the end of the studio factory system. By 1948, the federal government had obtained three Supreme Court antitrust decisions that together required the studios to produce and market each motion picture separately. No longer would costume designers and wardrobe staff enjoy multiyear contracts and steady income. Everyone in the movie business eventually became a free agent. MGM held on to the studio system longer than other studios; for example, costume designer Helen Rose remained at the studio until 1967.

Although almost all designers lost the security of studio contracts, they gained the freedom to pursue different projects with different filmmakers. In 1948 they also, finally, received their first recognition from the Academy of Motion Picture Arts and Sciences, with the advent of the Academy Award for costume design. "This is not a triumph for the studio designers but the result of a long and persistent struggle I have been waging for recognition and acknowledgment of their contribution to the making of pictures," Charles LeMaire, wardrobe director for 20th Century Fox, told the *New York Times*. Given at the twenty-first award celebration, the first Academy Awards for best costume design were for the black-and-white film *Hamlet,* designed by Roger K. Furse, and for a color film, *Joan of Arc,* designed by Dorothy Jeakins and Barbara Karinska.

During the war, Hollywood designers had set an example of self-sacrifice for American citizens. After it ended in 1945, however, they embraced fur and feathers, long full skirts, imported fabrics, and gold trim, with all the gusto they had shown before the war. In 1947, René Hubert spent $90,000 on the costumes for the period piece *Forever Amber*. The next year, total wardrobe costs for MGM's *The Pirate* (1948) starring Judy Garland and Gene Kelly, would top $141,000. Rosalind Russell awed the National Federation of Businesswomen when she joked, "I could order the clothes for my pictures in my sleep. I'd say to Jean Louis, Adrian, Irene, or Travis Banton, 'Make me a plaid suit, a striped suit, a gray flannel, and a negligee for the scene in the bedroom when I cry.'"

What didn't come back in the postwar years was cleavage. In the hands of the increasingly conservative Hays Office, the industry's self-imposed moral guidelines became inflexible restrictions. "The fact that the nude or semi-nude body may be *beautiful,*" said the Hays Code, "does not make its use in the films moral. For in addition to its beauty, the effects of the nude or semi-nude on the normal individual must be taken into consideration." Costume designers often became engaged in evaluating an "immoral" décolletage on the film set with the ubiquitous Censorship Compliance Officer. "Censorship was kind of crazy in that period," said Head, "because we could show a girl in the shortest little abbreviated underclothes as long as they looked like sportswear. But if they had lace on them we couldn't show them because then they were considered underwear." When Howard Hughes bought RKO, he bucked the Hays Office and released *The Outlaw* (1943) without its seal of approval—with Jane Russell's endowments, and sneer, intact.

For costume designers, the 1940s saw the streamlining of the assembly-line process, and the formalizing of internal hierarchies within costume departments. The departments were divided into three segments: costume designers, who created the look of each film and costume; costumers, who aided in the budgeting and organization of the production and worked on the set dressing the actors; and seamstresses and tailors, who toiled in the workroom manufacturing the costumes. The top designers still handled the lead actresses' costumes, working on several films at once and receiving only the credit "Gowns by." With the coming decade, this too would change.

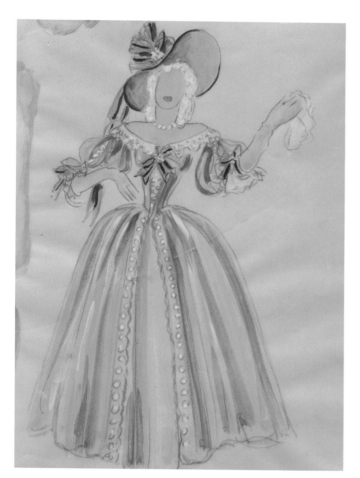 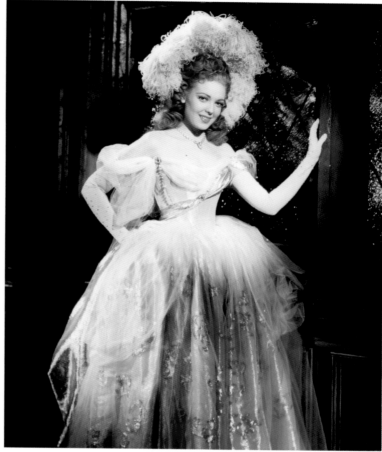

**Charles LeMaire (Fox wardrobe director):** "After I read *Forever Amber*, my job was to assign a designer to handle the costumes. I chose René Hubert. While he was reading the script, we made a wardrobe plot or chart to show just what costumes and accessories were needed in certain scenes. In the meantime, conferences were held with designers, shoppers, set girls, wardrobe foreladies, and the research department. While Hubert was making the sketches for Linda Darnell's clothes, the rest of the department was busy getting the clothes and costumes for the extras, bit players, and supporting cast. The sketches were then shown to William Perlberg, the producer; Otto Preminger, the director, and finally to Mr. Zanuck. After all three approved them, the shoppers began gathering the fabrics. By this time Linda was ready for her preliminary fittings. Five costumes were fitted at each session and her wardrobe was begun three and a half months before the picture went before the cameras. Then hats, jewels, shoes, and accessories were matched and the completed outfits photographed in black and white and Technicolor from every conceivable angle. By doing this, Hubert was able to avoid any mistakes that might be detected during the shooting and delay production."

## *FOREVER AMBER* (1947) · RENÉ HUBERT, COSTUME DESIGNER

**Richard Chace (writer):** "The costumes, mainly overalls and coarse blue shirts for the men and Mother Hubbards or cheap ginghams for the women, had to be picked up from the local Salvation Army or purchased direct from the migrant camps at Bakersfield or Stockton. Nothing new, nothing made up at a studio, would do. Clothes had to be worn and old, tattered and roughly patched together again, for people long used to poverty.

Denied even stockings, Jane Darwell went about for six weeks in an oversized pair of men's shoes. Sometimes she and Dorris had to go completely unshod and found it painful and unnerving, to stand before the cameras while chickens curiously pecked at their bare toes. The use of makeup, too, was out. Even the youthful Rosasharn was untouched by lipstick and rouge."

***THE GRAPES OF WRATH* (1940) · GWEN WAKELING, COSTUME DESIGNER**

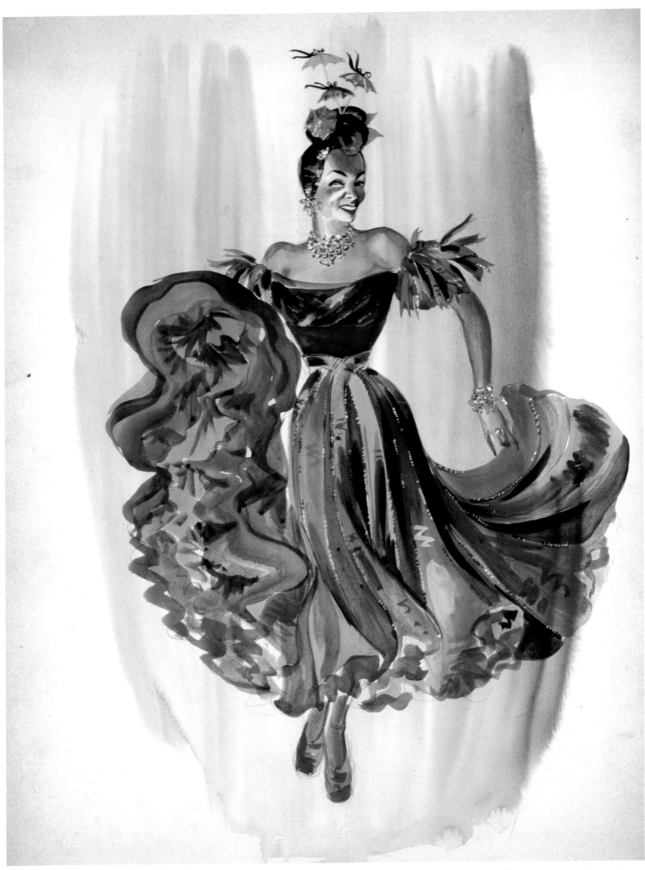

**Carmen Miranda (actress):** "I loff to wear my hair like Deanna Durbin, but I have to stoff eet een a turban. A turban that weighs 5433 pounds. And not only that—but I have to wear those crazy gowns. . . . Everything belongs to me (with a glance toward her neckline), nothing belongs to the studio."

*CARMEN MIRANDA* · HELEN ROSE, COSTUME DESIGNER

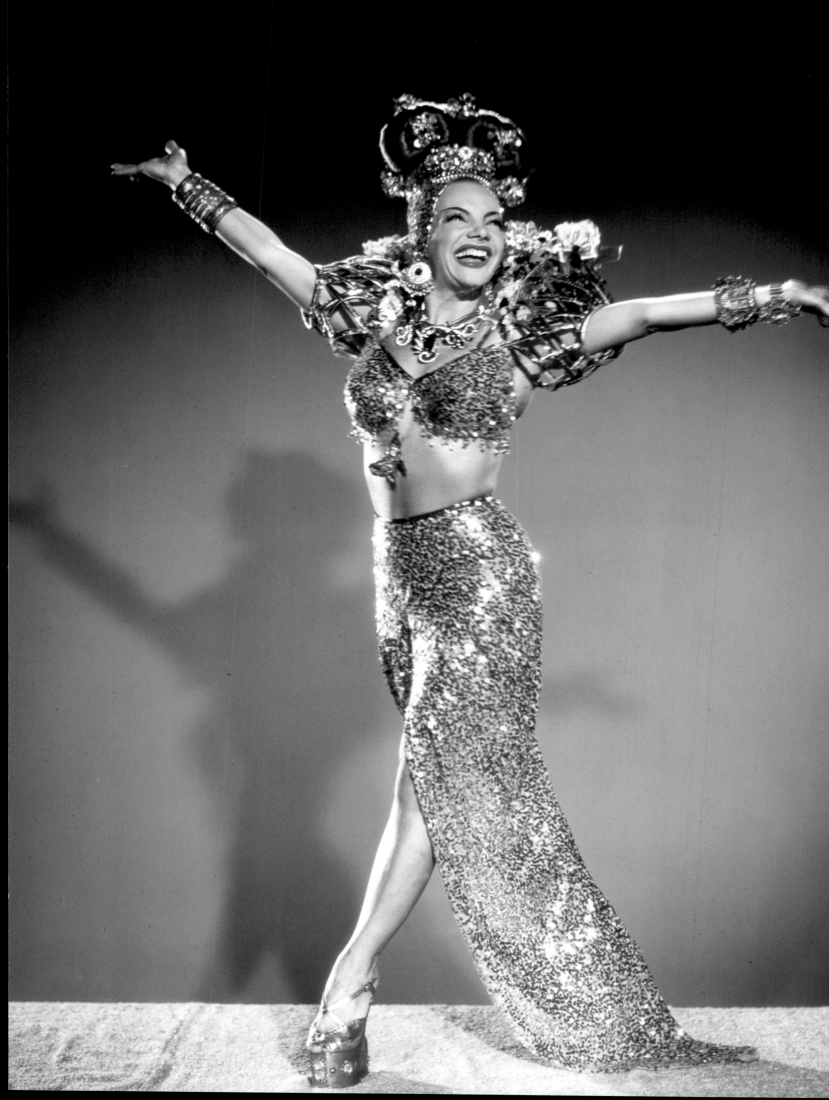

**Rosalind Russell (actress):** "'It'll be all right,' Hawks said. 'You'll be fine. Now go to Wardrobe and tell them I'd like you in a suit with stripes, rather flashy-looking.' We'd been shooting two days when I began to wonder if his instructing me that my suit should be kind of hard-boiled–looking was the only advice I was going to get from Mr. Hawks."

*HIS GIRL FRIDAY* (1940) ·
ROBERT KALLOCH, COSTUME DESIGNER

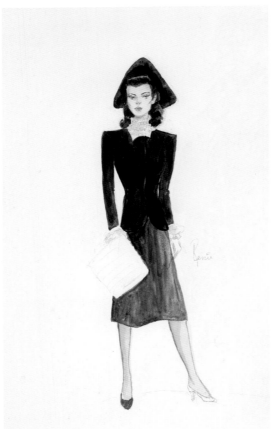

**Ginger Rogers (actress):** "After I had digested the script, I concluded that Kitty couldn't possibly be a blonde. She was the daughter of a proud Irishman and had to look and act like one. Dark hair, blue eyes, a quick wit, and a sting-ing tongue—that was the way Mr. Foyle saw his offspring. She could take care of herself, 'come hell or high water.'"

*KITTY FOYLE* (1940) · RENIÉ, COSTUME DESIGNER

**Barbara Stanwyck (actress):** "Nobody understands my figure as well as my Hollywood designer, Edith Head."

**Dee Lawrence (writer):** "At least a year prior to the film's release, Betty [Rowland, the real 'Ball of Fire'] was headlining at a downtown Los Angeles burlesque theater, the Follies, when Edith Head came in to see her show. Edith came backstage after Betty's set to check out the famed burlesque queen's wardrobe. One particular piece interested her: a floor-length cream silk crepe and sequined-paneled skirt with a matching long-sleeved cropped blouse. The skirt was slit up to the hip with a series of fringed panels, and both the skirt and blouse unhooked at the sides with large brass hooks and eyes—easy on the fingers but requiring the skills of a professional to remove gracefully."

*BALL OF FIRE* **(1941) · EDITH HEAD, COSTUME DESIGNER**

**Bette Davis (actress):** "Because California conservation laws prevented the use of stuffed birds on hats, Orry-Kelly borrowed a huge white dove, the epitome of taxidermist art, from the Louisiana Museum. Here perched the snowy fowl on a huge picture hat that featured a large dotted veil."

*THE LITTLE FOXES* (1941) · ORRY-KELLY, COSTUME DESIGNER

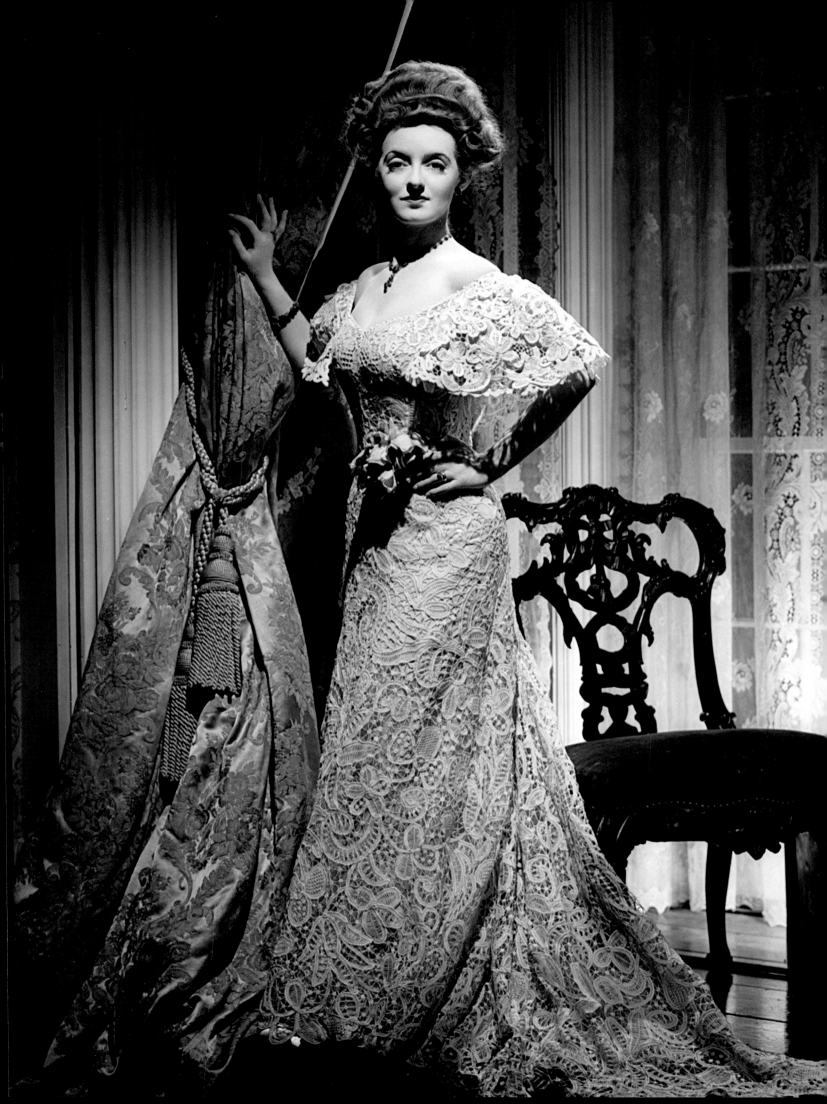

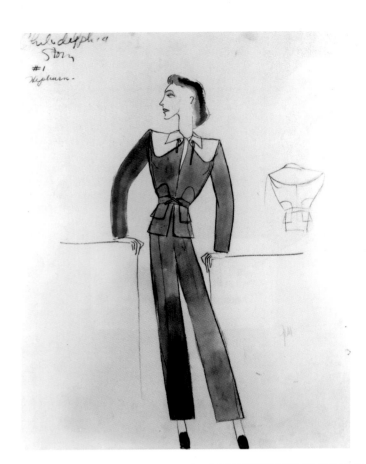

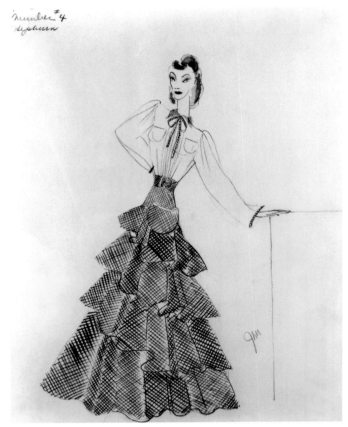

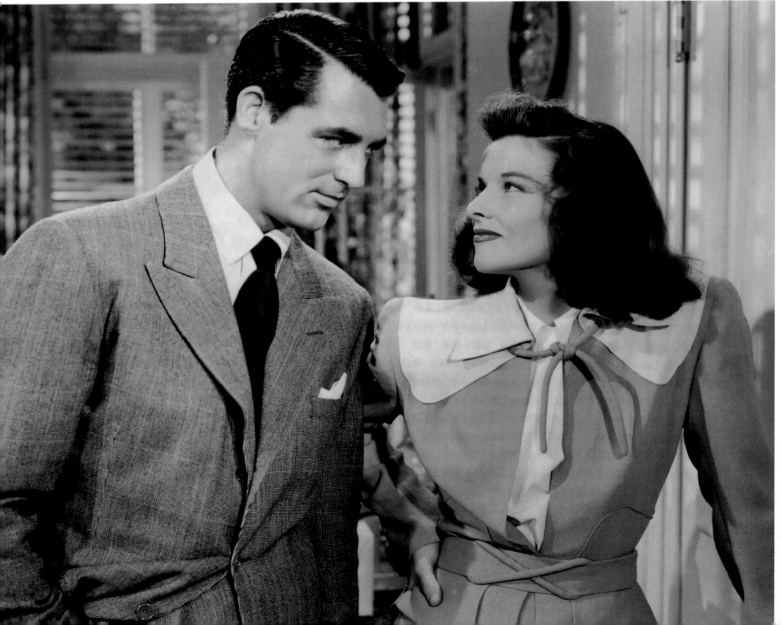

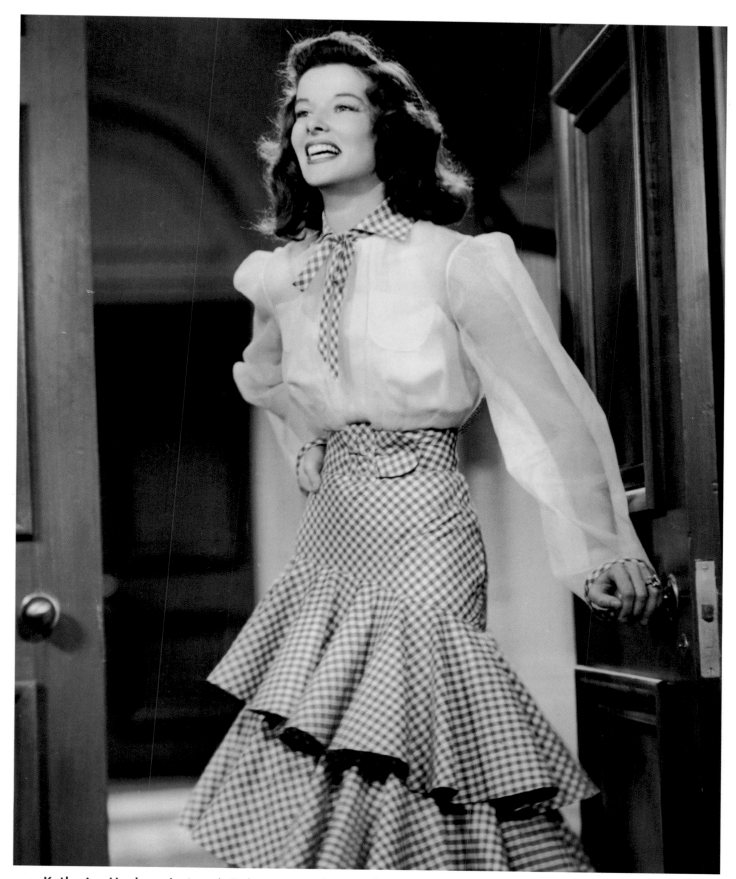

**Katharine Hepburn (actress):** "Adrian was my favorite designer. He and I had the same sense of 'smell' about what clothes should do and what they should say."

**George Cukor (director):** "Hepburn was never a 'love me, I'm a lovable little girl' kind of actress. She always challenged the audience, and that wasn't the fashion in those days. On the hoof, when people first saw her, they felt something arrogant in her playing. Later, by sheer feeling and skill, she bent them to her will. Of course, her quality of not asking for pity, and not caring whether people liked her or not, was the idea for *The Philadelphia Story.*"

**THE PHILADELPHIA STORY (1941) · ADRIAN, COSTUME DESIGNER**

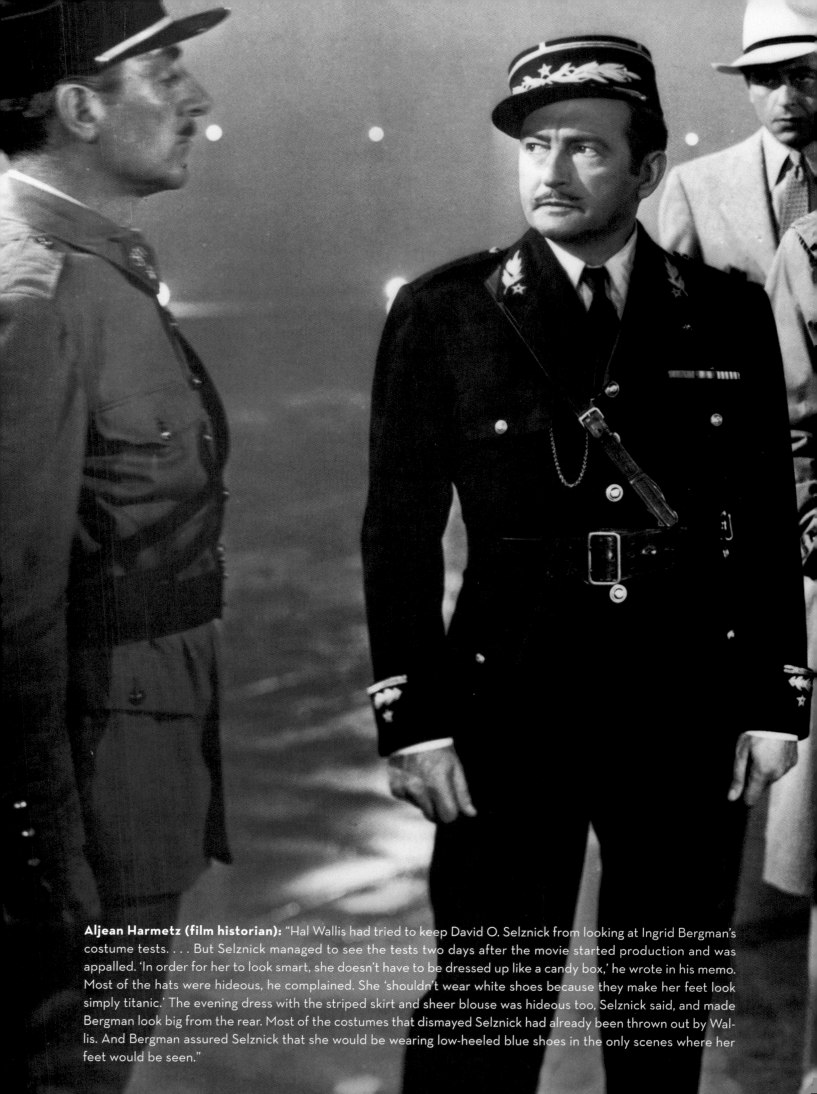

**Aljean Harmetz (film historian):** "Hal Wallis had tried to keep David O. Selznick from looking at Ingrid Bergman's costume tests. . . . But Selznick managed to see the tests two days after the movie started production and was appalled. 'In order for her to look smart, she doesn't have to be dressed up like a candy box,' he wrote in his memo. Most of the hats were hideous, he complained. She 'shouldn't wear white shoes because they make her feet look simply titanic.' The evening dress with the striped skirt and sheer blouse was hideous too, Selznick said, and made Bergman look big from the rear. Most of the costumes that dismayed Selznick had already been thrown out by Wallis. And Bergman assured Selznick that she would be wearing low-heeled blue shoes in the only scenes where her feet would be seen."

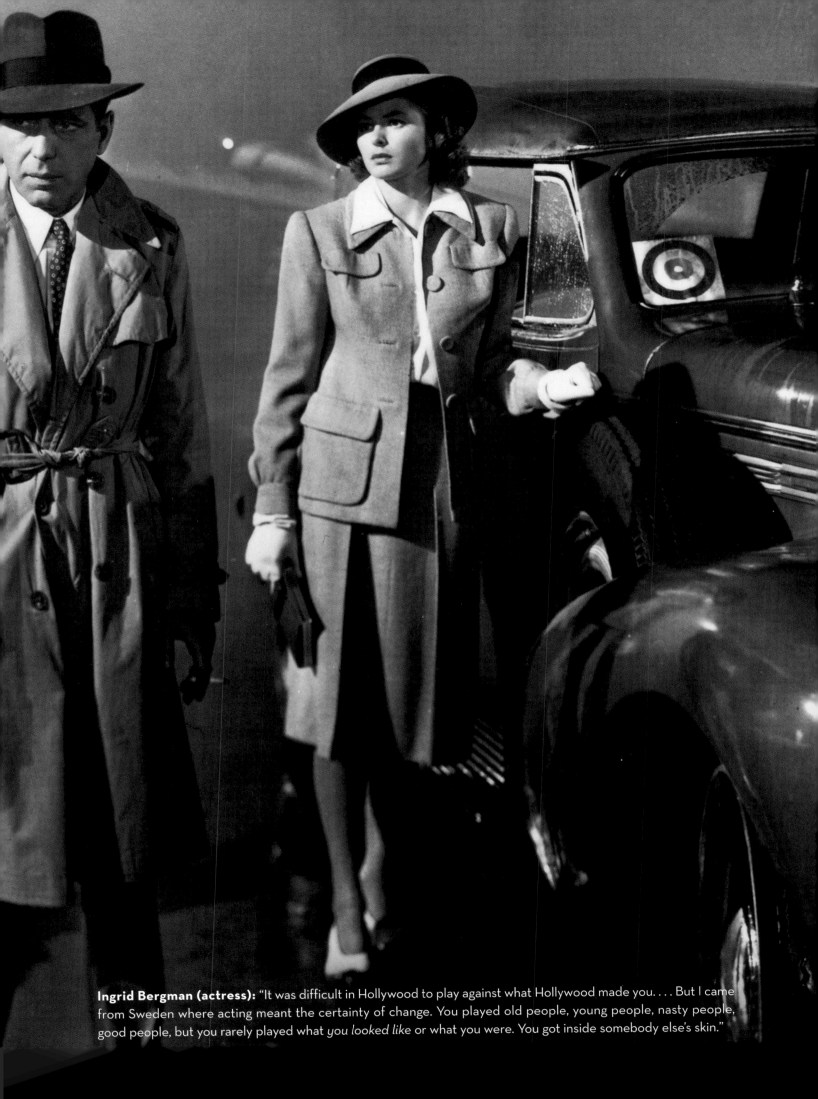

**Ingrid Bergman (actress):** "It was difficult in Hollywood to play against what Hollywood made you. . . . But I came from Sweden where acting meant the certainty of change. You played old people, young people, nasty people, good people, but you rarely played what *you looked like* or what you were. You got inside somebody else's skin."

**Vincente Minnelli (director):** "I wanted Petunia and Joe to look as attractive as possible, for the audience to be aware of their simple goodness. Making Lena into a beautiful siren was no problem."

*CABIN IN THE SKY* **(1943) · HOWARD SHOUP AND GILE STEELE, COSTUME DESIGNERS**

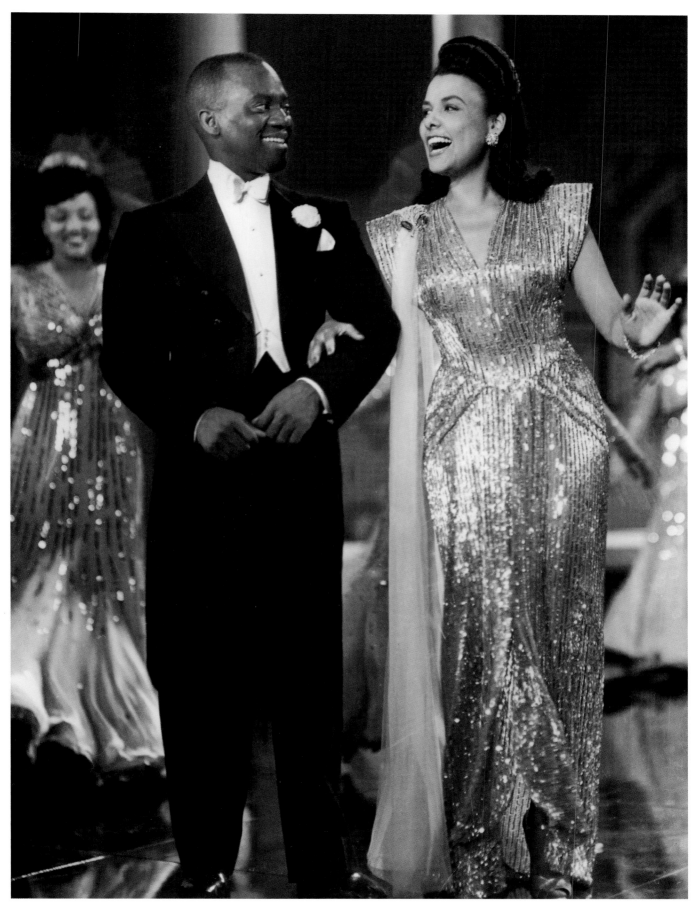

*STORMY WEATHER* (1943) · HELEN ROSE, COSTUME DESIGNER

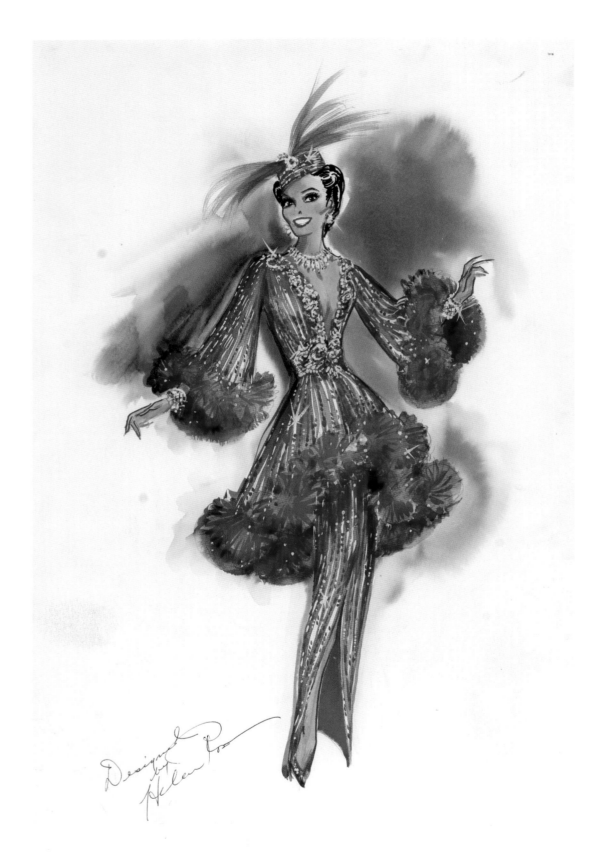

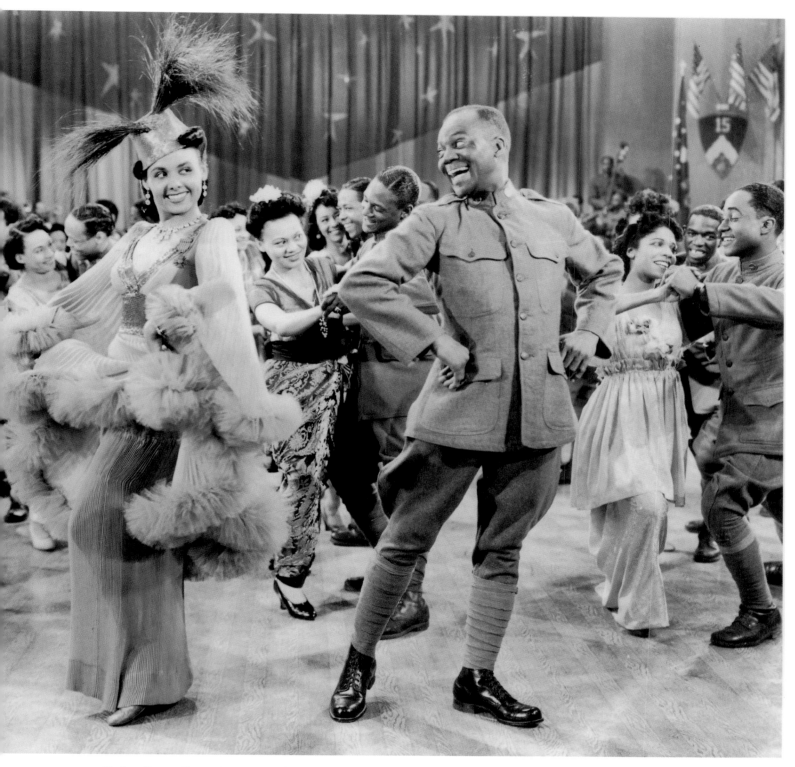

**Helen Rose:** "Lena Horne was being treated with very little tolerance or respect. She was beautiful, talented, elegant and intelligent, but she was considered a 'black woman,' which was still not acceptable in Hollywood in the 1940s. . . . A few years ago, she wrote, 'Me, so young and so scared, and you saying, *you can do it, Lena.* We talked about our children—they were real in the midst of all the fantasy. One thing I knew for certain—you made us look absolutely beautiful.'"

### *STORMY WEATHER* (1943) · HELEN ROSE, COSTUME DESIGNER

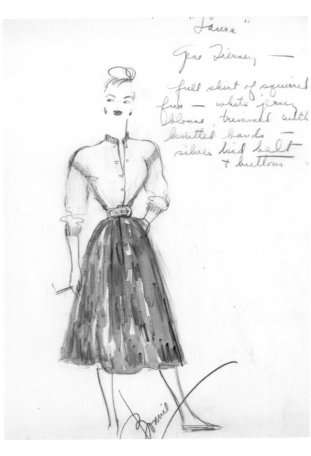

**Look Magazine:** "Producer Otto Preminger has gone to $15,000 lengths to provide Tierney with suitable trappings. They include such items as a 'home fireside' dress, with a skirt of gray-and-white squirrel: no phony glass jewelry, but real diamonds and pearls rented from a jeweler for the duration of the shooting, black-lace underwear threaded with baby-blue ribbon; orchid-pink pajamas embroidered with sequins. Costuming, under the glittering eye of designer Bonnie Cashin, started two months before anyone touched a camera. But Fox, looking hardheaded, boasts it will get back the $15,000 cost. Miss Tierney can buy whatever garments she wants: the rest will go back into the bin to be worn by secondary players in other films."

### *LAURA* (1944) ·
### BONNIE CASHIN, COSTUME DESIGNER

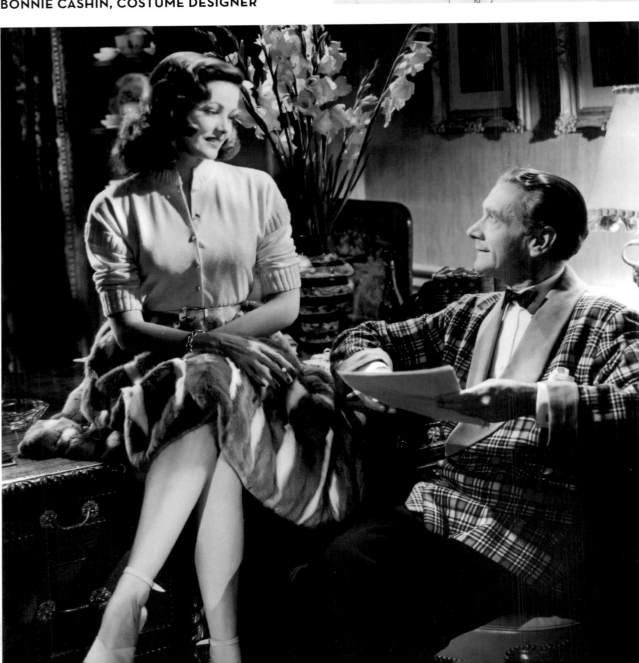

**Irene Sharaff:** "Realism in movies then was unreal. A star playing a secretary of modest financial means changed her dress and matching accessories for every scene. All leading ladies, however ordinary or drab or impoverished the character in the story, were coiffed and clothed immaculately, and had perfect teeth. My own attempt at period realism in *Meet Me in St. Louis*, set in 1905, dismayed the producer at first. When he saw my costume sketches, his pained remark was, 'How can you have a star with no cleavage?' I explained the straight-across bosom look of the period; he replied that it would be just fine for some characters in the film but Judy Garland could not possibly wear it."

**Irene Sharaff:** "Judy Garland has an extraordinary reaction to clothes. From the minute you put a gown on her, whether it has a Victorian bustle or a sleek modern drape, she immediately becomes what the gown represents."

### *MEET ME IN ST. LOUIS* (1944) ·
### IRENE SHARAFF, COSTUME DESIGNER

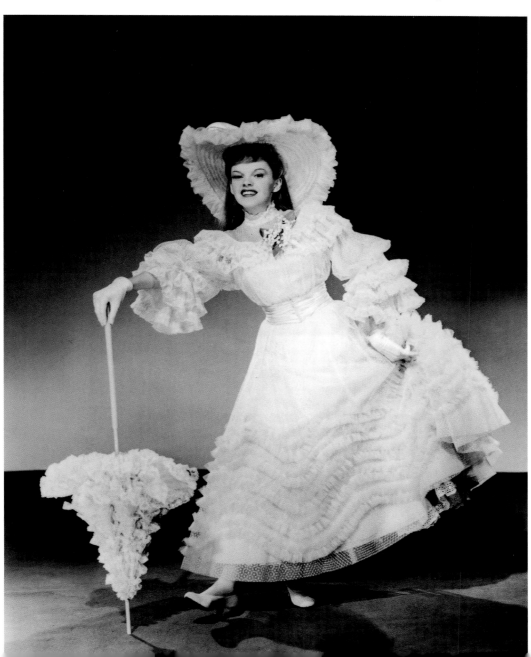

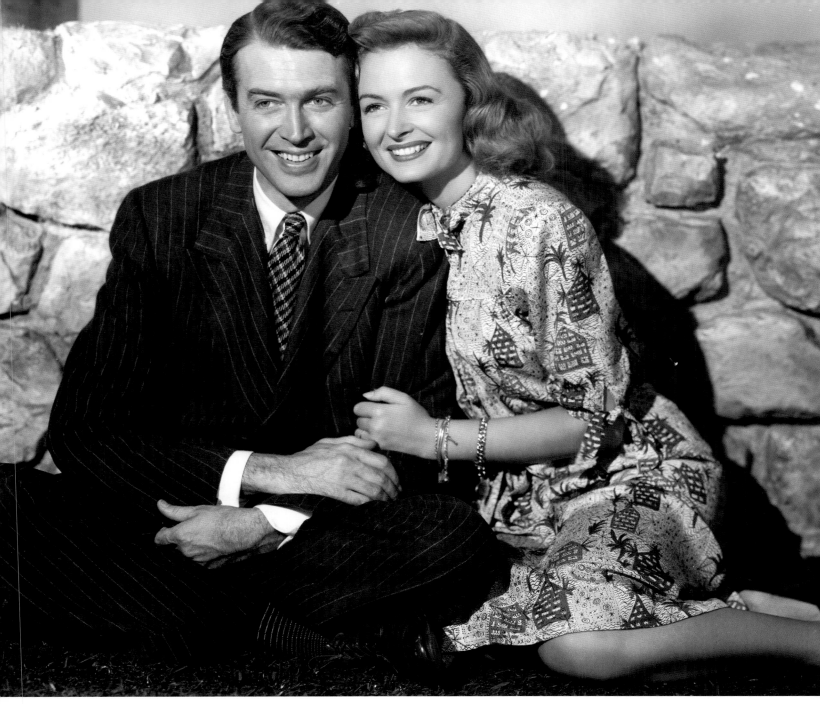

**James Stewart (actor):** "I don't know whether I would have made it after the war if it hadn't been for Frank. It was over four and a half years that I'd been completely away from anything that had to do with the movies. Then one day Frank Capra called me and he said he had an idea for a movie. He said, 'Now, you're in a small town and things aren't going very well. You begin to wish you'd never been born. And you decide to commit suicide by jumping off a bridge into the river but an angel named Clarence comes down from heaven and . . . uh, Clarence hasn't won his wings yet. He comes down to save you when you jump into the river, but Clarence can't swim, so you save him.' Then Frank stopped and he said, 'This story doesn't tell very well. Does it?' I just said, 'Frank, if you want to do a movie about me committing suicide, with an angel with no wings named Clarence, I'm your boy.'"

**Donna Reed (actress):** "I remember working harder for Capra than any other director before or after, for a deceptively simple, uncomplicated small-town 'girl and woman' character. I did things I had never done before, danced the Charleston, sang, fell over backward into a swimming pool, played light comedy as well as drama, aged from nineteen to forty years—and he made it all look so simple and easy on screen. That's the trick of film acting—it must always look simple and easy, even if you've nearly killed yourself doing it."

### *IT'S A WONDERFUL LIFE* (1946) • EDWARD STEVENSON, COSTUME DESIGNER

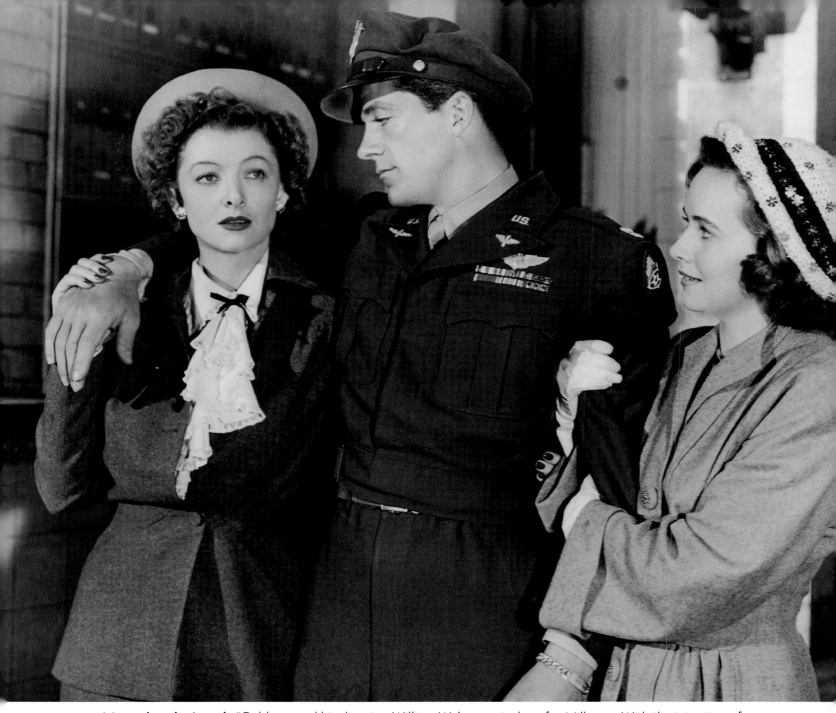

**Myrna Loy (actress):** "Goldwyn and his director, William Wyler, wanted me for Milly . . . . With the intention of persuading me, the Goldwyns arranged a dinner party. Sam launched his offensive, enumerating the advantages of accepting a small role—that not only required me to play Teresa Wright's mother—but wouldn't even have a 'designed' wardrobe, because he wanted me to shop with Irene Sharaff for clothes that a banker's wife would wear. He needn't have bothered; those things didn't trouble me. The story had won me in synopsis form—even before he had Bob Sherwood expand my part into a beautifully realized character."

**Irene Sharaff:** "Teresa Wright, Myrna Loy, Virginia Mayo, and Cathy O'Donnell represented widely divergent types. They had to be dressed accurately so that the audience could get a key to the characters through the clothes they wore. Virginia Mayo's dresses were flashy and in poor taste with all their frills and froufrou. They illustrated a lot of fashion *Don'ts*. One white evening gown was a clue to the type she portrayed—a cheap little siren.

"Teresa Wright's role in the same picture was exactly the opposite. She was young and gay, and did not try to look sophisticated. She was practical and sensible. This was a girl from a nice background and she would naturally reveal good taste in her wardrobe. So I gave her smart little cotton frocks, and gay woolen dresses. Her clothes showed that she was sweet, feminine, and wholesome. Off screen, I found Teresa Wright exactly what her face indicates: a wonderful, wholesome American girl. In pictures, of course, she has to take on a sophisticated quality, but her own fresh charm is even more attractive."

### *THE BEST YEARS OF OUR LIVES* (1946) · IRENE SHARAFF, COSTUME DESIGNER

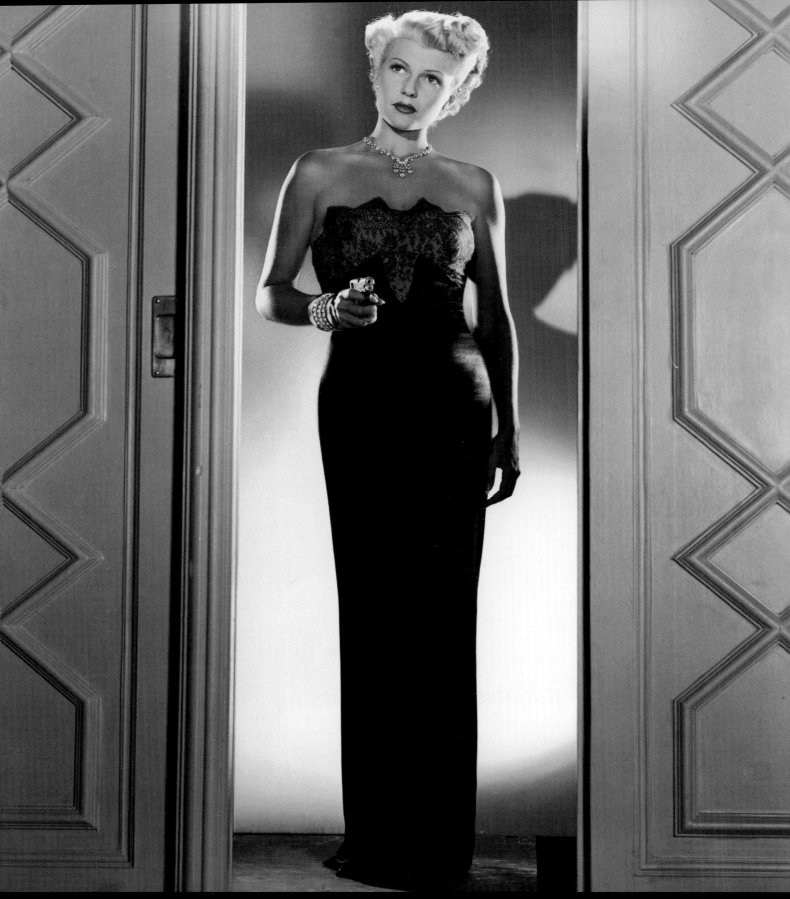

**Jean Louis:** "Columbia didn't have many stars to design for. They had Rita Hayworth. Period. I tried to make everything for her very special because it was also my chance to do special things. She was very easy; she just wore what we gave her. Rita was absolutely the most marvelous girl but she *hated* to fit. 'Get me out of it.' That's all she'd say.

"But I had great freedom in how I dressed her, she never, never said 'I don't like' one thing. You always had to design to show off her body—not her legs, but her body; you couldn't put her in a business suit. Not because the studio would have objected but because that was her personality. Rita Hayworth was known for being a beautiful woman and people didn't want to see Rita Hayworth in a suit."

*THE LADY FROM SHANGHAI* (1947) · JEAN LOUIS, COSTUME DESIGNER

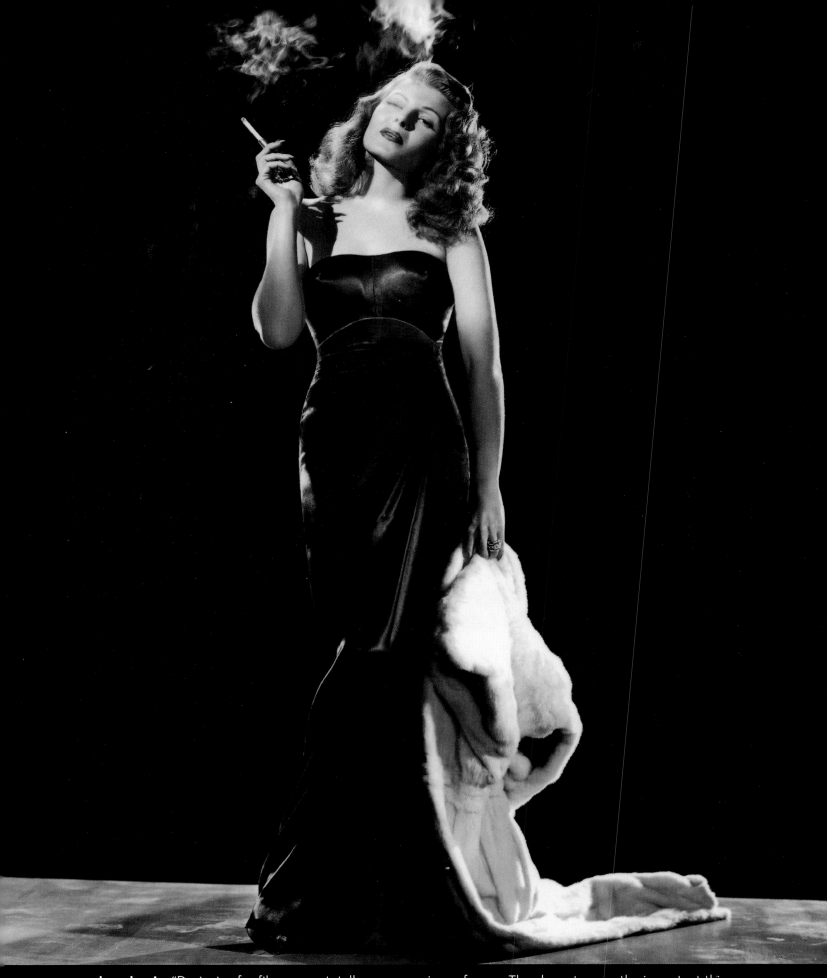

**Jean Louis:** "Designing for films was a totally new experience for me. The character was the important thing now. I couldn't dress Gilda as I would have dressed Rita Hayworth in her private life."

*GILDA* (1946) • JEAN LOUIS, COSTUME DESIGNER

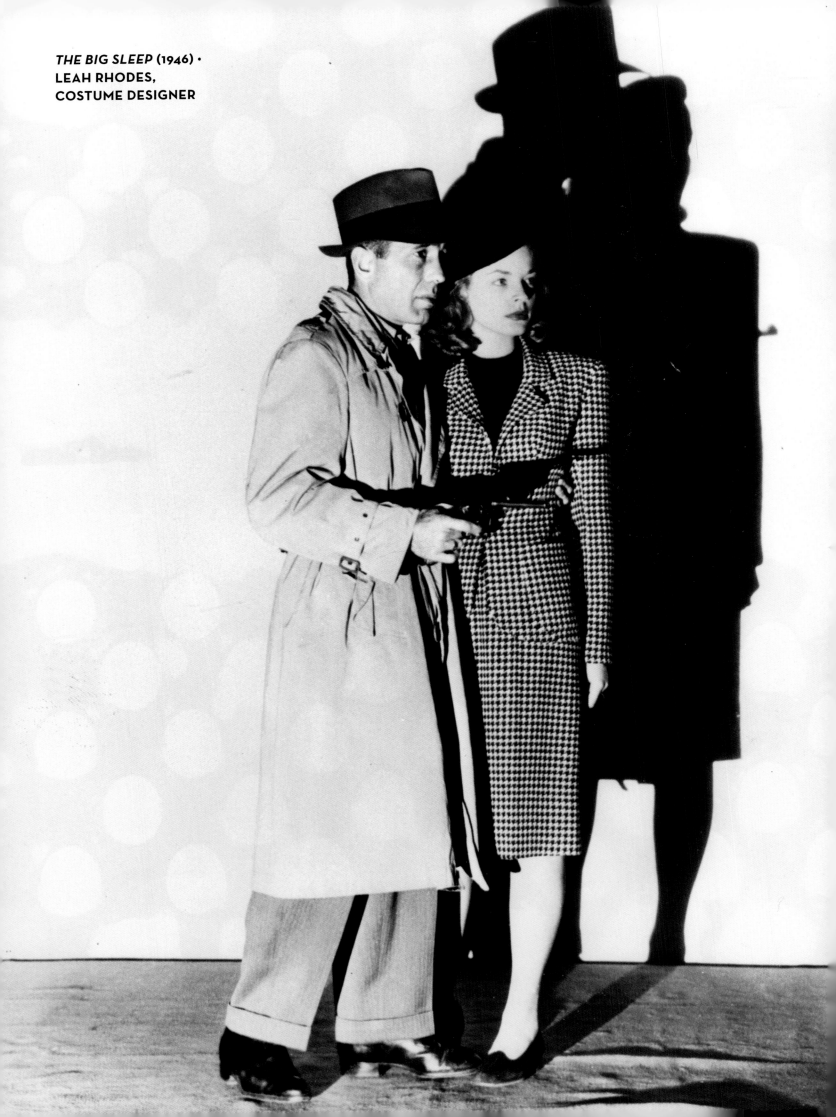

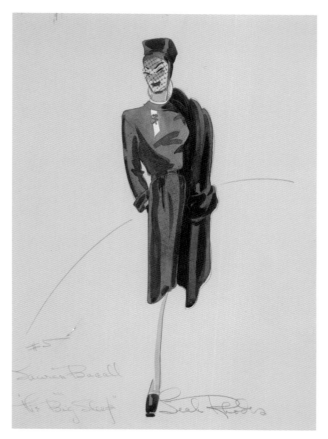
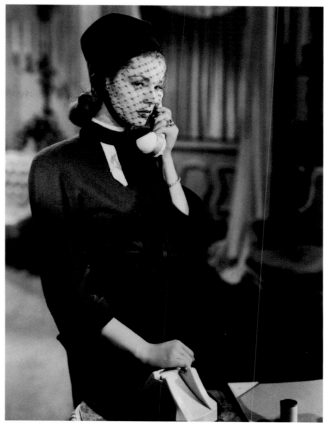

**Nelson B. Bell (writer):** "As the smoldering and seductive Vivian Sternwood, divorcée, Lauren Bacall provides the foil of a sultry and provocative performance."

### *THE BIG SLEEP* (1946) · LEAH RHODES, COSTUME DESIGNER

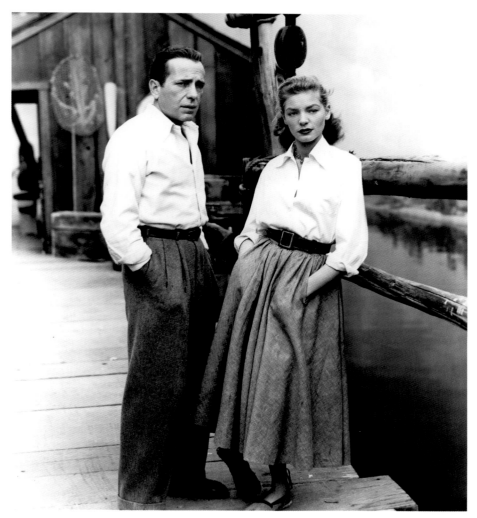

**John Huston (director):** "Everything must serve the idea—I must say this again and again. The means used to convey the idea should be the simplest and the most direct and clear. I don't believe in overdressing anything. Just what is required. No extra words, no extra images, no extra music. But it seems to me that this is a universal principle of art. To say as much as possible with a minimum of means."

### *KEY LARGO* (1948) · LEAH RHODES, COSTUME DESIGNER

**Lana Turner (actress):** "The director, Tay Garnett, came up with a brilliant costuming idea that was executed by Irene. As Garnett later explained it, 'There was a problem getting a story with that much sex past the censors. We figured that dressing Lana in white somehow made everything she did seem less sensuous. It was also attractive as hell . . . They didn't have "hot pants" then, but you couldn't tell it by looking at hers.' The reviewers loved it. My costumes stimulated as much discussion as the film itself."

*THE POSTMAN ALWAYS RINGS TWICE* (1946) • IRENE, COSTUME DESIGNER

**Joan Crawford (actress):** "For my early scenes, the studio designed some cotton frocks. Mr. Curtiz said no, they looked too smart. I went down to Sears Roebuck and bought the kind of housedresses I thought Mildred would wear. When I arrived on the set for wardrobe tests, Mr. Curtiz walked over to me, shouting, 'You and your damned Adrian shoulder pads. This stinks!' And he ripped the dress from neck to hem. 'Mr. Curtiz,' I sobbed, 'I bought this dress this morning for two dollars and ninety-eight cents—there are no shoulder pads,' and I rushed to my dressing room in tears. We had no more arguments about clothes."

### *MILDRED PIERCE* (1945) · MILO ANDERSON, COSTUME DESIGNER

**Jane Russell (actress):** "Jean Harlow, who starred in Howard Hughes's production of *Hell's Angels*, was notorious for going braless. But this star was one who couldn't and wouldn't. From the time I was sixteen I had bras custom-made for me by a small shop in Hollywood. Bras sold over the counter were skinny-strapped torture racks. Howard then decided it wouldn't be any harder to design a bra than it would be to design an airplane. He tried. When I went into the dressing room with my wardrobe girl and tried it on, I found it uncomfortable and ridiculous.

"So I put on my own bra, covered the seams with tissue, pulled the straps over to the side, put on my blouse, and started out. Emily, my wardrobe girl, was terrified. What if they found out? I assured her they'd never find out from me. Everybody behind the camera started, and Howard finally nodded okay and filming proceeded. I never wore his bra, and believe me, he could design planes, but a Mr. Playtex he wasn't."

***THE OUTLAW* (1943)**

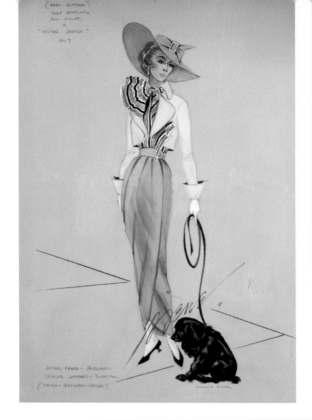

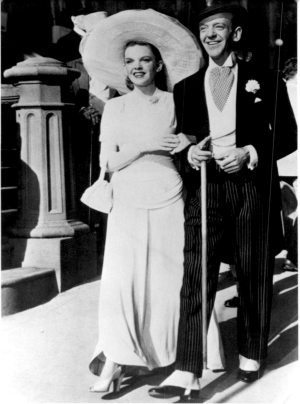

*EASTER PARADE* (1942) · IRENE AND VALLES, COSTUME DESIGNERS

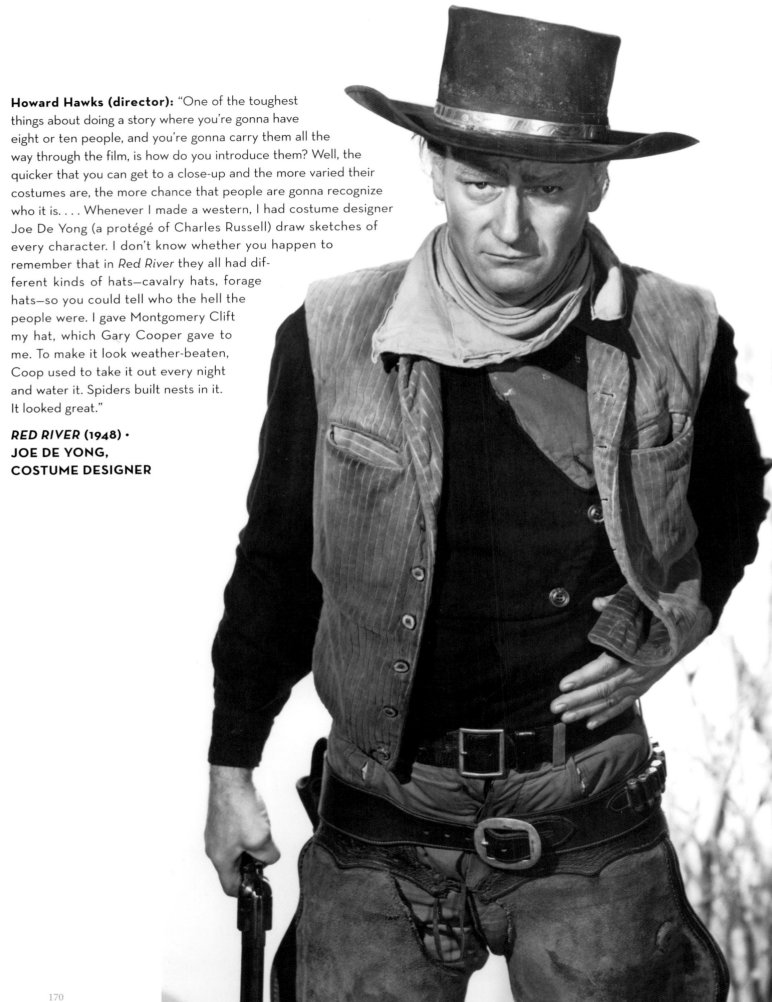

**Howard Hawks (director):** "One of the toughest things about doing a story where you're gonna have eight or ten people, and you're gonna carry them all the way through the film, is how do you introduce them? Well, the quicker that you can get to a close-up and the more varied their costumes are, the more chance that people are gonna recognize who it is. . . . Whenever I made a western, I had costume designer Joe De Yong (a protégé of Charles Russell) draw sketches of every character. I don't know whether you happen to remember that in *Red River* they all had different kinds of hats—cavalry hats, forage hats—so you could tell who the hell the people were. I gave Montgomery Clift my hat, which Gary Cooper gave to me. To make it look weather-beaten, Coop used to take it out every night and water it. Spiders built nests in it. It looked great."

**RED RIVER (1948) ·
JOE DE YONG,
COSTUME DESIGNER**

**David O. Selznick (producer):** "For months now I have been trying to tell everybody connected with *Rebecca* that what I wanted in the girl was an *unglamorous* creature, but one sufficiently pretty and appealing, for it to be understandable why Maxim would marry her. But I was apparently unsuccessful. The other day I sent verbal word to the set to be sure there was no misunderstanding that I wanted the girl to look as pretty and appealing as she could as long as she was *not* glamorous. The message was delivered to Miss Fontaine, to the cameraman, hairdresser, and everybody else that I wanted her to be 'glamorous.' This naturally threw everybody into confusion and obviously must have made everybody think I had suddenly gone mad."

*REBECCA* **(1940) • IRENE, COSTUME DESIGNER**

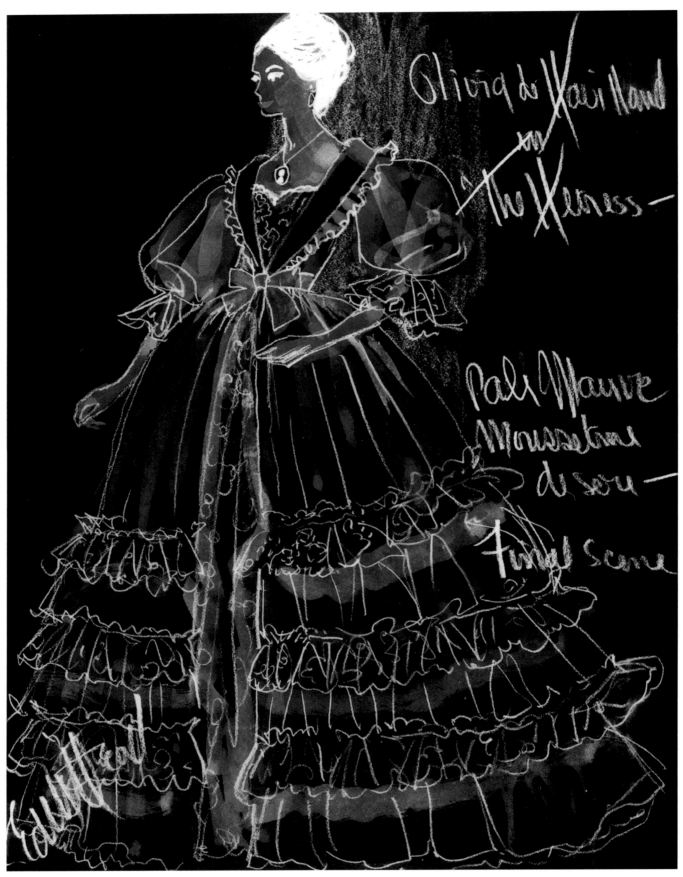

Olivia de Haviland
in
The Heiress—

Pale Mauve
Mousseline
de soie—

Final scene

Edith Head

**Edith Head:** "William Wyler is such a perfectionist. *The Heiress*, for example, was set in the 1840s and the 1850s, so we had to deal with two periods. We had crinolines, and we also had hoops, a slightly different silhouette. There were scenes in which Olivia de Havilland got dressed. You saw her in petticoats, in little corsets, and in corset covers. Wyler even sent me to a fashion institute in New York, to be sure that every button and every button-hole was absolutely accurate. If I had to choose a picture I did that was absolutely perfect down to the tiniest buttonhole, it was *The Heiress*. Wyler insisted on it."

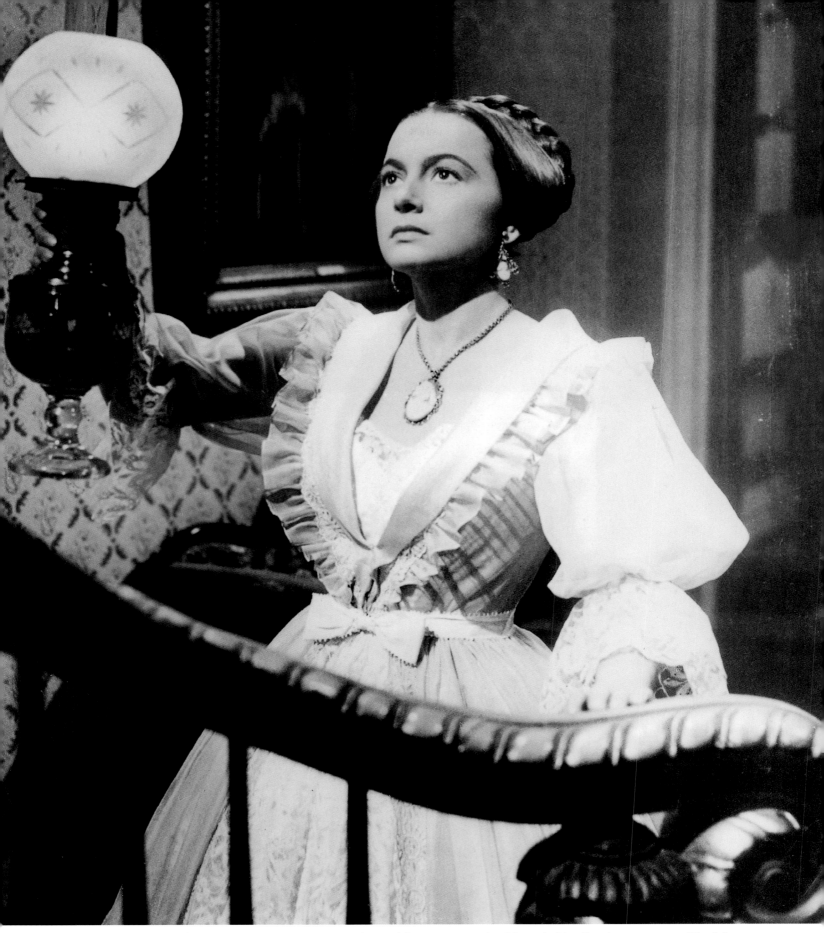

**Edith Head:** "The costumes were not pretty; the problem was to make Olivia de Havilland unattractive. The fabrics were harsh serge, stiff wools, uncompromising as to color, severe as to neckline. I dressed Olivia as a mature woman rather than as the girl she was, and placed her against a background of women who looked young and gay. At the dance, where the others wore tulle and organdy, she wore dark, heavy silk embroidered in jet. Then, toward the end of the picture, when she wished to get revenge on Montgomery Clift, allure him, we made a complete transition into softer, more feminine colors and fabrics."

### THE HEIRESS (1949) · EDITH HEAD, COSTUME DESIGNER

JOAN of ARC

Ingrid Bergman
2C
int. Dauphin's
chambers

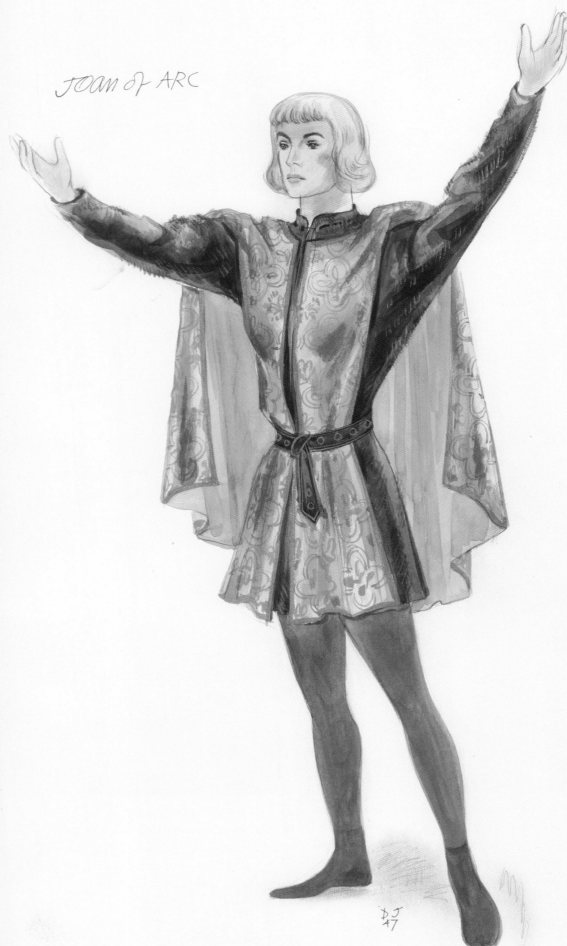

DJ
47

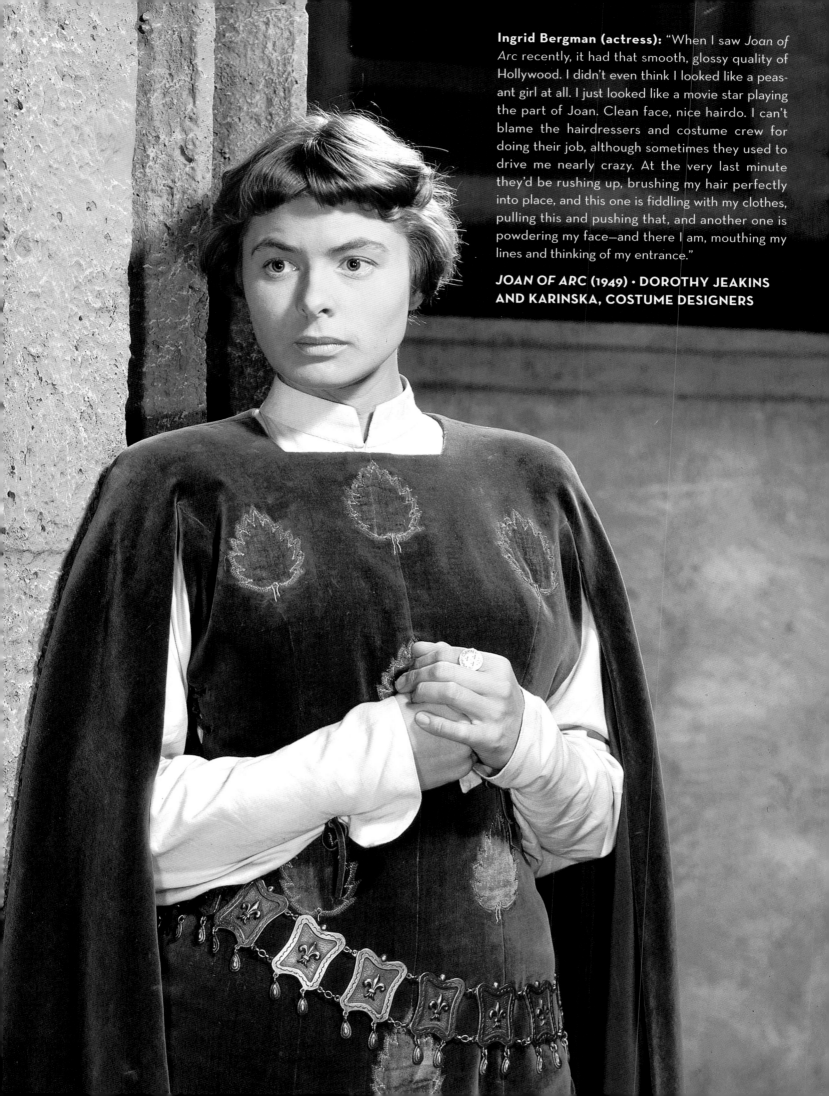

**Ingrid Bergman (actress):** "When I saw *Joan of Arc* recently, it had that smooth, glossy quality of Hollywood. I didn't even think I looked like a peasant girl at all. I just looked like a movie star playing the part of Joan. Clean face, nice hairdo. I can't blame the hairdressers and costume crew for doing their job, although sometimes they used to drive me nearly crazy. At the very last minute they'd be rushing up, brushing my hair perfectly into place, and this one is fiddling with my clothes, pulling this and pushing that, and another one is powdering my face—and there I am, mouthing my lines and thinking of my entrance."

**JOAN OF ARC (1949) · DOROTHY JEAKINS AND KARINSKA, COSTUME DESIGNERS**

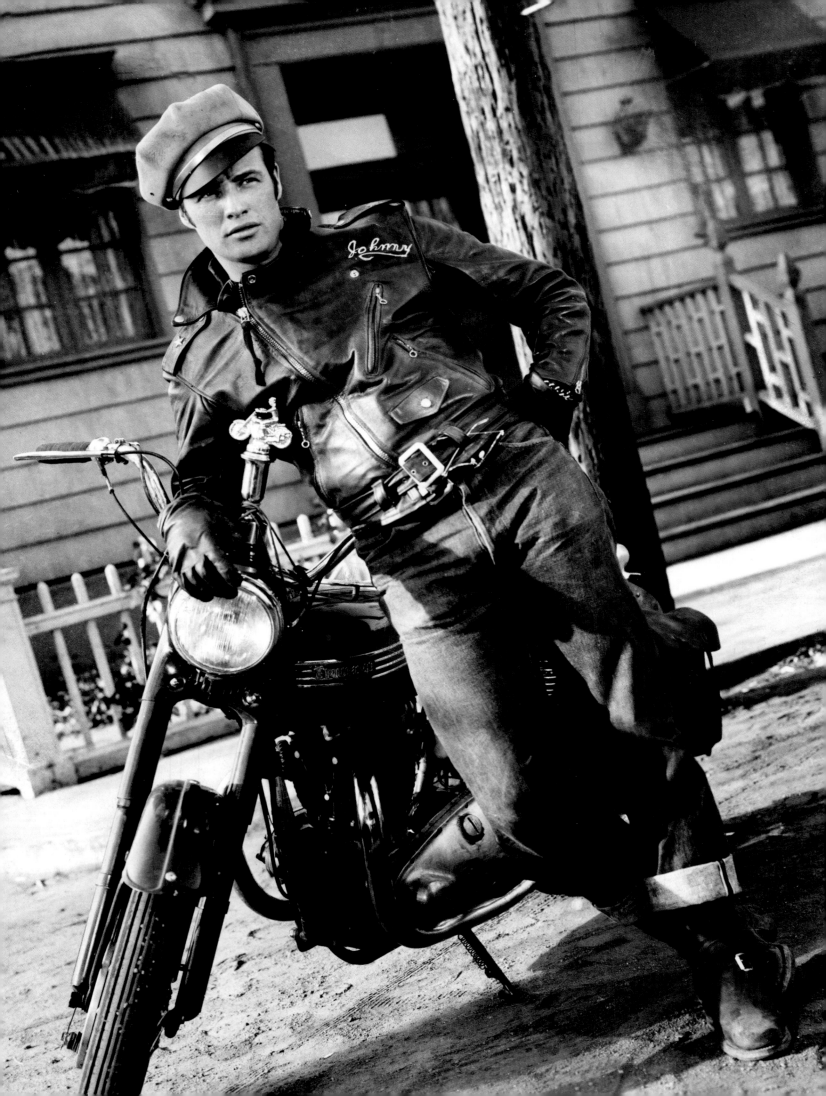

# 1950s

"I'm going to have my precious baby standing over a grate," costume designer William Travilla recalled of the steamy New York street scene in *The Seven Year Itch* (1955). "So I wondered what I could do with this most beautiful girl that Marilyn was to play, to look clean, talcum-powdered, and adorable. What would I give her to wear that would blow in the breeze and be fun and pretty? I knew there would be a wind blowing, and that would require a skirt." Travilla also knew that the script had been subjected to endless rewrites by the Hays Office for sexual innuendo; his costumes would have to play it safe. He conjured a white pleated halter dress for Marilyn Monroe, which avoided even the shadow of cleavage. To keep the bodice from moving (in either dangerous direction), Travilla inserted wire boning from neck to waist. The dress, a practical solution to the Hays Code's prudery, is now at the Smithsonian in Washington, D.C.—a cultural icon of sex appeal.

In the 1950s, filmmakers built on the powerful storytelling tools they had developed during nearly a half-century of moving pictures. The realism of the postwar years continued to capture

OPPOSITE: *"I had fun making it, but never expected it to have the impact it did. I was as surprised as anyone when T-shirts, jeans and leather jackets suddenly became symbols of rebellion. Sales of leather jackets soared." —Marlon Brando, The Wild One (1953)*

audiences with films such as director Elia Kazan's *On the Waterfront* (1954). Westerns took every shape and style—from singing cowboy Roy Rogers in the Bob Hope comedy *Son of Paleface* (1952) to John Ford's psychological melodrama *The Searchers* (1956). The Cold War inspired science fiction tales of intergalactic conquest such as *Invaders from Mars* (1953), which were relegated mostly to B screens. The tradition of Hollywood spectacles continued: Musicals like *Singin' in the Rain* (1952) and epics such as Cecil B. DeMille's 1956 remake of his own *The Ten Commandments* were painted in garish Technicolor. Each film required the creation of fictional characters in period, fantasy, or modern settings. Every production employed a costume designer (or wardrobe supervisor serving the same function) to clothe actors appropriately for each scene.

The images on the screen may have looked cheerful, but all was not well within the Hollywood system. Faced with declining movie attendance, which had been dropping increasingly since 1946 as Americans stayed home to watch television, studios sought new diversions to bring the audience back to the theaters. The creation of the drive-in movie theater, where B thrillers, science fiction fare, and "exploitation" pictures flourished, inadvertently hurt Hollywood's "A" features. Teenage audiences weren't escaping to the drive-in for serious drama; it was the Saturday night popcorn and horror films that encouraged back-seat romance.

How to Marry a Millionaire (1953) • *Travilla, costume designer*

The movie industry reached for new technologies to recover its mass audience, including stereophonic sound, 3-D, and the wraparound screen of Cinerama. CinemaScope was an innovation in projection involving the use of a special anamorphic lens; CinemaScope pictures required wider screens, but they produced an intense and vibrant picture. From the costume designer's point of view, the magnification of CinemaScope was so immense that some female figures were not flattered. *How to Marry a Millionaire* (1953) was the second movie made in CinemaScope. Its designer, William Travilla, complained that [production chief Richard] "Zanuck, the labs, everybody kept insisting there were no distortions with 'Scope. In truth there were such terrible distortions they couldn't shoot close-ups at all, and everybody was definitely widened." His cast, including Lauren Bacall, Marilyn Monroe, and wartime pinup Betty Grable, put up a fuss about the landscape effect the magnified scale of the voluminous fifties skirts would have on their vital statistics. The others relented, but throughout the film Monroe insisted upon wearing tight skirts. The distortion of the lens was too noticeable for many decorative fabrics, and designers resisted the use of horizontal-striped, broadly textured, and large-patterned textiles. But audiences loved the larger-than-life CinemaScope screen, and it was used throughout the decade.

The marketing of CinemaScope was a business decision made by studio executives, but there was another quiet revolution occurring: studio producers were losing command over the look of their movies to film directors. Alfred Hitchcock exerted artistic control over every frame of his films, using storyboards to illustrate the action. Edith Head, who designed a number of Hitchcock's movies, recalled the director as "very specific about costumes for his leading ladies. He

specified the colors in the screenplay because they were important to the plotline. If he wanted a skirt that brushed a desk as a woman walked by, he spelled that out too." For *The Birds* (1963), Hitchcock specified that the heroine, Melanie Daniels (Tippi Hedren), should wear a green dress during a scene where she was fleeing an attacking flock of crows. Head created a dress that allowed the freedom of movement required by the script. "There are wonderful designers who make you look good, very elegant, whatever," Tippi Hedren said later. "But Edith taught me that you not only design to make the person look according to the character, you have to make sure that the person can 'do' the action."

For the classic musical about Hollywood's comical transition from silent to sound, *Singin' in the Rain* (1952), costume designer Walter Plunkett drew on flapper dresses he had designed earlier in his career for silent film stars: "I entered the business at the height of the flapper's reign. Many of Jean Hagen's costumes are, nearly as I can remember, duplicates of some I did in all seriousness for Lillian Tashman. And she was the epitome of chic at the time." Producer Mervyn LeRoy remembers: "The period was that of Clara Bow, with horrible short skirts, straight sack dresses that hung from straps. The clothes Walter designed were reminiscent of bathtub gin and the torrid twenties. Some of the dresses got more laughs than any of the jokes. But they were good laughs; they reminded people of back when. The clothes weren't glamorous, but they had a sense of humor. *Singin' in the Rain* was a comedy, and comedy in the clothes was a plus."

In 1950 Paramount released director Billy Wilder's *Sunset Boulevard*, the story of Norma Desmond, a faded movie star trying to recapture her fame. Edith Head designed costumes for Gloria Swanson that reflected glamour of an earlier age, out of place in the modern world. "The result of the collaboration was a tour de force of movie costuming," Head later said. "Norma Desmond had a look of grandeur that was peculiarly out of place in a changed world." Everything about Desmond's clothes was slightly odd, an uncomfortable mix of old and new; a 1920s pin, worn with a contemporary dress, was a subtle but effective symbol of her unwillingness to let go of the past.

Costume designers could empathize. By the end of the decade, the in-house studio designer was becoming an anachronism, although the major studios held on to their executive designers through most of the 1950s. The studio factory system was being dismantled, giving new freedom to artists in good ways and bad. Creative professionals, including many costume designers, were free to work with people from any studio—but they lost the security of steady staff positions. In the 1950s, most designers no longer "belonged" to one studio or another. Some of the best-known designers retained their positions at least through the late 1950s: Jean Louis headed the wardrobe department at Columbia until 1958; 20th Century Fox retained Charles LeMaire as executive designer until 1959; Leah Rhodes was a fixture at Warner Bros. throughout the 1940s and '50s; and Edith Head lasted at Paramount until 1967. But in this decade most designers became freelancers—moving from picture to picture, and from studio lot to distant location.

As Head recalled, the designers' formal positions had been a function of the old studio position. "In the old days it wasn't very common for a designer to be 'loaned out' because each studio had a stable of stars whom we dressed over and over. Occasionally one of those stars would be loaned to another studio, and that studio would also borrow a designer since they were familiar with the star's taste and form." In the 1950s, costume designers began traveling where their personal networking took them, and their careers reflected those professional relationships. Their livelihoods were increasingly built on friendships rather than studio contracts. In 1953 costume

designers united to form the Costume Designers Guild, which served to provide moral support as designers weathered the transition from studio staff to freelance designer.

Costume design took on a greater importance in Westerns as the genre got a new lease on life during the decade, with A-pictures that were larger in both size and content. The black hat–white hat gun battles had been favorites for decades, but rarely required the expertise of a costume designer; most studios could simply pull what they needed from their own extensive warehouse of cowboy gear. But the Westerns of the 1950s were more serious fare, with more intense story lines

Grace Kelly and Gary Cooper in High Noon (1952) • Joe King and Ann Peck, costume designers

and characters who wrestled with moral and ethical dilemmas. In *High Noon* (1952), Gary Cooper played a retiring lawman facing the return of a man he had sent to prison and seeking the help of a frightened town. In *Shane* (1953), Alan Ladd portrayed a gunfighter trying to settle down with a family but drawn into a personal conflict. With the Western's rebirth as a high-budget commodity, the most established costume designers began lending their skills to the genre.

Television could never compete with the sound and scale of the new wide screens, and CinemaScope and Cinerama were perfect for supercolossal epics. The postwar years delivered a cornucopia of "sword and sandal" extravaganzas and gladiatorial contests for the whole family. The one-designer-per-picture gained prominence through the decade, but creating costumes for these casts of thousands required military precision and organization, and it wasn't uncommon for a studio to hire several costume designers to accomplish the job. MGM's *Quo Vadis* (1951) had a cast of 5,500 extras. Five costume designers—Edith Head, Gwen Wakeling, Gile Steel, Elois Jensen, and Dorothy Jeakins—are credited on Cecil B. DeMille's *Samson and Delilah* (1950), for which each was honored with an Academy Award for best costume. Six years later, another enormous DeMille biblical epic, *The Ten Commandments* (1956), found Head and Jeakins collaborating with another pair of designers, Ralph Jester and John Jensen.

Even as films took on biblical proportions, costumes retained their fundamental purpose of aiding the story. As producer/director Mervyn LeRoy stated, "In costume designing, the clothes should add to a characterization; they should help tell the story. There was a vast difference in the way Shelley Winters and Elizabeth Taylor were dressed for *A Place in the Sun* (1951). Shelley was a little factory girl. Elizabeth was a wealthy debutante. You knew this before either of them said a word. The sets, the clothes, all helped tell the story."

When glamorous clothes threatened to sabotage a role, a beautiful actress needed to be courageous and accept the sacrifices of emotional truth. Edith Head said, "Grace Kelly knew what was right for her for each part. When she saw the dreary wardrobe I'd designed for *Country Girl* (1954), she said, 'These are fine. These are going to help me look the part.' Nine out of ten actresses in that pre-blue-jean era would have hated the clothes and would have said so."

Jeans migrated from the western plains to the West Side, and became suddenly screenworthy when worn by Marlon Brando in *The Wild One* (1954) and James Dean in *Rebel without a Cause* (1955). Combustible, rebellious Brando and Dean ignited the large teenage audience that had been alienated from the mainstream films of the time. Their tight jeans and their jackets—Brando's black leather motorcycle number, with plenty of zippers, buckles, and epaulettes, and Dean's red windbreaker—made an enormous sartorial impression. The trend took to the street, as American teens emulated their antiheroes by aping their hip threads. The subgenre of juvenile delinquent films would continue to influence fringe fashion throughout the decade.

Creating the illusion of perfection—or imperfection—where none exists is part of the costume designer's art. "When one spends a lot of time in fitting rooms with stars they become just like anyone else in underwear—far from perfect in proportions," Irene Sharaff wrote in her memoir. "Though Elizabeth Taylor's face, with her extraordinary violet eyes, is probably one of the loveliest in the world, her body proportions were most difficult to work with. She was 5 feet 2, and had a high waist, large bosom, short arms, no behind, but wide hips." Helen Rose at MGM described Lana Turner as "the designer's dream girl with her typical American figure—small hips, long waistline. She has but one problem—she's short."

When she was designing 1953's *Roman Holiday,* Edith Head reflected on Audrey Hepburn's then-unfashionable body type: "scrawny arms, no breasts, and a neck that stretched on forever." Hepburn herself bemoaned her boyish figure. "You should wear falsies," Head suggested. "What are they?" Audrey replied. "She knew exactly how to highlight her good points," Head remembered. "What's funny is that her best look was a sophisticated naïf. What I liked best about her is that she calculated all her business decisions, but made it look as if she didn't have a clue." The following year, Hepburn would encounter the French couturier Hubert de Givenchy and establish a lifelong collaboration. If Head had dressed Hepburn as a gamine—the ugly duckling "before"—Givenchy established Hepburn's "after," and her singular aristocratic appeal soared. His unforgettable gowns for *Sabrina* (1954), *Funny Face* (1957), and *Breakfast at Tiffany's* (1961) assured Hepburn's stardom, while Hollywood veteran co-designers were responsible for keeping the rest of the cast of characters with their feet firmly planted in the reality of each script. One observer astutely described the difference between a fashion designer and a costume designer: "When Givenchy looked at Audrey Hepburn, he saw Audrey Hepburn. When Edith Head looked at Audrey Hepburn, she saw Holly Golightly."

In articles she wrote for fan magazines throughout this era, Edith Head often shared anecdotes about the popular stars she worked with. "Bette [Davis] walks in here like a small, disciplined cyclone," she says. "You don't discuss details with Bette. She shows you how she

*Audrey Hepburn in* Roman Holiday *(1953) • Edith Head, costume designer*

is going to play the part—how she is going to throw herself on the bed, sit on the desk and whirl around and walk out in a huff. 'That,' says Bette, 'is the way I want the clothes to act.'"

Costume designers are among the most resourceful members of a film crew, and often the demands made on a designer are unusual. Head recalled an incident when a young Shirley MacLaine was being fitted for a bat costume for the movie *Artists and Models* (1955). MacLaine sank into a chair in the costume department and said, "If I'm going to play a bat, I should know something about bats. Am I a mammal or a reptile, and how do I have my babies?" Edith Head replied, "That's the first reasonable request made of me today." Head called the vast Paramount research department for the answer.

"When you dress Hollywood's greatest stars," Head advised, "you have to be one part artist, two parts psychiatrist, and always a diplomat." Head convinced Kim Novak to don a gray suit—a color she refused to wear but which was called for in the script for *Vertigo* (1958)—by displaying for her an array of the most luxurious, soft, lightweight suiting fabrics, prompting Novak to say, "I don't mind wearing *that* gray at all!"

Edith Head referred to the Hays Office décolletage vigilantes as "The Bust Inspectors." Marilyn Monroe, who—along with Novak—was infamous for preferring to go braless, quipped, "The trouble with censors is that they worry whether a girl has cleavage. . . . They ought to worry if she hasn't any." In November 1953, the MPAA warned 20th Century Fox about Travilla's costumes for *Gentlemen Prefer Blondes*: "The business of the girls' dressing should be kept within careful limits of good taste. We have already rejected one costume suggested for this scene." Determined designers came up with a number of clever ways to comply with the Hays Code regulations, to the letter if not the spirit. "So long as there was a covering, however thin, the studio could claim that the actress was fully clothed," Irene Sharaff said.

Sharaff and Head were far from the only successful diplomats among Hollywood's costume designers. For the gender-bending comedy *Some Like It Hot* (1959), Orry-Kelly cooked up outrageously revealing clothes for Marilyn Monroe's character, Sugar Kane. One story circulating at the time claimed that Kelly argued that more nudity would be inappropriate: "Sugar Kane is the kind of girl who will go so far and no further." Monroe agreed. If any cleavage did make it onto film, the scene would have to be reshot, and the person responsible would be fired. These restrictions, and the censors who policed them, would dog Hollywood designers until 1968.

In the 1950s, epics and musicals dominated the color category at the Academy Awards; a second category for black-and-white films, given in cinematography, art direction, and costume design, most often produced awards for naturalistic, personal movies set in contemporary times. When the black-and-white category was terminated in 1967, it would effectively signal the end of recognition for excellence in modern costume design. In the last forty years, only two films set in modern times have won Oscars for best costume design: 1979's *All that Jazz* and 1994's *Priscilla: Queen of the Desert.* Costume designers would continue to interpret and illuminate the personalities and histories of everyday people, especially so in the newly liberated cinema of the 1960s and '70s. Yet the subtlety of their work would go almost universally unrecognized, as the voters handed award after award to period films and their elaborate, decorative costumes.

**Will Holtzman (biographer):** "Judy [Holliday] delivered herself to Jean Louis's designing genius, and even he was amazed at the changes wrought. There were thirteen costumes in all that charted the character's growth from tacky to tasteful. The early tight-fitting outfits had been a particular worry, given Judy's weight and apparent lack of glamour. But as George Cukor was the first to say, Judy saved her acting for the audience, and he'd take someone who could act beautiful over a model any day. The moment she put on the costumes, she became Billie Dawn."

**Jean Louis:** "When I saw [Judy Holliday] the first time in the fitting room, I thought, 'Oh, my God, what are we going to do with that?' She was standing with a sloping shoulder, exactly like this [please use your imagination].'. . . I said, 'Can you raise your shoulder a little bit?' She said, 'Oh, yes.' She was pretty dreadful. I said, 'Do you like this?' When you get no reaction you get so depressed and you're not sure of yourself. You have to have somebody who reacts. It gives you inspiration, particularly after fitting and fitting. I was absolutely panicked at the test . . . and suddenly Judy came on the screen a different woman. She was a great actress."

### *BORN YESTERDAY* (1950) · JEAN LOUIS, COSTUME DESIGNER

**Edith Head:** "A DeMille picture was completely different from anything in the world. It meant spending lots of time and attention and money. But because of censorship the correct costumes were not allowed. In designing the costumes for a picture like *Samson and Delilah*, there was not much to go by, though we checked Egyptian, Babylonian, and other early sources. But when you present someone in a bodice, you immediately have a costume that's not historically right. Because a woman's navel was censorable, you will notice that all Hedy Lamarr's costumes had narrow jewel belts."

### *SAMSON AND DELILAH* (1950) · EDITH HEAD, COSTUME DESIGNER

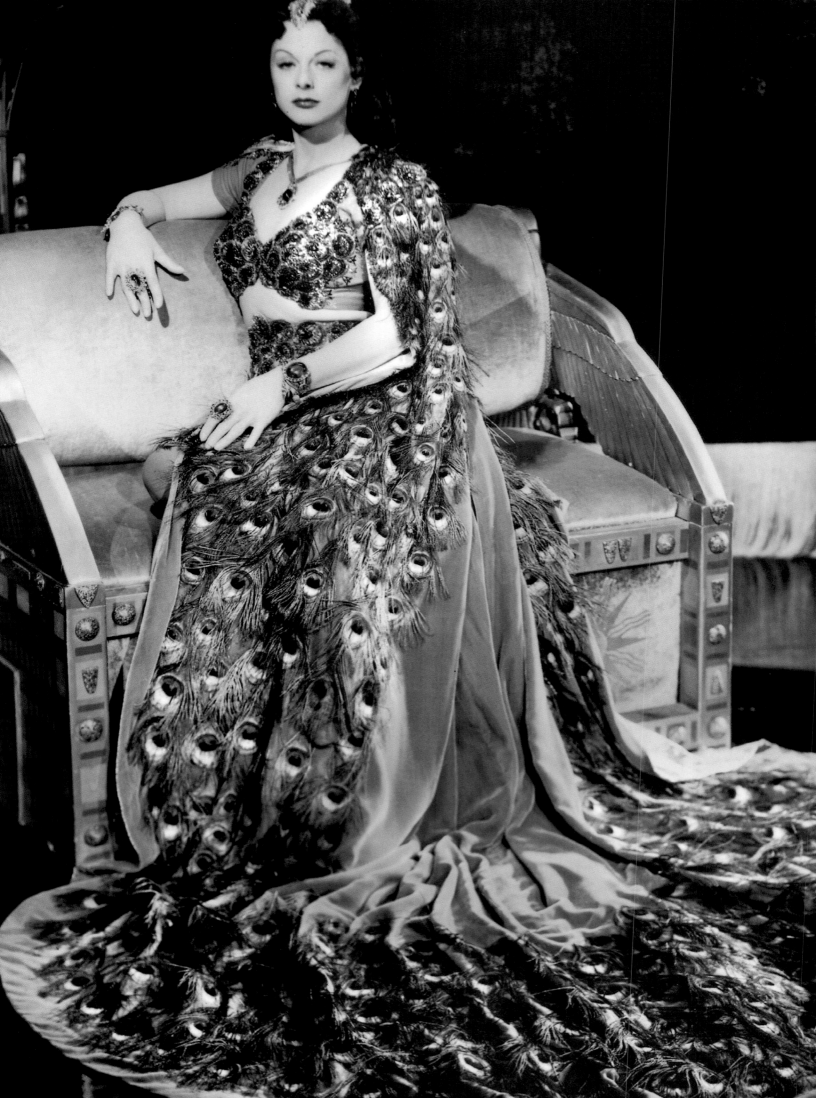

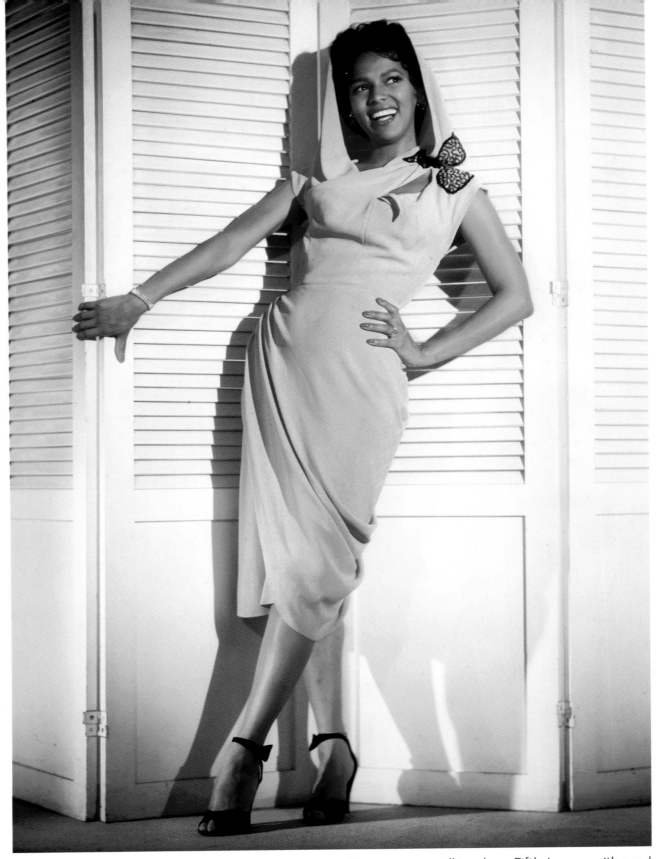

**Dorothy Dandridge (actress):** "Otto Preminger went on, 'I've seen you walking down Fifth Avenue, with a red coat flying. When I saw you I thought, How lovely, a beautiful butterfly—but not Carmen, my dear.' I hurried to Max Factor's studios and looked around for the right garb. I would return looking like 'Carmen' herself. I found a shaggy but brilliant blouse; I arranged it off the shoulder. Then I located a provocative skirt. I put on heavy lipstick, worked spit curls around my face. I made myself look like a hussy. Dressed like Carmen, I sidled around for a while feeling like a whore. On the following day I gave everything a final twist, as if to look a little disheveled. I needed one thing more: a tired look as if I had worn out a bed. I went to the gym and deliberately tired myself before going to see him. I arrived a little late, late enough so that it was noticed, but not so late as to become an irritation. 'Oh, Mr. Preminger, please forgive me . . . I just got back . . . I am not dressed . . .' I presented him with the most startling switch of personality he might have ever seen. 'My God, it's Carmen!'"

### CARMEN JONES (1954) · MARY ANN NYBERG, COSTUME DESIGNER

Bett Davis    "All about Eve"
                    1950

**Edith Head:** "The off-the-shoulder dress for the big party scene was an accident. My original sketch had a square neckline and a tight bodice. Because we were working with such tight deadlines, the dress was made up the night before Bette was scheduled to wear it. I went in early the day of the filming to make sure the dress was camera-ready. There was Bette, looking quizzically at her own reflection in the mirror. I was horrified. The dress didn't fit at all. Someone had miscalculated, and the bodice and neckline were too big. A change would delay the shooting, and I told Bette not to worry, that I would personally tell Joe Mankiewicz what had happened. I had just about reached the door, my knees feeling as if they were going to give out, when Bette told me to turn around and look. She pulled the neckline off her shoulders, shook one shoulder sexily, and said, 'Don't you like it better like this, anyway?'"

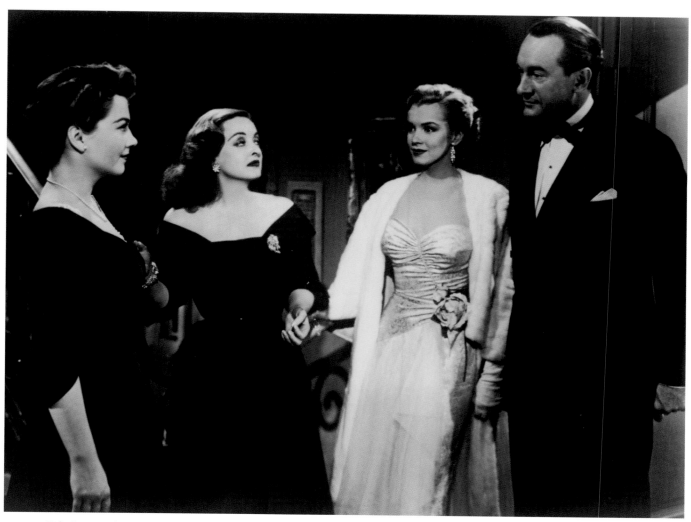

**Edith Head:** "When Bette Davis was being fitted for *All About Eve*, all of a sudden she threw herself on the floor. We all thought that somebody had stuck a pin into her or that she was having a fit. But there was a scene in the picture in which she had to throw herself down, and she wanted to see if the dress would work."

## *ALL ABOUT EVE* (1950) · EDITH HEAD AND CHARLES LEMAIRE, COSTUME DESIGNERS

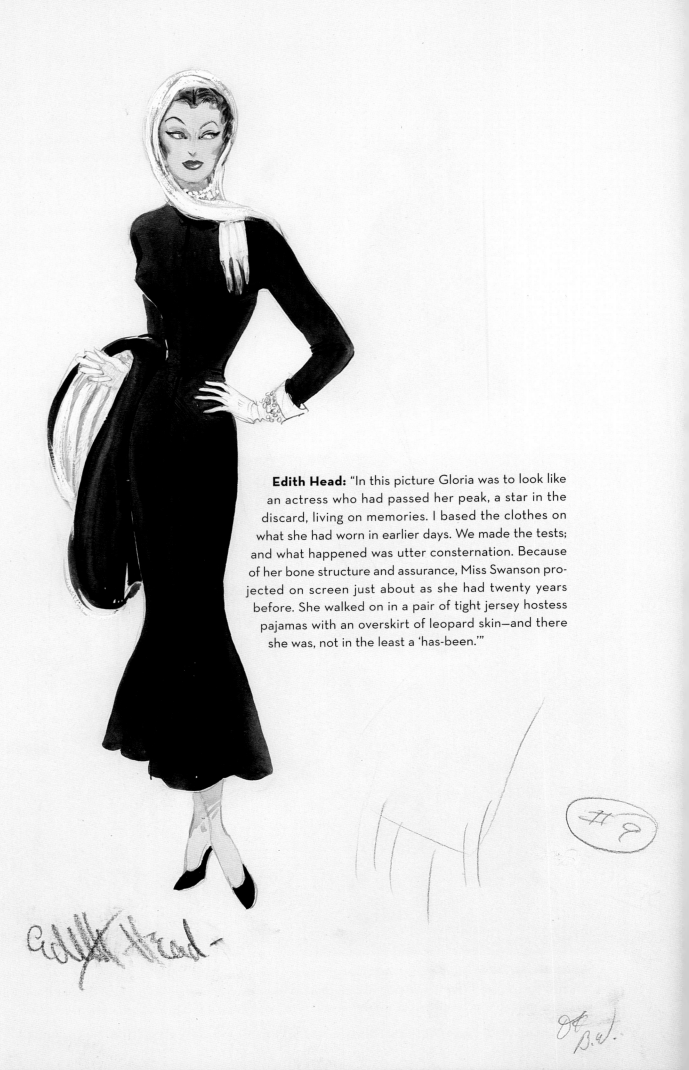

**Edith Head:** "In this picture Gloria was to look like an actress who had passed her peak, a star in the discard, living on memories. I based the clothes on what she had worn in earlier days. We made the tests; and what happened was utter consternation. Because of her bone structure and assurance, Miss Swanson projected on screen just about as she had twenty years before. She walked on in a pair of tight jersey hostess pajamas with an overskirt of leopard skin—and there she was, not in the least a 'has-been.'"

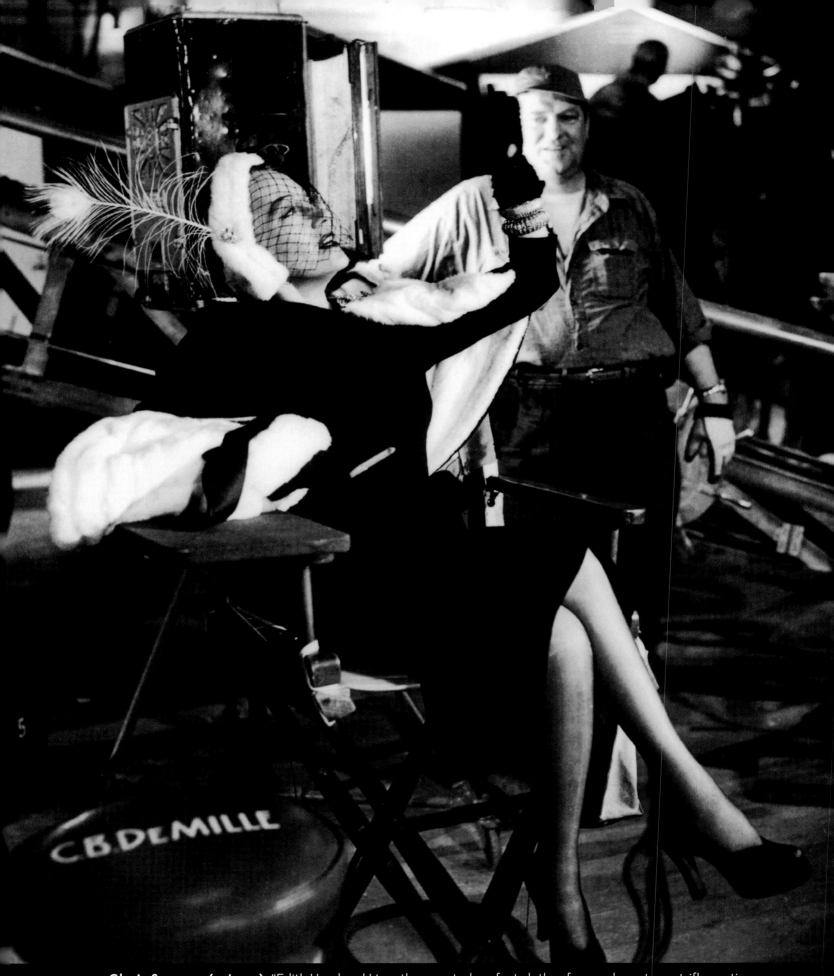

**Gloria Swanson (actress):** "Edith Head and I together created perfect clothes for my character—a trifle exotic, a trifle exaggerated, a trifle out of date. For my scene with Mr. DeMille, I designed a hat with a single white peacock feather, remembering the peacock-feather headdress everyone was so superstitious about when Mr. DeMille and I made the scenes with the lions in *Male and Female* (1919)."

***SUNSET BOULEVARD* (1950) · EDITH HEAD, COSTUME DESIGNER**

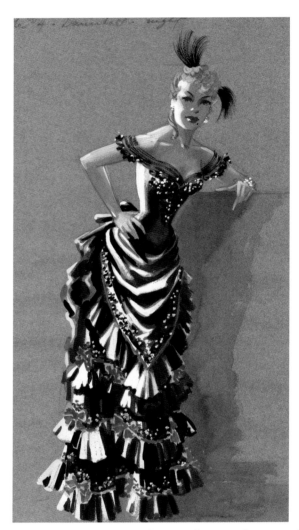 

**Anthony Mann (director):** "It took us nearly two months to find the right hat for Jimmy Stewart. Since the hat is rarely taken off, not even in a house, it's very important. If you don't get the right hat you may as well not get on a horse. John Wayne's a big man and he can wear a big hat. Jimmy is very slim and couldn't. Some of the tests we made were hysterical. Anyway, we eventually got him a hat full of holes and with a big, greasy sweatband. That hat got a great notice in the *New York Times*."

### *WINCHESTER '73* (1950) · YVONNE WOOD, COSTUME DESIGNER

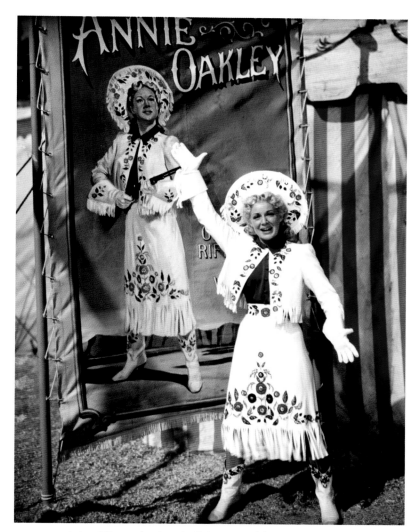
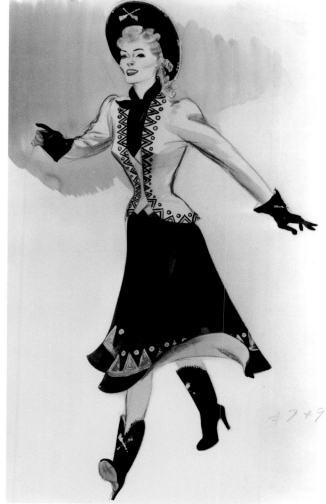

**Mae Tinee (writer):** "Metro-Goldwyn-Mayer seems to have set out to prove that anything the legitimate theater can do in the way of producing a lavish, colorful musical, the motion picture can do better. There are more horses and Indians than could be crammed on any stage, a spectacular sunset and a romantic moonrise, and in her handsome, cunningly contrived costumes, Betty Hutton puts her heart and soul into her role as Annie Oakley."

*ANNIE GET YOUR GUN* (1950) · HELEN ROSE, COSTUME DESIGNER

under
skirt

cloak

belt etc

cap shoes

facing

Rebecca
Jousting scene
# 3

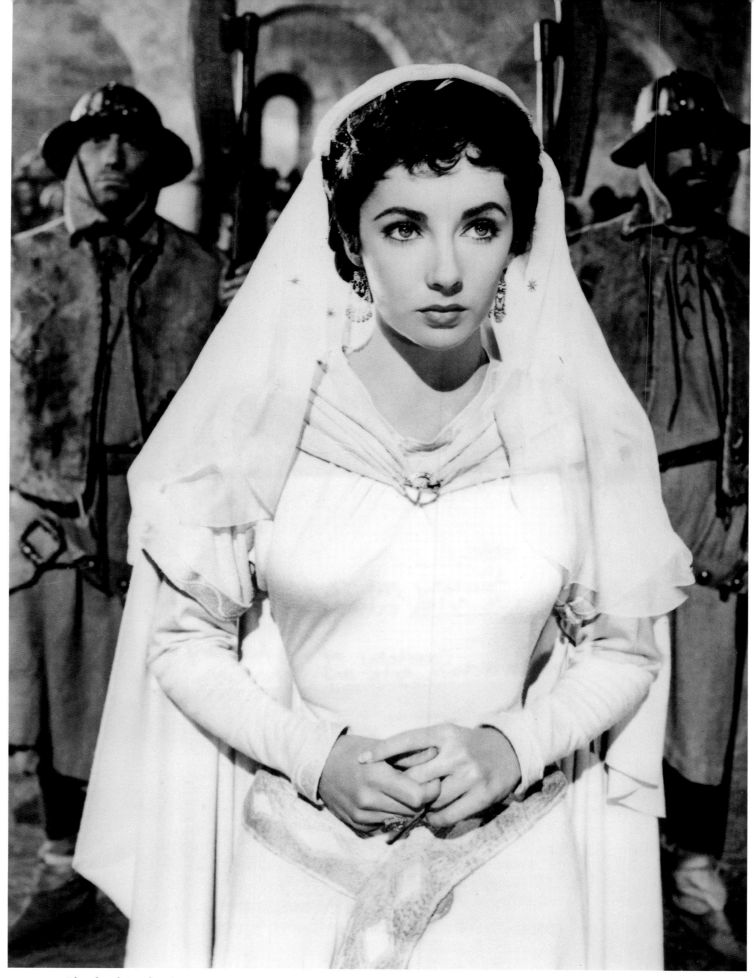

**Elizabeth Taylor (actress):** "My neck is killing me. Every morning at six o'clock they tape me into a wig that weighs two pounds. It's full of pins that stick into me all day long. By night I really have a neck-ache—and a headache. We wear long dresses of wool jersey and heavy capes, and it sometimes seems to take an hour to lace up a dress."

*IVANHOE* (1952) · ROGER FURSE, COSTUME DESIGNER

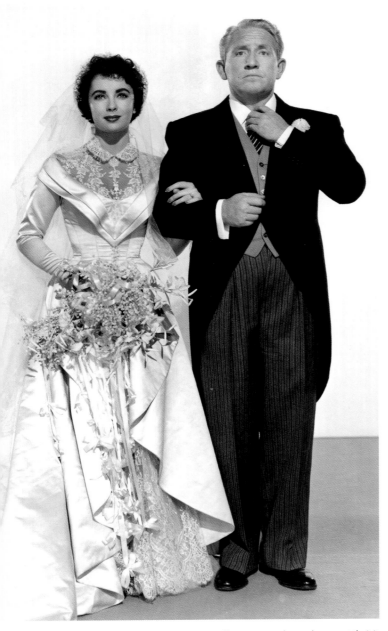

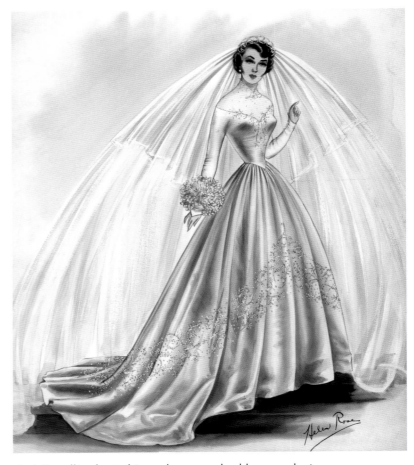

**Helen Rose:** "I especially enjoyed working with Vincente Minnelli, who in his early career had been a designer of sets and costumes. Vincente made no attempt to tell me how to design a costume but I could depend on him to choose exactly the right outfit for the wearer and the part she was portraying in the movie. If the character wore an evening gown, it was not just another formal but one that would make a definite statement. I usually gave him the choice of two or three sketches and he never missed. In 1950, *Father of the Bride* was scheduled with Vincente to direct the all-star cast. Vincente wanted the wedding dress to be elaborate and expensive in spite of Kay (Elizabeth Taylor) still being a teenager. From a group of sketches he chose the most spectacular and it proved to be a high spot in the picture."

**FATHER OF THE BRIDE (1950) • WALTER PLUNKETT AND HELEN ROSE, COSTUME DESIGNERS**

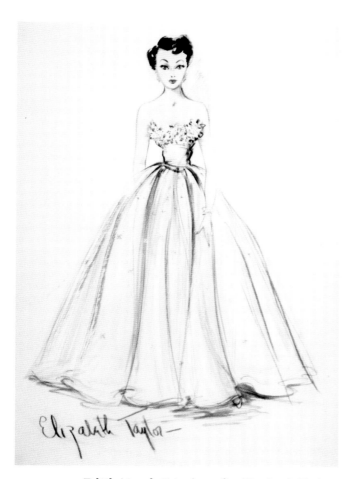

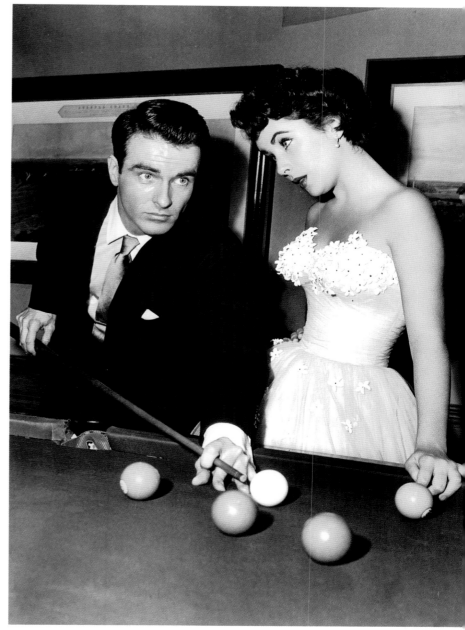

**Edith Head:** "My dress for Elizabeth Taylor in *A Place in the Sun* was taken up by a manufacturer of debutante party dresses. Someone at Paramount once counted at a party thirty-seven 'Elizabeth Taylors' dancing. All studio designers have created something that influenced fashion. I think two ingredients are necessary: You must have a successful film and a successful design. But a good costume designer shouldn't try to influence style, though naturally he hopes to hit upon something that many people will like."

## *A PLACE IN THE SUN* (1951) · EDITH HEAD, COSTUME DESIGNER

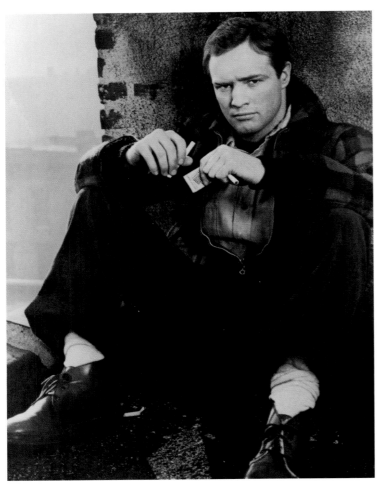

**Francis Ford Coppola:** "Well, you think of *On the Waterfront*, you think of Marlon Brando, and he's the guy out there on the waterfront, and he's got this one jacket that you see. Well, in the film image. . . when you see him, even in a long shot, that's his face. The fact that that plaid jacket is identified. It doesn't even have to be him. You could put in a 'stand-in' and have him walk by, and you'll think its Marlon because the wardrobe is the actor's face in loose shot and the audience begins to understand *who everyone is* and *what that character is* by this one costume."

**Elia Kazan (director):** "My wife used to hate those slips. She said, 'You keep putting women in white slips. What have you got about white slips?' . . . Actually, I always did like white slips."

**ON *THE WATERFRONT* (1954) • ANNA HILL JOHNSTONE, COSTUME DESIGNER**

**Peter Manso (biographer):** A crew of Con Ed ditchdiggers in midtown Manhattan provided the inspiration for the "undesigned" garb that was to become part of Kowalski-the-icon, the new symbol of American maleness. "Their clothes were so dirty," [costume designer Lucinda Ballard] recalled, seeing the laborers, "that they had stuck to their bodies. It was sweat, of course, but they looked like statues. I thought, 'That's the look I want . . . the look of animalness.'"

*A STREETCAR NAMED DESIRE* (1951) · LUCINDA BALLARD, COSTUME DESIGNER

**John Crosby (writer):** "As good an example as any of the things Hollywood can do—that television couldn't conceivably attempt. The picture ends with a ballet which may be the longest in picture history, which must contain all the dancers in Hollywood, and about 12 changes of costume for Kelly, who leaps into the fountains in the Place de la Concorde roughly 22 times and emerges dry. Pictures are not only better than ever, but bigger, costlier, more opulent, more colorful and more vivid than ever."

### *AN AMERICAN IN PARIS* (1951) · IRENE SHARAFF, COSTUME DESIGNER

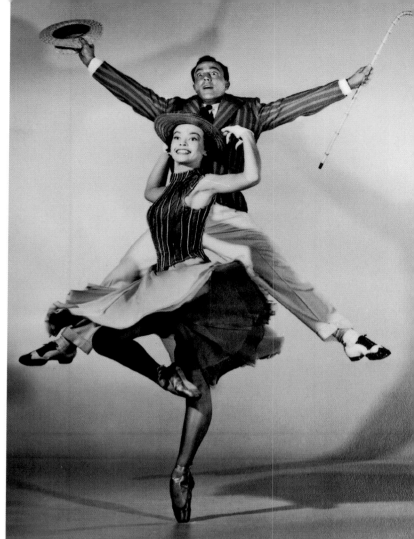
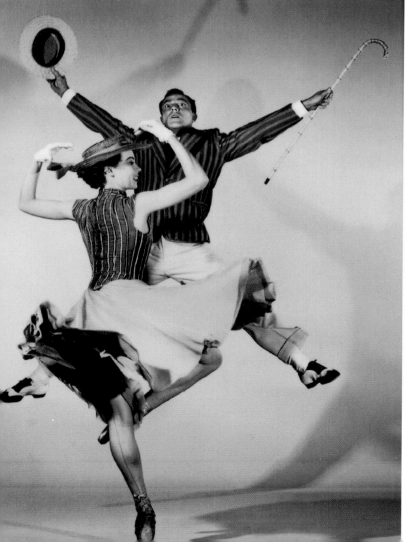
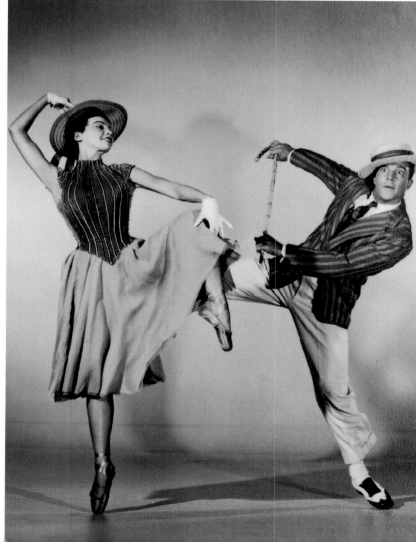

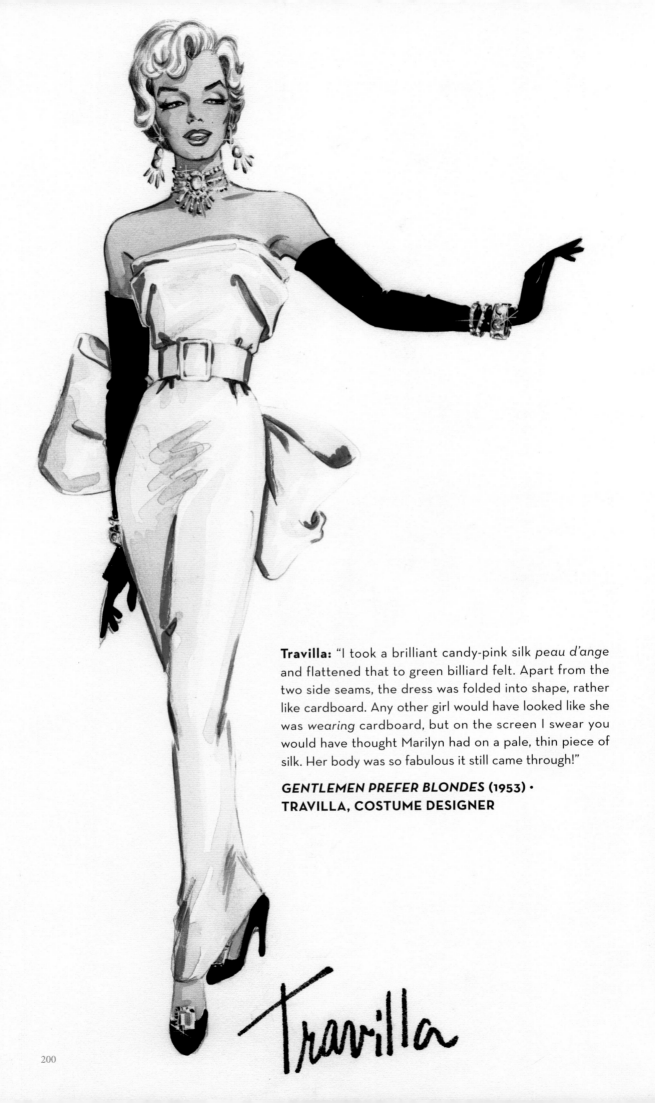

**Travilla:** "I took a brilliant candy-pink silk *peau d'ange* and flattened that to green billiard felt. Apart from the two side seams, the dress was folded into shape, rather like cardboard. Any other girl would have looked like she was *wearing* cardboard, but on the screen I swear you would have thought Marilyn had on a pale, thin piece of silk. Her body was so fabulous it still came through!"

### *GENTLEMEN PREFER BLONDES* (1953) • TRAVILLA, COSTUME DESIGNER

*Travilla*

**Katharine Hepburn (actress):** "It was now Tuesday—April 17th—Huston had made no effort to see me or talk about the script. On costumes we'd had one talk. I told him that I didn't want his woman; I wanted [dress historian Doris] Langley Moore and I would go to see what she had in the museum. . . . He gave up so easily on his choice, I was taken aback.

"Next day I saw Langley Moore. She had a really great collection, even down to [Queen] Victoria's underpants with a fifty-inch waistline—fascinating stuff. I'd borrow her things from her to take back to the hotel to show to Huston. . . . All the most hideous things he adored. And the grotesque underwear.

"He made me put on a combination and said that that was what I would play most of the picture in. A combination, incidentally, was a one-piece sort of shirt and pants combined. It is either split fore and aft for facility in the bathroom or it had a tab between the legs to hold it down. It was mid-thigh—this one was split fore and aft. My heart sank. I wondered just how stubborn he would turn out to be. . . . I wandered around in the combination feeling a perfect ass and showing mine."

***THE AFRICAN QUEEN* (1951) · DORIS LANGLEY MOORE AND CONNIE DE PINNA, COSTUME DESIGNERS**

George Stevens (director): "Most present day Westerns are inaccurate in even the smallest details. For example, there's no regard for clothing—the characters are dressed in garb just short of nylons and plastics. In casting we tried to get away from Sears Roebuck–type characters. Our women are frumpy and bedraggled-looking rather than glamorous, and our men wear beavers, not Stetsons."

*SHANE* (1953) · EDITH HEAD, COSTUME DESIGNER

**Debbie Reynolds (actress):** *"Singin' in the Rain* and childbirth were the hardest things I ever had to do in my life. The pain from childbirth was in the lower body but in *Singin' in the Rain* it was everywhere—especially my feet and my brain. As soon as shooting was completed, I went up to Lake Tahoe for a week's rest. My friend Jeanette went with me. She'd get up in the morning, go waterskiing, play tennis, and bring me my breakfast at noon. My first day there I slept for eighteen hours."

**SINGIN' IN THE RAIN (1952) • WALTER PLUNKETT, COSTUME DESIGNER**

**Walter Plunkett:** "The others—Fred and Ginger—they used to work their arses off rehearsing. Poor Debbie Reynolds used to be a puddle of sweat at the end of the day and say, 'Do I have to go for a costume fitting now?!' But she would come and then go back to rehearse. Donald O'Connor, Gene Kelly—they used to work for hours.'"

**Irene Sharaff:** "Suddenly Yul asked, 'What shall I do about my hair?' He was bald with one or two strands across the top of his head and a fringe of dark hair around the back. His face was attractive and full of vitality. On an impulse I replied, 'Shave it!' A look of horror crossed his face as he said, 'Oh no! I can't do that. I have a dip on the top of my head. With nothing covering it I'd look dreadful.' I pleaded, argued, entreated, bullied. The hair got trimmed a little shorter. Finally, Yul shaved his head close, with not one hair in sight. During the tussle over to shave or not to shave, neither of us had an inlking of some of the consequences. For Yul's dome, hairless and gleaming, encouraged an increasing number of bald men to copy him—as if by so doing magically they too might acquire the aura and attraction he seemed to possess. Yul's clippers gave him, as it were, a logo or trademark that has taken his name."

***THE KING AND I* (1956) · IRENE SHARAFF, COSTUME DESIGNER**

**Deborah Kerr (actress):** "Irene Sharaff is a brilliant woman. I did think, however, that those hoopskirts were terribly big and that the engravings of the period exaggerated their size the way our fashion illustrations today elongate the figure. But she insisted that she had some actual measurements of hoops. The hoops were made of metal and were extremely heavy, but that gave the skirts a flow they wouldn't have had if they had been cane. I had to put foam rubber pads on my hips in the 'Shall We Dance' number to keep from injuring myself with the hoops."

*THE KING AND I* (1956) · IRENE SHARAFF, COSTUME DESIGNER

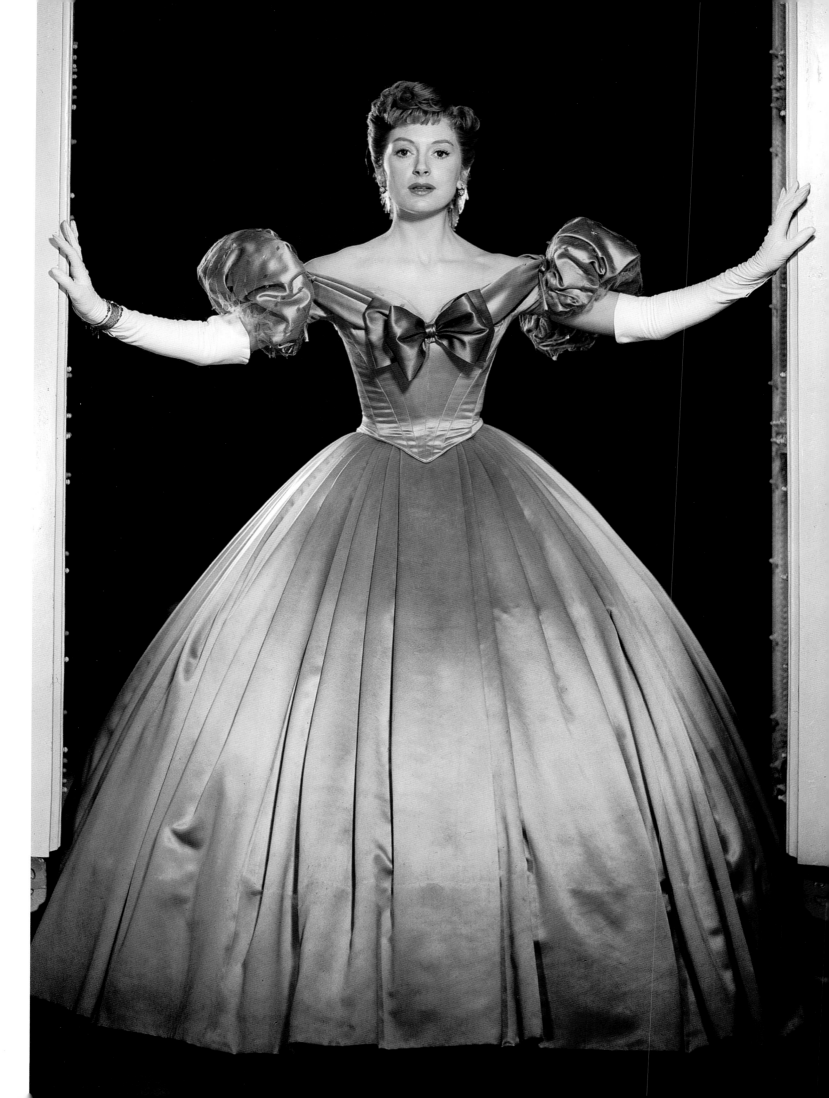

**Nicholas Ray (director):** "The first thing I did was pull a red jacket off the Red Cross man, dip it in black paint to take off the sheen and give it to Jimmy. Then I sent Natalie Wood to buy a green skirt off the rack, not some $450 designer special. I started Jimmy in this neutral brown and he graduated to the blue jeans and red jacket. When you first see Jimmy in his red jacket against his black 'Merc,' it's not just a pose. It's a warning. It's a sign."

*REBEL WITHOUT A CAUSE* (1955) •
**MOSS MABRY, COSTUME DESIGNER**

**Edith Head:** "I wasn't about to tamper with Elvis's image. In that sense, he was like a male version of Mae West— he knew the Elvis look."

*JAILHOUSE ROCK* (1957) • **EDITH HEAD, COSTUME DESIGNER**

**Delbert Mann (director):** "Without any question, when we were doing *Marty*, Paddy Chayefsky and I both had in our mind *Bicycle Thief* and *Open City* and the Italian postwar films. We were pressing our Hollywood camera-man to tone down the glamorizing lighting and we were going for a stylized realism, but nonetheless a realistic look. In retrospect I do think it had a very specific influence on us, trying to break the mold of the Hollywood glamorized look."

**MARTY (1955) · NORMA KOCH, COSTUME DESIGNER**

211

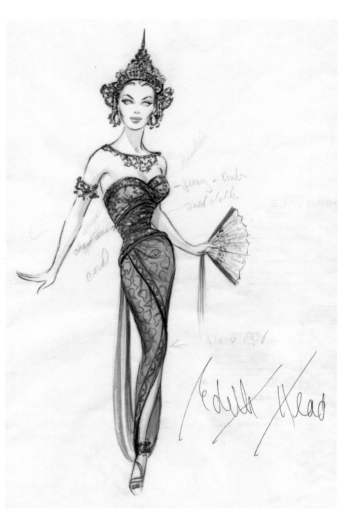

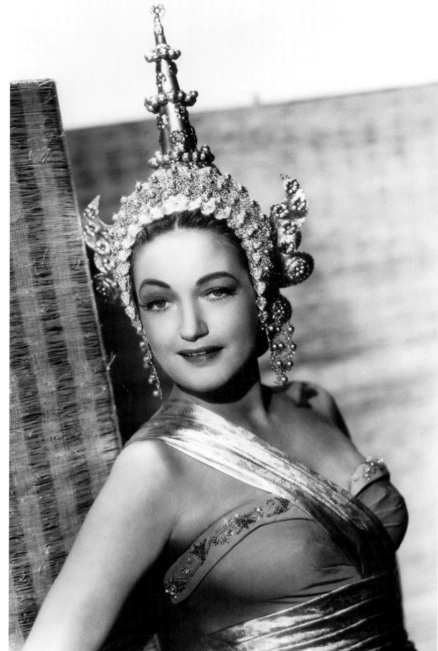

**Edith Head:** "At the start of every *Road* picture I would ... read the script to see where they were going, then call the research people and ask them to find out whatever they could about the locale. If Dottie [Dorothy Lamour] was playing the princess or queen of some obscure country, I would ask research to find pictures of that special brand of royalty. I could tell from the pictures whether they wore veils, turbans, crowns, or pompoms ...Then I would go down to Western Costume, the largest-stock costume house in Hollywood, and bring back samples of anything that might be a reasonable facsimile of costumes worn in the country ... The settings weren't restricted to the name of the film. In *Road to Singapore,* they [Bob Hope and Bing Crosby] landed on a South Seas island where they encountered the beautiful sarong-clad Mima (we had to get Dorothy into a sarong somehow, remember!) ... My job was to make sure that the costumes matched the frivolity. If somebody wrote 'Edith, in Morocco they don't wear headdresses like that,' I didn't give a damn. If Bob Hope wanted to wear it because it was funny, he wore it."

**Dorothy Lamour (actress):** "The wardrobe department felt the wartime shortages. A lot of Edith's extravagant designs called for full net skirts trimmed with cloth of gold, or pantaloons made of silk chiffon. Since silk was needed for the war effort, she substituted cotton with trimming of gold-painted kid. With Hollywood's magic touch, however, they looked like the real thing on film."

### *THE ROAD TO BALI* (1952) • EDITH HEAD, COSTUME DESIGNER

**Esther Williams (actress):** "Designers Helen Rose and Walter Plunkett fitted me in an extraordinary swim costume like a diver's body suit, only covered—including the soles of the feet—with gold sequins, fifty thousand of them—like chain mail. Atop a gold turban, which was wrapped around my head, they perched a gold crown. I took my position on the disk and the hydraulic lift started rising. Up . . . up . . . up I went . . . 'We're waiting, Esther!' Busby Berkeley [choreographer] barked. 'Jump!' I forced a smile for the camera and swan-dived from that tiny platform. "Hurtling down, I suddenly realized . . . the gold crown on my head was lightweight aluminum, a lot stronger and less flexible than my neck. I hit the water with tremendous force. The impact snapped my head back . . . I knew instantly that I was in big trouble. I hadn't paid enough attention to what it would mean to make that dive with a metal crown on my head, at least not until I was in the air."

### *MILLION DOLLAR MERMAID* (1952) · WALTER PLUNKETT AND HELEN ROSE, COSTUME DESIGNERS

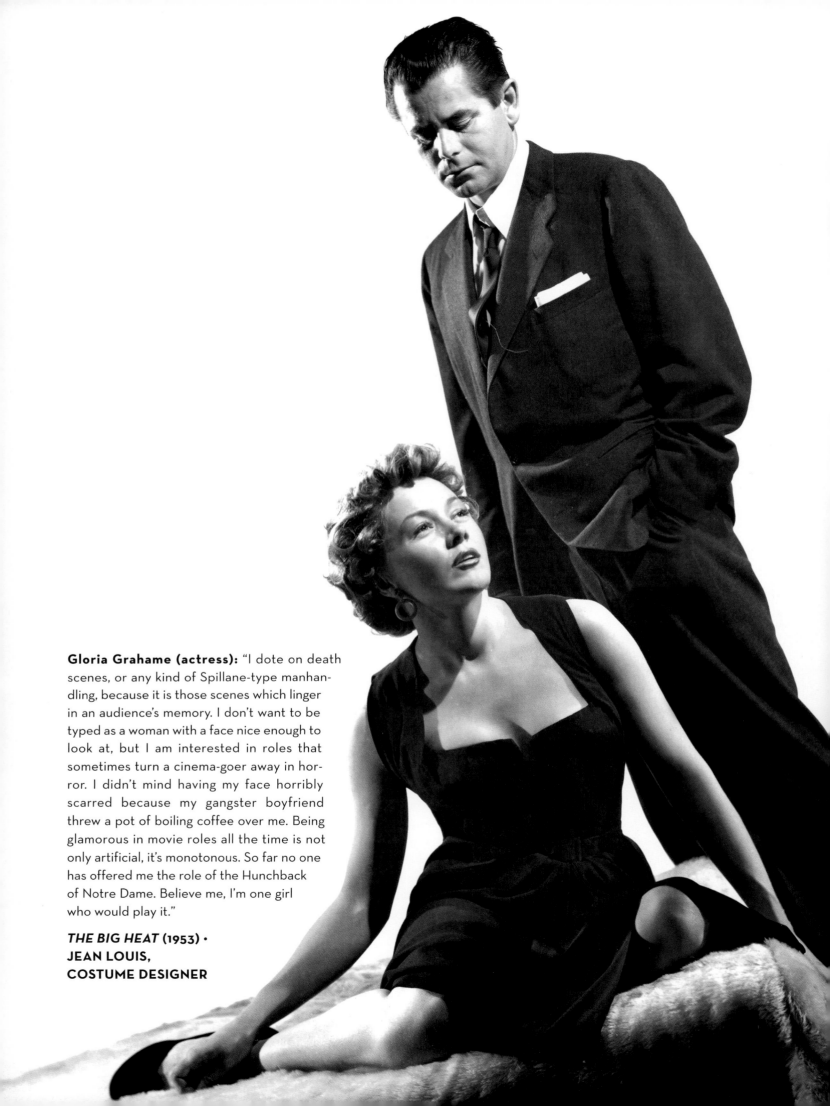

**Gloria Grahame (actress):** "I dote on death scenes, or any kind of Spillane-type manhandling, because it is those scenes which linger in an audience's memory. I don't want to be typed as a woman with a face nice enough to look at, but I am interested in roles that sometimes turn a cinema-goer away in horror. I didn't mind having my face horribly scarred because my gangster boyfriend threw a pot of boiling coffee over me. Being glamorous in movie roles all the time is not only artificial, it's monotonous. So far no one has offered me the role of the Hunchback of Notre Dame. Believe me, I'm one girl who would play it."

*THE BIG HEAT* (1953) •
**JEAN LOUIS,
COSTUME DESIGNER**

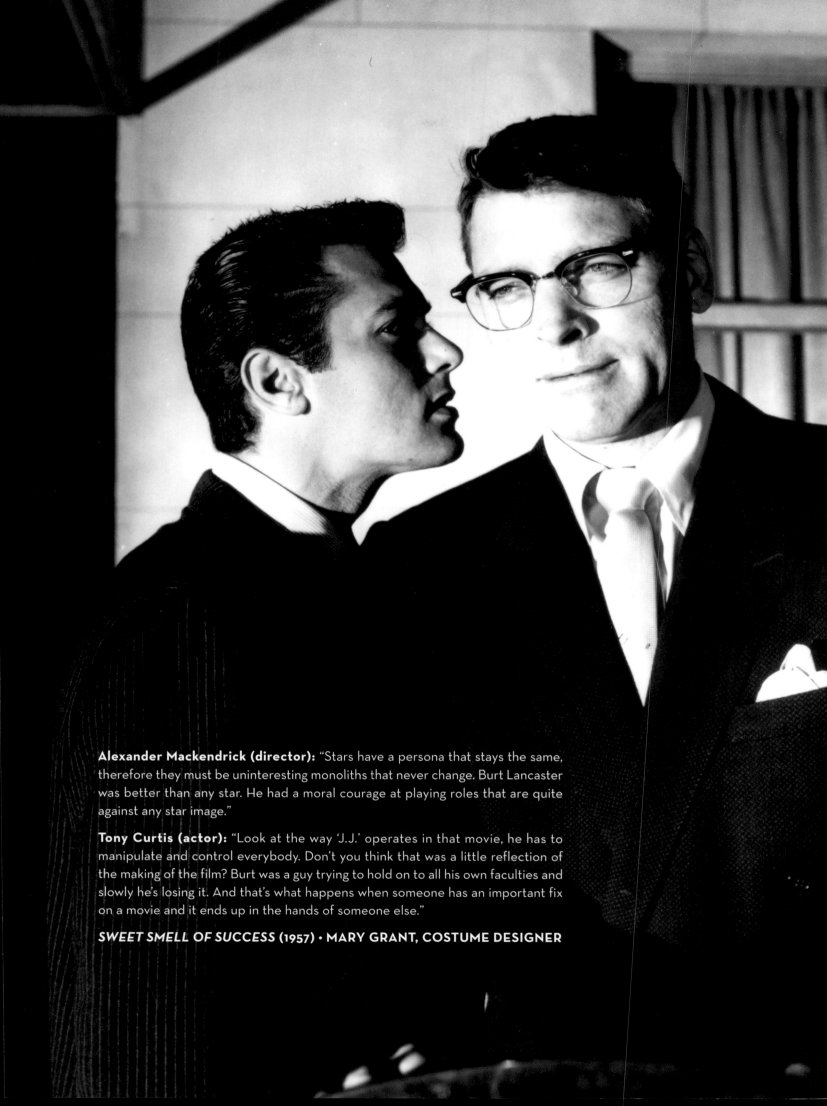

**Alexander Mackendrick (director):** "Stars have a persona that stays the same, therefore they must be uninteresting monoliths that never change. Burt Lancaster was better than any star. He had a moral courage at playing roles that are quite against any star image."

**Tony Curtis (actor):** "Look at the way 'J.J.' operates in that movie, he has to manipulate and control everybody. Don't you think that was a little reflection of the making of the film? Burt was a guy trying to hold on to all his own faculties and slowly he's losing it. And that's what happens when someone has an important fix on a movie and it ends up in the hands of someone else."

*SWEET SMELL OF SUCCESS* (1957) · MARY GRANT, COSTUME DESIGNER

**Ross Hunter (producer):** "Doris hadn't a clue as to her potential as a sex image and no one realized that under all those dirndls lurked one of the wildest asses in Hollywood. I came right out and told her. 'You are sexy, Doris, and it's about time you dealt with it.' 'Oh, Ross, cut it out, I'm just the old-fashioned peanut-butter girl next door, and you know it.' 'Now, listen, if you allow me to get Jean Louis to do your clothes, I mean a really sensational wardrobe that will show off that wild fanny of yours, and get some wonderful makeup on you, and chic you up and get a great hairdo that *lifts* you, why, every secretary and every housewife will say, Look at that—look what Doris has done to herself. Maybe I can do the same thing.'"

*PILLOW TALK* (1959) · JEAN LOUIS AND BILL THOMAS, COSTUME DESIGNERS

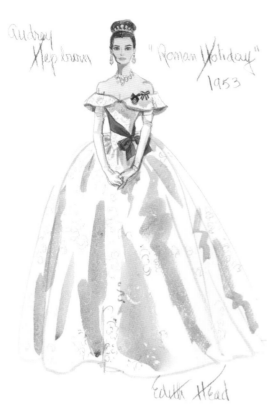

**Edith Head:** "To the sketches for *Roman Holiday,* Audrey Hepburn added a few of her own preferences: simpler necklines, wider belts. I returned to the coast, had the clothes made, and we tested them in New York. When I saw the test, I knew that this was not only a fine actress but one of the greatest models. The clothes translated her perfectly from a prim little princess to an eager young girl on the streets of Rome."

**Edith Head:** "Audrey had the assurance of a veteran. Audrey would say, with a sweetness that cut like a knife to the heart of the problem, 'I don't think the princess would be quite so shrewd, Edith darling, as to use that *particular* décolletage!' and I would think, 'Oh, my God, if she doesn't get to the top I'll eat Hedda Hopper's hats!'"

***ROMAN HOLIDAY* (1953) ·**
**EDITH HEAD, COSTUME DESIGNER**

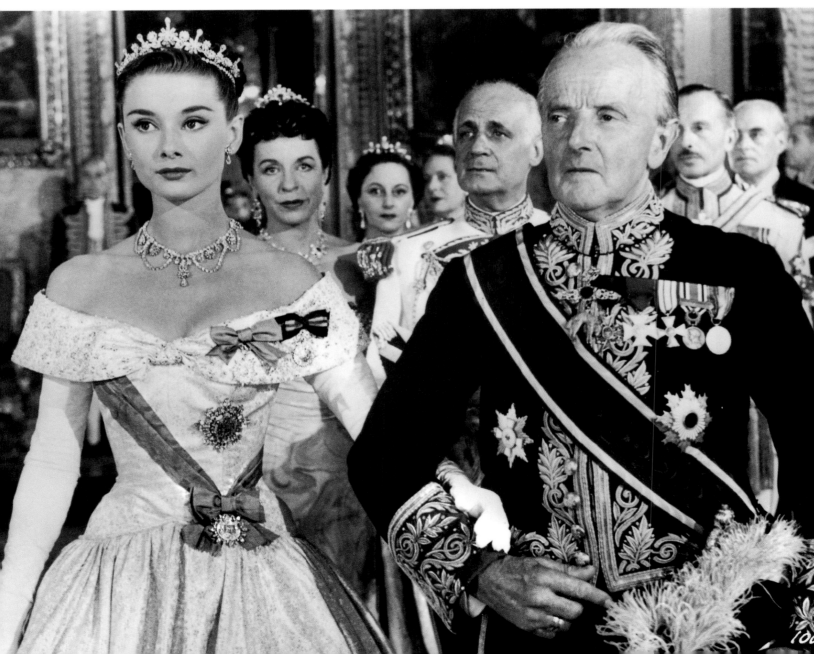

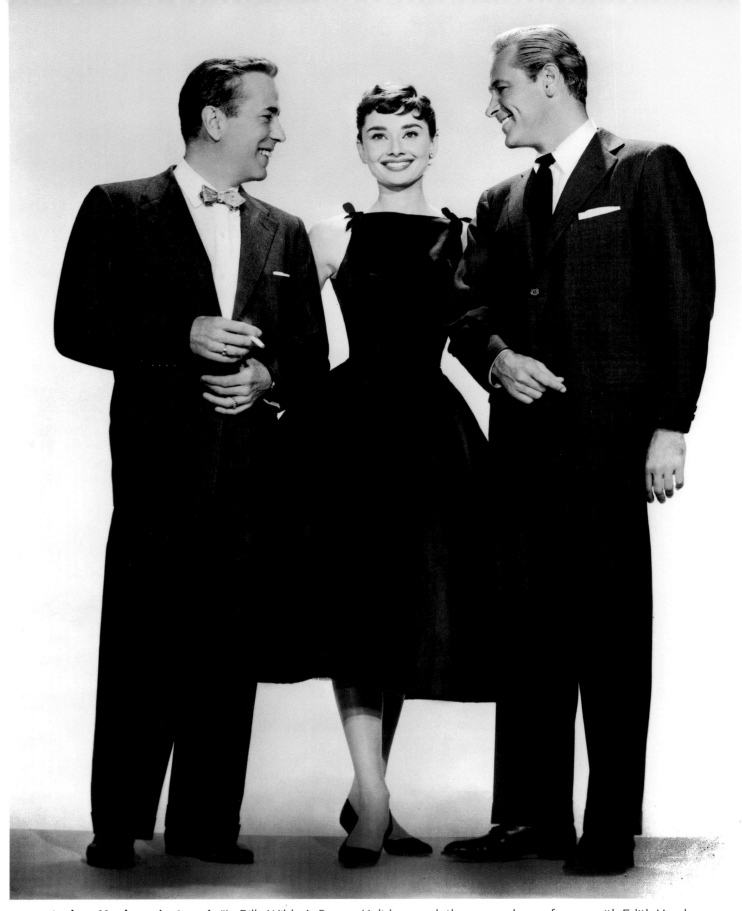

**Audrey Hepburn (actress):** "In Billy Wilder's *Roman Holiday* my clothes were chosen for me, with Edith Head as Costume Designer. For *Sabrina*, Billy Wilder agreed to let me add a few Parisian costumes to the ones created by Edith Head. The dresses put forward by Hubert de Givenchy were divine. I felt as though I had been born to wear them."

**Billy Wilder (director):** "I had a special little niche for Givenchy. I knew that Audrey had first-class taste, and I knew that she knew the character, and I let her go, and she never disappointed me. Of course, she did not wear Givenchy when she was with her father washing cars."

### *SABRINA* (1954) · EDITH HEAD AND HUBERT DE GIVENCHY, COSTUME DESIGNERS

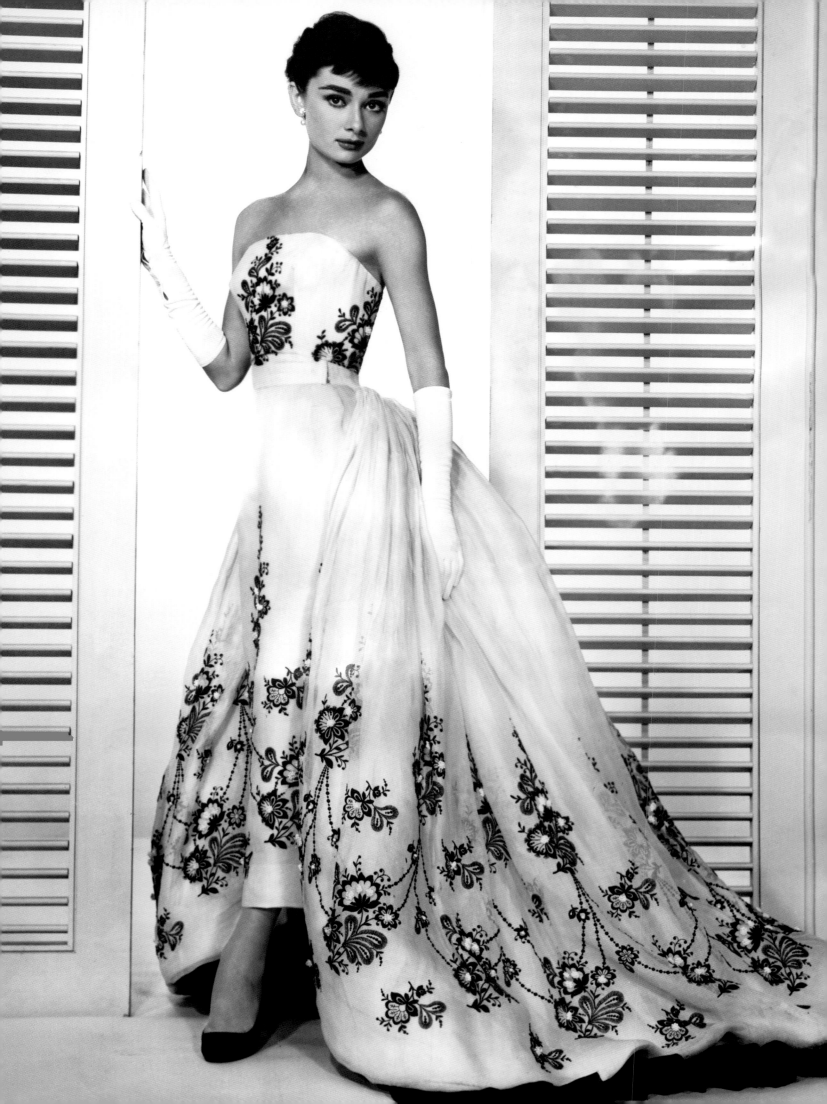

**The *New York Times*:** "If a man from another planet arrived at Washington, D.C. in his space ship, what would he be wearing? This is the kind of question that bothers Hollywood, so 20th Century Fox hired Perkins Bailey to design such a costume for the hero of its science-fiction film, *The Day the Earth Stood Still*. The next step, obviously, was to have the same expert design a sports jacket for ordinary earth-citizens, have it made by a noted sportswear house (McGregor), give it a transcendental name (Out of This World) and arrange to introduce it first at a well-known store (Wallachs) while the picture is playing. Astonishingly enough it all worked out. The jacket came in the other day. There are two pockets, one presumably for your disintegrator and the other for a Mars Bar."

***THE DAY THE EARTH STOOD STILL* (1951) • PERKINS BAILEY AND TRAVILLA, COSTUME DESIGNERS**

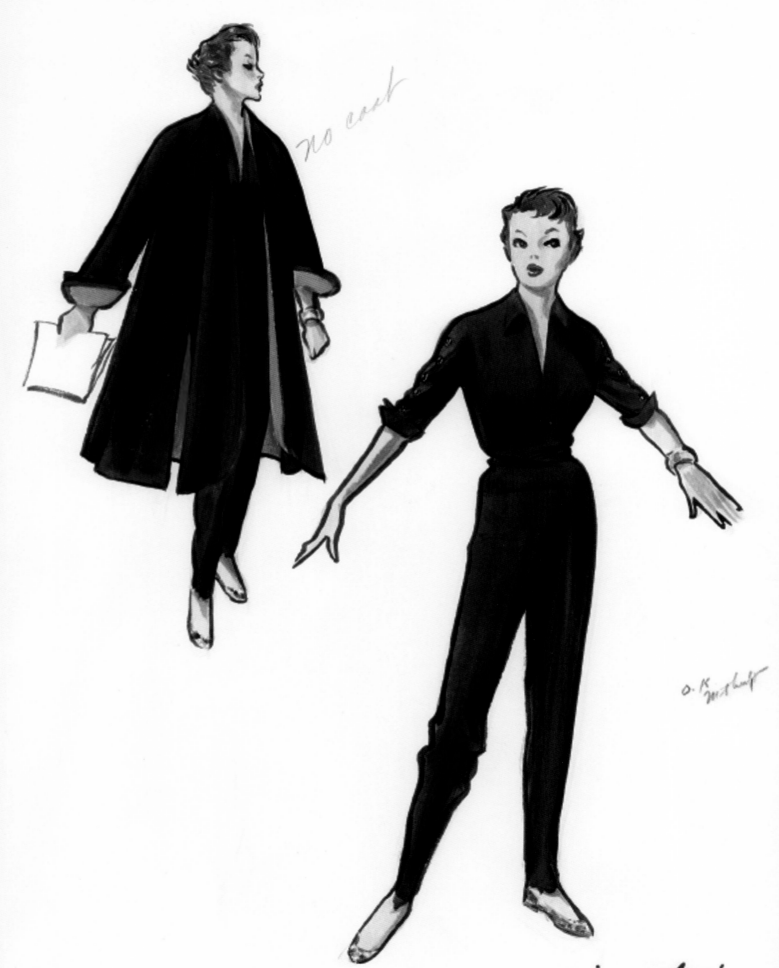

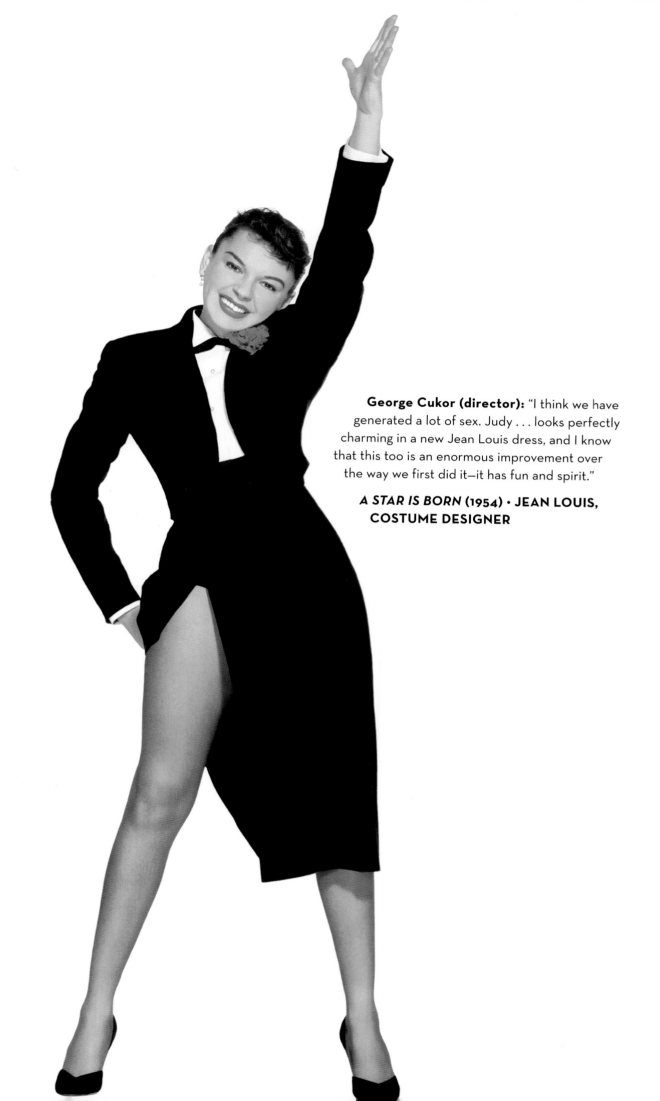

**George Cukor (director):** "I think we have generated a lot of sex. Judy . . . looks perfectly charming in a new Jean Louis dress, and I know that this too is an enormous improvement over the way we first did it—it has fun and spirit."

**A STAR IS BORN (1954) · JEAN LOUIS, COSTUME DESIGNER**

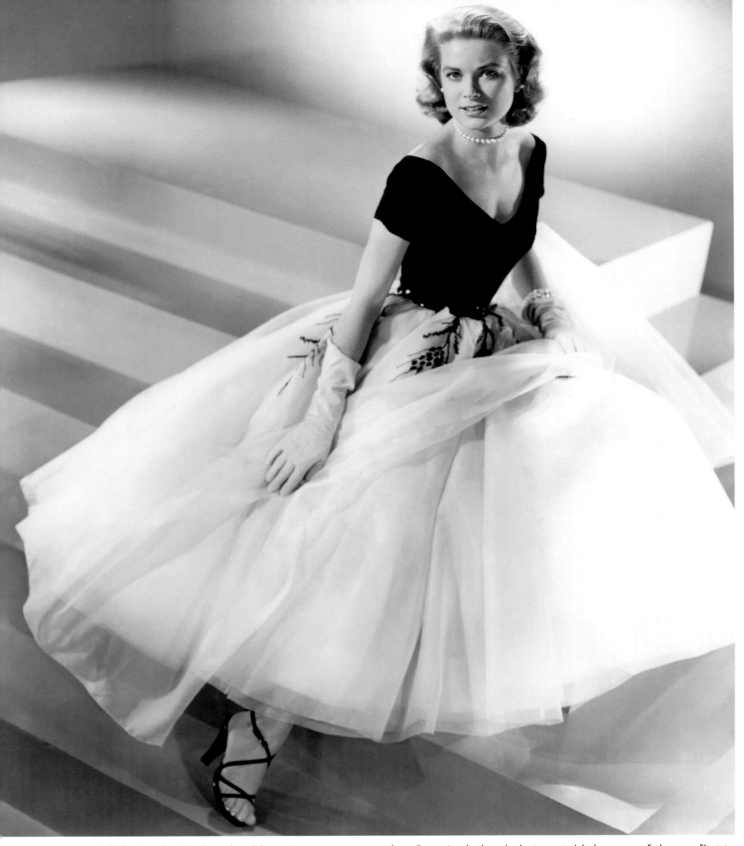

**Edith Head:** "Hitchcock told me it was important that Grace's clothes help to establish some of the conflict in the story. She was to be the typical sophisticated society-girl magazine editor who falls in love with a scruffy photographer, Jimmy Stewart. He's insecure and thinks that she thinks he isn't good enough for her. Hitch wanted her to look like a piece of Dresden china, something slightly untouchable. . . . The clothes also helped advance the narrative. The black-and-white dress I used in the first love scene had a simple neckline, which framed her face in close-ups. Then, as the camera pulled back, the beaded chiffon skirt immediately told the audience she was a rich girl. Grace appeared in a peignoir in Jimmy Stewart's bedroom, yet it was a very innocent scene. Why? Jimmy's leg was in a cast, and he was virtually helpless when it came to romance. Grace was showing him what he was missing. That was a perfect example of Hitchcock's offbeat sense of humor."

### *REAR WINDOW* (1954) · EDITH HEAD, COSTUME DESIGNER

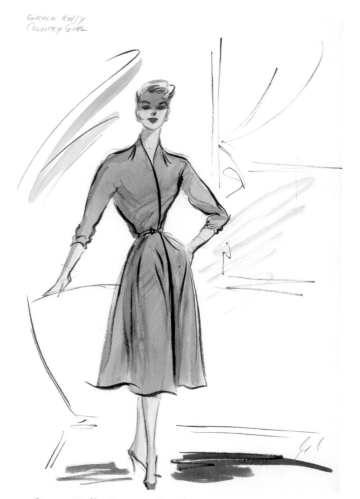

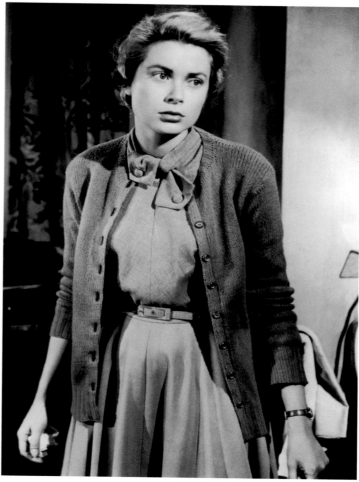

**Grace Kelly (actress):** "There's a real acting part in it for me. There's nothing glamorous about it. We live in a sleazy flat. I wear glasses, cheap skirts and sweaters—no gowns or anything like that. And the only makeup I use is what any housewife would."

**Edith Head:** "Grace understands, as Dietrich and Anna Magnani understand, the difference between fashion and costume. In the four pictures Grace and I made together, I was able to transform her from the high-fashion model of *Rear Window* to the drab, dull housewife of *The Country Girl*, whose dress had to look as if she'd worn it a long time, and as if she'd lost a great deal of weight. We found a shapeless wrap-around house dress and a sweater that had been in stock for years and put them through special washings to age them. At last, Grace looked not in the least 'Grace.' She felt very definitely that without this physical change to help her, it would have been most difficult to play the part."

## *THE COUNTRY GIRL* (1954) · EDITH HEAD, COSTUME DESIGNER

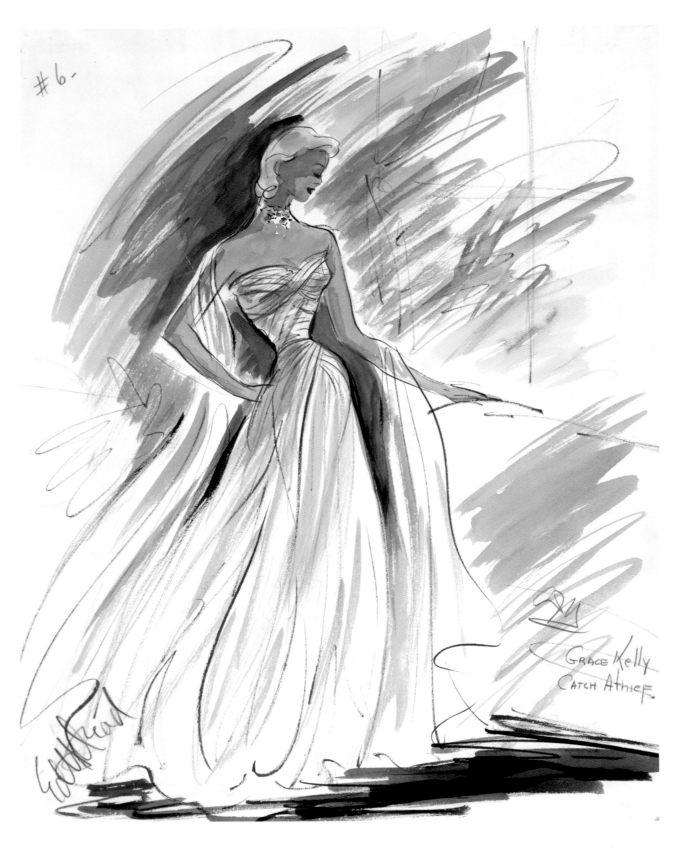

#6.

Grace Kelly
Catch A Thief

**Edith Head:** "Hitchcock had said, 'I want her to look like a fairy-tale princess.' A director can so easily give a word picture of what he wants."

### *TO CATCH A THIEF* (1955) · EDITH HEAD, COSTUME DESIGNER

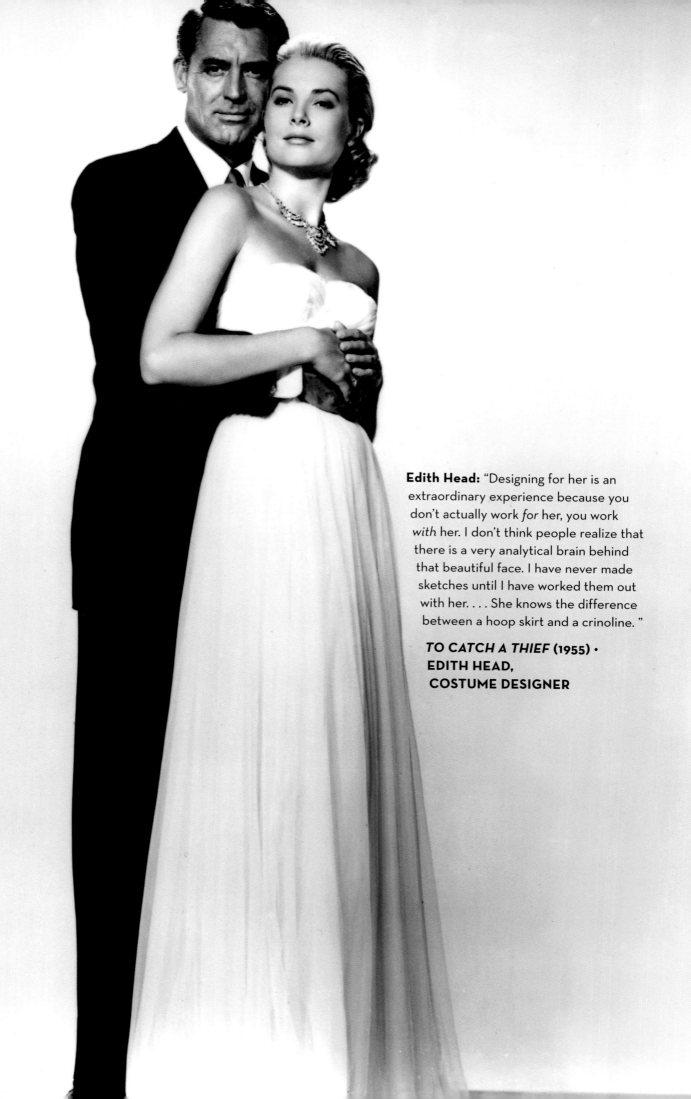

**Edith Head:** "Designing for her is an extraordinary experience because you don't actually work *for* her, you work *with* her. I don't think people realize that there is a very analytical brain behind that beautiful face. I have never made sketches until I have worked them out with her. . . . She knows the difference between a hoop skirt and a crinoline."

*TO CATCH A THIEF* (1955) · EDITH HEAD, COSTUME DESIGNER

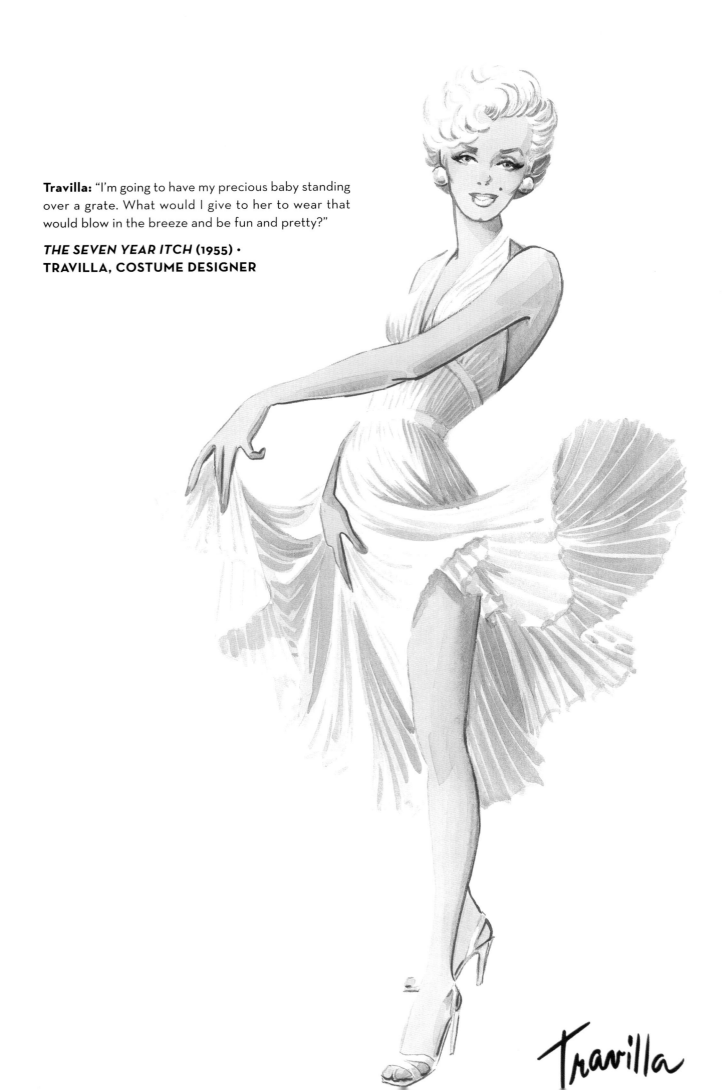

**Travilla:** "I'm going to have my precious baby standing over a grate. What would I give to her to wear that would blow in the breeze and be fun and pretty?"

***THE SEVEN YEAR ITCH* (1955) ·
TRAVILLA, COSTUME DESIGNER**

Travilla

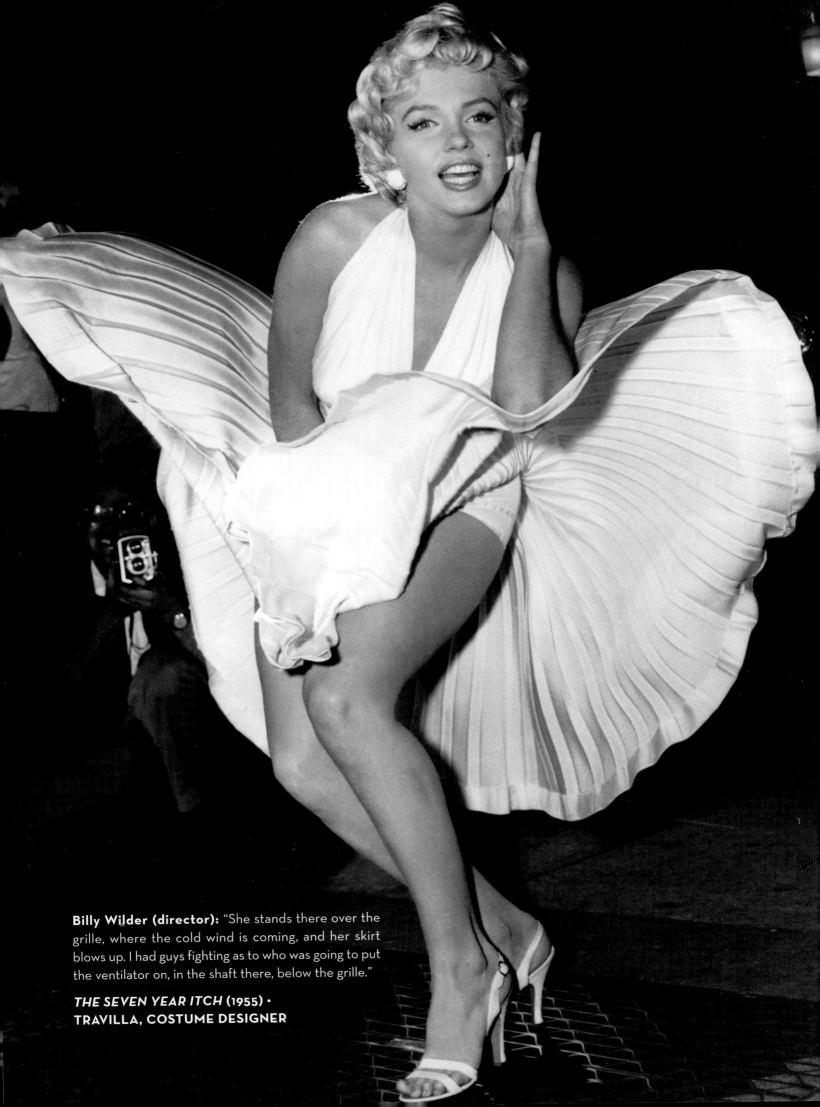

**Billy Wilder (director):** "She stands there over the grille, where the cold wind is coming, and her skirt blows up. I had guys fighting as to who was going to put the ventilator on, in the shaft there, below the grille."

*THE SEVEN YEAR ITCH* (1955) ·
TRAVILLA, COSTUME DESIGNER

**Joseph Laitin (journalist):** "Cecil B. DeMille had suddenly ordered the cameras to stop rolling as Nina Foch, playing the Pharaoh's daughter, emerged dripping wet from the 'Nile' bearing a blanket containing the baby Moses. With the dress clinging to her body, Miss Foch's personality came through as never before[.] The dress even looked flesh-colored. . . . The usual procedure is to test-dunk the material beforehand; in this case, Miss Head had deemed it unnecessary because the script merely said Miss Foch would 'wade' into the river. 'How should I know,' Edie said later, 'that Mr. DeMille's idea of wading is what I call deep-sea diving?'"

***THE TEN COMMANDMENTS* (1956) · ARNOLD FRIBERG, EDITH HEAD, DOROTHY JEAKINS, JOHN JENSEN, AND RALPH JESTER, COSTUME DESIGNERS**

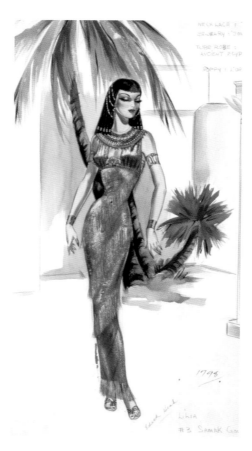

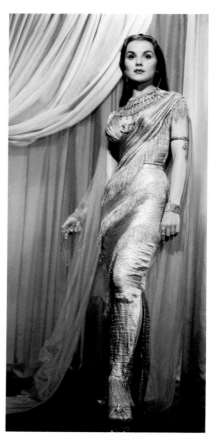

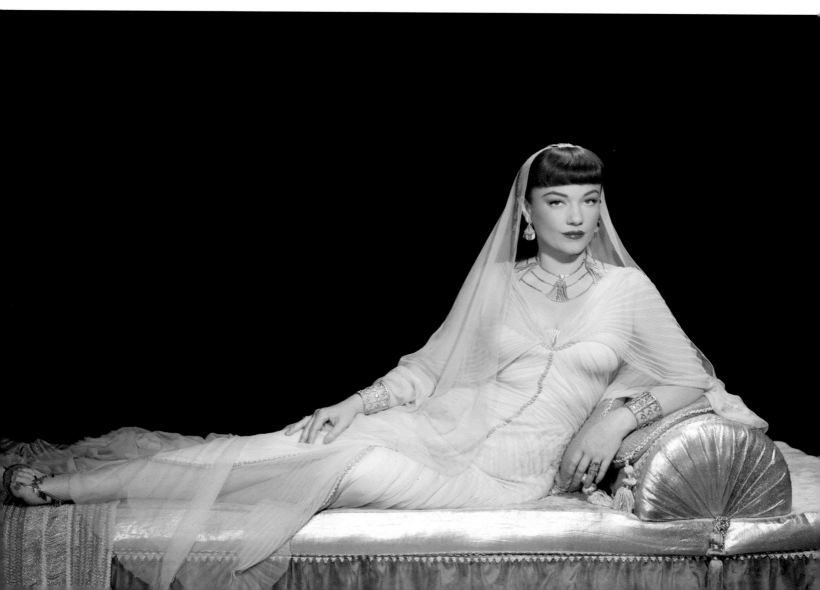

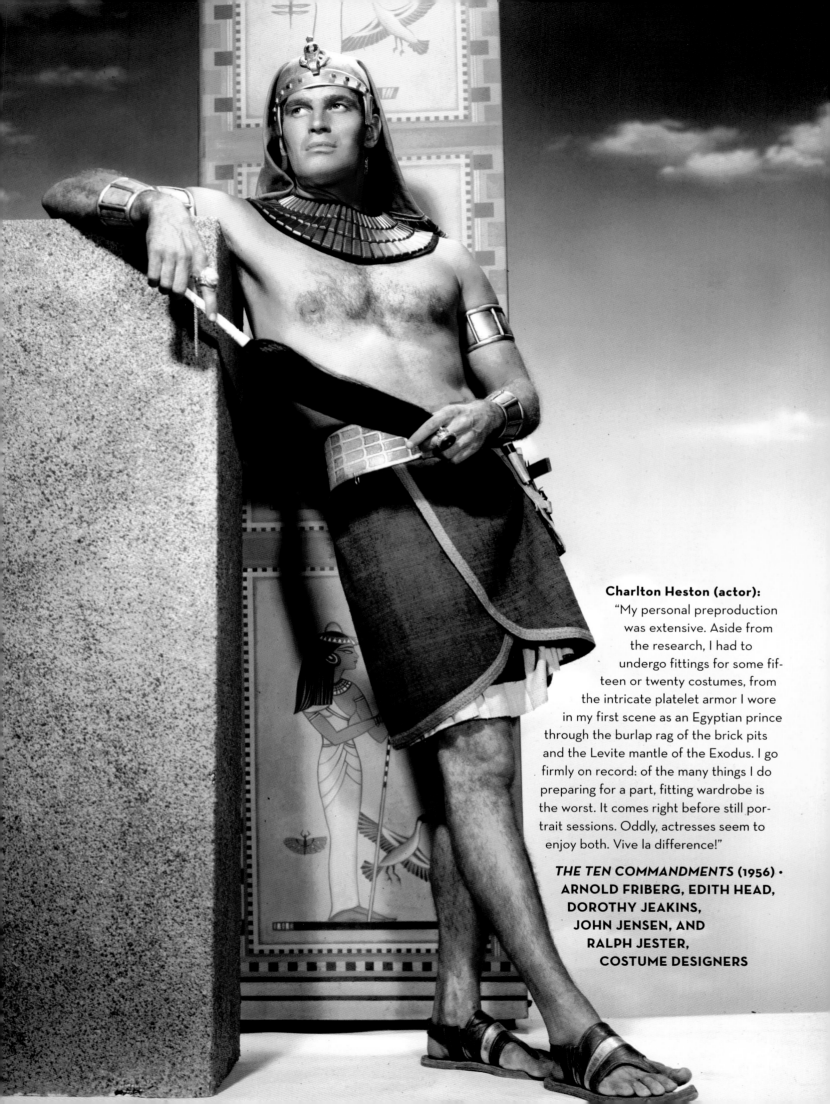

**Charlton Heston (actor):**
"My personal preproduction was extensive. Aside from the research, I had to undergo fittings for some fifteen or twenty costumes, from the intricate platelet armor I wore in my first scene as an Egyptian prince through the burlap rag of the brick pits and the Levite mantle of the Exodus. I go firmly on record: of the many things I do preparing for a part, fitting wardrobe is the worst. It comes right before still portrait sessions. Oddly, actresses seem to enjoy both. Vive la difference!"

*THE TEN COMMANDMENTS* (1956) ·
ARNOLD FRIBERG, EDITH HEAD,
DOROTHY JEAKINS,
JOHN JENSEN, AND
RALPH JESTER,
COSTUME DESIGNERS

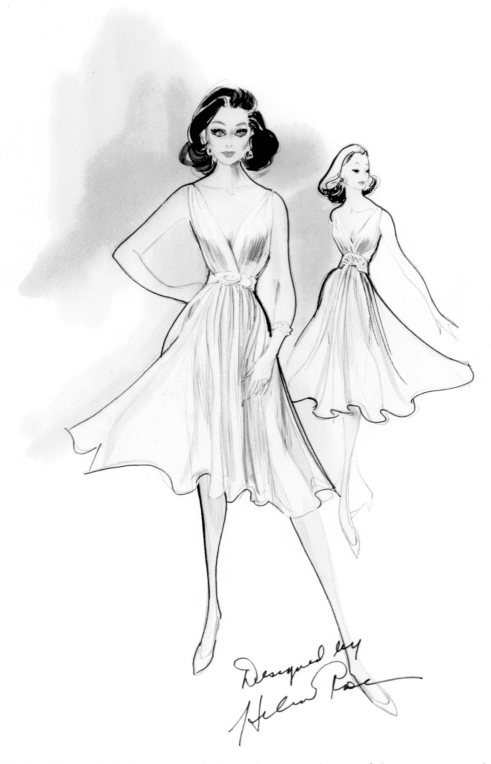

**Helen Rose:** "In this film [Elizabeth Taylor] wore only three changes and many of the scenes were played at a late-afternoon birthday party. I had made a sketch of a white chiffon dress with a V-neck, draped Grecian bodice and short circular skirt, but the director, Richard Brooks, thought it was too glamorous for 'Maggie the Cat' and he suggested a white silk shirtwaist instead; all men adore shirtwaists for women. I had designed the costumes for a number of pictures starring Elizabeth and I knew she would object to wearing something this understated for a party sequence. . . .

"After warm greetings between the star and director, and a bit of small talk, Elizabeth in her most dulcet tone of voice said, 'Richard, love, I can't wear this shirtwaist. I look awful in it!' And Richard, being such a complete man who appreciated beauty in women, looking into those gorgeous, blue-violet, black fringed eyes said, 'Darling, you wear whatever will make you happy!' And she did."

### *CAT ON A HOT TIN ROOF* (1958) · HELEN ROSE, COSTUME DESIGNER

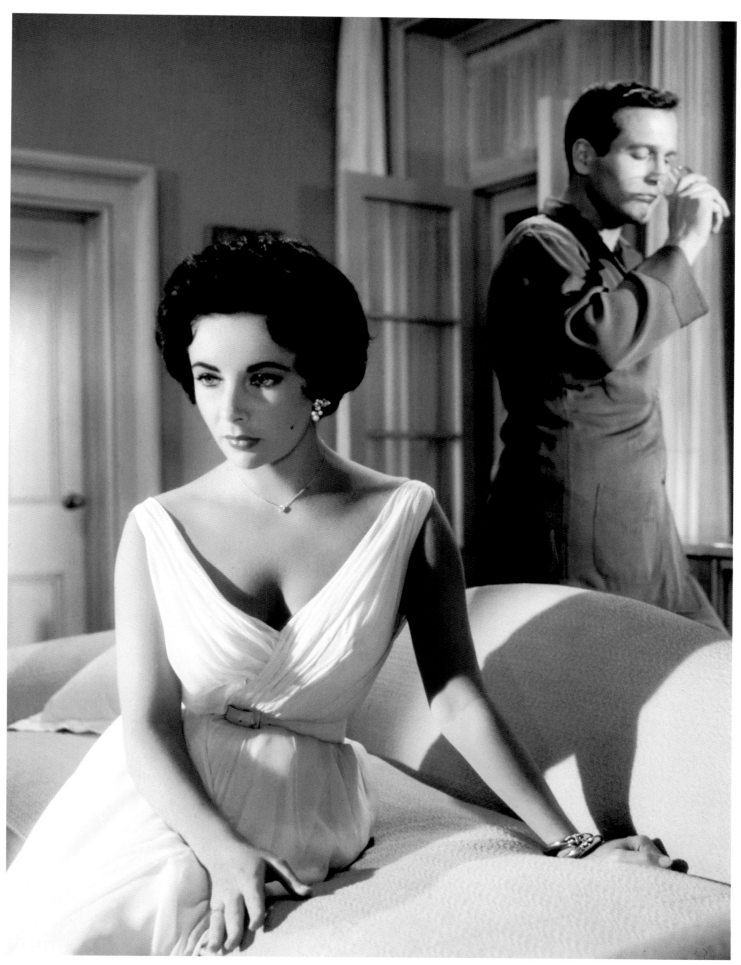

**Elizabeth Taylor (actress):** "When I look at myself in clothes from a movie, I think of myself only as that character—Maggie."

**CAT ON A HOT TIN ROOF (1958) · HELEN ROSE, COSTUME DESIGNER**

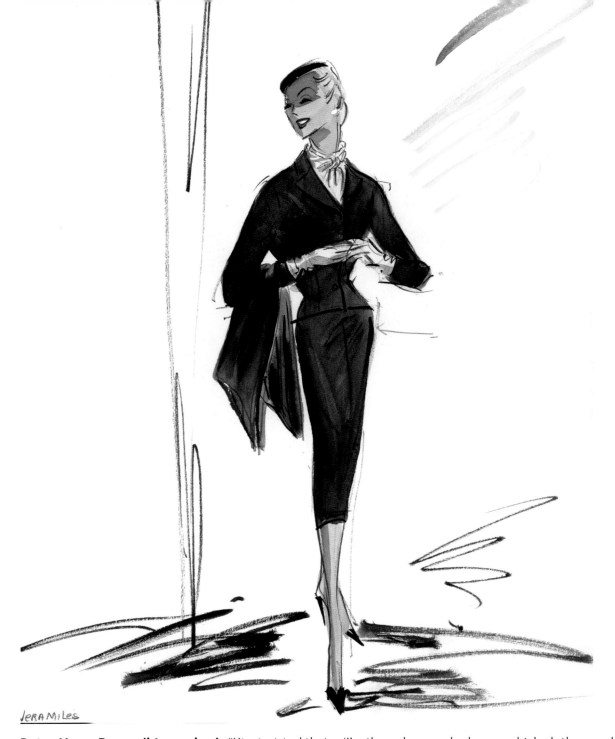

Jera Miles

**Peter Harry Brown (biographer):** "Kim insisted that … 'I'm the only one who knows which clothes work for me onscreen and which detract from the image I've built so carefully.' Naturally she clashed immediately with Hitch's favorite costume designer, Edith Head. 'Now, Miss Head,' she said, 'before we even discuss clothes, I want you to know that there are two things I don't wear. I don't wear suits, and I don't wear gray. Another thing, I don't wear black pumps. I *always* wear nude pumps the color of my hose. Outside of those conditions, I'll wear anything you wish.' Edith faced her impassively, but the sketch in her hand depicted a gray suit set off by black pumps—a costume specifically requested by Hitchcock. The designer explained: 'Miss Novak, could you please check the script again? It calls for a gray tailored suit and black shoes.' … 'And I tell *you* for the last time—I won't wear that outfit,' said Kim as she stood up and headed for the door.

"Edith phoned Hitch who eventually called Kim to his office. He told her somewhat sarcastically, 'My dear Miss Novak … The entire opening of the film hinges on the heroine's dash into a museum wearing a distinctive gray suit and identifiable black shoes.' Kim was silent, but obviously unmoved. Hitch finally broke the silence: 'I consider this matter closed.' 'Okay,' answered Kim. Shooting began five days later with Kim in a gray suit and distinctive black pumps."

### *VERTIGO* (1958) · EDITH HEAD, COSTUME DESIGNER

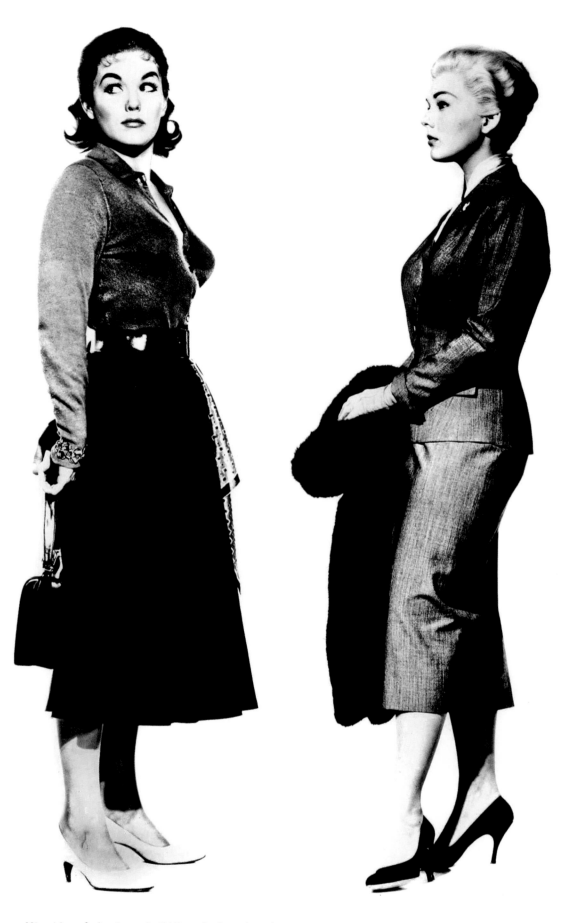

**Kim Novak (actress):** "When I played Judy, I never wore a bra. It killed me having to wear a bra as Madeleine but you had to because they had built the suit so that you had to stand very erect or you suddenly were not 'in position.' They made that suit very stiff. You constantly had to hold your shoulders back and stand erect. But, oh that was so perfect. That suit helped me find the tools for playing the role. It was wonderful for Judy because then I got to be without a bra and felt so good again. I just felt natural."

*VERTIGO* **(1958) · EDITH HEAD, COSTUME DESIGNER**

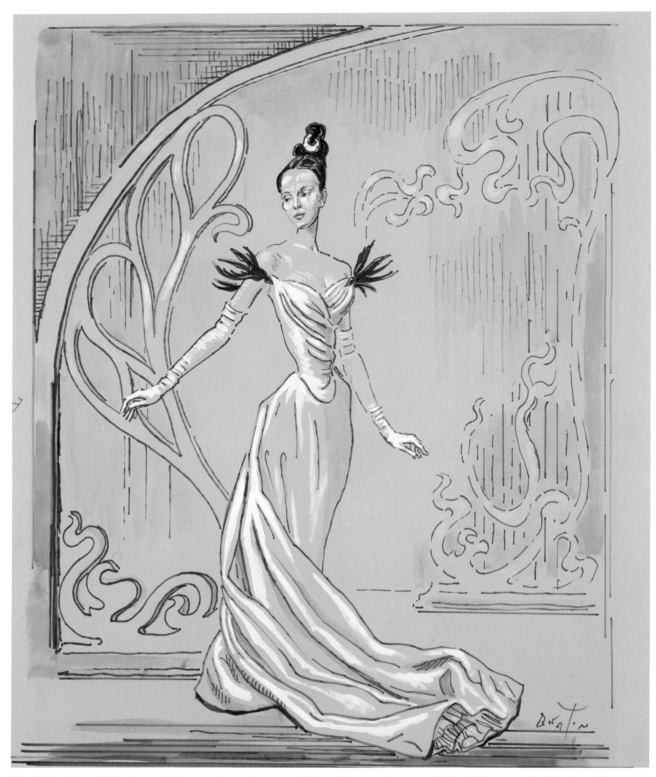

**Cecil Beaton:** "Most people have strangely vague ideas about a designer's job in films or the theater. They consider, perhaps, that a certain person is brought in to supply his favorite color schemes, to exert his personal preferences indiscriminately in fabric and furnishings. In fact, the designer's domain is far-reaching. His job is to paint the story, to supply in shapes, light and color, the plastic aspects of the lay. The harmonies and dissonances of shape and color are as important to a film, particularly a musical film, as is the orchestration of the instruments to the composer of a symphony."

**Vincente Minnelli (director):** "Cecil Beaton, in effect, did the casting for us. He'd designed settings and costumes for many Oscar Wilde plays, and had himself been hired because we felt no one evoked the Edwardian mood more brilliantly."

### *GIGI* (1958) • CECIL BEATON, COSTUME DESIGNER

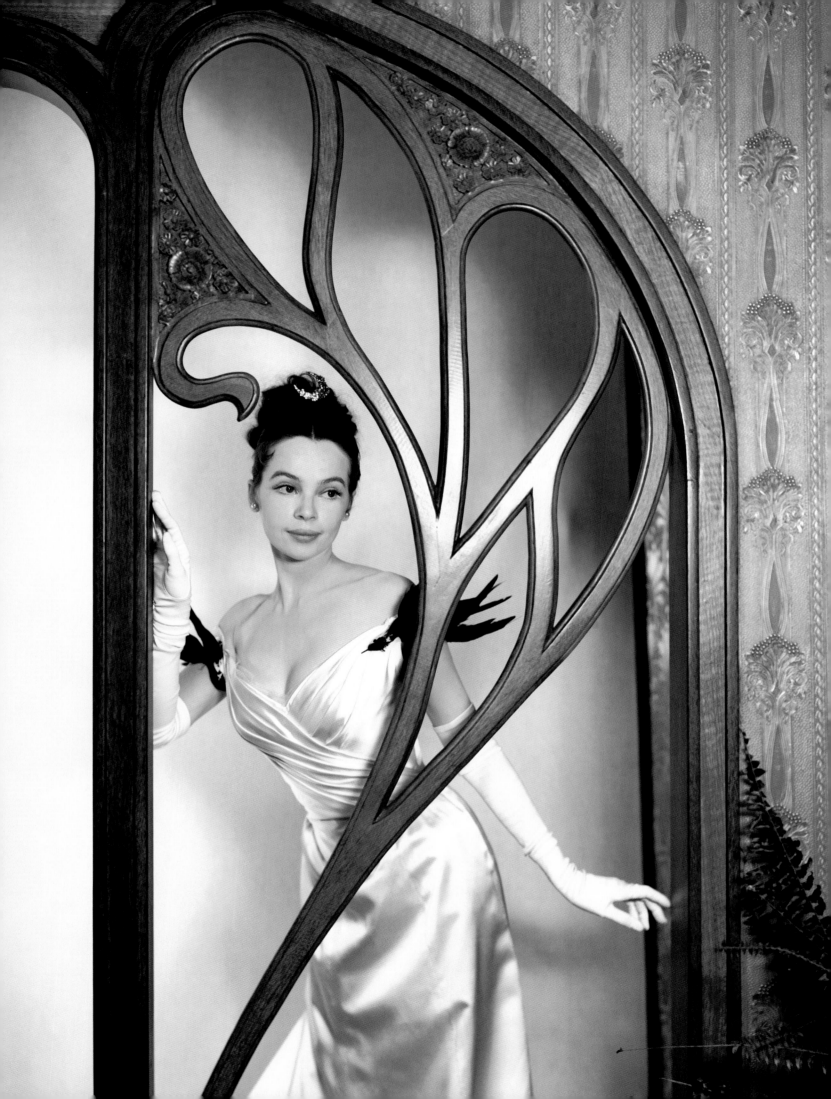

**Theodore Taylor (author):** "England's brilliant Elizabeth Haffenden was hired for MGM's *Ben-Hur*, and spent more than a year in preliminary work before the first foot of film moved through the camera in Rome. Throughout the filming, Miss Haffenden and her assistants presided over wardrobe, assembled in three buildings at Rome's Cinecitta Studios, which also housed the company's own dye works, dry-cleaning, and laundry services. A hundred craftsmen, including seamstresses, leather makers, armorers, and wardrobe personnel were needed to keep *Ben-Hur* properly attired."

### *BEN HUR* (1959) · ELIZABETH HAFFENDEN, COSTUME DESIGNER

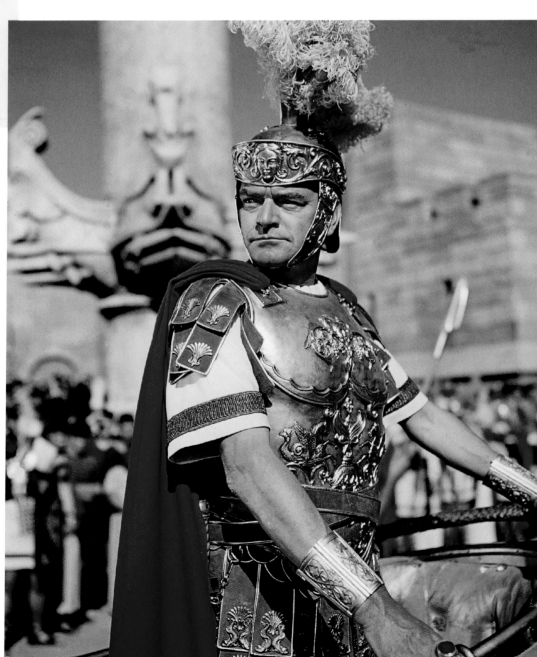

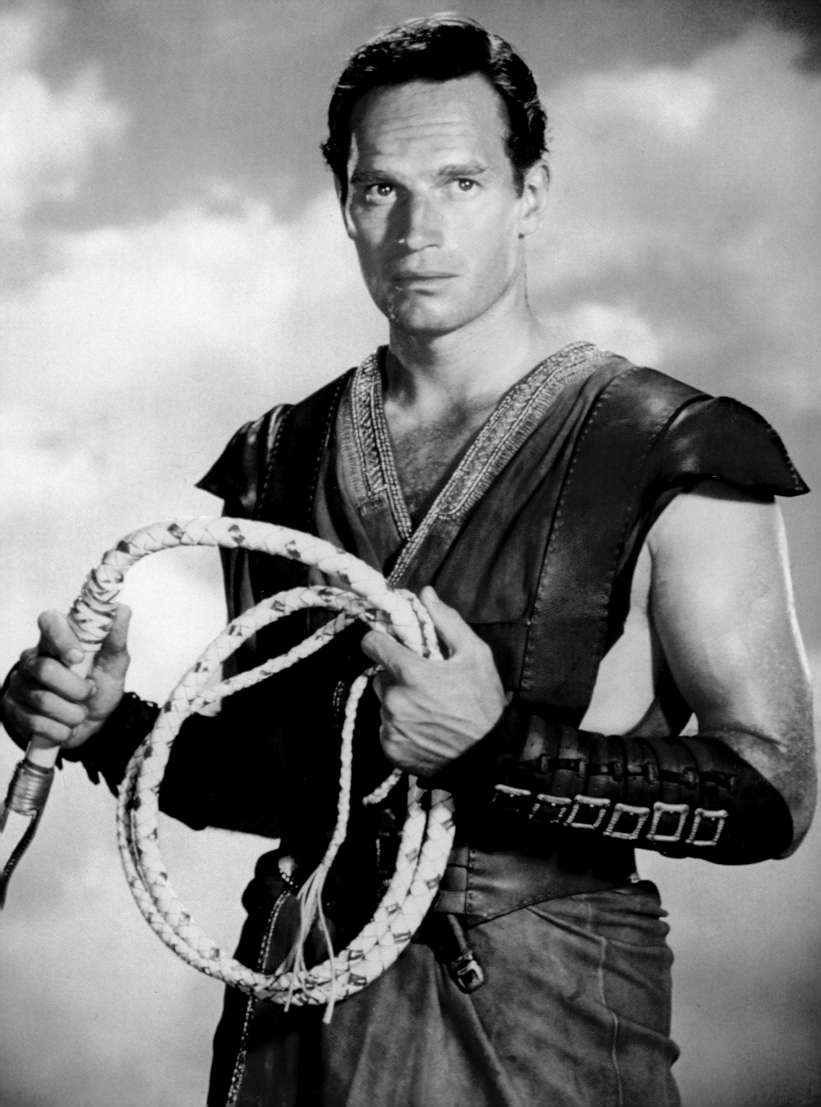

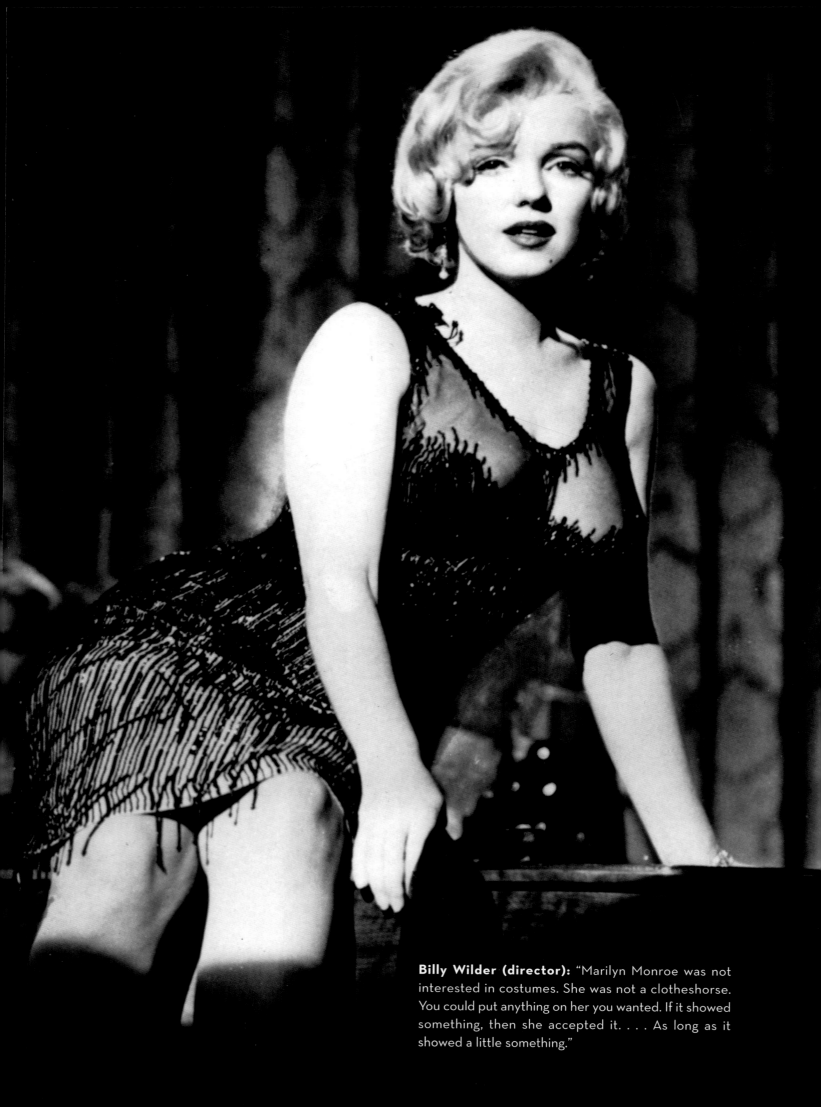

**Billy Wilder (director):** "Marilyn Monroe was not interested in costumes. She was not a clotheshorse. You could put anything on her you wanted. If it showed something, then she accepted it. . . . As long as it showed a little something."

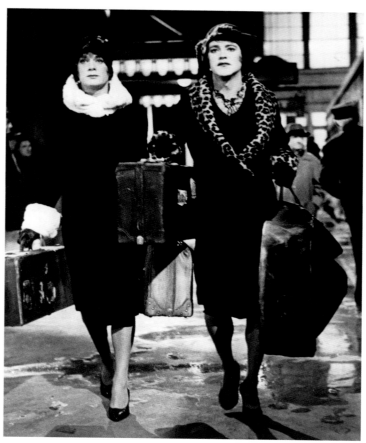

**Jack Lemmon (actor):** "We agreed that since it was lunchtime we would, like two ding-dongs, go down to the studio commissary dressed up like broads. One of us, I forget whether it was Tony or me, got the bright idea that a true test would be a visit to the ladies' room. So in we went! I mean, all the way! Obviously, all the women were in stalls . . . we weren't, you know, peeking or anything. Well, we futzed around in the lounge, pursed our lips and running our fingers over our brows and whatever else we could think of that ladies would do. Do you know, not one of the girls going in or out ever batted an eyeball? They thought we were extras doing a period film on the lot. That did it. That gave us the security we needed. . . . We figured if those women bought it, they'd sure as hell buy it on camera."

**Jack Lemmon (actor):** "'A lot of people thought Billy was crazy to attempt such a film. Friends told me I could be ruined because the audience would think I was faggy or had a yen to be a transvestite. . . . I finally decided the real trap was to ever think of the trap. . . .

"[Instead] I saw this character I was to play as a nut from the moon who never really stopped to think once in his life. He didn't act—he reacted—to whatever was happening. How else was it possible to justify a guy who, because he's dressed like a woman, delivers a line like: 'If those gangsters come in here and kill us, and we're taken to the morgue dressed like this I'll die of embarrassment!'? Now the line isn't that funny unless the character can say it and really *mean* it—because he doesn't *think*. He isn't concerned that he's going to be shot; he's worried he'll be caught in drag."

### *SOME LIKE IT HOT* (1959) · ORRY-KELLY, COSTUME DESIGNER

# 1960s

With President Kennedy presiding over an administration idealistically dubbed "Camelot," the grim postwar era was coming to an end. Optimism reigned, and with the new hope came rising hemlines. Our youthful and sexy president wore no top hat to his inauguration, and he inspired the country to reach for the moon; both fashion and furniture followed suit, turning a futuristic corner. But Hollywood was stuck in the Mesozoic Golden Age, as the archaic studio system struggled in its desperate competition with the free entertainment of television at home. The studios, which had cranked out hundreds of films each year, now faced a midlife crisis.

When the 1960s began, Hollywood was still riding the wave of big-budget musicals and epics that had seen it through the '50s. While the success of musicals would continue—at least for a time—the popularity of the sword-and-sandal epics began to ebb, and many of those released in the early 1960s flopped. Despite offering Charlton Heston and Sophia Loren in period dress, *El Cid* failed to deliver audiences in 1961. The epic production of *Cleopatra*, released two years later,

OPPOSITE: *"When I did Gypsy . . . they wouldn't even allow the shadow of my cleavage or my navel to show. So they would light my breast in such a way that there would be no shadows and they would glue rhinestone flowers to my navel." —Natalie Wood, Gypsy (1962) • Orry-Kelly, costume designer*

was a financial disaster that cost 20th Century Fox more than $40 million and left the studio on the verge of bankruptcy. The cost of clothing the cast of thousands ran to half a million dollars; Irene Sharaff's costumes for Elizabeth Taylor, including a gown of 24-carat gold thread, cost $130,000 alone. Costume designers Renié, Nino Novarese, and Sharaff won Academy Awards for their work, but the public didn't care.

Even as they watched the failure of these and other spectacular epics, like 1964's four-hour *Fall of the Roman Empire*, the studios were turning to smaller, more thematically complex dramas such as *To Kill a Mockingbird* (1962) and *Night of the Iguana* (1964). The naturalistic familiarity of contemporary pictures like *The Apartment* (1960) and *The Misfits* (1961) connected with an increasingly sophisticated public. Mike Nichols, who began his directing career in the '60s with *Who's Afraid of Virginia Woolf?* (1966), said, "An audience is a ruthless, heartless, and unruly monster, and if it doesn't sense *purpose* then get out of its way, because it's going to be difficult—difficult to get the attention of, difficult to make laugh, difficult to carry along on the journey that is any particular story." The public was hungry for innovation and relevance in an industry that had grown stale.

With the audience demanding modern subjects—and the accountants demanding belt-tightening measures—many studio production executives decided that clothes for their films could simply be purchased from local sources. Soon, the costume departments were on the cutting block. Edith Head didn't sugarcoat the matter: "The studio designer . . . was suddenly a thing of the past." Studios discouraged designers from creating modern clothes when a wide range of clothes were thought to be readily available. "More and more contemporary costumes were simply being purchased in Los Angeles and Beverly Hills department stores—and that was a job for an increasingly important person in the wardrobe department, the *shopper*," said Head, who left Paramount in 1967 when the studio declined to renew her contract.

By the studio executives' standards, costume design was not considered a skill requiring technical expertise, like cinematography. Production designers were considered architects of the film, creating blueprints and sometimes supervising storyboards. As art directors and cinematographers assumed fancy new titles—*production designer* and *director of photography*—costume design went on life support. Producers subscribed to the convenient and arguably sexist notion that anyone could "shop" the costumes for a modern movie. They thought that designing the costumes for a film was a matter of choosing a few flattering outfits and making sure they didn't clash with the scenery.

To save money, the designers' distinctive role was being filled increasingly by their costume crew, and costumers working as de facto costume designers. Although costume supervisors had coordinated the costumes for Westerns and B pictures for years, A pictures were understood to need the artistry only a costume designer could bring to a production. The role of the costume supervisor, or *costumer*, had been to manage the costumes on the production, to work with the designer to develop the budget, to oversee the manufacture, purchase, or rental of the costumes, to supervise the cleaning and storage of the costumes, and to dress the actors for each scene. It was not, by definition, a creative position. During this period, however, costumer supervisors increasingly stepped into the role of costume designer—without designer credit or compensation—filling both roles without the support of an additional costumer or costume designer.

The role of costume designer, and the prestige of the costume department, were diminished by this lack of respect and recognition. In the 1960s, many contemporary motion pictures and

television productions credited no costume designer at all—an omission the industry hadn't seen since the earliest silent pictures.

Yet this was also a time of generational shift; the executives, producers, directors, writers, cinematographers, art directors, and costume designers of old Hollywood, many of whom had been working since the silent era, were retiring. Taking their place was a new crop of filmmakers—and with them came a group of wildly talented costume designers. The stylistic and story revolution ignited by these filmmakers brought the audience back into the theaters. Mike Nichols, Arthur Penn, Roman Polanski, Robert Altman, Sydney Pollack, and Norman Jewison collaborated with designers Donfeld, Anthea Sylbert, Albert Wolsky, Theadora Van Runkle, Theoni Aldredge, and Ann Roth. These freelance designers, some from New York and others who had been assisting in Hollywood, started their design careers at a time of industry uncertainty.

Those lucky enough to find employment continued to do the designer's job—analyze the screenplay, do research, and work intimately with the director, actor, and production designer. Costume design was no longer an art that took place exclusively on the drawing table, in the fitting room and workroom; the adventuresome new designers combined their own work with finds they'd made at local retail shops, thrift stores, and flea markets. The studios thought they could save a bundle by altering or dyeing old costumes from their enormous wardrobe stock, or by renting from a costume house. Producers did not comprehend that every choice was a design choice, whether made in a department store or in a costume workroom. Costume designers once again engaged in the traditional collaborative conversations about the primacy of character, but now they achieved their ends by cobbling together their garments from many disparate sources.

Although costumers filled the role of costume designer in some modern films, period and fantasy pictures were still undeniably the realm of the costume designer. Designing the two Depression-era classics of the late 1960s, Donfeld and Theadora Van Runkle combined faded and frayed studio costume stock with designed and custom-made costumes for principal actors. For Sydney Pollack's 1969 film *They Shoot Horses, Don't They?* Donfeld remembered, "We had to capture the mood and flavor of an unfavorable era, the Depression. I had to design 1932-style costumes for Jane Fonda, Susannah York, and the leading man, as well as for the 350 to 700 extras we needed daily in the dance sequences."

The 'new ugly' film style, featuring sweaty, bloodied, beat-up but beautiful actresses (like *They Shoot Horses* stars Jane Fonda and Susannah York), proved influential beyond the borders of Hollywood. Style and glamour now found their inspiration in grungy nonfiction films and *cinema verité*. At the decade's end, the civil rights struggle, riots, assassinations, and the Vietnam War darkened the mood of the nation. Happy endings were rare in sophisticated Hollywood morality tales such as *Bonnie and Clyde* (1967), about two murderous bank robbers from the 1920s. "We didn't know what we were tapping into," director Arthur Penn once said. "The walls came tumbling down after *Bonnie and Clyde*. All the things that were in concrete began to just fall away." Van Runkle's romantic Depression-era designs for Faye Dunaway's Bonnie Parker sparked a worldwide fad, and Donfeld's washed-out floral shifts for *They Shoot Horses* sent scores of girls searching their grandparents' attics, flea markets, and thrift stores.

Audiences soundly rejected the artificiality and static frame that Hollywood films had come to represent. "Hollywood" connoted an artificiality that was no longer fashionable in stories, settings, or clothes. Costume designers had always taken their cue from studio "house" styles, codified by long-ago art directors and costume designers. Studio product had come to signify a slick,

uniform perfection, full of painted-doll actors with not one lacquered back-combed hair out of place. Ironically, the pressure to downsize productions and lower budgets worked to the advantage of a new style of storytelling. Blending purchased, rented, and manufactured modern costumes, costume designers (and costumers working as de facto designers) yielded a more naturalistic and gritty result.

In the films of the later 1960s, everyday characters looked more like the audience and less like the ultragroomed movie stars of yore. Donfeld reflected on Irene Sharaff's uncostumey modern-day ensembles for Mike Nichols's *Who's Afraid of Virginia Woolf?*: "I wouldn't say there was any one dress, suit, sweater or gown that sent people out of the theater wishing for 'one like it.' But when those characters spoke the audience listened. When Martha [Elizabeth Taylor] acted like a slob, she looked like a slob." Miss Sharaff's "real" clothes for *Virginia Woolf* won the last Academy Award for black-and-white costume design in 1967.

The new generation of film actors snubbed the old Hollywood glamour. Big hair and big jewelry were suddenly considered inconsistent with being taken seriously as an actor. Hippie chic and modish understatement prevailed. Beaded, feathered, and bias-cut gowns were still being manufactured in Hollywood, but now for television variety show stars Cher and Carol Burnett. Costume designer Bob Mackie, the genius behind these creations, never lost his sense of humor and never developed an allergy to glamour. It wasn't until the 1990s, with the rise of celebrity culture, that stars finally recognized that they could portray a "plain Jane" in a film and then appear unapologetically old-Hollywood glamorous on the red carpet.

Still photography also suffered from the reactionary anti-glamour sentiment among "serious" film actors. In previous decades, studio publicity departments had regularly hired the best still photographers to shoot contract players in every conceivable outfit and pose. From Bette Davis to Debbie Reynolds, these stars were photographed sporting tennis clothes and swimsuits, lounging in negligees and in ball gowns—and the regular stream of dazzling portraits helped promote their careers through national distribution to fan clubs and movie magazines. With the fall of the studio system, contract players were no longer a bankable studio asset. Stars no longer "dressed up" in their private lives, and no longer called on studio hairdressers and costume designers for their extracurricular appearances. As the internal structure of the studios disintegrated, the quality of movie stills spiraled downward; ultimately it was up to the still photographer on each set to grab what they could of the actors in costume.

*Annette Funicello and Frankie Avalon in* Beach Party *(1963) •*
*Marjorie Corso, costume designer*

The initiation of the modern movie ratings system, following the closure of the Hays Office in 1968, sparked a radical change in onscreen sexuality. Actors and costume designers were finally liberated from the interference of the censors. Still in force at the beginning of the 1960s, the Hays Code did not permit two-piece swimsuits on screen until 1963, the year *Beach Party* was released. It was Walt Disney who would not allow Annette Funicello to wear a bikini. No longer did a costume designer need to disguise cleavage, prevent jiggles, or dye underwear to create the illusion of nudity. With the new ratings system, films with nudity were simply allotted a more restrictive rating. For his role in *The Planet of the Apes* (1968), Charlton Heston wore "damn near no clothes. . . . The primitive, voiceless humans should of course have been naked," he said. "But all that frontal male nudity would be a problem in the film even today." Male and female nudity was welcomed with equal enthusiasm.

By the time Raquel Welch conquered the planet in *One Million Years B.C.* (1966), the Hays Office was no more. Designer Carl Toms's miniature cavewoman costume was billed as "mankind's first bikini," and achieved instant iconic status. Welch's miniature chamois shift stretched throughout the movie's filming from repeated soakings in salt water; scissors and glue were hastily proffered in an effort to save the costume. Realizing that the movie would be nothing to talk about, the filmmakers must have been anxious to ensure that there was plenty to look at.

Desperate for cash, MGM began to divest its physical holdings. In 1970 MGM auctioned off its stock of costumes, furniture, props—even Dorothy's "ruby slippers" from *The Wizard of Oz* (1939)—and raised nearly ten million dollars. Lesser pieces were sold at fire-sale prices on a sound stage on the legendary Culver City studio lot. The following year, 20th Century Fox followed with its own auction. These precious assets represented nearly seventy years of movie making and symbolized nothing less than the cultural iconography of Hollywood itself. Irreplaceable memorabilia and ephemera, relics and remnants of Hollywood's Golden Age were scattered to the winds. The dissolution of the studios' vast research libraries followed; by the late 1960s most of them had either disappeared or been sold. With their thousands of documents— including fashion publications, folios of original drawings, art history books, location research, furniture and interior décor catalogues, and trade pamphlets—these libraries had been used for primary

"The fabric was doe skin . . . as thin as a chamois. Every time I came up out of the sea, which was pretty often, the weight of the water caused the whole thing to stretch. We had to redrape it, trim off the excess and reglue bits of fur around the edges!" —Raquel Welch, One Million Years B.C. (1966) • Carl Toms, costume designer

research by art directors, set decorators, prop masters, and costume designers. Production designer Michael Baugh knew "people who personally salvaged books from dumpsters on the

[studio] lot," and added, "Of course many of MGM's valuable research books were later sold in the gift shop at the MGM Grand in Las Vegas." Most of the back lots were sold to real estate developers for an infusion of much-needed cash. The lot at 20th Century Fox was renamed Century City and promptly decorated with skyscrapers and a shopping mall. Desperate for cash, Paramount and others sold even their film libraries, never once suspecting the future value of "software."

The turning point for the industry came with the release of actor-director Peter Fonda's *Easy Rider* (1969). Peter's father, Hollywood star Henry Fonda, reflected: "Can you imagine Peter and

*Peter Fonda in* Easy Rider *(1969)*

Jack Nicholson and Hopper smoking joints and saying, 'Man! Man!' and capturing not only the mint but the reviews too? *Easy Rider* cost pennies, made a fortune, and Peter didn't even have to get on a horse." Film historians consider the mid-1960s the absolute end of "Old Hollywood." As Peter Biskind concluded in his 1998 study *Easy Riders, Raging Bulls: How the Sex, Drugs and Rock 'n' Roll Generation Saved Hollywood,* "The impact of *Easy Rider,* both on the filmmakers and the industry as a whole, was no less than seismic. . . . After nearly a decade of floundering the movies had finally *connected,* found a new audience."

The studios had entered the decade of the 1960s at a crossroads. Uncertain about the future, and suffering through an identity crisis that came from being absorbed by multinational media conglomerates, the studios and their production slates limped along for years, and the classic Hollywood studio factory system collapsed. Some studios survived, evolving into production plants, distribution companies, or franchises. The studio back lot era had ended and with it Hollywood's classical age. Yet, in the process, Hollywood film style had been deconstructed and redefined.

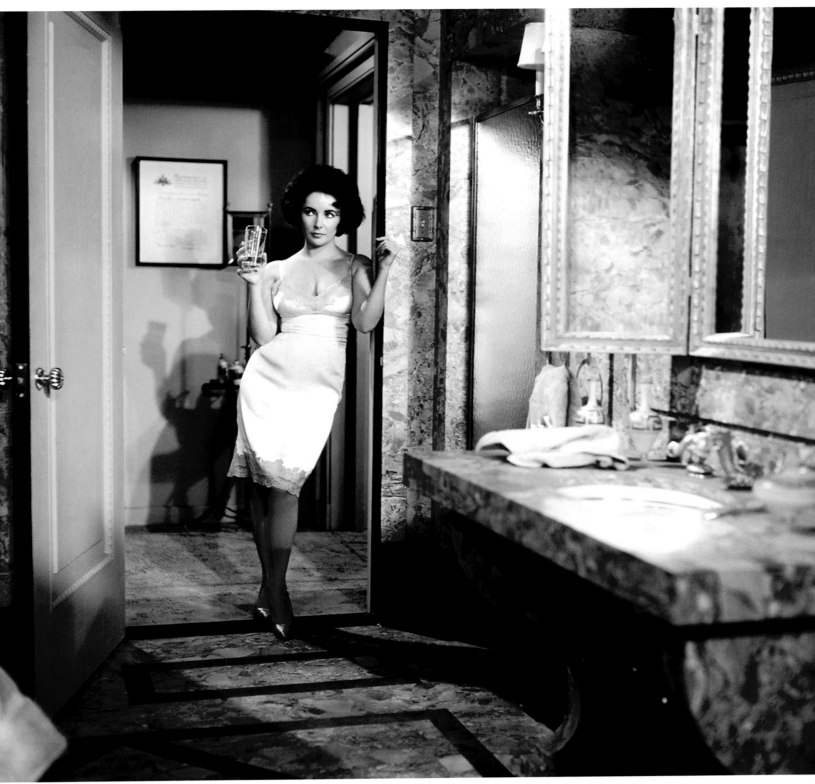

**Elizabeth Taylor (actress):** "I am *not* a 'sex queen' or a 'sex symbol.' I really don't think that's why people come to my movies. I don't think I *want* to be one. 'Sex symbol' kind of suggests bathrooms in hotels or something."

*BUTTERFIELD 8* (1960) · HELEN ROSE, COSTUME DESIGNER

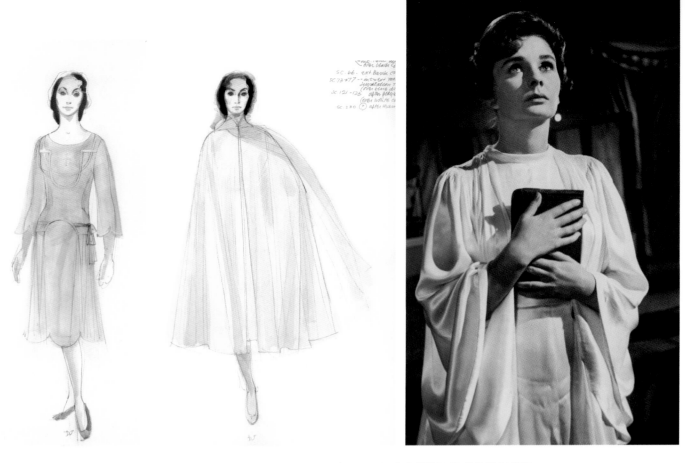

*ELMER GANTRY* (1960) • DOROTHY JEAKINS, COSTUME DESIGNER

**Janet Leigh (actress):** "The slip mentioned in the novel and script became a bra and a half-slip. For the opening love scene, a white bra and half-slip were chosen. Then, after Marion steals the money and is changing for the ride to see Sam we switched to a black bra and half-slip. Mr. Hitchcock wanted even the wardrobe to reflect the good and evil each of us has lurking within our inner selves."

*PSYCHO* (1960) • HELEN COLVIG, COSTUME DESIGNER

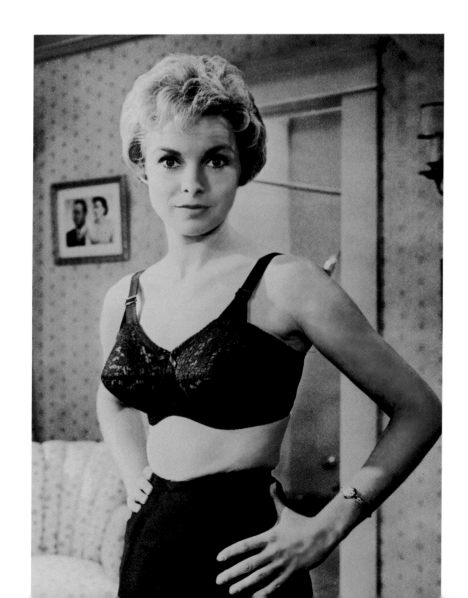

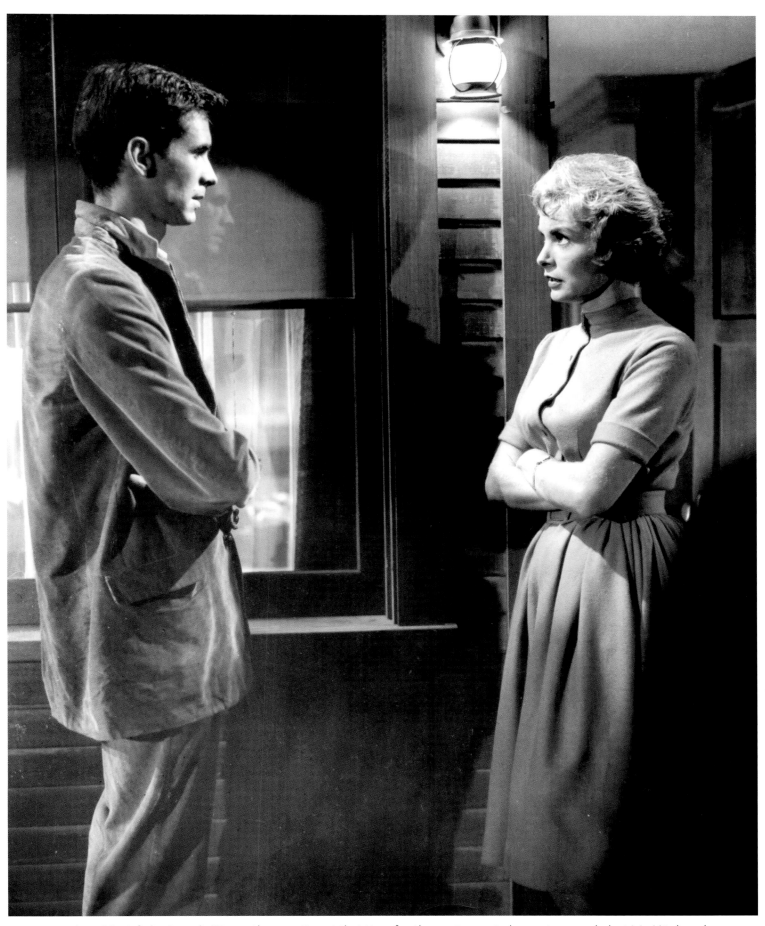

**Janet Leigh (actress):** "It was the practice at that time for the costumes to be custom-made but Mr. Hitchcock insisted we shop in a regular ready-to-wear store. He asked us to buy Marion's two dresses off the rack and only pay what a secretary could afford. We all agreed. [Costumer] Rita Riggs and I went to JAX, a then-popular boutique in Beverly Hills, and found two simple, solid-colored, shirtwaist dresses. One was an off-white cotton, the other a blue wool jersey because Rita noted, 'Mr. Hitchcock likes good wool jersey; it reads well in black and white.'"

*PSYCHO* **(1960) · HELEN COLVIG, COSTUME DESIGNER**

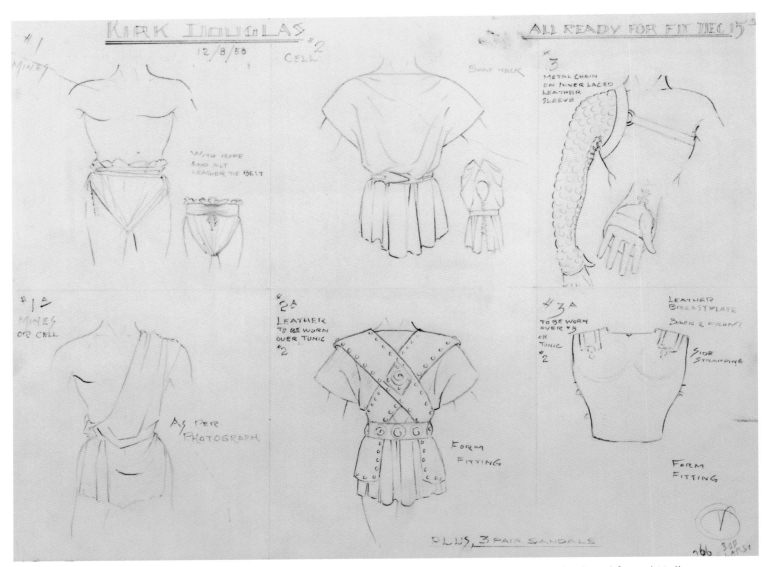

**Vincent LoBrutto (biographer):** "Douglas wanted a distinctive look as Spartacus, so he hired famed Hollywood hairstylist, Jay Sebring, to design a look for the slaves. Sebring's hair design called a 'cow-do' featured a crew cut on top, long hair in the back, and a pony tail, a style quite ahead of its time."

## *SPARTACUS* (1960) · BILL THOMAS, VALLES, AND WILLIAM WARE THEISS, COSTUME DESIGNERS

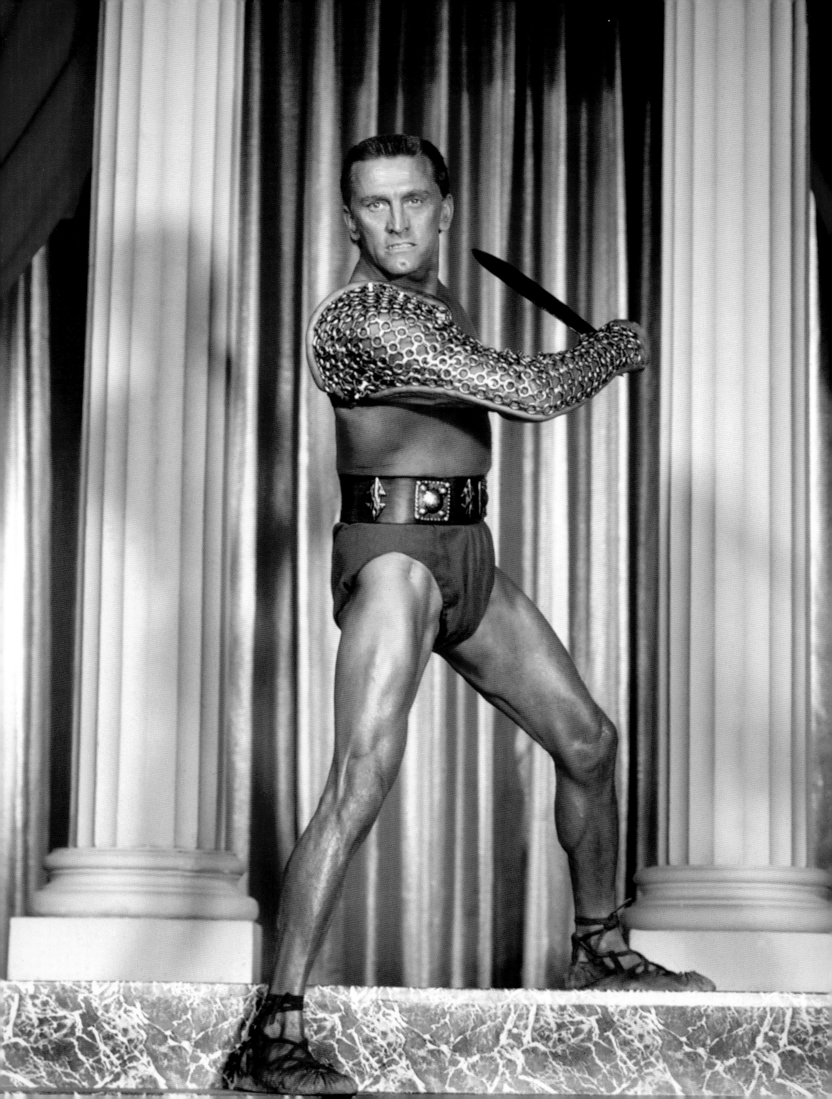

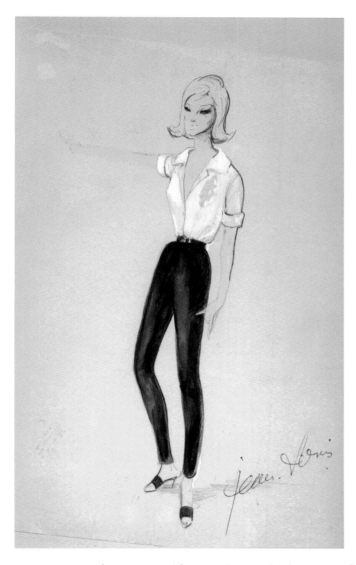

**John Huston (director):** "We had costume fittings with Marilyn in New York. Arthur Miller said Marilyn was afraid that if she didn't get enough sleep she wouldn't look her best the next day; this idea amounted to an obsession, so she was taking pills to go to sleep and pills to wake up in the morning. I was very disturbed by her actions and appearance. She seemed to be in a daze half the time."

*THE MISFITS* (1961) • JEAN LOUIS, COSTUME DESIGNER

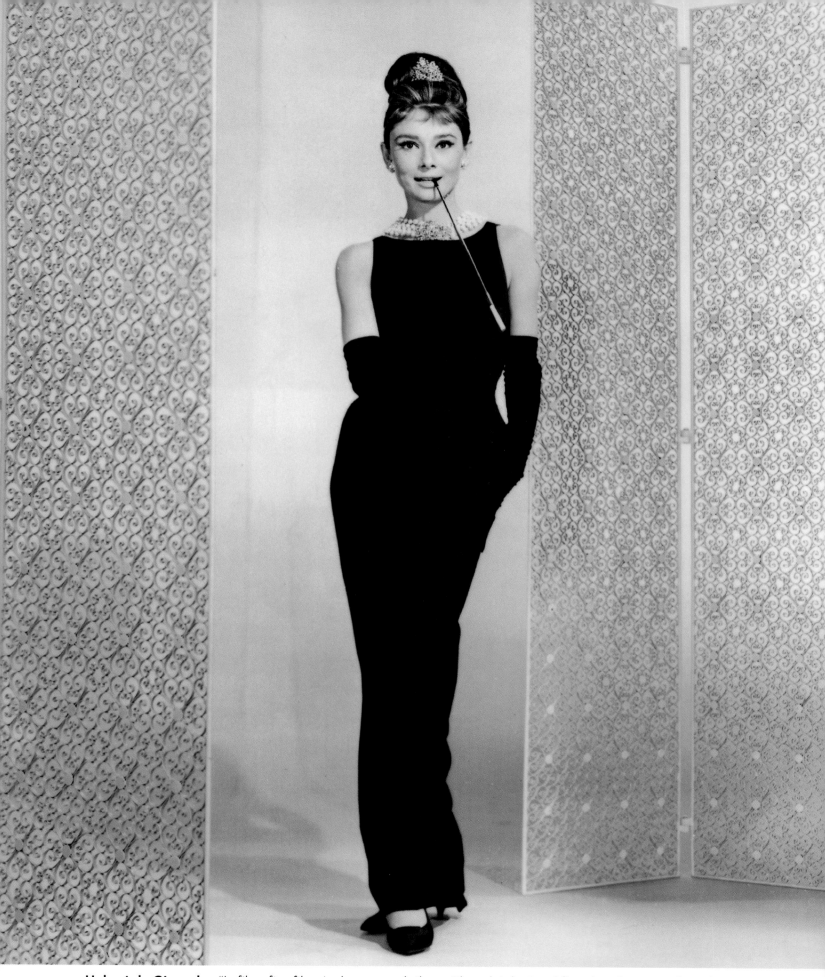

**Hubert de Givenchy:** "In film after film, Audrey wore clothes with such talent and flair that she created a style, which in turn had a major impact on fashion. Her chic, her youth, her bearing, and her silhouette grew ever more celebrated, enveloping me in a kind of aura or radiance that I could never have hoped for. The Hepburn style had been born, and it lives today."

*BREAKFAST AT TIFFANY'S* (1961) · **HUBERT DE GIVENCHY, COSTUME DESIGNER**

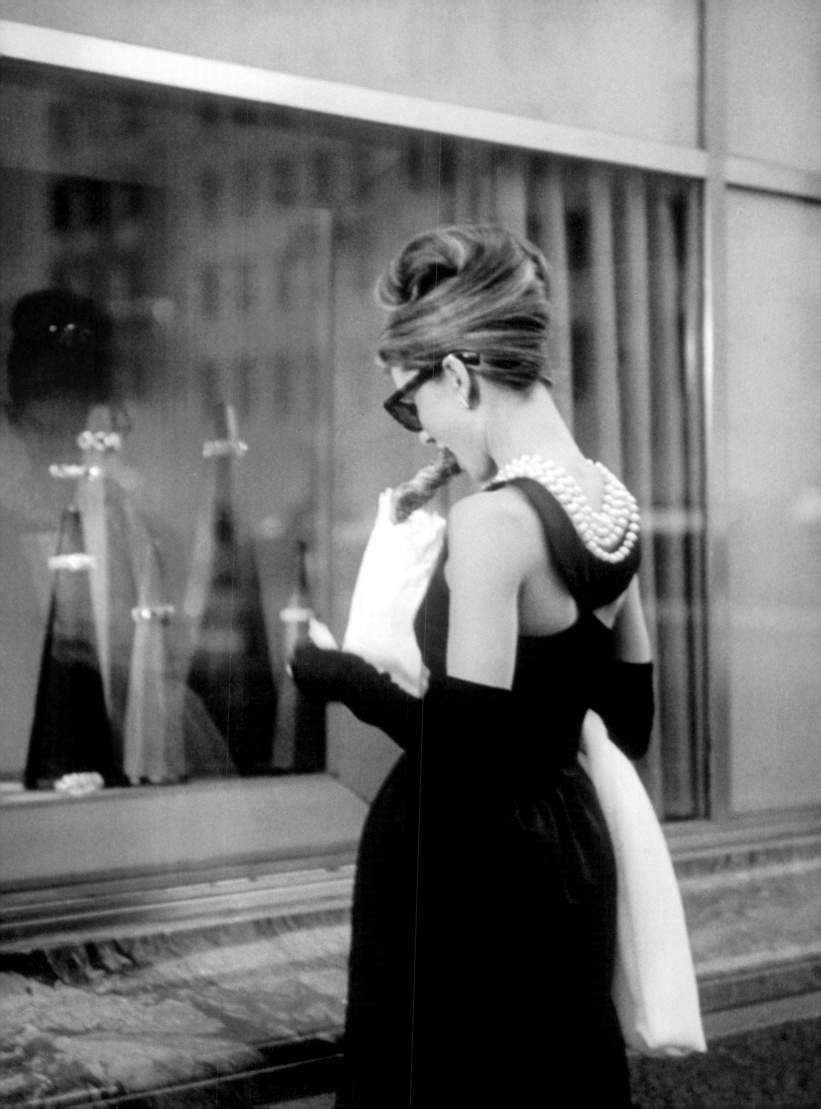

**Irene Sharaff:** "In the costumes for both the stage and screen versions of *West Side Story* exaggeration and fantasy had no place and literalness would not have helped visually. I relied on color to contrast the two gangs with touches in their outfits that were taken from Renaissance clothes. In the fifties, the teenage boys on the streets of New York had arrived at a uniform of their own—not yet taken up as fashionable by men and women—consisting of blue jeans or chinos, T-shirts, windbreakers, and sneakers. It was an outfit economical and comfortable. For the Sharks, the Puerto Rican gang, I used sharp purple, pink-violet, blood red, and black; for the Jets, the other gang, I chose muted indigo blues, musty yellows, and ochre. The colors seemed to suit their physical appearance; moreover, even though in the story the Puerto Ricans were the weaker gang and on the defensive, their outfits gave them an aggressive quality."

### *WEST SIDE STORY* (1961) · IRENE SHARAFF, COSTUME DESIGNER

Academy of Motion
Picture Arts and
Sciences Library
Beverly Hills, Ca

Orry-Kelly

**Jane Fonda (actress):** "I dreamed up a great dress that I thought a nympho would wear, got all nymphoed up, and went to see George Cukor. He burst out laughing and cast me as a frigid widow."

*THE CHAPMAN REPORT* (1962) · **ORRY-KELLY, COSTUME DESIGNER**

**Bette Davis (actress):** "Never were there two more opposite performers in a film than Joan Crawford and Bette Davis. On the day we made our tests for *Baby Jane*, Joan came to my dressing room and said, 'I do hope my color scheme won't interfere with yours.' '*Color scheme???* Joan, I haven't a speck of color in any dress I wear. Wear any color you want. Besides, it is a black-and-white film.'"

***WHAT EVER HAPPENED TO BABY JANE?* (1962) • NORMA KOCH, COSTUME DESIGNER**

**Harper Lee (novelist):** "I'd never seen Mr. Peck, except in films, and when I saw him at my home I wondered if he'd be quite right for the part. The next time I saw him was in Hollywood when they were doing wardrobe tests for the film. They put the actors in their costumes and slam them in front of the camera to see if they photograph correctly. It was the most amazing transformation I had ever seen. A middle-aged man came out. He looked bigger, he looked thicker through the middle. He didn't have an ounce of makeup, just a 1933-type suit with a collar and a vest and a watch and chain. The minute I saw him I knew everything was going to be all right because he *was* Atticus."

***TO KILL A MOCKINGBIRD* (1962) • ROSEMARY ODELL, COSTUME DESIGNER**

**Shirley MacLaine (actress):** "I want to be part of something that's real. I want to make pictures that are an expression of people, that are authentic. It takes a big star to endorse that kind of picture and I'll try and do it. If everyone told the truth then no one would be offended. It's only when half the people don't that the trouble starts."

*THE APARTMENT* (1960) · IRENE GAINE AND FORREST T. BUTLER, COSTUME DESIGNERS

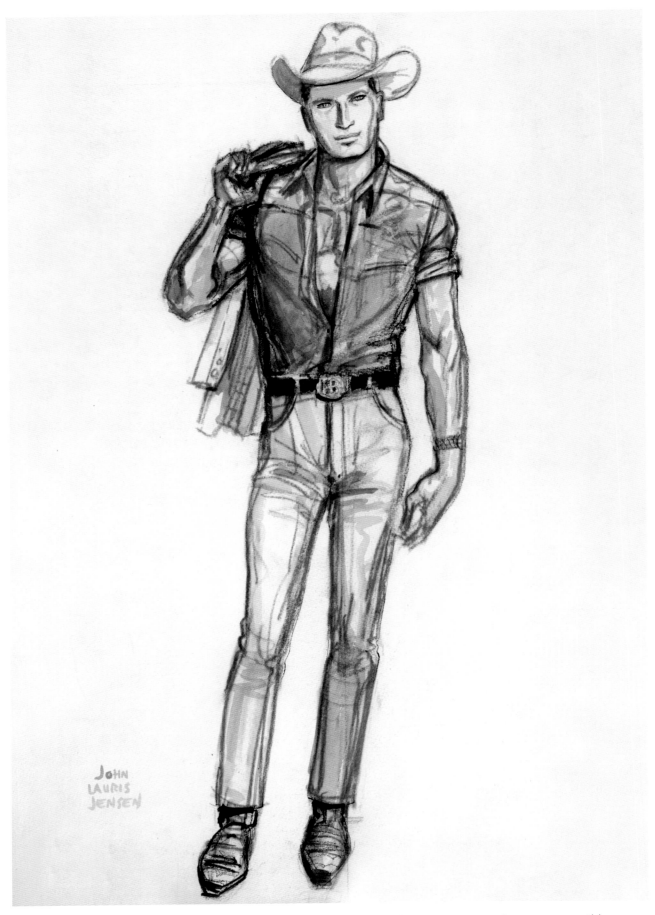

**Edith Head:** "Martin Ritt wanted the clothes on Paul Newman to typify a very egotistical man, a very ruthless man. A man who's vain about his appearance, a bit of a braggart. And still—this, I think, is a particularly important thing— he said, 'I want you to notice Paul Newman; I do not want to notice his clothes. I do not want to have anything like fancy cowboy boots or a trick belt or an unusually cocked hat. I want them to be honest clothes. I don't want them to be theatrical, but I don't want them to be poor or dull.' I would bring in several kinds of shirts, two or three kinds of jeans aged in different ways, different hats. And we would do the tests. Because no matter how good a designer you may be, until you actually see something on the screen you are not sure."

*HUD* (1963) · EDITH HEAD, COSTUME DESIGNER

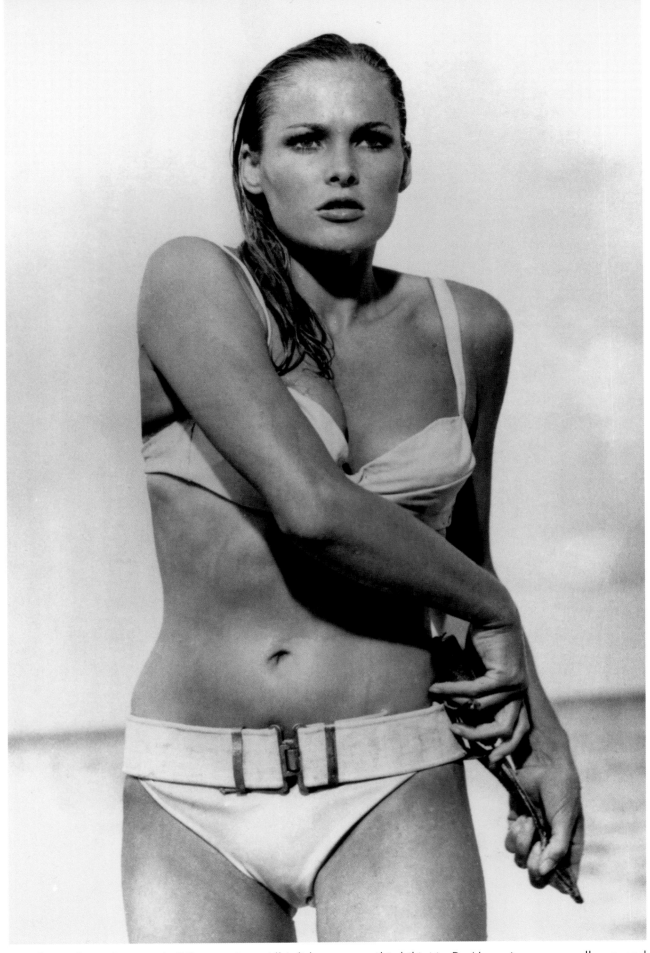

**Ursula Andress (actress):** "It's a mystery. All I did was wear this bikini in *Dr. No*, not even a small one, and *Whoosh!* Overnight I have made it. For that film I got $10,000; suddenly I was worth $50,000."

**DR. NO (1962) · TESSA PRENDERGAST, COSTUME DESIGNER**

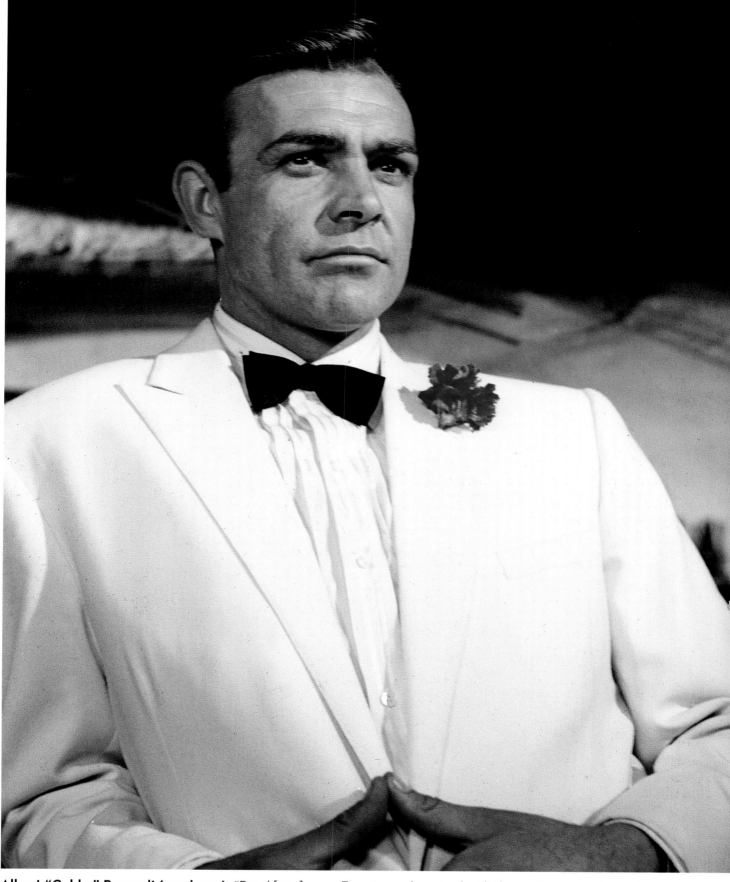

**Albert "Cubby" Broccoli (producer):** "Bond [was] an ex-Eton type who mixed with the aristocracy, belonged to the most exclusive clubs, gambled at Monte Carlo and wore handmade silk shirts and Sea Island cotton pyjamas. Once we had signed Sean Connery, we threw everything into grooming him for the part. We wanted to bring out all those features, which are the unmistakable James Bond hallmark. The casual but well-cut suits, the black, soft-leather moccasins—007 would never tie a shoelace—the silk kimonos—all these were carefully designed to work the Bond style into Sean's macho image."

**Terrence Young (director):** "I used to make him go out in these clothes . . . because Sean's idea of a good evening out would be to be dressed in a lumber jacket."

### *GOLDFINGER* (1964) · ELSA FENNELL, COSTUME DESIGNER

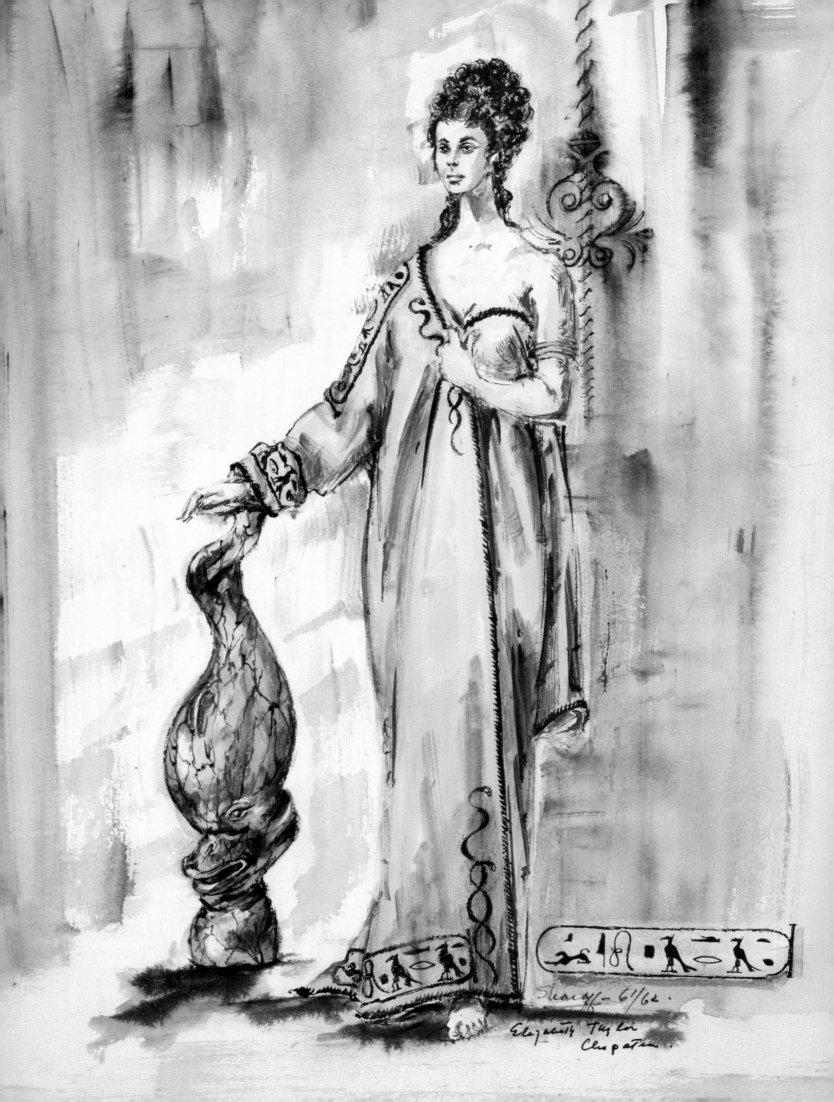

Sharaff — 6/62.

Elizabeth Taylor
Cleopatra.

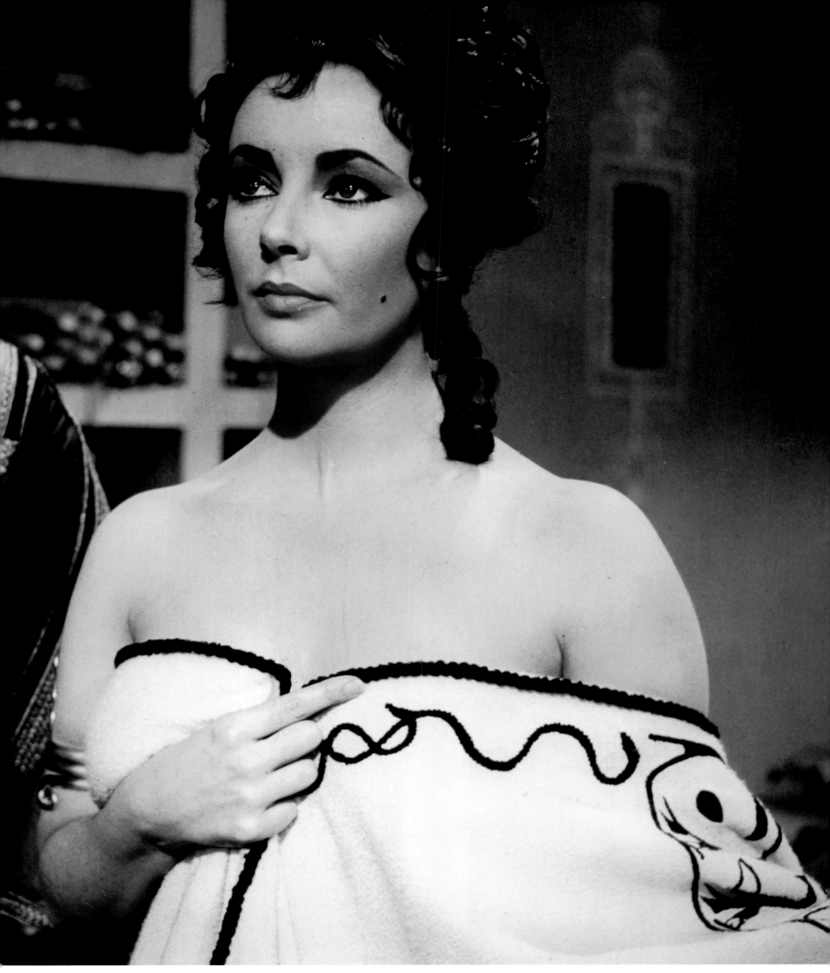

**Irene Sharaff:** "For *Cleopatra*, in which I designed sixty costumes for Elizabeth Taylor, I started using a chart to help keep things clear. It covered one wall of the small office, was useful for the color plan, and served to tell at a glance which costumes and accessories had been shot, which were needed next, and which would be called for later. From then on I used charts for all large productions."

**CLEOPATRA (1963) · IRENE SHARAFF, COSTUME DESIGNER**

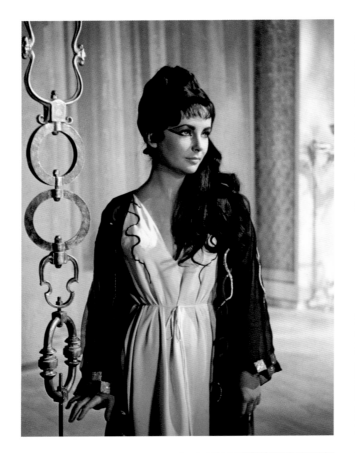

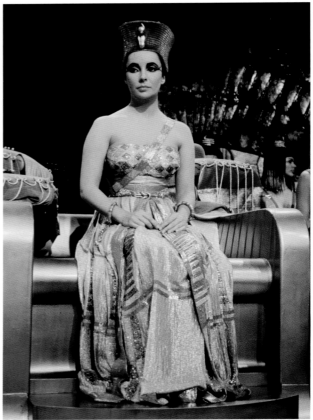

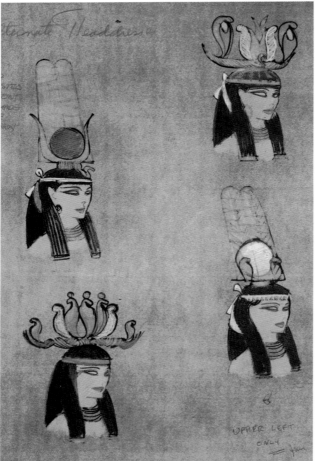

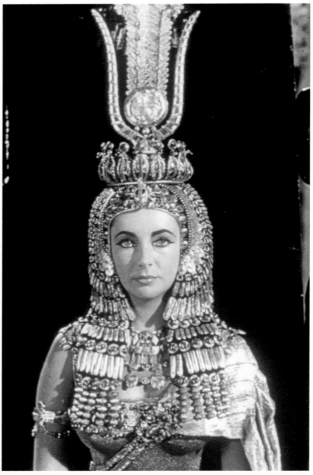

**Irene Sharaff:** "The script called for sixty changes of costume for Cleopatra, from a girl of seventeen to a woman of thirty-seven. One tends to think of Cleopatra as looking the same through her relatively short life, but of course the maturing had to be indicated. . . . All the ceremonial costumes were based on ancient Egyptian tomb paintings; the second group were the clothes such as Roman women of the upper classes might have worn; and the last group made use of one of the oldest garments, the djellabah."

*CLEOPATRA* (1963) · **IRENE SHARAFF, COSTUME DESIGNER**

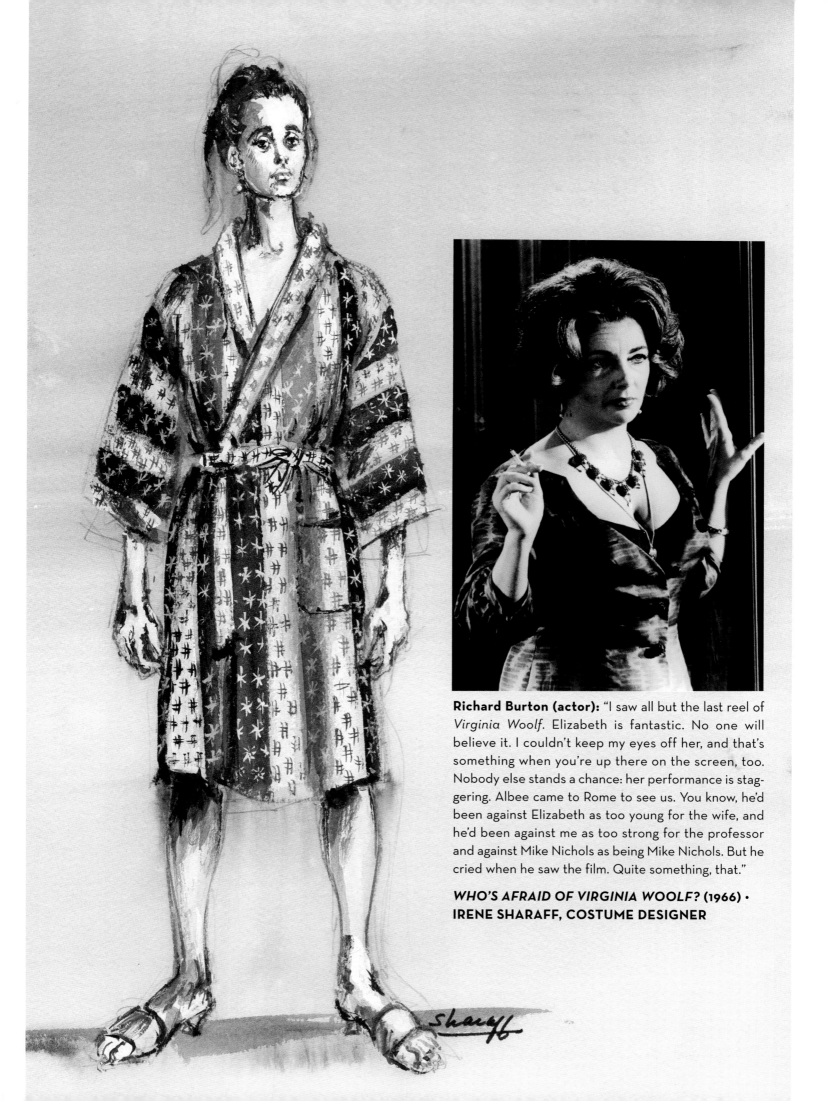

**Richard Burton (actor):** "I saw all but the last reel of *Virginia Woolf*. Elizabeth is fantastic. No one will believe it. I couldn't keep my eyes off her, and that's something when you're up there on the screen, too. Nobody else stands a chance: her performance is staggering. Albee came to Rome to see us. You know, he'd been against Elizabeth as too young for the wife, and he'd been against me as too strong for the professor and against Mike Nichols as being Mike Nichols. But he cried when he saw the film. Quite something, that."

### *WHO'S AFRAID OF VIRGINIA WOOLF?* (1966) • IRENE SHARAFF, COSTUME DESIGNER

**Anne Bancroft (actress):** "Look at the script of *The Miracle Worker*. What is the whole thing about? It's about a woman who, if she does not teach this child, both she and the child will perish. Of course, I have nothing like that in my own life, I have to take something else in my life, in which I have to say, if I don't do a certain thing, *I will perish.*"

### *THE MIRACLE WORKER* (1962) · RUTH MORLEY, COSTUME DESIGNER

**Cecil Beaton:** "Geoff Allan, a burly youth from the outskirts of London, has become an expert at 'aging' clothes. Today he was breaking down the black velveteen jacket in which Eliza first visits Higgins's house. In a test, the coat had appeared too elegant. Geoff put the coat in a boiling vat. After a few hours the black velvet had become a cream color. Now Geoff started to make the coat many shades darker, spooning on dye, leaving light patches where the sun might have faded the collar and shoulders. The coat was then dried in a furnace. To me, it looked like something found in an ancient Egyptian tomb, as brittle and brown as a wafer. Geoff then gave the garment a few deft strokes with a wire brush, saying, 'This bit of pile will soon disappear.' It did. Later Geoff said, 'I'll sew the frogs on again—coarsely, with black thread. Then I'll rip them off. Then I'll knife the seam open here as if it's split. Afterwards, with coarse thread, I'll patch it. The collar will have to be stained a bit—tea stains—and there must be greasy marks on the haunches where she wipes her dirty hands. Naturally the skirt will have to be muddy around the hem.' I gave Audrey's coat seven different dyings to make it look as old as that. But I was upset when the crown of her hat fell apart. It became nothing but a handful of black filings."

*MY FAIR LADY (1964)* • CECIL BEATON, COSTUME DESIGNER

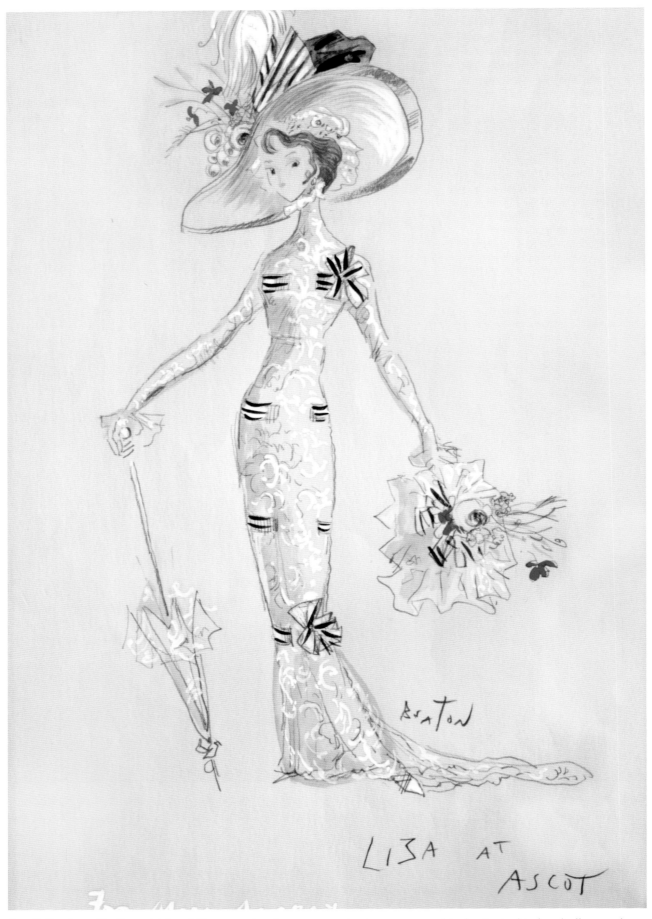

BEATON

LISA AT ASCOT

**Cecil Beaton:** "In the middle of the crowds of race-goers Audrey appeared to be tested in her ballroom dress and coiffure. Never has she more lived up to her name, and never was her allure more obvious than now as she smiled radiantly or shyly, flickered her eyelids, lowered her lashes, blinked, did all the tricks of allure with enormous assurance. She gyrated in front of the camera while two hundred extras watched. She was vastly entertained that some of them were scrutinizing her through their race glasses."

*MY FAIR LADY* (1964) • CECIL BEATON, COSTUME DESIGNER

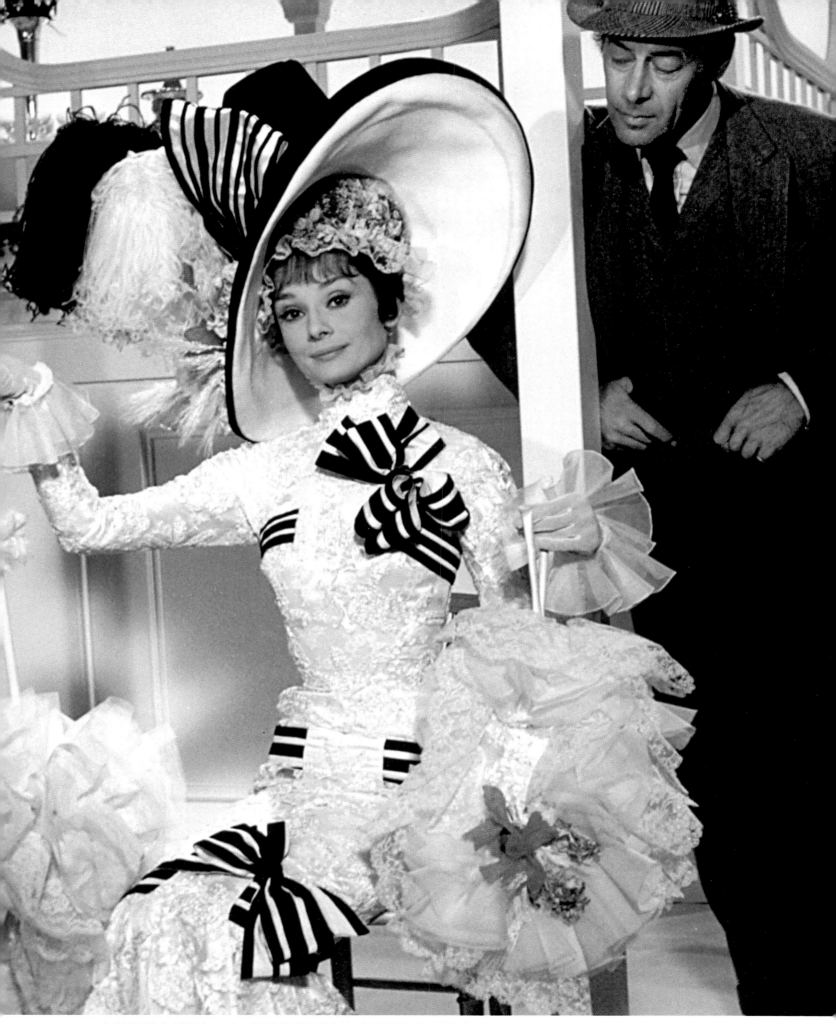

*MY FAIR LADY* (1964) · CECIL BEATON, COSTUME DESIGNER

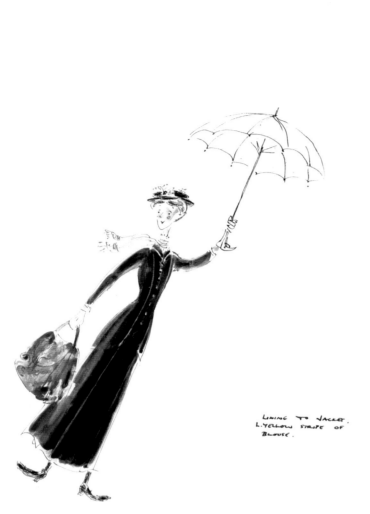

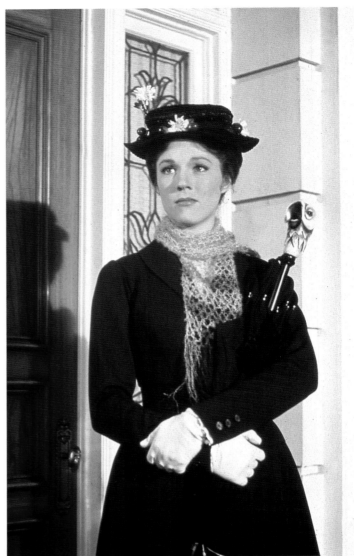

LINING TO JACKET.
L. YELLOW STRIPE OF
BLOUSE.

**Julie Andrews (actress):** "Walt Disney promised I can have the hat from *Mary Poppins*; it's my favorite hat in all the world."

**Tony Walton:** "Walt Disney presented me with an intriguing challenge: Although he had acquired the rights to the *Poppins* books, he didn't have the rights to the illustrations. They had been done by the daughter of Ernest Shepherd, who illustrated all the Winnie the Pooh books and *Wind in the Willows*. Disney was going through a legal tangle in connection with the Pooh films, and wanted to avoid complicating matters further with the Shepherd estate. Therefore, he said, 'We must have the costumes suggest the appearance of all the characters in the books without actually using any specific detail from those illustrations.' Quite a tricky proposition!

"I was helped by the change of era but, in particular, I decided to try to suggest a sort of secret life for Mary by giving her excitingly colored linings to the otherwise low-key palette of her wardrobe. Even the daisies on her hat were organized to suggest something a little nuttier in her otherwise staid and precise character. This was also true for the shape of her shoes. Her scarf came about as a result of Walt's enthusiasm for the knitted mohair tights I'd designed for Zero Mostel and the other clowns in *A Funny Thing Happened on the Way to the Forum* on Broadway (which he had seen the night before checking out Julie in *Camelot*). Zero [had had] a bad and unpleasant-looking leg wound (he had been knocked down by a bus), [so] he could not be bare-limbed as a Roman slave, and since he was a sweaty fellow, I had his mohair knitted on needles the size of drainpipes so that the 'loops' would be big enough to allow ventilation while the mohair 'fuzz' would conceal the loop size. Walt was quite tickled by this, and kept saying, 'maybe there's a way we can use that look in *Poppins*' . . . so I used the drainpipe knitting needles for Mary's scarf . . . which made him very happy."

### *MARY POPPINS* (1964) • TONY WALTON, COSTUME DESIGNER

**Robert Wise (director):** "The sentimentality and *gemütlichkeit* that worked on stage could easily become heavy-handed on the screen ... To avoid this, production designer Boris Leven and costume designer Dorothy Jeakins checked carefully to avoid backgrounds or clothing that might be too ginger-bready or cloying."

*THE SOUND OF MUSIC* (1965) · DOROTHY JEAKINS, COSTUME DESIGNER

Maria II ³
wedding day

2-3

sheer dress over bangalore silk -- deep hem
velveteen bodice w. satin piping
organza veil bound w. soft satin 1" wide, attached to fluted cap

Lily --
Dearest Friend,

Dorothy J 72

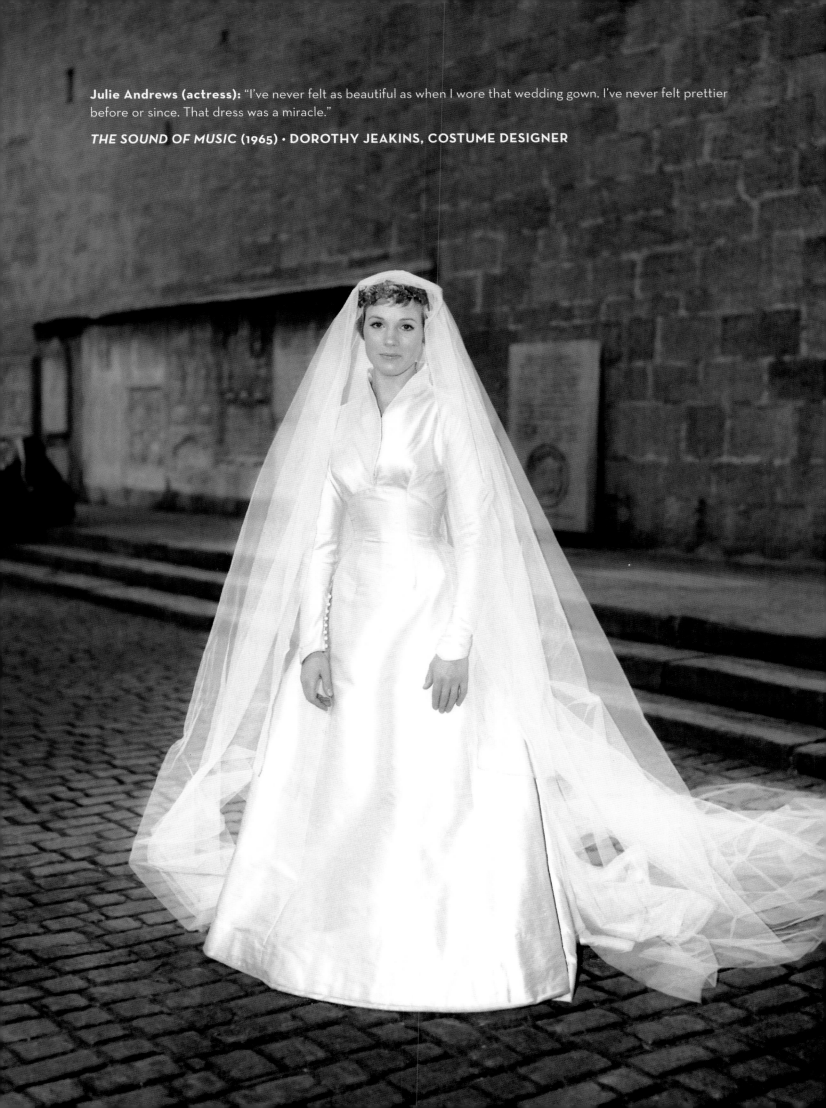

**Julie Andrews (actress):** "I've never felt as beautiful as when I wore that wedding gown. I've never felt prettier before or since. That dress was a miracle."

*THE SOUND OF MUSIC* (1965) · DOROTHY JEAKINS, COSTUME DESIGNER

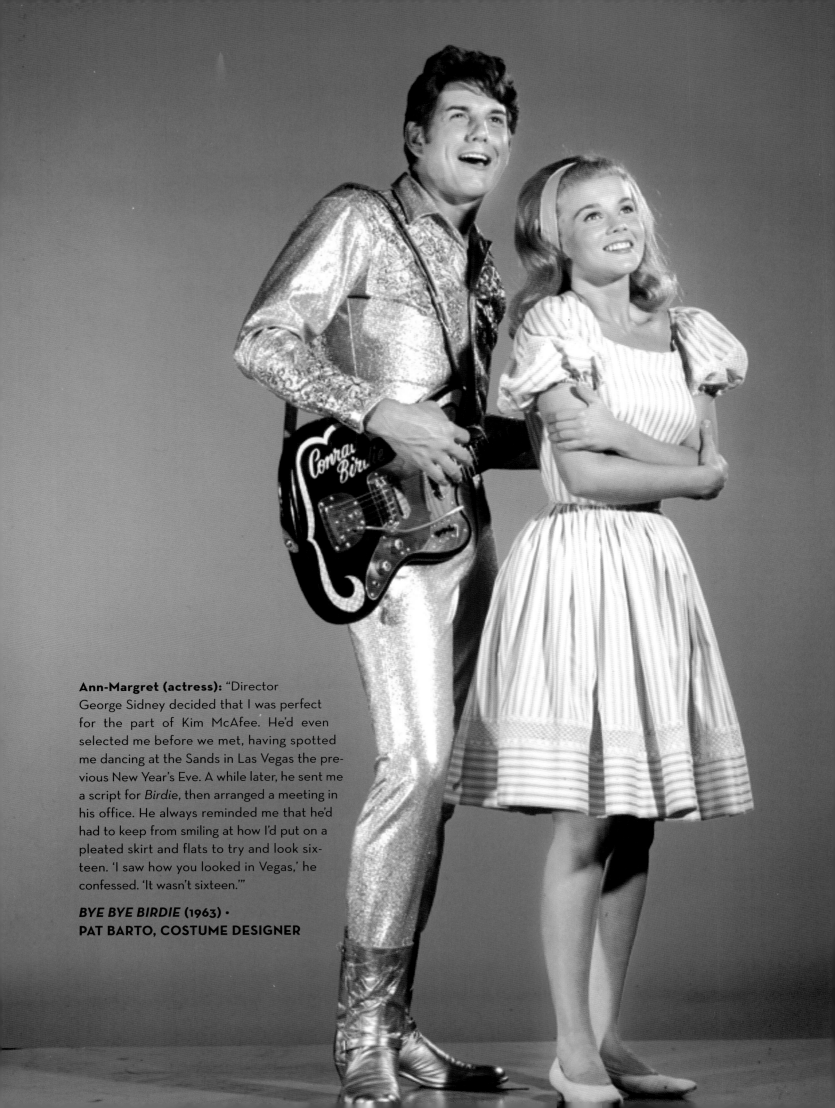

**Ann-Margret (actress):** "Director George Sidney decided that I was perfect for the part of Kim McAfee. He'd even selected me before we met, having spotted me dancing at the Sands in Las Vegas the previous New Year's Eve. A while later, he sent me a script for *Birdie*, then arranged a meeting in his office. He always reminded me that he'd had to keep from smiling at how I'd put on a pleated skirt and flats to try and look sixteen. 'I saw how you looked in Vegas,' he confessed. 'It wasn't sixteen.'"

*BYE BYE BIRDIE* (1963) ·
PAT BARTO, COSTUME DESIGNER

**Jane Fonda (actress):** "*Barbarella* is a film that's always brought up, but as a matter of fact, I was hardly ever nude. Most of the pictures where I was dressed to the teeth and played a cute little ingénue were more exploitative than the ones with nudity because they portrayed women as silly, as mindless, as motivated purely by sex in relation to men. . . . I never felt like *Barbarella*. I never felt like the American Brigitte Bardot. I always felt slightly out of focus. There was Jane, and there was this public figure. It was extremely alienating. I never liked it. I never felt comfortable with it."

***BARBARELLA* (1967) · JACQUES FONTERAY AND PACO RABANNE, COSTUME DESIGNERS**

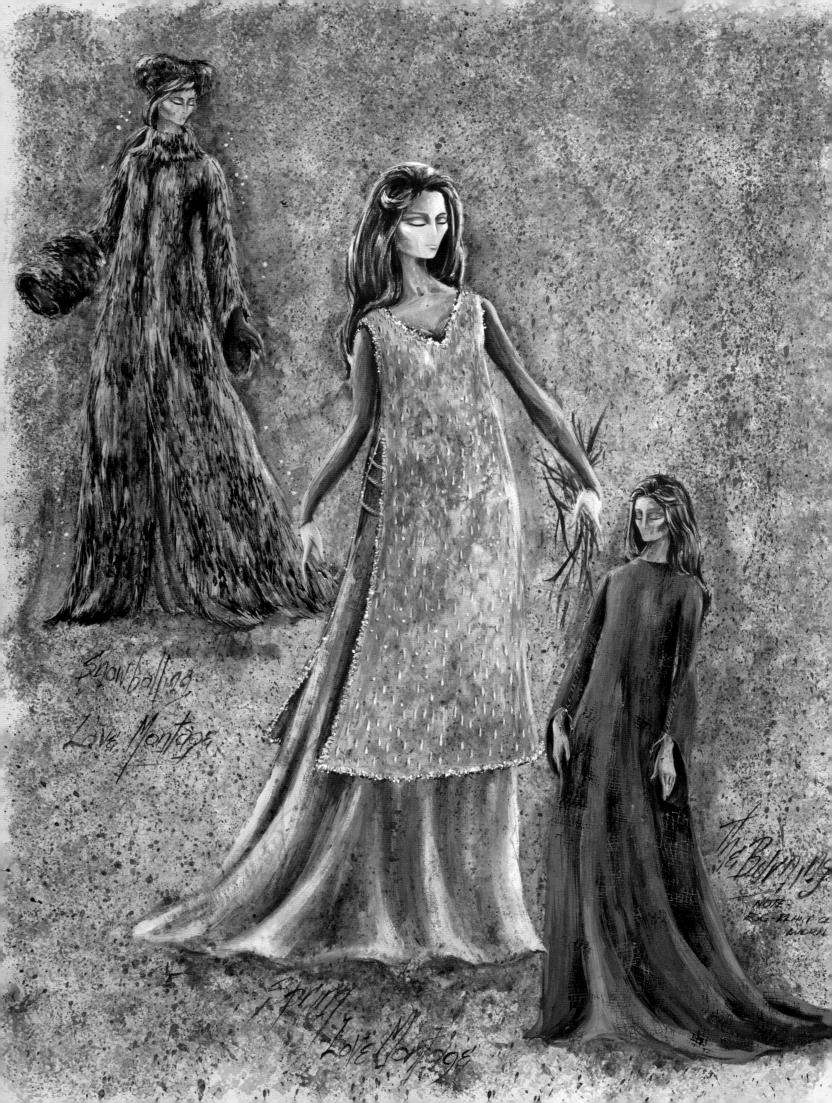

Snowballing
Love Montage

**Vanessa Redgrave (actress):** "I was taken for measurements and fittings into the building where the cutters, fitters, seamstresses, embroideries, worked—about one hundred skilled men and women. I saw the wedding dress being made for Guinevere, hundreds of finely crocheted woolen spider webs sewed together with tiny red shells sewed into the center of each web and bleached melon seeds instead of pearls hanging from each corner."

*CAMELOT* (1967) · JOHN TRUSCOTT, COSTUME DESIGNER

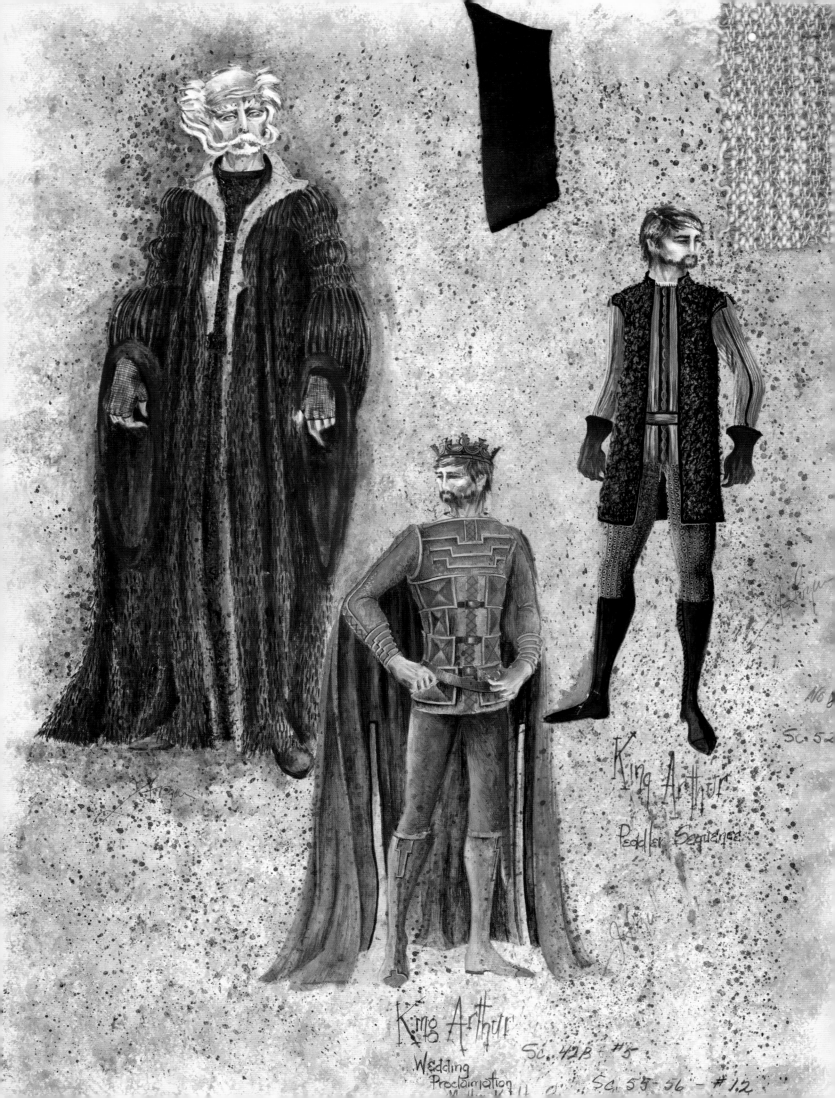

King Arthur
Wedding
Proclamation

Sc. 42B #5

King Arthur
Peddler Sequence

Sc. 55-56 - #12

**John Truscott:** "We have made a calculated effort to create our own Camelot period; one which draws from the past but which is without identification to any specific place or period. The 3,500 costumes are products of the imagination, not of a reference book, and have an aura of timelessness and romanticism that often turns out to be surprisingly contemporary.'"

*CAMELOT* **(1967) · JOHN TRUSCOTT, COSTUME DESIGNER**

BONNIE

BANK ROBBING
OUTFIT SCENE:*

they have to fa
clothes at last

**Faye Dunaway (actress):** "After I got the role of Bonnie, Arthur Penn and I started talking about what she might wear. I thought jeans, maybe, pants of some sort since they were robbing banks and making quick getaways. But Warren and Arthur wanted to put her in dresses, great costumes that would give her style. They had decided to give Theadora Van Runkle (a young sketch artist with a great eye) a shot at designing the costumes. Until I met Theadora, clothes—getting a certain look, and creating an effect—had just been part of the job. She taught me just how much fun it can be. The look for Bonnie was smack out of the thirties, but glamorized and very beautiful. She designed this wonderful Norfolk jacket, I recall. All great, even that first poor little dress that I wore with Clyde was great. They all were cut on a bias and they swung."

**BONNIE AND CLYDE** (1967) · **THEADORA VAN RUNKLE, COSTUME DESIGNER**

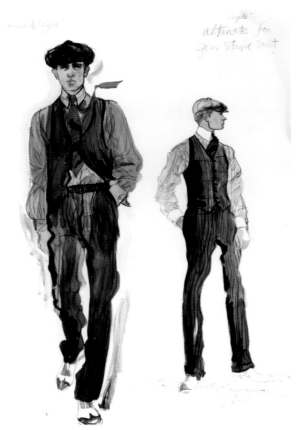

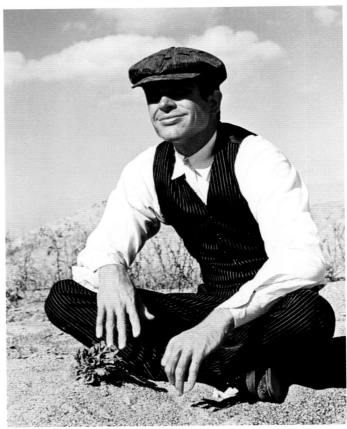

**Faye Dunaway (actress):** "The night after the Paris premiere, a box full of berets was delivered to my room in the Hotel George V. They were from a small village in the French Pyrenees where the traditional French berets are made. After the release of *Bonnie & Clyde*, demand had pushed production from 5,000 to 12,000 berets a week, and they wanted to thank me."

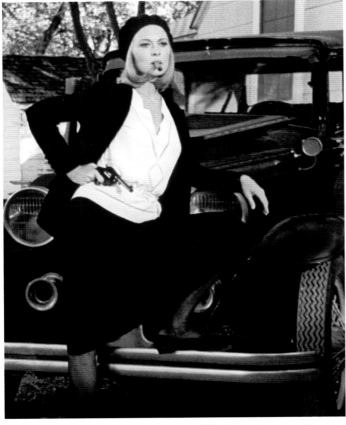

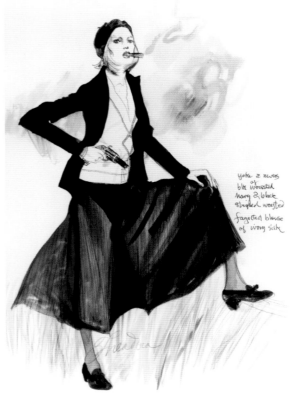

**Theadora Van Runkle:** "How could I have been so fortunate to have someone as ravishingly beautiful as Faye Dunaway for my first leading lady? She was the perfect choice for that character. You really felt that she was naked under the clothes. I think it was the first time since Jean Harlow was making movies that somebody on screen had nothing on beneath her costume."

*BONNIE AND CLYDE* (1967) • THEADORA VAN RUNKLE, COSTUME DESIGNER

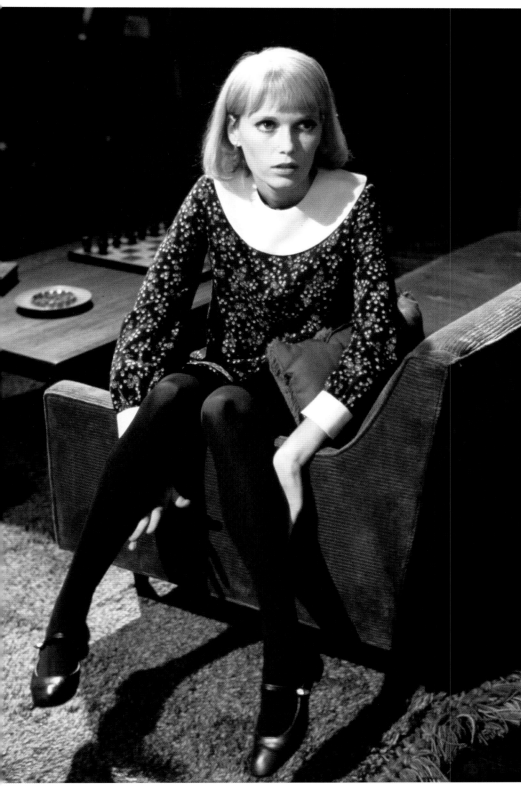

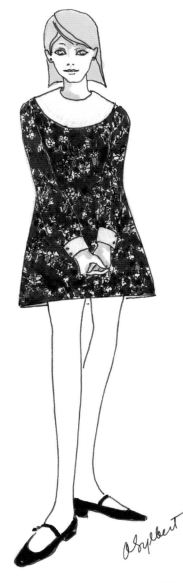

**Roman Polanski (director):** "My prime concern was to re-create the specific mood and atmosphere of the year in which the action took place—1965, or only two years earlier. Anthea Sylbert captured the contemporary look to a T. I also put in another highly topical allusion. 'Don't tell me you *paid* for this?' says Guy when Rosemary comes home with her hair bobbed. 'It's Vidal Sassoon,' she retorts, 'and it's very in.'"

**Anthea Sylbert:** "[The year 1965] was the beginning of the shortening of skirts. I remember, in my very own life, being rather timid about all this, once a month taking up another half-inch tuck and then another half-inch and another half-inch. . . . [In the film,] we started out below the knee and we ended up about mid-thigh. It never got to be the real miniskirt yet. But in the process of that movie, subtle though it may be, her skirts go up."

### *ROSEMARY'S BABY* (1968) · ANTHEA SYLBERT, COSTUME DESIGNER

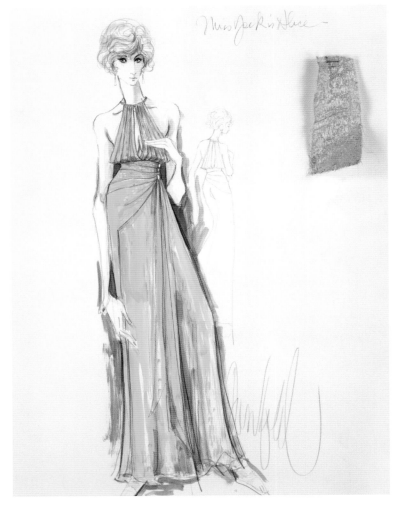

**Donfeld:** "I had to design 1932-style costumes for Jane Fonda, Susannah York and the leading man, as well as for the 350 to 700 extras we needed daily in the dance sequences. I had two key people helping me, plus twenty assistants, one hundred ladies sewing in wardrobe, and twenty tailors. Not one costume sent people out of the theater wishing for one like it. But when those characters spoke, the audience listened."

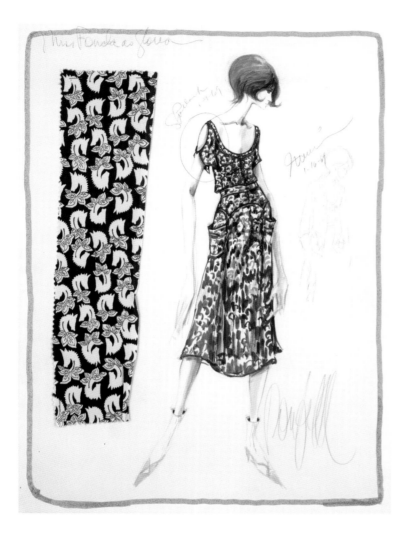

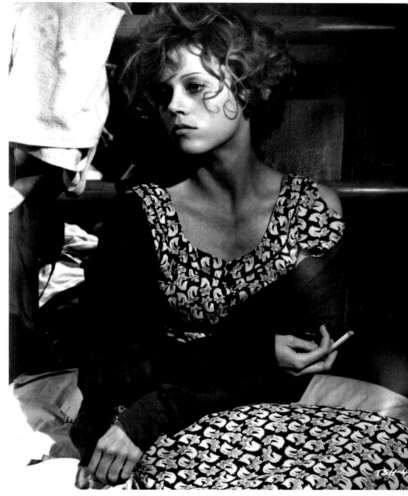

**Joyce Haber (writer):** "Donfeld collected authentic records of the '20s, then played them on his office stereo during fittings with its star, Jane Fonda. He even suggested a game to maintain the mood. 'If Gloria weren't a hooker,' he asked Miss Fonda, 'what would she be?' 'A carhop,' Jane replied. To, 'If she were a singer, whom would she idolize?' 'Ruth Etting,' Jane answered. One day the star said, as she gazed in the mirror, 'I AM Gloria!' For Donfeld, the task and transformation were complete. "

***THEY SHOOT HORSES, DON'T THEY?* (1969) · DONFELD, COSTUME DESIGNER**

**Charlton Heston (actor):** "I had time to grow my own beard and thus wore no makeup at all (and damn near no clothes either, except a loincloth not unlike the one I wore pulling galley oak Number Forty-one in *Ben-Hur*). The primitive, voiceless humans should of course have been naked, but all that frontal male nudity would be a problem in the film even today. . . .

"I noted a curious anomaly on the location shoots. At lunch, the ape actors lunched separately, since their makeups limited them to liquid foods taken through a straw. Beyond that, they self-segregated by species: gorillas at one table, chimps at another, and orangutans at still a third. I leave it to the anthropologists to figure this out."

*PLANET OF THE APES* **(1968) ·**
**MORTON HAACK, COSTUME DESIGNER**

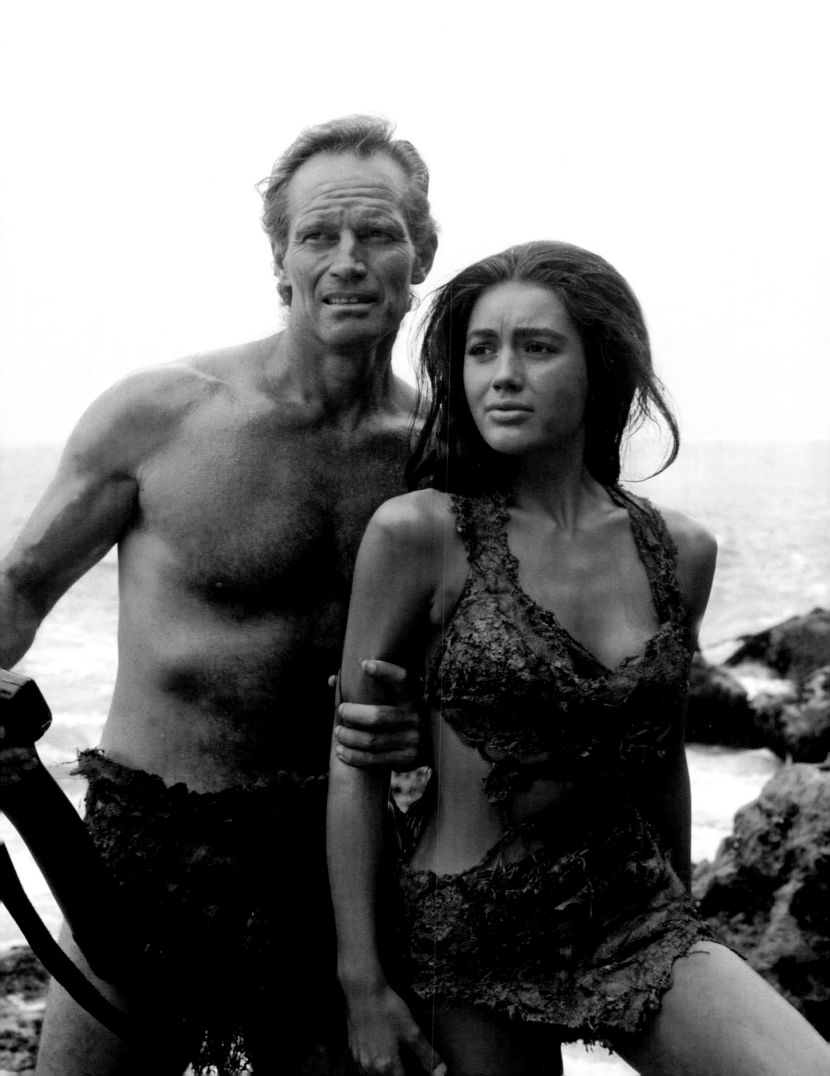

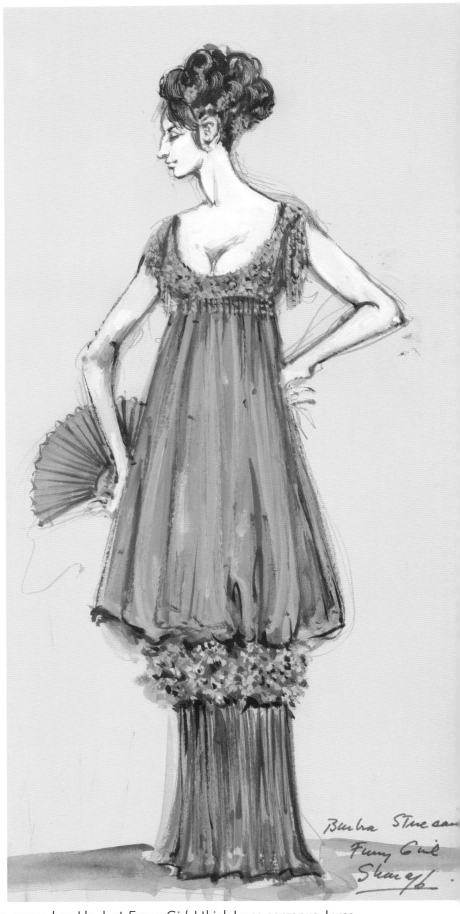

**Barbra Streisand (actress):** "One thing's for sure: now when I look at *Funny Girl,* I think I was gorgeous. I was too beautiful to play Fanny Brice."

### *FUNNY GIRL* (1968) · IRENE SHARAFF, COSTUME DESIGNER

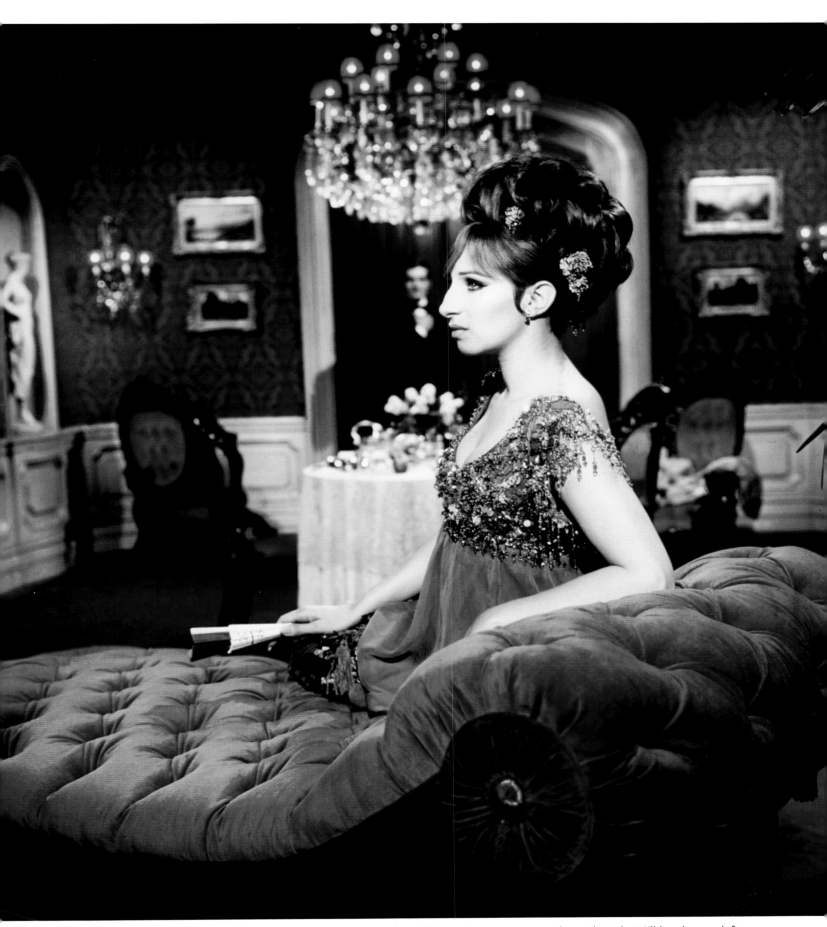

**Rex Reed (writer):** "It took the combined efforts of God knows how many people to do it, but I'll be damned if they haven't made Streisand beautiful. In the most remarkable screen debut I will probably ever see in my lifetime, the toadstool from Erasmus High School has been turned into a truffle."

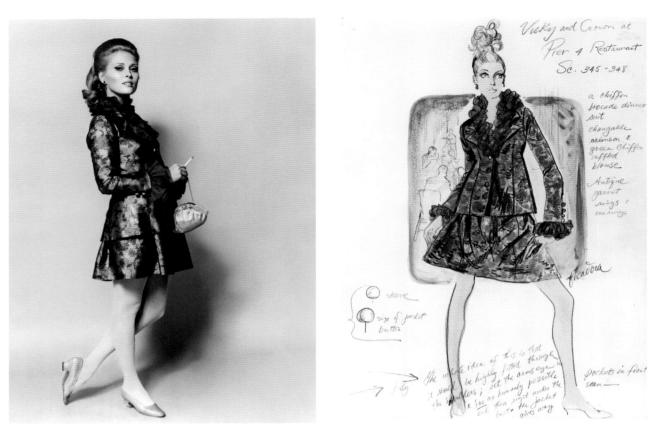

**Faye Dunaway (actress):** "It was the age of the mini, just as it was starting to happen. I said to Thea, 'Let's go very short, this woman doesn't do anything by half measures.' And Thea said, 'Fine, let's do.' And the micro-mini was born."

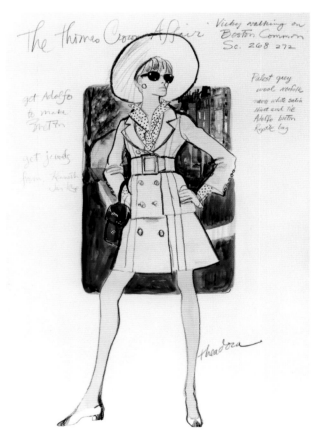

**Faye Dunaway (actress):** "Steve McQueen and I had both grown up on the wrong side of the tracks, but by the time I got to *Thomas Crown*, I'd shaken off anything that might hint of that. . . . Steve, on the other hand, never stopped feeling he was a delinquent and any day he'd be found out. He worked for weeks until he mastered life in a suit. . . . It took him a while to get the kind of fluid movement of someone who is not merely comfortable, but demands that sort of tailoring. But by the time production began, he had it down beautifully."

**Faye Dunaway (actress):** "You don't know who this woman is or what she's up to. But you know it's going to be something pretty spectacular."

*THE THOMAS CROWN AFFAIR* **(1968)** • **THEADORA VAN RUNKLE, COSTUME DESIGNER**

**Stanley Kubrick (director):** "2001 is a nonverbal experience; out of two hours and nineteen minutes of film, there are only a little less than forty minutes of dialogue. I tried to create a visual experience, one that bypasses verbalized pigeonholing and directly penetrates the subconscious with an emotional and philosophic content. To convolute McLuhan, in 2001, the message is the medium. I intended the film to be an intensely subjective experience that reaches the viewer at an inner level of consciousness, just as music does."

**Vincent LoBrutto (biographer):** "Kubrick asked a large field of designers to submit their costume ideas on dress in the year 2001. Some reached back to the Edwardian era, others had futuristic ideas. Before settling on designer Hardy Amies, Kubrick talked to journalist Jeremy Bernstein about the challenge presented by the costumes. 'The problem is to find something that looks different and that might reflect new developments in fabrics but that isn't so far out as to be distracting. Certainly buttons will be gone. Even now there are fabrics that stick shut by themselves.'"

### 2001: A SPACE ODYSSEY (1968) · HARDY AMIES AND HARRY LANGE, COSTUME DESIGNERS

**Edith Head:** "William Goldman had been very explicit in the script about what Etta [Katherine Ross's character] wore. That made it much easier for me. The only discussions I had with Robert Redford and Paul Newman were about their hats, which of course are very important to a couple of cowpokes. Since I had dressed so many horse operas in my early days in the industry I was able to tell them about the various styles cowboys wore. Paul's hat was a lot more macho, the cocky cowboy hat, while Bob's hat was more functional and worked very well with his square jaw and mustache."

***BUTCH CASSIDY AND THE SUNDANCE KID*
(1969) · EDITH HEAD, COSTUME DESIGNER**

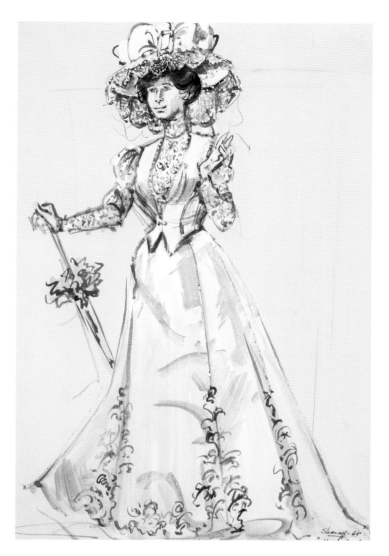

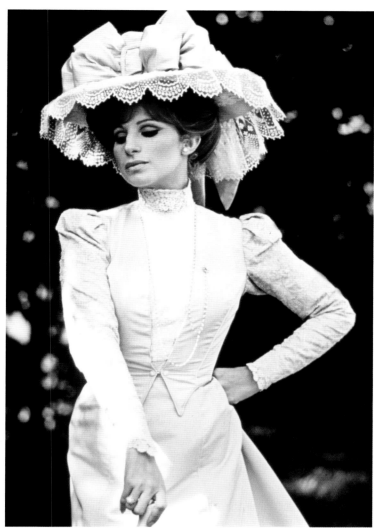

**Irene Sharaff:** "Barbra had an extraordinary memory about movies and stars. With the strong streak of Walter Mitty in her, she would turn up in fittings impersonating stars, usually of the '20s. The best was when she imagined herself as Garbo, dressed like and giving a full performance of that unique star. She adored clothes and wore them with flair. She liked to vary the size of padding in her bras, which I found amusing but which was maddening to the fitters."

**Irene Sharaff:** "The best designs are done with a star, not crammed down her throat. When an actress helps give birth to a dress, she's a better salesman when she wears it."

*HELLO, DOLLY!* (1969) •
**IRENE SHARAFF,
COSTUME DESIGNER**

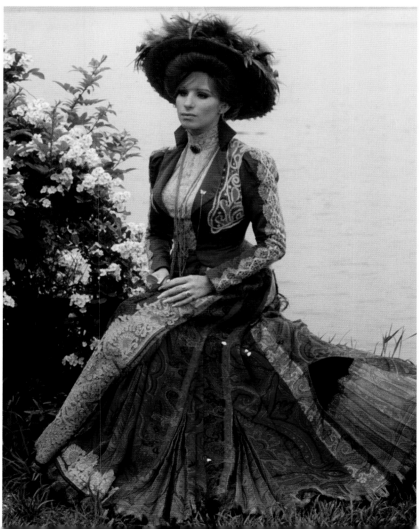

**Gene Saks (director):** "Redford hated wearing a blue suit, button-down collar and tie all day. He seemed anxious that people on set know that he wasn't really like that character. He would wear a black Western hat and cowboy boots around the set when he wasn't on camera."

***BAREFOOT IN THE PARK* (1967) ·
EDITH HEAD, COSTUME DESIGNER**

**Mike Nichols (director):** "The parts of me that did identify with Benjamin predominate in what I did with the movie. By that I mean I didn't cast Redford. Dustin has always said that Benjamin is a walking surfboard. And that's what he was in the book, in the original conception. But I kept looking and looking for an actor until I found Dustin, who is the opposite, who's a dark, Jewish, anomalous presence, which is how I experience myself. So I stuck this dark presence into Beverly Hills, and there he felt that he was drowning in things, and that was very much my take on that story."

***THE GRADUATE* (1967) ·
PATRICIA ZIPPRODT,
COSTUME DESIGNER**

**Peter Fonda (director):** "I affected a great deal of public opinion in my own way. That movie was not about the war, just about attitudes. I look at it as my *Grapes of Wrath*, I don't say my acting was anywhere near my dad's; it was a different style, a different stanza, a different piece of music, but it was still music. It affected an entire culture and it continues to. I have accomplished in my sweet, short life what most people connected with films dream about doing."

***EASY RIDER* (1969)**

**Gordon Dawson:** "Phil Feldman [producer] called me and said, 'There's this picture called *The Wild Bunch*, Sam [Pekinpah] wants you to do the wardrobe on it.' I said, 'Oh, absolutely not, not even in question.' Feldman kept calling me over a period of five or six weeks and they started putting money into it, and then lots of money, twice as much as any wardrobe man had ever been paid. Feldman said, 'Sam refuses to do the picture without you.' I didn't even think Sam would remember my name. Finally I got a call, it was from Sam, he said, 'Well, Dawson, you chickenshit, it's time for guts poker, you up for this or not? Come on, you want to take a walk on the wild side? . . . So I agreed to do it.

"I only had three-hundred-fifty Mexican soldier uniforms and we blew up six thousand of them. I had a uniform-repair factory going right behind the blood hits. They'd come through there after getting shot and get hit with hot water, washed off. We put tape behind the bullet hole and I had a painter that would be painting them khaki. They'd come in bloody, ragged, torn, they'd be taped up, painted over the tape, stuck in front of a heater lamp to dry the paint, a guy would go over the patch with dirty gloves to make it look like aged cloth, and then we'd throw them back in front of the cameras to get blown up again. It was quite an operation."

**THE WILD BUNCH (1969) · GORDON DAWSON, COSTUME DESIGNER**

**Ann Roth:** "The invention for Dustin was the most creative of everything. It was a suit that I found on 42nd Street. It was dark red and I overdyed it green and then white. I pretended that it came out of the trash can and that some high school kid had thrown up on it after his graduation party or prom. And the pants came from this shop called Robin's next to Port Authority, where they had a table out front with pants for five bucks each, with a dirty ridge where they'd been folded. They were white because I imagined that since Ratso was Italian, he'd fantasized about a Marcello Mastroianni look."

**MIDNIGHT COWBOY (1969) ·
ANN ROTH, COSTUME DESIGNER**

In 1967 42nd Street featured in the window of its sleazyiest, cheapest store a maroon mohair suit. The crease on the trousers was discolored as it had been sunbleached. This suit inspired me. The shoes were fake crocodile or alligator and I made them a higher heel and hollowed out one heel and weighted it so that the shoe would help him to drag

Ratso Rizzo

Ann Roth
1967

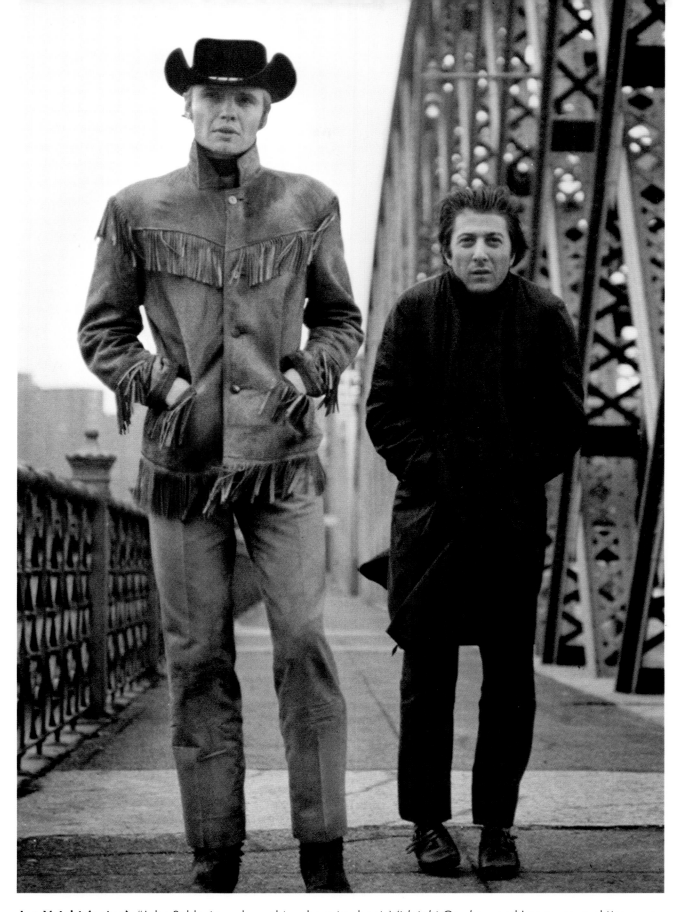

**Jon Voight (actor):** "John Schlesinger brought us here to shoot *Midnight Cowboy*, and I came several times on my own dressed in my cowboy stud clothes. Men would come up to me and try to pick me up and I would keep them talking for a long time. You wouldn't believe some of the stories I heard. It's like a real community unto itself, you know?"

**Ann Roth:** "I found a shirt for Dustin Hoffman at a fire sale. It was just horrible. Poor Dustin had to wear that same shirt throughout the entire picture. . . . There were no three or four of them like there are today."

### *MIDNIGHT COWBOY* (1969) · ANN ROTH, COSTUME DESIGNER

# SEVEN

# 1970s

T he studios entered the 1970s suffering from an identity crisis, skeleton production staffs, and panic-stricken stockholders. The economic devastation of the film business in the decade between 1965 and 1975 left the remaining studios resembling ghost towns. Production was at a near standstill. "Nobody knows anything," mused screenwriter William Goldman about the "business." The overwhelming feeling at the onset of this decade was one of an industry asleep.

Yet, as Peter Lev observed in *American Films of the 70s: Conflicting Visions,* it was also a time when, "in desperation, major companies bypassed established talent to take a chance on younger producers, directors and actors." With movies like Robert Altman's irreverent *M*A*S*H* (1970) and Peter Bogdanovich's intimate small-town narrative *The Last Picture Show* (1971), the new generation that had emerged in the 1960s took the wheel. Hollywood was about to experience a complete makeover.

With the last craftsmen of the studio system on the cusp of retirement, the producers and executives who had entered the movie business in the 1960s caused a seismic shift in the social

*OPPOSITE: Raquel Welch in* Myra Breckinridge (1970) • Theadora Van Runkle, costume designer

*Donald Sutherland and Elliot Gould in M\*A\*S\*H (1970) • Wesley Trist and Mary Tait, costume designers*

*John Belushi in Animal House (1978) • Deborah Nadoolman, costume designer*

strata of the filmmaking community. With the exception of Lew Wasserman at Universal, the old guard gradually left the management of the major studios to the young second-in-commands and film school graduates who were entering the executive pool—"baby moguls," in journalist Maureen Orth's phrase.

If the transition between silent and sound was a traumatic one for the industry, this generational explosion was no less cataclysmic for Hollywood. In a business where status is king, the "right" music, houses, fashion, and cars changed with the studio hierarchy. Gone was the old regime, and with them their hierarchies, their lifestyles—even their restaurants. Dave Chasen's chili (which Elizabeth Taylor had flown to her on the set of *Cleopatra*) and Scandia's Swedish meatballs were suddenly passé, replaced by sushi and "northern Italian" cuisine. It was a time of "health food" and sun worship, a culture skewered by Woody Allen in his 1977 *Annie Hall*.

Although they frequented different eateries, the '70s freshmen had the profound advantage of being tutored by the last survivors of the Golden Age, the film pioneers who had created the language of American movies. When this original community dwindled over the following decade, the emerging filmmakers became the bridge from silent-picture factories to the modern media conglomerates.

Reflecting in 1993 on this uneasy transition between eras, studio executive Michael Medavoy wrote, "The seventies auteurs took risks with the storytelling process; they broke down the traditional approach to film narrative, told their stories from the anti-hero's perspective, and delved into darker themes, such as drug abuse, sexual license, and the pathologies of violence. They made movies about their own ethnic cultures and shot them in a style influenced by cinema verité that would have left American directors of the thirties and forties slack-jawed." Hollywood had made subculture movies before, but the ubiquity of traditional comedy, Western, mystery, and dramatic fare on television made business as usual seem boring. Finding the way out of this conundrum—and to profitability—was the challenge of the new young establishment. As *Animal House* director John Landis joked, the 1970s brought about "the revenge of the nerds"—the high school audio-visual guys who grew up to become George Lucas, Martin Scorsese, and Steven Spielberg.

And yet, as it happened, rumors of the death of the studios were greatly exaggerated. An eclectic mix of the old guard—including many film pioneers—survived in studio workrooms. Prodigal writers and directors were the beneficiaries of their experience, and inspiration flowed in both directions. The directors were often the youngest people on the crew. George Lucas was a USC student when he visited director Francis Ford Coppola (a UCLA graduate) on the set of *Finian's Rainbow*. Lucas was astonished to find that "we were the only people on the production under fifty." Newcomers worked side by side with the veterans, rapidly absorbing the protocols, customs, and traditions of earlier Hollywood production eras. These intense personal relationships between young and old affected the evolution of each film craft—including cinematography, art direction, and costume design. When costume designer Ann Roth started in Hollywood, she recalls that "the studios still had one or two designers under contract and active wardrobe workrooms. Helen Rose and Walter Plunkett were at MGM. There was a reverence for the craft of costume making then. Today you don't see people developing expertise in aging costumes, hand stitching, crocheting, or embroidering. We no longer care about whether someone can make a bonnet."

For costume designers in Hollywood, it was a tough time. It was an era defined by constant change—which may explain why so little has been written about costume design during these years. "Half of Hollywood [was] teetering on an economic tightrope," reported a 1971 *Los Angeles Times* article headlined "The Costume Design Revolution." "The way it looks for costume designers, they might as well jump. Their equilibrium, it seems, has been upset not only by the move to shoestring cinema but by a radical shift in how actors and actresses should look and who should help them look that way." The giant steps backward of the late 1960s persisted: On shoestring budgets, independent modern films (as during the early primitive days of Hollywood), actors were increasingly asked to provide their own clothes as costumes, and a Screen Actors Guild contract clause allowed that an actor "may be required to supply his own modern wardrobe." Prior to the production of *Airport* (1970), the 104 actors on the plane received notes from producer Ross Hunter asking them to bring clothes that would be appropriate for the "sort of passenger" they were playing. "Twenty years ago," sighed Edith Head, the film's nominal costume designer, "I would have designed all 104."

With the preponderance of contemporary films and the dramatic reduction of big "costume" productions, the desolate wardrobe departments took on a funereal cast, their sewing machines and mirrors draped in pristine white muslin. Burbank Studios (a product of the merger of the Warner Bros. and Columbia lots) was a decrepit anachronism. Staffed by expert seamstresses and costumers, the wardrobe department had long outgrown its storage space, and costumes were thrown in any unlit corner of the studio lot. An ancient, leaky barn held rows of chaps, gun belts, and dusters hung on pegs from fifty years of Westerns; an abandoned soundstage was littered with the caps, helmets, and uniforms of every age and nation, peacefully packed in cardboard boxes arranged in no certain order. The best costumes, their labels reading "Bette Davis" or "Rita Hayworth," were smashed together in locked wooden wardrobes adjacent to the workroom. Hangers poked through faded gowns worn by the Warner Bros. stars of the 1920s, '30s, and '40s. Exploiting every asset, the studios recycled ragged costumes until they were ready for the dumpster, but little money was reinvested into the infrastructure of the costume department. With the dual ascendancy of the situation comedy on television and cinema verité on the big screen, conventional wisdom held that the art of costume design would soon become obsolete.

A modern screenplay demands that costumes recede behind characterization, requiring costumes to become imperceptible–the costumes need to "disappear." Costume designers became victims of their own virtuosity. Designers were so proficient that the public never noticed the research, the color palette, and the arc of the character; all they saw were clothes like the ones they were wearing. The hand of the designer could never be seen, although the costumes needed to be correct for character (researched), to fit (or not), to be aged and thus blend unnoticed into the invented, but realistic, environment. Unfortunately, this tricky equation also led to the disappearance of the designer from the consciousness of the industry and the public alike. A world of unheralded artistry and effort was expended to make the contemporary movies of the 1970s look natural and unencumbered by style or glamour—yet producers remained reluctant to hire costume designers for a contemporary film.

In these years, too, fashion and costume design were conflated by industry professionals, fashion publications, and the public alike, lumped together by the untrained eye. In 1976, fashion doyenne Diana Vreeland celebrated earlier eras of the art of costume design at the Metropolitan Museum Costume Institute's exhibition "Romantic and Glamorous Hollywood Design." In her preface to the accompanying catalogue *Hollywood Costume: Glamour, Glitter, Romance,* Vreeland eulogized Hollywood style wistfully, and entirely in the past tense. "What we remember most about Hollywood is the glamour and the romance they gave us. How they glorified their heroes and worshipped their heroines." And that was that—"Hollywood glamour" was officially pronounced dead. Given the moribund state of the film business and producers' ambivalence to costume design, Vreeland and coauthor Dale McConathy deemed the television variety show the natural heir of Hollywood movie glamour, devoting their final chapter to Cher's costumes and the brilliant Bob Mackie.

Worthy as Mackie was, McConathy and Vreeland missed the point. In the watershed that was the 1970s, film actors rededicated themselves to authentic characterizations. Ten years later, when Cher won her best actress Oscar for Norman Jewison's *Moonstruck* (1987), she was dressed down—in costumes designed by Broadway veteran Theoni Aldredge. Cher's normal clothes for the widowed Brooklyn bookkeeper Loretta Castorini were inseparable from her character. Ironically, Cher received her Oscar nearly naked, wearing an outrageous tulle and beaded showgirl confection supplied by Mackie. McConathy and Vreeland had failed to foresee the second coming of glamour—in the phenomenon of the red carpet, which was starting to emerge as the center of the media's attention.

It was not, however, a time of total hiatus for professional costume design. Ann Roth established an intimate collaboration with director John Schlesinger, setting the tone for the coming decade with the 1969 contemporary drama *Midnight Cowboy.* "John and I tend to dissect and analyze the characters endlessly," Roth said, "and our mutual interest in the story behind the characters make us a good team. I like to really imagine a character's life: his income (salary/inheritance), where he sleeps, who does his laundry, where do his clothes land when he takes them off at night—on the floor? Is he a neat person? What is his visual, sensual fantasy of himself? What does he read? This is my search in creating a character and it was great to work with a director who is so supportive of the process."

*Shampoo* (1975), a comedy set in 1968 (and therefore a period picture), was a biting social satire and sex farce written by Robert Towne and Warren Beatty, and directed by Hal Ashby. With Julie Christie and Lee Grant leading the well-heeled ladies who lunched, costume designer Anthea

Sylbert sought Beverly Hills chic and accuracy, not caricature. Sylbert explained that she borrowed the costumes from friends—a conscious strategy, not a last resort. "I didn't do it because we didn't have the money to design costumes; I did it because I didn't know any other way. I can buy thirty or forty dresses from the '20s, '30s or '40s, but I could not find one from the '60s. So I went to the telephone and said, 'Hello, what do you have left over in your closet from around 1968?'" Sylbert was expert at bridging the gap between real life and the demands of the screen: "If a character reads like she should have fifteen costume changes," she advised, "make do with four, but have those four be really perfect for the character and let them repeat—as in life."

Costume designers working in contemporary films ignited entire fashion movements. Designer Joe Aulisi's dashing leather jacket for Richard Roundtree in *Shaft* (1971), and Ruth Morley's famous eclectic layered menswear for Diane Keaton in *Annie Hall* (1977), still resonate. *Annie Hall* defined an era, establishing a new vocabulary for alternative glamour. The suit vests, men's shoes, baggy pleated pants, knotted ties, and floppy hats imbued Keaton's character with a romantic, asexualized innocence: "She always seems a bit like a child playing dress-up," Keaton mused. No sooner had the movie been released than the "Annie Hall look" became a fad, and Ruth Morley's androgynous mix was coveted by women across the nation. One observer said that *Annie Hall* had done as much for pants in her time as Marlene Dietrich and Katharine Hepburn had before her.

By mid-decade, the film industry was growing cautiously optimistic about a recovery. According to producer Mike Medavoy, "The decade that gave the movie industry the American auteur also gave it the broad-audience event film," and the year of *Shampoo*'s release has been considered a pivotal one in Hollywood films. Medavoy continued: "1975 was a year of transition between the rebellious films of the Hollywood Renaissance circa 1970 and the optimistic genre films to come." With *Jaws* (1975), *Close Encounters of the Third Kind* (1977), and *Star Wars* (1977), Hollywood regained the audience it had lost a decade before—this time, in the guise of a fourteen-year-old boy. The event movie, the blockbuster, special effects, and the adolescent male became the object of the studios' affection—a love affair that, in many ways, persists today.

Beyond contemporary drama, this next generation offered a wide array of textures: innovative science fiction like *Star Wars*, authentic period films like *Paper Moon* (1973), stylish, influential musicals such as *Cabaret* (1972) and *Grease* (1978). The diversity helped costume designers reestablish their presence. With the sublime *Chinatown*, *Godfather 2*, and *The Great Gatsby* all nomi-

*Jack Nicholson in* Chinatown *(1974) • Anthea Sylbert, costume designer*

nated for a best costume Oscar in 1974, directors like Roman Polanski, Frances Ford Coppola, and Jack Clayton were demanding costume-designer collaborators. The "baby moguls" were now

making big-budget pictures of their own. As sleepy studio workrooms came back to life and new costume production workrooms were established off the studio lot, costume designers reveled in the ease of the unshackled new filmmaking style. Some changes demanded adjustment—location shooting, for instance, was becoming a regular component of most filming schedules—but whatever the scale and ambition of a given film, adherence to the narrative and the normative workflow of costume design remained constant throughout the 1970s for costume designers. The resuscitation of costume design paralleled the reinvention of the film industry, fueled by the same unabated passion and determination to make great movies.

Still, the rebound of the 1970s was a double-edged sword. Flush with power (and gross points), the new directors produced a host of blockbusters and modern classics. Yet deals were increasingly leveraged on the drawing power of stars, based on the opening weekend box-office grosses. As the movie business found its equilibrium, budgets grew, and greater risks were taken. Although the director continued to serve as *auteur*, the axis of power was shifting. With blockbuster-level money at stake, by the end of the 1970s Hollywood films began to drift away from the expressive visions of the "new" American directors who had held such promise at the start of the decade.

Barry Lyndon *(1975) • Milena Canonero and Ulla-Britt Suderlund, costume designers*

**Jane Fonda (actress):** "My friend Sally Field once said to me that the anxiety and emotionalism just before starting a new role is part of the process of becoming raw and porous, so that the new character can inhabit you. Seen this way, the discomfort is a necessary stage in the morphing, when you are not quite *you* anymore but not quite someone new yet."

**_KLUTE_ (1971) · ANN ROTH, COSTUME DESIGNER**

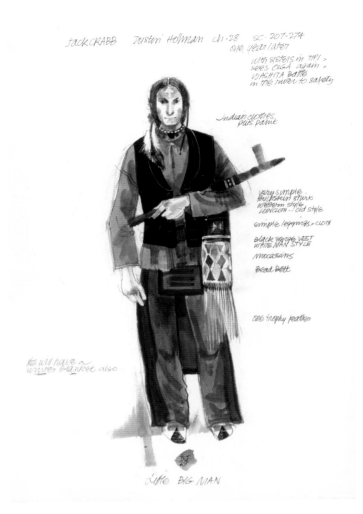

JACK CRABB Dustin Hoffman ch.28 sc. 207-274
one year later
with sisters in tipi >
sees olga again >
WASHITA BATTLE
in the river to safety

Indian clothes
plus paint

very simple
Buckskin shirt
western style
Loincloth - old style

simple leggings > cloth

black serge vest
white man style

moccasins

Bead belt

one trophy feather

he will have a
winter blanket also

Little BIG MAN

**Dorothy Jeakins:** "I was always a director's designer more than an actor's designer. My work was literary. What concerns me most is the canvas. The canvas is the script, and the designer is the painter. What colors do you put on the canvas and why?"

### *LITTLE BIG MAN* (1970) · DOROTHY JEAKINS, COSTUME DESIGNER

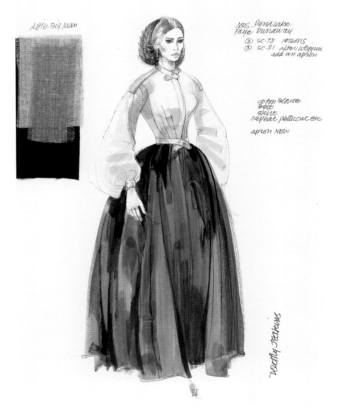

Little Big Man

MRS. Pendrake
Faye Dunaway
② SC·78 lessons
③ SC·81 after whipping
add an apron

cotton sleeve
belt
skirt
repeat petticoat etc

apron NEW

Dorothy Jeakins

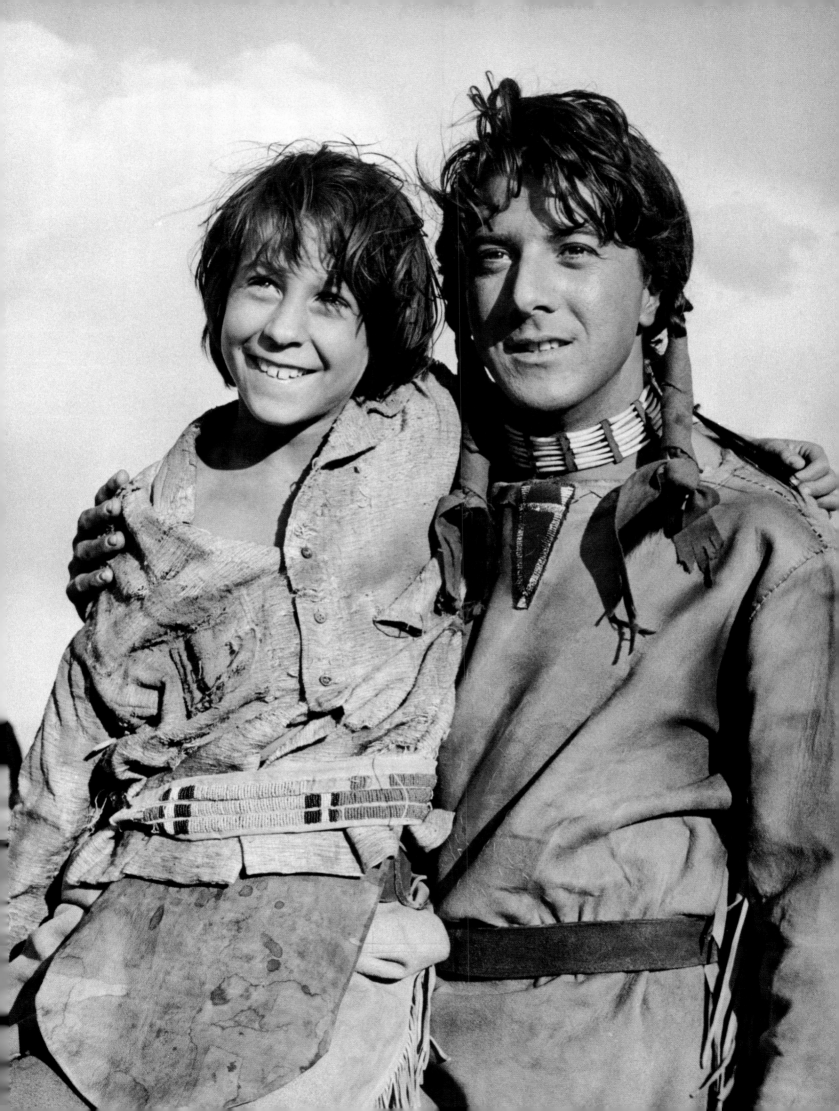

**Robert Altman (director):** "We do research for a Western picture through photographs or drawings that people made at that time. . . . You see a picture of a cowboy with a big hat. The assumption is that everybody wore these big hats. Well, a glass plate for a camera cost about two dollars in those days, so you didn't go around and take snapshots everywhere. A photographer was very careful about what he took a picture of. My contention is that some guy comes into town and he's got this big hat on, everybody in town runs down the street and they run to the photographer and say, 'Hey, there's a guy out there with the goddamnedest-looking hat you've ever seen. Go take a picture of it.'

"Most of the American West was populated by first-generation Europeans—Irish and some Italians, English, Dutch. All the clothes they had would have been European. . . . I actually got wardrobe of that period from Warner Bros., took it up to Vancouver and hung it up on racks, then assembled my cast and said: "Everybody gets to have one pair of pants, two shirts, one vest, sweater, light coat, one heavy raincoat, one hat, and then there's objects that you can go and pick around." Everybody picked their own wardrobe. Of course, all this wardrobe had holes in it and was tattered to make it look aged and old. From this, I could tell the personality of each actor—the guy who wanted to be the most flamboyant picked the most flamboyant stuff, and so on.

"I said, 'Now, the needles and threads and patches are over here, and you've got two days to sew up your holes, because otherwise you'll die from cold up here.' So they repaired all their clothes—because people didn't run around with clothes with holes in them—and suddenly that wardrobe became part of their characters, and they became part of the wardrobe's character. And everybody was eccentric, and yet everybody was the same."

*McCABE AND MRS. MILLER* (1971) • ILSE RICHTER, COSTUME DESIGNER

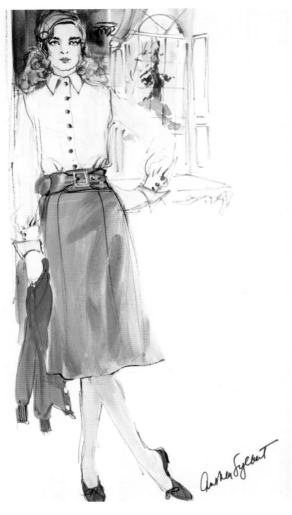

**Anthea Sylbert:** "A costume designer really is an extension of the writer, the director, and the actor. If you do your job correctly and if you have done your thinking correctly, you have helped them; if not, you have sabotaged them. You start with a screenplay. You read it, and it gives you the settings; it gives you a year; it gives you the characters. Now, there are all sorts of decisions that have to be made about the characters if the information is not in the screenplay. What economic bracket are they in? What is their background? If they are rich, were they always rich? These are things that have to be decided with a director and, finally, an actor. To think that a costume designer just puts clothes on people is a mistake."

## *CARNAL KNOWLEDGE* (1971) · ANTHEA SYLBERT, COSTUME DESIGNER

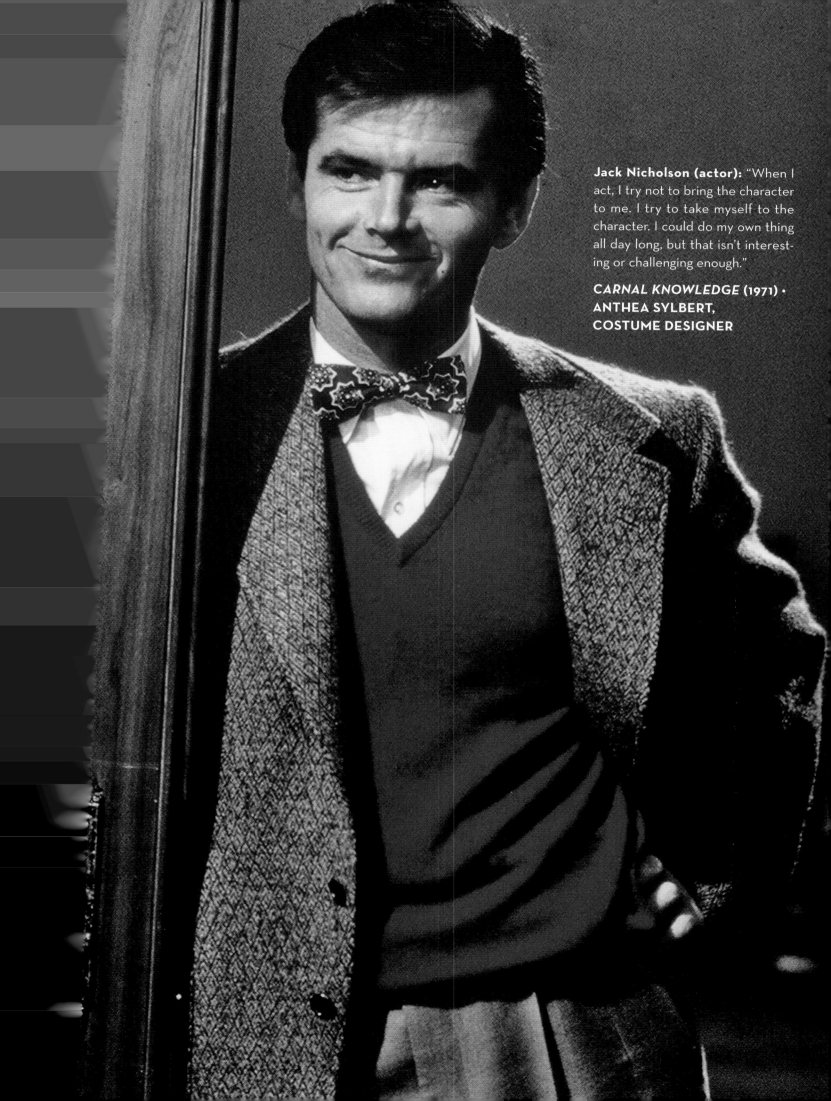

**Jack Nicholson (actor):** "When I act, I try not to bring the character to me. I try to take myself to the character. I could do my own thing all day long, but that isn't interesting or challenging enough."

*CARNAL KNOWLEDGE* (1971) · ANTHEA SYLBERT, COSTUME DESIGNER

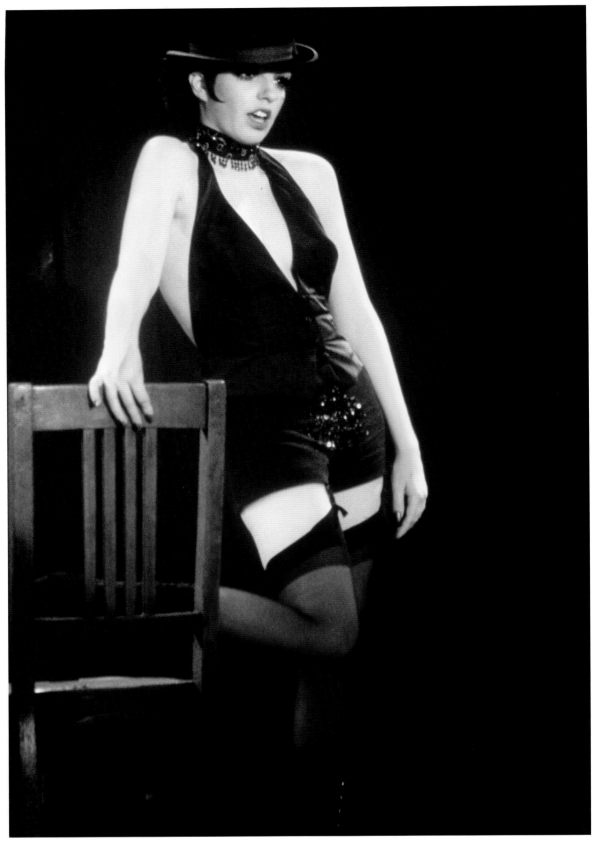

**Liza Minnelli (actress):** "When I told Daddy [Vincente Minnelli] I was doing *Cabaret*, he asked, 'What are you going to look like? I got a blank expression on my face and said, 'I don't know. Sally looks like a kook, but a kook gets boring unless she's specific. What should I look like?' Daddy told me I had to look special, but also like me. Three days later, I walked into Daddy's room and on his bed were books and pictures. I had thought there was only that incredibly sophisticated Dietrich look in the thirties, but then Daddy and I discussed Louise Brooks (the famous twenties actress who wore her hair like a pixie) and who, like Sally Bowles, was a curious enigma. He said, 'Yes, *she* will give you the effect you want.' Oh, Daddy was so helpful!"

### *CABARET* (1972) · CHARLOTTE FLEMMING, COSTUME DESIGNER

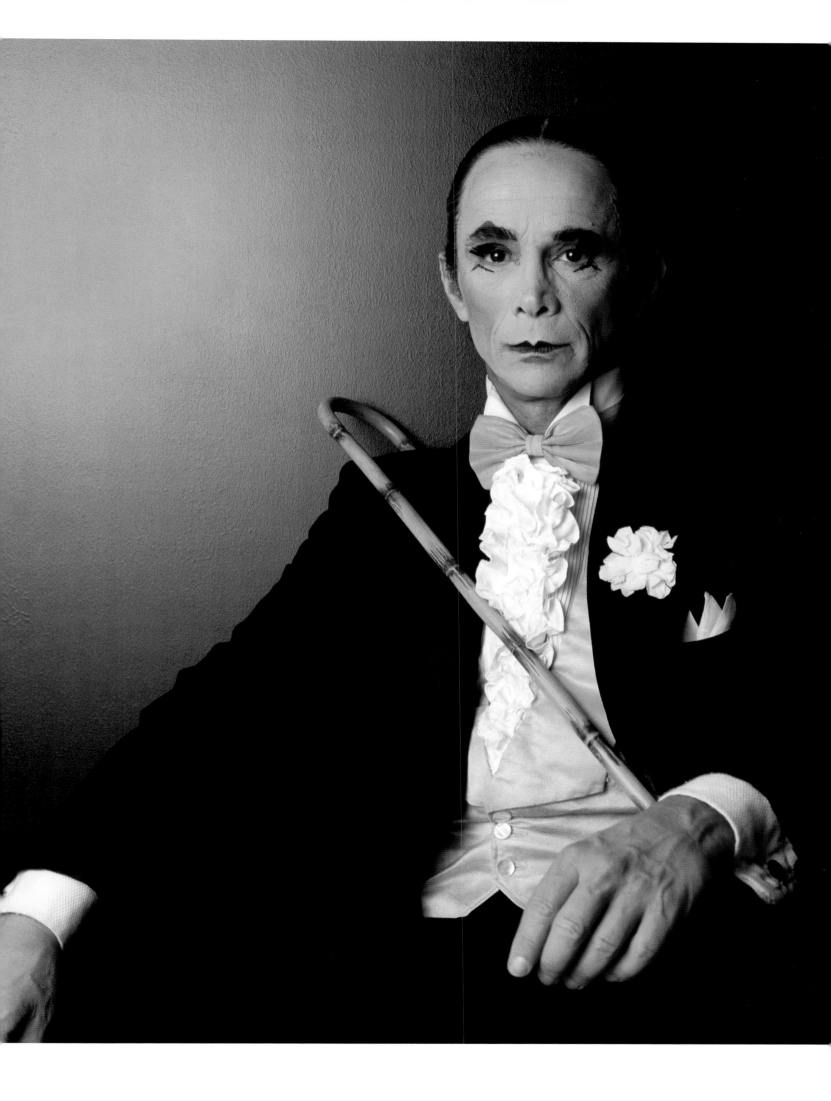

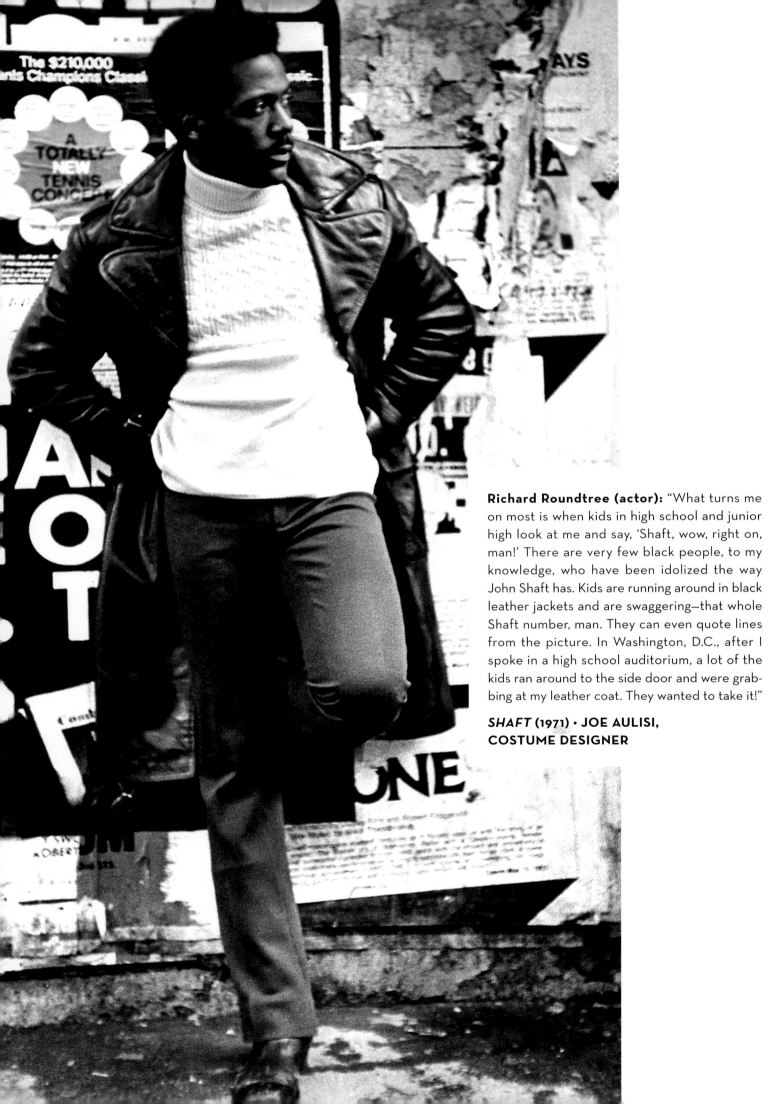

**Richard Roundtree (actor):** "What turns me on most is when kids in high school and junior high look at me and say, 'Shaft, wow, right on, man!' There are very few black people, to my knowledge, who have been idolized the way John Shaft has. Kids are running around in black leather jackets and are swaggering—that whole Shaft number, man. They can even quote lines from the picture. In Washington, D.C., after I spoke in a high school auditorium, a lot of the kids ran around to the side door and were grabbing at my leather coat. They wanted to take it!"

*SHAFT* (1971) · JOE AULISI, COSTUME DESIGNER

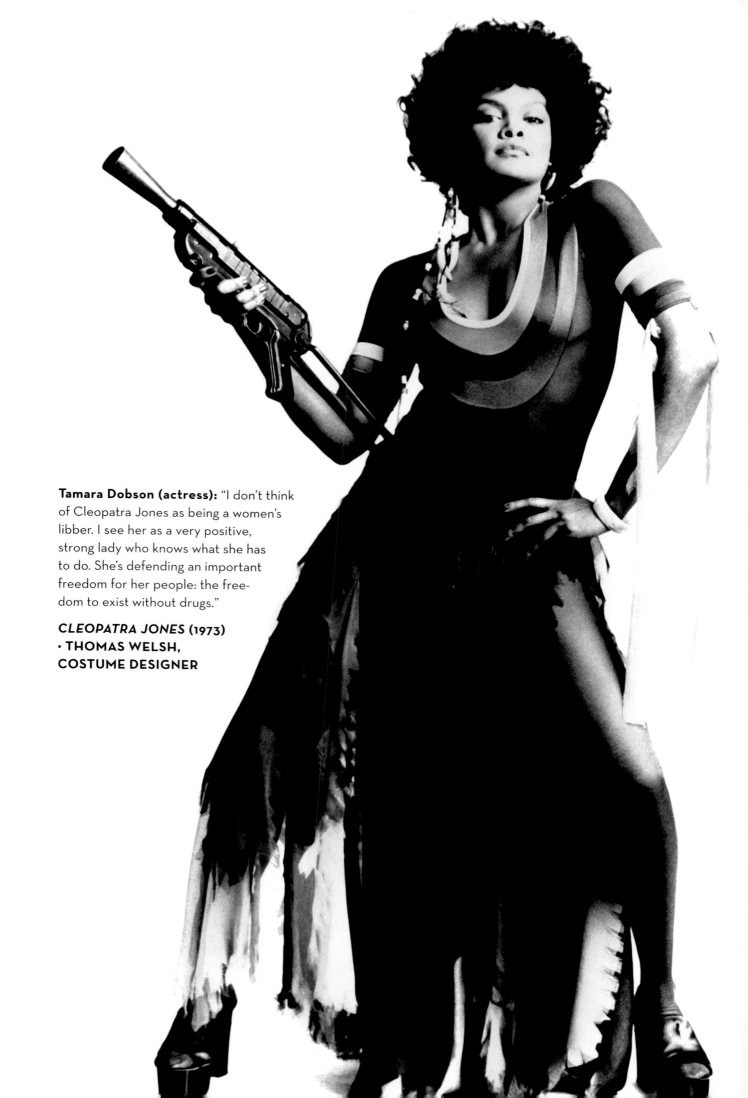

**Tamara Dobson (actress):** "I don't think of Cleopatra Jones as being a women's libber. I see her as a very positive, strong lady who knows what she has to do. She's defending an important freedom for her people: the free-dom to exist without drugs."

***CLEOPATRA JONES* (1973) • THOMAS WELSH, COSTUME DESIGNER**

**Al Pacino (actor):** "In the first *Godfather*, the thing that I was after was to create some kind of enigma, an enigmatic-type person. You felt that we were looking at that person and didn't quite know him. You see Michael in some of those scenes looking wrapped up in a kind of trance, as if his mind were completely filled with thoughts; that's what I was doing. I was actually listening to Stravinsky on the set, so I'd have that look. That was the drama in the character, that was the only thing that was going to make him dramatic. Otherwise, it could be dull. I never worked on a role quite like that. It was the most difficult part I ever played."

**Francis Ford Coppola (director):** "The person I learned the most about costumes from was Johnnie Johnstone—Anna Hill Johnstone—who was a very important New York costume designer. . . . Such things as: Costume designers always come up to you, and want to discuss all the changes; 'This is the dress, she wears this in the morning and then in the afternoon, throw the sweater over her; and then she's gonna just keep the blouse, and at the last act she's gonna come as . . .' Johnnie Johnstone said, 'No! We're not gonna have any changes. We're gonna give every character in the movie one costume, and that actor is gonna wear that costume, even if it's not logical, all the time.' Now, why is this good? . . . [Because] that jacket, or that raincoat, or that woman's coat [will] say something about that character.

"When [I'm] cutting a movie, I get rid of all the [costume] changes, except what's absolutely essential. Because when I'm doing a scene, and I decide to take this scene . . . and move it four scenes earlier, I don't wanna ever get in that situation where you can't put that in there because he's wearing the other clothes."

**THE GODFATHER (1972) • ANNA HILL JOHNSTONE, COSTUME DESIGNER**

**Cybill Shepherd (actress):** "My wardrobe consisted of thin cotton dresses from a vintage clothing store and a pair of jeans from the Columbia wardrobe graveyard labeled 'Debbie Reynolds'—many inches shorter and pounds lighter than I."

*THE LAST PICTURE SHOW* (1971) • POLLY PLATT, COSTUME DESIGNER

**Richard Dreyfuss (actor):** "Haskell Wexler, the cinematographer . . . used to ask me to stand in front of the camera so that he could get focus on the test pattern that I was wearing. I hated that shirt. I thought it was geeky."

**Aggie Guerard Rodgers:** "The madras shirt was a request from George [Lucas]. I bought two at Brooks Brothers and had the collars changed. The first day of shooting: fine. Second day, at the end of the day: fine. Except then I realized that I could never wash them, as madras ran!! So I would say that was why Richard hated them— no washing the whole time and twenty-seven days of shooting!"

*AMERICAN GRAFFITI* (1973) • AGGIE GUERARD RODGERS, COSTUME DESIGNER

**Andrew Yule (biographer):** "Pacino was refused a table in his favorite New York restaurant when he turned up in Serpico's 'hippie' regalia, the deferential treatment he had received up until then strictly off the menu. He made a little fuss because the incident perfectly summed up the dilemma he perceived in stardom. 'Right now,' he said, 'I'm trying to work out how to be a star and at the same time manage to live a quiet life. The only part that really counts is how I play Al Pacino. The fringe benefits of stardom leave me cold.'"

*SERPICO* (1973) · ANNA HILL JOHNSTONE, COSTUME DESIGNER

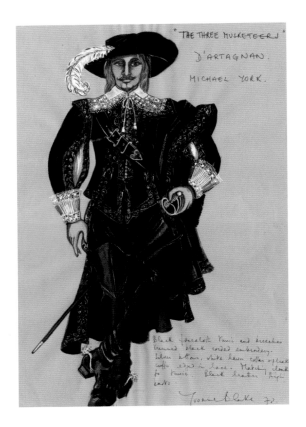

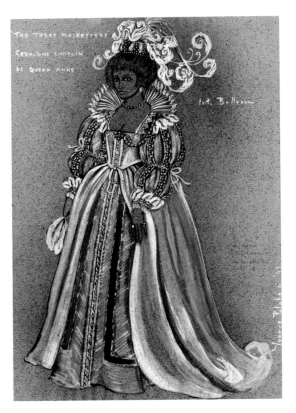

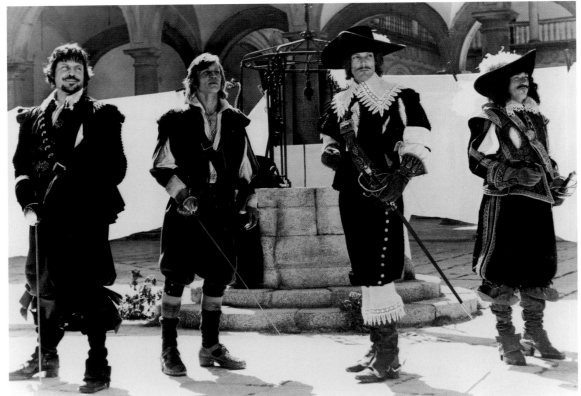

**Richard Lester (director):** "Dumas liked his heroes somewhat less than most people imagine; the musketeers are mercenaries—they'll fight if anyone gives them the money to have a pretty horse or a pretty suit and they're just bully boys. I'm after the balance of a romantic adventure with some cynical comedy in it, rooted as closely as possible in the 1620s. You should be aware that even though it's a romantic piece, everyone was pretty filthy, that they never washed and they urinated on all those tapestries that are now in the museums."

*THE THREE MUSKETEERS* (1973) • YVONNE BLAKE, COSTUME DESIGNER

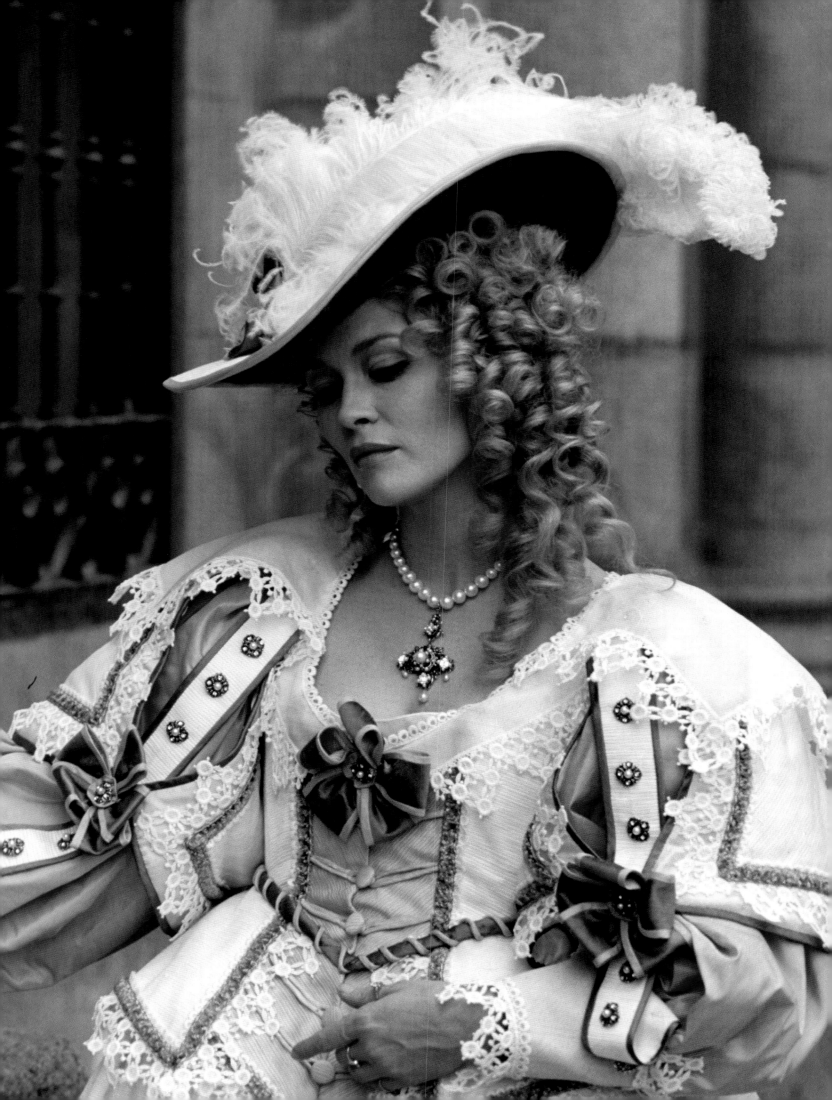

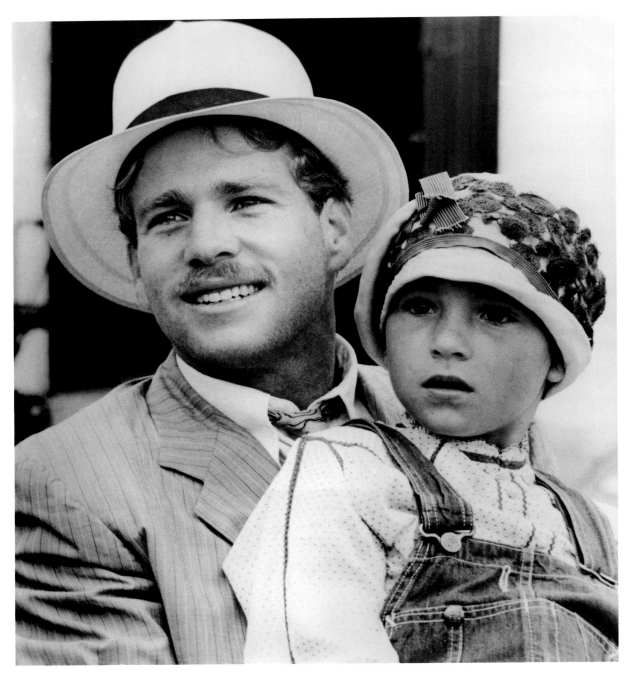

**Tatum O'Neal (actress):** "Peter Bogdanovich decided that *Paper Moon* should be black and white to give it an intensity and a period feel. He also feared that in color my father and I would come off as too blond and attractive to seem convincing as Depression-era con artists. I thought there was nothing attractive—or even nice—about my costumes. My hair was cut very short like a boy's and they put me in overalls and orthopedic-looking, 1930s-style shoes. 'You can't make me wear these,' I protested, horrified by the way I looked. Peter had to make a personal plea to convince me. 'Come on Tatesky,' he coaxed, using his pet name for me, which I kept for years. 'Baby, you look beautiful, it's just for a short time, I love you, and you're gonna be great.'"

## *PAPER MOON* (1973) · POLLY PLATT, COSTUME DESIGNER

**Gene Hackman:** "When we first started, I was pretty unsure of myself, because this guy had to be pretty ruthless. When we shot a scene with the drug pusher that I chase down the street in the first scene of the movie, I wasn't very good. And I went to Billy and I said, 'I don't know if I can do this or not.'. . . He said, 'We'll put it aside for now and continue on and maybe we can reshoot the scene later.' And that's what happened. After having worked in the streets of New York for three and a half months, I was very happy to beat the hell out of that guy."

***THE FRENCH CONNECTION* (1971) ·
JOSEPH FRETWELL III, COSTUME DESIGNER**

**Ali MacGraw (actress):** "That was my own hat and it became the *Love Story* hat. It looked terrific on anybody who ever wore it. They all wanted to look like me because the movie was so popular."

***LOVE STORY* (1970) ·
ALICE MANOUGIAN MARTIN
AND PEARL SOMNER,
COSTUME DESIGNERS**

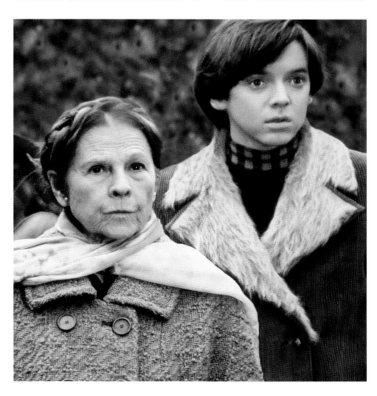

**Ruth Gordon (actress):** "We were to make six tests for *Harold and Maude*. My cue came, I stepped out of the shadows onto the platform, I wore an electric blue jersey skirt to a suit that Mainbocher had made fourteen years before, which a dry cleaner plus the Maine sunshine had faded and stretched. Like my character Cass, it had seen better days. Clothes for the stage or movies that aren't supposed to be stylish ought to be from the back of someone's closet, be contrived out of bargain remnants, ought to have *once* been good. Poor people don't *try* to look like poor people. Crooks don't *try* to look like crooks. Unpopular girls don't try to look unpopular. Mary of Scotland, in her cell, did *not* bring a black high-necked, untrimmed dress. . . . Clothes should remind us of what has been, of what might be."

***HAROLD AND MAUDE* (1971) ·
WILLIAM THEISS, COSTUME DESIGNER**

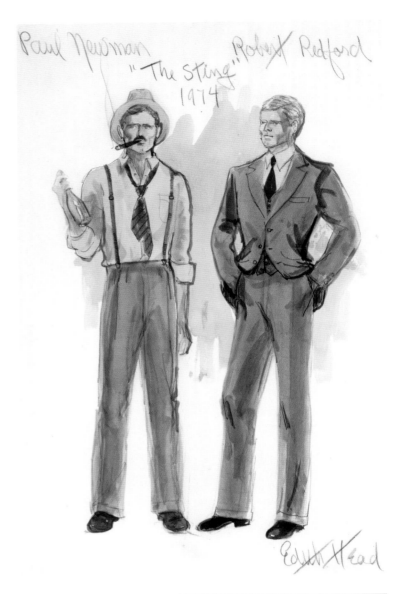

**Edith Head:** "Bob [Redford] is more meticulous than Paul [Newman] about what he wears; he likes to look a certain way, but Paul just wants to be comfortable. *The Sting* was the first time in the history of the Academy Awards that a predominantly male film won a costume award. I was very proud of that fact, but no matter how good the costumes are, if the actors aren't good or the film isn't a success, nobody will notice them. Both Newman and Redford look extremely sophisticated in suits. To keep Bob from looking too worldly, I gave him a newsboy's cap and a garish wide-patterned tie. Coupled with his impish grin, they made him look rather naive. When I wanted Paul to come across as a tough guy, I made sure his undershirt was showing. He'd pull his hat down low on his forehead to look rather menacing and sly. They both have blue eyes, so they'd argue over which one was going to wear the blue necktie or the blue shirt. It was all in fun. I would have shown favoritism if I gave one of them a blue tie, so I ended up giving them both blue ties.

"In the case of Redford and Newman the costumes started a whole new trend in male fashion. Suddenly men were wearing shirts with band collars, two-tone shoes, and newspaper-boy caps. They brought back chalk-stripe suits. It was fascinating. I don't ever remember a male cast having such an impact on fashion."

***THE STING* (1974) · EDITH HEAD, COSTUME DESIGNER**

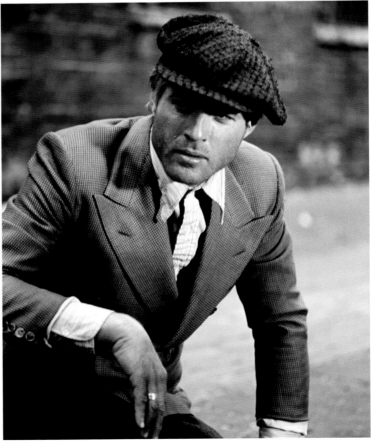

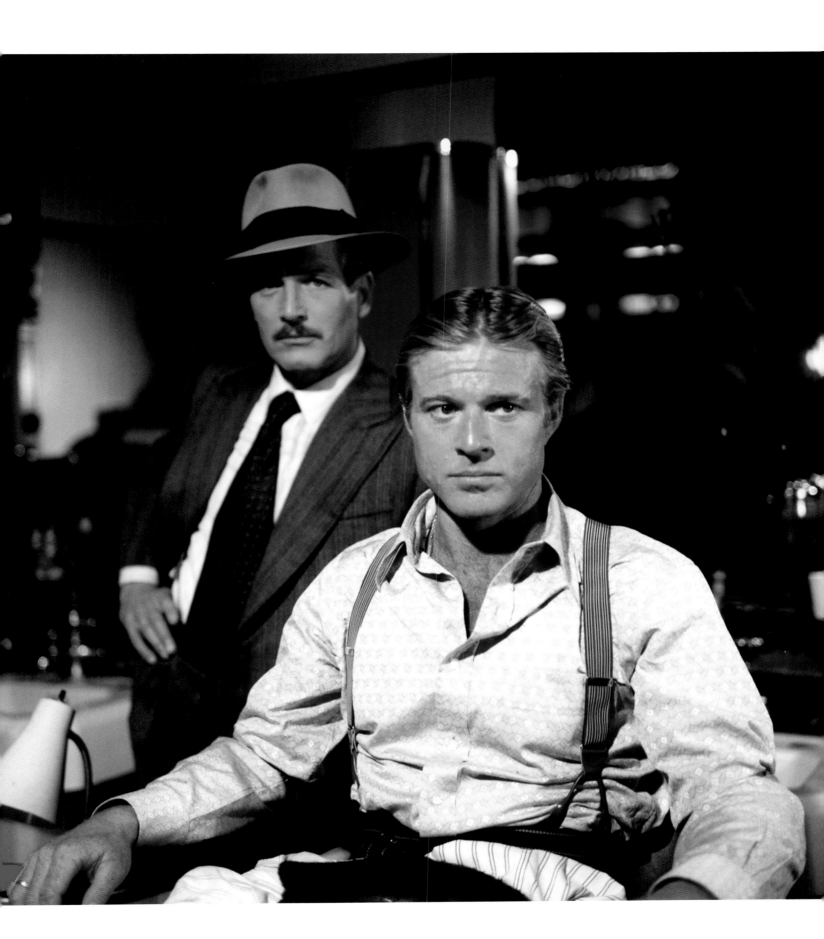

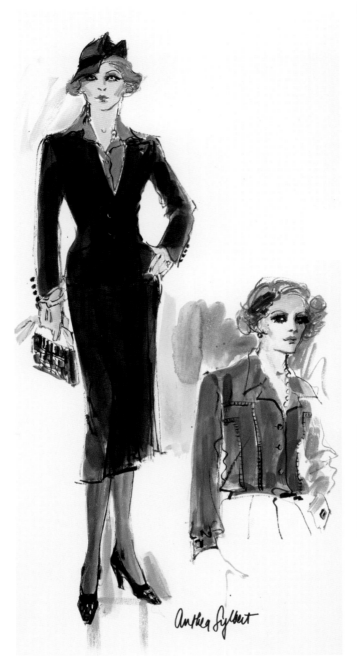

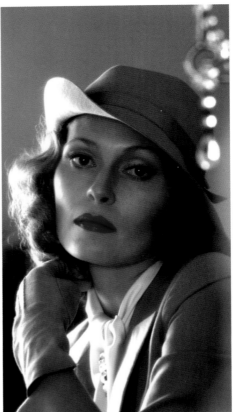

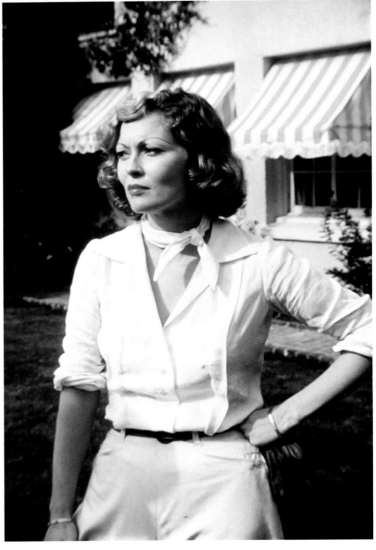

**Anthea Sylbert:** "The thing about most rich people who've had money a long time is that it gets simpler and simpler, not more and more fussy. The mistake many people make when they're trying to represent someone rich is they think they have to put a lot of jewelry on because that's supposed to represent 'rich.' There are different layers of rich, and you have to choose which rich she is. She's the heroine of the film, so you can't choose to make her a dumpy rich person. She's also Faye Dunaway. You can choose to make her rather chic. I've never seen Babe Paley wear anything but brown, gray, off-white, and black. I assume Faye does the same thing as Mrs. Mulwray."

### *CHINATOWN* (1974) ·
### ANTHEA SYLBERT, COSTUME DESIGNER

Carmella in the tenement

Michael Corleone
in his office Sc. I

navy flannel blazer
with gold buttons
white long sleeves lisle
shirt
expensive gold watch
grey flannels. Daks.
red & green paisley ascot

This outfit to be
worn again in
meetings etc. with
tie & button down

Oyster White slubbed
silk for the party

navy blue suede & alligator shoe

*THE GODFATHER: PART II (1974)* • THEADORA VAN RUNKLE, COSTUME DESIGNER

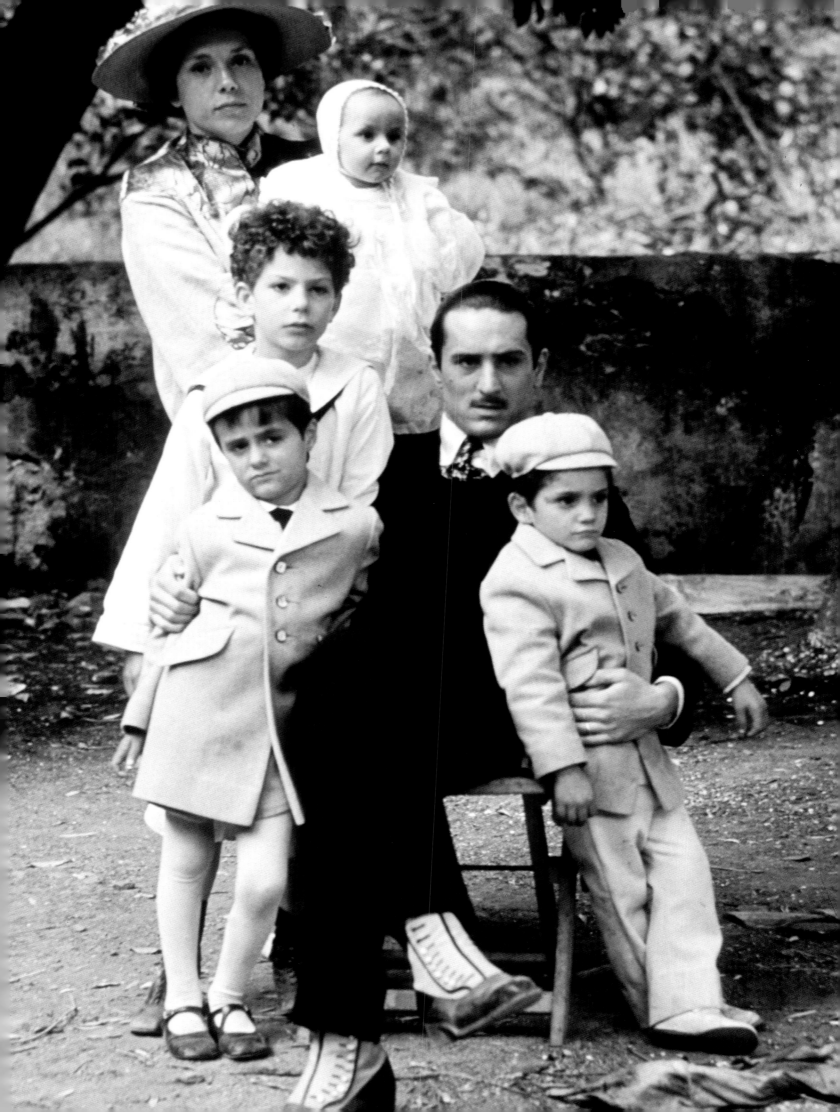

**Theadora Van Runkle:** "On the first day we were on location, Francis walked out (it was the party scene on Lake Tahoe) and Al Pacino was in gray slub silk, very Italiany, and Francis had expected them all to be in tuxedoes. He said, 'Why aren't they in tuxedoes, Theadora?' And I said, 'Well, it's an afternoon party and they're trying to become WASPs. They would never wear tuxedoes.' He turned his back on me and walked into his cottage and slammed the door. Finally, he came out about fifteen minutes later and said, 'I thought it over and you're right.' He let me get away with it and it certainly influenced a lot of looks after that. Other people got credit, but it was *Godfather II* that started that revival."

***THE GODFATHER: PART II* (1974) · THEADORA VAN RUNKLE, COSTUME DESIGNER**

Freddo
at the Tahoe party

in dark India
Madras
dinner jacket

TB.

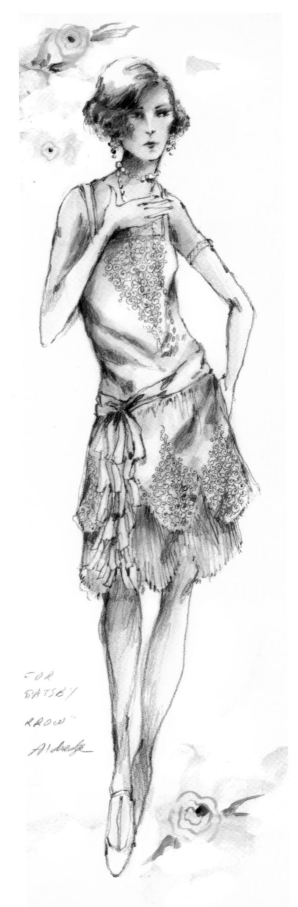

FOR
GATSBY
"RROW"

Aldredge

**Theoni V. Aldredge:** "Everything worn by the main characters is white to pale, pale lavender. Rich people did not get soiled, and they didn't care, they thought they could throw it all away."

**Theoni V. Aldredge:** "All of Daisy's gowns will be memory pieces, beaded to look like daisies. She will flutter and be frail. She is a Southern belle who looks pretty, has no whims, can't boil an egg or heat up coffee."

*THE GREAT GATSBY* (1974) ·
THEONI V. ALDREDGE, COSTUME DESIGNER

**Milos Forman (director):** "Because they happen to look physically too much like another, and since the patients in the mental ward have few lines to say, [the] audience must remember each simply by their look. Also there was this paradox, that I must find twenty men who, though by nature nuts, mysterious, are together-enough guys to be confined eleven weeks in an actual Oregon mental hospital without cracking themselves. My God, the process of making any movie, even some musical comedy, can break an actor apart."

**Louise Fletcher (actress):** "I envied the other actors tremendously. They were so free and I had to be so controlled. I was so totally frustrated that I had the only tantrum I've ever had. The still photographer kept taking pictures of all the crazies and I asked why he didn't take any pictures of me and he said, 'You're so boring, always in that white uniform.'"

### *ONE FLEW OVER THE CUCKOO'S NEST* (1975) · AGGIE GUERARD RODGERS, COSTUME DESIGNER

**Sylvester Stallone (actor):** "If macho means I like to look good and feel strong and shoot guns in the woods, yes, I'm macho. I don't think that women's lib wants all men to become limp-wristed librarians. I don't know what is happening to men these days, there's a trend towards a sleek, subdued sophistication. In discos, men and women look almost alike and if you were a little bleary-eyed you'd get them mixed up. I think it's wrong and I think women are unhappy about it. There doesn't seem to be enough real men to go around."

**ROCKY (1976) · JOANNE HUTCHINSON, COSTUME DESIGNER**

*YOUNG FRANKENSTEIN* (1974) · DOROTHY JEAKINS, COSTUME DESIGNER

**Valerie Perrine (actress):** "I have the album *How to Strip for Your Husband* and I've always had a secret desire to be a stripper. But I don't want people to think I was a topless dancer in Vegas, that's wrong. Oh, I came out with my boobs out but I was also wearing $2,000 worth of feathers and beads."

*LENNY* (1974) · ALBERT WOLSKY, COSTUME DESIGNER

**Tim Curry (actor):** "It's an Edwardian corset worn backwards and it came from a wheelbarrow in the market in Glasgow. I wore it first in a production of Genet's *The Maid*, with costumes designed by Sue Blane, and the genesis of the look with the torn stockings later glamorized for the movie. It was the beginning of punk in London. *Rocky Horror*, the play, was sort of truck-driver drag and it suddenly got rather more chic. I preferred the original; grungy and tacky and more like the version that the kids wear now in the cinema. One of the most brilliant things Sue Blane did was the over-sized pearl necklace. It's such a perversion of the bourgeois uniform, rather '50s—like the add-on pop beads but it still refers to everybody's mother."

*THE ROCKY HORROR PICTURE SHOW* **(1975) · SUE BLANE, COSTUME DESIGNER**

**Anthea Sylbert:** "I love dressing Warren because he always looks so wonderful when you're done. Socially, he's one of those people with a very short attention span. But working, he's relentless. Always asking questions about why you're doing what you're doing, whether you really think it's right. He plays the devil's advocate. He wants to know everything there is to know."

 color sample for dye - (Tank Top)

**Anthea Sylbert:** "I just thought it would be funny when we first saw Julie, if she looked so proper, like the queen mother with a mink stole, and then when she turned around, there she was, right down to the crack of her ass."

**Anthea Sylbert:** "*Shampoo* is about a very specific place at a very specific time historically—Beverly Hills, California, on the day, night, and morning after the 1968 presidential election. It is more difficult when it is that close to you, because you start wanting to deny certain things that you did: 'I didn't wear my skirts that short.'...Then you start looking at photographs, and there it is: men did in fact open their shirts down to the navel and hang seven thousand things around their necks....Warren Beatty in the movie is the sex object. None of the women is. So you say, OK, if I'm going to put him in a leather jacket...I want it to be the softest leather; when you touch it, it should be a sexual experience....We started to make it, and I started to think that zippers are not really sexy because they have something rigid about them and keep me from seeing his body as well as I want to see it. We started from scratch again and we laced the jacket, had fringes hanging, so there was movement...we started just buying jeans; after all, jeans are jeans. Well, you couldn't see his body well enough, so we custom-made the jeans....Everything he wore had some kind of sexuality to it. It was one of the times when youth was revered and age was not....

"Julie Christie, the Beverly Hills mistress, wears one of those silk blouses cut rather low, with a push-up bra, stuffed from underneath. Why would I concern myself with their underwear at all? Because it helps the actor to feel a certain thing, and whatever an actor is feeling should finally affect the audience. You give Julie Christie an uplifted bra with pads and it makes her a whole other person....She has a brain but she knows what she's using that brain for: it is to make herself most appealing to the men who are going to keep her. Your obligation is to help the director and the actor create an atmosphere and an attitude, and your obligation does not end with what you can physically see: it has to do with giving the actor underwear, keys, stuffing pockets, having the actor wear the clothes, get used to them. It is a good thing to give a woman like that real jewelry—not that it photographs any differently, but it makes her feel different."

*SHAMPOO* (1975) • ANTHEA SYLBERT, COSTUME DESIGNER

 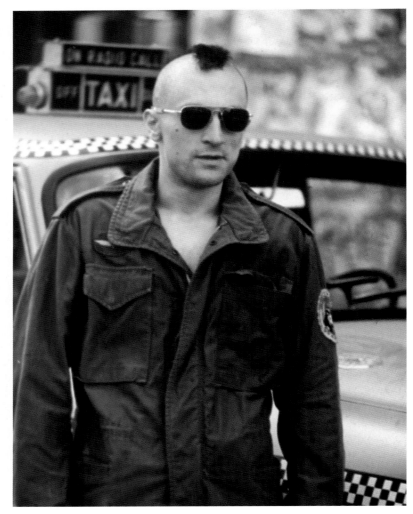

**Ruth Morley :** "I like working with actors who *care* more than with actors who say 'Put something on me.' In *Taxi Driver*, when I finally found the plaid shirt, army jacket, and the pants Bobby De Niro wanted to wear, well, *he wanted to wear it*. Some wardrobe people would get hysterical. They'd say: 'You can't let him take it home and live in it!' But I said: 'Look, if he really wants to live in it for a while, *sleep* in it, let him!' I knew that with Bobby there was no question that he would lose it. *He loved it too much*."

**Mrs. Foster (actress Jodie Foster's mother):** 'I couldn't believe how she looked in her wardrobe. Suddenly she had legs. I don't think I'd ever seen her with her hair curled. I was very happy when she returned to her grubby little self.'"

**TAXI DRIVER (1976) · RUTH MORLEY, COSTUME DESIGNER**

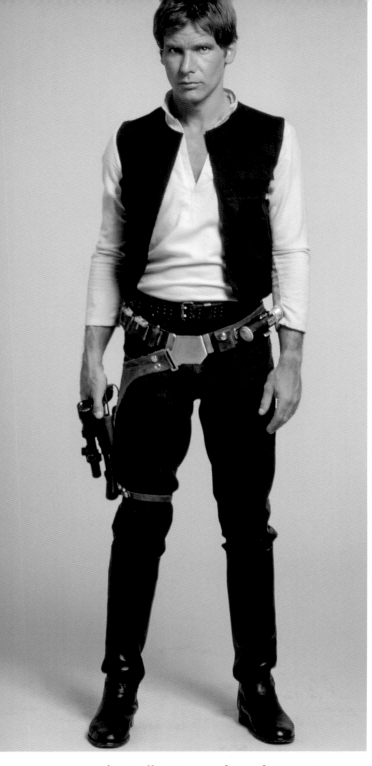

**John Mollo:** "George [Lucas] was quite keen on what we called 'Custer' shirts, a cavalry shirt. Han wore a black flap jacket vest with numerous pockets, and blue brushed-denim britches. George suggested stripes down the side of the trousers, again like the U.S. cavalry. We thought that might be a bit obvious, so we had strips of cloth machine-woven with little red rectangles down the side."

**John Mollo:** "George wanted Luke's costume to be soft, very simple. His famous remark to me at the beginning of preproduction for the first *Star Wars* movie was that he didn't want to notice the costumes. We used a lot of soft materials, like Viyella and brushed denim, which was quite popular at the time. Luke had a Japanese jujitsu shirt, his britches of brushed denim, all in very pale colors, and his boots had puttees to be wound around his legs."

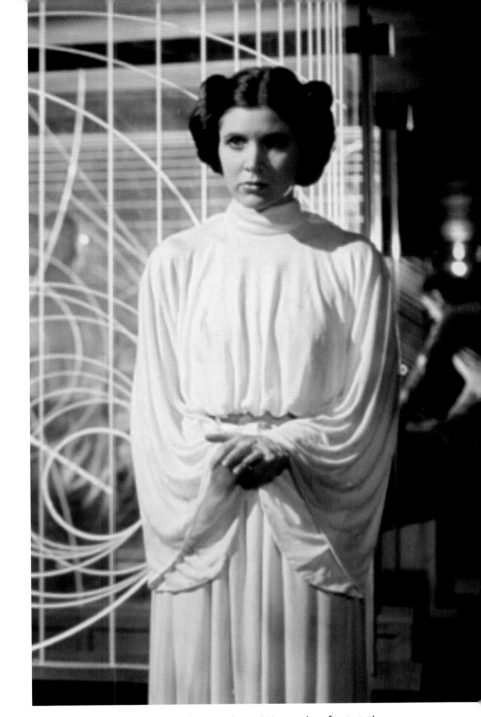

**George Lucas (director):** "In *Star Wars*, the first trilogy, Princess Leia's costumes are very, very simplistic, they're designed to not call attention to themselves. The Empire has taken over; fashion has gone out the window. Everybody wears gray or white in a world where evil is sort of in control of things."

**Carrie Fisher (actress):** "Turtlenecks on dresses are bizarre . . . I'm not a white person; I'm a black person. . . . The hair. I loathed it . . . I was always hot . . . Weird belt. They were always futzing with me. . . . Couldn't wear a bra. My breasts would bounce and we had to reshoot. Breasts don't bounce in space; there's no jiggling in the Empire."

***STAR WARS* (1977) • JOHN MOLLO, COSTUME DESIGNER**

**Patrizia Von Brandenstein:** "The white suit was to become not just an emblem for the film but a talisman for John. When we went to clubs, we loved the strobing effect the big block lights had on white. Someone casually said at a meeting, 'But heroes wear white.' 'Exactly.' The whole point had to be that it wasn't a designer suit, it was worn by a Brooklyn kid who could barely afford to go out on a Saturday night but spends eighty percent of his income on clothes."

***SATURDAY NIGHT FEVER* (1977) • PATRIZIA VON BRANDENSTEIN, COSTUME DESIGNER**

**John Travolta (actor):** "It wasn't easy because I'd never played a Fifties dude on screen before. I felt that I had to think a lot about how a guy's behavior would have differed 25 years or so before I was born, I mean, movement had to be different."

**Sean Moran (dancer):** "My God, we all almost died. We hadn't seen Sandy's 'transformation costume' before. When Olivia came out, half the boys fell to their knees in amazement, and the other half wanted the outfit."

**John Travolta (actor):** "I put a walk in that was sort of 'black bop.' I made the character a little more *black* fifties, because I think the cool side of the fifties was based more on a black undertone. I was really a white person trying to imitate black jive."

### *GREASE* (1978) · ALBERT WOLSKY, COSTUME DESIGNER

**Faye Dunaway (actress):** "Theoni Aldredge designed the costumes, and created these great sexy little blouses and skirts for Diana. They were audacious and feminine at the same time."

**_NETWORK_ (1976) · THEONI V. ALDREDGE, COSTUME DESIGNER**

**Jason Bonderoff (biographer):** "In *Norma Rae*, for the first time in her career, she wore jeans (not the designer kind), cheap T-shirts, and the least makeup possible. She sweated visibly on screen; she cursed; she even suffered a nosebleed. And she gave one of the grittiest—and most moving—performances in movie memory. At the start of the film, Norma Rae's lover told her, 'You got dirt under your fingernails and you pick your teeth with a matchbook.' It was a perfect description. With that single line of dialogue, the Flying Nun finally disintegrated before our eyes—and a brand-new Sally Field was born."

***NORMA RAE* (1979) · AGNES LYON, COSTUME DESIGNER**

**Deborah Nadoolman:** "*Animal House* was very much an ensemble piece, and it was based on the combined autobiographical memories of the three writers—Chris Miller, Harold Ramis, and Doug Kenney. It was really about Chris Miller's experiences at his fraternity at Dartmouth, and of the animal house on his campus. There were archetypal college characters, the bullies and the preps. In my research I used their family albums and home movies, and went back directly to personal photographs.

"John Landis wanted each fraternity to be distinct. The good guys were mostly slovenly and thrown together, except for the ladies' man, Otter (Tim Matheson). The bad guys were all wearing Brooks Brothers preppie—very, very uptight. The toga party existed in the script, but the togas themselves were my invention. When I had gone to camp as a little girl, every week we created costumes out of found objects among the cabins and I always said I could do anything with a beach towel and a sheet. In other words, they were not made by seamstresses in a workroom. I crowned John Belushi with the Caesarian laurel leaf."

*ANIMAL HOUSE* (1978) · **DEBORAH NADOOLMAN, COSTUME DESIGNER**

**Albert Wolsky:** "Fosse was always a mystery and was intense. Not a lot of laughs on the set. But there was something about the material that told me what to do, and he was never that specific unless he had an image of something. A director doesn't have to tell me blue, pink, green dress. It's other things—I need to know why a director likes the material, what it means to him."

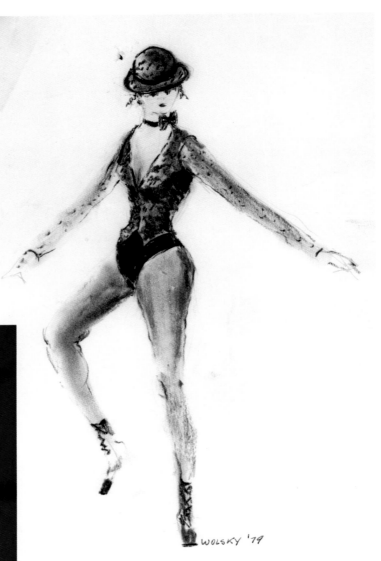

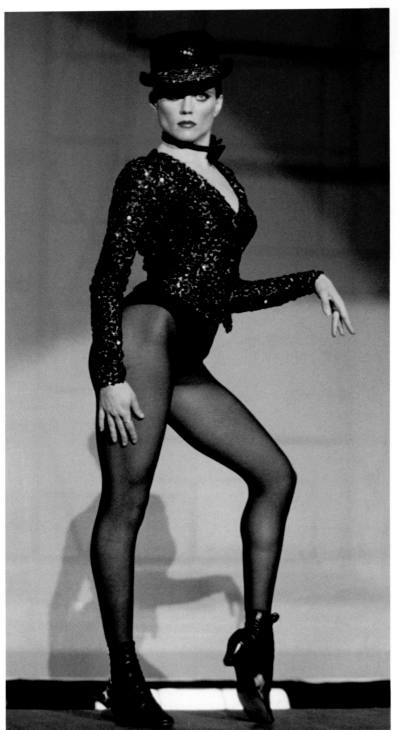

**Albert Wolsky:** "For *All That Jazz* Fosse decided that he wanted to see the veins on the dancers. I quickly had the veins painted on to the leotards, only to see the paint start bleeding once the dancer began to perspire. To solve the problem I decided to have all the veins appliquéd on to the fabric. That was a much better way of solving it and it gave depth and texture to the effect. Learning from one's mistakes is part of moviemaking."

**ALL THAT JAZZ (1979) · ALBERT WOLSKY, COSTUME DESIGNER**

**Michael Cimino (director):** "I think that one of the reasons that the movie maintains its vitality, for lack of a better word, is that the actors were asked to give very much. All of the actors were asked to go beyond themselves. All of the actors were asked to do things that they had never done before. Those guys, I had them sleep in those uniforms and never take them off, wet or dry, for one entire month. They never shaved, they never bathed, which is what happens in combat. You don't get a hot shower every night. The small details like that. Everyone allowed themselves to be inspired by what everyone else was doing. It was a rare occasion."

**Meryl Streep (actress):** "'I thought of all the girls in my high school who *wait* for things to happen to them; the kind who waits for someone to ask them to the prom, who waits for a lover to come back from war. Linda waits for a man to take care of her, to make her life happen.'"

***THE DEER HUNTER* (1978) •
ERIC SEELIG, COSTUME DESIGNER**

**Sigourney Weaver (actress):** "In the original script, there was some nudity, just people getting up from their 'hypersleep' vaults and being naked in space. The whole idea of people moving through a hard, technological environment just in their skin was so provocative. I thought it was a nice concept, but they decided not to do it because they would lose potential markets for the film. There was talk that the Alien would see this being transform in front of its eyes, from a green thing to a beige, soft thing, and that would be fascinating to it, yes, perhaps turn the alien on. Ripley is very kinky about these things, I think it was a compromise just to have Ripley undress partway."

### *ALIEN* (1979) · JOHN MOLLO, COSTUME DESIGNER

*"It is a vast responsibility to be the trendsetter in the world of elegance and style, but I can cut it."*

—MISS PIGGY

**MISS PIGGY · CALISTA HENDRICKSON AND GWEN CAPITANOS, COSTUME DESIGNERS**

"BEING THERE."
PETER SELLERS

scene 12-39.

CHANCE

MAY ROUTH.
DECEMBER 1978.

#3

**Peter Sellers (actor):** "I have no personality of my own. I reached my present position by working hard and not following Socrates' advice—'know thyself' . . . To me, I am a complete stranger. I can't do anything from within myself. I have nothing to project. I've got so many inhibitions that I sometimes wonder whether I exist at all."

*BEING THERE* (1979) • MAY ROUTH, COSTUME DESIGNER

# 1980s

B y 1980, Hollywood had regained its equilibrium. The new establishment had taken the reins, and the internal structure of the business had stabilized. Burbank Studios became Warner Bros. once again, and like the other established studios (Paramount, Universal, and 20th Century Fox) was given a multimillion-dollar facelift. Repainted, replanted, polished, and stylishly remodeled to evoke the grandeur of the old Hollywood lots, the studios finally looked like dream factories.

At Paramount and Burbank Studios, the wardrobe departments—which had occupied prime real estate at the front of the studio, in historic early-1920s buildings—were turned into executive offices. Tailor shops and cutting tables, costume stock, and fitting rooms either found alternative digs at the back of the lot, with the prop department and the lumber mill, or were

OPPOSITE: *Jennifer Beals in* Flashdance. *"I'm often asked if it was my intent to create a trend with the 'torn sweatshirt' design, which created such a stir in the early 1980s in the film* Flashdance. *Besides the impossibility of instigating a trend knowingly, it would be negligent of me as a costume designer to put anything before the character. Jennifer Beals was playing Alex, a would-be dancer, earning a living as a welder. Her character also expresses an interest in fashion. The sweatshirt . . . was appropriate for a working-class character, and cutting and redesigning it seemed a perfect way to personalize and adapt it to her specific style and to the warm-up needs of a dancer. Jennifer's beautiful shoulders didn't hurt."*
*—Michael Kaplan, costume designer,* Flashdance (1983)

dissolved completely. Cutter-fitter Catena Passalaqua, who had started working at Warner Bros. in the 1960s, had become the studio's wardrobe manager by the late 1970s. "We had to make money," Passalaqua said of the 1980s. "We could loan our clothes out to Warner Bros. productions, but they wanted us to promote our public rentals."

In another cost-cutting trend, the studios were beginning to move production away from Los Angeles to the southern United States, Canada, and Australia. Off the studio campus, costume designers were obliged to set up workrooms on locations around the world.

And there were other changes. Film executives were now more likely to be lawyers or ex-agents, and their performance was scrutinized by stockholders. The baby moguls tried to anticipate audience tastes, but movie success continued to be unpredictable and elusive. Each executive had his share of hits and misses. Ned Tanen, a former president of Universal who became president of Paramount in 1984, reflected, "If I had green-lit [made] every picture I put in turn-around [rejected] and put in turn-around every picture I had green-lit—the results would have been the same."

The gradual absorption of the movie studios by multinational conglomerates continued. Paramount was a Gulf & Western company; MCA/Universal was acquired by Matsushita Electrical in 1991; both became mere line items in a much larger ledger. This consolidation of entertainment and programming properties would continue for the next twenty years; film studios frequently lost money, but it was still glamorous to own one.

Talent agencies such as the Creative Artists Agency (CAA) became powerful, offering the ability to assemble and leverage "packages" with marketable stars and directors. In search of reliable cash cows, the studios also reached for presold properties: serials (*Raiders of the Lost Ark*, 1981, and its sequels, *Indiana Jones and the Temple of Doom*, 1984, and *Indiana Jones and the Last Crusade*, 1989), classic television series (*The Untouchables*, 1987), comic books (*Batman*, 1989), best-selling novels (*Prizzi's Honor*, 1985), and—especially—remakes (such as *Scarface*, 1983). From the very beginning of the industry, the studios had always recast, remade, and resold their properties: *What Price Hollywood* (1932) was remade as *A Star Is Born* (1937) and *A Star Is Born* (1954) and *A Star Is Born* (1976). Now more than ever, if a film did well the first time at the box office, it was expected to do well again—especially if it had a recognizable title.

By the 1980s, marketing costs for the average film amounted to a third of its total budget, and the promotion of a recognizable brand became a powerful plus for studio accountants. With the explosion of home video as a new market, the studios had a new opportunity to resell both recent releases and classics from their film vaults. Pleasing the public was serious business, and polling groups and market research had become key elements in the control of the final product. Now, mustering every available strategy to guarantee a successful opening weekend, studios pressured directors to edit their films to conform to the polling "numbers" from public focus groups. These preview cards became an established part of the filmmaking process, and a film's "preview numbers" became a subject of speculation and gossip among industry insiders—though the numbers often bore no relation to a film's eventual success or failure in the marketplace.

With a flurry of "popcorn" movies, the studios garnered some of the top-grossing films of all time. Writer/director John Hughes's teen-driven films *The Breakfast Club* (1985) and *Pretty in Pink* (1986) led journalist Jonathan Bernstein to call the 1980s "the decade when Hollywood gave up any pretense of engaging the emotions and challenging the intellect, concentrating solely on meeting the demands of the marketplace. It was a time dedicated to catering to the basest of whims." The 1980s confirmed that teenagers were a reliable audience, contributing to the success

of the *Indiana Jones* series, *E.T.: The Extraterrestrial* (1982), and *Back to the Future* (1985). As Michael Medavoy put it, "the generational shift that began in the '70s was completed. Teenagers became the biggest movie going audience and never gave up that throne." Movie studios actively pursued the teen audience and the merchandising gold mine they promised.

As marketing costs skyrocketed, established movie stars gained ever more power. A star's drawing power was now based on the box-office receipts his latest film drew on its opening weekend—and the canniest stars leveraged their grosses into ever-increasing salaries, in a skyward trajectory that continues today. Stars whose careers began in the mid-1960s and early 1970s wielded enormous power in green-lighting productions. Without the studio system to develop star vehicles, actors launched their own production companies, producing their own films and actively developing new projects.

Salaries and profit participation put actors significantly ahead of the rest of the creative team, and the differential between superstar and movie budget had never been so great. Although the industry had always been top-heavy, these astronomical salaries began to take their toll on film budgets. Studios began to squeeze money from the "below the line" production budget, which covered sets and costumes, in order to meet the "above the line" salaries of the writers, producers, directors, and actors. With budgets shrinking to make space on top for stars, costume designer and newly hired Warner Bros. executive Anthea Sylbert commented, "The costume part of a budget is usually the smallest part of a budget."

By the end of the 1980s, the shortage of bankable stars who could "get a picture made" resulted in a very short casting list for which every studio competed. The superstars' growing ancillary costs (trainer, masseuse, dresser, hair stylist, assistants, bodyguards) were increasingly

*Henry Thomas in E.T. the Extra-Terrestrial (1982) • Deborah L. Scott, costume designer*

factored into the bottom line, eating away further at production budgets. Once again, costume design was one of the casualties. Designers were often brought in for just the first couple of weeks of a production; once the principal costumes had been "set," some producers felt, a designer's work was finished. Gone were the costume crews, long responsible for the continuity and maintenance of the wardrobe after the costume designer departed. "You don't just design something and say goodbye," Sylbert complained. "What if I get an idea at the last minute and want to change something?"

With location shooting increasingly prevalent, filming schedules in these years often changed because of the weather or other availability issues. Bob Ringwood, costume designer of *Dune*

*Kyle McLachlan in Dune (1984) • Bob Ringwood, costume designer*

(1984), remained on site for that extraordinary movie's filming. "I've been on the film for fifteen months," he reported at the time, "and we're still making clothes during this, my last week, on the picture."

The 1980s saw the emergence of another new phenomenon that continues today: late casting, a source of high anxiety that had a serious effect on the costume design process. The scarcity of bankable stars compelled the studios to push their production schedules to suit each star's convenience. As a result, the rest of the supporting cast often went unhired until the last possible moment.

It was a burden that hit the costume process especially hard. Where production designers could start their research, deliver blueprints, and begin set construction long before an actor was hired, costume designers needed to wait for final casting before they could set pen to paper. The studios were reluctant to hire costume designers until the cast was confirmed, and the cast often wasn't confirmed until the star was available. Preproduction time was foreshortened, and costume designers found themselves under pressure to design a movie in less time with less money than ever before.

On-camera wardrobe tests were another casualty of late casting and the budget squeeze. Jeff Kurland, who designed Woody Allen's films *Broadway Danny Rose* (1984), *The Purple Rose of Cairo* (1985), and *Hannah and Her Sisters* (1986), enjoyed this luxury, no longer available to most of his colleagues, simply because Allen saw their value. Kurland was "shocked that people didn't do wardrobe tests because it's so important." Tests were a tool to determine how a costume would photograph on film and whether they were successful for the character.

Designer Ellen Mirojnick, whose credits include *Fatal Attraction* (1987), takes such screen time seriously. "I get scared stiff the character will look like a cardboard cutout up there on the screen. If the actor can't move *into* the character's clothes—then the audience will notice the clothes, not the man, not the woman, and I've failed."

The misperception that designing contemporary films was an easy business persisted into the 1980s, as Sylbert bemoaned. "Certain filmmakers assume that if you're doing a modern film nobody has to sit down and make a sketch and then make a costume." Mirojnick concurred:

"There's no way that the preparation is less on a contemporary movie. In fact, sometimes it can be more complex. A designer's understanding of the time, place, and story have to be keen to reproduce what one might find familiar in everyday life."

During the filming of *Wall Street* (1987), director Oliver Stone's stockbroker friends—characters similar to those portrayed in the film—visited the set. Unfamiliar with theatrical conventions, including the enhancement of a look to make an impact onscreen, "They'd come to the set and they'd say, 'Nobody dresses like that,'" Miro-

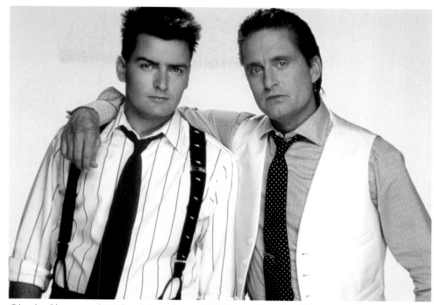

*Charlie Sheen and Michael Douglas in* Wall Street *(1987) • Ellen Mirojnick, costume designer*

jnick lamented. "And I said, 'Well, Gordon Gekko does.' I looked at the Ivan Boeskys of the world and I made an amalgamation. We can *push it*," she decided, "because [the film] was about seduction." The result was predictable: after *Wall Street*'s release, Gordon Gekko's signature suspenders and white collars became ubiquitous at brokerage houses.

The 1980s teemed with such collisions between fashion and film (Michael Kaplan's off-the-shoulder sweatshirts for Jennifer Beals in *Flashdance,* which sent scores of young women to their closets with scissors, were just another example). The 1988 film *Coming to America* popularized African cotton batik prints, which were virtually impossible to find in the United States before the movie's release. After researching sources in the United States and coming up empty, I ordered hundreds of yards of African fabric from a stall in London's Brixton Market. *Coming to America* helped power an Afrocentricity that was brewing in the cultural zeitgeist; by the following year, kente cloth was everywhere. Theoni Aldredge's solution for Cher's character in *Moonstruck* (1987) was to "try to stay on the classic side so it doesn't look totally ridiculous two years from now. Period costuming is far more easy to do than contemporary, because no one knows enough to complain. A hoop skirt is a hoop skirt."

Costume was a crucial storytelling tool in the modern comedy *Tootsie* (1982). Dustin Hoffman plays an actor (Michael Dorsey) pretending to be an actress (Dorothy Michaels) who lands a role (Emily Kimberly) on a TV soap opera. "There are really three characters on Dustin's back in this film," explained designer Ruth Morley. "I tried to keep them all separate. The problem was not *just* to make him look like a woman, but [to make him look like] two different women. Michael Dorsey created Dorothy Michaels, but a bunch of soap opera writers created Emily Kimberly." Each costume change and ensemble was designed to reflect Hoffman's frantic inner state of mind. "The costume was not a costume," Morley said, "it was a casing of support right next to the skin of this actor, who was trying to find a whole new world *inside* himself by spinning a whole new skin *outside* himself." Actors use costumes to transform themselves and channel other people whether the film is period or contemporary.

The one genre on which costume designers never lost their hold was the period drama. All producers agreed that these were "costume pictures." As designer Ann Roth noted, "Despite the fact that the story of *Places in the Heart* (1984) took place in 1935, the women's clothes have more of the flavor of 1930 . . . on purpose. Those poor people were media-proof. It was the Depression,

and some of them were very poor and they wore old clothes. If they made a new dress, they reused a pattern from a couple of seasons back."

For her work on *Out of Africa* (1985), designer Milena Canonero faced a very different challenge. In researching the film, a "bio-pic" of author Isak Dinesen (Karen Blixen) set in East Africa in the 1910s, Canonero scoured the family photograph albums and memoirs for details on the trim and accessories of the Belle Époque dress worn by Dinesen and the film's other European characters in Europe and in East Africa. The seriousness of the film required Canonero to reproduce the tribal costume of the East Africans on Blixen's plantation and surrounding farmlands accurately—though, as she noted, "it [wasn't] easy to find references in books showing what the Somalis wore in those days." The romantic linen and khaki costumes she created for Meryl Streep in the film led to a surge of safari lookalike retail fashions in the late '80s.

The costume–fashion connection went both ways, and not always for the better. Product placement began to seduce some producers in the late '80s with promises of cash kickbacks and free merchandise. Designers were frequently encouraged to approach fashion manufacturers to offset inadequate budgets, even when such placement might be inappropriate for the character or destructive to the story. As the studio doors opened, Italian, French, and Seventh Avenue designers began to lend clothes to modern films. Immediately costume designers found that they were ceding film design credit to clothing manufacturers who had contributed one shirt, one suit, or one gown to a movie. As these huge marketing and fashion licensing machines took full advantage of the Hollywood connection, the costume designers' names became lost in the barrage of branding.

This confusion between fashion and costume design is still prevalent throughout the film business. Recently, veteran Patricia Norris, designer of the iconic *Scarface* (1983), received a call from a powerful young director asking where she had purchased Al Pacino's suits. Norris said the suits were "made to order." "But who was the designer?" the director repeated. Norris said that she had designed the suits. "No," the director insisted. "They must have been made in Italy." Norris patiently explained that as the costume designer of *Scarface,* she had designed and manufactured all of Pacino's suits for the film, along with Michelle Pfeiffer's costumes. Norris added diplomatically, "My *tailors* were Italian!"

Modern costume in the 1980s was not entirely designed, shopped, or rented, but a combination of all three. Working often on distant locations, designers were ever-resourceful with materials and funds. When offered, designers used a minimum of product placement for maximum effect. And the employment of costume designers expanded, as producers and directors rediscovered that their films—in both look and storytelling quality—would be enhanced by the collaboration of a talented costume designer. As Mike Nichols put it, designers "find ways to express the underneath without words; sometimes it's the opposite of the words . . . unexpressed undercurrents that are palpable."

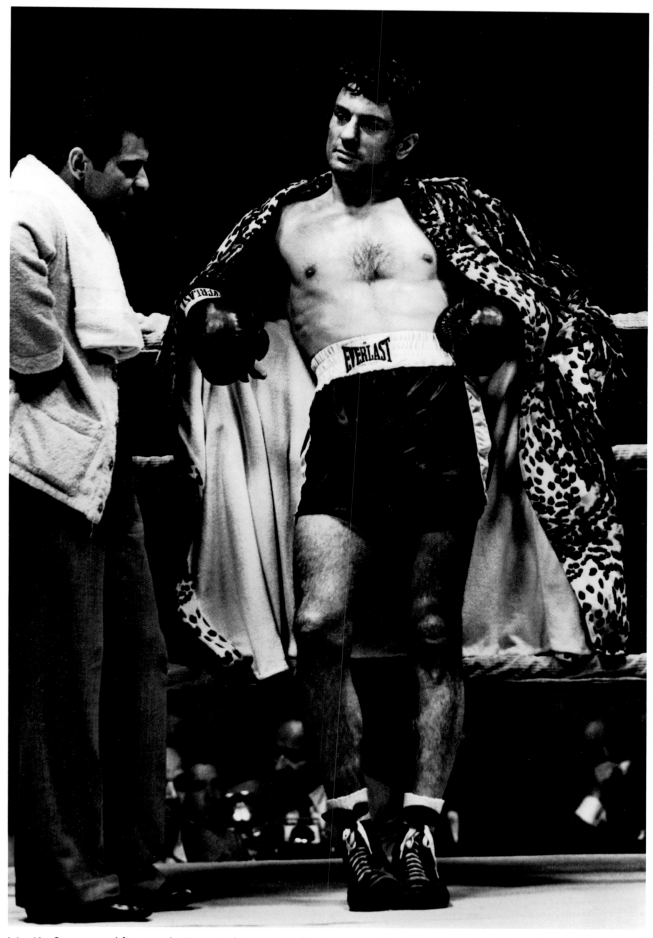

**Martin Scorsese (director):** "I wanted *Raging Bull* to be something very special. . . .[I knew] it would also help us with the period look of the film to make it black and white. We had an idea of making the film look like a tabloid, like the *Daily News*, like Weegee photographs."

*RAGING BULL* **(1980) · JOHN BOXER AND RICHARD BRUNO, COSTUME DESIGNERS**

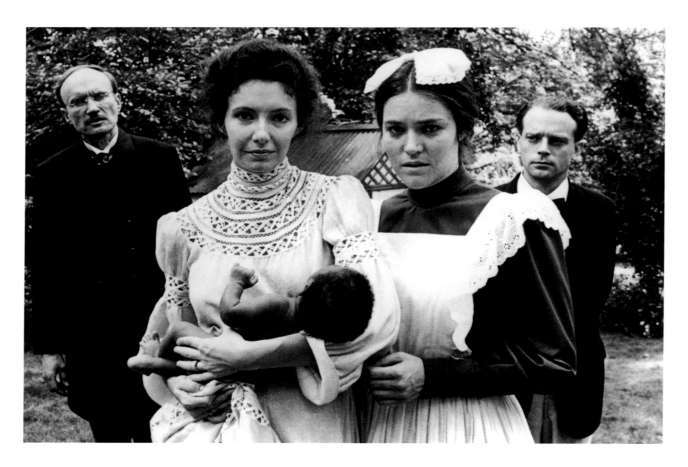

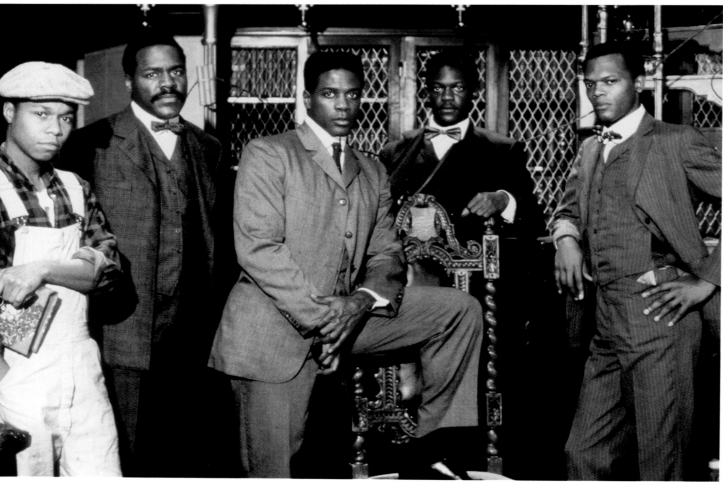

**Milos Forman (director):** "It's very important that the three main collaborators are, when it comes to taste and intelligence, in sync. And that's the cinematographer, and the set designer, and the costume designer. Because if these three elements serve the same kind of taste and the same kind of philosophy of picture, then you are well off. You are very well off."

*RAGTIME* (1980) • ANNA HILL JOHNSTONE, COSTUME DESIGNER

**Sissy Spacek (actress):** "In the beginning, when Loretta Lynn was so poor, she didn't have enough money to buy doodads and rickrack for more than one dress. So between acts she'd go backstage and take the rickrack off one dress and stitch it on another. Do you *believe* that?"

**COAL MINER'S DAUGHTER (1980) · JOE TOMPKINS, COSTUME DESIGNER**

**Robert Duvall (actor):** "I told them, I don't want anybody to 'act' in this movie. The whole experience reinforced what I had always thought, which is that you should be as natural and truthful as possible, and try to 'act' as little as you can."

**TENDER MERCIES (1983) ·
ELIZABETH MCBRIDE,
COSTUME DESIGNER**

**THE ELEPHANT MAN** (1980) · PATRICIA NORRIS, COSTUME DESIGNER

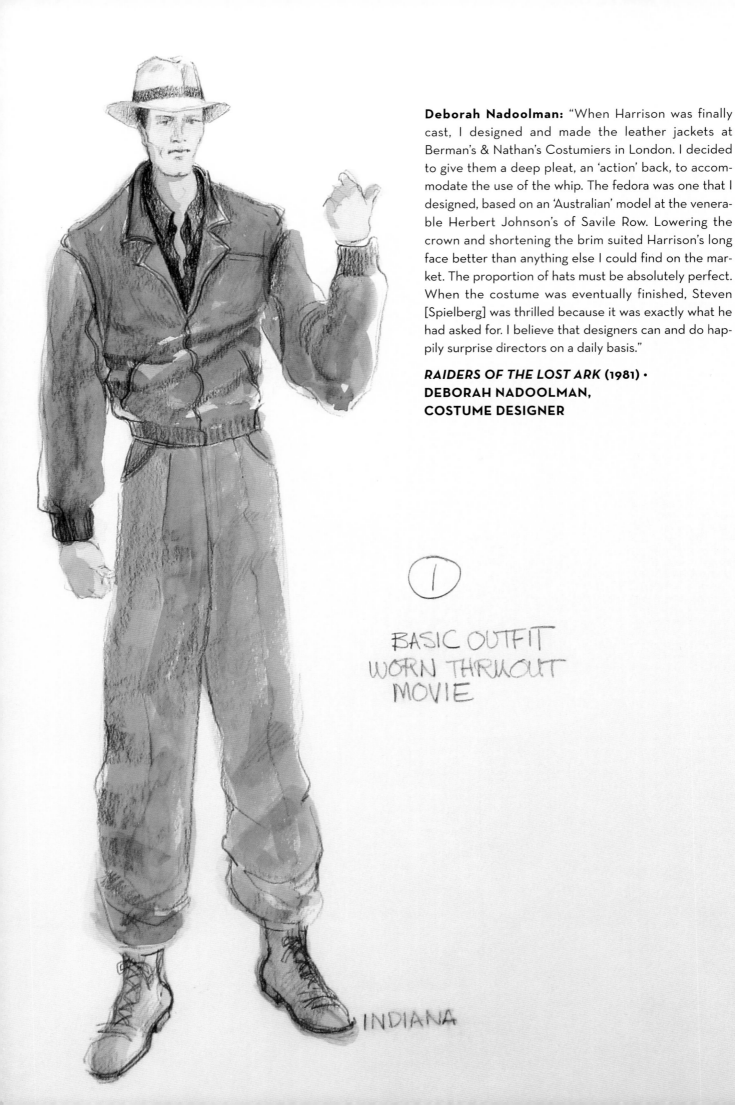

**Deborah Nadoolman:** "When Harrison was finally cast, I designed and made the leather jackets at Berman's & Nathan's Costumiers in London. I decided to give them a deep pleat, an 'action' back, to accommodate the use of the whip. The fedora was one that I designed, based on an 'Australian' model at the venerable Herbert Johnson's of Savile Row. Lowering the crown and shortening the brim suited Harrison's long face better than anything else I could find on the market. The proportion of hats must be absolutely perfect. When the costume was eventually finished, Steven [Spielberg] was thrilled because it was exactly what he had asked for. I believe that designers can and do happily surprise directors on a daily basis."

***RAIDERS OF THE LOST ARK* (1981) ·
DEBORAH NADOOLMAN,
COSTUME DESIGNER**

BASIC OUTFIT
WORN THRUOUT
MOVIE

INDIANA

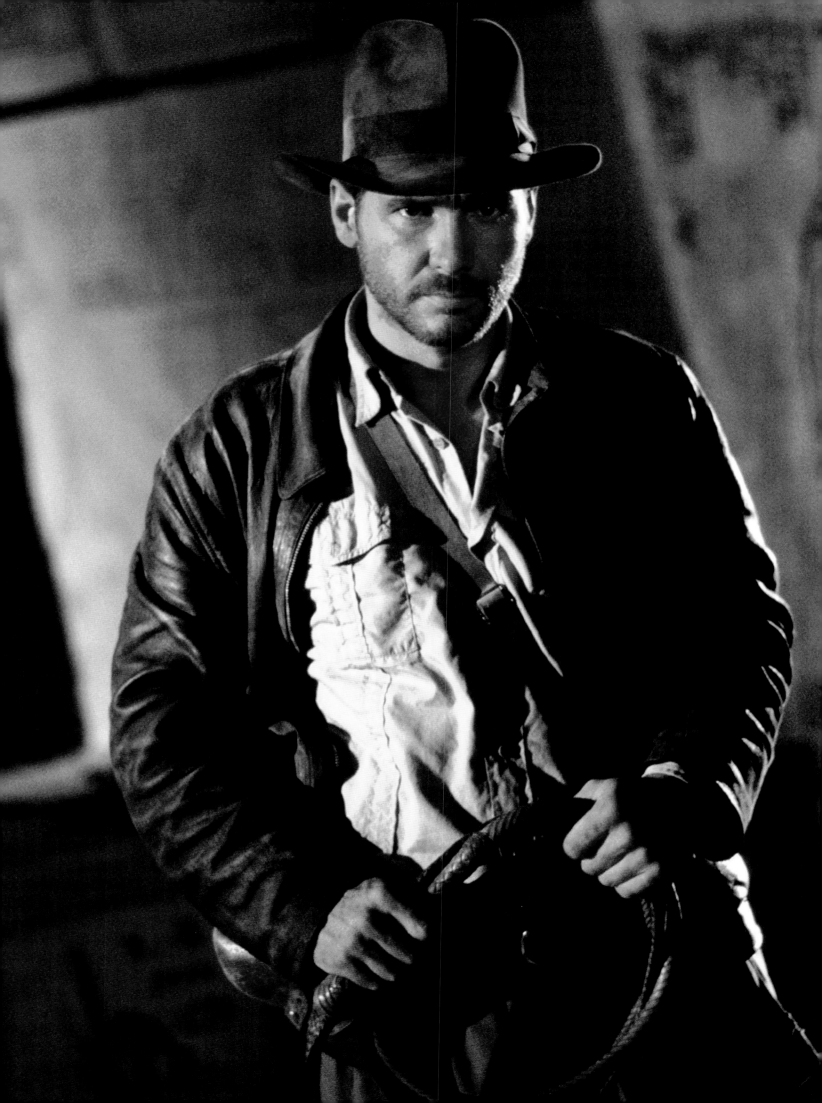

**Ruth Morley:** "There are really three characters on Dustin's [Hoffman] back. I tried to keep them all separate. The problem was not just to make him look like a woman, but *two different women*, with different clothes coming from the minds of their creators. Michael Dorsey created Dorothy Michaels. But a bunch of soap opera writers created Emily Kimberly."

**Jessica Lange (actress):** "When someone asked me if I found it distracting playing opposite someone in drag, I said it had never occurred to me that he was in drag."

*TOOTSIE* (1982) · **RUTH MORLEY, COSTUME DESIGNER**

**Kristi Zea:** "Three weeks before we were starting to shoot, director Jim Brooks said, "I've decided that Aurora [Shirley Maclaine] is not from Texas, or from the South, but from New England." Shirley came to me in an absolute state of despair. 'What are we going to do? All my clothes are predicated on the fact that I am from the South?' We scrambled. I just kept thinking about cardigans over the shoulder, the Nantucket handbags, and the Dock-sider shoes. Relieved, she said 'You got it. That's it.' The simplicity of those clothes was a wonderful counterpoint to what happens later in the script. Had Aurora been from the South, there wouldn't have been a contrast between her character as the New England Mom and as love interest for Jack [Nicholson]. Later, when they date, she buys a preposterous frilly dress that oozes Southern influence. This radical costume change allowed the audience to experience her growth. Aurora and Emma [Deborah Winger] were solid New England stock; there was a simplicity to them and no artifice. Everything they represented was rooted and not superficial."

### *TERMS OF ENDEARMENT* (1983) · KRISTI ZEA, COSTUME DESIGNER

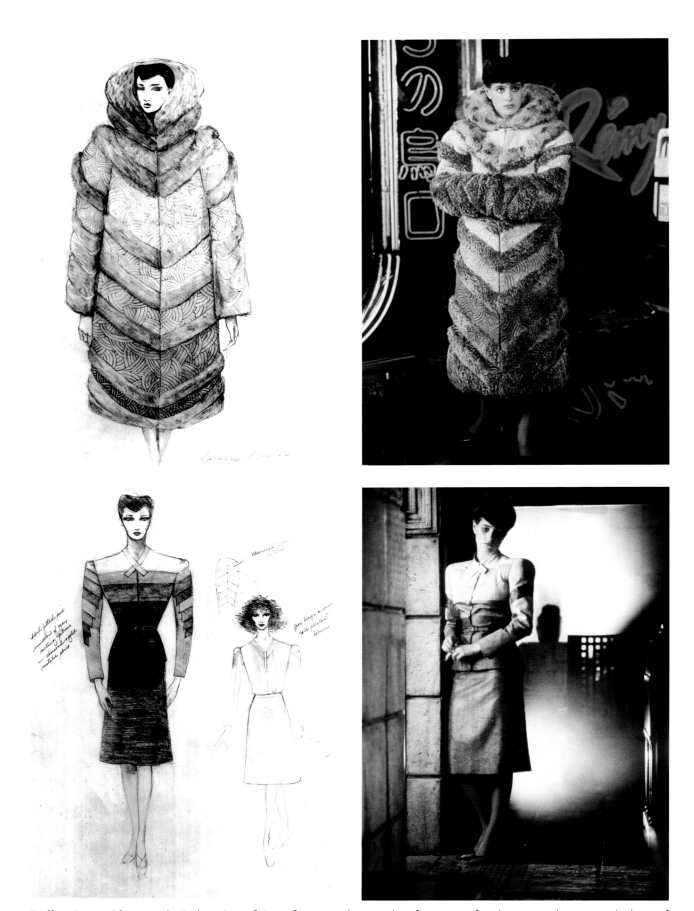

**Ridley Scott (director):** "When Sean [Young] was made up in her forties outfit, she somewhat reminded me of Rita Hayworth. She had that look. And Hayworth had been my ideal of the sphynxlike femme fatale ever since I saw her in *Gilda*. I suppose you could say Rachael was my homage to *Gilda*."

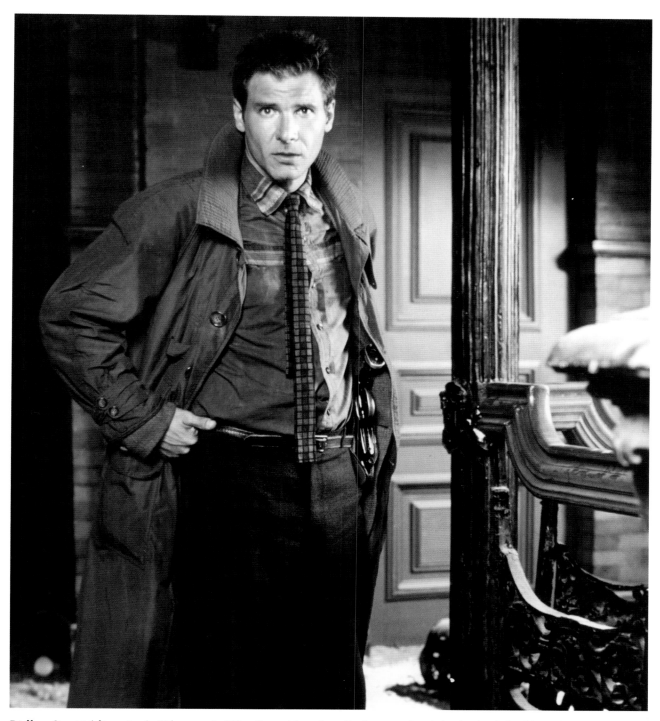

**Ridley Scott (director):** "The most difficult problem for all of us involved the look of the film. The nightmare in my mind was that this 'look' would merely become an intelligent speculation concerning a city forty years in the future, and nothing more. I insisted that *Blade Runner's* final look be authentic, not just speculative. For instance, take clothes and cars. What if you could take someone, a contemporary man, and whisk him back to the Times Square of forty years ago? He wouldn't, I think, have that many shocks in store for him. [he] . . . wouldn't be puzzled by forties clothing, either, since we're seeing something of a resurgence in forties fashions right now. Fashion is always cyclical. So you're going through a rather frightening process every time you make a design decision. Whether it's a telephone, or a bar, or the shoes a character will wear, once it has been designed, it must be lumped in with everything else in the film. For better or for worse."

**Ridley Scott (director):** "Harrison [Ford] signed on to *Blade Runner* in late October of 1980. . . . He drove into London and I think he still had that goddamn hat on he wore as Indiana Jones. I thought, 'Oh, shit!' Because up to that point, we'd seen Deckard wearing the same kind of hat. The kind they used to sport in those old noir thrillers. So there went Deckard's hat. I thought, 'Okay, if the hat's out the window, we'll give him a crew cut!' Which is where Deckard's brush cut came in."

**BLADE RUNNER (1982) · MICHAEL KAPLAN AND CHARLES KNODE, COSTUME DESIGNERS**

**Brian De Palma (director):** "Tony and Elvira, Al and Michelle, were doomed people, and it was drugs that doomed them. That was the message. I think we underplayed the violence. The drug world is much more violent, brutal, and cruel. We made no attempt to romanticize it, which is why we got so many negative opinions. But I think everyone pulled their weight, and we got the anti-drug message across. There was certainly nothing glamorous about Michelle's character. Oh, she looked good on the outside, but she was a mess beneath that beautiful shell."

**Brian De Palma (director):** "When you're making a movie about gangsters, you shouldn't romanticize them. There should be something about them that makes your skin crawl. They're murderers. You have to show the reason they are who they are, and why they do what they do. *Scarface* is about power, and the modern aphrodisiac of power is cocaine. I was trying to show what this power means in its most grandiose, absurd sense. Movies have to be 27 times bigger than real life simply to communicate what the reality of the situation really is."

### *SCARFACE* (1983) · PATRICIA NORRIS, COSTUME DESIGNER

Places in the Heart
Sally Fields as Edna

Silk stockings
used here only.

— 13½

Cotton pickers
**Places in the Heart.**

**Ann Roth:** "The story took place in 1935, [but] the women's clothes have more of the flavor of 1930 on purpose. Those people are media proof. It's the Depression and some of them are very poor, so they wear old clothes. Or, if they've made a new dress, they have reused a pattern from a couple of seasons back. They've caught onto some basic things of the mid-'30s—such as low hemlines—but these women probably would never have worn extremely short skirts even in the '20s. Sally Field's character's sister (played by Lindsay Crouse) is more sophisticated. She has a small beauty parlor in her home. Although the sisters are very close, I felt that Sally would usually manage to take care of her own hair. I also knew that she would usually wear a girdle. Not when she was picking cotton, of course, but most of the time around the farmhouse, and surely whenever she went into town. It was just considered the proper thing to do at the time. Sally wanted to make it very real. Otherwise, she wouldn't have agreed to do the picture."

### *PLACES IN THE HEART* (1984) · ANN ROTH, COSTUME DESIGNER

**April Ferry:** "We all went to a small town in South Carolina just before Thanksgiving and immediately started hanging out together, as we all lived in the same complex near the ocean. It was a summer tourist town and we were there in midwinter. That was such a help as I got to interact with everyone and talk endlessly about character and story. The clothes that I brought from Hollywood wound up on different characters than planned from the process that occurred there. I found a wonderful small department store in the town that had been open for many years that had older-looking underwear, socks, sweaters, etc., that were very useful. It gave it that well-worn, used look. The actors were all just starting in film and their enthusiasm was an inspiration. It was probably the most organic clothing I've ever created."

## *THE BIG CHILL* (1983) · APRIL FERRY, COSTUME DESIGNER

**Deborah Nadoolman:** "John Belushi and Dan Aykroyd had established Jake and Elwood Blues on *Saturday Night Live*. They based the look on 1950s bluesman John Lee Hooker: a snap-brimmed black fedora, black sunglasses, white shirt, narrow black tie and black suit. When we were about to start the movie I said, 'Well, let's really define the silhouette so that even in the dark, even walking away, even by their very shadow—the audience will know who these two characters are.' Jake and Elwood are sympathetic and sleazy impoverished lowlifes whose suits fit them awfully well. I deliberately did not age or make those suits greasy, oily, smelly or noticeably dirty. . . . Jake and Elwood are forever the Laurel and Hardy of the blues."

**THE BLUES BROTHERS (1980) · DEBORAH NADOOLMAN, COSTUME DESIGNER**

**Meryl Streep (actress):** "Karen wasn't settled, she was always looking for trouble. There are people who are always exploring possibilities, looking around to make waves. That was the way she seemed to me. She was a very difficult person. My heart breaks for her. She was only twenty-eight or twenty-nine when she died and it was a real waste. I'm really glad I got the chance to step into her shoes for awhile."

**Mike Nichols (director):** "You find ways to express the underneath without words; sometimes it's the opposite of the words or a tangent of the words. I think *Silkwood* has a lot of those things—unexpressed undercurrents that are palpable."

**SILKWOOD (1983) · ANN ROTH, COSTUME DESIGNER**

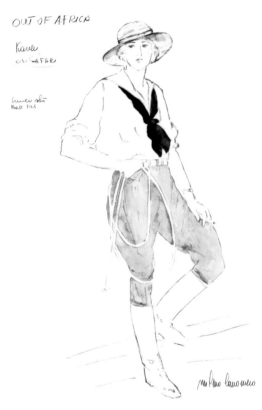

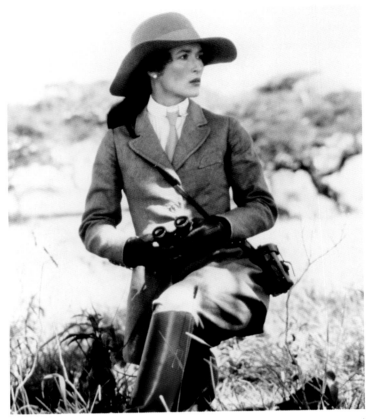

**Milena Canonero:** "*Out of Africa* was very challenging from a research perspective. I had only about two and one-half months to prepare. I went to Denmark to visit Isak Dinesen's family and examine her family archives. This gave me wonderful insights into her character. I wanted to achieve the many looks of Dinesen, but also [to] design clothes that were right for Meryl Streep. We were not making a documentary. I was very fortunate to actually locate a contemporary of Dinesen's who had amassed a great collection of Somali references. It isn't easy finding information on what the Somalis wore in those days. . . . I [also] relied on Stephen Grimes, the production designer. He arrived on location in Kenya before I did and he would call and describe for me what he was doing in each scene. He sent me color copies of his paintings so I could see the colors he was using. It was great to know exactly how he was approaching the design before I got there.

"The costumes in *Out of Africa* had quite an impact on fashion. It was as though the fashion world was ready for the styles of the film; the costumes just caught something that was in the air. When I'm sketching a costume, I'm thinking about the personality of the actor or actress who will wear it. I have to consider the performer's body. Perhaps he has short legs, and I need to lengthen a line. A fashion designer [in contrast] knows that his model will have a perfect figure and he is designing with a completely different end result in mind."

**Meryl Streep (actress):** "What I liked about Blixen, more than any of the other characters I've played, is that she was victimized by her own passions. She was a woman who knew who she was, yet she was very contradictory in her letters. And the more she contradicted herself, the more I loved her. She was a very vivid character and she left a strong impression of who she was."

## *OUT OF AFRICA* (1985) · MILENA CANONERO, COSTUME DESIGNER

**Molly Ringwald (actress):** "Claire is not like me at all, or like anything I've ever played before. I thought it would be fun to play somebody I've observed for so many years and disliked in school—because there's one of those Claires in every school."

*THE BREAKFAST CLUB* (1985) · MARILYN VANCE, COSTUME DESIGNER

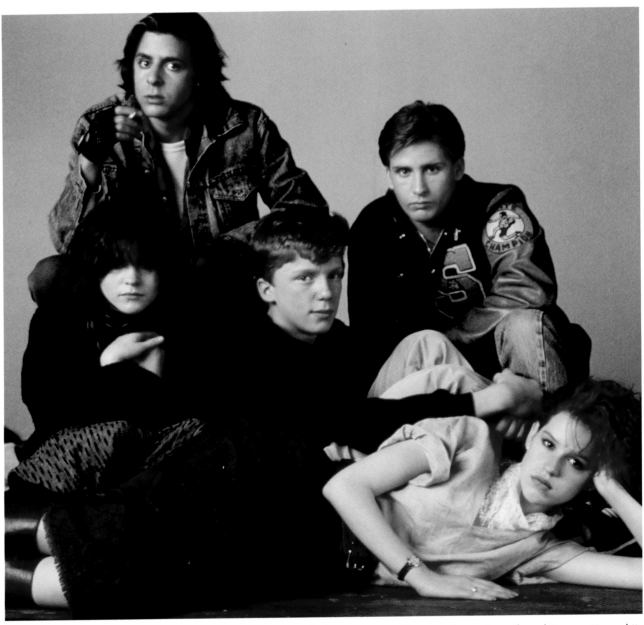

**John Hughes (director):** "We had a rehearsal period where we tore the script apart, analyzed it, questioned it, examined it. We made up background stories for each of the characters. The kids really became the roles they were playing. I didn't want people who would say, 'Here I am, what do I say, where do I stand?' I think that if you've really got your characters, anything they say is right."

*THE BREAKFAST CLUB* (1985) · MARILYN VANCE, COSTUME DESIGNER

**Matthew Broderick (actor):** "Things aren't going so well for Ferris. He's one of those people who appears to have everything—but if you think about it, he's really not in such a great spot after all. He's in real danger of being arrogant. He's learned how to deal with high school; he's got it mastered, but he's about to lose it. It's the last flicker of a star that's about to burn out."

***FERRIS BUELLER'S DAY OFF (1986) • MARILYN VANCE, COSTUME DESIGNER***

**Marilyn Vance:** "For *The Untouchables* I created clothes that would make each character instantly recognizable by their class and background. There were earthy tones for the out-of-uniform beat cop played by Sean Connery and the police academy graduate Andy Garcia, and shades of gray for the treasury men Kevin Costner's and Charles Martin Smith's suits. I had engaged an Italian fashion company to be my manufacturer, and went to Italy to develop the look for the characters. I brought fabric swatches, suit and coat shapes from the 1930s, and color charts for each of the character groups. Before leaving for Italy, these character boards, fabrics, and color charts were approved by director Brian De Palma.

"[The clothes] arrived late, exaggerated-looking, and mostly unusable. The entire Paramount studio's tailor shop came to Chicago and started from scratch for the principal actors. My crew tells horror stories of overdyeing the suits that arrived from Italy. In desperation we used them on extras, including overcoats. Sean Connery's corduroy fabric for the jacket in the photo was dyed in the bathroom of my apartment in Chicago, dried in the laundry room, and given to the tailors in the makeshift workroom, who built a mannequin to Sean's size. A little old lady named Mary made Andy's suede jacket and leather vest at her shop called Leathers by Mary on State Street. Kevin Costner's and Charlie Martin Smith's suits were recut and lightly overdyed. All this in itself could have been a movie.

"No matter what the mess, you've got to straighten out that mess without anyone the wiser. . . . And the audience, especially the audience, never gets to know it!"

### *THE UNTOUCHABLES* (1987) · MARILYN VANCE, COSTUME DESIGNER

**Albert Wolsky:** "Very few projects offer the costume designer the chance to create for three women, each one an entity: a Polish peasant, an educated concentration camp survivor, and a sexpot."

***ENEMIES: A LOVE STORY* (1989) • ALBERT WOLSKY, COSTUME DESIGNER**

**Cher (actress):** "I really prefer not to play glamorous women in movies because my heroes in film, for the most part, are usually people that you wouldn't know about unless someone like me brought them to the screen, like everyday kinds of people. . . . [It's] about the reality of people's lives and getting inside them, and letting you see what's going on and how much the character is like the person that's watching."

***MOONSTRUCK* (1987) • THEONI ALDREDGE, COSTUME DESIGNER**

SILK UNDEROBE.
QUILTED UNDEROBE
QUILTED TROS.
OVEROBE.
JACKET.
HAT.
SHOES.
SOCKS.

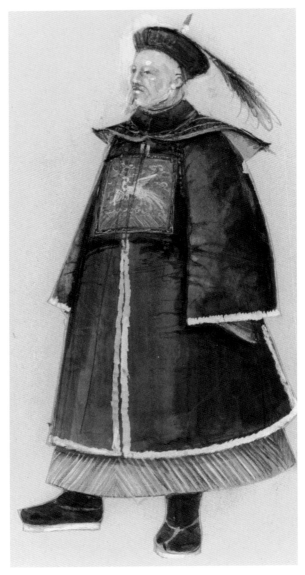

**James Acheson:** "[Director Bernardo] Bertolucci said, 'You cannot be unfaithful until you know the truth.' And what he meant by that was that if you really throw yourself into the research, and you can get [the] essence of the world that you're designing within, then you can start to design . . . to break the rules, to be unfaithful with confidence.

"The first day of shooting, he begged and pleaded, could he shoot a Saturday, rather than a Monday, because he just wanted to get this 'little scene'? And I said, 'Yeah, of course we can do that.' And we had about fifty extras in a marketplace, and there was one extra with a turban on, a little bit of a raggedy turban. And Bernardo said, 'You have such a beautiful head, can I take that off?' And I said, 'Sure, yeah, sure you can.' 'Let's go together and look.' And he took it off and I thought, 'He's talking to me about what he can do with the fiftieth extra on the left.'

"I got a phone call one day to go to the set, to the Forbidden City. I'd already been there at five o'clock in the morning; I was now preparing the thousand extras for the next day. And [then,] 'Bernardo wants you. You must go to the set.' So, you drive through the rush hour of Beijing, . . . And he says, 'I want you to see your work.' And I said, 'Bernardo, I saw it at five o'clock this morning.' And he said, 'No, no, you don't understand. This camera, my box, it records not only what I am shooting, but also the energies and the love, the passion, of all my creators. And I need you . . . to be here. Not only as a witness, but to somehow be part of this.' Isn't that great? . . . This is a man who had never, ever, communicated with me like that before. And who would say, 'I can see the character in the quarter of an inch of a hem being raised.'"

***THE LAST EMPEROR* (1987) · JAMES ACHESON, COSTUME DESIGNER**

**John Malkovich (actor):** "I don't go out and buy a false nose every time I pick up a script. I don't lose or gain 40 pounds. But I think about stuff like that. I've done a monocle part or two. It just seems to me that monocles and canes are only useful if they help the performance."

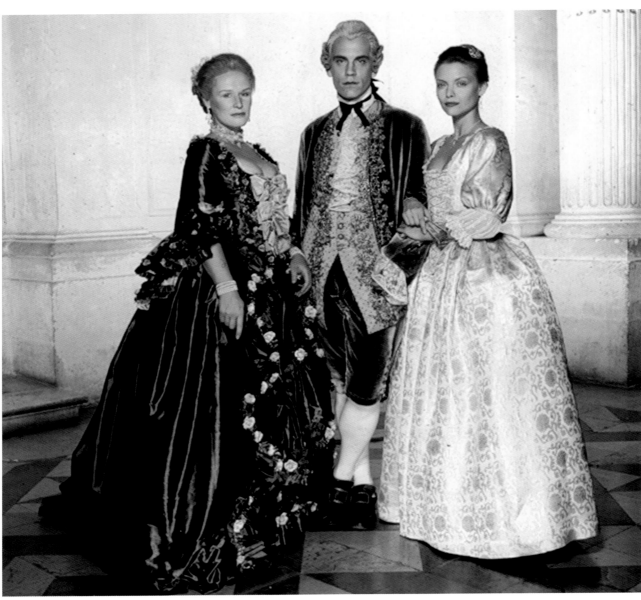

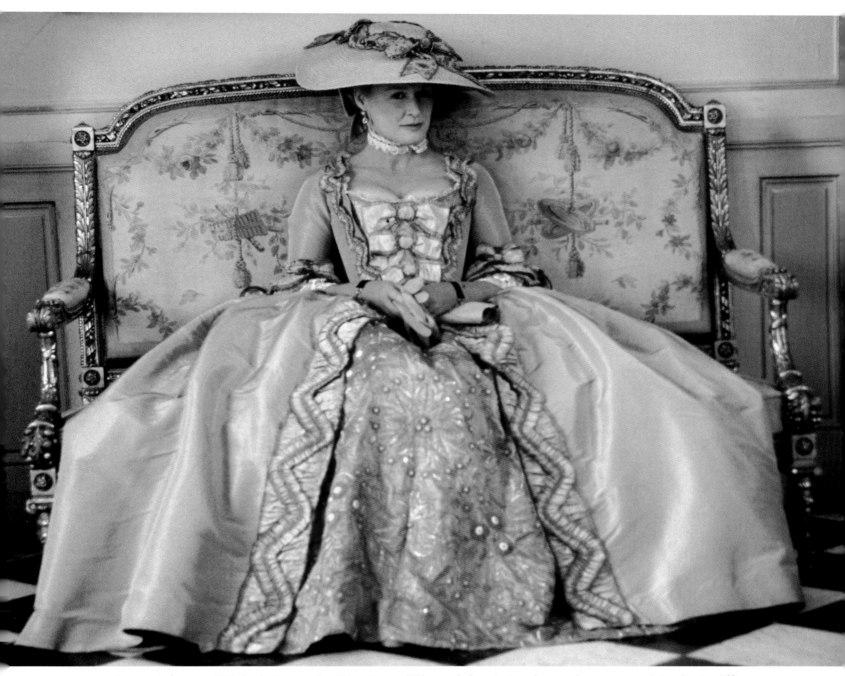

**James Acheson:** "We had nine weeks. We set up a little workshop in London, and we gave each 'maker' a different character. And I didn't know anything about the eighteenth century, so I just started looking and looking and looking. What was most important—seemed to be the delight with which those portraits had been painted in terms of folds and fabric. It struck me that if we could find some fabrics . . . but nothing was woven in the right way, nothing had [that] buttery sculptural quality.

"We looked at lots of real clothes. I remember one frock for Glenn Close. We'd found this beautiful bit of original eighteenth century embroidered silk, and had just enough to make the bodice of the dress. We'd dyed the silk for the skirt, and we got through the two fittings. But with the amount of fingering and the amount of hand work that had gone on, by the time the dress arrived on set, it was disintegrating. And I knew it would have to work for a month; continuity-wise, it was never going to stand the test. It was literally falling apart. Finally, I said, 'Listen, we have to reject this. This will not survive.' It was one of Glenn's favorites. This film is shot nearly always in close-up. When you occasionally get one wide establishing shot, which I think helped the movie, you suddenly get this treat."

### *DANGEROUS LIAISONS* (1988) • JAMES ACHESON, COSTUME DESIGNER

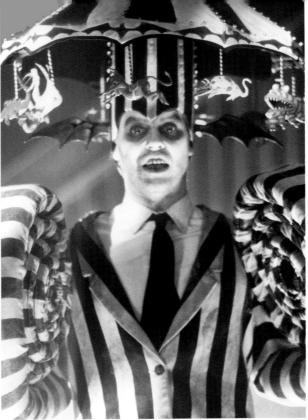

**Tim Burton (director):** "[The costume] is . . . the visual representation of the internal side of people. That's what I love. People putting on sheets or a bat costume to have some effect. It's a boldly sad statement. It's like a pathetic last ditch attempt before death. *This is it,* in a way."

**Michael Keaton (actor):** "I wanted my hair to stand out like I was wired and plugged in, and once I started getting that, I actually made myself laugh. I thought 'Well, this is a good sign, this is kind of funny.' Then I got the attitude, and once I got the basic attitude, it really started to roll."

**Aggie Guerard Rodgers:** "I had a seven-week deal on *Beetlejuice* and I wish I had more. It was so much fun. . . . Catherine O'Hara's clothes were nearly all Japanese. My favorite is a sweater that Jeffrey [Jones] wore as usual . . . and then Catherine wore it as a skirt! Upside down with her legs through the sleeves and a belt. That was '80s supreme!"

### *BEETLEJUICE* (1988) • AGGIE GUERARD RODGERS, COSTUME DESIGNER

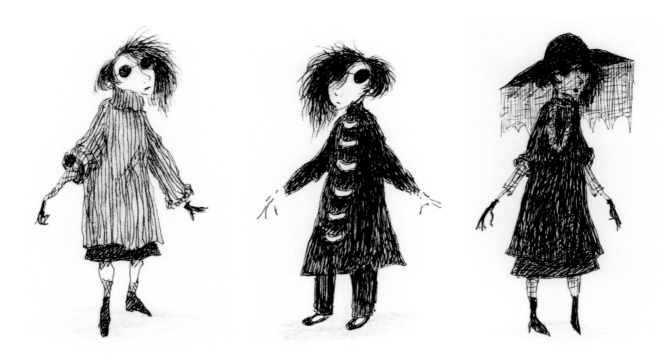

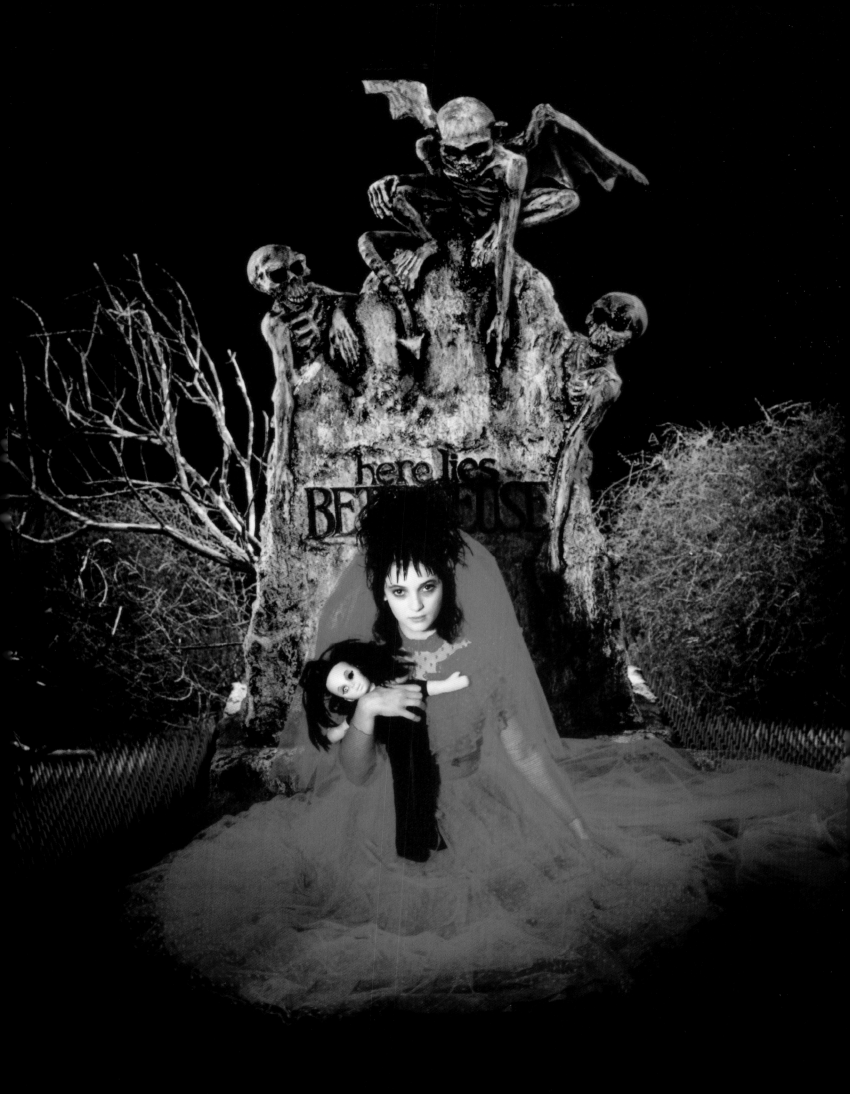

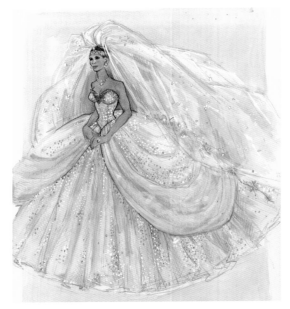

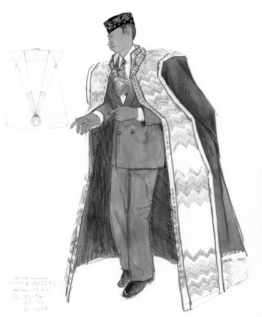

**John Landis (director):** "I [said], I want 'Cinderella,' but make it African. It's a fantasy—we invented the kingdom and culture of Zamunda. Everyone should look wealthy, beautiful, elegant, and be a little over the top. [Deborah] created an African Ascot and Africanized the royal court, which was inspired by the oriental design of the Brighton Pavilion in England. There were wonderful ceremonial regalia on the tuxedos, and Lisa's wedding dress at the end is very much a fairytale princess with a twenty-foot train. It was made to look like cotton candy."

***COMING TO AMERICA* (1988) • DEBORAH NADOOLMAN, COSTUME DESIGNER**

**Ann Roth:** "I went down to the bottom of the World Trade Center and sat there and watched people getting off the Staten Island ferry and walking in. . . . The hair was very exciting to me—you know, it was the big tease. It was the 1980s [with] a Staten Island flavor. They usually don't come to Manhattan, but those girls who come and work as secretaries, getting off the boat, their shoes would be in their purses. . . . And they were sexy. That's the point. They were very sexy."

***WORKING GIRL* (1988) • ANN ROTH, COSTUME DESIGNER**

**Gloria Gresham:** "We know Sally is a strong person with a lot of individuality. She has a certain style of her own. I don't think we thought of her as chic, but as individual. She dresses to please herself."

***WHEN HARRY MET SALLY* (1989) • GLORIA GRESHAM, COSTUME DESIGNER**

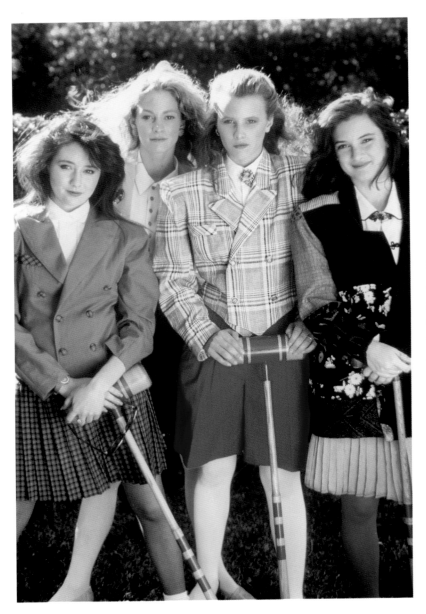

**Winona Ryder (actress):** "The film is obviously exaggerated but I think it rings true. Anyway, isn't that the whole concept of being a teenager? It's a time when everything in your life is exaggerated. Every motion, every event."

**HEATHERS (1989) ·
RUDY DILLON,
COSTUME DESIGNER**

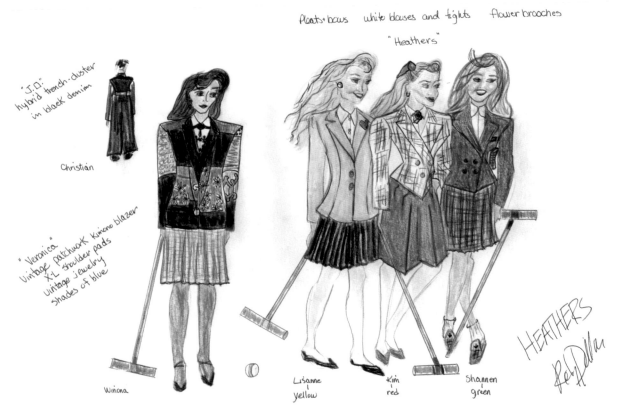

Pleats+bows white blouses and tights flower brooches

"Heathers"

"J.D.":
hybrid trench-duster
in black denim

Christian

"Veronica"
vintage patchwork kimono blazer
X-L shoulder pads
vintage jewelry
shades of blue

Winona    Lisanne
yellow  Kim
red  Shannen
green

HEATHERS

**Dustin Hoffman (actor):** "I accepted the fact that in order to be authentic, Raymond couldn't have the dramatic arc that actors always look for in roles. And that instead of a full-scale painting, I would have to do a pen-and-ink drawing, a poem, a haiku. The thing was to remember the dignity of the character. You don't cheapen the character if you don't violate him."

*RAIN MAN* **(1988) · BERNIE POLLACK, COSTUME DESIGNER**

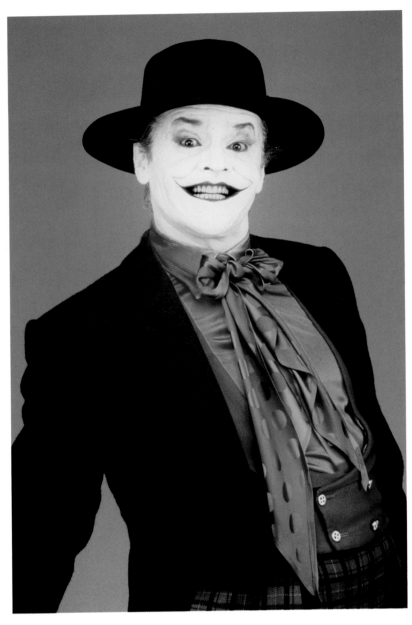

**Tim Burton (director):** "The idea was to humanize Batman. He dresses like this for theatrical effect. We had to find a psychological basis for his dress code. You can't just do, 'Well, I'm avenging the death of my parents—Oh! a bat's flown in through the window. Yes, that's it. I'll become Batman!' That's all stupid comic book stuff and we don't explore it all. He dresses up as a bat because he wants to have an amazing visual impact. . . . He switches identities to become something else entirely, so why shouldn't he overdo it? Bob's design was less of an outfit, more of a complete body suit. It isn't tights and underwear worn on the outside, but a complete operatic costume to overstate the image Batman has of himself."

### *BATMAN* (1989) • BOB RINGWOOD, COSTUME DESIGNER

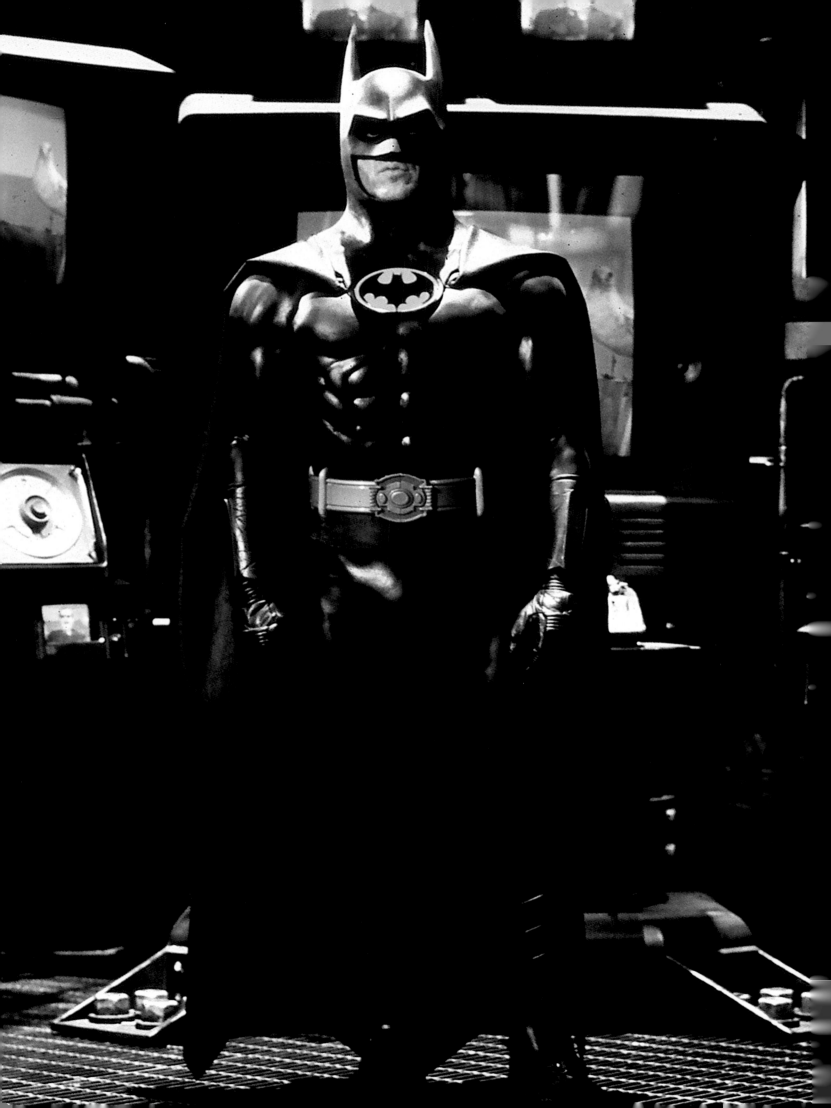

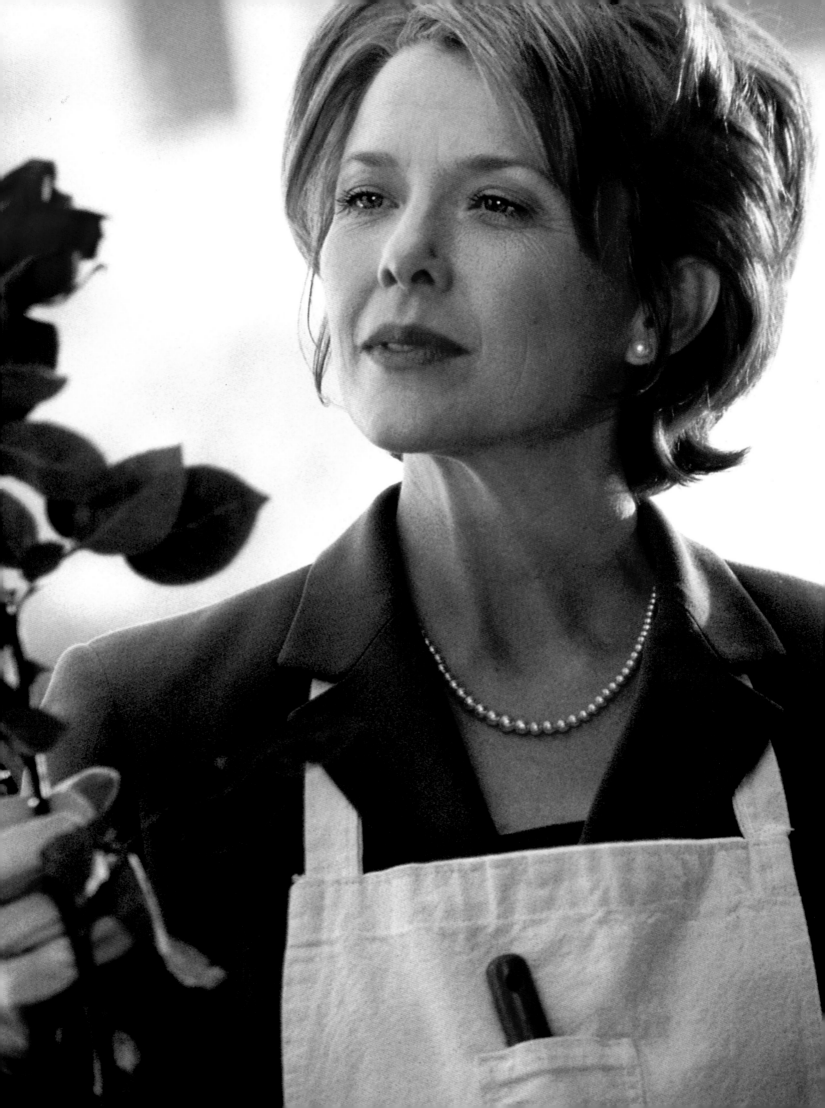

# NINE

# 1990s

As the twentieth century drew to a close, studios continued to release full-length features as entertainment for all ages. Baby boomers wanted to take their children to the movies and enjoy "family" entertainment together. Full-length animated films were revitalized by the Michael Eisner and Jeffrey Katzenberg team at Disney, whose witty kid-friendly movies included the Oscar-nominated *Beauty and the Beast* (1992) and director John Lasseter's revolutionary *Toy Story* (1995). The proliferation of excellent animated films was so pronounced that the films soon earned their own Academy Award category. Established costume designers like Joseph Porro were even drafted to design costumes for animated casts, as in *Stuart Little* (1999).

Yet the 1990s were perhaps most notable for the rising popularity of the independent film. The mainstream studios first took notice of this trend after the success of Quentin Tarantino's *Pulp Fiction* (1994), which cost $8 million and took in more than $100 million at the U.S. box office. By the time of the 1996 Academy Awards race, four of the five best picture nominees were from independents. The "indies" constituted an industry that ran not so much against Hollywood

OPPOSITE: *"I think there's no way you can play characters without liking them. You have to get behind their eyes and look at the world from their perspective." —Annette Bening,* American Beauty *(1999) • Julie Weiss, costume designer*

*Uma Thurman in* Pulp Fiction *(1994) • Betsy Heimann, costume designer*

*Sketch from* American Beauty *(1999) • Julie Weiss, costumer designer*

as parallel to it. Hollywood responded by institutionalizing the movement; the major talent agencies added independent film departments, and the studios developed their own in-house "independent" production arms, making films with artistic, edgy, or serious social issues, featuring respectable ensemble casts instead of major stars.

Earning studio-level grosses became a near necessity in the new economics of independent films, with every studio looking for the next *The English Patient* (1996). The opportunity to make a fortune on a small investment was exploited masterfully by independent juggernauts like Miramax, which produced and purchased "low budget" (often nonunion) pictures and then spent fortunes marketing them. Soon there emerged a clear dichotomy between the success of the expensive blockbuster—often top-heavy with big-name stars, special effects, and big budgets—and the rise of the indie. Independent films were most often made inexpensively, on location, with minimal effects; their makers had modest opening weekend ambitions, but critical success sometimes made them among the most profitable films of a given year. Still, there remained a wide disparity in budget and box office between award-winning independent films like *Shakespeare in Love* (1998) and blockbusters like *Independence Day* (1996), which relied more than ever on the power of special effects.

Huge advances in digital technology gave filmmakers new tools in their quest to tell the story. Computer-generated imagery (CGI) made a stunning impression in *Terminator 2: Judgment Day* (1991), with its liquid metal and morphing effects integrated into action sequences throughout the film. Two years later, *Jurassic Park* integrated CGI and live-action so flawlessly that it almost single-handedly transformed the movie industry, marking Hollywood's transition from stop-motion animation and conventional optical effects to digital techniques. The following year, CGI was used in a decidedly non-action movie, *Forrest Gump*, allowing for the digital removal of actor Gary Sinise's amputated legs—something that once would have been accomplished with a practical effect. Two-dimension CGI was an increasing presence in traditionally animated films, and in 1995 the first fully computer-generated feature film, Pixar's *Toy Story*, was a resounding commercial success.

The 1990s were also marked by the national reporting of weekly box-office returns, populist ratings (thumbs up or down), and the death of the long-suffering drive-in. At the proliferating multiscreen Cineplexes across the country, the rush to break opening day records dominated the studios' linked production and marketing strategies. Huge opening day profits for such films as *Titanic* and *Men in Black* (both 1997) led to even greater opening weekend pressure on producers. The formulaic blockbuster served as bait to studio executives, luring the public to multiplexes with new digital special effects, Dolby Sound, and an overall sense of spectacle that a TV screen could not possibly match. While many studio films went on to gross more than $100 million, the effects-laden formulaic scripts left the door open for audiences seeking the more personal, smaller scale, character-driven narratives found in independent films.

As pressure mounted for every major film to deliver a big opening weekend, and actors' salaries expanded exponentially, the late-casting problem only grew—even as budgets continued to shrink in the costume department (and all the below-the-line departments). "When films must cut corners on costumes," says Antoinette Muto, co-owner of Muto-Little Inc., a Los Angeles costume house, "they set precedents for successive costume budgets." Eventually, she warned, "the budgets get increasingly smaller until they're not realistic." In short, it was becoming almost impossible for costume designers to get the job done.

*Kate Winslet and Leonardo DiCaprio in* Titanic *(1997) • Deborah L. Scott, costume designer*

Indeed, business imperatives were now driving almost every aspect of the industry. Foreign markets grew to about 60 to 70 percent of the total revenue of the film business on any given picture. The average number of films produced per year rose from 450 to 500, and much of this product—by some estimates nearly 40 percent—went direct to video, with no theatrical release. The time between theatrical release and a movie's television airdate was shrinking, and the studios were anxious to exploit their old inventory with great speed. In the late 1990s, the first digital video discs (DVDs) entered the retail market, bringing sharper resolution, durability, interactive extras, and more secure copy protection to the home-video industry. In 1998, Disney executive Doug Probert called the DVD a "tremendous opportunity for us to heighten the at-home entertainment experience"; before long, the DVD would overtake VHS as the medium of choice. The gold rush continued: Suddenly, it appeared, even marginal fare that might never have worked in theaters could find a market—and generate a profit.

By the 1990s, the Hollywood labor unions were suffering from the scourge of "runaway productions"—films developed in the United States but filmed abroad to save money. As industry trend researcher Steven Katz noted, "The overwhelming success of Canada's 1998 production incentives opened the floodgates for imitators. Increasingly these incentive programs target big budget productions." Studios could not afford to resist the favorable currency exchange, tax

rebates, and exclusion of fringes (pension and health) that came with filming abroad. Between 1998 and 2001, Katz reported that the U.S. economy lost an estimated $4.1 billion and 25,000 jobs to overseas film production, much of it to Canada, Australia, and Eastern Europe.

Runaway production compromised the future of film and television production in the United States, threatening direct production spending, lost wages, and tax revenue; despite efforts by the DGA and SAG to make domestic film production more competitive, ten years would pass before the industry rebounded. The impact on the field of costume design was manifold. Costume designers boarded planes for Toronto, Prague, and Queensland, Australia, and when they arrived they were often forced to reinvent the entire studio costume workroom for each new location shoot. As Betsy Heimann explained, "On *Almost Famous* we made everything including the T-shirts; I wasn't in a department store or a boutique for over a year." Working outside Los Angeles and New York often involved training the shallow local labor pool, and bringing modest costuming and construction skills up to the demanding standards of a Hollywood production. For decades, designers working on distant locations had been forced to hire local crew, set up workrooms, and source goods and services. Traditionally, Hollywood productions scheduled combined studio work with few location weeks. But the studio base no longer existed.

The cast of Almost Famous (2000) • Betsy Heimann, costume designer

Without the physical plant of the studio (with its vast quantities of clothes, stocks of fabrics, trims, and notions) and the support of an experienced costume crew (costumers, seamstresses, and tailors), designers were under pressure to be more resourceful on location. Noting this spiraling cycle, Jan Lindstrom wrote in *Variety:* "Those who succeed at this challenge do so under diminishing costume budgets and without the benefit of vast studio wardrobe staffs. Tight deadlines, fewer fully stocked costume rental houses and a shortage of skilled artisans further hinder their work." Eddie Marks, president of Western Costume, noted that the Hollywood workroom had supported twenty-five men's tailors and seamstresses when he arrived in 1988; now, with designers being pulled to distant locations, "my men's staff is [down to] five, with the same number in the women's department. Their expertise is more often used to alter off-the rack clothes."

Having one costume designer on each location shoot also limited opportunities for collegial interaction and trading of ideas on the job. Mimi Avins lamented this lack of peer support in the *Los Angeles Times*: "When costume designers are isolated on location in Prague, Vancouver, or Auckland for months at a time, it can be difficult to share information or feel invested in a common cause."

Costume designers were under pressure to produce more costumes with less time and for less money than ever before. To streamline the process on modern films, some producers suggested outsourcing the clothes. The problem was twofold: characters don't dress like models in commer-

cials, and films take a year to be released—almost ensuring that the clothes in such a film would be out of fashion by the time it hit theaters. As Jeffrey Kurland said of *My Best Friend's Wedding* (1997): "In fashion, you design clothing for people; in costume design, you design characters. Designers treat 'now' as a period; they have to be familiar with what's out there."

The fashion industry's love affair with Hollywood, always a passionate one, heated up during the 1990s. Studio marketing departments were eager to create product placement partnerships everywhere they could, and producers anxious to offset costs were often tempted by the seduction of fashion-related product placement, which some considered a "necessary evil" of the industry. As Jean Penn wrote in the *Hollywood Reporter* in 1998, "Fashion placement is increasingly being pushed by those who want to squeeze in every dollar they can." Judi-

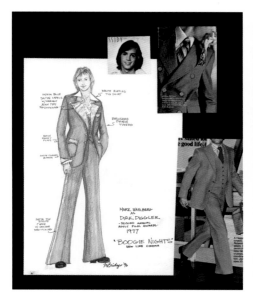

*Mark Wahlberg in* Boogie Nights *(1997)* • *Mark Bridges, costume designer*

anna Makovsky remembers: "I interviewed for a film, and when the director said, 'We've already contacted several fashion designers,' I said, 'Well, I hope they have a good time standing on the set seventeen hours a day, because I won't be there.'" Some fashion designers sought to profit by associating their name with a film, even putting their own brand on clothes originally designed by the film's costume designer—such as the Versace collection called "Fight Club" (named for a film whose costumes were designed by Michael Kaplan). Producers trawled for cash payments to offset the costume budget, even risking the credibility of the characters and the integrity of the movie. Louise Mingenbach explained: "On every movie there's a producer who comes up with the idea to use fashion designers, like it's a new idea, and it's going to work this time. But it always falls apart; fashion designers can't provide you with what you need."

Fashion magazines, celebrity magazines, and style pages wanted to know not just which designers the actors wore on the red carpet, but also which designers they wore on screen. After Renée Zellweger appeared in *Jerry Maguire* (1996) in a little black date dress, Betsy Heimann said, "Every girl in America called to ask where to buy it." Heimann continued, "When the fashion magazines ask, 'Who made that coat for Jennifer Lopez in *Out of Sight* [1998]?' I say, 'I did.'"

The prestige of the costume designer continued to be affected by the illusion that any given stylist could costume a picture, that it was essentially a shopping job—a notion perpetuated by stars who saw themselves as personalities rather than actors. Costume designer Jacqueline West explained that her "choices are just based upon what the character's choices would be." The sober endeavor of creating authentic fictional characters was nearly eclipsed by the cult of celebrity and stardom.

The confusion between the role of fashion and costume design, and between actors and the characters they play, was further exacerbated by the red-carpet phenomenon. In a 1998 *Vogue* article about the emergence of the movie star as red-carpet retailer, writer Julie Baumgold noted that "fashion designers, like casinos jealously coddling their high rollers, are happy to give. Their

clothes function as costumes on these actors." The Hollywood awards season exemplified this fusion of fantasy with fact, role with reality. With actors like Hilary Swank modeling high fashion on the red carpet—even as they won Oscars for their unglamorous roles in such films as *Boys Don't Cry* (1999)—the divergent functions of fashion design and costume design should have been obvious. While these fashion idols received nominations and awards for looking plain on screen, they received megamedia coverage for looking great on the red carpet. Heartland favorites like *Us Weekly*, *People*, and *Entertainment Weekly*, and their advertisers, stoked this celebrity-obsessed culture, their weekly barrage of coverage muddying the distinction between star and character.

For some fans, watching a character on film wasn't enough: collectors wanted the real thing. As costume designer Deena Appel remarks, "New Line was the first studio to have its own auction site. In the process it spawned rabid collectors like Doug Haase, who has amassed a huge collection of *Austin Powers* costumes." Bidders at the New Line site receive a "Letter of Authenticity," complete with "a small hologram" suitable for framing. Costume auctions were one more venue for studios to recover the costs of production—a measure that, ironically, may have saved many valuable historic garments from destruction inside studio workrooms.

Until 1996, when Warner Bros. took the initiative to create a small studio museum on its back lot in Burbank, the studios simply placed most costumes into rental wardrobe stock, where they were continuously recycled or allowed to rot. Each major studio followed a different philosophy regarding the care and maintenance of costumes returning from a film production. But most employed no archivist or curator to safeguard the costumes or preserve their historic value. Almost every garment was available to be altered or reworked until it became unrecognizable. Wedding gowns were cut and dyed, transformed into cocktail and party dresses; cuffs and hems came and went. Costume stock existed to generate money for the multinational parent company; to its owners, it had no other value. Conscientious costume designers, costume supervisors, and crew saved historic film costumes from decimation, sometimes taking the costumes home themselves. As Appel noted, "The fans see the long-term historical and monetary value of the costumes where the studios don't."

Whether available in auction houses, on the street or the Web, or languishing on studio racks, the work of the costume designer went largely unrecognized, both within the industry and by the public. Without proprietary labels but with vast influence on fashion and culture, in 1998, a group of distinguished designers and members of Costume Designers Guild, Local 892, met to discuss raising the profile and visibility of costume design. After a thirty-year hiatus, the Costume Designers Guild Awards returned in 1999 with a ceremony at the Beverly Hills Hotel, hosted by Anjelica Huston. The following year, the CDG would honor period and contemporary costume in film with separate awards. Colleen Atwood and Julie Weiss, the costume designers of *Sleepy Hollow* and *American Beauty*, won the coveted prize. For the first time in cinema history, modern and period costuming were valued as an equal artistic accomplishment. Proactive, feisty, and proud, designers asserted to the world that perfectly dressed modern characters were as beautifully costumed as the figures in any wigged and bejeweled saga.

Every picture, in short, was *a costume picture.*

**Nicholas Pileggi (screenwriter):** "Everyone's fascinated by characteristics of their ethnic group, because it's the key to your identity. You see little things about yourself—the Italian opera, the Italian mob, the Italian artisans, the Italian immigrant experience, the structure of the family. In all of this you will find clues to yourself and your family."

**Michael Ballhaus (cinematographer):** "Marty [Scorsese] knows so much about the subject that he wants everything to be absolutely correct. So we spend a little extra time to get it right. The clothes, the crimes they commit and how they commit them—all must be done the right way. We are not experts on that, so we need help from people who know better than we do. All that is time-consuming. . . . How they do things, the way they move, has to have very special style. And that's amazing in this film; it all looks real."

*GOODFELLAS* **(1990) · RICHARD BRUNO, COSTUME DESIGNER**

**Caroline Thompson (screenwriter):** "Tim Burton had the image of this character. He said he didn't know what to do with it, but the minute he described it and said the name 'Edward Scissorhands,' I knew what to do. It was Tim who came up with the image of the guy with the hedge-clipper hands and I came up with everything that had to do with them. It was the perfect joining of our talents."

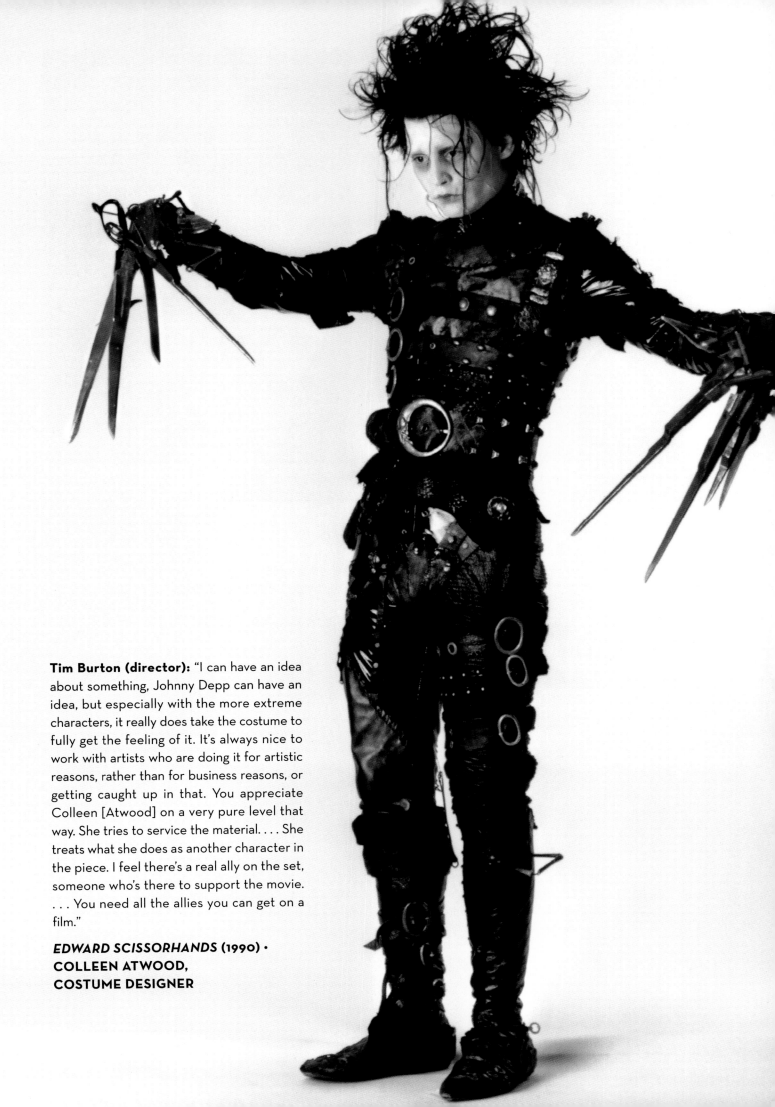

**Tim Burton (director):** "I can have an idea about something, Johnny Depp can have an idea, but especially with the more extreme characters, it really does take the costume to fully get the feeling of it. It's always nice to work with artists who are doing it for artistic reasons, rather than for business reasons, or getting caught up in that. You appreciate Colleen [Atwood] on a very pure level that way. She tries to service the material. . . . She treats what she does as another character in the piece. I feel there's a real ally on the set, someone who's there to support the movie. . . . You need all the allies you can get on a film."

*EDWARD SCISSORHANDS* (1990) ·
COLLEEN ATWOOD,
COSTUME DESIGNER

**Stephen Frears (director):** "This film is essentially about poor people, and in terms of the design, that means a distinct sense of space and color. You try to get the emotional temperature of a scene right visually by color, which Richard Hornung rightfully attached enormous importance to. And it's always good for the cinema to have to deal with emotion."

**Anjelica Huston (actress):** "I'd just broken up with Jack [Nicholson] and felt vulnerable. I put a lot of heart into Lilly Dillon, though with some people, love comes out warped. This was the only time I ever played a blonde. And [director] Stephen Frears wanted Annette Bening and me to have white nails, which helped us to be icy, evil."

*THE GRIFTERS* (1990) • RICHARD HORNUNG, COSTUME DESIGNER

**Marilyn Vance:** "I fell in love with the russet color matching Julia's hair and the fabric was so proper for the polo match, without standing out too much. Beverly Silks and Woolens had one polka dot piece of silk left and we had just enough fabric to make a ballerina length dress. Then I found the hat and then I needed a band for the hat. I said to Garry [Marshall, director] and my producers, 'We could make this dress knee-length and I could get a band for the hat, or it could be ballerina length with a flat Chanel shoe.' So we screen-tested the dress. She pinned the hem up once and then we tested it at the ballerina length with the two different shoes, and the hats, and the solid belt. Those were my sweet-sixteen earrings she was wearing."

*PRETTY WOMAN* (1990) • MARILYN VANCE, COSTUME DESIGNER

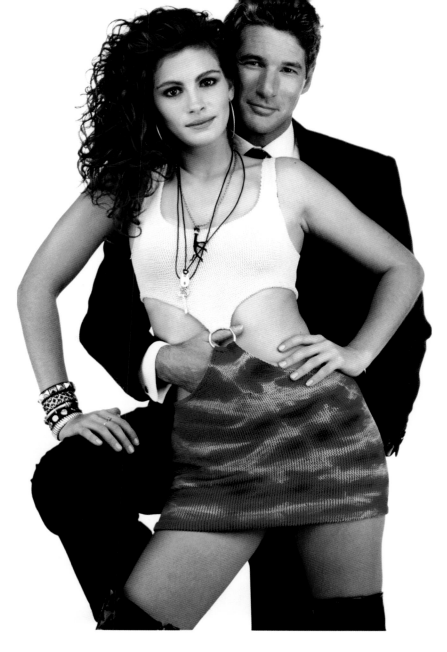

**Julia Roberts (actress):** "Just wearing that skanky dress was awful! I'd get catcalls and stupid remarks from guys on the street when we'd be doing exteriors. It wasn't fun at all. I felt so offended. I don't get that in real life."

**Garry Marshall (director):** "The contrast of her in that outfit and him in his and every move was something that we tried to do [to] build character, 'cause character is how you engage the audience."

**Richard Gere (actor):** "We worked very hard within the structure of what it was and the style that it was to find a human truth there. The style is a very romantic style. This is not a gritty movie. She's not a gritty hooker. This is a Disney hooker."

***PRETTY WOMAN* (1990) ·
MARILYN VANCE, COSTUME DESIGNER**

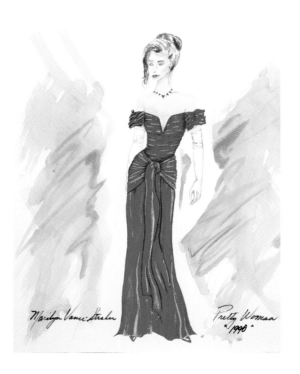

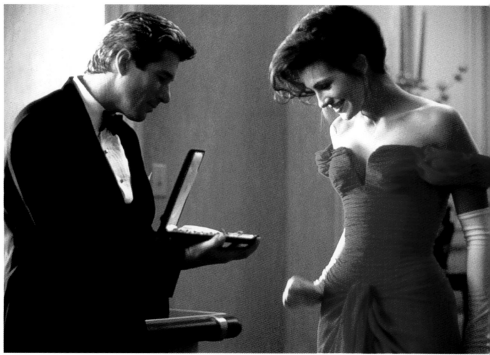

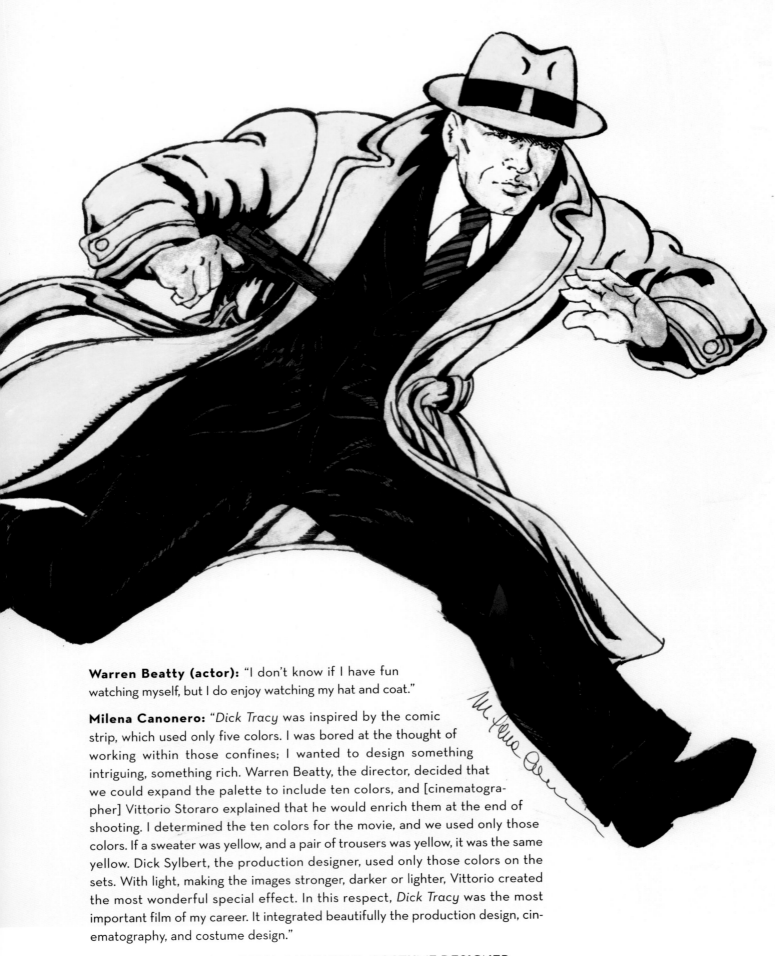

**Warren Beatty (actor):** "I don't know if I have fun watching myself, but I do enjoy watching my hat and coat."

**Milena Canonero:** "*Dick Tracy* was inspired by the comic strip, which used only five colors. I was bored at the thought of working within those confines; I wanted to design something intriguing, something rich. Warren Beatty, the director, decided that we could expand the palette to include ten colors, and [cinematographer] Vittorio Storaro explained that he would enrich them at the end of shooting. I determined the ten colors for the movie, and we used only those colors. If a sweater was yellow, and a pair of trousers was yellow, it was the same yellow. Dick Sylbert, the production designer, used only those colors on the sets. With light, making the images stronger, darker or lighter, Vittorio created the most wonderful special effect. In this respect, *Dick Tracy* was the most important film of my career. It integrated beautifully the production design, cinematography, and costume design."

### *DICK TRACY* (1990) · MILENA CANONERO, COSTUME DESIGNER

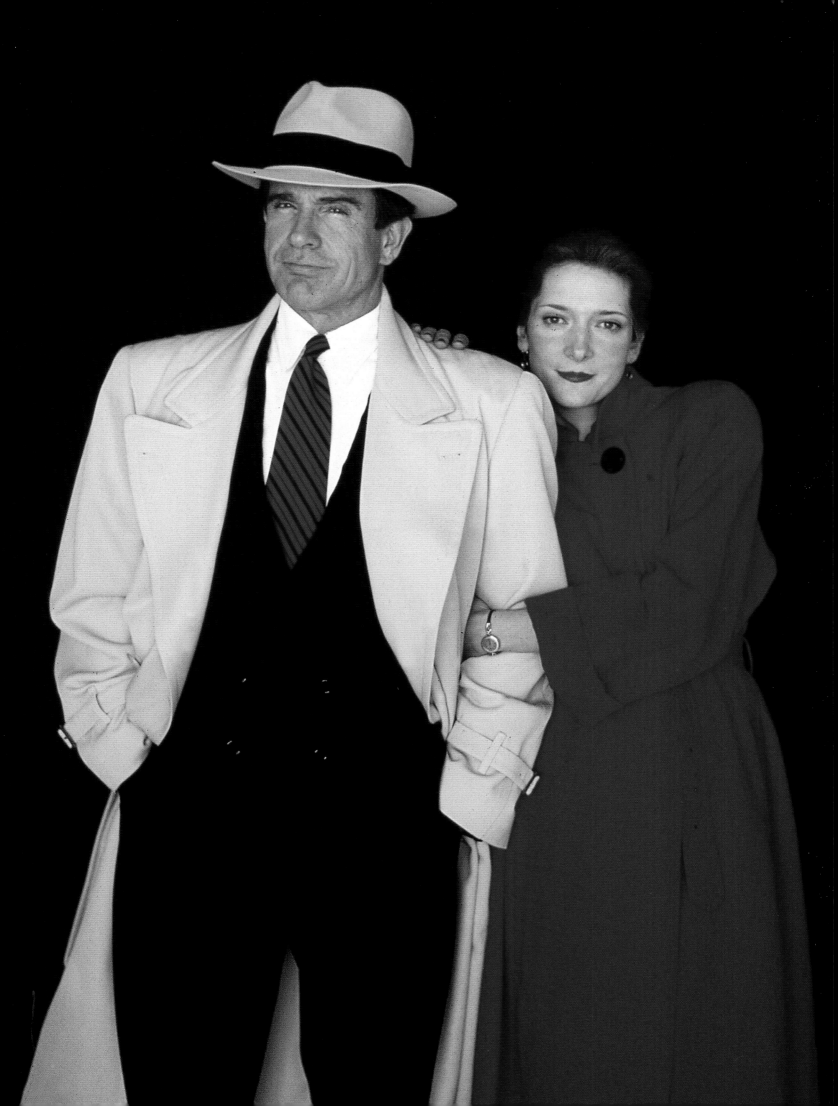

**Marlene Stewart:** "Having one costume is actually much more difficult than having twenty. Designers are much more worried about making the choice for one costume than they are about designing twenty individual looks. Jim [Cameron, director] is a perfectionist and he wanted the classic and iconic Marlon Brando motorcycle jacket and that fit Arnold's [Schwarzenegger] proportions. Yet it had to have a Sci Fi vibe. Arnold was such a pleasure to work with and he has such a great sense of humor. The challenge was getting the exact color for the T-shirt. Jim uses a lot of grays on his sets and we probably went through fifteen different versions of grays that we then dyed and camera-tested. Arnold had at least two dozen jackets and at least four dozen T-shirts, which we kept making during the shoot that went on for close to one year."

*TERMINATOR 2: JUDGMENT DAY* **(1991) • MARLENE STEWART, COSTUME DESIGNER**

**Ice Cube (actor):** "I can relate to Doughboy. He's a lot like me, and I brought my knowledge of street life to the character. I think the character and the script itself are realistic."

*BOYZ N THE HOOD* **(1991) • DARRYLE JOHNSON, COSTUME DESIGNER**

**Susan Sarandon (actress):** "For a while, we never even got dirty. I had to hold a meeting. 'Ridley [Scott, director],' I said, 'We've got to get dirty.'"

***THELMA & LOUISE*** **(1991) · ELIZABETH MCBRIDE, COSTUME DESIGNER**

Virginia Hill
Annette Bening

Albert Wolsky
'91

BACK

Bugsy

**Barry Levinson (producer):** "He was a celebrity in a town of celebrities. He was like a movie star. That was his perception, and that was the reality of Bugsy. The way he dressed exhibited a real flamboyance. He was referred to as a 'sportsman' in the newspapers. Warren plays Bugsy with an elegance that's basic to the character. The character is charming, intelligent, a woman's man. He also has a dark side and very complex human frailties."

***BUGSY* (1991) · ALBERT WOLSKY, COSTUME DESIGNER**

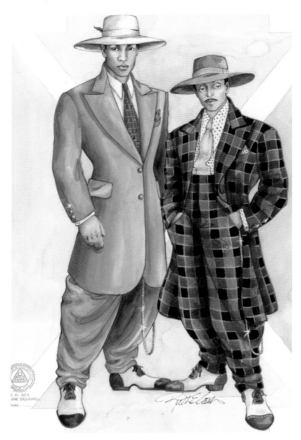

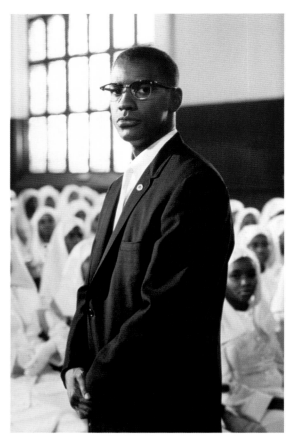

**Ruth Carter:** "I wanted to know him and understand who he was before we began the project. The research has really paid off. Denzel and I have discussed every detail about Malcolm's clothes—his eyeglasses, his shoes, his ties—and what was happening in his life during particular periods. Photographs and research materials about Malcolm and his era helped us a lot."

**Ruth Carter:** "I have pictures of Malcolm X in a zoot suit from the 1940s. You will see zoot suits in the movie, but not the one that he wore in real life. I took some liberties in terms of color and texture of the clothing, and created a bright palette, because we wanted to show you quickly that this is how his life felt visually."

## *MALCOLM X* (1992) · RUTH CARTER, COSTUME DESIGNER

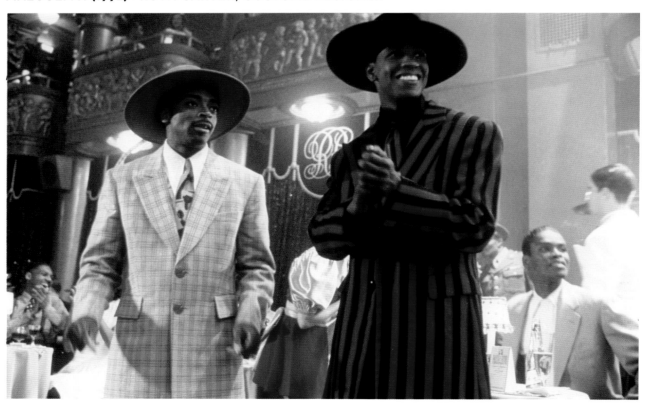

**Sharon Stone (actress):** "Paul [director Paul Verhoeven] said I had to take my underwear off because they were reflecting white light, and it was a story point in the scene before that I wasn't wearing any. Paul said, 'You won't see anything. It will be shown in shadows.' I felt violated, humiliated—pissed. I could have put out an injunction against the release of the picture, but I believe too much in it as a whole. Men have been able to flaunt their sexuality for centuries and *shove* it down your throat. And you see Catherine sitting there going, 'How do you like it buddy? Does that make you uncomfortable? I bet it does.'"

***BASIC INSTINCT* (1992) • ELLEN MIROJNICK, COSTUME DESIGNER**          427

**Francis Ford Coppola (director):** "Sometimes in this art form one element is made subservient to another. . . . I said, 'Well, on this movie . . . the sets are not gonna be important. We're not gonna spend a lot of money on sets; we're gonna diminish the sets. The costumes are gonna be the sets. Of course, the set designer fought that right up to the end. . . . The costume designer, Eiko [Ishioka] had a wild, graphic imagination . . . I just had to reassure [her] that it was okay to go pretty far out.'"

**Eiko Ishioka:** "Throughout the film, red is highly significant as the color that symbolized blood. Therefore I decided to use red only for Dracula. The only exception was for the dress that Mina wears when she dances with Dracula on their 'first date.' This was a dress Dracula had made especially for her, the object of his passionate love, so for this dress he chose his theme color, suggesting that Mina soon will become a vampire."

### *BRAM STOKER'S DRACULA* (1992) • EIKO ISHIOKA, COSTUME DESIGNER

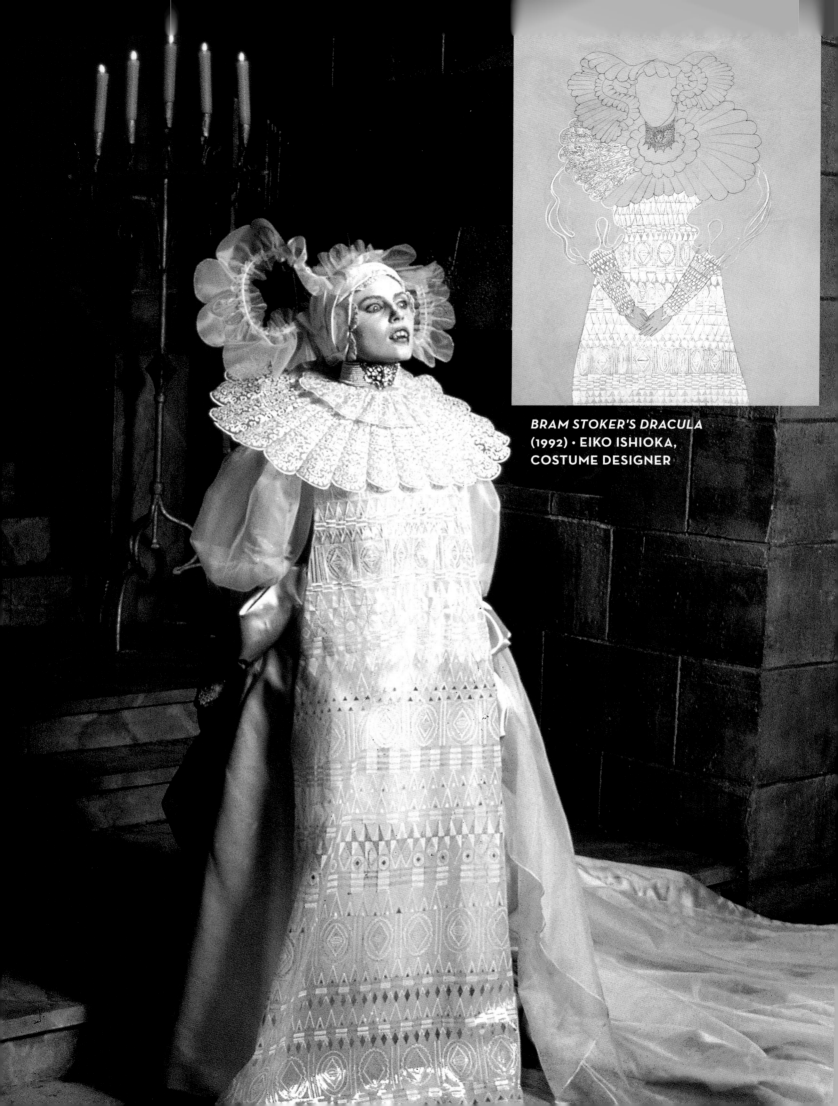

*BRAM STOKER'S DRACULA*
(1992) · EIKO ISHIOKA,
COSTUME DESIGNER

**Gabriella Pescucci:** "This was all a new world for me: not only the world of Edith Wharton, but working in America for the first time, too. But I believe that, whatever the place and whenever the time, a personal mode of dressing reflects a person's way of thinking, as well as character and social class. All the people who populated the story became, after a while, my companions, and soon, very soon, I started to feel at home in my new worlds."

*THE AGE OF INNOCENCE* **(1993) •
GABRIELLA PESCUCCI, COSTUME DESIGNER**

MALLORY
NBK

GRACE'S FRIENDS
ARE MURDERED
J. LEWIS

MICKEY
NBK

E KILLS GRACES
FRIENDS
W. HARRELSON

432

**Quentin Tarantino (screenwriter):** "I didn't want the audience to sympathize with Mickey and Mallory. I want the audience to enjoy them, because every time they show up on screen they create mayhem that is exciting to watch. You watch that opening scene and you think, 'Yeah, that was really neat, that was really fun.' You see them posturing and being cool and surly, and they're romantic and they're exciting. Then you see them killing people that you know *don't* deserve to die and, hopefully, the audience will turn back on it and say, 'Wait a minute, this isn't fun anymore. Why aren't I having fun? And more important, why was I having fun at the beginning?'"

*NATURAL BORN KILLERS* (1994) · RICHARD HORNUNG, COSTUME DESIGNER

**Dianne Wiest (actress):** "The first few scenes, I just couldn't get a handle on this character. I knew it wasn't going well, and when Woody [Allen, director] told me, 'Something's wrong. Go see the dailies and figure out what needs to be done,' I had thoughts of the role evaporating. The change came when I was having costume fittings with designer Jeffrey Kurland, who is also a good friend of Woody's. I confided to him that I had looked at the dailies, and I didn't know how to fix it. Jeffrey continued pinning the costume, and, affecting a deep whiskey baritone voice, said, 'Darling, you look divine.' I thought he hadn't been listening to a word I'd said. But I good-naturedly replied, lowering my voice into that same baritone range, 'Divine, indeed!' The next day, when I said my first line of dialogue, I used that voice. I didn't even look at Woody, I knew I had it."

*BULLETS OVER BROADWAY* (1993) ·
JEFFREY KURLAND, COSTUME DESIGNER

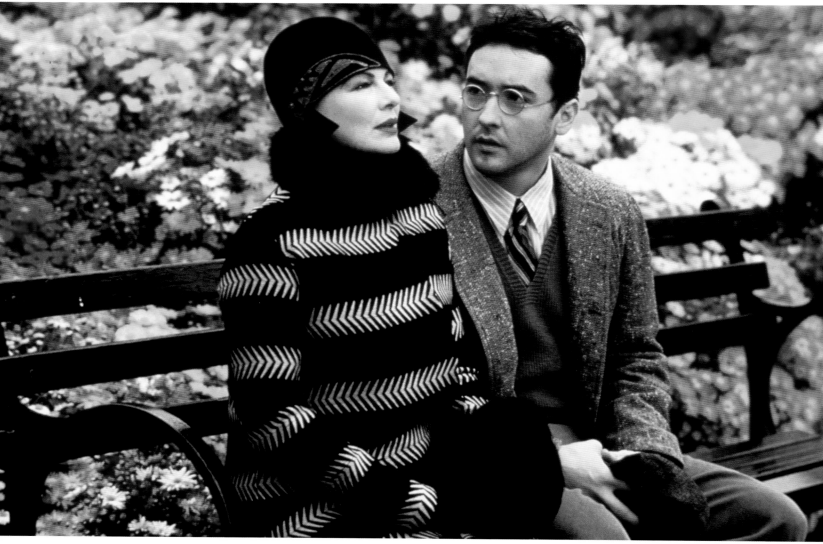

**Joseph Porro:** "The basic concept of *Stargate* was futuristic Egyptian; as if they had evolved on their own without outside influences for a thousand years. We made everything in the silhouette and the shape of traditional garments, but used sophisticated materials and didn't follow the rules of what was used in ancient Egypt. Sculptors made the bronze transparent opalescent discs and a harness that weighed about seventy-five pounds. The fabric was plastic tubing that was heat sealed onto a silk polymer blend. It looked like Fortuny pleating but it was all done by machine. Jaye Davidson looked at it and said 'Oh, darling! This is glorious!' He wanted to bring it back to London and wear it in the clubs. It was an expensive garment; it came in at about $95,000. The producer, Mario Kassar, said to me at our first meeting, "I don't care what it costs, but if these costumes aren't absolutely amazing, you are fired."

## *STARGATE* (1994) · JOSEPH PORRO, COSTUME DESIGNER

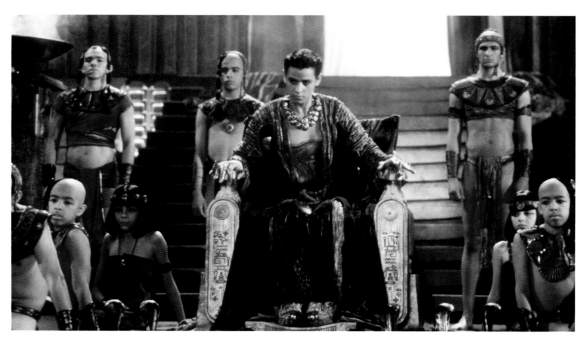

 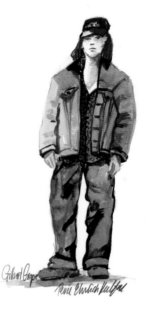

**Lasse Hallstrom (director):** "All of my movies have the ambition of being truthful. If you want to imitate life, you have to blend drama and comedy since life is dramatic and comedic."

**Johnny Depp (actor):** "In life we tend to judge people harshly based on their appearance, whether they're overweight, handicapped, ugly, or mentally challenged. Sometimes these people are looked upon as freaks because they're different. What a lot of this film is saying is that they're human like everybody else."

### *WHAT'S EATING GILBERT GRAPE* (1993) · RENÉE EHRLICH KALFUS, COSTUME DESIGNER

**Betsy Heimann:** "I used the three- and four-button jacket, because that's what I could find in multiples, and that's what fit the skinny guys. Steve Buscemi and Tim Roth were wearing almost vintage leather Beatles coats with black Levis and boots. And I'm telling you, that's the Prada silhouette. Those films really entered the American consciousness."

**Eddie Bunker (actor and former real life thief/bank robber):** "I mean it was absurd. There were these guys going to pull this big robbery and they're sitting in a coffee shop all dressed alike and the waitress knows them and they're tipping her (or not as the case may be). If they went and pulled this big million dollar robbery, she'd pick up the newspaper and say, 'Hey, I know these guys.'"

### *RESERVOIR DOGS* (1992) · BETSY HEIMANN, COSTUME DESIGNER

**Joanna Johnston:** "In Forrest's mind, this was his best outfit for the occasion. The exceedingly average-looking blue plaid shirt he wears at the bus stop bench was custom-made by Venice Custom Shirts in Los Angeles. I mismatched all the blue plaid deliberately and made one side of the collar slightly longer than the other so it looks cheap—an early '70s 'made in Korea' type. Forrest always buttoned his collar up to the top, a character style for him. The well-pressed '60s tropical suit was based on the formality of southern dress that had been instilled in Forrest since he was a child by his mother. His shoes were the precious Nikes that Jenny had given him in 1972, and appropriate to wear at the bus stop for this meeting after their time apart. Although they were no longer fresh (he just happened to run across the country a couple of times), he had put in new laces. His socks were hand-knitted in stripes, a gift from childhood from a friend or neighbor. Forrest was a child of the '50s, steady during troubled times, imbued with a great sense of practical discipline and uninterested in trends or fashion."

### FORREST GUMP (1994) ·
### JOANNA JOHNSTON, COSTUME DESIGNER

FORREST GUMP     SAVANNAH, GA. 1994

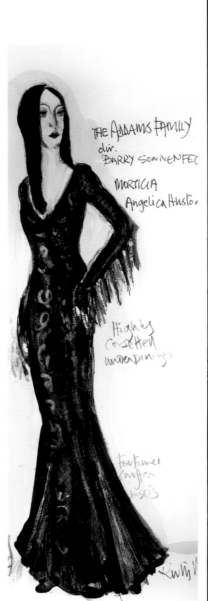

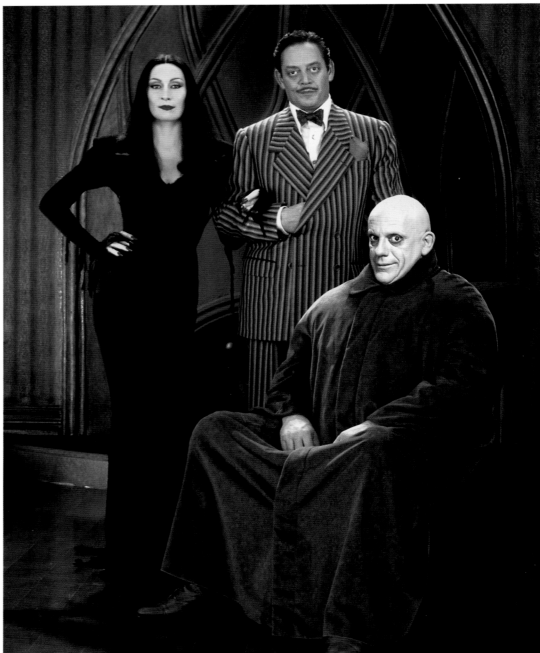

**Ruth Myers:** "I didn't want it to look like a costume party—I wanted to express that these were people who just wore these things all the time and lived this very odd existence. The idea always was to express the sense from the cartoons that these people were almost like royalty, people of endless wealth and taste. In that sense, what I tried to do was make them look so beautiful that you feel they're right, and the rest of the world is wrong."

### *THE ADDAMS FAMILY* (1991) · RUTH MYERS, COSTUME DESIGNER

**Betsy Heimann:** "People want to emulate characters they find appealing. If they find Uma Thurman's character in *Pulp Fiction* intriguing, they want to look like her. She's six feet tall, and every pair of pants I put on her was too short. So I said, 'Let's just go with it. Let me cut off another two.' People said, 'Wow, I want that.' I made all her clothes, but every designer in the world has claimed credit for her white blouse, because they knocked it off."

***PULP FICTION* (1994) · BETSY HEIMANN, COSTUME DESIGNER**

# Clueless

**Mona May:** "I love designing comedies, because you can use the humor in the clothes, and make fun of fashion to a degree. In *Clueless*, the characters were fashion victims. . . . I wanted to create something outrageous. I concentrated on the European look and incorporated that into the fashion sense of the Beverly Hills kids who have money."

**CLUELESS (1995) · MONA MAY, COSTUME DESIGNER**

Dionne & Cher
1st Day of School

Costume
Designer: Mona May

**Rita Ryack:** "What I enjoy most is the social research. . . . Mr. De Niro and I flew down to meet Lefty [Frank 'Lefty' Rosenthal] at his house on the golf course in Boca. . . . He was the kind of guy who never wore the same piece of clothing twice and had saved almost everything, so I had a really, really fantastic tour of his closet. And he was so bitter about his marriage that he was very happy to give me all his wedding albums. That is just gold, that kind of research. Sharon resembled her uncannily. And although we didn't copy anything, we could reproduce the feeling in a way that would suit these actors.

"I had a lot of clothing from Lefty's closet. He had saved all his old neckties, and I brought them up and we put them on Bob and he looked like he was going to Wall Street. So we really had to heighten the color, and we developed that monochromatic look—I invented that look—on the roof of the Beverly Hills Hotel as we draped him at sunset in these bolts of fabric. Lefty's own clothes, which were, in fact, mint and lavender and all these crazy colors, were a little too conservative for De Niro's Ace Rothstein.

"In the opening credits, Bob De Niro is wearing his apricot suit and is blown up in his car. We created more than seventy suits for Bob; everything was built, from the shoes up. Marty said, 'Oh, let's use the apricot suit right in the beginning because it's really in your face and the minute the audience sees it, they'll know exactly what the movie's about, and they can choose then to leave the theater.' I've worked with De Niro a lot, and he likes to be involved very, very early in the process. He really finds the character—builds the character—through the clothes."

*CASINO* (1995) · **JOHN DUNN AND RITA RYACK,
COSTUME DESIGNERS**

**Mel Gibson (actor/director/producer):** "The thirteenth century couldn't have been a picnic. I wanted to create something based on reality, but there is nothing I can show you that's as bad as the hell of that kind of warfare."

*BRAVEHEART* (1995) • CHARLES KNODE, COSTUME DESIGNER

**Frances McDormand (actress):** "I err on the side of truthfulness, so I didn't care how I looked as Marge. Joel Coen [director] was always telling me, 'You don't have to look that bad.' Because of my own insecurities about the way I look, I do sometimes sabotage the looks of my characters by making them as homely as possible. I've never done a glamour part. I'd like to someday, though I don't know if I could pull it off."

*FARGO* (1996) · MARY ZOPHRES, COSTUME DESIGNER

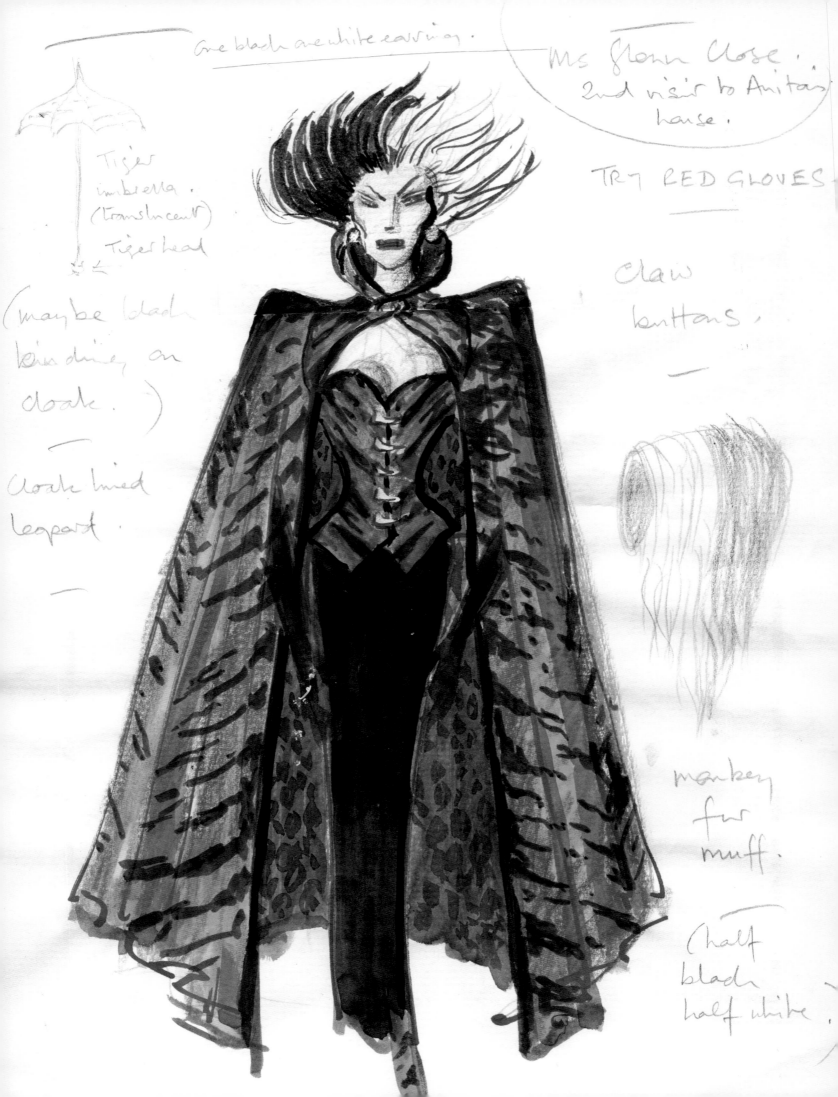

One black one white earring.

Tiger
umbrella.
(translucent)
Tiger head

(maybe black
binding on
cloak. )

Cloak lined
leopard.

Mrs Glenn Close.
2nd visit to Anita's
house.

TRY RED GLOVES.

Claw
buttons.

monkey
fur
muff.

(half
black
half white)

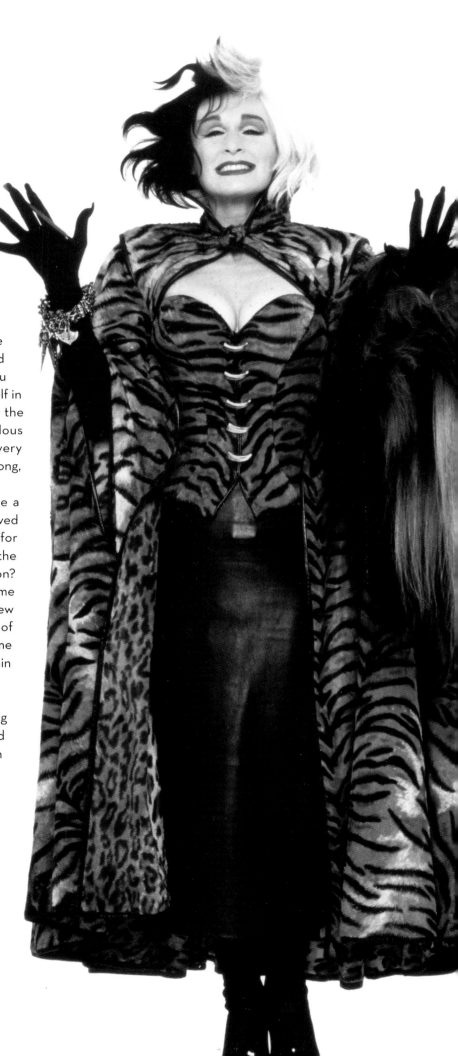

**Anthony Powell:** "Glenn Close is as fearless as a lion. . . . She asked me to design Cruella De Vil's clothes for *101 Dalmatians*. When I asked for her thoughts on the character, she said, 'You just design it, and at the end I shall look at myself in the mirror and then I shall decide how to play the part.' I thought, 'Oh my God!' It's a tremendous responsibility to persuade an actor into a very extreme look. If they trust you and you get it wrong, they will actually give the wrong performance.

"Each character that I design has to have a past—even a character as extreme and as removed from reality as Cruella De Vil. It's impossible for me to design for the actor unless I know who the character is. What are the roots of that person? Where do they come from? There has to be some basis in reality. Cruella had parents, and she grew up in a house. Glenn and I had to invent all of that. . . . It seemed to me that she probably came from a military background, which would explain a lot of things—her attitude and her manner."

**Glenn Close (actress):** "The process of getting into Cruella every day was definitely completed by the time the final piece of costume was on my body. I consider Anthony [Powell] an absolutely indispensable collaborator as far as this character is concerned. If nothing else, he sets the size of what I do, just by not having the costumes totally eat me up."

***101 DALMATIANS* (1996) · ANTHONY POWELL, COSTUME DESIGNER**

**Andy Paterson (producer):** "Big scale costume jobs tend to be either period or foreign, and when you are talking about buying the most expensive lace in the world to get the foreground detail right on one hand, and maybe using rubber moldings to dress hundreds of extras convincingly on the other, the knack is to use the costumes as part of the storytelling. What James is so incredibly good at is the finish: making it look as if people really live in those costumes, not just take them off the rail and put them back. They are cut in such a way that it almost makes actors move in the way they would have done in those times."

### *RESTORATION* (1995) • JAMES ACHESON, COSTUME DESIGNER

**Cate Blanchett (actress):** "It's a gossamer thing, feeling that you've captured a moment. The filming was incredibly intense, there was a heightened sense of chaos and melodrama on the set, which probably did help my acting. Instability is what characterized the beginning of Elizabeth's reign, after all. Queen Elizabeth, because she spent her childhood in the public eye, had a strong sense of performance. She relished an audience and was an incredible actress herself."

*ELIZABETH* **(1998) · ALEXANDRA BYRNE, COSTUME DESIGNER**

SC 76-79
DINING SALOON, NIGHT 3
KATE WINSLET AS "ROSE"
"TITANIC"

**Deborah L. Scott:** "We filled a whole wall of the office with photographs of *Titanic*'s passengers, and we'd look at them very analytically: 'So Jock Hume was wearing that, and Lady Duff Gordon might have been wearing that.' And while I was standing there, with all these faces staring back at me, I suddenly thought, 'We're not looking at research here. We're looking at the real people who were on that ship, who lived that moment.' It was eerie. It becomes more than just making a movie—you want to live up to history."

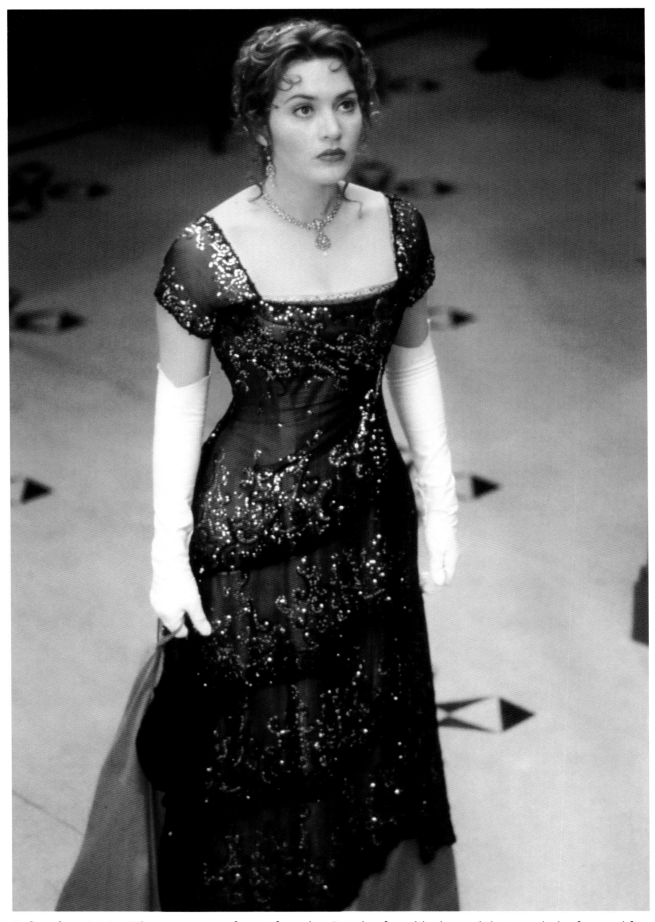

**Deborah L. Scott:** "This was an era of great formality. People of wealth changed their wardrobe four and five times a day. Their clothes were so elaborate that personal maids and valets were absolutely necessary. The clothes were incredibly beautiful and detailed."

*TITANIC* **(1997) · DEBORAH L. SCOTT, COSTUME DESIGNER**

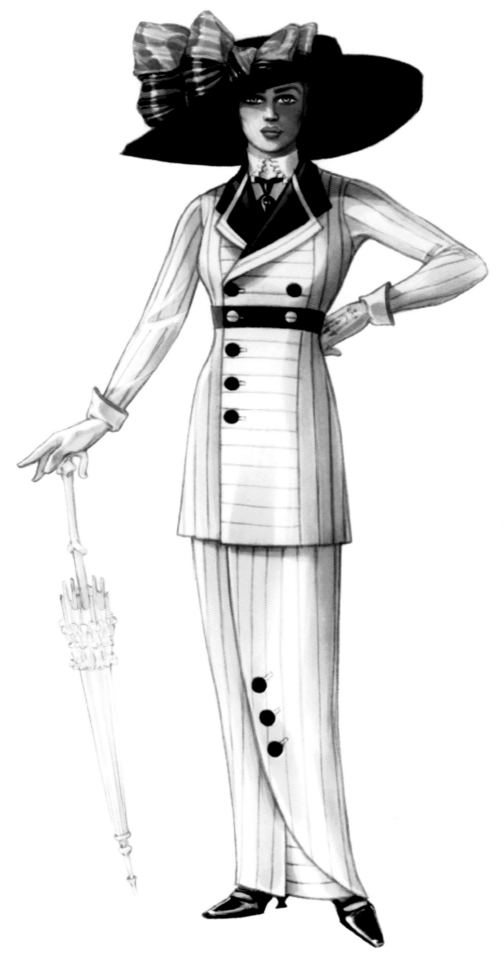

**Deborah L. Scott:** "She comes from an incredibly strict, structured lifestyle, and the first thing she wears in the movie is a tight suit tailored to the $n$th degree. It's got a hobble skirt, so she can barely walk; she's got a tie, a high neck, and a stiff collar; and she's got a giant hat."

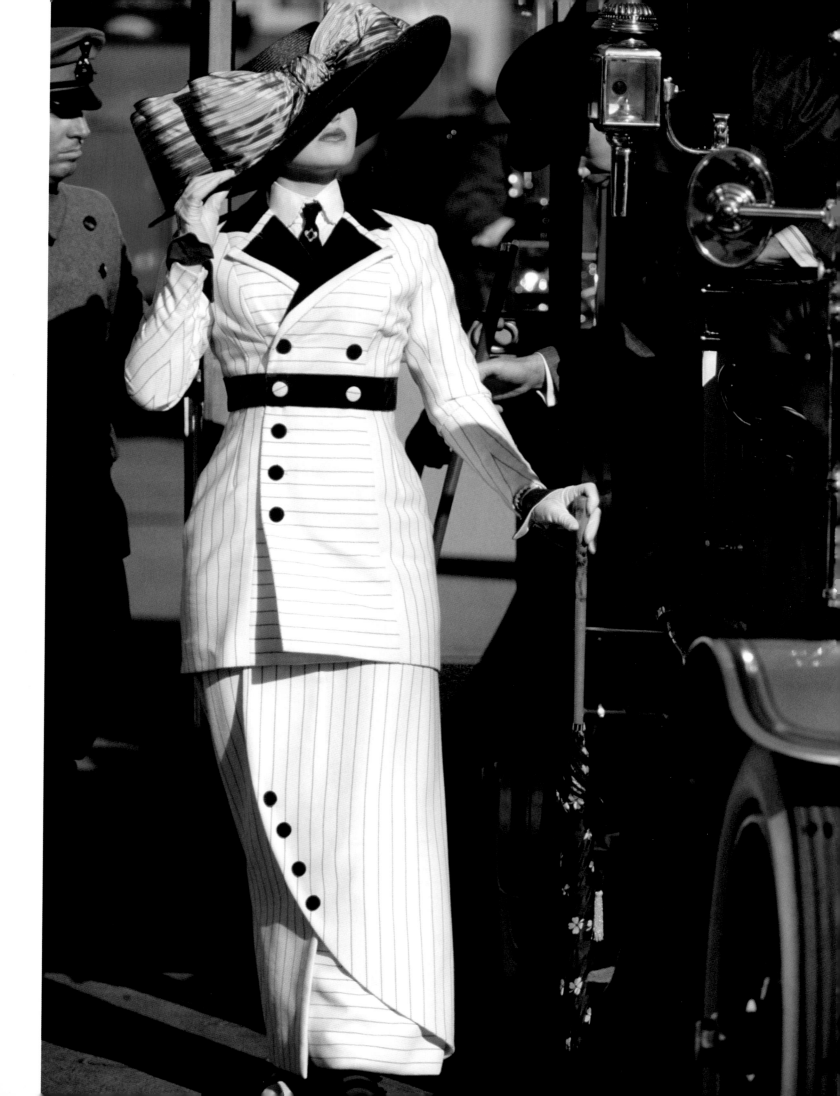

**Mary Vogt:** "I wanted the look to be clean and sharp and slightly imposing. I wanted them to look like they were somebody."

*MEN IN BLACK* (1997) ·
**MARY VOGT, COSTUME DESIGNER**

**Deena Appel:** "Austin Powers is a fashion photographer and gentleman spy lost in a contemporary time, with the trappings of his own larger-than-life world. Austin's signature silhouette started with research from Carnaby Street and the mod era, but I found more reference in the world of music than the world of fashion, and particularly in George Harrison, who was quite a dandy. I looked at source material from the '60s, Pop Art, dresses made out of plastic, feathers, extreme design, couturiers Rudi Gernreich, Cardin and Courrèges, magazines and films from the period, including the Bond films."

***AUSTIN POWERS:
INTERNATIONAL MAN
OF MYSTERY (1997) ·
DEENA APPEL,
COSTUME DESIGNER***

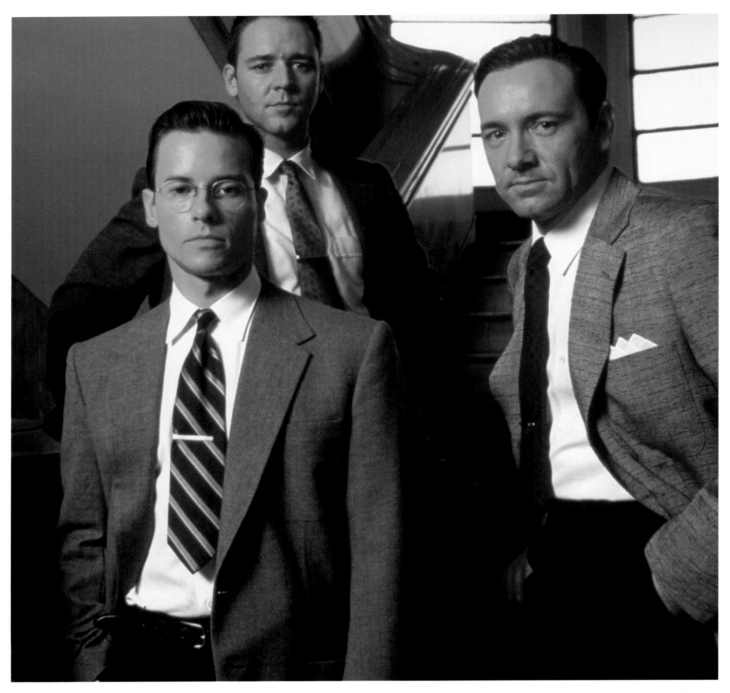

**Curtis Hanson (director):** "I put together a group of fifteen photographs and mounted each one on a piece of posterboard—the first one was that postcard that's the first shot of the movie. I would sit with each collaborator and I would go through these pictures, and they represented how the movie would look, feel, and the theme of the movie. . . . The idea being, it was true to the '50s, but putting the accent on the forward-looking '50s. . . . I wanted each collaborator to see what the movie would feel like and look like, and then said, 'Now we're going to keep the period stuff in the background. We're going to shoot it in such a way that it's contemporary.' We avoided setup that would draw attention to the window dressing of the period, whether it be the car or the clothes or the set dressings. [I wanted] character and emotion in the forefront, and ideally let the audience, on a scene by scene basis, forget that it's a period movie, so they're just in there with the characters. So (for instance) there's a minimum of people wearing hats. Detectives, a lot of them, did wear hats in 1953. But I have them not wearing hats, because that would remind you."

**Curtis Hanson:** "Physically people were different; they weren't all aerobicized. It's seven or eight years after the war. The police force was made up of ex-soldiers. The cops had beer bellies. They weren't jogging or going to the gym; they all had sidewall haircuts. People smoked and drank, and the women had that look of indeterminate age that gave them the appearance of wisdom beyond their years."

*L.A. CONFIDENTIAL* **(1997) · RUTH MYERS, COSTUME DESIGNER**

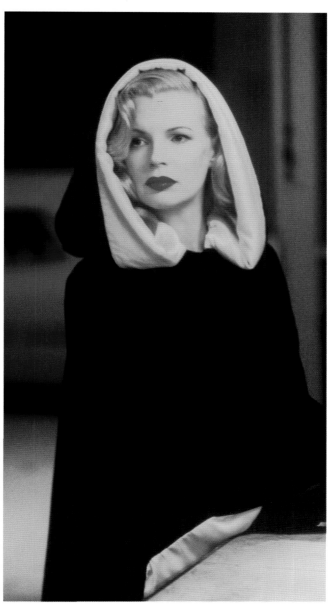

**Kim Basinger (actress):** "After reading the script, I wasn't sure I wanted to play a call girl, the sweet whore. But I loved Curtis and that he had so much belief in me. And I loved the dialogue, and I loved the idea of going into Veronica Lake's life. By day, Lynn Bracken was Veronica Lake, so I had to capture a little bit of her spirit. She was more known for her 'peek-a-boo' hair than her ability, but she was an amazing actress. She had it down."

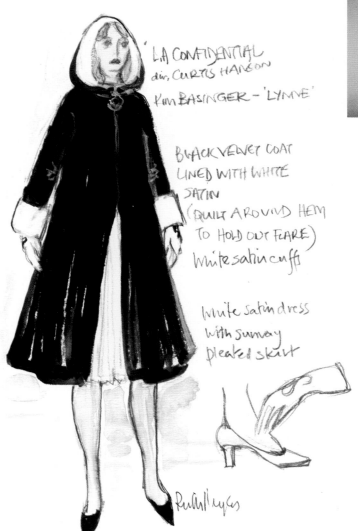

'L.A CONFIDENTIAL
dir, CURTIS HANSON
Kim BASINGER - 'LYNNE'

BLACK VELVET COAT
LINED WITH WHITE
SATIN
(QUILT AROUND HEM
TO HOLD OUT FLARE)
white satin cuffs

white satin dress
with sunray
pleated skirt

**Paul Thomas Anderson (director):** "It was terrifying putting actors in those sexy outfits, because once they felt that polyester rubbing against their skin, the tendency was to get carried away. These actors are all great, but they have their quirks and the story obviously has great camp potential, so my job as director was to keep it simple and stop them from camping it up."

***BOOGIE NIGHTS* (1997) ·
MARK BRIDGES,
COSTUME DESIGNER**

**Jeff Dowd (The real "Dude"):** "When my daughter saw a poster of the movie, she said, 'Daddy, where did they get all your clothes?' Which, of course, were not my clothes. They were something the costume designer and Bridges were good enough to do. The jellies—the footwear—were actually his."

*THE BIG LEBOWSKI* (1998) · MARY ZOPHRES, COSTUME DESIGNER

**Todd Solondz (screenwriter/director/producer):** "In American films, this period of life is not treated seriously. You have either the cute and cuddly Disney kid or the evil devil monster. For me it's fertile territory—middle-class kid growing up in the suburbs. That correctional-facility architecture that is endemic to the landscape of American suburbia."

***WELCOME TO THE DOLLHOUSE* (1995) · MELISSA TOTH, COSTUME DESIGNER**

**Hilary Swank (actress):** "People couldn't figure out what I was, and if they couldn't fit me into their stereotypical definition of a boy or girl, they didn't want anything to do with me. Sometimes I'd go home and just cry the whole day because I'd realize that I was just an actress, but for people living out there like this, what a sad place. I was the same person I was when I had long hair. All I did was cut my hair, strapped and packed, and all of a sudden I was treated differently—yet I was the same person with the same dreams and needs."

***BOYS DON'T CRY* (1999) · VICTORIA FARRELL, COSTUME DESIGNER**

**Molly Maginnis:** "The evolution of this costume was rather interesting. Jim Brooks (whom I adore) told me repeatedly that this was 'the most important costume in the movie!' I did about thirty sketches to try to accommodate the line that Jack Nicholson says to her, 'Why do I have to wear a jacket, when you're in a housedress?' It was important that the dress have the feel of a housedress and yet make Helen's character feel like she looks great. I wanted the dress to have a button front and a natural waistline. I decided to go to Palace Costumes to look at '50s housedresses for inspiration. Sure enough, I saw this wonderful red organza 'housedress' with white dots that looked amazing. The color was gorgeous but the buttons were less fortunate. We ended up screen testing ten sets of mother of pearl buttons to find the perfect set. I found an old '50s red patent leather belt in the Sony wardrobe stock. I found five yards of fantastic vintage '50s printed silk organza for a shawl. For a touch of reality, I found the red shoes at Sears and her handbag came out of my closet—something I had from the '80s. Helen Hunt loved the outfit and she really put across the notion of a woman feeling confident about her possibilities."

### *AS GOOD AS IT GETS* (1997) · MOLLY MAGINNIS, COSTUME DESIGNER

**Oprah Winfrey (actress):** "The morning was abuzz with talk of a meeting in my trailer. Word was we needed a conference about me looking 'too pretty.' This is a first! In all my days I never have been called 'too pretty' or expected this to be a subject of discussion. My teeth are too white. I'm too 'luminescent.' I need more sweat. . . . Lord, it is a new day."

*BELOVED* (1998) · COLLEEN ATWOOD, COSTUME DESIGNER

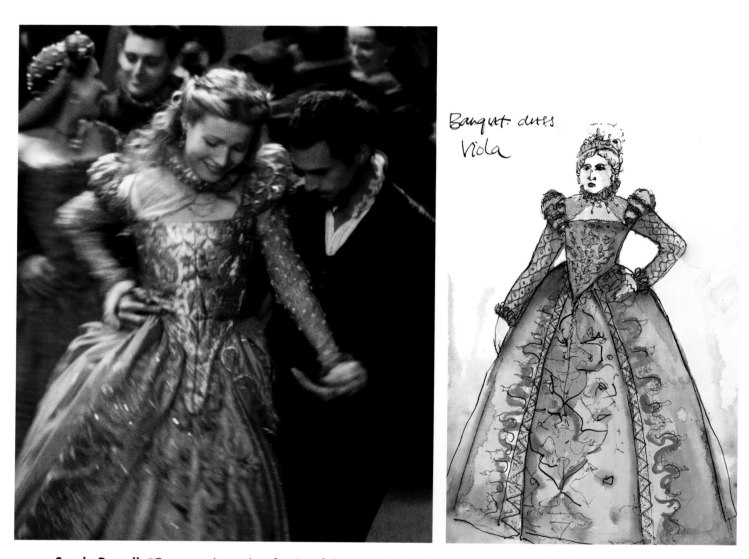

Banquet dress
Viola

**Sandy Powell:** "Compared to other frocks of the period, Viola's are relatively simple. That is just what suits Gwyneth; she looks beautiful in the softer colors and we've scaled down things like the amount of heavy jewelry on her dress. She still looks grand but never brash."

**Sandy Powell:** "It is really such a juicy period with these huge and rather crazy sculptural costumes. My aim was not to create absolutely historically accurate costumes, but to use a bit of artistic license and as the script is so fresh and light I felt there was room for the imagination, whilst always keeping it convincing."

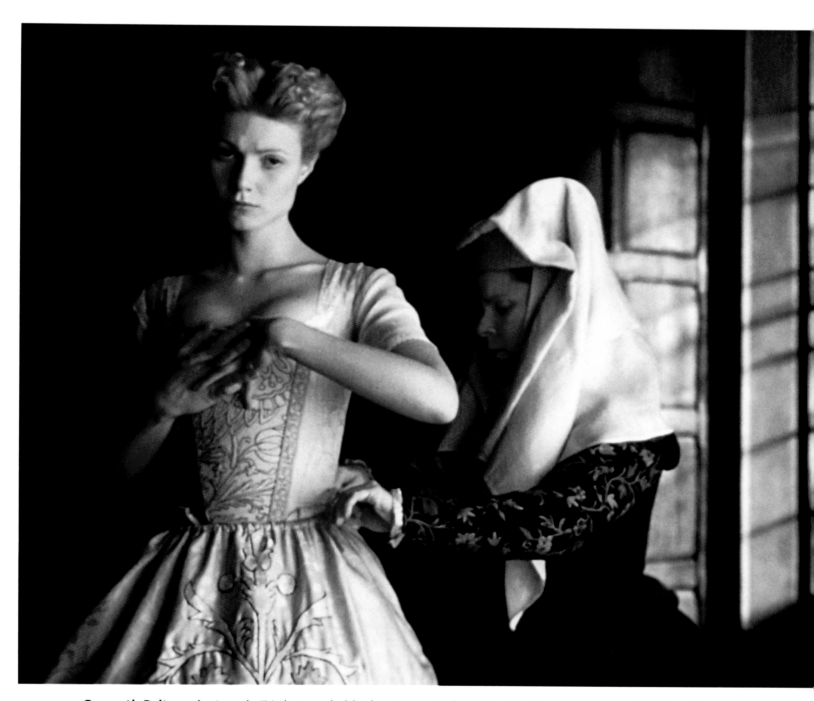

**Gwyneth Paltrow (actress):** "Viola is probably the strongest character I've played. Underneath all that Eliza-bethan finery, she's a real pioneer woman. You can actually visualize her going to America and making a home for herself and her family in Virginia."

*SHAKESPEARE IN LOVE* (1998) · SANDY POWELL, COSTUME DESIGNER

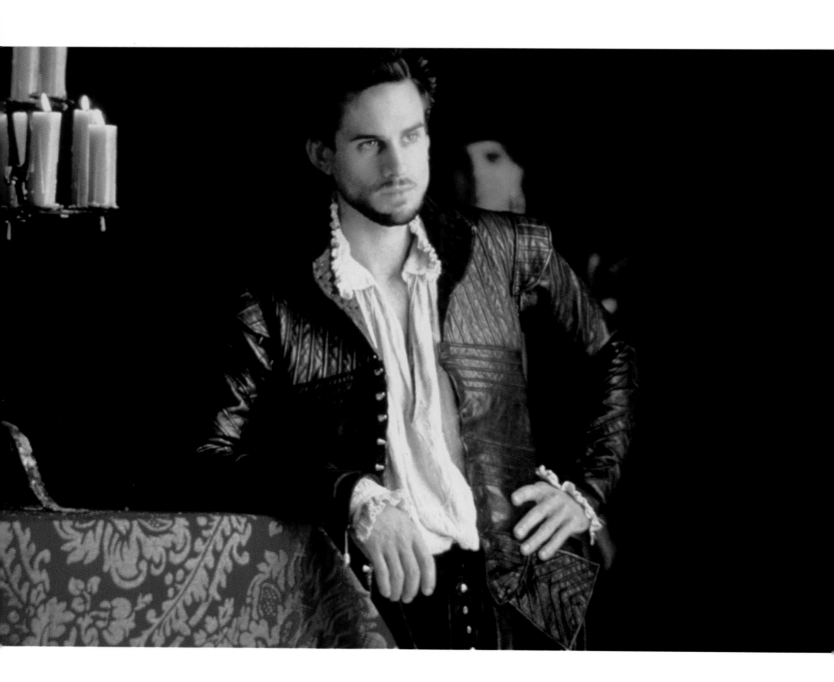

Thomas
Viola

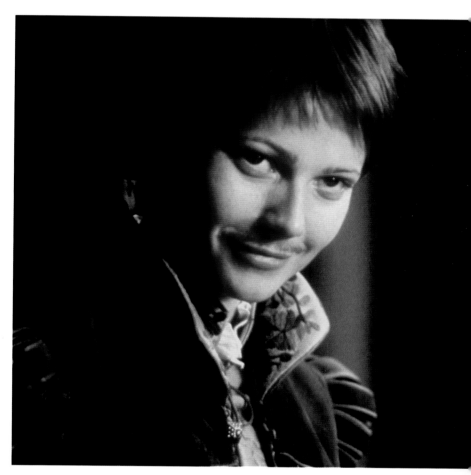

**Sandy Powell:** "I began with Viola as a boy, because I was worried about getting that to be convincing. This period is actually quite easy to hide a girl's figure because it is so solid and structured and the classic male silhouette of the period is actually quite feminine, as it accentuates the hips. Even though we're not trying to trick the audience into believing this is a boy, we wanted to be convincing enough that the other characters are fooled. I was surprised how once she was in her costume, without her long hair, how really boyish she could look."

**Gwyneth Paltrow (actress):** "The costume department made me this heavy triangular-shaped beanbag which I stuffed in my tights—it's great to have that weight, that shift of gravity. It's the only form of method acting I've ever done, but it really helped."

**Sandy Powell:** "On *Shakespeare in Love* the studio was very worried about the pants. It's a difficult period for men not to look stupid, so the executive types kept asking. 'Will there be tights?' So we made the jackets a little longer, the pants a little longer. You want to have believable clothes for the period, but you don't want your actors to look silly."

### *SHAKESPEARE IN LOVE* (1998) · SANDY POWELL, COSTUME DESIGNER

**Keanu Reeves (actor):** "When you first put [the costume] on, it's very exciting and it really does inform a lot of your character. It's so iconoclastic. I have twenty-three different versions of that costume depending on the lighting, the fighting, acting, rain or no rain. They wanted different ones because they catch different things. It has monastic, clerical, priestly overtones, but what kind? It's an individual priest, the archetypal cape, it's the overcoat, it's Superman. In the odd way, it's the lone wolf . . . the man apart . . . it's evocative of many things."

***THE MATRIX* (1999) · KYM BARRETT, COSTUME DESIGNER**

**Kym Barrett (costume designer):**
"Andy and Larry [Wachowski, directors] were very descriptive in their character description. They wanted Trinity to feel like 'an oil slick, slippery like mercury, like she can slip through your fingers.' They definitely weren't thinking about a period or fashion. The characters in *Matrix* would need functional clothes for the roles they played in their own universe."

**Michael Kaplan:** "Tyler Durden [was] a really flamboyant character, and I was a little nervous about having such a flamboyant character in a David Fincher film, because I didn't know if he would go for it. I went to David and said, 'How far can I go with this character?' And David said, 'You can't go too far.'

"In the wardrobe trailer we had Edward Norton's clothes hanging on one side and Brad's [Pitt, actor] directly across. When you walked down the center aisle, you couldn't believe these two characters were in the same film. Edward's palette was gray and beige, conservative and just totally, totally boring. You'd fall asleep talking to this person. On the other side of the aisle were scarlets, fuchsia, orange, yellow, and rust; pattern on pattern, outrageous pornographic prints, a shirt emblazoned with HUSTLER, a fake-fur coat— outrageous clothes from thrift shops, clothes from the '70s, clothes from the '80s. The contrast between the characters was hysterical.

"I saw Tyler like the male of many animal species, brilliant, proud, cocky, and more colorful than the female. Brad's character Tyler had no money, and to make it believable his clothes needed to look like they came from thrift shops but because there were so many fights involved in the film we needed tons and tons of multiples. . . . That meant making almost everything. I designed a red leather jacket that Brad wore through a lot of the movie and I styled it like a '70s jacket and then had the leather dyed to this grotesque dried blood color, which said a lot about the title of the film and the character. But I also got vintage buttons put on the jacket and then broke some of them and cracked them and distressed the leather so that it looked like it had lives before it became Tyler's. That was the case with all of his clothes. Sometimes I'd even take little store tags and staple them to the clothes like they do in a lot of thrift shops, and then rip them off leaving the staples and a little bit of cardboard."

### *FIGHT CLUB* (1999) · MICHAEL KAPLAN, COSTUME DESIGNER

**Natalie Portman (actress):** "Being in the costumes themselves and having the strange makeup and hair really made me feel different . . . and when you feel different, it's easier to act like a different person. It also changes your movement—if you've got a big [thing] on your head, you have to walk straighter—you can't slouch like an American teenager. You have to stand straight like a queen so that it doesn't knock you over."

**Trisha Biggar:** "Coming to film from a theatrical background, where costumes were often elaborately Jacobean, Elizabethan, or Victorian, I understand that attire can dictate how an actor moves, but I never underestimate what they can achieve even while wearing large, sometimes awkward period clothing. George [Lucas] has long asserted that the *Star Wars* movies are not futuristic—that they are period pictures, drawn from the past, 'a long time ago in a galaxy far, far away.' Many challenges are common to all film costuming: ensuring that an actor feels right in their outfit and is able to accomplish any action required of them; that the director is happy with the costumes and feels that they help define the character's role by giving the audience clues about the individual's personality and status; and that the costumes and characters fit into the context of the whole film. The additional challenge on a *Star Wars* film is just how to do all of that in an imaginary universe, spread over dozens of planets, cultures, and life-forms.

"A multitude of influences were drawn upon for inspiration: global cultures and art, painting and sculpture, historical costumes ranging from early civilizations to contemporary fashion, from ethnic clothing to elaborate imperial court attire. None of the usual constraints applied. Whether Japanese, Mongolian, Chinese, African, European, Eskimo, and Tibetan (to name just a few of the influences that can be seen in the myriad *Star Wars* styles), the aim was to create a unique look by combining cultures, styles, and periods to shape new fashions. Padmé Amidala's costumes had to encompass the many different aspects of her character's journey: from outfits befitting her royal station, through elaborate, but more sedate Senatorial attire, to unconstructed maternity wear. As Queen Amidala in *The Phantom Menace*, Natalie wears nearly a dozen outfits; far fewer were originally planned, but by the time the script was finalized, George's desire to expand the fashion universe had led to an almost threefold increase. She wears a different outfit in nearly every scene."

### *STAR WARS: EPISODE I—THE PHANTOM MENACE* (1999) · TRISHA BIGGAR, COSTUME DESIGNER

# TEN

# 2000s

I n 2002, the annual sales of DVDs eclipsed box-office returns. The cost of opening a feature film—both prints and marketing costs—were already skyrocketing, driven largely by TV advertising. The studios had long held to the theory that a film would be profitable if it made back two and a half times its production budget, but now that standard went the way of the double feature. The marketing budget was becoming an increasing factor in the overall budget of a film—and could sometimes determine whether a film was produced at all.

Technology continued to change every aspect of the industry. There were new promotions through community-based websites like MySpace and direct-to-consumer text messages, which proved a cost-effective way to target young consumers. The digital revolution also promised to change distribution forever. Frank Mancuso, the former head of MGM and Paramount Pictures, foresaw "a day when you can press a button and have a picture go out to Tuscaloosa, Alabama, and Frankfurt, Germany, at the same time." These globalizing forces served to give studio marketing departments greater power in the creation of the product, for better and for worse. As the DVD

*OPPOSITE: Leonardo DiCaprio in Blood Diamond (2006) • Ngila Dickson, costume designer*

market expanded, studios sought to fill DVD menus with provocative content and programming. They repackaged their theatrical product with special "Director's Cut" packages, wide-screen editions, and special "unrated" DVD versions for teenage audiences. The packages were often filled with extra features—film trailers, interviews with the actors and crew, and voice-over commentaries by directors. Even costume designers were given the opportunity to discuss their design process and their rich creative relationship with the director and the actors.

Yet even such enticing packages couldn't stop DVD sales from declining by 2005. Emerging platforms such as video games and the Internet were competing for audience attention: *Halo 2*, an X Box video game, grossed more on its opening day than either *Titanic* or Pixar's animated hit *The Incredibles* (2004). And the emergence of new small-screen media (laptops, iPods, cell phones) raised questions about the future of film production. Scott Ross, Chairman and CEO of Digital Domain, suggested that the tiny format might influence direction, cinematography, and editing: "We may start to see tighter shots being used, so that images are viewable on two-inch screens. Who's to say you can't reframe the entire film for a different medium? You could have an iPod cut, a television cut, a 16:9 hi-def cut and a 2:35 scope cut." As the screen shrinks, production design is relegated to the corners of the screen—a daunting prospect, perhaps, for many set designers. The work of the costume designer, on the other hand, seemed likely to remain a focal point, as the actors and their costumes continued to fill the frame.

As for the process of filmmaking itself, it was undergoing a digital revolution that affected both amateurs and professionals. "The cycles of new technology used to come in twenty-year intervals," ThinkFilm chief Mark Urman said. "Now, they seem to be coming in twenty-month or twenty-week intervals. It's accelerating so fast that you need to be a science-fiction writer to imagine what the experience of the movies will be like in a few years." A democratization of filmmaking occurred that allowed anyone to pick up a digital camera, and with the installation of Final Cut Pro on their laptop make a professional-looking movie that could be distributed internationally. Directors Guild president Michael Apted conceded that shooting digitally provided access to a medium once limited to experienced professionals. Yet he questioned the benefits of such easy access: "Shooting hundreds of hours of material—does it encourage you *not to think*? You can't just embrace it as though 'this is nirvana' and as if digital is the solution for everything."

As for the studios, they sought to up the ante by harnessing new advances in digital technology, eager to offer the public a product far beyond anything amateur moviemakers could produce themselves. CGI and motion-capture animation were seen as the panacea to the studios' problems. Photorealistic CGI human beings began to emerge on screen—synthesized "actors" capable of performing feats far beyond the abilities of their human doppelgangers. As Scott Ross notes, "The question is: Why? If you have an alien that has eight arms, then [the reason is clear]: the makeup would be a killer. It could be that the 'synthetic' is doing stuff that the human can't do. But the cutting-edge stuff doesn't come cheap."

In 2002, George Lucas's *Star Wars: Attack of the Clones* became the first major feature film to be filmed entirely on digital video. But the potential of digital special effects went far beyond its obvious uses in science fiction. Soon CGI was replacing conventional effects tools such as matte painting, blue screen, and practical effects. Virtual stunt doubles replaced principal actors, and computer-generated toga-clad extras filled the Roman Colosseum. Yair Landau, president of Sony Pictures Digital, joked that "The key to great filmmaking is the suspension of disbelief, and you could suspend people's disbelief a lot easier in the 1920s than you can in 2005." Especially prom-

ising was the advent of motion capture and facial motion capture, in which a performer wears electronic markers to track each motion—and even facial expression—he makes. Director Robert Zemeckis, who pioneered the technique as director of *The Polar Express* (2004) and co-executive producer of Gil Kenan's *Monster House* (2006), felt that motion capture "created an avenue to make movies that can't be made in live-action and shouldn't be made as animated cartoons," and that the technology "fills a void in the medium of cinematic storytelling."

Costume designer Joanna Johnston, who worked on *The Polar Express,* shares her director's enthusiasm. For her, the new technology led to a richer collaborative process—what she calls "that dream of the round table." She recalls: "We were sharing ideas in early development, pooling contributions from every department. Costume designers and digital artists can get so much from each other concerning movement, action, and how it applies digitally to the costumes. The digital designers benefit from our understanding of the technical construction of costumes, fabrics, and their textures. The technology has made huge advances since *Polar*. It's great breaking new ground together with traditional expertise but applying it another way."

*Monster House* costume designer Ruth Myers found the experience liberating. "As always, I started with the script and had talks with the director. I was given computerized models that were wearing homogeneous clothes and my job was to help turn these models into authentic characters—but I had no budget limitations! I could get whatever fabric in whatever color. There was no shopping, no cuttings, no fittings, and no staffing problems. My enthusiasm for this kind of costuming is endless."

Such technological revolutions, then, are already expanding the role of the costume designer in unexpected ways. In some effects-heavy productions, costumes on actors became one of the only practical elements left. In one modern comedy, costume designer Isis Mussenden used a boring gray-suited businessman's tie as a device to show the passage of time. She created a tie made of "green screen" fabric whose patterns and colors could be changed in post production. "Who decides what that tie should look like in 'post'?" she asks. "The costume designer does."

Even animated productions were now enlisting the help of costume designers in creating a more realistic picture. For nearly a century, animators themselves were the sole character designers on animated films; costume designers were not a part of the process. When the rise of motion capture ushered in a new world of computer-generated characters, however, reality became an essential component of sophisticated animated films—and costume designers embraced the challenge.

"There were design questions that I could ask on *Narnia* (2005) that before *Shrek* (2001) I wouldn't even have known to ask," Mussenden recalls. "Such things as: 'How many images are going to be manipulated?' 'What elements are going to be added to the live action characters?' 'Where is the "blend" going to start?' 'Are there

*Shrek and Donkey in* Shrek *(2001) • Isis Mussenden, costume designer*

eleven ogres or one thousand, ten thousand, fifteen thousand?'" Asking these questions at the beginning ensures that the design won't be compromised in post-production. Communication

with the animators is vital to protecting the costume designer's intentions throughout the process. Mussenden is adamant about keeping a visual effects bible that "contains ideas for the multiplication of characters; samples of textiles for color, texture, scale of pattern, weave, and movement; and photographs of actual clothes. These fabric choices seem obvious to a costume designer and helps the visual effects companies produce something real and believable." For "designers who feel that it's an alien world," Joanna Johnston offers reassurance: "It's really not. . . . It's just an expansion of what we already do."

With entertainment technology undergoing all these seismic shifts, professionals could only speculate about the new directions the industry might take. Jim Banister, an online executive with Warner Bros., talked about the concept of "story dwelling," in which audiences would be offered not just a single narrative, but a kind of miniature world full of endless potential variations to be explored at will. Story dwelling, he suggested, could be a "more immersive" experience, both "physically [and] psychologically." John Gaeta, visual effects supervisor of *The Matrix,* agreed.

Sharen Davis: "This was a revolutionary time in fashion, and creating the costumes for Dreamgirls let me run the gamut from what was happening on the street to the ultimate in glamour for the concert stage ... The cast had as much fun wearing the costumes as I did designing them." Jennifer Hudson, Beyoncé Knowles, and Anika Noni Rose in Dreamgirls (2006) · Sharen Davis, costume designer

"There will always be a place for the linear entertainment experience, but once you're deeply into playing games for ten, twenty, thirty minutes, a certain trancelike state occurs. Merging great animation and digital-effects work with the equivalent on the interactive game side, 'hybrid entertainment,' is beginning already. It's time to channel the potential of high-fidelity real-time technology into content."

One of the first franchises to be expanded was, ironically, also one of the oldest: the James Bond series. In 2004 electronic artists drew on the skills of film artists to create *Goldeneye: Rogue Agent,* a video game designed to animate the Bond universe. Working with costume designer Kym Barrett (*The Matrix*), visual effects designer Rene Morrel, and veteran Bond production designer Ken Adam, Electronic Arts sought to bring the Bond franchise and "the Bond gaming experience to an area never explored before."

And yet, even as such provocative new technologies dominated the conversation in the industry, love stories, melodramas, and genre pictures of every budget continued to fascinate audiences around the world. Whether designing a cutting-edge video-game universe or a glamorous eighteenth-century epic, costume designers have always helped actors, directors, and the audience answer the question: "Who is it?" As long as film stories concern people, the costume designer will be searching for the keys to unlock the truths of their characters. Costume design is a humanistic discipline, one that demands a talent for both intuition and forensics. Beyond simple dressmaking, each fold, each pleat, each texture and color, each fastener and accessory is chosen by a costume designer in the interest of

revealing the character. Since the earliest days of the movies, often with little budget and less time, costume designers have employed every technology, shortcut, innovation, and resource available to meet the challenges presented by a given script. From Charlie Chaplin's derby and bamboo cane to Indiana Jones's hat and leather jacket, costume has expressed personality to the audience before one single word of dialogue is spoken.

As the gray-haired baby moguls who run the studios approach retirement age, another generational shift is under way. The current generation of filmmakers is filled with recent film school graduates; winners of the Sundance, Toronto, and Berlin film festivals are being hired at rookie's salaries to direct commercial Hollywood products. Few of these young artists have experience with costume design as a storytelling tool, as cinema programs at USC and many other prestigious film schools do not include film design in the mandatory curriculum for directors. Costume designers are present on their sets, but many young directors are unprepared to communicate about the realization of their characters or the look of the movie. More than at any other time in the history of Hollywood, first-time directors are thick on the field; many

*Hilary Swank in* Million Dollar Baby *(2004) • Deborah Hopper, costume designer*

will have only one chance to make a movie. Will their work be significantly affected by this startling omission? We shall see.

Whatever the case, Hollywood must, and will, keep reinventing itself. The industry will adapt, as it did when silent movies became talkies, when black–and–white films gave way to glorious Technicolor, when television, VHS, DVD, video games, and the Internet offered their various challenges and opportunities. "We still need all the drama and excitement of movies," declares visual effects pioneer Doug Trumbull (*2001: A Space Odyssey*), "and we need compelling content and stories, yet we need to develop new ideas about the form of the experience." The traditional costuming skills—including character analysis, research, drawing, and costume making—provide designers with a solid foundation for the uncertain future ahead. As Sony Digital chief Yair Landau has observed, the history of entertainment has always involved "the integration of technology [with the goal of] furthering human endeavor." For costume designers, new technologies may open new creative avenues—but their unique role in the process, and their contribution to character and story, cannot be automated or digitized. From the simplest silent film to the most elaborate CGI adventure, it is impossible to imagine any human story being successfully filmed without the benefit of their expertise on dress, culture, and the human experience.

As long as we continue to portray the human world on film, costume designers will be needed to help tell the story.

**Colleen Atwood:** "*Chicago* began for me when I walked into a room full of mirrors and watched Rob Marshall and three choreographers dance the entire show. It was a powerful inspiration and continued to be as the collaboration expanded. Rob definitely had a vision of film, but as far as specifics about the costumes, he was very open to what I thought. We tried to keep a contrast between the real world Roxie lived in and the imagined world of the stage. It's like parallel universes. The designs were based on quite a lot of research of the period, with a nod toward what a movie musical is, somewhat filtered through the eyes of today. . . . If we'd gone strictly with the '20s, the movement would have been impaired. The costumes had to serve the choreography."

**CHICAGO (2001) · COLLEEN ATWOOD, COSTUME DESIGNER**

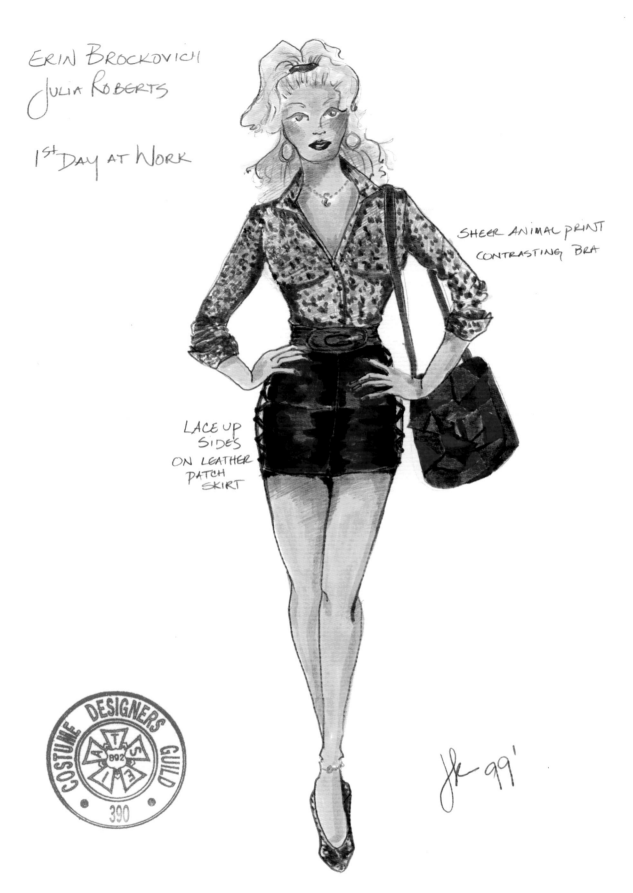

ERIN BROCKOVICH
JULIA ROBERTS

1ST DAY AT WORK

SHEER ANIMAL PRINT
CONTRASTING BRA

LACE UP
SIDES
ON LEATHER
PATCH
SKIRT

**Steven Soderbergh (director):** "This is not really a movie about a lawsuit. It's about a person who cannot seem to reconcile how she views herself with how others view her. Erin is very bright and very quick but she also has a tendency to be very confrontational . . . in two ways: the way she dresses, which is very provocative and eye-catching, almost audible it's so loud, and in her language. She has a tendency to be very colorful in the way that she expresses herself, very direct. People respond to it in a way that is interesting."

*ERIN BROCKOVICH (2000)* • **JEFFREY KURLAND, COSTUME DESIGNER**

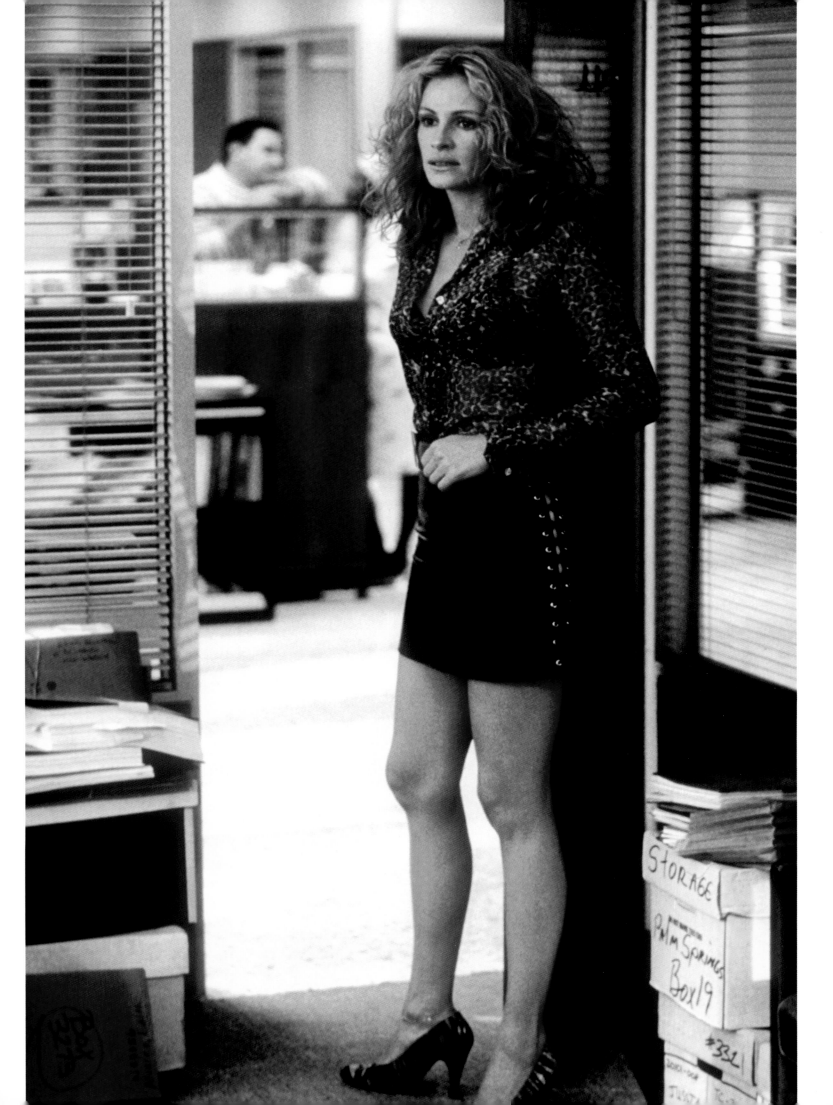

**Cameron Crowe (director):** "Penny Lane's coat, really, is a combination of an homage to the girls of the time who would hang out at the Continental Hyatt House. And also, I'll tell you a secret, it is mostly a tribute to Fran Kubelik's coat in *The Apartment*, which is my favorite movie, along with *To Kill a Mockingbird*. So it's kind of a strange reminiscent tribute-to-Billy Wilder/Shirley MacLaine-medley of a coat. And it's perfect."

**Betsy Heiman:** "All of Penny's clothes were designed and were reminiscent of vintage things. Nothing was a real piece, although when they saw *Almost Famous* people thought that they were looking at a movie that was shopped in thrift stores. We made all the costumes and overdyed all the fabrics. Penny was the girl whose inner radiance would shine if she had on a sweatshirt and blue jeans. I used a muted olive color for her coat and then I picked a big furry cream collar because it was very glamorous, and the cream color bounced light off her face. Cinematographer John Toll and I went through a lot of different shades of cream figuring out which would be the best for Kate's complexion. The coat is really glamorous—I'm thinking about Marlene Dietrich, but in a '70s rock way."

**ALMOST FAMOUS (2000) •
BETSY HEIMAN, COSTUME DESIGNER**

**Terry Zwigoff (screenwriter and director):** "We were almost trying to incorporate certain noir elements such as paranoia, alienation, and cynicism into the landscape. But none of that was conscious, although, of course, I love film noir. But I certainly wasn't trying to copy that noir style in any visual way—I thought an updated realistic reproduction of the way I see the world was grim enough! You know, it's colorful and bright, but that doesn't necessarily mean it's cheerful; it's almost a contrived, phony, corporate cheerfulness. I spent a lot of time trying to get the extras just right—sort of glum, bland, modern slobs and schmucks."

**GHOST WORLD (2000) · MARY ZOPHRES, COSTUME DESIGNER**

**Jacqueline West:** "Philip Kaufman, the director, wanted the Marquis de Sade, played by Geoffrey Rush, in one costume for his entire time in prison, as he supposedly lived in one suit for twenty-five years. Philip envisioned a pristine white *peau de soie* suit disintegrating into tatters—a fabulous 1790s suit turning into rags. In prison, all of the Marquis de Sade's writing implements were confiscated— he had no paper and no ink. He resorts to writing in his own blood upon the only object left to write on—his suit. There is only one suit written in blood, because it was so expensive and labor intensive for us to produce. Francis Bennett wonderfully mastered the Marquis de Sade's handwriting from an original manuscript."

### *QUILLS* (2000) · JACQUELINE WEST, COSTUME DESIGNER

Gold & Silver inlay hand engraved helmet

SALADIN: BATTLE ARMOUR

Gold Chainmail

Gold & Red Gold Petal Cuirass

Gold Bullion hand - Embroidered Sash & Cloak —

Gold Bullion Embroidered boots

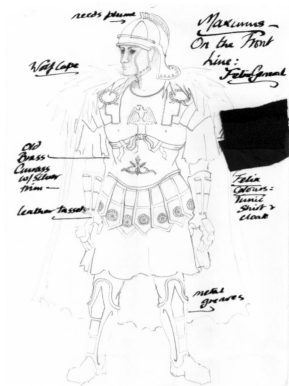

reeds plume

Maximus — On the Front Line: Felix General

Wolf Cape

Old Brass Cuirass w/ Silver trim —

leather tassels —

Felix Colours: Tunic Shirt & Cloak

metal greaves

**Janty Yates:** "It was imperative to Ridley [Scott, director] that Russell Crowe look manly and virile despite the required Roman tunic. I was after the ragged look of a Scotsman in his kilt. Each character was delineated very clearly so that their costume story was simple and clear. Russell went from general to slave, to gladiator-in-training, to gladiator number one. Joaquin Phoenix was less ornate when he was emperor-in-waiting, and he became more flamboyant as his madness emerged."

**Russell Crowe (actor):** "With these stories it's all well and good having the costumes and the scale but if there's a key to it, it's the humanity. That's what every single one of our conversations were about. With me and Ridley [Scott, director] it wasn't about stunts and special effects and things like that, it was all about keeping the characters real."

**GLADIATOR (2000) · JANTY YATES, COSTUME DESIGNER**

489

**Jeffrey Kurland (costume designer):** "I pored over books and photos from the '50s, '60s, and '70s of Las Vegas, Reno, and Atlantic City. We had that style legacy of the original Rat Pack movie, and I wanted to remain true to it."

**Rusty Ryan (Brad Pitt):** "I hope you were the groom."

**Danny Ocean (George Clooney):** "Ted Nugent called. He wants his shirt back."

***OCEAN'S ELEVEN* (2001) · JEFFREY KURLAND, COSTUME DESIGNER**

"ELLE WOODS"

COURTROOM

CONTRAST COLLAR

INSET BELT

INSET CUFF
SELF COVERED BUTTONS

SIDE SLIT
CONTRAST LINING.

WHAT SHOES SHOULD
ELLE WEAR ??

**Sophie de Rakoff Carbonelle:** "For the scenes shot in L.A., I was inspired by Goldie Hawn in *Shampoo*. We wanted Reese's [Whitherspoon, actress] clothes to have an early-sixties feel, partly because of how she looks and the silhouettes that suit her. Originally, we thought about different signature colors for Elle, like blue and purple, but then Reese and I went to a college-sorority meeting for research purposes and everyone was in pink."

*LEGALLY BLONDE* (2001) • SOPHIE DE RAKOFF CARBONELLE, COSTUME DESIGNER

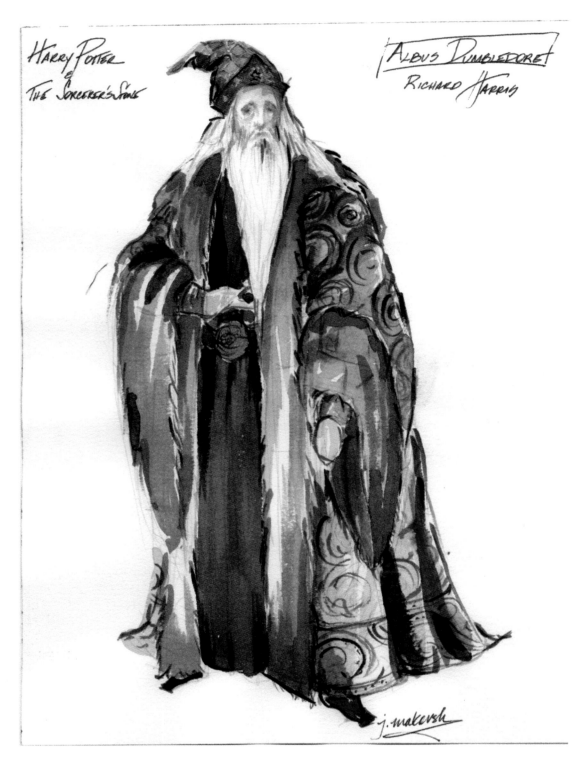

*Harry Potter e The Sorcerer's Stone*

*Albus Dumbledore*
*Richard Harris*

*j. makovsh*

**Judianna Makovsky:** "We researched everything from medieval sources to images of a Mexican surrealist painter. Most of the garments are based on academic robes, and no matter what period, you'd recognize who's the teacher and who's the student. . . . I had only one conversation with J. K. Rowling. One of my questions for her was: How did she see Dumbledore? She replied she thought he was a bit of a clotheshorse and had large flowing robes, which we then determined to be sort of Renaissance after looking at a few pieces of research I had brought to the meeting. That was all the info I really ever got. I tried to have a sense of humor with Dumbledore, with that patchworky hat, like those old nineteenth-century Arthur Rackham paintings."

### *HARRY POTTER AND THE SORCERER'S STONE* (2001) · JUDIANNA MAKOVSKY, COSTUME DESIGNER

**Judianna Makovsky:** "There are many different covers for that book all over the world, so there is no definitive Harry Potter. Chris Columbus [director] wanted to use the American version, with Harry wearing a striped Rugby shirt, jeans and sneakers. But every time I put it on Daniel Radcliff, Chris would say, 'I don't think I like that.' So we never ended up using it."

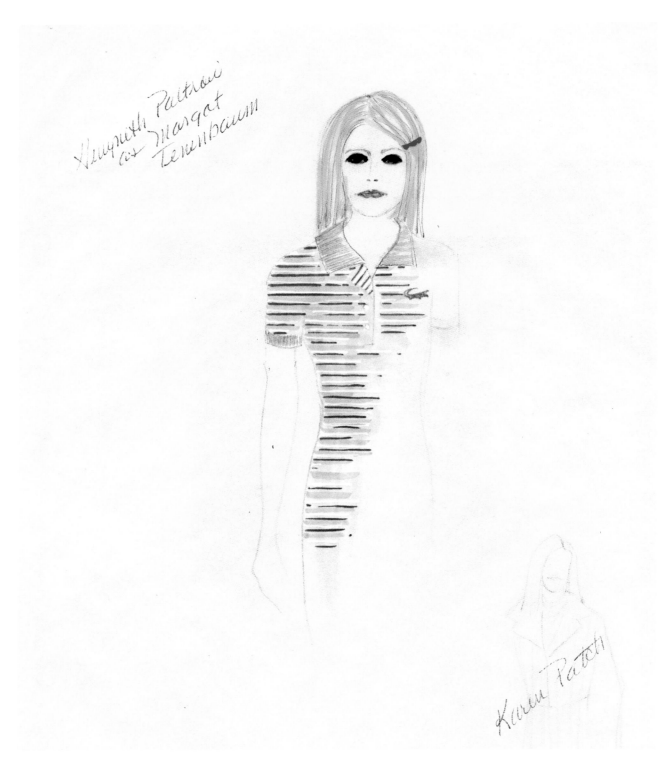

Gwyneth Paltrow as Margot Tenenbaum

Karen Patch

**Karen Patch:** "Wes Anderson has become more and more involved and interested in using wardrobe as a tool to develop the characters. The way we work together is, he starts talking about the characters, and it may or may not have anything to do with the wardrobe. He'll say, 'Well, I saw this locket . . .' It can be the smallest detail. I keep a notebook, and keep adding ideas as he calls me. I do a lot of sketching, but Wes does too. I would send him sketches, and then he would send back a sketch—basically, a drawing in one continuous line, like an outline. He'll say, 'I think maybe the lapel is wider'; we're talking buttons here, [he's that] specific. By the time I get the script, we've pretty much fleshed out all the characters."

### *THE ROYAL TENENBAUMS* (2001) · KAREN PATCH, COSTUME DESIGNER

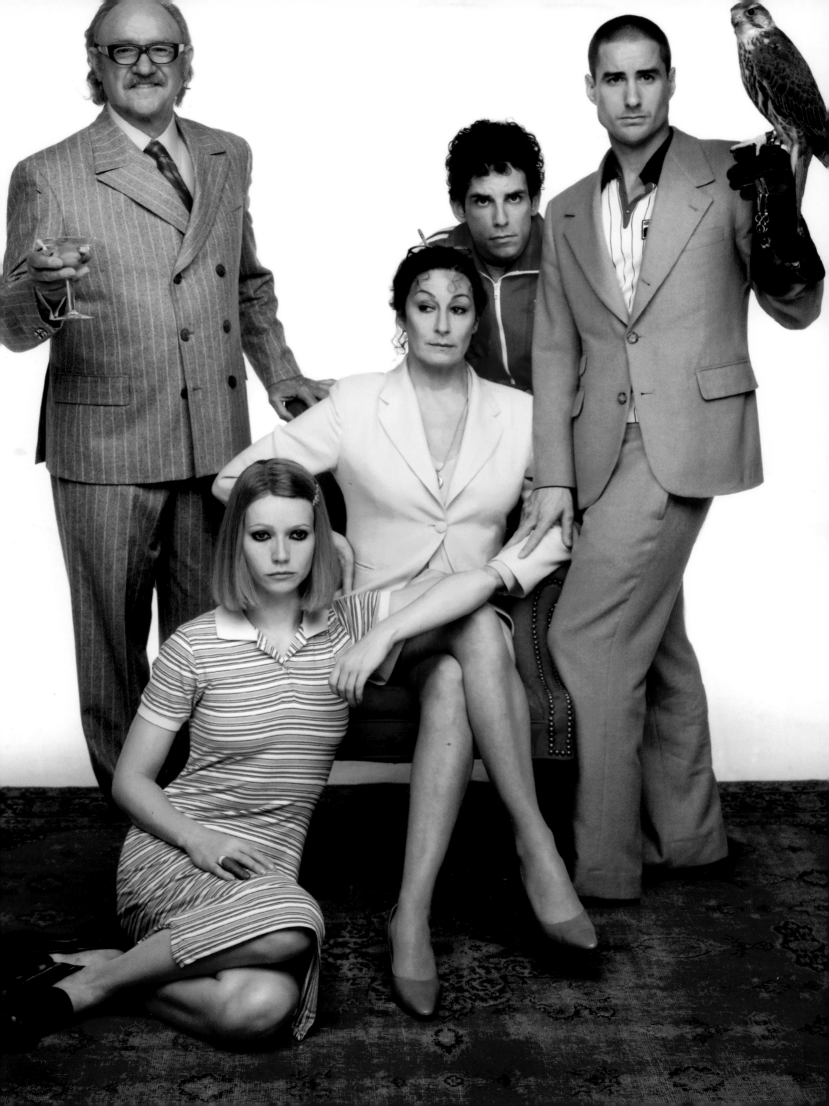

**Catherine Martin:** *"Director Baz Luhrmann cares as much about the embroidery detail on a can-can skirt as he does about lens size or dialogue."*

*MOULIN ROUGE* (2001) • CATHERINE MARTIN AND ANGUS STRATHIE, COSTUME DESIGNERS

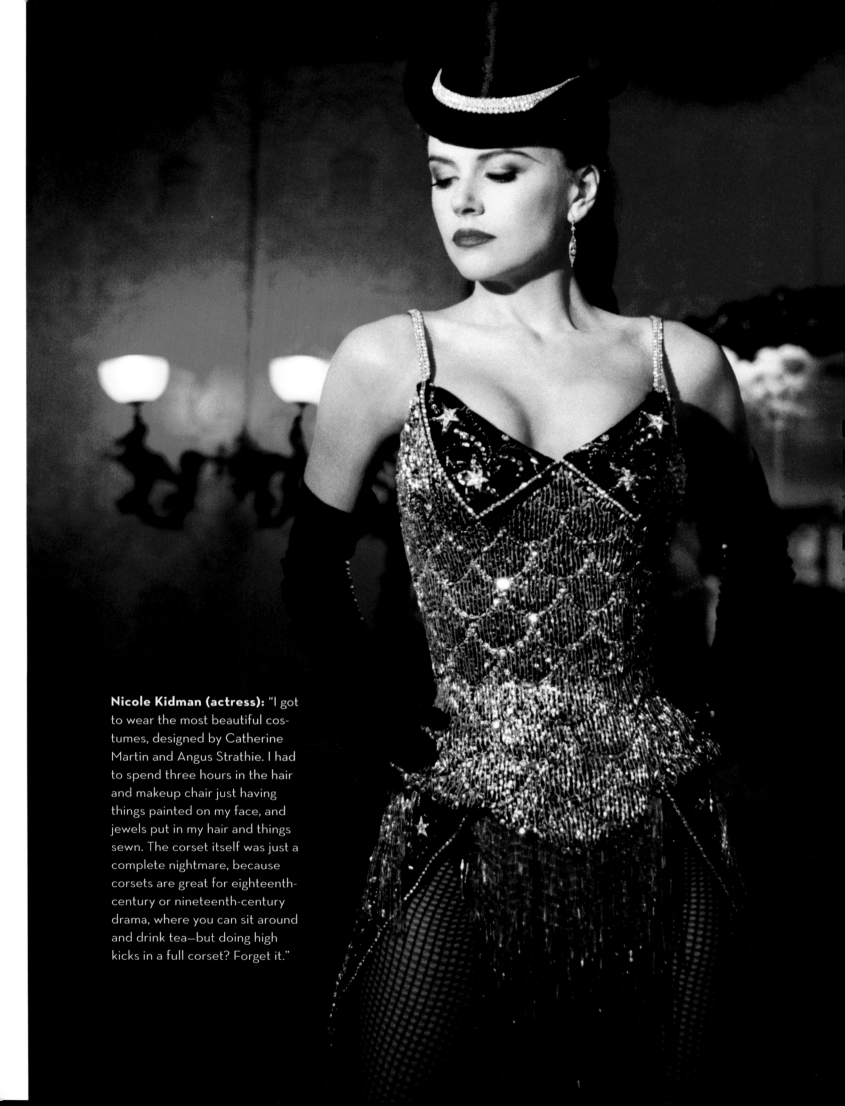

**Nicole Kidman (actress):** "I got to wear the most beautiful costumes, designed by Catherine Martin and Angus Strathie. I had to spend three hours in the hair and makeup chair just having things painted on my face, and jewels put in my hair and things sewn. The corset itself was just a complete nightmare, because corsets are great for eighteenth-century or nineteenth-century drama, where you can sit around and drink tea—but doing high kicks in a full corset? Forget it."

**Ian McKellan (actor):** "I *loved* the hat! It had to look as though it had been pulled through a hedge backward—several hedges, in fact—and by the time we were through, that's *exactly* how it looked! . . . I came up with a number of ideas as to how I might use the hat when I wasn't wearing it—including thinking of it (since it could be a magic hat) as a kind of bottomless knapsack that I might carry over my shoulder and in which I could keep all manner of things—rather like Mary Poppins's carpet bag."

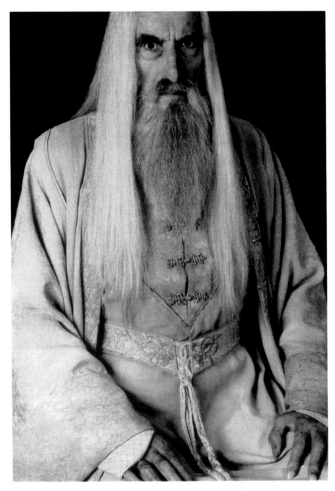

**Peter Jackson:** "When it came to Saruman, I wanted him to look blue, white, and icy cold. But I decided if I changed those eyebrows, that I'd lose the face and ruin the look. If there's an essential feature to an actor's face, then you don't mess with it! To make the eyebrows work, however, I left traces of black hair running through the white beard so that it created a triangle on Christopher's [Lee, actor] face: the dark eyebrows above, and the shadow of darkness within the beard below."

**Ngila Dickson:** "The two Wizards are the extremes of the Istari, Saruman so grand and fine and aloof, Gandalf the benevolent tramp roaming the countryside and in touch with its people. Saruman's costume draws reference from the Elves, in its fabric and style. It had to have an imminence power to it, and I really wanted to accentuate Christopher Lee's height, a towering character, like Orthanc. In contrast, Gandalf's costume is very earthy and rumpled, the depth of his power hidden behind this genial outward appearance. The Wizards have a deep connection to the Elves. There's a sense that the people who move in and around powerful magic understand the similar power of the Elves."

### *THE LORD OF THE RINGS: THE FELLOWSHIP OF THE RING* (2001) · NGILA DICKSON AND RICHARD TAYLOR, COSTUME DESIGNERS

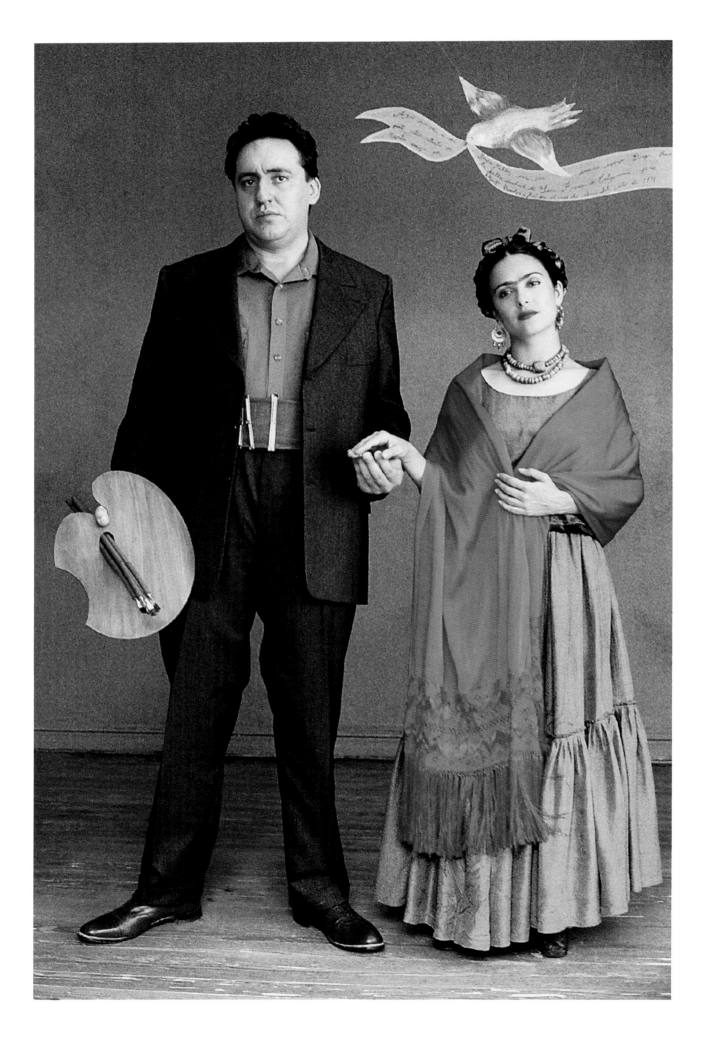

**Julie Weiss:** "Where did I get the clothes? Everywhere. I traded on the streets. Western Costume. People would come to the set. They would say, 'I knew Frida.'. . . Someone else would come and with great care take away tissue paper and say, 'It would be an honor if you took this roboso. My grandmother wore it at her wedding.' The great thing about working in a city that understands and adores Frida Kahlo and Diego Rivera and being so welcomed there is the fact that you realize that things cost everything and things cost nothing. Frida was a nontraditionalist who wore traditional clothing. She wore traditional pieces that represent regional dress, working-class people. By wearing them out of context, she understood the beat of her fellow countrymen."

### *FRIDA* (2002) · JULIE WEISS, COSTUME DESIGNER

**Ann Roth:** "We go through the same thing every time. I say to her [Meryl Streep], 'Now just be quiet and pretend you're a dummy and let me play.' And nothing . . . nothing . . . nothing . . . then all of a sudden you throw some blue sunglasses on her and the character in *The Hours* starts to happen."

**Nicole Kidman (actress):** "I don't know why, but this hankie in the pocket of the dress, this sort of housedress, did it. Everyone would look at my face and say, 'You look so different.' But it wasn't the makeup that did it for me; it was the smoking and that handkerchief. Then I changed the way I walked, and suddenly, Virginia was alive."

**Michael Cunningham (novelist):** "Nicole Kidman: She's got guts. She's been humanized. She takes risks. And she's the movie star the world has fallen in love with."

*THE HOURS* (2002) · ANN ROTH, COSTUME DESIGNER

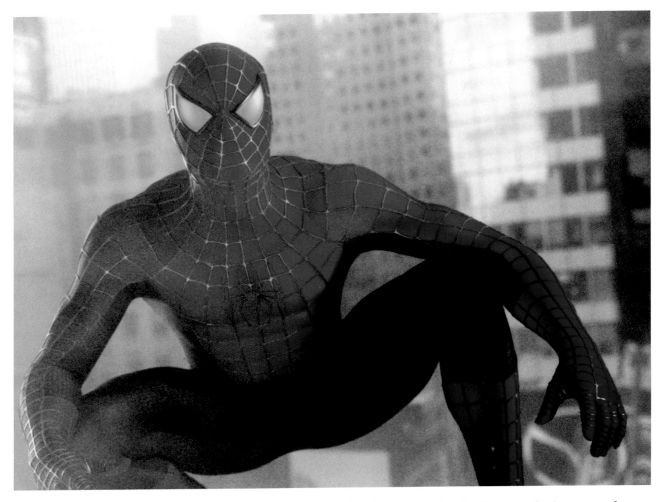

**Toby Maguire (actor):** "The Spider-Man suit gave me a freedom that I didn't otherwise feel. I mean, if I was moving around the way Spider-Man moves without that suit on . . . crawling across this table with my clothes on, I'd probably be a little embarrassed about it."

**James Acheson:** "We had all sorts of ideas for a 'new-look Spidey,' but the further we went away from the famous iconic image, the less truthful it looked. We needed to bring the comic to life. It's a big enough leap of faith to believe that Peter Parker could build this suit in his bedroom in Queens. It had to look simple, it had to be extremely flexible—and, Oh, can he still look slim and athletic with a flying harness hidden underneath?"

### *SPIDER-MAN* (2002) · JAMES ACHESON, COSTUME DESIGNER

**Jon Heder (actor):** "Jared [Hess, director] wanted to create this setting that was like a time capsule. They have the Internet, they have Backstreet Boys—but there's no one there to keep them in check about what's up-to-date and what's cool and what's not. That's why you see people wearing '70s and '80s clothes, and you see people wearing the Hammer pants and Uncle Rico wearing all the '70s stuff. I literally think of Preston, Idaho, as a big attic where you throw all your stuff—and you just don't throw stuff away."

### NAPOLEON DYNAMITE (2004) • JERUSHA HESS, COSTUME DESIGNER

**Sacha Baron Cohen (actor):** "I wear that costume and never wash it. And I have never washed it since I got it, and it's actually a few years old. And it totally stinks. [I'm] not allowed to wear deodorant as well. Because we want subtle things . . . to give the person the impression that it is real."

### BORAT: CULTURAL LEARNINGS OF AMERICA FOR MAKE BENEFIT OF GLORIOUS NATION OF KAZAKHSTAN (2006) • JASON ALPER, COSTUME DESIGNER

**Daniel Day-Lewis (actor):** "Sandy Powell's work on the film (which I personally think is magnificent), apart from the significance it has for the film as an entire piece of work, makes a huge difference to us as individuals. Clothes become part of your life, part of the life that you're trying to re-create. Sandy and I had a chance to meet in Dublin before we started shooting. She spoke from her point of view, and I from mine, and then she showed me a collection of pictures, etchings, ideas that were beginning to move her imagination. And then we went our separate ways, and when I came back a month later, to my astonishment I found the rack of clothes she had created. I hadn't imagined Bill being such a peacock, but the discovery was a really wonderful one, a hooligan dandy. It made me think a little differently. In fact, the more you disguise it the more remarkable the stench, the greater the menace. That we should wear our new-found wealth so ostentatiously seemed fitting—an almost consciously obscene parody of the uptown swells. Yet the threat is a kind of joke, because whilst everybody else making money in the city thinks only to emulate their 'betters,' we, through a blend of fierce tribalism and working-class pride, are inextricably bound to the streets we come from. From the moment I tried on the costumes, I was utterly delighted."

### GANGS OF NEW YORK (2002) · SANDY POWELL, COSTUME DESIGNER

**Jennifer Aniston (actress):** "The haggard look came easy because I was shooting *Friends* and the film at the same time. I don't usually have an easy time watching anything I've done, so I think it's a good sign that I was able to make it through watching this movie without cringing, and I think I'm actually proud of it. And it didn't even bother me seeing my 'relaxed-seat' jeans!"

*THE GOOD GIRL* (2002) • NANCY STEINER, COSTUME DESIGNER

**Clint Eastwood (director):** "I just got together with Deborah Hopper at the beginning and told her that I'd like to have the colors kind of muted and the wardrobe. . . . Don't forget, this is a blue-collar neighborhood—there's no tuxedo balls or anything like that. I said, I just want to approach the movie like it's black and white, so use a lot of brown, lots of dark colors, black, white, blue."

*MYSTIC RIVER* (2003) • DEBORAH HOPPER, COSTUME DESIGNER

**Nikki Reed (actress):** "Evie is insecure. She definitely grew up too fast and was faced with a lot of things. You never really know what's going on with her because she lies a lot. Obviously, she's been abandoned and she's in survivor mode. She takes what she needs because all her life, she had to take care of herself. I saw her being four years old and watching her mother OD'ing on the carpet, or something like that . . . hard things like that that we shouldn't see when we're young."

*THIRTEEN* (2003) · CINDY EVANS, COSTUME DESIGNER

**Penny Rose:** "When Johnny Depp and I were introduced, I said, 'What do you think of Jack Sparrow?' and he just looked me in the eye and said, 'He's a rock 'n' roller.' . . . The famous boots in the first fitting were two sizes too big for Johnny and fur-lined. I said to him, 'Look, I know you love these, but they're not your size and you can't possibly have fur-lined boots in the Caribbean,' and he said, 'Oh, but I love them!' And I said, 'Well you've got to trust me about this. These boots were made by Pompeii in Rome. That's where I get my boots made. He will have the identical boot, without the lining, in your size.' A week later I met him in Paris; he paraded up and down a five-star hotel in these new boots and said, 'You're good at this, aren't you?' So they fitted and he loved them and we had six pairs."

*PIRATES OF THE CARIBBEAN: CURSE OF THE BLACK PEARL* (2003) • **PENNY ROSE, COSTUME DESIGNER**

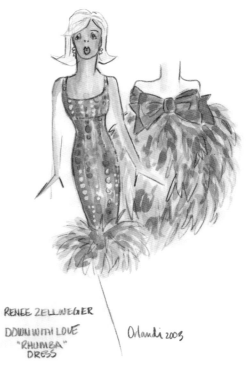

RENEE ZELLWEGER
DOWN WITH LOVE
"RHUMBA"
DRESS

Orlandi 2003

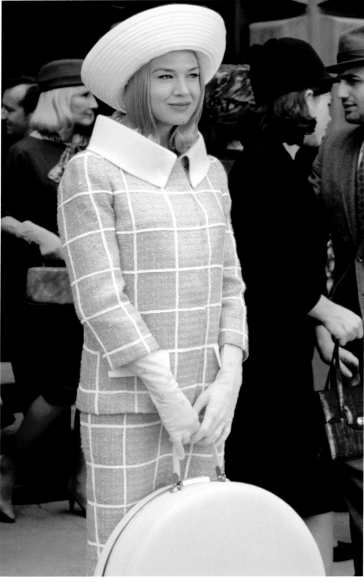

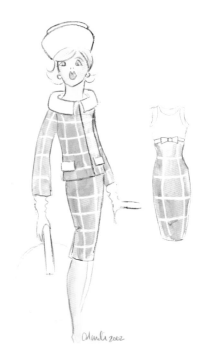

Orlandi 2002

**Daniel Orlandi:** "It's 1963, but it's Hollywood/Doris Day 1963. For *Down with Love*, we went for the authentic, unrealistic look of those movies, and what working women wore for the Hollywood back-lot soundstage look. We wanted that Technicolor sparkling candy-colored look in sets, with costumes that matched. Peyton Reid, the director, wanted the costumes to be like another character in the movie. The girls walk in, the music starts, and they show off their fabulous outfits."

**DOWN WITH LOVE (2003) ·
DANIEL ORLANDI, COSTUME DESIGNER**

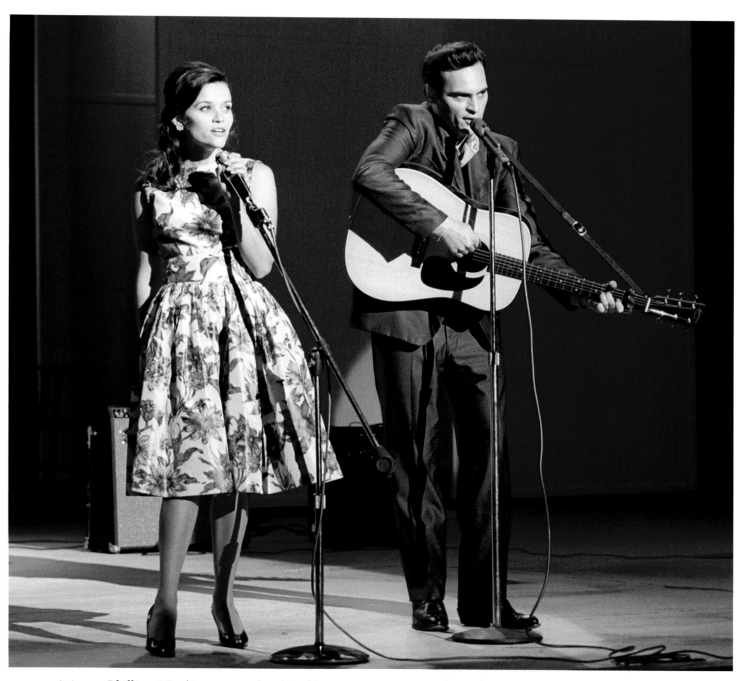

**Arianne Phillips:** "Cash's mom made a lot of his stage costumes in the early years, in the '50s, and there's a real homemade quality to them. I tried to bring that in. This is really about the journey. At the end of our film he becomes the Man in Black, which represents him finding his identity as an artist."

**James Mangold (director):** "People think the more outlandish the costumes, the more amazing the designer is. I trust [Arianne] Phillips not to impose her taste on the performers. She goes with what works for them, not what works for her. She has a very gentle way of finding her characters and of leading us there."

**_WALK THE LINE_ (2005) · ARIANNE PHILLIPS, COSTUME DESIGNER**

**Quentin Tarantino (director):** "One of the thoughts—it's never talked about, it's never suggested, and maybe you get it and maybe you don't—but when you see Lucy Liu's character, O-Ren Ishi, as a deadly viper, she's dressed like the rest of them with the turtleneck, she's in the red leather and stuff. But then, from the point where you see her as Queen of the Crime Council of Tokyo, she has a complete change in look. She's never dressed as modern ever again. Back in the Deadly Vipers, she talked English and kicked around and everything, and once she became Queen of the Crime Council, she was traditional in every sense of the word. [There was] just a wonderful combination of bouncing off of Uma and her yellow jumpsuit splashed with blood and Lucy in this beautiful white kimono and a black undershirt, and to me she just looked like a snowbird. She blends in with the snow and it made her even more delicate, even more of a figurine. . . . Contrasting the two looks makes Uma look towering and tall, and makes Lucy look even smaller, even more fragile, like a blown glass snowbird."

C.D. 3924
COSTUME DESIGNER
SIGNATURE

**Uma Thurman (actress):** "The pressure was immense. Mind you, when I first put my tracksuit on for my makeup and hair test, it was the first time I was remotely in the physical shape of someone who was gonna take on eighty-eight people. I had tears in my eyes, because the entire wardrobe department had bloody fingers from taking that costume in every week. . . . I was slowly, slowly shrinking, and it was getting down to the wire: Is she gonna make it? Or is this gonna be kinda funny for Quentin [Tarantino, director], this kind of large-bottomed Samurai?"

*KILL BILL: VOL. 1 (2003)* ·
**CATHERINE MARIE THOMAS
AND KUMIKO OGAWA,
COSTUME DESIGNERS**

"AILEEN WOURNOS"
Charlize Theron

**Charlize Theron (actress):** "The cool thing my makeup artist did was not to fall into doing the caricature, like the wearing of a fat suit and applying pure prosthetics on my face. Instead I decided to go through the body transformation by eating and eating and eating. Of course, we had to do quite an incredible makeup job. We had the full loads of contacts for my eyes and fake teeth. I think the result is quite surprising."

**Charlize Theron:** "Transforming is just another aspect of being an actor. I do not think you can do the emotional side without doing the physical side. It is like characters waking up in the morning with lipstick on—does that make sense? I am fine with the glamour as long as you treat it for what is. I believe that there are a handful of actors out there who are aware of what their job consists of—that transformation physically is part of it. It is not personal, and it is not about me. I do not sit around and think that people think that that is me being ugly. It has nothing to do with me, it is a character."

*MONSTER* (2003) · RHONA MEYERS, COSTUME DESIGNER

**Rob Marshall (director):** "I wanted a fictional impression of a world as opposed to a documentary vision, which gave me the license to break rules. People think of the geisha as a prostitute, because prostitutes started wearing white makeup and silk kimonos and calling themselves geishas, and the line became blurred. But the actual word means 'artist.' Yes, they entertain men. But, more importantly, they're great dancers and musicians and great conversationalists. They were also the fashionistas of their time. They were like supermodels."

### *MEMOIRS OF A GEISHA* (2005) · COLLEEN ATWOOD, COSTUME DESIGNER

**Bob Ringwood:** "I got catalogues from every museum around the world that had anything and then spent several days in the British Museum really studying everything and seeing how the clothes and armor were made and what they were made of. I looked a lot at the bas-relief sculptures, which are thousands of tiny figures—I kept setting off the alarms in the museum by getting too close—but if you make the effort to study them, they're actually quite accurate depictions. I was able to base the court clothes on them, which are the most historically accurate costumes in the film. I think one of the most important things about making an ethnic historical film is that you use ethnic fabrics and ethnic peoples to make it. If you try and make them with modern fabrics in modern factories they just look modern, and so we bought all the fabrics from all over the world and they were often fabrics that have been made the same way for three thousand years. I had about a hundred and fifty people working for me and then we outsourced all over the world, to Iraq, Turkey, India, Sri Lanka, China."

*TROY* (2004) · BOB RINGWOOD, COSTUME DESIGNER

*"Those Greeks,
they liked the mini.
Not only that, but
apparently they
fought with all the
tackle hanging out.
They didn't mind
it a bit."*

—BRAD PITT

**TROY (2004) · BOB RINGWOOD, COSTUME DESIGNER**

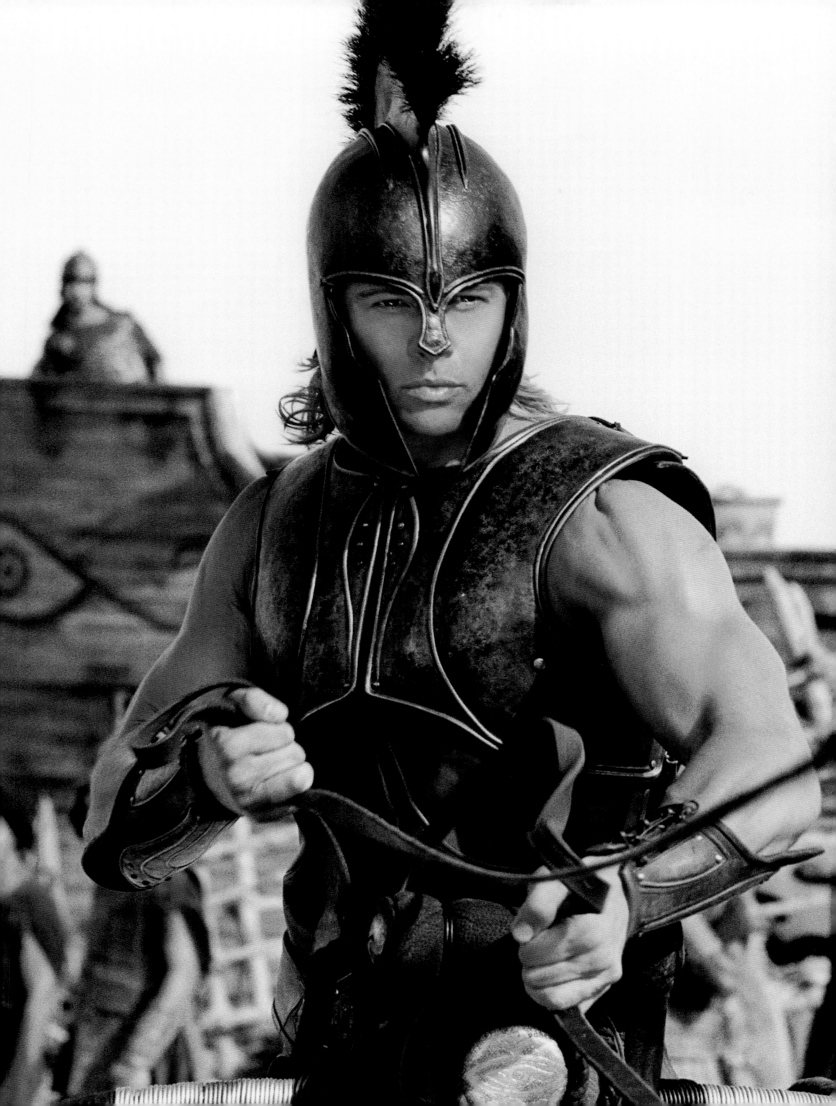

**Colleen Atwood:** "I wanted [Count Olaf] to intimidate the kids, to appear to tower over them, as if he were miles taller than they were. I felt the people in the books and film were extensions of that sort of caricature, so it worked to have the clothing look like illustrations."

**Brad Siberling (director):** "Jim Carrey's Count Olaf is a larger-than-life awful guy; by building in a lot of stripes and verticality to his look, Colleen stretched the dimensions of his badness."

*LEMONY SNICKET'S A SERIES OF UNFORTUNATE EVENTS (2004)* ·
COLLEEN ATWOOD, COSTUME DESIGNER

**James L. White (screenwriter):** "When Mr. Charles came up, black men didn't curse a lot, especially not in public. Black men had to make themselves look presentable—even if they were a janitor, they'd put on a three-piece suit to walk to work."

*RAY (2004)* • SHAREN DAVIS, COSTUME DESIGNER

**Kate Winslet (actress):** "Clementine is such a complex mixture of positives and negatives. I did not want her to be obvious and I didn't want her to be a nail-biting neurotic with a twitch, but at the same time I didn't want her to be all hearts and chocolates. I tried on loads of stuff—we wanted to find things that were quirky but not totally outrageous. And I loved her hair colors. She went from blue to orange to pink and back. I had so much fun with those wigs. That was my 'fake nose.'"

***ETERNAL SUNSHINE OF THE SPOTLESS MIND* (2004) · MELISSA TOTH, COSTUME DESIGNER**

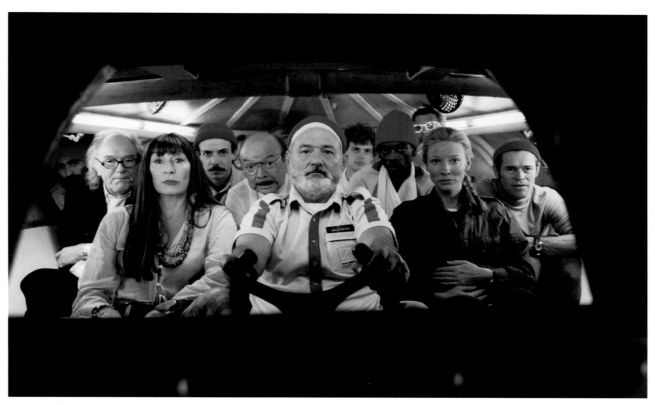

**Wes Anderson (director):** "I am not trying to make them naturalistic or normal in any way. I am trying to come up with characters surprising to people and surprising to me. People who like weird people, I guess, are more likely to like my films than people who call people weirdos."

***THE LIFE AQUATIC WITH STEVE ZISSOU* (2004) · MILENA CANONERO, COSTUME DESIGNER**

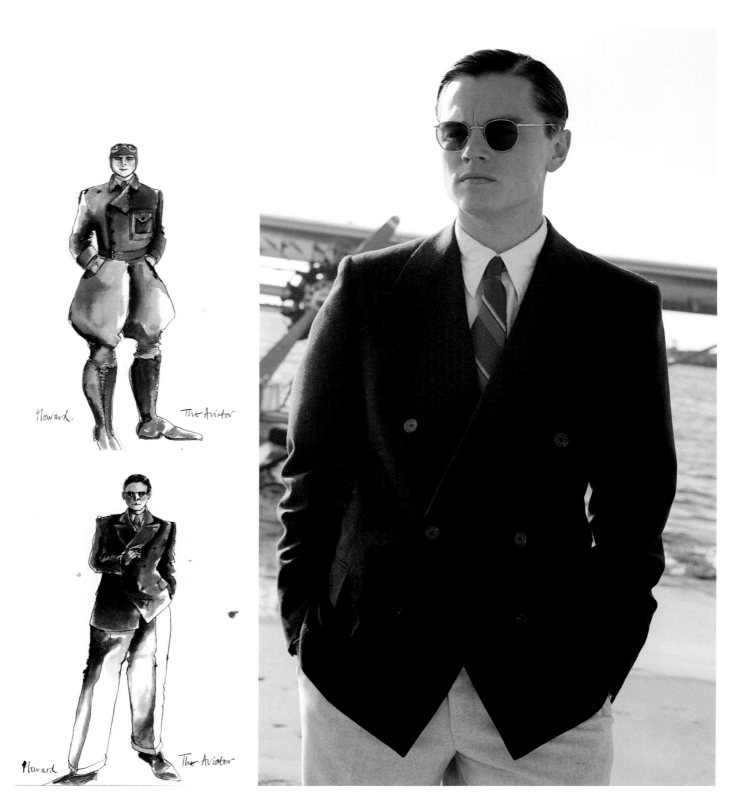

**Sandy Powell:** "We've tried to be as authentic as possible and as close as possible to the character that we are portraying. I've looked at all of the things Howard Hughes actually wore, and really tried to re-create that. I mean, not absolutely, completely, down to the tiniest detail—I obviously can't get some of the same fabrics. The pictures I am looking at are in black and white most of the time, and we're doing color, so I have to imagine what the colors would have been. He starts off as a young man, fairly well off. He did actually have all of his suits tailor-made at Savile Row. Expensively dressed, well-made. As time passes and he gets a little older, he gets less concerned with his appearance, and although his clothes probably are expensive, they start to not look it. They start to be worn in a kind of scruffy way. Clothing and his appearance are not important to him. There is a deterioration."

***THE AVIATOR* (2004) • SANDY POWELL, COSTUME DESIGNER**

Major William Avery Bishop
Victoria Cross

**Marit Allen:** "[Annie] Proulx's story is so pure and tender that the costumes and wardrobe needed gentle handling. Hopefully you don't notice the clothing, but you feel the emotions that the clothes convey. In that sweeping landscape, those two figures and their clothing act as subliminal telegraphs. Everything worn by cowboys and ranchers has a meaning and a cultural reference. It would be very easy for an outsider unfamiliar with the code to make a mistake. For instance, cowboys wear Wrangler jeans (they're much tighter) and ranchers wear looser Levi's. Even the shape and heel height on a cowboy boot tells a tale. So does the height, color, brim, and shape of a hat, which also varies from state to state. For instance, Jack's broader Texas hat is different than the one Ennis wears in Wyoming. And all of this is unspoken but rigorously observed. . . . The '70s shoulder was much higher and the armholes were tighter. The shirts were also more constricted. And that period's polyester was much different from polyester used now. It hugged the body and has a sexual connotation that a pure cotton just doesn't convey."

**_BROKEBACK MOUNTAIN_ (2005) •
MARIT ALLEN, COSTUME DESIGNER**

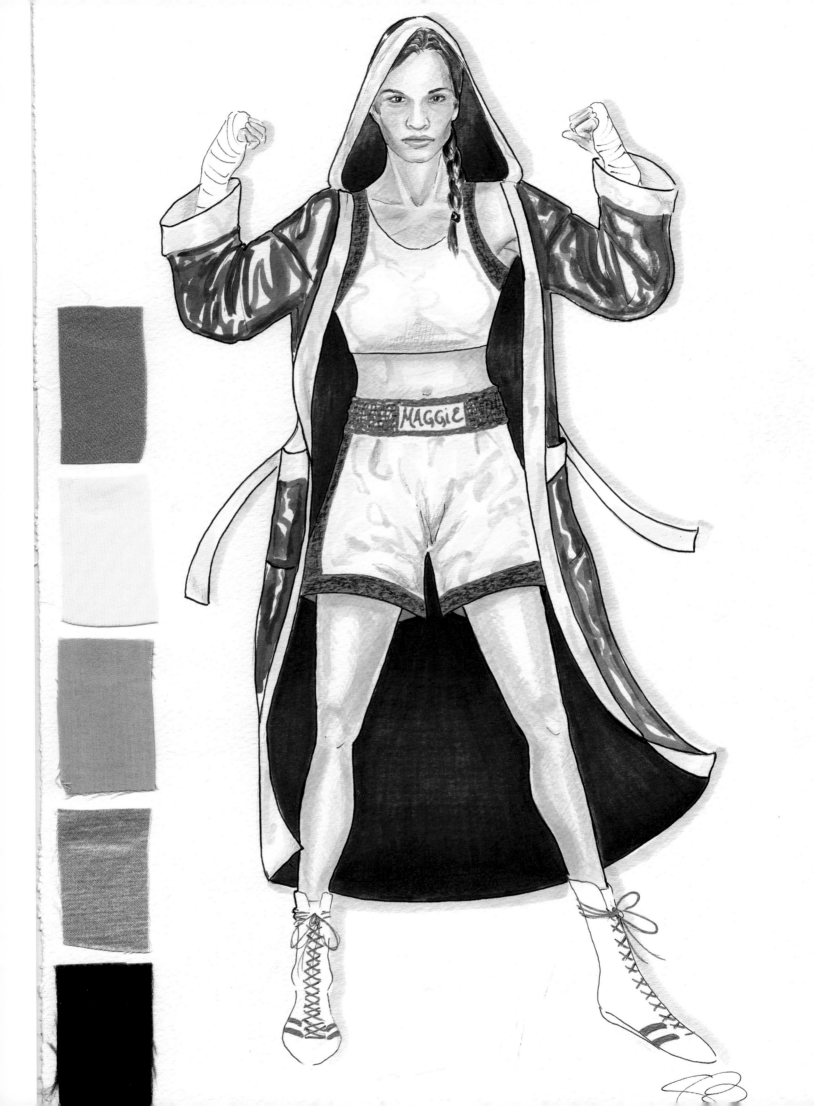

**Hilary Swank (actress):** "Clint [Eastwood, director] is probably the first man who ever made me blush. I was halfway through my training, and I was in a wardrobe fitting, and he came by. I blushed because I was still in the middle of this physical boxing thing I was trying to do. I was so worried about what he was going to think—had I gone far enough yet? Was I looking more like a boxer? I still had another month to go, but there I was, in my sports bra and little biker shorts, and my face turned as red as a tomato."

### *MILLION DOLLAR BABY* (2004) · DEBORAH HOPPER, COSTUME DESIGNER

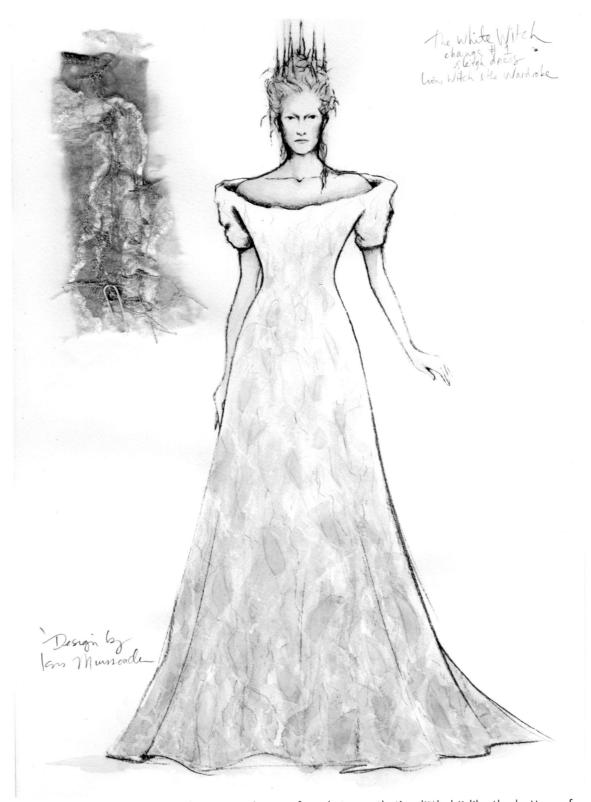

The White Witch
change #1
sleigh dress
Lion, Witch & the Wardrobe

Design by
Isis Mussenden

**Tilda Swinton (actress):** "The dress is made out of a substance that's a little bit like the bottom of an amazing waterfall I saw in the middle of New Zealand. It's like the White Witch is made of water or ice, or smoke, or, something natural. And being the epitome of all evil—and this comes very strongly from the book—she's covered in fur. And she has hair that doesn't look like hair, it looks like it's come from the ground—maybe it's roots or something. And her crown is made of ice and it melts throughout the film. It's not going to look like a costume that she got out of a wardrobe anywhere. It's like she just whipped it up out of somewhere. And I wish that it were really a computer-generated costume because it was really difficult to wear!"

### THE CHRONICLES OF NARNIA (2005) · ISIS MUSSENDEN, COSTUME DESIGNER

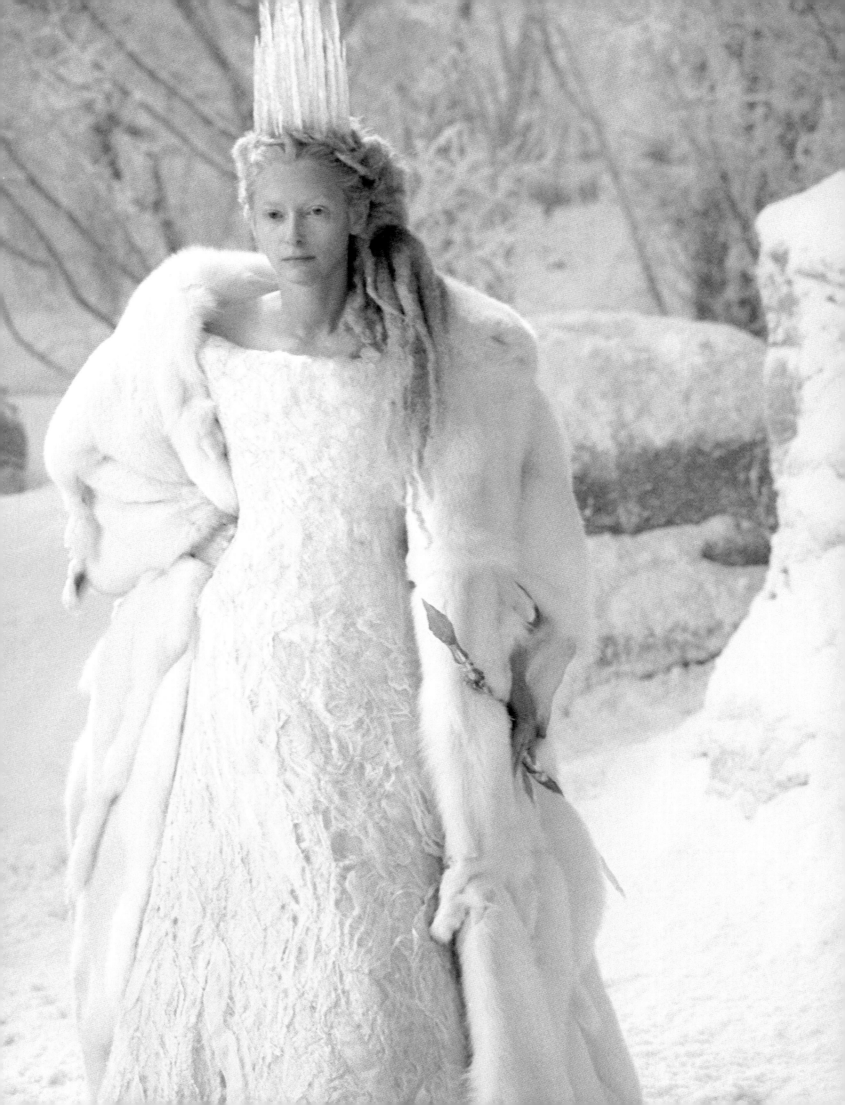

*"I'm a notorious pain-in-the-butt for any costume designer . . . For me, clothes are a kind of character."*

—MERYL STREEP

**THE DEVIL WEARS PRADA (2006) · PATRICIA FIELD, COSTUME DESIGNER**

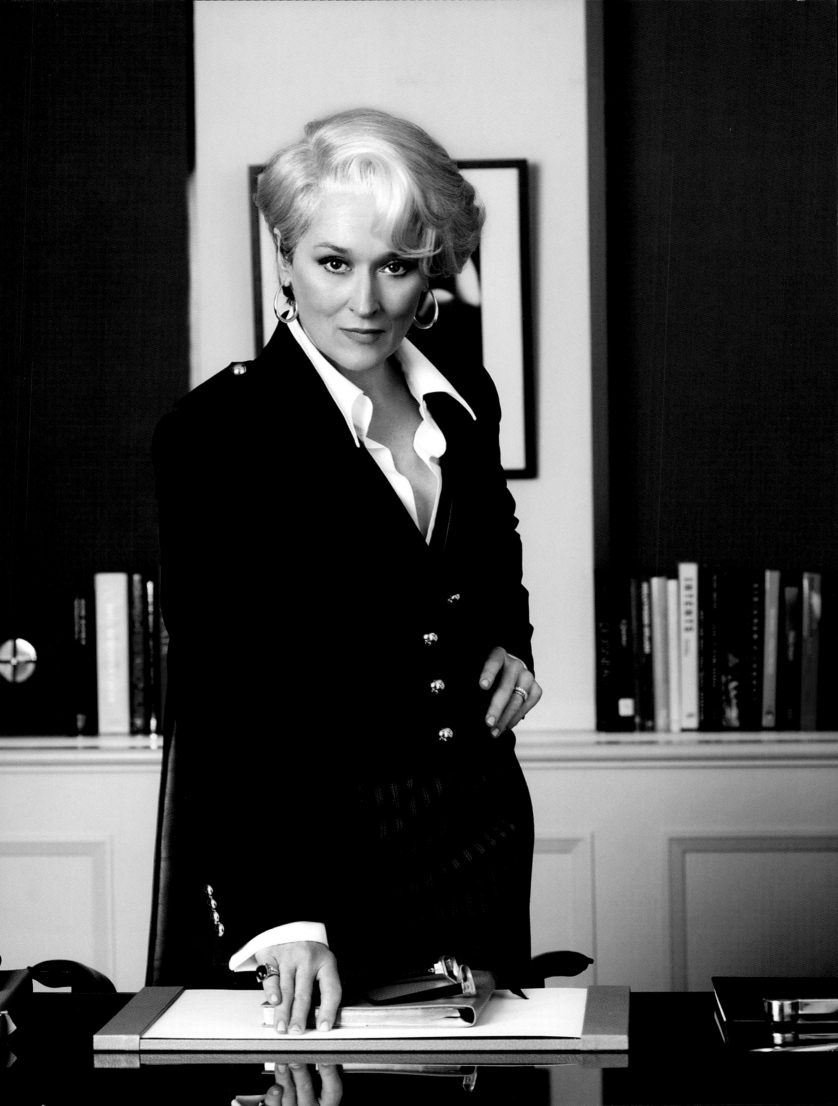

**Martin Scorsese (director):** "This is the first film that takes place in the present day that I've done in twenty-one years. . . . I wanted it all stripped down, I wanted to strip away the complexity of colors, and for characters to come to the forefront. This idea was an homage, or reference, based on the noir genre. It's different in the sense that it takes place in the modern day, and the noir of today reflects a different culture and time in the world. But I wanted visual references back to noir photography at its height—back to [famed noir cinematographer] John Alton and people like that in the 1940s, when noir was born after *Double Indemnity*."

**Matt Damon (actor):** "In all of Marty's films there is an authenticity that you just can't fake, because he uses a lot of real people and his actors have access to these real people and get as much understanding of the people that they're playing. Ultimately it's a giant magic trick. We're just trying to be believable, and if you're taken out of the movie at all, then we haven't done our job right."

*THE DEPARTED* (2006) • SANDY POWELL, COSTUME DESIGNER

Pocahontas "Turtle dress"

**Jacqueline West:** "For Pocahontas, Terry [Terrance Malick, director] wanted the costume to be quite simple at first, indicating a free spirit unencumbered by possessions. After she meets John Smith, Pocahontas's character evolves as she becomes more self-conscious, very gradually she gives up her breech cloth and then her buckskin dress."

**Jacqueline West:** "Designing the costumes for the English [involved] getting the clothes of the period to look like they'd been through what they had to have gone through getting from Britain to Virginia. . . . Captain John Smith was tricky, because men in tights can be scary. I got my inspiration for his costumes from the swashbuckling adventures, but with authentic period feeling. Men in that time usually had one suit of clothing, because for someone of John Smith's level in society, it would cost almost as much as if you'd had your portrait done by a painter. Clothing was so at a premium that articles like a leather doublet would be bequeathed to someone in your family . . . it was that valuable. We also gave him elements of things he'd collected in his world adventures and travels: a Transylvanian dragon earring and a Moorish cape, for example. "

### *THE NEW WORLD* (2005) · JACQUELINE WEST, COSTUME DESIGNER

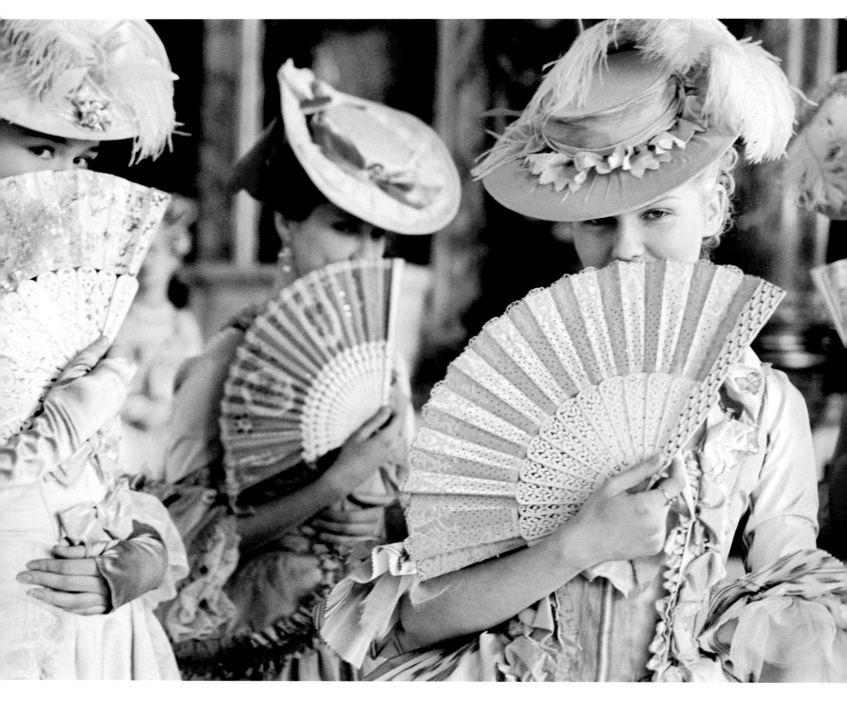

**Sofia Coppola (director):** "To me the core element of the story is that she was a symbol of decadence and frivolity and end of an era for France. . . . I wanted to build our own costumes and create our own look using a young girl's candy-colored palette. Because we're making a movie about Marie Antoinette I thought we needed lots of silk and macaroons, and I asked Milena the costume designer to make the whole palette of the film in the macaroon colors for the young part of her life, and when I visited the real private apartments of Marie Antoinette they had the fabrics that she liked which were turquoise and pink. I wanted to make the film from her point of view and have it feel hopefully very vital and fresh and not like some other period films where you feel like you're looking at history from a distance. A lot of the time you see the clothes, or the paintings of the era have faded, and that creates a barrier with the audience, I think."

*MARIE ANTOINETTE* (2006) • MILENA CANONERO, COSTUME DESIGNER

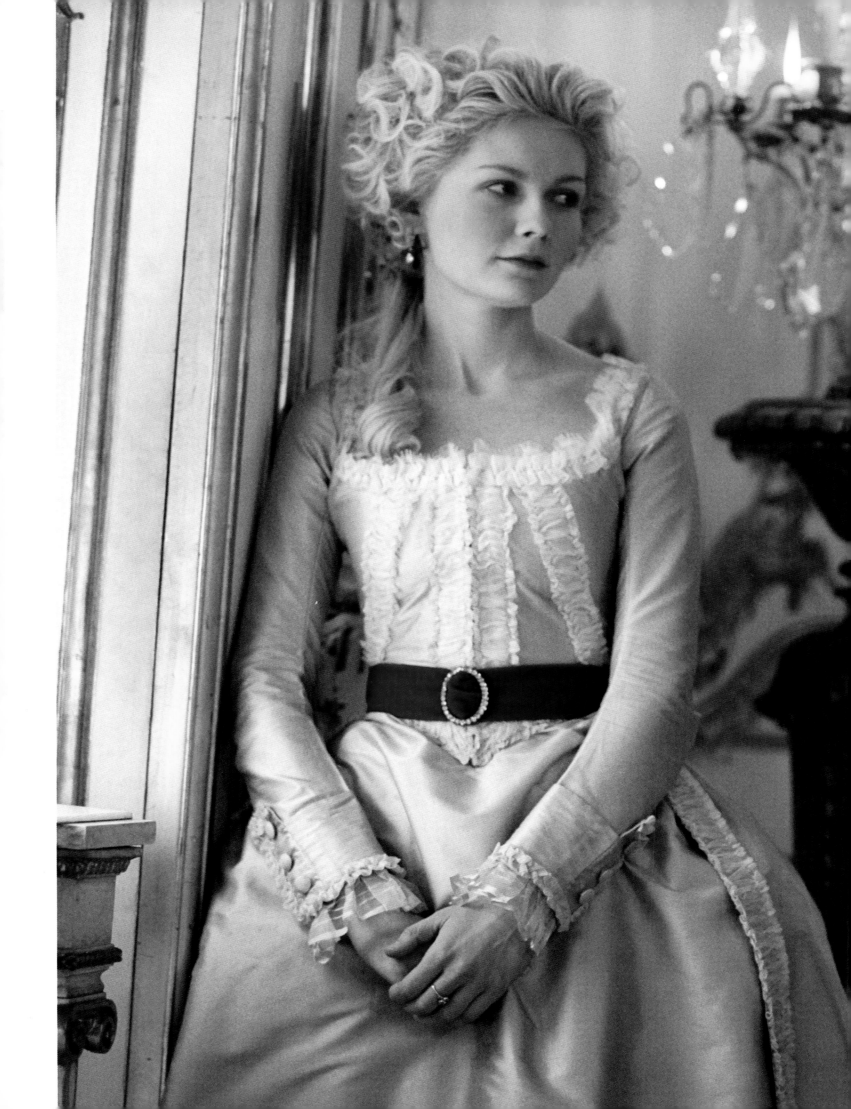

**Nancy Steiner:** "We wanted each character to be their own person, sort of a [caricature] of themselves. Color was important too. That each person had their own color scheme. I liked that Frank just tried to end his life and yet he looks like an angel, pure in a way. We decided that red was Olive's color. And I wanted to portray a little girl with an imagination and a quirkiness, like some of the kids I know. I think the major difference in designing contemporary films is that the options are endless. With a period film you are creating a memory, or a precise slice of time that has already happened, already been defined in a way. We are living in the world now so it hasn't yet been distilled down to memories."

*LITTLE MISS SUNSHINE* (2006) • NANCY STEINER, COSTUME DESIGNER

# ACKNOWLEDGMENTS

Dressed is the most comprehensive book available on Hollywood costume design because of the invaluable support and advice provided by scholars, collectors, professionals, and friends. The costume illustrations, photographs, and quotations within this volume depended on the generosity of a multitude of private and public collections and archives. I did not create this book in a vacuum. Like any major film production, it ends with a long list of credits.

Special acknowledgment and thanks to the following individuals and organizations for the use or loan of rare costume illustrations: Dr. Victoria Steele, Octavio Olvera, and Stephanie Day Iverson at the UCLA Library, Department of Special Collections, for sharing their sensational Dorothy Jeakins and Lucile illustrations; Sharon Takeda, Nicole LaBouffe, Piper Wynn Severance, and Cheryle T. Robertson at the Los Angeles County Museum of Art for access to their remarkable Hollywood Golden Age costume sketches; and Mary Volk, Amanda Walker, and Jane Greenwood at the Yale School of Drama and Planned Parenthood New York, without whose help Irene Sharaff's Broadway to Hollywood sketches would not be published here; Principal Librarian Deirdre Lawrence, who opened the acid-free boxes of sketches at the Brooklyn Museum of Art; and the Wisconsin Historical Society, Wisconsin Center for Film & Theater Research, and Archivist Maxine Ducey, for the mother lode of Edith Head designs. Many thanks to Collection Managers John Cahoon and Beth Werling at the Seaver Center for Western History Research at the Los Angeles County Museum of Natural History for their remarkable series of Top Hat sketches; James D'Arc, Curator at the Cecil B. DeMille Archive at Brigham Young University in Provo, Utah; Steve Wilson, Associate Curator of Film, at the Harry Ransom Center at the University of Texas, Austin, who allowed me to linger over Walter Plunkett's Gone with the Wind sketches and costumes in the David O. Selznick Archive; and Bill Haber, Eddie Marks, and Bobi Garland at Western Costume Company for sharing their rich history and many treasures.

My sincere gratitude to the generous costume illustration collectors: David Copley, Leonard Stanley, William Sutton, Tom Culver, David Chierichetti, Christian Esquevin, Robert Evanko, Forrest Paulett, Robert Romanus, Burl Stiff, and Bill Sarris, for their cooperation, expertise, and support. I would particularly like to acknowledge William Sutton, who graciously shared his time, advice, and precious contacts. Motion picture costume design illustrations would not have survived except for these determined collectors. Most are published here for the first time.

Warmest appreciation is extended to the following archives and individuals for their assistance in procuring sketches and photographs: Director Linda Mehr and Graphic Arts Librarian Anne Coco at the Academy of Motion Picture Arts & Sciences' Margaret Herrick Library answered many requests with enthusiasm and efficiency; Photographic Services Curator Robert Cushman and library staff members Robert Smolkin, Matt Severson, Faye Thompson, and Neal Romanek, at the Herrick Library helped me navigate their vast collection; Dr. Anthony Bannon, Curator Dr. Patrick Loughney and Assistant Curator Jim Healy at Eastman House in Rochester filled my silent film still wish list; Ron Mandelbaum at Photofest searched tirelessly for just the right picture, and Nina Harding and the British Film Institute for being so patient and efficient. The village of Hollywood still exists, and Peter Bateman at Larry Edmunds Bookshop, Inc., John Kantas and Ken Leicht at Hollywood Book & Poster Co., and Clare Brandt at Eddie Brandt's Saturday Matinee patiently looked through dusty file cabinets to dig for photographs. Corbis, Getty, and Moviemarket's online services were invaluable. I am deeply indebted to Lauretta Dives, Martin Dives, Phil Moad, and Jamie Vuignier, from Picture Desk/The Kobal Collection, who were determined to deliver the best images and resolved to improve and upgrade those that were not absolutely perfect. Our mutual admiration grew during the years we spent assembling this book. And professional researcher Meg McVey plugged many of the most stubborn holes.

One of the pleasures of Dressed has been the opportunity to interview costume designers and illustrators who shared their war stories, sketches, and stills: James Acheson, Theoni Aldredge, Marit Allen, Pauline Anon, Deena Appel, Colleen Atwood, Joe Aulisi, Kym Barrett, Luster Bayless, Yvonne Blake, Trisha Biggar, Mark Bridges, Tom Bronson, Richard Bruno, Milena Canonero, Ruth Carter, Betsy Cox, Shay Cunliffe, Sharen Davis, Robert De Mora, Sophie de Rakoff Carbonell, Ngila Dickson, Rudy Dillon, Donfeld, John Dunn, Cindy Evans, April Ferry, Marie France, Louise Frogley, Jane Greenwood, Gloria Gresham, Betsy Heimann, Deborah Hopper, Eiko Ishioka, Darryl Johnson, Joanna Johnston, Renee Ehrlich Kalfus, Michael Kaplan, Kelly Kimball, Jeffrey Kurland, Molly Maginnis, Judianna Makovsky, Mona May, Catherine Martin, Rhona Meyers, Louise Mingenbach, Ellen Miro-

jnick, Isis Mussenden, Ruth Myers, Patricia Norris, Daniel Orlandi, Karen Patch, Arianne Phillips, Bernie Pollack, Joseph Porro, Anthony Powell, Sandy Powell, Robin Richesson, Rita Riggs, Bob Ringwood, Aggie Rodgers, Penny Rose, Ann Roth, May Routh, Rita Ryack, Deborah Scott, Nancy Steiner, Marlene Stewart, Casey Storm, Angus Strathie, Anthea Sylbert, Catherine Thomas, Joe Tompkins, Theadora Van Runkle, Marilyn Vance, Mary Vogt, Patrizia Von Brandenstein, Tony Walton, Julie Weiss, Jacqueline West, Albert Wolsky, Janty Yates, Kristi Zea, and Mary Zophres.

My debt to cinema scholars, film fans, and friends is enormous. My special gratitude goes to: Leonard Maltin, Kevin Brownlow, Dr. Thomas Schatz, Dave Kehr, Jim Healy, Sir Christopher Frayling, Jay Cocks, Adam Rifkin, and Joe Dante, who helped narrow the field of films to include in this work. They cheerfully allowed me to pick their brains. Without the constant encouragement of Professor Sir Christopher Frayling there would have been no doctoral dissertation in costume design, and no Dressed to follow it.

Dozens of individuals shared their knowledge and pointed me in the direction of sketches, photographs, and reference materials. Archivist Ned Comstock at the USC Cinema Library spent many hours digging through silent screen magazines for pithy costume quotes. Archivist Leith Adams at the Warner Bros. Museum; Curator Edward Maeder at Historic Deerfield; Daryl Maxwell, Collections Specialist for Disney Studios; Kimberley Ashley for sharing her Travilla archive., Archivist Anahid Nazarian at Zoetrope Studios; John Singh, Tracy Cannobbio, and the Lucasfilm Archives; and Librarian Tatyana Pakhladzhyan at the Metropolitan Museum of Art, Costume Institute, all generously contributed to this major undertaking.

Although it would be impossible to include everyone in this lifelong research project, warmest thanks are due to the following individuals for their contribution to Dressed: Jenny Agutter, Jack Allen, Michael Apted, Jeremy Aynsley, Donna and Dan Aykroyd, Sarah and Christopher Bailey, Curator Mary Lea Bandy at MOMA, Jaclyn Bashoff, Hilary Baxter, Marshall Bell, Marissa Berenson, Peter Bogdanovich, Joan and Mark Boyle, Lauren Buisson, Gurinder Chadha and Paul Berges, Charlotte Chandler, Michael Clancy, Eleanor and Francis Coppola, Jonathan Demme, Jean Firstenberg, Alice and Jon Flint, Lily Fonda, Lourdes Font, Mary Francis, Sid Ganis, Michelle and Costa Gavras, Hilary and Daniel Goldstine, Josh Goldstine, John Gray, Dean Sam Grogg, Randy Haberkamp, Melissa and Emily Hacker for making sure their mother, Ruth Morley, received full credit for designing Annie Hall, Susan Hilferty, Barbara Inglehart, Ange Jones, Professor Pat Kirkham, Solange and Jean Claude Landau, Robert Levine, George Lucas, Summer and Michael Mann, Richard Martin, Russell Merritt, Lori and Michael Milken, Dr. Wolffe Nadoolman for a hundred vintage costume books, Diane and James Neal, Al Nichol, Maria Norman, Catena Passalaqua, Natalie Perr, Amanda Pisani, Regis Philbin, Susan Perez Prichard for her superb annotated bibliography of costume, Tom Rand, Gil Cates and Judith Reichman, Debbie Reynolds for our shared passion, Dr. Aileen Ribeiro from whom I learn so much, Jimmie and Michael Ritchie, Joan Rivers for her wit and kindness, Tracy Roberts for making sure Eiko's work made it into my hands, David Robinson for his inspired writing, Mary Rose for her mentorship, Robert Rosen, Dr. Nancy Rosser, Karen and David Sachs, Pamela Shaw, Hope Singer, Dr. Valerie Steele for her cheerleading, Nadja Swarovski, Michael Taylor, Isabel and Ruben Toledo, Michelle Tolini, Lawrence Turman, and Ret Turner.

Throughout this long project my resourceful research assistants, Natasha Rubin and Heather Vaughan, were an unfailing source of positive energy. Dressed looks great because of Natasha's native stubbornness and tenacity: if a decent picture or quote existed she was determined to find it. My grammatical fairy godmother, Brenda Royce Posada, kept my addiction to commas in check while copy editing my chapters before they left the time zone. My enthusiastic interns included talented costume design and filmmaking students from UCLA, USC, and NYU: Oran Bumroonghart, Meghan Corea, Jennifer Y. Hong, Sarah Le Feber, Michelle Liu, Monique Lyons, Erica Palay, Kaitlyn Ramirez, Russell Dauterman, John Bowers and Leighton Aycock. This was my reinvention of the costume crew. After a lifetime in the movies I thrive in an atmosphere of collaborative creativity.

As an Academy Award–winning actress and Directors Guild of America Award–nominated director, Anjelica Huston is a quintessential filmmaker. She is the granddaughter of actor Walter Huston and daughter of artists: prima ballerina Ricki Soma and director John Huston. Costume designer Dorothy Jeakins, a close friend of the family, sent young Anjelica exotic gifts from her world travels. This early relationship, and the personal and professional intimacy she has shared with the costume designers who followed, was nothing less than cathartic. Anjelica has graced Dressed with a foreword that is also a memento. Thank you so much for sharing these touching remembrances.

Thanks to HarperCollins for their confidence in Dressed. My editor, Cal Morgan, kept his cool and his equilibrium throughout this rollercoaster year, editing the chapters and hundreds of first-person quotes with much patience and care. It helps that he loves movies. Cal enriched the project with his judicious eye while nudging me to improve the photographs. Cassie Jones and Brittany Hamblin provided support in all the stages of publication, and Chase Bodine for staying the course. Veteran designer Richard Ljoenes ensured that the book would look its best.

Dressed exists because Judith Regan decided that a glorious book on costume design was needed, and that I was the one to write it. She championed Dressed (her title) from the beginning and was determined that it met the highest standards of style and scholarship.

None of this would have been possible without the love and forbearance of my children, Max and Rachel, and my parents, Laura and Milton Nadoolman, who imbued me with a love of history. My husband, filmmaker John Landis, has been my patron, underwriter, editor, and resident cineaste. His knowledge of production, critical writing, biography, and film history is unmatched anywhere. It is to John that I should like to dedicate this book. "L'enfer, c'est les autres." —Jean Paul Sartre.

—DEBORAH LANDIS, 2007

# QUOTATION SOURCES

## CHAPTER ONE: EARLY YEARS

ix   **Prizzi's Honor** Aljean Harmetz, "Anjelica of the Huston's, Back in the Family Fold," *New York Times,* June 27, 1985.
xv   **Charlie Chaplin** Charles Chaplin, *My Autobiography* (New York: Simon & Schuster, 1964), p. 144.
1   **Rags** E. E. Barrett, "Clothes That Count," *The Picturegoer,* October 1928.
6   **Tom Mix** Leonard Matthews, *History of Western Movies* (London: Hamlyn Publishing Group Ltd., 1984), pp. 18, 23.
8   **Male and Female** Gloria Swanson, *Swanson on Swanson* (New York: Random House, 1980), p. 130.
9   **Pullman Bride** Gloria Swanson, *Swanson on Swanson* (New York: Random House, 1980) p. 113.
10   **La Reine Élisabeth** P. Wollen, "Strike a Pose," *Sight and Sound,* March 1995, p. 14.
12   **The Rise of Susan** William Lord Wright, "Dame Fashion and the Movies." *Motion Picture Magazine,* September 1914, p. 109.
14   **Bronco Billy** Gilbert M. Anderson, *Oral History Collection of Columbia University,* June 1958. p. 24.
14   **Hell's Hinges** William S. Hart, *My Life East and West* (Chicago: Lakeside Press, 1994), p. 245.
14   **Squaw Man** Cecil B. DeMille, *The Autobiography of Cecil B. DeMille* (Englewood Cliffs, NJ: Prentice-Hall Inc., 1959), p. 88.
15   **Birth of a Nation** Lillian Gish, *The Movies, Mr. Griffith and Me* (New York: Avon, 1969), p. 138.
16   **Gloria's Romance** Roberta Courtland, "My Lady's Wardrobe," *Motion Picture Classic,* December 1916.
18   **Intolerance** Lillian Gish, *The Movies, Mr. Griffith and Me* (New York: Avon, 1969), p. 136.
18   **Intolerance** Bessie Love, *From Hollywood with Love* (London: Elm Tree Books, 1977), p. 82.
19   **Intolerance** Karl Brown, *Adventures with D. W. Griffith* (New York: Farrar, Straus & Giroux, 1973), p. 135.
20   **Virtuous Wives** Hedda Hopper, *From Under My Hat* (Garden City, NY: Doubleday, 1952), p. 104.
21   **Cleopatra** Ronald Genini, *Theda Bara: A Biography of the Silent Screen Vamp* (London: McFarland & Company, Inc., 1996), p. 38, 40.
21   **Cleopatra** Ronald Genini, *Theda Bara: A Biography of the Silent Screen Vamp* (London: McFarland & Company, Inc., 1996), p. 42.
22   **Macbeth** Constance Collier, *Harlequinade: The Story of My Life* (London: The Bodley Head Ltd., 1929), p. 241.
23   **Perils of Pauline** Pearl White, *Just Me* (New York: George H. Doran Company, 1919), pp. 160-61.
23   **Stella Maris** Mary Pickford, *Sunshine and Shadow* (Garden City, NY: Doubleday, 1955), pp. 241-42.
24   **Male and Female** Michael Webb, ed., *Hollywood: Legend and Reality* (Boston: Little, Brown, 1986), p. 110.
26   **Rebecca of Sunnybrook Farm** Lady Duff Gordon, *Discretions and Indiscretions* (London: Jarrolds Publishers, 1932), p. 225.
27   **Broken Blossoms** Lillian Gish, *The Movies, Mr. Griffith and Me* (New York: Avon, 1970), p. 220.

## CHAPTER TWO: 1920s

29   **The Canary Murder Case** Louise Brooks, *Lulu in Hollywood* (New York: Alfred A. Knopf, 1982), pp. 108-09.
33   **Queen of Sheba** Mae Tinee, "Sheba Goes to Visit Solomon; Fox Tells About It," *Chicago Daily Tribune;* November 11, 1921.
35   **Laurel and Hardy** Randy Skretvedt, *Laurel and Hardy: The Magic Behind the Movies* (Beverly Hills: Moonstone Press, 1987), p. 55.
36   **The Scarlet Letter** "Danish Designer Guided by Screen Personalities," *New York Times,* February 20, 1927.
37   **Orphans of the Storm** Lillian Gish, *The Movies, Mr. Griffith and Me* (New York: Avon, 1969), p. 243.
38   **The Impossible Mrs. Bellew** Gloria Swanson, *Swanson on Swanson* (New York: Random House, 1980), p. 182.
39   **The Great Moment** photography caption, *Washington Post,* August 21, 1921, p. 55.
40   **Pollyanna** Robert Windeler, *Sweetheart: The Story of Mary Pickford* (New York: Praeger Publishers, 1973), p. 132.
40   **Dorothy Vernon of Hadden Hall** David Chierichetti, *Mitchell Leisen: Hollywood Director* (Los Angeles: Photoventures Press, 1995), p. 32.
41   **Foolish Wives** William H. McKegg, "What a Man Should Not Wear," *Picture Play,* April 1927, pp. 86, 106.
42   **Salome** Gavin Lambert, *Nazimova* (New York: Knopf, 1997), p. 256.
43   **The Thief of Baghdad** Raoul Walsh, *Each Man in His Time* (New York: Farrar, Straus & Giroux, 1974), p. 166.
44   **Greed** Thomas Quinn Curtiss, *Von Stroheim* (New York: Vintage Books, 1971), pp. 166–67.
45   **Buster Keaton** Eleanor Keaton and Jeffrey Vance, *Buster Keaton Remembered* (New York: Harry N. Abrams, Inc., 2001), p. 213.
46   **Robin Hood** David Chierichetti, *Mitchell Leisen: Hollywood Director* (Los Angeles: Photoventures Press, 1995), p. 25.
43   **Covered Wagon** Kevin Brownlow, *The Parade's Gone By* (Berkeley: University of California Press, 1968), pp. 380-81.
48   **You Never Know Women** H. M. K. Smith, "Mannequin and Movie Queens," *McClure's,* vol. 60, no. 3, March 1928, p. 52.
50   **Ben Hur** Allan R. Ellenberger, *Ramon Novarro: A Biography of the Silent Film Idol, 1899–1968; With a Filmography* (Jefferson, NC: McFarland & Company, Inc. Publishers, 1999), p. 45; J. J. Cohn, interview, April 12, 1993, Beverly Hills, CA.
53   **Monsieur Beaucaire** "Many Work on One Film," *New York Times,* June 29, 1924, p. x2.
53   **Monsieur Beaucaire** "Lavish Costumes for 'Monsieur Beaucaire,' *New York Times,* February 17, 1924, p. x4.
54   **The Big Parade** King Vidor, *A Tree Is a Tree: An Autobiography* (Hollywood: Samuel French, 1953, 1981), pp. 114–15.
55   **Flaming Youth** John Kobal, *People Will Talk,* (New York: Alfred A. Knopf, 1985), p. 32.
56   **My Lady of Whims** Hedda Hopper, "How Stars Have Made Styles in the Studios of Hollywood," *Washington Post,* June 5, 1938.
57   **The Son of the Sheik** Edwin Schallert, "Playdom: 'Sheik No Shocker," *Los Angeles Times,* July 10, 1926, p. a7.
58   **Ella Cinders** "American Girl Able Designer," *Los Angeles Times,* December 13, 1925.
60   **The Temptress** Howard Gutner, *Gowns by Adrian: The MGM Years 1928–1941* (New York: Harry N. Abrams, Inc., 2001), pp. 72–73.
60   **The Temptress** "Gowning Women for Films More than Attaining Beauty, Asserts Designer André-Ani," *Los Angeles Times,* December 20, 1925.
61   **Sunrise** E. E. Barrett, "Clothes That Count," *Picturegoer,* vol. 16, no. 94, October 1928, pp. 24–25.
61   **Applause** John Kobal, *Gotta Sing, Gotta Dance: A Pictorial History of Film Musicals* (London: Hamlyn Publishing, 1970), pp. 67–69.
62   **Wings** Edith Head and Paddy Calistro, *Edith Head's Hollywood* (New York: E. P. Dutton, 1983). p. 15.
63   **The Love of Sunya** Gloria Swanson, *Swanson on Swanson* (New York: Pocket Books, 1981), pp. 296, 302.
64   **Sadie Thompson** Louis Raymond, "Original Glamour Girl Returns"; *Motion Picture,* vol. 62, no. 3, October 1941, p.80.
66   **Show People** "What Their Clothes Cost," *Photoplay,* October 1924, pp. 34–35, 112–14.
67   **Our Dancing Daughters** Howard Gutner, *Gowns by Adrian: The MGM Years 1928–1941* (New York: Harry N Abrams, Inc., 2001), p. 104.
68   **The Mystic** Erté, *Things I Remember: An Autobiography* (New York: Quadrangle, 1975), p. 83.

## CHAPTER THREE: 1930s

71  **The Thin Man** James Kotsilibasa-Davis and Myrna Loy. *Myrna Loy: Being and Becoming* (New York: Alfred A. Knopf, 1987), p. viii.

77  **Belle of the Nineties** Lydia, "'Thanks Paris!' says Mae West," *Screen Book,* vol. 11, no. 4, November 1933, p. 14.

78  **Madam Satan** Rosalind Shaffer, "Costume Ball on Zeppelin in DeMille's New Picture," *Chicago Daily Tribune,* April 6, 1930, p. G5.

80  **An American Tragedy** Thomas Doherty, "An American Tragedy," *History Today,* vol. 52, no. 5, May 2002, p. 31ff.

80  **Red Dust** Stephen Watts, ed. "Clothes," *Behind the Screen: How Films Are Made* (New York: Dodge Publishing Company, 1938), pp. 53–57.

81  **Public Enemy** Murray Schumach, *The Face on the Cutting Room Floor: The Story of Movie and Television Censorship* (New York: William Morrow & Co., 1964), p. 168.

82  **Mata Hari** Jack Jamison, "Garbo on the Set," *Modern Screen,* March 1932, p. 114.

82  **Anna Christie** Jack Jamison, "How Clothes Made Garbo," *Hollywood,* vol. on. 8, 1930, pp. 7, 13

84  **Frankenstein** Jonah Maurice Ruddy, "The Dulwich Horror," *Screen Actor,* March/April, pp. 33–34, reprinted in *The Frankenscience Monster,* ed. Forrest J. Ackerman (New York: Ace Publishing Corporation, 1969).

85  **Bride of Frankenstein** Elsa Lanchester, *Elsa Lanchester Herself* (New York: St. Martin's Press, 1983), p. 135.

86  **Rain** Dorothy Donnell, "Sex Appeal: And the Clothes You Wear," *Motion Picture,* April 1934, p. 47.

87  **Scarface** Michael B. Druxman, *Paul Muni: His Life and His Films* (Cranbury, NJ: A. S. Barnes and Co., 1974), p. 20.

88  **Grand Hotel** Joan Crawford, *My Way of Life* (New York: Simon & Schuster, 1971), p. 159.

88  **The Bride Wore Red** Dorothy Donnell, "Sex Appeal: And the Clothes You Wear," *Motion Picture,* April 1934, p. 47.

89  **Letty Lynton** Wes Colman, "Fads," *Silver Screen,* October 1932, p. 44.

89  **Letty Lynton** Howard Gutner, *Gowns by Adrian: The MGM Years, 1928–1941* (New York: Harry N. Abrams, 2001), p. 120.

90  **Gold Diggers of 1933** Ginger Rogers, *Ginger: My Story* (New York: HarperCollins, 1991), p. 197.

90  **42nd Street** *Photoplay,* December 1929, quoted in John Kobal, *Gotta Sing, Gotta Dance: A Pictorial History of Film Musicals* (London: Hamlyn Publishing, 1970), p. 305.

90  **Footlight Parade** John Kobal, *Gotta Sing, Gotta Dance: A Pictorial History of Film Musicals* (London: Hamlyn Publishing, 1970), p. 130.

91  **Christopher Strong** Jocelyn Tey, "Walter Plunkett: Always in Fashion," *American Classic Screen,* July/August 1982, pp. 19–20.

92  **It Happened One Night** Stella Bruzzi, *Undressing Cinema: Clothing and Identity in the Movies* (New York: Routledge, 1997), p. 5, citing Farid Chenoune, *A History of Men's Fashion,* trans. Richard Martin (Paris: Flammarion, 1993), p. 182.

93  **Dodsworth** Mary Astor, *My Story: An Autobiography* (New York: Doubleday & Company, 1959), p. 170.

93  **The Good Earth** "The Final Fling," *Fan Magazine,* reprinted in *Hollywood and the Great Fan Magazines,* ed. Martin Levin (New York: Arbor House, 1971), p. 65.

94  **Cleopatra** Leon Surmelian, "Studio Designer Confesses," *Motion Picture,* December 1938, p. 67.

95  **Imitation of Life** Helen Harrison, "Hollywood's Own Revolt," *Screenland,* March 1935, p. 33.

96  **Dinner at Eight** Dorothy Donnell, "Sex Appeal: And the Clothes You Wear," *Motion Picture,* April 1934, p.74.

97  **Shirley Temple** Marion Blackford, "Miss Temple's Best Bib and Tucker," *Screen Play,* August 1936, p. 33.

98  **Belle of the Nineties** Michael Webb, ed., *Hollywood: Legend and Reality* (Boston: Little, Brown, 1986), p. 116.

100  **Fashions of 1934** Bette Davis, *The Lonely Life: An Autobiography* (New York: Berkeley Books, 1990), p. 133.

100  **Jezebel** Bette Davis with Whitney Stine, *Mother Goddam* (New York: Berkeley Books, 1975), p. 61.

101  **Of Human Bondage** Whitney Stine, *"I'd Love to Kiss You . . .": Conversations with Bette Davis* (New York: Pocket Books, 1990), p. 80.

101  **Of Human Bondage** *California Monthly,* June/July 1981, p. 15.

102  **Desire** Marian Fowler, *The Way She Looks Tonight: Five Women of Style* (Toronto: Random House of Canada, 1996), p. 257.

102  **Scarlet Empress** *Motion Picture,* December 1938, p. 67.

103  **Blonde Venus** Josef Von Sternberg, *Fun in a Chinese Laundry* (San Francisco: Mercury House, Inc., 1988), p. 147.

104  **Top Hat** Ginger Rogers, *Ginger: My Story* (New York: HarperCollins, 1991), pp. 140–44.

104  **Top Hat** "Edith Head Dresses Down the Fashion Flitters," *Los Angeles Times,* April 1, 1973.

104  **Top Hat** Ginger Rogers, *Ginger: My Story* (New York: HarperCollins, 1991), pp. 140–44.

106  **Alice Adams** Katharine Hepburn, *Me: Stories of My Life* (New York: Alfred A. Knopf, 1991), p. 230.

107  **Little Women** Gavin Lambert, *On Cukor* (New York: G. P. Putnam's, 1972), p. 99.

107  **Sylvia Scarlett** Guy Babineau, "Scene Stealers: An Exhibit at the Leo Awards Shows How Film and Videos Affect Our Style Sense," *Vancouver Sun,* May 31, 2005, p. C1.

109  **The Great Ziegfeld** Dorothy Donnell, "Sex Appeal: And the Clothes You Wear," *Motion Picture,* April 1934, p. 47.

110  **Tarzan and His Mate** Thomas Doherty, *Pre-Code Hollywood* (New York: Columbia University Press, 1999), pp. 261–62.

111  **Jungle Princess** Dorothy Lamour and Dick McInnes, *My Side of the Road* (Englewood Cliffs, NJ: Prentice-Hall, Inc. 1974), p. 48.

111  **Jungle Princess** Mike Steen, "Costume Design: Edith Head," *Hollywood Speaks! An Oral History* (New York: G. P. Putnam's Sons, 1974), p. 250.

112  **Dracula** Gary J. Svehla and Susan Svehla, eds., *Bela Lugosi* (Baltimore, MD: Midnight Marquee Actors Series, 1995), p. 26.

112  **Dracula** Gregory William Mank, *Karloff and Lugosi: The Story of a Haunting Collaboration* (Jefferson, NC: McFarland & Company, Inc., 1990), p. 14.

113  **Flash Gordon** Michael Benson, *Vintage Science Fiction Films, 1896–1949* (Jefferson, NC: McFarland & Co., 1985), p. 93.

113  **Flash Gordon** Michael Benson, *Vintage Science Fiction Films, 1896–1949* (Jefferson, NC: McFarland & Co., 1985), p. 96.

114  **The Adventures of Robin Hood** Milo Anderson, "Accessories Emphasized," *Los Angeles Times,* February 21, 1938.

116  **Marie Antoinette** Whitney Williams, "Hollywood Newsreel," *Hollywood,* vol. 27, no.3, p. 6.

116  **Marie Antoinette** Helen Louise Walker, "Dress Up and Live," *Silver Screen,* May 1938, p. 75.

118  **The Plainsman** Kathleen Howard, "Fashion Letter for December," *Photoplay,* December 1936, p. 79.

119  **Stagecoach** Tony Macklin and Nick Pici, eds., *Voices from the Set: The Film Heritage Interviews* (Lanham, MD: Scarecrow Press, 2000), pp. 134–35.

120  **The Wizard of Oz** John Fricke, Jay Carfone, and William Stillman, *The Wizard of Oz* (Warner Books: New York, 1989), p. 50.

120  **The Wizard of Oz** Jay Carfone and William Stillman, *The Wizardry of Oz* (Gramercy Books: New York, 1999), p. 65.

121  **The Wizard of Oz** John Fricke, Jay Carfone, and William Stillman, *The Wizard of Oz* (Warner Books: New York, 1989), p. 45-47.

121  **The Wizard of Oz** L. Frank Baum, *The Wonderful Wizard of Oz* (The Pennyroyal Press: London England, 1986), p. 27-28.

122  **Gone with the Wind** "Walter Plunkett, Dressing Right for 'Gone with the Wind," *American Classic Screen.* September/October 1982, p. 20.

123  **Gone with the Wind** Cynthia Fuchs, "Beyond Tara: The Extraordinary Life of Hattie McDaniel," http://www.popmatters.com/tv/reviews/b/beyond-tara.html.

124  **Gone with the Wind** Jocelyn Tey, "Walter Plunkett. Dressing Right for 'Gone with the Wind,'" *American Classic Screen,* September/October 1982, pp. 19–20.

126  **Gone with the Wind** Dale McConathy and Diana Vreeland, *Hollywood Costume: Glamour, Glitter, Romance* (New York: Harry N. Abrams, 1976), pp. 164–66.

128  **The Private Lives of Elizabeth and Essex** Bette Davis, interviewed by Bruce Williamson, July 1982, in *The Playboy Interviews: Larger Than Life,* eds. Stephen Randall and *Playboy* magazine (Milwaukee, OR: M Press, 2006), p.115.

131  **The Women** Rosalind Russell and Chris Chase. *Life Is a Banquet* (New York: Random House, 1977), p. 82.

132  **Juarez** Bette Davis with Whitney Stine. *Mother Goddam* (New York: Berkeley Books, 1980), p. 119.

## CHAPTER FOUR: 1940s

135  **The Cat People** Vincente Minnelli, with Hector Arce, *I Remember It Well* (Doubleday: Garden City, NY, 1974), p. 276.

141  **Forever Amber** Charles LeMaire, "Couture Important to Films," *New York Times,* November 2, 1947.

142-143  **The Grapes of Wrath** Richard Chace, "'The Grapes of Wrath' Emerges as a Startling Challenge to Hollywood's Courage," *Modern Screen,* vol. 20, no. 4, March 1940, p.71.

144  **Carmen Miranda** Virginia Macpherson, "No More Turbans: Miss Miranda Through with 'Fruit Salads,'" *Citizen News,* June 3, 1948.

146  **His Girl Friday** Rosalind Russell and Chris Chase, *Life is a Banquet* (New York: Random House, 1977) p. 86.

146  **Kitty Foyle** Ginger Rogers, *Ginger: My Story* (New York: HarperCollins, 1991), p. 225.

147  **Ball of Fire** David Chierichetti, *Edith Head: The Life and Times of Hollywood's Celebrated Costume Designer* (New York: HarperCollins, 2003), p. 42.

147  **Ball of Fire** Dee Lawrence, "That Stanwyck Girl," *Washington Post,* November 23, 1941.

148  **The Little Foxes** Bette Davis with Whitney Stine, *Mother Goddam* (New York: Berkeley Books, 1980), p. 157.

151  **Philadelphia Story** Calvin Klein, interview by Howard Gutner, program for the 1985 Council of Fashion Designers of America Awards/CFDA Lifetime Achievement Award to Katharine Hepburn, 1977.

151 **Philadelphia Story** Gavin Lambert, *On Cukor* (New York: G. P. Putnam's Sons, 1972), p. 124.
152 **Casablanca** Aljean Harmetz, *Round Up the Usual Suspects: The Making of Casablanca—Bogart, Bergman, and World War II* (New York: Hyperion, 1992), pp. 167–69.
153 **Casablanca** Ingrid Bergman and Alan Burgess, *My Story* (New York: Delacorte Press, 1972), pp. 114–15.
154 **Cabin in the Sky** Vincente Minnelli with Hector Arce, *I Remember It Well* (Garden City, NY: Doubleday, 1974), p. 121.
157 **Stormy Weather** Helen Rose, *The Glamorous World of Helen Rose* (Riverside, CA: Rubidoux Printing Co, 1983), pp. 9–10.
158 **Laura** "Fifteen Thousand Dollars Worth of Clothes for Gene Tierney," *Look,* October 17, 1944.
159 **Meet Me in St. Louis** Irene Sharaff, "Hollywood Dress Parade," *Good Housekeeping,* September 1976, pp. 78, 80–82, 84.
159 **Meet Me in St. Louis** Irene Sharaff, as told to Bee Bangs, "Your Clothes," *Silver Screen,* March 1947, vol. 17, no. 5. p. 93.
160 **It's a Wonderful Life** Joseph McBride, *Frank Capra: The Catastrophe of Success* (New York: Simon & Schuster, 1992), p. 525.
160 **It's a Wonderful Life** Victor Scherle and William Turner Levy, *The Films of Frank Capra* (Secaucus, NJ: Citadel Press, 1977), p. 226.
161 **The Best Years of Our Lives** James Kostilibas-Davis and Myrna Loy, *Myrna Loy: Being and Becoming* (New York: Alfred A. Knopf, 1987), p. 196.
161 **The Best Years of Our Lives** Irene Sharaff and Bee Bangs, "Your Clothes Tell Exactly What You Are," *Silver Screen,* vol. 17, no. 5, March 1947, p. 49.
162 **The Lady from Shanghai** John Kobal, *People Will Talk* (New York: Alfred A. Knopf, 1985), p. 444.
163 **Gilda** Oscar Rimoldi, "The Great Hollywood Designers," *Hollywood Studio Magazine,* vol. 19, no. 12, December 1986, p. 19.
165 **The Big Sleep** Nelson B. Bell, "Expository Mr. Bogart Keeps 'Big Sleep' from Being Total Mystery," *Washington Post,* August 30, 1946.
165 **Key Largo** Andrew Sarris, ed., *Interviews with Film Directors* (New York: Avon, 1973), p. 273.
166 **The Postman Always Rings Twice** Lana Turner, *Lana: The Lady, The Legend, The Truth* (New York: E. P. Dutton Inc., 1982), p. 101.
167 **Mildred Pierce** Joan Crawford with Jane Kesner Ardmore, *A Portrait of Joan* (New York: Doubleday & Company, 1962), p. 139.
168 **The Outlaw** Jane Russell, *Jane Russell: My Path and My Detours* (New York: Franklin Watts, Inc., 1985), p. 58.
170 **Red River** Joseph McBride with Howard Hawks, *Hawks on Hawks* (Berkeley: University of California Press, 1982), pp. 84–85.
171 **Rebecca** Memo from David O. Selznick to Raymond Klune, October 6, 1939, reprinted in *Memo from David O. Selznick,* Rudy Behlmer, ed., (New York: The Viking Press, 1972), p. 281.
172 **The Heiress** Edith Head, "Dialogue on Film: Edith Head," *American Film,* May 1978, p. 38.
173 **The Heiress** Edith Head and Jane Kesner Ardmore, *The Dress Doctor* (Boston: Little, Brown, 1959), p. 89.
175 **Joan of Arc** Ingrid Bergman and Alan Burgess, *My Story* (New York: Delacorte Press, 1972), pp. 183–84.

## CHAPTER FIVE: 1950s

177 **The Wild One** Marlon Brando with Robert Lindsey, *Brando: Songs My Mother Taught Me* (New York: Random House, 1994), pp. 175–76.
183 **Born Yesterday** Will Holtzman, *Judy Holliday* (New York: G.P. Putnam's Sons, 1982), p. 138.
183 **Born Yesterday** John Kobal, *People Will Talk* (New York: Alfred A. Knopf, 1985), p. 446.
184 **Samson and Delilah** Edith Head, "Dialogue on Film: Edith Head," *American Film,* May 1978, pp. 43–44.
186 **Carmen Jones** Dorothy Dandridge and Earl Conrad. *Everything and Nothing: The Dorothy Dandridge Tragedy* (New York: Perennial, 2000), pp. 166–67.
187 **All About Eve** Edith Head and Paddy Calistro, *Edith Head's Hollywood* (New York: E. P. Dutton, Inc., 1983), p. 93.
187 **All About Eve** Edith Head, "Dialogue on Film: Edith Head," *American Film,* May 1978, p. 42.
188 **Sunset Boulevard** Edith Head and Jane Kesner Ardmore, *The Dress Doctor* (Boston: Little, Brown, 1959), p. 98.
189 **Sunset Boulevard** Gloria Swanson, *Swanson on Swanson* (New York: Pocket Books, 1981), p. 499.
190 **Winchester '73** Jonathon Coe, *Jimmy Stewart: A Wonderful Life* (New York: Arcade Publishing, 1994), p. 110.
191 **Annie Get Your Gun** Mae Tinee, "Comedy Hits Among June's 4 Best Films," *Chicago Daily Tribune,* July 9, 1950.
193 **Ivanhoe** Dick Sheppard, *Elizabeth: The Life and Career of Elizabeth Taylor* (Garden City, NY: Doubleday & Company, Inc., 1974), p. 109.
194 **Father of the Bride** Helen Rose, *The Glamorous World of Helen Rose* (Riverside, CA: Rubidoux Printing Co., 1982), pp. 56–57.
195 **A Place in the Sun** Edith Head, "Dialogue on Film: Edith Head," *American Film,* May 1978, p. 43.
196 **On the Waterfront** Francis Ford Coppola, interview by Deborah Landis for "Scene and Not Heard: The Role of Costume in the Cinematic Storytelling Process," doctoral dissertation, The Royal College of Art, 2003.
196 **On the Waterfront** Jeff Young, *Kazan: The Master Director Discusses His Films* (New York: Newmarket Press, 1999), p. 170.
197 **A Streetcar Named Desire** Peter Manso, *Brando: The Biography* (New York: Hyperion, 1994), p. 228-29.
198 **An American in Paris** John Crosby, "The TV Man: Finds Movies Also Bigger Than Ever," *Washington Post,* October 12, 1951.
200 **Gentlemen Prefer Blondes** Maureen Reilly, *Hollywood Costume Design by Travilla* (Atglen, PA: Schiffer Publishing Co., 2003), p. 90.
202 **African Queen** Katharine Hepburn, *The Making of "The African Queen" or How I Went to Africa with Bogart, Bacall and Huston and Almost Lost My Mind* (New York: Alfred A. Knopf, 1987), pp. 15–16.
203 **Shane** Joe Hyams, "Making Shane," in *George Stevens: Interviews* (Jackson: University Press of Mississippi), p. 11.
204 **Singin' in the Rain:** Debbie Reynolds with David Patrick Columbia, *Debbie: My Life* (William Morrow and Company, Inc.: New York, 1988), p. 92.
205 **John Kobal,** *Gotta Sing Gotta Dance: A Pictorial History of Film Musicals* (Hamlyn Publishing: London, 1970), p. 181.
206 **The King and I** Irene Sharaff, *Broadway & Hollywood: Costumes Designed by Irene Sharaff* (Van Nostrand Reinhold Company: New York, 1976), p. 82.
208 **The King and I** David Chierichetti, *Hollywood Costume Design* (New York: Harmony Books, 1976), p. 129.
210 **Rebel Without a Cause** Howlett, John, *James Dean: A Biography* (London: Plexus Publishing, 1975), p. 234.
210 **Jailhouse Rock** Julie Mundy, *Elvis Fashion: From Memphis to Vegas* (New York: Universe Publishing/Rizzoli, 2003), p. 52.
211 **Marty** Gorham Kindem, *The Live Television Generation of Hollywood Film Directors: Interviews with Seven Directors* (Jefferson, NC: McFarland & Company, Inc., 1994), p. 130.
212 **Road to Bali** Edith Head and Paddy Calistro, "Edith Head's Hollywood," (New York: E. P. Dutton, Inc., 1983). p. 48.
212 **Road to Bali** Dorothy Lamour and Dick McInnes, *My Side of the Road* (Englewood Cliffs, NJ: Prentice-Hall, Inc. 1974), p. 116.
213 **Million Dollar Mermaid** Esther Williams with Digby Diehl, *The Million Dollar Mermaid: An Autobiography* (New York: Simon & Schuster, 1999), p. 221.
214 **The Big Heat** Vincent Curcio, *Suicide Blonde: The Life of Gloria Grahame* (New York: William Morrow, 1989), p. 154.
215 **Sweet Smell of Success** Kate Buford, *Burt Lancaster: An American Life* (New York: Alfred A. Knopf, 2000), p. 183, 181.
216 **Pillow Talk** A. E. Hotchner, *Doris Day: Her Own Story* (New York: Bantam Books, 1975), p. 233.
217 **Roman Holiday** Edith Head and Jane Kesner Ardmore, *The Dress Doctor* (Boston: Little, Brown, 1959), pp. 118–19.
217 **Roman Holiday** Charles Higham, *Audrey: The Life of Audrey Hepburn* (New York: Macmillan Publishing Company, 1984), pp. 52–53.
218 **Sabrina** Catherine Join-Diéterle and Frances Faure, eds. *Givenchy: 40 Years of Character* (Paris: Paris-Musées, 1991), p. 85.
218 **Sabrina** Cameron Crowe, *Conversations with Wilder* (New York: Alfred A. Knopf, 1999), pp. 218–19.
220 **The Day the Earth Stood Still** "Fasten Your Seat Belts," *New York Times,* October 10, 1951.
223 **A Star Is Born** Ronald Haver, *A Star Is Born: The Making of the 1954 Movie and Its 1983 Restoration* (New York: Alfred A. Knopf, 1988), p. 177.
224 **Rear Window** Edith Head and Paddy Calistro, *Edith Head's Hollywood* (New York: E. P. Dutton, Inc., 1983), p. 109.
225 **The Country Girl** Marjorie P. Katz Weiser, *Grace Kelly* (New York: Coward-McCann, 1970), pp. 65–66.
225 **The Country Girl** Edith Head and Jane Kesner Ardmore, "I Dressed the World's Most Glamorous Women," *Good Housekeeping,* vol. 148, March 1959, p. 66.
226 **To Catch a Thief** Donald Chase, "The Costume Designer," in *Filmmaking: The Collaborative Art* (Boston: Little, Brown, 1975), p. 197.
227 **To Catch a Thief** Gwen Robyns, *Princess Grace* (London: W. H. Allen, 1976), pp. 88–89.
228 **The Seven Year Itch** Maureen Reilly, *Hollywood Costume Design by Travilla* (Atglen, PA: Schiffer Publishing Co., 2003), p. 109.
229 **The Seven Year Itch** Cameron Crowe, *Conversations with Wilder* (New York: Alfred A. Knopf, 1999), p. 85.
230 **The Ten Commandments** Joseph Laitin, "Up in Edie's Room," *Collier's,* vol. 136, no. 5, April 1955, p. 30.
231 **The Ten Commandments** Charlton Heston, *In the Arena: An Autobiography* (New York: Simon & Schuster, 1995), p. 128.
232 **Cat on a Hot Tin Roof** Helen Rose, *The Glamorous World of Helen Rose* (Riverside, CA: Rubidoux Printing Co., 1982), pp. 56–57.
233 **Cat on a Hot Tin Roof** Merle Ginsberg, "Dame Elizabeth Taylor and Michael Kors talk fashion," *Harper's Bazaar,* August 2006, p. 120.

234  **Vertigo** Peter Harry Brown, *Kim Novak: Reluctant Goddess* (New York: St. Martin's Press, 1986), pp. 143–44.

235  **Vertigo** Stephen Rebello, March 2003, http://www.labyrinth.net.au/~muffin/kim_novak_c.html.

236  **Gigi** Cecil Beaton, *Cecil Beaton's Fair Lady* (New York: Holt, Rinehart and Winston, 1964), p. 8.

236  **Gigi** Vincente Minnelli with Hector Arce, *I Remember It Well* (Garden City, NY: Doubleday, 1974), p. 310.

238  **Ben Hur** Theodore Taylor, "Art Direction, Set Direction, and Costumes," in *People Who Make Movies* (Garden City, NY: Doubleday, 1967), pp. 64–65.

240  **Some Like It Hot** Cameron Crowe, *Conversations with Wilder* (New York: Alfred A. Knopf, 1999), p. 221.

241  **Some Like It Hot** Don Widener, *Lemmon: A Biography* (New York: Macmillan Publishing Co., Inc, 1975), p. 169.

241  **Some Like It Hot** Don Widener, *Lemmon: A Biography* (New York: Macmillan Publishing Co., Inc, 1975), pp. 166–67.

### CHAPTER SIX: 1960s

243  **Gypsy** Jeff Freedman, "She Never Did, But Now," *Interview*, October 1978.

247  **One Million Years B.C.** Raquel Welch, letter to the author, July 19, 2007.

249  **Butterfield Eight** Elizabeth Taylor, *Elizabeth Taylor: An Informal Memoir* (New York: Avon, 1965), p. 202.

250  **Psycho** "Mommie Dearest: Inside the Head of PSYCHO," *Empire* (UK), no. 110, August 1998, p. 88.

251  **Psycho** Janet Leigh, with Christopher Nickens, *Psycho: Behind the Scenes of the Classic Thriller* (New York: Harmony Books, 1995). p. 43.

252  **Spartacus** Vincent LoBrutto, *Stanley Kubrick: A Biography* (New York: Donald I. Fine/Penguin USA, 1997), p. 170.

255  **The Misfits** John Huston, *An Open Book* (New York: Alfred A. Knopf, 1980), pp. 287–88.

256  **Breakfast at Tiffany's** Françoise Mohrt, *The Givenchy Style* (Paris: Assouline, 1998), p. 10.

258  **West Side Story** Irene Sharaff, *Broadway & Hollywood: Costumes Designed by Irene Sharaff* (New York: Van Nostrand Reinhold, 1976), p. 100.

261  **The Chapman Report** Jack Stewart, *Henry, Jane and Peter: The Fabulous Fondas* (New York: Belmont Tower Books, 1976), p. 128.

262  **What Ever Happened to Baby Jane?** Bette Davis with Michael Herskowitz, *This 'N' That* (New York: G. P. Putnam's Sons, 1987), pp. 138–39.

262  **To Kill a Mockingbird** Roy Newquist, *Counterpoint* (Chicago: Rand McNally, 1964). (as reprinted at http://www.chebucto.ns.ca/culture/HarperLee/roy.html).

263  **The Apartment** Richard W, Nason, "Offbeat Success Saga," *New York Times*, May 24, 1959.

264  **Hud** Donald Chase, *Filmmaking: The Collaborative Art* (Boston: Little, Brown, 1975), p. 79.

266  **Dr. No** Alan Barnes and Marcus Hearn, *Kiss Kiss Bang! Bang!* (London: BT Batsford, 1997), p. 14.

267  **Goldfinger** Cubby Broccoli with Donald Zec, *When the Snow Melts: The Autobiography of Cubby Broccoli* (London: Boxtree, 1998), pp. 169–70.

267  **Goldfinger** Richard Schenkman, "The Terrence Young Interview, Part 1," *Bondage Magazine*, 1981.

269  **Cleopatra** Irene Sharaff, *Broadway & Hollywood: Costumes Designed by Irene Sharaff* (New York: Van Nostrand Reinhold, 1976), p. 65.

270  **Cleopatra** Irene Sharaff, *Broadway & Hollywood: Costumes Designed by Irene Sharaff* (New York: Van Nostrand Reinhold, 1976), p. 106.

271  **Who's Afraid of Virginia Woolf?** Charles Champlin, "Untamed Burtons Try to Tame a 'Shrew,'" *Los Angeles Times*, April 27, 1966.

272  **The Miracle Worker** *Show*, vol. 1, no. 1, October 1961, p. 95.

273  **My Fair Lady** Cecil Beaton, "My Fair Lady: Everyone's Favorite Musical Becomes a Movie," *Ladies Home Journal,* January/February 1964, p. 64.

274  **My Fair Lady** Cecil Beaton, *Cecil Beaton's Fair Lady* (New York: Holt, Rinehart & Winston, 1964), p. 105.

276  **Mary Poppins** Hedda Hopper, "The Other Side of Julie Andrews," *Los Angeles Times*, November 1, 1964.

276  **Mary Poppins** Tony Walton, letter to the author, April 16, 2007.

277  **The Sound of Music** Robert Wise, "Why 'Sound of Music' Sounds Differently," *Los Angeles Times* (1886-Current File); Jan 24, 1965; ProQuest Historical Newspapers *Los Angeles Times* (1881-1985), p. B7.

279  **The Sound of Music** Julia Antopol Hirsch, *The Sound of Music: The Making of America's Favorite Movie* (Chicago: Contemporary Books, Inc., 1993), p. 91.

280  **Bye Bye Birdie** Ann-Margret with Todd Gold, *My Story* (New York: G. P. Putnam's Sons, 1994), p. 98.

281  **Barbarella** Jack Stewart, *Henry, Jane and Peter: The Fabulous Fondas* (New York: Belmont Tower Books, 1976), p. 166.

283  **Camelot** Vanessa Redgrave, *Vanessa Redgrave: An Autobiography* (New York: Random House, 1994), p. 153.

285  **Camelot** Evelyn Livingstone, "Dreamlike Gowns Real in 'Camelot,'" *Chicago Tribune*, October 11, 1967.

287  **Bonnie & Clyde** Faye Dunaway with Betsy Sharkey, *Looking for Gatsby: My Life* (New York: Simon & Schuster, 1995), pp. 127–28.

288  **Bonnie & Clyde** Faye Dunaway with Betsy Sharkey, *Looking for Gatsby: My Life* (New York: Simon & Schuster, 1995), pp. 127–28.

288  **Bonnie & Clyde** Theadora Van Runkle, interview by Deborah Landis, May 7, 2002.

289  **Rosemary's Baby** Roman Polanski, *Roman by Polanski* (New York: William Morrow, 1984), p. 267.

289  **Rosemary's Baby** Seminar, *Producing the Film* (American Film Institute, February 17, 1976).

290  **They Shoot Horses, Don't They?** "Costume Designer: Donfeld," *M Look*, November 3, 1970.

291  **They Shoot Horses, Don't They?** Joyce Haber, "Costume Designer Gives the Stars a Dressing Down," *Los Angeles Times,* April 19, 1970.

292  **Planet of the Apes** Charlton Heston, *In the Arena: An Autobiography* (New York: Simon & Schuster, 1995), pp. 395, 397.

294  **Funny Girl** Richard Schickel, "The Way She Isn't" *Time*, November 25, 1996.

295  **Funny Girl** Donald Zec and Anthony Fowles, *Barbra: A Biography of Barbra Streisand* (New York: St. Martin's Press, 1981), p. 19.

296  **The Thomas Crown Affair** Faye Dunaway with Betsy Sharkey, *Looking for Gatsby: My Life* (New York: Simon & Schuster, 1995), p. 166.

296  **The Thomas Crown Affair** Faye Dunaway with Betsy Sharkey, *Looking for Gatsby: My Life* (New York: Simon & Schuster, 1995), p. 165.

297  **The Thomas Crown Affair** Faye Dunaway with Betsy Sharkey, *Looking for Gatsby: My Life* (New York: Simon & Schuster, 1995), p. 171.

299  **2001: A Space Odyssey** Stephen Randall, ed., *The Playboy Interviews: The Directors* (Milwaukie, OR: M Press, 2006), p. 220.

299  **2001: A Space Odyssey** Vincent LoBrutto, *Stanley Kubrick: A Biography* (New York: Donald I. Fine, 1997), p. 283.

300  **Butch Cassidy and the Sundance Kid** Edith Head and Paddy Calistro, *Edith Head's Hollywood* (New York: E. P. Dutton, 1983). p. 148.

301  **Hello, Dolly!** Karen Swenson, "One More Look at . . . the Making of *Funny Girl.*" *Barbra Magazine*, vol. 2, no. 3 (also known as issue #7), 1982, p. 36.

301  **Hello, Dolly!** Hedda Hopper, "Three Designing Women and a Man Reveal Screen Secrets," *Los Angeles Times,* September 12, 1954, p. D1.

302  **Barefoot in the Park** James Spada, *The Films of Robert Redford* (Secaucus, NJ.: Citadel Press, 1984), p. 106.

302  **The Graduate** Gavin Smith, "Metaphors and Purpose: Mike Nichols Interviewed," *Film Comment*, May/June, 1999.

303  **Easy Rider** Henry Fonda, as told to Howard Teichmann, *Fonda: My Life* (New York: New American Library, 1981), p. 331.

304  **The Wild Bunch** David Weedle, *If They Move . . . Kill 'Em!: The Life and Times of Sam Peckinpah* (New York: Grove Press, 1994). p. 344.

304  **Midnight Cowboy** William J. Mann, *Edge of Midnight: The Life of John Schlesinger* (New York: Billboard Books, 2005), p. 315.

305  **Midnight Cowboy** Rex Reed, "A 'Cowboy' Walks on the Wild Side," *New York Times*, May 25, 1969.

305  **Midnight Cowboy** Advertisement for Hamilton Watches, *Premiere*, vol. 17, no. 2, October 2003.

### CHAPTER SEVEN: 1970s

313  **Klute** Jane Fonda, *My Life So Far* (New York: Random House, 2005), pp. 248–51.

314  **Little Big Man** Lawrence Van Gelder, "Dorothy Jeakins Dies at 81; Designed Costumes for Films," *New York Times,* November 30, 1995.

317  **McCabe and Mrs. Miller** David Sterritt, ed., *Robert Altman: Interviews* (Jackson: University Press of Mississippi, 2000), pp. 196–97.

318  **Carnal Knowledge** *Hollywood: Legend and Reality*; Michael Webb, ed. (Little, Brown and Company, Boston) p. 117, (quoted in: *Filmmakers on Filmmaking*, Volume 1, pp. 153-155).

319  **Carnal Knowledge** Dan Knapp, "Jack Nicholson, the Bender of Film Boundaries," *Los Angeles Times,* August 8, 1971.

320  **Cabaret** Alan W. Petrucelli, *Liza! Liza!: An Unauthorized Biography of Liza Minnelli* (New York: Karz-Cohl, 1983), pp. 87–88.

322  **Shaft** Judy Klemesrud, "Shaft—A Black Man Who Is for Once a Winner," *New York Times*, March 12, 1972.

323  **Cleopatra Jones** Judy Klemersrud, "Not Super Fly but Super Woman: Tamara Dobson, Star of 'Cleopatra.'" *New York Times,* August 19, 1973.

324  **The Godfather** Lawrence Grobel, "The *Playboy* Interview with Al Pacino," *Playboy,* December 1979, p. 116.

324  **The Godfather** Francis Ford Coppola, interview by Deborah Landis, for "Scene and Not Heard: The Role of Costume in the Cinematic Storytelling Process," doctoral dissertation, The Royal College of Art, 2003.

326  **The Last Picture Show** Cybill Shephard and Aimee Lee Ball, *Cybill Disobedience* (New York: Avon, 2000), p. 103.

326  **American Graffiti** *American Graffiti,* commentary, DVD Bonus Features, Universal Pictures, 1998.

326  **American Graffiti** Aggie Guerard Rodgers, letter to the author, May 20, 2006.

327  **Serpico** Andrew Yule, *Life on the Wire: The Life and Art of Al Pacino* (New York: Donald I. Fine, 1991), p. 80.

328  **The Three Musketeers** Mark Shivas, "Lester's Back and the 'Musketeers' Have Got Him," *New York Times,* August 5, 1973.

330  **Paper Moon** Tatum O'Neal, *A Paper Life* (New York: HarperEntertainment, 2004), pp. 43–44.

331  **The French Connection** Alysse Minkoff, "Gene Hackman on Top of His Game," *Cigar Aficionado,* September/October 2000.

331  **Love Story** Sandy Schrier, *Hollywood Dressed & Undressed: A Century of Cinema Style* (New York: Rizzoli, 1998), p. 20.

331  **Harold and Maude** Ruth Gordon, *Ruth Gordon: An Open Book* (Garden City, NY: Doubleday & Company, Inc., 1980), pp. 300–301.

332  **The Sting** Edith Head and Paddy Calistro, *Edith Head's Hollywood* (New York: E. P. Dutton, Inc., 1983), p. 156.

334  **Chinatown** "Seminar with Richard and Anthea Sylbert" (American Film Institute, December 10, 1974, Center for Advanced Film Studies, Beverly Hills, CA, December 10, 1974), pp. 21, 62.

338  **Godfather II** Theadora Van Runkle, interview by Deborah Landis, *Screencraft: Costume Design*, 2002.

341  **The Great Gatsby** Ricky Rosenthal, "Costuming 'Great Gatsby,'" *Christian Science Monitor,* May 21, 1973.

341  **The Great Gatsby** Ricky Rosenthal, "Costuming 'Great Gatsby,'" *Christian Science Monitor,* May 21, 1973.

342  **One Flew Over the Cuckoo's Nest** Tom Burke, "Forman: 'Casting Is Everything,'" *New York Times,* March 28, 1976.

342  **One Flew Over the Cuckoo's Nest** Aljean Harmetz, "The Nurse Who Rules the 'Cuckoo's Nest,'" *New York Times,* November 30, 1975.

343  **Rocky** Judy Klemesrud, "'Rocky Isn't Based on Me,' Says Stallone, 'But We Both Went the Distance,'" *New York Times,* November 28, 1976.

344  **Lenny** Judy Klemesrud, "Valerie Perrine, or, The Return of the Hollywood Sex Kitten," *New York Times,* December 1, 1974.

345  **Rocky Horror Picture Show** Tim Curry, interview by Deborah Landis, April 2007.

346  **Shampoo** Beth Ann Krier, "Costume Designer for the Famous," *Los Angeles Times,* August 4, 1974, p. m1.

346  **Shampoo** Jan Lindstrom, "Material Girl: Sylbert's Keen Sense of Story Pays Off," *Daily Variety,* February 9, 2005.

347  **Shampoo** Michael Webb, *Hollywood: Legend and Reality* (Boston: Little, Brown, 1986), pp. 117–22, quoted from *Filmmakers on Filmmaking,* vol. 1, pp. 153–55.

348  **Taxi Driver** Susan Dworkin, *Making Tootsie: A Film Study with Dustin Hoffman and Sydney Pollack* (New York: Newmarket Press, 1983), p. 29.

348  **Taxi Driver** Louis Chunovic, *Jodie: A Biography* (Chicago: Contemporary Books, Inc., 1995), p. 30.

350  **Star Wars** Trisha Biggar, *Dressing a Galaxy: The Costumes of Star Wars* (New York: Harry N. Abrams, 2005), p. 154.

351  **Star Wars** Trisha Biggar, *Dressing a Galaxy: The Costumes of Star Wars* (New York: Harry N. Abrams, 2005), p. 136.

351  **Star Wars** *Dressing a Galaxy: The Costumes of Star Wars,* DVD Special Features, Lucasfilm, 2005.

351  **Star Wars** Amy M. Spindler, "The Princess Line," *New York Times Magazine,* January 31, 1999.

352  **Saturday Night Fever** Nigel Andrews, *Travolta: The Life* (New York: Bloomsbury, 1998), p. 62.

353  **Grease** Bob McCabe, *John Travolta: Quote Unquote* (Bristol, UK: Parragon Book Service Ltd., 1996), p. 37.

353  **Grease** Didi Conn, *Frenchy's Grease Scrapbook* (New York: Hyperion, 1998), pp. 98, 100.

353  **Grease** Nigel Andrews, *Travolta: The Life* (New York: Bloomsbury, 1998), p. 83.

354  **Network** Faye Dunaway and Betsy Sharkey, *Looking for Gatsby: My Life* (New York: Simon & Schuster, 1995), p. 300.

355  **Norma Rae** Jason Bonderoff, *Sally Field* (New York: St. Martin's Press, 1987), p. 81.

357  **Animal House** Deborah Landis, "Scene and Not Heard: The Role of Costume in the Cinematic Storytelling Process," doctoral dissertation, The Royal College of Art, 2003.

358  **All That Jazz** Deborah Landis, *Screencraft: Costume Design* (Boston: Focal Press, 2003).

359  **All That Jazz** Deborah Landis, *Screencraft: Costume Design* (Boston: Focal Press, 2003).

360  **The Deer Hunter** Michael O'Connor, *Battling the Past: An Encounter with Michael Cimino,* www.threemonkeysonline.com, August 2005.

360  **The Deer Hunter** Scot Haller, "Star Treks," *Horizon,* August 1978, p. 47, quoted from Eugene E. Pfaff, Jr. and Mark Emerson, *Meryl Streep: A Critical Biography* (London: McFarland & Company, Inc., 1987), p. 28.

361  **Alien** William K. Knoedelseder Jr., "'Alien's Sigourney Weaver: The Hero Is a Woman," *Los Angeles Times,* June 4, 1979.

362  **The Muppet Movie** Jennings Parrott, "Newsmakers: Pink Curtains? House Is Not a Home," *Los Angeles Times,* January 20, 1978.

365  **Being There** David Ansen, "The Great Impersonator," *Newsweek,* August 4, 1980, p. 43.

**CHAPTER EIGHT: 1980s**

367  **Flashdance** Michael Kaplan, letter to the author, July 2006

373  **Raging Bull** Kevin J. Hayes, ed., *Martin Scorsese's "Raging Bull"* (Cambridge: Cambridge University Press, 2005), p. 35.

374  **Ragtime** "Remembering Ragtime," special feature, *Ragtime* DVD (Widescreen Collection, Paramount Pictures, 2004).

375  **Coal Miner's Daughter** Mary Ann O'Rourke, "Sissy Spacek: From Carrie to Coal Miner's Daughter," *McCall's,* May 1980, vol. 107, no. 8.

375  **Tender Mercies** Leslie Bennets, "For Duvall, 52 Is Only Halfway in His Career," *New York Times,* April 25, 1983.

378  **Raiders of the Lost Ark** Melissa Morrison, "Tough Acts to Follow," *Moving Pictures Magazine,* August/September 2005, p. 25,; Deborah Landis, "Scene and Not Heard: The Role of Costume in the Cinematic Storytelling Process," doctoral dissertation, The Royal College of Art, 2003.

380  **Tootsie** Susan Dworkin, *Making Tootsie: A Film Study with Dustin Hoffman and Sydney Pollack* (Newmarket Press: New York, 1983), p. 30.

380  **Tootsie** J. T. Jeffries, *Jessica Lange: A Biography* (New York: St. Martin's Press, 1986), p. 41.

381  **Terms of Endearment** Kristi Zea, interview by Deborah Landis, May 1, 2007.

382  **Blade Runner** Paul M. Sammon, *Future Noir: The Making of Blade Runner* (New York: HarperPrism, 1996), p. 383.

383  **Blade Runner** Paul M. Sammon, *Future Noir: The Making of Blade Runner* (New York: HarperPrism, 1996), pp. 73–74.

383  **Blade Runner** Paul M. Sammon, *Future Noir: The Making of Blade Runner* (New York: HarperPrism, 1996), p. 86.

384  **Scarface** Brian De Palma, http://www.pfeiffertheface.com/Bio_018.htm. (Website designed and maintained by Fran J González, interview quote by Brian De Palma was posted on this website with no citation.)

385  **Scarface** Dale Pollack, "De Palma Takes a Shot at Defending 'Scarface,'" *Los Angeles Times,* December 5, 1983.

387  **Places in the Heart** David Chierichetti, "Cinematic Realism Replaces Fading Images of Glamour," *Los Angeles Times,* December 14, 1984.

388  **The Big Chill** April Ferry, letter to the author, April 18, 2007.

389  **The Blues Brothers** Deborah Landis, "Scene and Not Heard: The Role of Costume in the Cinematic Storytelling Process," doctoral dissertation, The Royal College of Art, 2003.

389  **Silkwood** "In Search of 'Silkwood,'" *American Film,* December 1983, p. 52, quoted in Eugene E. Pfaff Jr. and Mark Emerson, *Meryl Streep: A Critical Biography.* (Jefferson, NC: McFarland & Company, 1987), p. 89.

389  **Silkwood** Gavin Smith, *Film Comment,* May/June 1999.

390  **Out of Africa** Deborah Landis, *Screencraft: Costume Design* (Boston: Focal Press, 2003).

390  **Out of Africa** Tom Sabulis, "Dark Continent's Beauty Seduced Meryl Streep," *Dallas Times-Herald,* January 1, 1986.

392  **The Breakfast Club** Jeff Silverman, "Youth!," *Los Angeles Herald Examiner,* February 15, 1985.

392  **The Breakfast Club** Richard Levinson, "A Growing Up Intensive," *Movie Magazine,* Winter 1984, p. 4.

393  **Ferris Bueller's Day Off** Karen Stabiner, "Matthew Broderick Is on a Ferris Wheel of Fame," *Toronto Star,* August 31, 1986.

394  **The Untouchables** Marilyn Vance, interview by Deborah Landis, April 2007.

395  **Enemies: A Love Story** Sandy Schrier, *Hollywood Dressed & Undressed: A Century of Cinema Style* (New York: Rizzoli, 1998), p. 140.

395  **Moonstruck** Michael Schmidt, "Cher's Fashion History: I Got Clothes, Babe," *Details,* 1989.

397  **The Last Emperor** James Acheson, interview by Deborah Landis, *Screencraft: Costume Design*, 2002.

398  **Dangerous Liaisons** John Malkovich, interview by Cynthia Rose, "Interview: John Malkovich," www.muchacreative.com, 1990.

399  **Dangerous Liaisons** James Acheson, interview by Deborah Landis, *Screencraft: Costume Design*, 2002.

400  **Beetlejuice** David Edelstein, "Odd Man In," in *Tim Burton Interviews,* ed. Kristian Fraga (Jackson: University Press of Mississippi, 2005), p. 32.

400  **Beetlejuice** Holly George-Warren, Shawn Dahl, Ann Abel, Barbara O'Dair, and David Wild, eds., *Winona* (New York: Rolling Stone Press, 1997), p. 32.

**400** **Beetlejuice** Aggie Guerard Rodgers, letter to the author, May 20, 2006.

**402** **Coming to America** John Landis, interview by Deborah Landis for "Scene and Not Heard: The Role of Costume in the Cinematic Storytelling Process," doctoral dissertation, The Royal College of Art, August 7, 2002.

**403** **Working Girl** Deborah Landis, *Screencraft: Costume Design* (Boston: Focal Press, 2003).

**403** **When Harry Met Sally** Betty Goodwin, "Fashion: Screen Style," *Los Angeles Times*, August 11, 1989.

**404** **Heathers** Nigel Goodall, *Winona Ryder: The Biography* (London: Blake, 1998), p. 78.

**405** **Rain Man** Donald Chase, "On the Road with Hoffman and Cruise," *New York Times*, December 11, 1988.

**406** **Batman** Kristian Fraga, ed., *Tim Burton Interviews* (Jackson: University Press of Mississippi, 2005), pp. 27–28.

CHAPTER NINE: 1990s

**409** **American Beauty** "*Bugsy*: Production Information," TriStar Pictures press pack, 1991, p. 7.

**415** **Goodfellas** Mary Pat Kelly, *Martin Scorsese: A Journey* (New York: Thunder's Mouth Press, 1991), p. 261.

**415** **Goodfellas** Mary Pat Kelly, *Martin Scorsese: A Journey* (New York: Thunder's Mouth Press, 1991), pp. 272–73.

**416** **Edward Scissorhands** Nigel Goodall, *Winona Ryder: The Biography* (London: Blake, 1998), p. 116.

**417** **Edward Scissorhands** Jan Lindstrom, "The Chameleon," *Daily Variety*, February 9, 2006.

**418** **Grifters** *In Style,* March 2006, p. 342.

**418** **Grifters** "*The Grifters*: Production Notes," press pack (Miramax, 1990), pp. 5–6.

**418** **Pretty Woman** Marilyn Vance, interview by Deborah Landis, April 2007.

**419** **Pretty Woman** Patrick Goldstein, "Julia Roberts—Living Life in the Fast Lane," *Los Angeles Times*, March 23, 1990.

**419** **Pretty Woman** *Pretty Woman*, 15th Anniversary Special Edition DVD Bonus Features (Audio Commentary with director Garry Marshall, Touchstone Home Entertainment, 2005).

**419** **Pretty Woman** Richard Gere, interview by Terry Gross, *Fresh Air* from WHYY, April 4, 2007.

**420** **Dick Tracy** Deborah Landis, *Screencraft: Costume Design* (Boston: Focal Press, 2003).

**420** **Dick Tracy** Jack Matthews, "The Look of 'Tracy,'" *Los Angeles Times,* March 23, 1990.

**422** **Terminator 2: Judgment Day** Marlene Stewart, interview by Deborah Landis, April 2007.

**422** **Boyz N the Hood** "*Boyz N the Hood:* Production Information," Columbia Pictures press pack, 1991, p. 5.

**423** **Thelma & Louise** Jay Carr, "Maverick Star; Susan Sarandon Speaks Up and Stands Out," *Boston Globe,* May 19, 1991, sec. Arts & Film.

**425** **Bugsy** "*Bugsy*: Production Information," TriStar Pictures press pack, 1991, p. 3.

**426** **Malcolm X** *Malcolm X: Production Information* (press pack), Warner Bros., 1992, pp. 7–8.

**426** **Malcolm X** *TCI New York,* February 1993, vol. 27, no. 2, p. 38.

**427** **Basic Instinct** Brian D. Johnson, "A Role No One Wanted; *Basic Instinct* Belongs to Sharon Stone," *Maclean's*, March 30, 1992, p. 55.

**428** **Bram Stoker's Dracula** Francis Ford Coppola, interview by Deborah Landis for "Scene and Not Heard: The Role of Costume in the Cinematic Storytelling Process," doctoral dissertation, The Royal College of Art, 2003.

**428** **Bram Stoker's Dracula** Diana Landau, ed., *Bram Stoker's Dracula: The Film and the Legend* (New York: Newmarket Press, 1992), p. 98.

**431** **The Age of Innocence** Martin Scorsese and Jay Cocks, *The Age of Innocence: A Portrait of the Film Based on the Novel by Edith Wharton* (New York: Newmarket Press, 1993), p. 181.

**433** **Natural Born Killers** Gerald, Peary, ed., *Quentin Tarantino Interviews* (Jackson: University Press of Mississippi, 1998), pp. 60–61.

**434** **Bullets over Broadway** Bonnie Churchill, "Dianne Wiest's Chutzpah Lands Her a Juicy Role," *Christian Science Monitor,* October 31, 1994, p. 14.

**435** **Stargate** Joseph Porro, interview by Deborah Landis, April 2007.

**436** **What's Eating Gilbert Grape?** "*What's Eating Gilbert Grape?*: Handbook of Production Information," Paramount press pack, 1993, p. 4.

**436** **What's Eating Gilbert Grape?** Brian J. Robb, *Johnny Depp: A Modern Rebel* (London: Plexus, 1996), p. 95.

**436** **Reservoir Dogs** John Calhoun, *Entertainment Design*, March 2000, vol. 34, no. 3, pp. 38–41.

**436** **Reservoir Dogs** Jerome Charyn, *Raised by Wolves: The Turbulent Art and Times of Quentin Tarantino* (New York: Thunder's Mouth Press, Avalon, 2006), p. 58.

**437** **Forrest Gump** Joanna Johnston, letter to Deborah Landis, August 31, 2006.

**438** **The Addams Family** "*The Addams Family*: Handbook of Production Information," Paramount Pictures press pack, 1991, pp. 12–13.

**439** **Pulp Fiction** John Calhoun, *Entertainment Design*, March 2000, vol. 34, no. 3, pp. 38–41.

**440** **Clueless** John Calhoun, *Entertainment Design*, March 2000, vol. 34, no. 3, pp. 38–41; Jessica Kerwin and Dahlia Dean, "Fashion Movie for Teens Dressed for Success," *Toronto Star*, August 10, 1995.

**443** **Casino** Deborah Landis, moderator, "Character Comes First: Costume Design in the 21st Century: Period Costumes," Academy of Motion Picture Arts and Sciences (AMPAS) series.

**444** **Braveheart** "*Braveheart:* The Long and Sword of It," *Los Angeles Times*, May 21, 1995.

**445** **Fargo** Graham Fuller, "How Frances McDormand Got Into 'Minnesota Nice,'" *New York Times*, March 17, 1996.

**447** **101 Dalmatians** Deborah Landis, *Screencraft/Costume Design*, Focal Press, 2003, p.98. Deborah Landis, ed., *50 Designers/50 Costumes: Concept to Character* (Beverly Hills: Academy of Motion Picture Arts and Sciences/University of California Press, 2004), p. 84.

**447** **101 Dalmatians** Glenn Close, interview by Stephen Applebaum, "*102 Dalmatians*: Glenn Close Interview." http://stag1new-gui.server.virgin.net:81/movies/features/feature_7063.html, June 12, 2000.

**448** **Restoration** Jackie Burdon, "Dressing Up for Third Oscar Win," *Press Association*, March 26, 1996.

**449** **Elizabeth** "An Interview with Cate Blanchett," www.renaissancemagazine.com, 1999.

**450** **Titanic** Ed W. Marsh, *James Cameron's "Titanic"* (New York: HarperPerennial, 1997), p. 38.

**451** **Titanic** http://www.titanicmovie.com/present/bts_index.html.

**452** **Titanic** "That Sinking Feeling," *TCI New York*, January 1998, p. 24.

**454** **Men in Black** Sylvia Rubin, "Men in Black and the Women Who Dress Them," *San Francisco Chronicle*, July 10, 1997.

**455** **Austin Powers: International Man of Mystery** Deborah Landis, ed., *50 Designers/50 Costumes: Concept to Character* (Beverly Hills: Academy of Motion Picture Arts and Sciences/University of California Press, 2004), p. 10.

**456** **LA Confidential** "Confidential Commentary," *SPLICED*, September 3, 1997, www.splicedonline.com.

**456** **LA Confidential** Bernard Weinraub, "Between Image and Reality in Los Angeles," *New York Times*, September 7, 1997. Pg. 2.52.

**457** **LA Confidential** Jean Oppenheimer, "LA Woman," http://www.boxoffice.com (Media Enterprises, L.P., 1995–2005). September 1997.

**459** **Boogie Nights** Kristine McKenna, "Knows It When He Sees It," *Los Angeles Times*, October 12, 1997.

**460** **The Big Lebowski** Jeff Dowd, interview by Ivana Redwine, "Interview: Jeff Dowd and *The Big Lebowski*." http://homevideo.about.com, (About, Inc., 2005).

**461** **Welcome to the Dollhouse** Lisa Nesselson, "Todd Solondz on *Welcome to the Dollhouse*," http://www.filmscouts.com.

**462** **Boys Don't Cry** Celebetty Interviews: Hilary Swank – Boys Don't Cry, 1999-2001. http://www. beatboxbetty.com/celebetty/hilaryswank/hilaryswank/hilaryswank.htm.

**463** **As Good As It Gets** Molly Maginnis, letter to Deborah Landis, April 12, 2007.

**464** **Beloved** Oprah Winfrey, *Journey to Beloved* (New York: Hyperion, 1998), p. 65.

**466** **Shakespeare in Love** "Breeches and Braids: Costumes and Makeup," *Shakespeare in Love*, press kit.

**466** **Shakespeare in Love** "Breeches and Braids: Costumes and Makeup." *Shakespeare in Love*, press kit.

**467** **Shakespeare in Love** Philip Wuntch, "Gwyneth Paltrow is too happy to fret about what might have been," *Calgary Herald*, December 31, 1998.

**469** **Shakespeare in Love** "Breeches and Braids: Costumes and Makeup," *Shakespeare in Love*, press kit.

**469** **Shakespeare in Love** Anthony Holden, "Will's Secret History." *Observer* (London), January 3, 1999.

**469** **Shakespeare in Love** Lynn Hirshberg, "A Dresser for the Ages," *New York Times Magazine*, December 20, 1998, p. 60.

**470** **The Matrix** Stephen Horn "Interview with Keanu Reeves: Neo chats about the end of the Matrix world, the coat, and getting ready for the film," www.filmforce.ign.com, May 15, 2003. http://movies.ign.com/articles/403/403077p1.html.

**471** **The Matrix** Deborah Landis, ed., *50 Designers/50 Costumes: Concept to Character* (Beverly Hills: Academy of Motion Picture Arts and Sciences/University of California Press, 2004), p. 14.

**473** **Fight Club** Deborah Landis, ed., *50 Designers/50 Costumes: Concept to Character* (Beverly Hills: Academy of Motion Picture Arts and Sciences/University of California Press, 2004), p. 52.

**474** **Star Wars: Episode I—The Phantom Menace** *Dressing a Galaxy: The Costumes of Star Wars,* DVD Special Features, Lucasfilm, 2005.

**474** **Star Wars: Episode I—The Phantom Menace** Trisha Biggar, *Dressing a Galaxy: The Costumes of Star Wars* (New York: Insight Editions/Harry N. Abrams, 2005), pp. 42–43.

### CHAPTER TEN: 2000s

**480** **Dream Girls** Emanuel Levy, "Dreamgirls: Creating Authentic Look through Costumes," EmanuelLevy.com, available FTP: http://www.emanuellevy.com/article.php?articleID=3901

**482** **Chicago** Colleen Atwood, acceptance speech for the Academy Award for Best Costume Design, 2002; Keith Bush, "Dressed to Kill: Colleen Atwood," at www.keith.bush.com/article_atwood.htm.

**484** **Erin Brokovich** "Assembling the Team," http://www.erinbrockovich.com/assemble.html, (Universal Studios, 2000).

**486** **Almost Famous** *Almost Famous, the Bootleg Cut* DVD, audio commentary, Dreamworks LLC, 2001.

**486** **Almost Famous** Deborah Landis, ed., *50 Designers/50 Costumes: Concept to Character,* (Beverly Hills: Academy of Motion Picture Arts and Sciences/University of California Press, 2004), p. 44.

**487** **Ghost World** "Production Notes," MGM, http://www.ghostworld-the-movie.com/ie/index.html, (MGM).

**488** **Quills** Deborah Landis, ed., *50 Designers/50 Costumes: Concept to Character* (Beverly Hills: Academy of Motion Picture Arts and Sciences/University of California Press, 2004), p. 106.

**489** **Gladiator** Deborah Landis, ed., *50 Designers/50 Costumes: Concept to Character* (Beverly Hills: Academy of Motion Picture Arts and Sciences/University of California Press, 2004), p. 112.

**489** **Gladiator** "Russell Crowe—Exclusive print interview," http://www.femalefirst.co.uk/celebrity_interviews/91242004.htm. Play-2-Win Ltd., September 14, 2005.

**490** **Ocean's Eleven** Deborah Landis, ed., *50 Designers/50 Costumes: Concept to Character* (Beverly Hills: Academy of Motion Picture Arts and Sciences/University of California Press, 2004), p. 56.

**491** **Ocean's Eleven** Jeff Hudson, *George Clooney: A Biography* (London: Virgin Books, 2003), p. 216.

**492** **Legally Blonde** Victoria Hardy, "*Legally Blonde* Is a Fashion Bombshell," *Us Weekly*, July 23, 2001, p.56.

**494** **Harry Potter** Deborah Landis, ed., *50 Designers/50 Costumes: Concept to Character* (Beverly Hills: Academy of Motion Picture Arts and Sciences/University of California Press, 2004), p. 60.

**495** **Harry Potter and the Sorcerer's Stone** "Timeless Style: Hamilton and Premiere Celebrate Hollywood's Designers and Stylists," *Premiere*, April 2004.

**496** **The Royal Tenenbaums** John Calhoun, "Storybook Pink: David Wasco and Karen Patch Create an Offbeat Look for *The Royal Tenenbaums*," *Entertainment Design*, January 2002, vol. 36, no. 1, p. 14.

**498** **Moulin Rouge** Catherine Martin, acceptance speech for the Academy Award for Outstanding Achievement in Costume Design, 2001.

**499** **Moulin Rouge** Moulin Rouge DVD Special Features, (20th Century Fox, 2003).

**500** **The Lord of the Rings: The Fellowship of the Ring** Brian Sibley, *The Lord of the Rings: The Making of the Movie Trilogy* (Boston: Houghton Mifflin, 2002), p. 95.

**501** **The Lord of the Rings: The Fellowship of the Ring** Brian Sibley, *The Lord of the Rings: The Making of the Movie Trilogy* (Boston: Houghton Mifflin, 2002), p. 90.

**501** **The Lord of the Rings: The Fellowship of the Ring** Gary Russell, *The Lord of the Rings: The Art of the Fellowship of the Ring* (Boston: Houghton Mifflin, 2002), p. 119.

**503** **Frida** Claudia Figueroa, "Creating an Oscar-Worthy Look," [interview with Julie Weiss], in *50 Designers/50 Costumes: Concept to Character,* ed. Deborah Landis, (Beverly Hills: Academy of Motion Picture Arts and Sciences/University of California Press, 2004), 7–8; *California Apparel News*, March 21–27, 2003, p. 4.

**504** **The Hours** "Timeless Style: Hamilton and Premiere Celebrate Hollywood's Designers and Stylists," *Premiere*, June 2004.

**505** **The Hours** Michael Cunningham, "Nicole Kidman: [She's got guts. She's been humanized. She takes risks. And she's the movie star the world has fallen in love with"], *Interview*, February 2002.

**506** **Spider-Man** Patrick Lee, "Sam Raimi and His Spider-Man Actors Show Great Power and Responsibility." *Science Fiction Weekly*, www.scifi.com, May 6, 2002.

**506** **Spider-Man** James Acheson, interview by Deborah Landis, ed, *50 Designers/50 Costumes: Concept to Character,* Deborah Landis, ed. (Beverly Hills: Academy of Motion Picture Arts and Sciences/University of California Press, 2004).

**507** **Napoleon Dynamite** Jon Heder, interview by Mike Russell, "Sweet! An Interview with *Napoleon Dynamite* Star Jon Heder!" *Oregonian*, July 4, 2004.

**507** **Borat** "Behind the scenes insight from Sacha Baron Cohen and Dan Mazer," The Unofficial Borat Homepage, www.boratonline.co.uk.

**508** **Gangs of New York** Martin Scorsese, *Martin Scorsese's Gangs of New York: Making the Movie* (New York: Miramax, 2002), pp. 61–62.

**510** **The Good Girl** "The Unglam Girl," www.urbancinefile.com.au, April 24, 2003.

**510** **Mystic River** Bill Desowitz, "Eastwood Commends Longtime Collaborators," *Below the Line*, January 2004, p.18.

**511** **Thirteen** Nikki Reed, interview by Thomas Chau, "Interview: Nikki Reed of *Thirteen*," *Cinema Confidential*, www.cinecon.com, August 20, 2003.

**512** **Pirates of the Caribbean: Curse of the Black Pearl** Deborah Landis, ed., *50 Designers/50 Costumes: Concept to Character* (Beverly Hills: Academy of Motion Picture Arts and Sciences/University of California Press, 2004), pp. 6, 92.

**514** **Down with Love** Deborah Landis, ed., *50 Designers/50 Costumes: Concept to Character* (Beverly Hills: Academy of Motion Picture Arts and Sciences/University of California Press, 2004), p. 74.

**515** **Walk the Line** Ruth La Ferla, "Stepping Out of Hollywood's Dressing Room," *New York Times,* March 5, 2006.

**515** **Walk the Line** Anthony Breznican, "Phoenix Could Turn Cash into Gold." *USA Today*, October 20, 2005.

**516** **Kill Bill: Vol. 1** Quentin Tarantino, interview by Sean Chavel, "*Kill Bill* Week: Interview with Quentin Tarantino," *Cinema Confidential*, www.cinecon.com, October 7, 2003.

**517** **Kill Bill: Vol. 1** Transcript of press conference for *Kill Bill*, available at MyMovies.net, October 16, 2003.

**518** **Monster** Roxanna Bina and Emmanuel Itier, "Charlize Theron," *Independent Film Quarterly*, www.independentfilmquarterly.com.

**518** **Monster** *An Interview with Charlize Theron,* http://www.handbag.com/gossip/celebrityinterviews/charlizetheron/.

**520** **Memoirs of a Geisha** Claudia Puig, "'Geisha' is more art than realism," *USA Today*, September 13, 2005, p. 8D.

**521** **Troy** Production notes, "*Troy*: Horses, Ships, and Costumes", available at www.celebritywonder.com.

**522** **Troy** "Pitt, Byrne Talk *Troy*: The Lowdown from the Cast," www.filmforce.ign.com, July 7, 2003.

**524** **Lemony Snicket's A Series of Unfortunate Events** Jamie Diamond, "A Costume Drama in Modern Dress," *New York Times*, February 24, 2005.

**525** **Lemony Snicket's A Series of Unfortunate Events** Jamie Diamond, "A Costume Drama In Modern Dress" *The New York Times*, February 24, 2005, p. F1.

**526** **Ray** Patrick Goldstein, "The Soul of 'Ray': Capturing the Spirit, if Not Each Event, of the Late Musical Legend's Amazing Life," *Los Angeles Times*, November 3, 2004.

**527** **Eternal Sunshine of the Spotless Mind** Raymond Meier, "The Unsinkable Kate Winslet"; *New York Times Magazine*, Fall 2004, p. 234; Justine Picardie, "Kate Winslet's Sexy New Confidence," *Harper's Bazaar*, October 2004, no. 3515, p. 224.

**527** **The Life Aquatic with Steve Zissou** Suzie Mackenzie, "Into the Deep," *Guardian*, February 12, 2005, http://film.guardian.co.uk/.

**528** **The Aviator** *The Aviator,* DVD special features, Warner Home Video, 2005.

**530** **Brokeback Mountain** Elizabeth Snead, "The Envelope: Styles & Scenes," *Los Angeles Times*, January 6, 2006, p. E2.

**533** **Million Dollar Baby** Stephanie Scott, "Profiles: Hilary Swank," *Hollywood Reporter*, January 2005, p. 57.

**534** **Chronicles of Narnia** Tilda Swinton, *New Straits Times*, available at www.narniaweb.com, May 13, 2005.

**536** **The Devil Wears Prada** Meryl Streep, interview by Ethan Ames, *Cinema Confidential*, "Interview: Meryl Streep on *The Devil Wears Prada*," www.cinecon.com, June 22, 2006.

**538** **The Departed** Michael Goldman, "Scorsese: Gangster Style," www.digitalcontentproducer.com, October 1, 2006.

**539** **The Departed** Brad Balfour, *Meeting with Martin and "The Departed*," www.timessquare.com, February 27, 2007.

**540** **The New World** *The New World* CD press kit, MMV New Line Productions, 2005.

**540** **The New World** *The New World* CD press kit, MMV New Line Productions, 2005.

**542** **Marie Antoinette** Gaynor Flynn, *Sofia Won't Be Losing Her Head*, www.theblurb.com.au, no. 73.

**544** **Little Miss Sunshine** Melinda McCrady, "Nancy Steiner on Modern Costume Design and Her Work in *Little Miss Sunshine*," Resource411.com; Issue 36, August 2006, http://www.resource411.com/411Update/Issue_36/Articles/Contemporary_Costumes_for_Quirky_Characters.cfm

# COSTUME DESIGNER AND ILLUSTRATOR CREDITS

# PHOTOGRAPHY CREDITS

**Foreword:** ii: Bud Fraker/Paramount/Kobal Collection; viii: Icon Entertainment International/courtesy of Anjelica Huston; x: courtesy of Anjelica Huston; xii: courtesy of Anjelica Huston; xiii, left: Kerry Hayes/Gemma La Mana/20th Century Fox/Photofest; xiii, right: collection of William Sutton.

**Introduction:** xiv: courtesy of the Academy of Motion Picture Arts and Sciences (AMPAS); xvii: Yanco/Tao/Recorded Picture Co./Kobal Collection; xix: Danjaq/Eon/United Artists/courtesy of Deborah Landis; xxii: Paramount/Kobal Collection; xxiii: Brian Hamill/United Artists/Kobal Collection.

**The Early Years:** xxvi: Paramount/courtesy of AMPAS; 2: Photofest; 3: Fox/courtesy of AMPAS; 5: Gene Kornman/Kobal Collection; 7: courtesy of AMPAS; 8: Paramount/courtesy of AMPAS; 9: Sennett/Keystone/Kobal Collection; 10–11: Histrionic Film/courtesy of AMPAS; 12: Department of Special Collections, Charles E. Young Research Library, UCLA; 13: World Film/courtesy of AMPAS; 14, top left: Kobal Collection; 14, top right: Triangle Film/courtesy of AMPAS; 14, bottom: Lasky Productions/courtesy of AMPAS; 15, top: Epoch/Photofest; 15, bottom: Epoch/courtesy of AMPAS; 16: Department of Special Collections, Charles E. Young Research Library, UCLA; 17: K-E-S-E Service/courtesy of AMPAS; 18, top: Wark Producing Company/Kobal Collection; 18, bottom: Wark Producing Company/courtesy of AMPAS; 19: Wark Producing Company/courtesy of AMPAS; 20, left: Department of Special Collections, Charles E. Young Research Library, UCLA; 20, right: First National/courtesy of AMPAS; 21, top: Fox/courtesy of AMPAS; 21, bottom: Fox/courtesy of AMPAS; 22: Triangle Film/courtesy of AMPAS; 23, top: Pathé/courtesy of AMPAS; 23, bottom: Artcraft/Famous Players-Lasky/courtesy of AMPAS; 24–25: Paramount/courtesy of AMPAS; 26, left: Department of Special Collections, Charles E. Young Research Library, UCLA; 26, right: Fox/courtesy of AMPAS; 27: D.W. Griffith Productions/Kobal Collection.

**1920s:** 28: Paramount/Kobal Collection; 31: Kobal Collection; 32: United Artists/courtesy of AMPAS; 33: Fox/courtesy of AMPAS; 35:Kobal Collection; 36: MGM/Kobal Collection; 37: Griffith/United Artists/courtesy of AMPAS; 38: Paramount/courtesy of AMPAS; 39: Paramount/courtesy of AMPAS; 40, top: United Artists/courtesy of Deborah Landis; 40, bottom: United Artists/Kobal Collection; 41: Universal/courtesy of AMPAS; 42: United Artists/courtesy of AMPAS; 43, left: Collection of David Chierichetti; 43, right: United Artists/courtesy of AMPAS; 44: MGM/courtesy of AMPAS; 45: Associated First National/courtesy of AMPAS; 46: United Artists/Kobal Collection; 47: Paramount/courtesy of AMPAS; 48: Paramount/Kobal Collection; 49: top left: Museum Associates/LACMA, Costume Council Fund; 49, top middle: Museum Associates/LACMA, Costume Council Fund; 49, top right: Museum Associates/LACMA, Costume Council Fund; 49, bottom: MGM/Kobal Collection; 50, left: MGM/courtesy of AMPAS; 50, right: Collection of Christian Esquevin; 51: MGM/Kobal Collection; 52, top: courtesy of Western Costume Company; 52, bottom: courtesy of Western Costume Company; 53: Famous Players/Paramount/courtesy of AMPAS; 54: MGM/courtesy of AMPAS; 55: First National/Kobal Collection; 56: Arrow Pictures/courtesy of AMPAS; 57: United Artists/courtesy of AMPAS; 58: Universal/courtesy of AMPAS; 59: Universal/courtesy of AMPAS; 60: MGM/courtesy of AMPAS; 61 top: Fox/Kobal Collection; 61, bottom: Paramount/courtesy of AMPAS; 62: Paramount/courtesy of AMPAS; 63: Russell Ball/United Artists/Kobal Collection; 65: United Artists/Photofest; 66: MGM/courtesy of AMPAS; 67: MGM/courtesy of AMPAS; 68, left: Kobal Collection; 68, right: MGM/Kobal Collection; 69, left: MGM/Kobal Collection; 69, right: Kobal Collection.

**1930s:** 70: MGM/Photofest; 74: Selznick/MGM/The Everett Collection; 75: MGM/ Kobal Collection; 76: Pioneer/The British Film Institute (BFI); 77: Don English/Paramount/courtesy of AMPAS; 78: courtesy of AMPAS/The Leonard Stanley Collection; 79: Clarence Sinclair Bull/MGM/courtesy of AMPAS; 80, top: Milton Browne/Paramount/courtesy of AMPAS; 80, bottom: MGM/Kobal Collection; 81: Scotty Welbourne/Warner Bros./courtesy of AMPAS; 82, top: Clarence Sinclair Bull/MGM/courtesy of AMPAS; 82, bottom: Clarence Sinclair Bull/MGM/courtesy of Deborah Landis; 83: Clarence Sinclair Bull/MGM/courtesy of AMPAS; 84: Universal/courtesy of AMPAS; 85: Universal/courtesy of AMPAS; 86: United Artists/courtesy of AMPAS; 87: Gene Kornman/United Artists/Kobal Collection; 88, top: George Hurrell/MGM/courtesy of AMPAS; 88, bottom left: MGM/courtesy of AMPAS; 88, bottom right: Frank Tanner/MGM/courtesy of AMPAS; 89: George Hurrell/MGM/courtesy of Deborah Landis; 90, top: Warner Bros./courtesy of AMPAS; 90, bottom left: Charles Scott Welbourne/Warner Bros./courtesy of AMPAS; 90, bottom right: Charles Scott Welbourne/Warner Bros./courtesy of AMPAS; 91: RKO/courtesy of AMPAS; 92: Columbia/courtesy of Deborah Landis; 93, top: Goldwyn/courtesy of AMPAS; 93, bottom: Frank Tanner/MGM/courtesy of AMPAS; 94, top: Ray Jones/Paramount/courtesy of AMPAS; 94, bottom: courtesy of AMPAS; 95, left: Collection of Forrest Paulette and Robert Evanko; 95, right: Universal/Kobal Collection; 96: MGM/courtesy of Deborah Landis; 97: Cliff Maupin/20th Century Fox/courtesy of Deborah Landis; 99: Don English/Paramount/courtesy of AMPAS; 100, top: Warner Bros./courtesy of AMPAS; 100, middle right: Museum Associates/LACMA, Gift of Linda Descenna; 100, bottom: Mack Elliot/Warner Bros./First National/courtesy of AMPAS; 101: Alex Kahle/RKO/courtesy of Deborah Landis; 102, top: Paramount/courtesy of AMPAS; 102, bottom: Paramount/courtesy of Deborah Landis; 103: Paramount/courtesy of Deborah Landis; 104, left: Seaver Center for Western History Research, Los Angeles County Museum of Natural History; 104, right: Seaver Center for Western History Research, Los Angeles County Museum of Natural History; 105: John Miehle/RKO/courtesy of AMPAS; 106: RKO/courtesy of Deborah Landis; 107, top: John Sayers/RKO/Kobal Collection; 107, bottom: RKO/© John Springer Collection/Corbis; 108, top left: courtesy of AMPAS; 108, top right: MGM/courtesy of AMPAS; 108, bottom left: courtesy of AMPAS; 108, bottom right: MGM/courtesy of AMPAS; 109: MGM/courtesy of AMPAS; 110: MGM/Kobal Collection; 111: Paramount/courtesy of AMPAS; 112: Universal/Kobal Collection; 113, left: Universal/courtesy of AMPAS; 113, right: Universal/courtesy of Deborah Landis; 114: Mac Julian/Warner Bros./courtesy of AMPAS; 115: Mac Julian/Warner Bros./Kobal Collection; 116: MGM/courtesy of AMPAS; 117: Laszlo Willinger/MGM/courtesy of AMPAS; 118: Paramount/courtesy of AMPAS; 119: Ned Scott/United Artists/Kobal Collection; 120, top: MGM/Kobal Collection; 120, bottom: MGM/Kobal Collection; 121: MGM/Kobal Collection; 122, top: courtesy of AMPAS; 122, left: courtesy of AMPAS; 122, right: courtesy of AMPAS; 123: Fred Parrish/Selznick/MGM/courtesy of Deborah Landis; 124: Photofest; 125: Fred Parrish/Selznick/MGM/Kobal Collection; 126: courtesy of AMPAS; 127: Fred Parrish/Selznick/MGM/Photofest; 128: George Hurrell/Warner Bros./First National/courtesy of AMPAS; 129: Warner Bros./First National/Kobal Collection; 130: Laszlo Willinger/MGM/courtesy of AMPAS; 131: MGM/courtesy of AMPAS; 132: Elmer Fryer/Warner Bros./courtesy of AMPAS; 133, left: George Hurrell/Warner Bros./courtesy of AMPAS; 133, right: Elmer Fryer/Warner Bros./courtesy of AMPAS.

**1940s:** 134: Ernest Bachrach/RKO/Kobal Collection; 138: Warner Bros./Kobal Collection; 141, left: Collection of Forrest Paulette and Robert Evanko; 141, right: 20th Century Fox/courtesy of AMPAS; 142–43: Emmett Schoenbaum/20th Century Fox/courtesy of AMPAS; 144: Seaver Center for Western History Research, Los Angeles County Museum of Natural History; 145: MGM/Kobal Collection; 146, top: Columbia/courtesy of AMPAS; 146, bottom left: Collection of Christian Esquevin; 146, bottom right: RKO/courtesy of AMPAS; 147: RKO/Lester Glassner Collection/Neal Peters; 148: RKO/Samuel Goldwyn/courtesy of Deborah Landis; 149: George Hurrell/RKO/Samuel Goldwyn/Kobal Collection; 150, top left: courtesy of AMPAS; 150, top right: courtesy of AMPAS; 150, bottom: MGM/courtesy of Deborah Landis; 151: MGM/courtesy of AMPAS; 153–53: Warner Bros./courtesy of Deborah Landis; 154: MGM/courtesy of AMPAS; 155: 20th Century Fox/courtesy of AMPAS; 156: Collection of William Sutton; 157: 20th Century Fox/courtesy of AMPAS; 158, top: Brooklyn Museum Libraries, Special Collections; 158, bottom: Frank Polony/20th Century Fox/courtesy of AMPAS; 159, top: courtesy of the Yale School of Drama/Planned Parenthood New York; 159, bottom: MGM/courtesy of AMPAS; 160: RKO/Photofest; 161: RKO/courtesy of AMPAS; 162: Columbia/courtesy of Deborah Landis; 163: Robert Coburn/Columbia/courtesy of AMPAS; 164: Warner Bros./Kobal Collection; 165, top left: courtesy of AMPAS; 165, top right: Warner Bros./courtesy of AMPAS; 165, bottom: Mac Julian/Warner Bros./Kobal Collection; 166: MGM/Kobal Collection; 167: Milton Gold/Warner Bros./courtesy of AMPAS; 168: George Hurrell/RKO/Kobal Collection; 169, top left: Collection of Christian Esquevin; 169, top right: Eddie Hubbell/MGM/courtesy of Deborah Landis; 169, bottom: Eddie Hubbell/MGM/Photofest; 170: United Artists/Kobal Collection; 171: Selznick/United Artists/courtesy of Deborah Landis; 172: courtesy of AMPAS; 173: G.E. Richardson/Paramount/courtesy of AMPAS; 174: courtesy of AMPAS; 175: Bud Graybill/Sierra Pictures/Kobal Collection.

**1950s:** 176: Columbia/Kobal Collection; 178: 20th Century Fox/Kobal Collection; 180: Stanley Kramer Productions/United Artists/Kobal Collection; 181: A. Di Giovanni/Paramount/Kobal Collection; 183: Columbia/courtesy of Deborah Landis; 184, top: Collection of William Sutton; 184, bottom left: courtesy of AMPAS; 184, bottom right: Glen E. Richardson/Ed Henderson/Paramount/Kobal Collection; 185: Glen E. Richardson/Ed Henderson/Paramount/courtesy of AMPAS; 186: 20th Century-Fox/Kobal Collection; 187, top: 20th Century-Fox/courtesy of AMPAS; 187, bottom: Ray Nolan/20th Century-Fox/Kobal Collection; 188: Collection of Christian Esquevin; 189: Glen E. Richardson/Paramount/courtesy of AMPAS; 190, left: Collection of Tom Culver; 190, right: Universal/courtesy of AMPAS; 191, left: courtesy of AMPAS; 191, right: Edward Hubbell/MGM/Kobal Collection; 192: courtesy of AMPAS; 193: MGM/courtesy of AMPAS; 194, left: MGM/Photofest; 194, right: courtesy of AMPAS; 195, left: courtesy of AMPAS; 195, right: Paramount/Kobal Collection; 196, top: Columbia/courtesy of AMPAS; 196, bottom: Columbia/Kobal Collection; 197: Warner Bros./Photofest; 198: courtesy of the Yale School of Drama/Planned Parenthood New York; 199: MGM/courtesy of AMPAS; 200: Collection of Bill Sarris; 201: 20th Century Fox/courtesy of Deborah Landis; 202: United Artists/Photofest; 203: Paramount/Kobal Collection; 204: Eric Carpenter/MGM/Photofest; 205: MGM/Photofest; 206: 20th Century Fox/Photofest; 207: courtesy of the Yale School of Drama/Planned Parenthood New York; 208: courtesy of the Yale School of Drama/Planned Parenthood New York; 209: 20th Century Fox/Kobal Collection; 210, top: Warner Bros./Kobal Collection; 210, bottom: MGM/Kobal Collection; 211: United Artists/Kobal Collection; 212, left: Collection of Tom Culver; 212, right: Paramount/Kobal Collection; 213: MGM/courtesy of AMPAS; 214: Columbia/Photofest; 215: United Artists/Photofest; 216: Ed Estabrook/Universal/Photofest; 217, top: courtesy of AMPAS; 217, bottom: A. Di Giovanni/Paramount/courtesy of AMPAS; 218: Paramount/courtesy of Deborah Landis; 219: Paramount/Kobal Collection; 220: courtesy of Western Costume Company; 221: 20th Century Fox/courtesy of AMPAS; 222: Collection of Tom Culver; 223: Pat Clark/Warner Bros./Photofest; 224: Bud Fraker/Paramount/The Everett Collection; 225, left: Wisconsin Center for Film and Theater Research; 225, right: Paramount/courtesy of AMPAS; 226: Wisconsin Center for Film and Theater Research; 227: Bill Avery/Paramount/courtesy of Deborah Landis; 228: Collection of Bill Sarris; 229: Sam Shaw/20th Century Fox/Kobal Collection; 230, top left: Seaver Center for Western History Research, Los Angeles County Museum of Natural History; 230, top right: Paramount/Kobal Collection; 230, bottom: Paramount/Kobal Collection; 231: Paramount/Kobal Collection; 232: Collection of William Sutton; 233: MGM/Kobal Collection; 234: Wisconsin Center for Film and Theater Research; 235: Robert Coburn, Jr./G. E. Richardson/Paramount/Kobal Collection; 236: courtesy of AMPAS; 237: MGM/© Sunset Boulevard/Corbis; 238, top: Collection of William Sutton; 238, bottom: MGM/Kobal Collection; 239: MGM/courtesy of Deborah Landis; 240: Floyd McCarty/United Artists/Kobal Collection; 241, left: courtesy of AMPAS; 241, right: Floyd McCarty/United Artists/Kobal Collection.

**1960s:** 242: Warner Bros./Photofest; 246: AIP/Hulton Archive/Getty Images; 247: 20th Century Fox/Copyright © Twentieth Century Fox All Rights Reserved; 248: Susan Wood/Hulton Archive/Getty Images; 249: MGM/Photofest; 250, top left: Collection of Tom Culver; 250, top middle: Collection of Forrest Paulette and Robert Evanko; 250, top right: Al St. Hilaire/United Artists/courtesy of Deborah Landis; 250, bottom: Herbert Bayer/Paramount/courtesy of Deborah Landis; 251: Paramount/Photofest; 252: courtesy of AMPAS; 253: Bryna/Universal/courtesy of Deborah Landis; 254, left: United Artists/Seven Arts/Photofest; 254, right: courtesy of AMPAS; 255, left: Collection of Forrest Paulette and Robert Evanko; 255, right: United Artists/Seven Arts/Photofest; 256: Paramount/courtesy of AMPAS; 257: Paramount/Kobal Collection; 258, top: courtesy of AMPAS; 258, bottom: Ernst Haas/Mirisch-7/United Artists/courtesy of AMPAS; 259: Ernst Haas/Mirisch-7/United Artists/Photofest; 260: courtesy of AMPAS; 261: Warner Brothers/MPTV.net; 262, top: Don Christie/Warner Bros./Photofest; 262, bottom: Rollie Lane/Universal/courtesy of AMPAS; 263, top: Jack Harris/United Artists/Kobal Collection; 263, bottom: Jack Harris/United Artists/courtesy of Deborah Landis; 264: Wisconsin Center for Film and Theater Research; 265: Paramount/courtesy of AMPAS; 266: Bert Cann/Danjaq/Eon/United Artists/courtesy of Deborah Landis; 267: Danjaq/Eon/United Artists/courtesy of AMPAS; 268: courtesy of AMPAS; 269: 20th Century Fox/Kobal Collection; 270, top left: 20th Century Fox/Silver Screen Collection/Hulton Archive/Getty Images; 270, top left: 20th Century Fox/Kobal Collection; 270, bottom left: Collection of Christian Esquevin; 270, bottom right: 20th Century Fox/courtesy of Deborah Landis; 271, left: courtesy of the Yale School of Drama/Planned Parenthood New York; 271, right inset: Robert Willoughby/Warner Bros./courtesy of AMPAS; 272, top: courtesy of Melissa and Emily Hacker; 272, bottom: United Artists/Kobal Collection; 273: Warner Bros./© 1978 Bob Willoughby/MPTV.net; 274: Collection of David Copley; 275: Warner Brothers/Photo by Mel Traxel/MPTV.net; 276, left: courtesy of Tony Walton; 276, right: Disney/Lester Glassner Collection/Neal Peters ; 277, top right: Department of Special Collections, Charles E. Young Research Library, UCLA.; 277, bottom: 20th Century Fox/Copyright © Twentieth Century Fox All Rights Reserved; 278: courtesy of AMPAS; 279: James Mitchell/20th Century Fox/courtesy of AMPAS; 280: Mel Traxel/Columbia/Kobal Collection; 281: Carlo Bavagnoli/Paramount/courtesy of Deborah Landis; 282: Collection of Tom Culver; 283: Warner Brothers/Photo by Mel Traxel/MPTV.net; 284: Collection of Tom Culver; 284: Warner Bros./Photofest; 286: courtesy of AMPAS; 287: Warner Bros./© Sunset Boulevard/Corbis; 288, top left: courtesy of AMPAS; 288, top right: Warner Bros./Kobal Collection; 288, bottom left: Warner Bros./Kobal Collection; 288, bottom right: courtesy of AMPAS; 289, left: Paramount/© 1978 Bob Willoughby/MPTV.net; 289, right: Collection of Tom Culver; 290, left: Robert Willoughby/Palomar/ABC/Kobal Collection; 290, right: courtesy of AMPAS; 291, left: courtesy of AMPAS; 291, right: Palomar/ABC/Photofest; 292, top: courtesy of Western Costume Company; 292, bottom: Larry Prather/20th Century Fox/courtesy of Deborah Landis; 293: Larry Prather/20th Century Fox/courtesy of Deborah Landis; 294, top left: Columbia/Kobal Collection; 294, bottom left: Columbia/courtesy of Deborah Landis; 294, right: Collection of Forrest Paulette and Robert Evanko; 295: Columbia/Kobal Collection; 296, top left: United Artists/courtesy of AMPAS; 296, top right: courtesy of AMPAS; 296, bottom left: United Artists/courtesy of AMPAS; 297: United Artists/courtesy of AMPAS; 298, left: MGM/BFI; 298, bottom right: MGM/BFI ; 298–99, top: John Jay/MGM/courtesy of AMPAS; 299: John Jay/MGM/BFI/Kobal Collection; 300, top: courtesy of AMPAS; 300, bottom: 20th Century Fox/© Douglas Kirkland/Corbis; 301, top left: 20th Century Fox/courtesy of AMPAS, The Leonard Stanley Collection ; 301, top right: Ernst Haas/20th Century Fox/courtesy of Deborah Landis; 301, bottom: Hulton Archive/Getty Images; 302, top: Paramount/courtesy of Deborah Landis; 302, bottom: Robert Willoughby/Embassy/BFI; 303, top: Peter Sorel/Columbia/Photofest; 303, bottom: Peter Sorel/Columbia/Photofest; 304, top: Bernie Abramson/Warner Bros-Seven Arts/Kobal Collection; 304, bottom: courtesy of Ann Roth; 305: United Artists/courtesy of Deborah Landis.

**1970s:** 306: Bruce McBroom/20th Century Fox/courtesy of Deborah Landis ; 308, top: 20th Century Fox/Copyright © Twentieth Century Fox All Rights Reserved; 308, bottom: John R. Shannon/Universal/Photofest; 311: Paramount/BFI; 312: Warner Bros./BFI; 313: Robert Willoughby/Warner Bros./Photofest; 314, top: courtesy of AMPAS; 314, bottom left: Mel Traxel/Cinema Center/Kobal Collection ; 314, bottom right: Department of Special Collections, Charles E. Young Research Library, UCLA; 315: Cinema Center/© Bettmann/Corbis; 316: Warner Bros./Photofest; 317: Warner Bros./Kobal Collection; 318, left: Collection of Christian Esquevin; 318, right: Mary Ellen Mark/Avco Embassy/Photofest; 319: Mary Ellen Mark/Avco Embassy/courtesy of Deborah Landis; 320: ABC/Allied Artists/Kobal Collection; 321: ABC/Allied Artists/© Douglas Kirkland/Corbis; 322: Randy Munkacsi/MGM/Photofest; 323: Warner Bros./Kobal Collection; 324, top: Paramount/BFI; 324, bottom: Paramount/BFI; 325: Paramount/BFI; 326, top: Columbia/Kobal Collection; 326, bottom left: Lucasfilm/Coppola/Universal/courtesy of Deborah Landis; 326, bottom right: Lucasfilm/Coppola/Universal/Kobal Collection; 327: Paramount/Photofest; 328, top left: courtesy of Yvonne Blake; 328, top right: courtesy of Yvonne Blake; 328, bottom: Film Trust Production/courtesy of Deborah Landis; 329: Film Trust Production/Kobal Collection; 330: Paramount/Kobal Collection; 331, top: 20th Century Fox/Kobal Collection; 331, middle: Paramount/Kobal Collection; 331, bottom: Jack Geraghty/Paramount/Photofest; 332, top: courtesy of AMPAS; 332, bottom: Universal Pictures/MPTV.net; 333: Universal Pictures/MPTV.net; 334, top left: courtesy of AMPAS; 334, top right: Paramount/MPTV.net; 334, bottom right: Paramount/BFI; 335: Paramount/BFI; 336, top left: Paramount/BFI; 336, top right: courtesy of AMPAS; 336, bottom left: Paramount/BFI; 336, bottom right: Collection of Forrest Paulette and Robert Evanko; 337: Paramount/BFI; 338–39: Paramount/BFI; 339, top right: Paramount/Collection of Tom Culver; 340: Paramount/The Everett Collection; 341, left: courtesy of AMPAS; 341, right: Paramount/courtesy of AMPAS; 342, top: United Artists/MPTV.net; 342, bottom: Peter Sorel/Fantasy Films/United Artists; 343: United Artists/Photofest; 344, top left: 20th Century Fox/Photofest; 344, top right: 20th Century Fox/courtesy of Deborah Landis; 344, bottom left: United Artists/courtesy of Deborah Landis; 344, bottom right: United Artists/Photofest; 345: 20th Century Fox/Photo by John Jay/MPTV.net; 346, left: courtesy of AMPAS; 346, right: courtesy of AMPAS; 347: Peter Sorel/Columbia/Kobal Collection; 348, left: Columbia/BFI; 348, right: Columbia/courtesy of Deborah Landis; 349: Columbia/courtesy of Deborah Landis; 350, top left: 20th Century Fox/Photofest; 350, top right: 20th Century Fox/courtesy of Deborah Landis; 350–51, bottom: 20th Century Fox/courtesy of Deborah Landis; 351, right: John Jay/20th Century Fox/courtesy of Deborah Landis; 352, top: courtesy of Patrizia von Brandenstein; 352, bottom: Paramount/MPTV.net; 353, top left: courtesy of Albert Wolsky; 353, top right: Dave Friedman/Paramount/Kobal Collection; 353, bottom: Paramount/Kobal Collection; 354: Michael Ginsburg/United Artists/Kobal Collection; 355: 20th Century Fox/Copyright © Twentieth Century Fox All Rights Reserved; 356, top: courtesy of Deborah Landis; 356, bottom: John R. Shannon/Universal/courtesy of John Landis; 357: John R. Shannon/Universal/courtesy of John Landis; 358, bottom left: Josh Weiner/20th Century Fox/Columbia/Kobal Collection; 358, top right: courtesy of AMPAS; 359, top: courtesy of Albert Wolsky; 359, bottom: 20th Century Fox/Neal Peters Collection; 360, top left: Greer Cavagnaro/Katrina Franken/Universal/Kobal Collection; 360, top right: Universal/courtesy of Deborah Landis; 360, bottom: Universal/courtesy of Deborah Landis; 361, left: Robert Penn/20th Century Fox/Photofest; 361, right: Robert Penn/20th Century Fox/Neal Peters Collection; 363: John R. Shannon/ITC/Photofest; 364: courtesy of AMPAS; 365: United Artists/© 1979 Ed Thrasher/MPTV.net.

**1980s:** 366: Paramount/Neal Peters Collection; 369, left: Bruce McBroom/Universal/courtesy of Deborah Landis; 369, right: courtesy of Deborah L. Scott; 370: George Whitear/Universal/courtesy of Deborah Landis; 371: Andrew D. Schwartz/20th Century Fox/Kobal Collection; 373: United Artists/courtesy of AMPAS; 374, top: Muky Muncasi/Robert Penn/Paramount/courtesy of Deborah Landis; 374, bottom: Paramount/courtesy of Deborah Landis; 375, top left: courtesy of Joe Tompkins; 375, top right: Don Smetzer/Universal Pictures/courtesy of Deborah Landis; 375, bottom: Ron Phillips/Emvantron Media/courtesy of Deborah Landis; 376: courtesy of AMPAS; 377: Frank Connor/Paramount/Kobal Collection; 378: courtesy of Lucasfilm; 379: Albert Clark/Paramount/courtesy of Lucasfilm; 380: Brian Hamill/Columbia/Kobal Collection; 381:

Zade Rosenthal/Paramount/courtesy of Deborah Landis; 382, top left: courtesy of Michael Kaplan; 382, top right: The Ladd Company/Warner Bros./BFI; 382, bottom left: courtesy of Michael Kaplan; 382, bottom right: The Ladd Company/ Warner Bros./BFI; 383: The Ladd Company/Warner Bros./Photofest; 384: Sidney Baldwin/Universal/Kobal Collection; 385: Universal/The Everett collection; 386, left: courtesy of Ann Roth; 386, right: courtesy of Ann Roth; 387: Zade Rosenthal/TriStar/Kobal Collection; 388: Michael Ginsburg/Columbia/Photofest; 389, top: Peter Sorel/Universal Pictures/courtesy of John Landis; 389, bottom left: courtesy of Ann Roth; 389, bottom right: Zade Rosenthal/20th Century Fox/Kobal Collection; 390, left: courtesy of Milena Canonero; 390, right: Frank Connor/Universal/Kobal Collection; 391: Universal/courtesy of Deborah Landis; 392, top left: courtesy of Marilyn Vance; 392, top right: courtesy of Marilyn Vance; 392, bottom: Universal/Kobal Collection; 393: Laurel Moore/Paramount/Kobal Collection; 394: Zade Rosenthal/Paramount/Kobal Collection; 395, top: Eric Leibowitz/Morgan Creek/20th Century Fox/courtesy of Deborah Landis; 395, bottom: Jurgen Vollmer/David Whittaker/MGM/Photofest; 396, top left: courtesy of James Acheson; 396, top right: Angelo Novi/Yanco/TAO/Recorded Picture Co./Kobal Collection ; 396, bottom left: courtesy of James Acheson; 396, bottom right: courtesy of James Acheson; 397: Yanco/TAO/Recorded Picture Co/© Fabian Cevallos/Corbis Sygma; 398, top: courtesy of James Acheson; 398, bottom: Etienne George/Warner Bros./Kobal Collection; 399: Warner Bros./Neal Peters Collection; 400, top left: courtesy of AMPAS; 400, top right: Jane O'Neal/Geffen/Warner Bros./courtesy of AMPAS; 400, bottom: courtesy of AMPAS; 401: Jane O'Neal/Geffen/Warner Bros./courtesy of AMPAS; 402, top left: courtesy of Deborah Landis; 402, middle left: courtesy of Deborah Landis; 402, bottom left: Bruce McBroom/Paramount/Photofest; 402, right: Lord Snowdon/Paramount/courtesy of Deborah Landis; 403, top: Andrew D. Schwartz/Jean Pagliuso/20th Century Fox/Kobal Collection; 403, bottom: Columbia/Neal Peters Collection; 404, top: Michael Paris/Cinemarque-New World/courtesy of Deborah Landis; 404, bottom: courtesy of Rudy Dillon; 405: Stephen Vaughan/United Artists/courtesy of Deborah Landis; 406, left: Warner Bros./DC Comics/courtesy of Deborah Landis; 406, top right: courtesy of Bob Ringwood; 406, bottom right: courtesy of Bob Ringwood; 407: Warner Bros./DC Comics/BFI.

**1990s**: 408: Dreamworks LLC/Kobal Collection; 410, top: Linda R. Chen/Miramax/Buena Vista/Photofest; 410, bottom: courtesy of Julie Weiss; 411: 20th Century Fox/Paramount/courtesy of 20th Century Fox; 412: Neal Preston/Dreamworks LLC/courtesy of Deborah Landis; 413, left: courtesy of Mark Bridges; 413, right: Gillian Lefkowitz/New Line/courtesy of Mark Bridges; 415: Dirck Halstead/Warner Bros./courtesy of Deborah Landis; 416: courtesy of Western Costume Company; 417: Zade Rosenthal/20th Century Fox/courtesy of AMPAS; 418, top left: Cineplex-Odeon Films/Photofest; 418, top right: Suzanne Hanover/Cineplex-Odeon Films/courtesy of Deborah Landis; 418, bottom: Ron Batzdorff/Touchstone Pictures/Photofest; 419: Ron Batzdorff/Touchstone Pictures/courtesy of Marilyn Vance; 419, bottom left: courtesy of AMPAS; 419, bottom right: Ron Batzdorff/Touchstone Pictures/Photofest; 420: courtesy of Milena Canonero; 421: Touchstone/Neal Peters Collection; 422, top left: courtesy of Marlene Stewart; 422, top right: Carolco Pictures/Kobal Collection; 422, bottom left: D. Stevens/Columbia/Kobal Collection; 422, bottom right: courtesy of Darryle Johnson; 423: Roland Neveu/MGM/Pathé/Photofest; 424: courtesy of Albert Wolsky; 425: TriStar/Neal Peters Collection; 426, top left: courtesy of Ruth Carter; 426, top right: Warner Bros./Neal Peters Collection; 426, bottom: David Lee/Warner Bros./Kobal Collection; 427: Firooz Zahedi/Carolco Pictures/Photofest; 428, top left: courtesy of Eiko Ishioka; 428, top right: Columbia/Neal Peters Collection; 428, bottom left: courtesy of Eiko Ishioka; 428, bottom right: Columbia/Neal Peters Collection; 429: Ralph Nelson, Jr./American Zoetrope/Columbia/Tri-Star/courtesy of Deborah Landis; 430: Columbia/Neal Peters Collection; 430, right inset: courtesy of Eiko Ishioka; 431, left: Columbia/Photo by Phillip Caruso/MPTV.net; 431, right: Phillip V. Caruso/Columbia/courtesy of Deborah Landis; 432, left: courtesy of Mark Bridges; 432, right: courtesy of Mark Bridges; 433: Warner Brothers/Photo by Sidney Baldwin/MPTV.net; 434, top: courtesy of Jeffrey Kurland; 434, bottom: Brian Hamill/Magnolia/Sweetland/Photofest; 435, top: courtesy of Joseph Porro; 435, bottom: Claudette Barius/Le Studio Canal (US)/Carolco Pictures/Kobal Collection; 436, top left: Peter Iovino/Paramount/courtesy of Deborah Landis; 436, top right: courtesy of Renée Ehrlich Kalfus; 436, bottom: Linda R. Chen/Live Entertainment/courtesy of Deborah Landis; 437, top: courtesy of Joanna Johnston; 437, bottom: Paramount/Neal Peters Collection; 438, left: courtesy of Ruth Myers; 438, right: Melinda Sue Gordon/Orion/Paramount/courtesy of Deborah Landis; 439: Miramax/Buena Vista/The Everett Collection; 440, top: courtesy of Mona May; 440, bottom: Elliott Marks/Paramount/Kobal Collection; 441: Elliott Marks/Paramount/Kobal Collection; 442: Phillip V. Caruso/Universal/courtesy of Deborah Landis; 443, top: Phillip V. Caruso/Universal/courtesy of Deborah Landis; 443, middle: Universal/BFI; 443, bottom: Phillip V. Caruso/Universal/courtesy of Deborah Landis; 444: Frank Trapper/Andrew Cooper/Icon/Ladd Co./Paramount/Photofest; 445: Gramercy Pictures/Neal Peters Collection; 446: courtesy of Anthony Powell; 447: Clive Coote/Walt Disney Pictures/courtesy of Anthony Powell; 448, top left: courtesy of James Acheson; 448, top middle: David Appleby/Segue Productions/Avenue Pictures/Kobal Collection; 448, top right: courtesy of James Acheson; 448, bottom: Miramax/Neal Peters Collection; 449: Alex Bailey/Polygram/Kobal Collection ; 450: courtesy of Deborah L. Scott; 451: Merie W. Wallace/20th Century Fox/Paramount/courtesy of AMPAS; 452: courtesy of Deborah L. Scott; 20th Century Fox/Copyright © Twentieth Century Fox All Rights Reserved; 454, top: courtesy of Mary Vogt; 454, bottom: Columbia/Neal Peters Collection ; 455, top left: courtesy of Deena Appel; 455, top right: courtesy of Deena Appel; 455, bottom: Kimberly Wright/New Line/courtesy of Deborah Landis; 456: Monarchy/Regency/© Corbis Sygma; 457, left: courtesy of Ruth Myers; 457, right: Merrick Morton/Monarchy/Regency/courtesy of Deborah Landis; 458–59: Gillian Lefkowitz/New Line/courtesy of AMPAS; 460: Gramercy Pictures/MPTV.net; 461: Jennifer Carchman/Suburban/courtesy of Deborah Landis; 462: Bill Matlock/Fox Searchlight/Kobal Collection; 463: Ralph Nelson/Jr., John Baer/TriStar/Gracie Films/Photofest; 464, top left: courtesy of Colleen Atwood; 464, top right: courtesy of Colleen Atwood; 464, bottom: Ken Regan/Touchstone/Photofest; 465: Ken Regan/Touchstone/Photofest; 466, left: Miramax/Photo by Laurie Sparham/MPTV.net; 466, right: courtesy of Sandy Powell; 467: Miramax/Photo by Laurie Sparham/MPTV.net; 468: Miramax/Universal/© Corbis Sygma; 469, left: courtesy of Sandy Powell; 469, right: Laurie Sparham/Miramax/Universal/Kobal Collection; 470, left: Jasin Boland/Warner Bros./courtesy of Deborah Landis; 470, right: courtesy of Kym Barrett; 471, left: courtesy of Kym Barrett; 471, right: Jasin Boland/Warner Bros./courtesy of Deborah Landis; 472: Merrick Morton/20th Century Fox/Kobal Collection; 473, left: courtesy of Michael Kaplan; 473, middle: courtesy of Michael Kaplan; 473, right: Merrick Morton/20th Century Fox/courtesy of Deborah Landis; 475: Keith Hamshere/Lucasfilm/Photofest.

**2000s**: 476: Jaap Buitendijk/Warner Bros./Kobal Collection; 479: Dreamworks LLC/Photofest; 480: Dreamworks LLC/BFI; 481: Merie W. Wallace/Warner Bros./courtesy of Deborah Landis; 482, top left: courtesy of Colleen Atwood; 482, top right: Miramax/courtesy of Colleen Atwood; 482, bottom: David James/Miramax/courtesy of Colleen Atwood; 483: David James/Miramax/courtesy of Colleen Atwood; 484: courtesy of Jeffrey Kurland; 485: Bob Marshak/Universal/Kobal Collection; 486, top: courtesy of Betsy Heimann; 486, bottom: Neal Preston/Dreamworks LLC/courtesy of Deborah Landis; 487, top: courtesy of Mary Zophres; 487, bottom: Tracy Bennett/Capitol/Granada/Jersey/UA/courtesy of Mary Zophres; 488, top: courtesy of Jacqueline West; 488, bottom: David Appleby/Fox Searchlight/Kobal Collection; 489, top left: courtesy of Janty Yates; 489, top right: courtesy of Janty Yates; 489, bottom: Jaap Buitendijk/Dreamworks LLC/Universal/courtesy of Deborah Landis; 490–92: Warner Brothers/Photo by Bob Marshak/MPTV.net; 491, top: courtesy of Jeffrey Kurland; 491, middle: courtesy of Jeffrey Kurland; 491, bottom: courtesy of Jeffrey Kurland; 492: courtesy of Sophie de Rakoff Carbonelle; 493: Tracy Bennett/MGM/courtesy of Deborah Landis; 494: courtesy of Judianna Makovsky; 495: Peter Mountain/Warner Bros./courtesy of AMPAS; 496: courtesy of Karen Patch; 497: James Hamilton/Touchstone/courtesy of Karen Patch; 498: courtesy of Bazmark; 499: Sue Adler/Merick Morton/Ellen von Unwerth/20th Century Fox/Bazmark; 500, top left: courtesy of Ngila Dickson; 500, top right: New Line/Photo by Michael O'Neill/MPTV.net; 500, bottom left: courtesy of Ngila Dickson; 500, bottom right: New Line/courtesy of Ngila Dickson; 501, right: New Line/courtesy of Deborah Landis; 502: Miramax Films/Dimension Films/Photofest; 503: courtesy of Julie Weiss; 504, left: Paramount/Miramax/© Steve Sands/New York Newswire/Corbis; 504, right: courtesy of Ann Roth; 505, left: courtesy of Ann Roth; 505, right: Clive Coote/Paramount/Miramax/courtesy of Deborah Landis; 506: Zade Rosenthal/Columbia/Marvel/courtesy of Deborah Landis; 507, top: Aaron Ruell/Access Films/MTV Films/Napoleon Pictures Ltd/courtesy of Deborah Landis; 507, bottom: 20th Century Fox/Kobal Collection ; 508: courtesy of Sandy Powell; 509: Miramax/Neal Peters Collection; 510, top: Dale Robinette/Fox Searchlight/Photofest; 510, bottom left: courtesy of Deborah Hopper; 510, bottom right: Merie W. Wallace/Warner Bros./courtesy of Deborah Landis; 511: Brandy Eve Allen/20th Century Fox/courtesy of Deborah Landis; 512, top: courtesy of Penny Rose; 512, bottom: Elliott Marks/Walt Disney Pictures/Kobal Collection; 513: Elliott Marks/Walt Disney Pictures/courtesy of Deborah Landis; 514, top left: 20th Century Fox/Regency/The Everett Collection; 514, top right: courtesy of Daniel Orlandi; 514, bottom left: Merrick Morton/20th Century Fox/Regency/Photofest; 514, bottom right: courtesy of Daniel Orlandi; 515: Suzanne Tenner/Fox 2000/20th Century Fox/Photofest; 516, top: Andrew Cooper/A Band Apart/Miramax Films/Kobal Collection; 516, bottom: courtesy of Catherine Thomas; 517: Andrew Cooper/A Band Apart/Miramax Films/courtesy of Catherine Thomas; 518: courtesy of Rhona Meyers; 519: Gene Page/MDP/New Market/courtesy of Rhona Meyers; 520: courtesy of Colleen Atwood; 520, bottom: David James/Columbia/Dreamworks/Spyglass/Kobal Collection; 521: courtesy of Bob Ringwood; 523: Alex Bailey/Warner Bros./courtesy of Deborah Landis; 524, top left: courtesy of Colleen Atwood; 524, top middle: courtesy of Colleen Atwood; 524, top right: courtesy of Colleen Atwood; 524, bottom: Francois Duchamel/Paramount/courtesy of Deborah Landis; 525: Paramount/courtesy of Deborah Landis; 526: Nicola Goode/Universal/courtesy of Deborah Landis; 527, top: David C. Lee/Focus Features/courtesy of Deborah Landis; 527, bottom: Philippe Antonello/Touchstone Pictures/Collectin of Deborah Landis; 528, top left: courtesy of Sandy Powell; 528, bottom left: courtesy of Sandy Powell; 528, right: Andrew Cooper/Warner Bros./Kobal Collection; 529: Andrew Cooper/Warner Bros./Kobal Collection; 530–31: Kimberly French/Focus Features/Kobal Collection; 532: courtesy of Deborah Hopper; 533, top: Merie W. Wallace/Warner Bros./Kobal Collection; 533, bottom: Merie W. Wallace/Warner Bros./courtesy of Deborah Landis; 534: courtesy of Isis Mussenden; 535: Phil Bray/Walt Disney Pictures/Walden Media/Kobal Collection; 537: Brigitte Lacombe/20th Century Fox/Kobal Collection; 538, left: Andrew Cooper/ Warner Bros./Kobal Collection; 538–39, middle: Andrew Cooper/ Warner Bros./Kobal Collection; 539, right: Andrew Cooper/ Warner Bros./Kobal Collection; 540, top left: courtesy of Jacqueline West; 540, top right: Merie W. Wallace/New Line Cinema/Kobal Collection; 540, bottom left: courtesy of Jacqueline West; 540, bottom right: New Line Cinema/courtesy of Deborah Landis; 541: Merie W. Wallace/New Line Cinema/courtesy of Deborah Landis; 542: Columbia/Pathé/Sony/Kobal Collection; 543: Columbia/Pathé/Sony/Kobal Collection; 544: courtesy of 20th Century Fox/Fox Searchlight Pictures.

# INDEX